MEDIEVAL ART
PAINTING · SCULPTURE · ARCHITECTURE
4TH-14TH CENTURY

MEDIEVAL ART

PAINTING · SCULPTURE · ARCHITECTURE
4TH-14TH CENTURY

JAMES SNYDER

Prentice Hall, Inc.

Harry N. Abrams, Inc.

For Kit

Project Director: SHEILA FRANKLIN LIEBER

Editor: JOANNE GREENSPUN

Designer: DIRK J. VAN O. LUYKX

Photo Research: JENNIFER BRIGHT

Library of Congress Cataloging-in-Publication Data
Snyder, James.
 Medieval art: painting-sculpture-architecture. 4–14th century/
James Snyder.
 p. cm.
 Bibliography: p. 487
 Includes index.
 1. Art, Medieval. 2. Christian art and symbolism—Medieval,
500–1500. I. Title.
N5975.S58 1988b 709'.02–dc19 88–9909
ISBN 0-13-573494-0

Prentice Hall, Inc.
Englewood Cliffs, New Jersey 07632
A Paramount Communications Company

Printed and bound in Japan

CONTENTS

PREFACE AND ACKNOWLEDGMENTS

The term "medieval" is derived from the Latin *medius* (middle) and *aevum* (age). It is generally applied to the era that lies between the demise of the Greco-Roman world and the beginnings of the Renaissance in Europe. Opinions vary as to the dates when the Medieval period begins and ends, however. For this book I have chosen the dates just prior to the reign of Constantine the Great, the first Roman emperor to sanction the Christian church (Edict of Milan, A.D. 313), to the second quarter of the fourteenth century, when Europe was devastated by the Black Death. The one unifying factor in European culture between those dates was the Christian church, and the arts that survive are for the great part those that served the church and the worshippers.

It is impossible to survey a thousand years of art in a comprehensive fashion in one volume. Nor can one hope to give a thorough analysis of architectural structure for such a vast period with changing styles. For these reasons I have focused my attention on the Christian house of worship as a theater of the arts. I am more concerned with the symbolic and aesthetic qualities of buildings and their decorations than with their external form. Remarkable continuities in the arts existed from the period of the Early Christian basilica to that of the Gothic cathedral in terms of programs of decoration and style of presentation, whether they be in the medium of mosaics, frescoes, sculptures, or stained glass. I have concentrated my discussion mostly on the church arts of Italy, Byzantium, France, and Germany.

I am indebted to many teachers, colleagues, and students for the ideas presented here. While a graduate student at Princeton I was stimulated by the fascinating seminars and lectures of Albert Mathias Friend, Jr., that dealt with Early Christian and Byzantine iconography.

Earl Baldwin Smith opened my eyes to the complexities of architectural types and symbols. Professor Kurt Weitzmann introduced me to the study of narrative cycles in book illustration, a subject that has never ceased to fascinate me. To these great scholars I owe very much, although I am not sure that they would endorse some of the ideas and conclusions presented here.

My students and colleagues at Bryn Mawr are a constant source of help and inspiration. Among my colleagues I owe special thanks to Dale Kinney, Phyllis Bober, and Charles Mitchell for their conversations and ideas. Myra Uhlfelder and Gloria Ferrari Pinney helped me with problems in Latin translations. I also thank Eileen Markson, who was untiring in solving library problems at every stage in the research. Mary Campo and Jerry Lindsay were very helpful in keeping my correspondence in order.

Finally, a very special thanks are due to Sheila Franklin Lieber and her excellent staff at Abrams. Without the help of my editor, Joanne Greenspun, with whom I spent long hours in consultation, this book would never have reached the press. Jennifer Bright arduously but lovingly sought out the photographs and colorplates reproduced here, and Dirk Luykx, with Jean Smolar, did the handsome design and layout for the book. I would also like to express my gratitude to an astute scholar, known to me only as "reader number two," who offered a number of excellent suggestions regarding this material and the composition of the text.

James Snyder
Bryn Mawr
April 1988

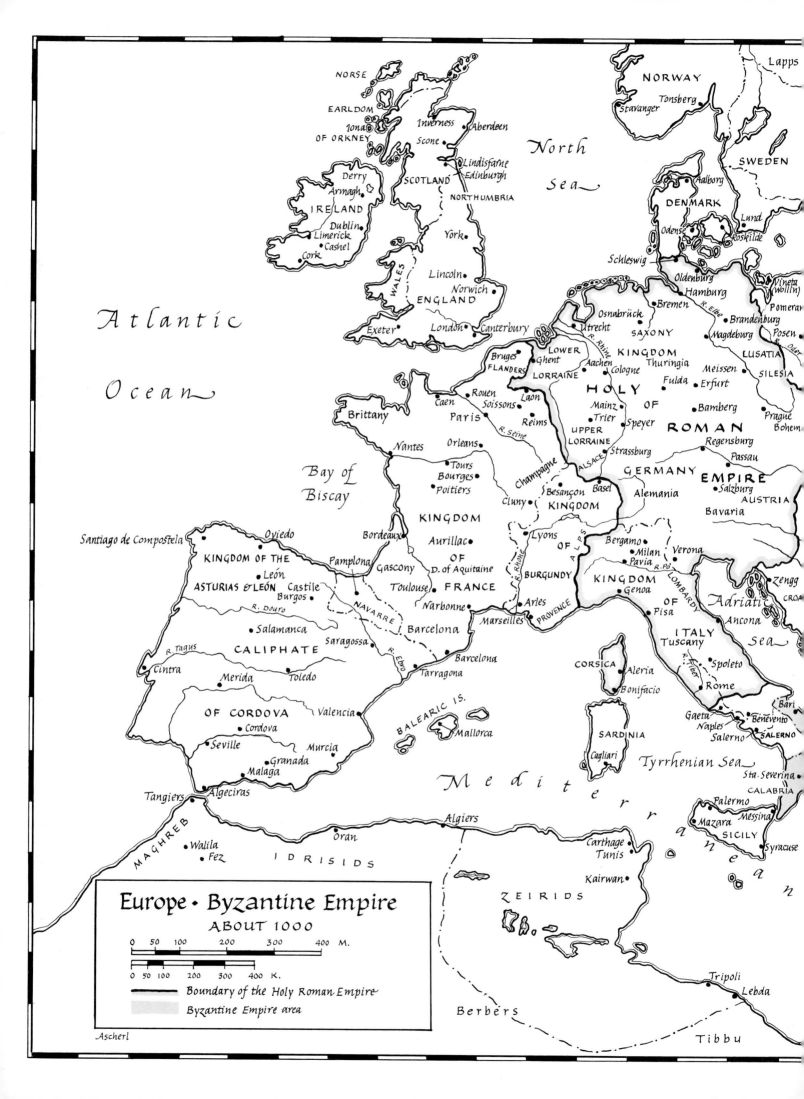

NORSE

EARLDOM
OF ORKNEY

Iona

Derry
Armagh

IRELAND

Dublin
Limerick
Cashel

Cork

Inverness
Scone
Aberdeen

SCOTLAND

Lindisfarne
Edinburgh

NORTHUMBRIA

York

WALES

Lincoln

Norwich

ENGLAND

Exeter

London
Canterbury

North

Sea

Lapps

NORWAY
Tonsberg
Stavanger

SWEDEN

Aalborg

DENMARK

Lund

Odense
Roskilde

Schleswig

Oldenburg
Hamburg

Vineta
(Wollin)

Pomerania

Bremen

R. Elbe

Brandenburg

Osnabrück

Posen

Utrecht

SAXONY

Magdeburg

LUSATIA

Atlantic

Ocean

Bruges
Ghent

FLANDERS

LOWER

LORRAINE

Aachen

KINGDOM

Cologne

Thuringia

R. Rhine

HOLY

Meissen

SILESIA

Fulda

Erfurt

Rouen
Caen

Soissons

Laon

OF

Prague

Bohem.

Brittany

Paris

Reims

Mainz
Trier

Speyer

ROMAN

Bamberg

UPPER

Regensburg

Passau

R. Seine

LORRAINE

Strassburg

Nantes

Orleans

Champagne

ALSACE

GERMANY

EMPIRE

Bay of

Biscay

Tours
Bourges
Poitiers

Cluny

Besançon

Basel

Alemania

Salzburg

AUSTRIA

KINGDOM

KINGDOM

Bavaria

Santiago de Compostela

Oviedo

Bordeaux

AURILLAC

OF

Lyons

OF

Bergamo

Verona

KINGDOM OF THE

Pamplona

Gascony

D. of Aquitaine

R. Rhone

BURGUNDY

Milan
Pavia

Zengg

León

ASTURIAS & LEÓN

Castile

FRANCE

ALPS

R. Po

KINGDOM

Adriatic

CROA.

Burgos

Toulouse

Genoa

LOMBARDY

R. Douro

NAVARRE

Narbonne

OF

Pisa

Ancona

Salamanca

Saragossa

Arles

PROVENCE

Marseilles

ITALY

Sea

CALIPHATE

R. Tagus

R. Ebro

Barcelona

Tuscany

R. Tiber

Spoleto

Cintra

Toledo

Tarragona

CORSICA

Aleria

Rome

Merida

Bonifacio

OF CORDOVA

Valencia

BALEARIC IS.

Gaeta

Bari

Cordova

Mallorca

Naples

Benevento

Seville

Murcia

SARDINIA

Salerno

SALERNO

Granada

Cagliari

Sta. Severina

Malaga

Tyrrhenian Sea

CALABRIA

Tangiers

Algeciras

Palermo

MAGHREB

Algiers

Mazara

Messina

Walila

Oran

SICILY

Syracuse

Fez

IDRISIDS

Mediterranean

Carthage
Tunis

ZEIRIDS

Kairwan

Europe · Byzantine Empire
ABOUT 1000

0 50 100 200 300 400 M.

0 50 100 200 300 400 K.

———— Boundary of the Holy Roman Empire

Byzantine Empire area

Ascherl

Tripoli
Lebda

Berbers

Tibbu

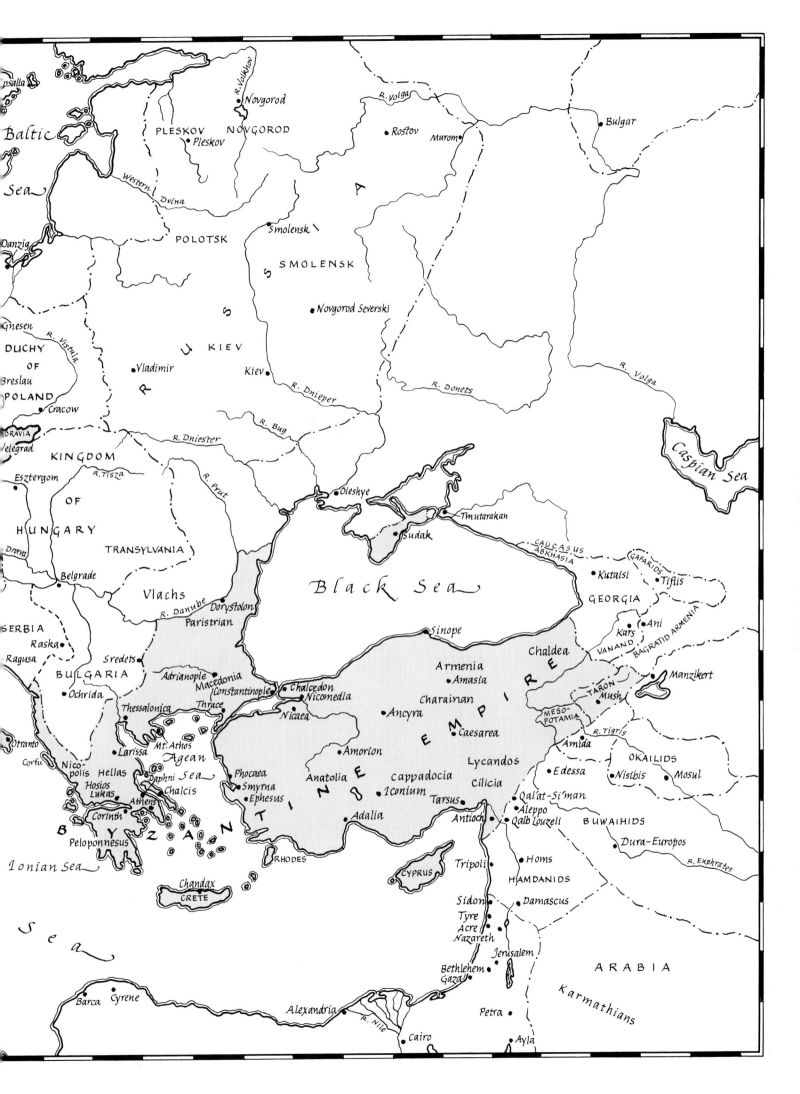

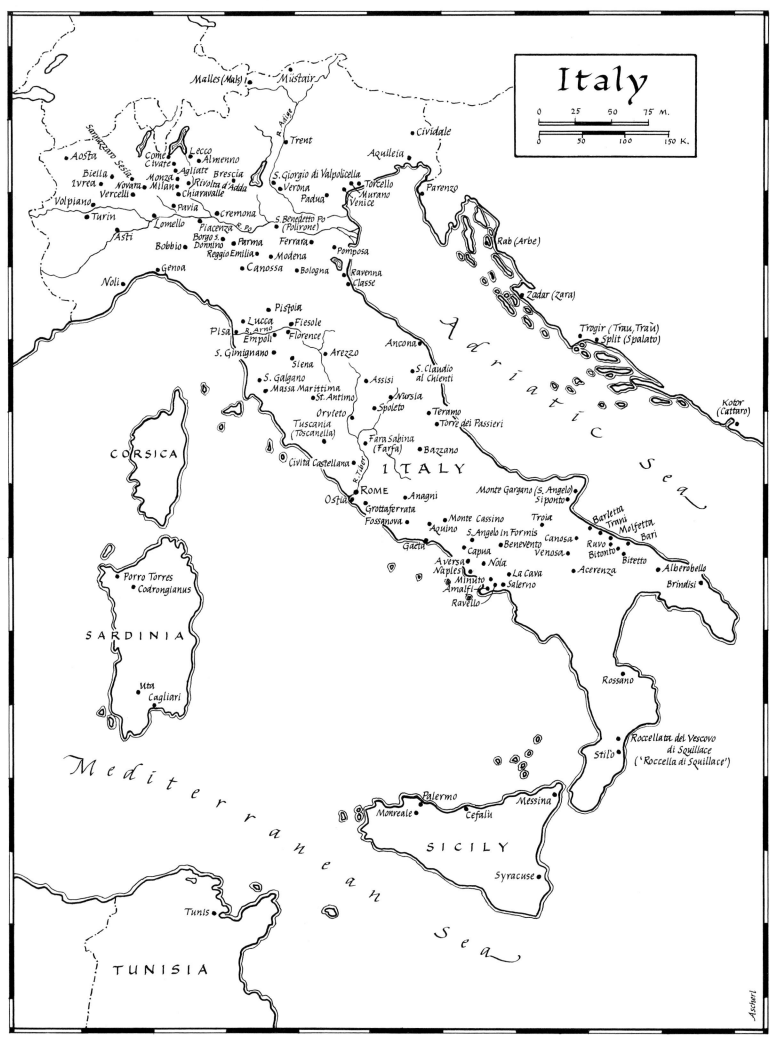

Italy

0 25 50 75 M.

0 50 100 150 K.

Malles (Mals)
Müstair
Cividale
R. Adige
Trent
Aquileia
Aosta
Sanguazaro Sesia
Como
Lecco
Almenno
Civate
Agliate
Brescia
S. Giorgio di Valpolicella
Biella
Monza
Verona
Torcello
Parenzo
Ivrea
Novara
Milan
Rivolta d'Adda
Murano
Vercelli
Chiaravalle
Padua
Venice
Volpiano
Pavia
Cremona
Turin
Lomello
Piacenza
R. Po
S. Benedetto Po
(Polirone)
Rab (Arbe)
Asti
Borgo S.
Donnino
Parma
Ferrara
Pomposa
Bobbio
Reggio Emilia
Modena
Canossa
Bologna
Ravenna
Classe
Zadar (Zara)
Genoa
Noli
Pistoia
Lucca
Fiesole
Pisa
R. Arno
Trogir (Trau, Traù)
Empoli
Florence
Split (Spalato)
S. Gimignano
Arezzo
Ancona
Siena
S. Claudio
al Chienti
S. Galgano
Assisi
Massa Marittima
St. Antimo
Nursia
CORSICA
Orvieto
Spoleto
Tuscania
(Toscanella)
Teramo
Torre dei Passieri
Kotor
(Cattaro)
Fara Sabina
(Farfa)
Bazzano
R. Tuber
ITALY
Civita Castellana
ROME
Monte Gargano (S. Angelo)
Ostia
Anagni
Siponto
Adriatic Sea
Grottaferrata
Troia
Barletta
Monte Cassino
Trani
Molfetta
Fossanova
Aquino
Canosa
Ruvo
Bari
S. Angelo in Formis
Bitonto
Gaeta
Benevento
Venosa
Bitetto
Aversa
Capua
Nola
Acerenza
Alberobello
Naples
La Cava
Porro Torres
Minuto
Salerno
Brindisi
Codronglanus
Amalfi
Ravello
SARDINIA
Rossano
Uta
Cagliari
Roccellata del Vescovo
di Squillace
('Roccella di Squillace')
Stil'o
Mediterranean
Palermo
Messina
Monreale
Cefalù
SICILY
Syracuse
Sea
Tunis
TUNISIA

Ascherl

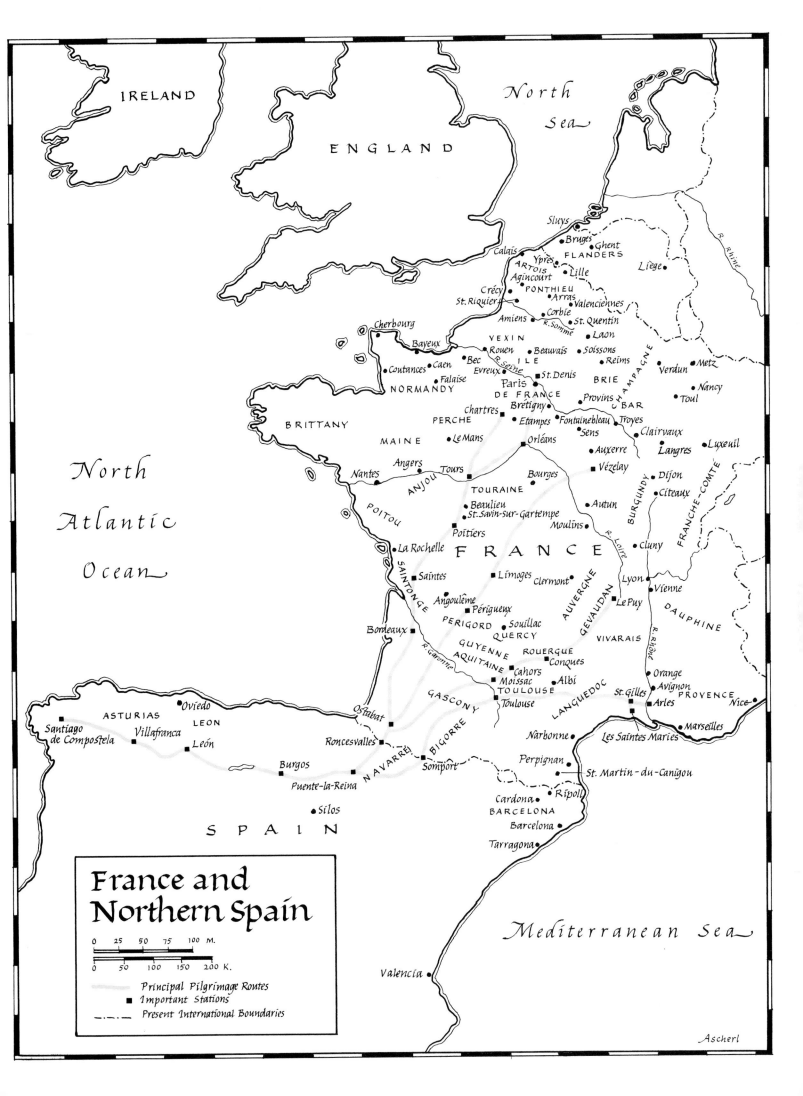

IRELAND

North Sea

ENGLAND

North Atlantic Ocean

Sluys
Bruges
Ghent
Calais
Ypres
FLANDERS
Liège
ARTOIS
Agincourt
Lille
Crécy
PONTHIEU
St. Riquier
Arras
Valenciennes
Amiens
Corbie
St. Quentin
R. Somme
Cherbourg
Laon
VEXIN
Bayeux
Rouen
Beauvais
Soissons
Reims
Verdun
Metz
Coutances
Caen
Bec
ILE
Evreux
R. Seine
St. Denis
BRIE
Nancy
NORMANDY
Falaise
Paris
Toul
DE FRANCE
Provins
BAR
BRITTANY
Chartres
Brétigny
Fontainebleau
Troyes
PERCHE
Etampes
Sens
Clairvaux
MAINE
Le Mans
Orléans
Auxerre
Langres
Luxeuil
Angers
Tours
Vézelay
Dijon
Nantes
Bourges
Citeaux
ANJOU
TOURAINE
Autun
BURGUNDY
FRANCHE-COMTÉ
Beaulieu
St. Savin-sur-Gartempe
Moulins
Cluny
POITOU
Poitiers
R. Loire
La Rochelle
F R A N C E
Lyon
Saintes
Limoges
Clermont
Vienne
SAINTONGE
Angoulême
Périgueux
AUVERGNE
Le Puy
DAUPHINE
Bordeaux
PERIGORD
Souillac
GEVAUDAN
QUERCY
VIVARAIS
R. Garonne
GUYENNE
ROUERGUE
Orange
AQUITAINE
Cahors
Conques
Avignon
PROVENCE
Moissac
Albi
St. Gilles
Nice
GASCONY
TOULOUSE
Arles
Ostabat
Toulouse
LANGUEDOC
Marseilles
BIGORRE
Narbonne
Les Saintes Maries
Oviedo
Roncesvalles
Perpignan
ASTURIAS
LEON
NAVARRE
Somport
St. Martin-du-Canigou
Santiago de Compostela
Villafranca
Cardona
Ripoll
León
BARCELONA
Burgos
Puente-la-Reina
Barcelona
Silos
Tarragona
S P A I N
R. Rhine
R. Rhône
CHAMPAGNE

Mediterranean Sea

Valencia

France and Northern Spain

Ascherl

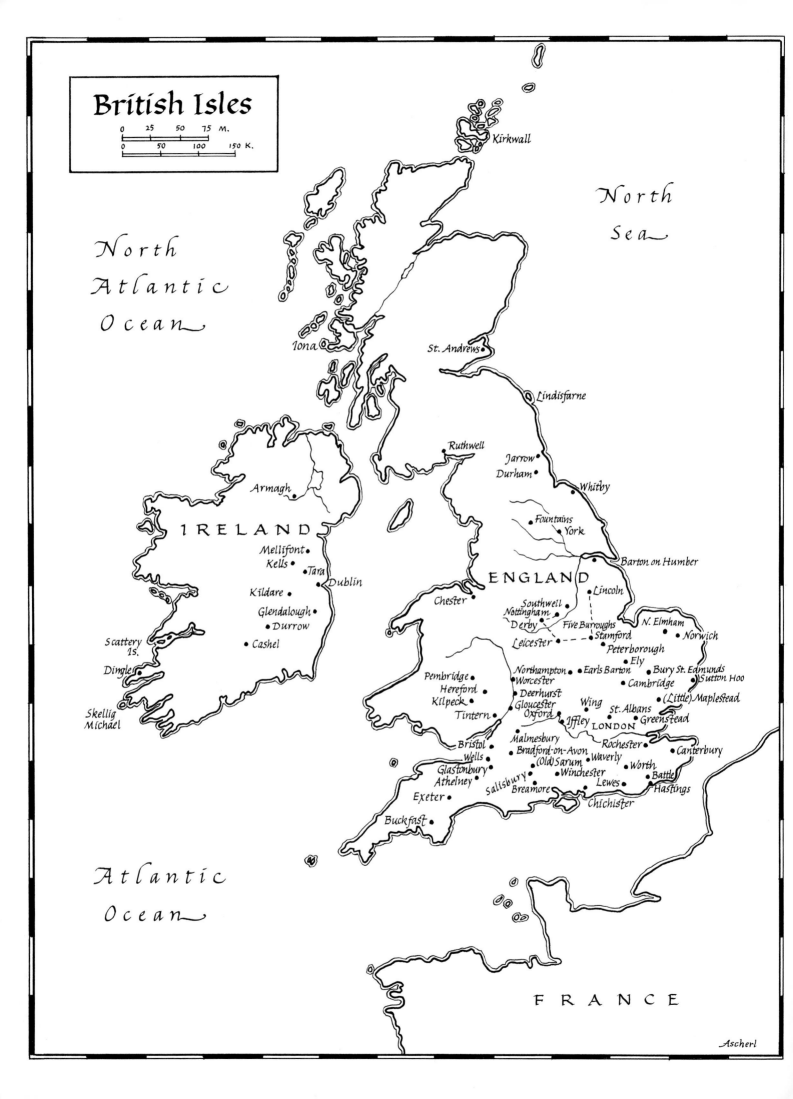

PART ONE

THE BEGINNINGS OF CHRISTIAN ART

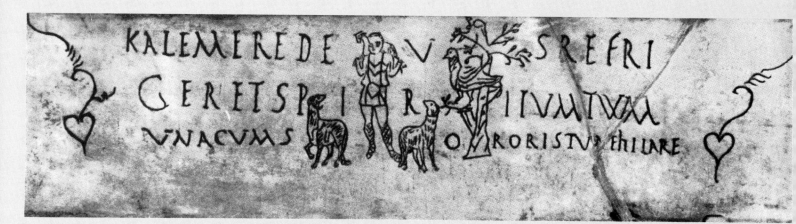

1. *"Kalimere, may God refresh your soul, together with that of your sister, Hilara."* Epitaph from the Roman catacombs. 4th century. Courtyard, Lateran Museum, Rome

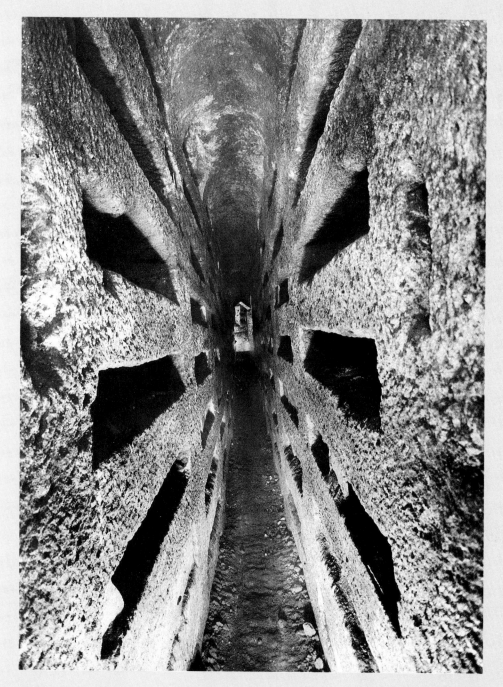

2. Gallery, Catacomb of San Panfilo, Rome. 3rd or 4th century

PEACE AND REFRESHMENT IN LIFE AFTER DEATH

KALIMERE, may God refresh your soul, together with that of your sister, Hilara." These words are coarsely incised on a stone funerary slab today embedded in the wall of the inner courtyard of the Lateran Museum in Rome (fig. 1). The simple but poignant invocation is interrupted by four images scratched across the middle of the Latin words, breaking the continuous flow of letters into fragments that are at first difficult to put together. The central figure is that of a youthful shepherd, garbed in a short tunic and sandals, standing frontally and carrying a lamb across his shoulders. Two sheep, heraldically posed, stand below him with their heads turned upward. To the right a dove perched in an olive tree is added like some childish scribble. These simple sign-images are easy to read: the souls of the deceased and his sister Hilara (the sheep) are commended to God (the Good Shepherd), who dutifully cares for his flock in the peaceful and refreshing pastures of paradise (dove and olive tree).

Hundreds of such decorated funerary inscriptions of the third and fourth centuries have been uncovered in Rome and elsewhere in the Early Christian world, and many of them depict more complex signs, symbols, or pictures than the one cited above. These images have often been found in the tomb chambers of the mysterious subterranean burial sites, the catacombs, once excavated outside the city walls but today frequently discovered buried beneath the debris and landfill of urban expansion.[1]

The earliest arts of the Christians that we now recognize are simple variations on such hieroglyphs, and it was only after the emperor Constantine the Great officially proclaimed Christianity a state religion in A.D. 313 that more sophisticated arts began to appear. But Christianity was a vigorous religion long before Constantine—nearly a third of Rome's population professed it by the time of his conversion—appealing particularly to the masses of lower-class citizenry, who either were excluded from the more hieratic state cults or felt unmoved by the exoticism of the many syncretic sects of Late Antiquity available to them. Christianity, like a number of other mystical faiths that had seeped into Rome from the east Mediterranean world, had an attraction for the common man in that it was simple and direct in its teachings and accessible to anyone willing to join the congregation who believed in the promise of peace and refreshment in life after death.

With few exceptions, the first Christians in Rome were not members of a class that could patronize the arts; as a group their economic status was too meager to promote and finance costly buildings or artistic projects. But even if they had in their midst some of the wealthier citizens of Rome, there were other reasons why sculpture, painting, and imposing edifices were shunned. There was a general distrust among the Christians of anything that remotely evoked the presence of pagan idols in sumptuous temples so long associated with Greco-Roman religions. It is important to remember that Christianity was founded in the east Mediterranean as a mystical cult that was an offshoot of Hebraic teachings in the Old Testament, and so the early Christians had assumed, along with other Mosaic precepts in the Ten Commandments, the one especially relevant for the arts, the second: "Thou shalt not make to thyself a graven thing, nor the likeness of any thing that is in heaven above, or in the earth beneath, nor of those things that are in the waters under the earth. Thou shalt not adore them, nor serve them: I am the Lord thy God, mighty, jealous" (Exod. 20:4–5).

This is the fundamental admonition accounting for the Christian abhorrence of images throughout history, and the basis for iconoclasm (image-breaking) that frequently is provoked by more puritanical sects. The earliest Christian authorities of the church—Origen, Clement of Alexandria, Irenaeus, Tertullian—professed this belief, and at one of the first church synods (conventions or councils) held in Elvira in Spain about A.D. 315, a canon or rule citing the second commandment was included to establish the position of the Christian fathers concerning imagery in the churches.[2]

Yet the arts could not long be so abruptly banished and censured. The world into which Christianity was born was one in which visual imagery served an important role as communication as well as embellishment, as messages as well as objects of adoration. A pictorial language had long existed that illustrated much of the complex state and civic policies to an audience not always capable of or concerned with reading texts; a wealth of pictorial clichés, much as in

modern advertising, informed everyone who walked the streets or gathered in the markets of the cities in the Roman empire. Such communication was vital and was bound to survive. Later we shall see how many of the pagan signs and symbols were appropriated, often with little or no change, for Christian use.

After A.D. 313, with the transformation of the Christian church from a simple, domestic, congregational meeting of *ecclesia* to a state-sponsored spectacle performed before the public in great basilicas, the prohibitions of a few words of the Jewish commandment or the fears of the opponents of paganism were soon to give way to a Christian society that made full use of art, whether in the form of tiny decorative motifs or elaborate public displays, whether enhancing a simple utilitarian object or adorning the walls of monumental edifices rising in abundance within and outside the walls of the city. Already in the fourth century, writers such as Prudentius and Paulinus of Nola leave ample testimonies to the proliferation of images and their use as isolated paintings marking the graves of martyrs or elaborate mural schemes for the decoration of churches. We shall return to their texts later.

One answer to the Jewish rejection of the figurative arts was obvious in a world accustomed to visual imagery. The second commandment was voiced against idols—graven images—to be adored, but it did not condemn pictures that served simply as exempla for those unable to read. Often cited is the pronouncement of Pope Gregory the Great, who, in a letter (c. A.D. 600) to a bishop of Marseilles, explained the point as follows: "Pictures are used in churches in order that those ignorant of letters may by merely looking at the walls read there what they are unable to read in books."[3] Paulinus of Nola implied the same function of pictures when he described their didactic role for the initiates who gathered in the atrium for instructions. Later, more philosophical justifications for the use of pictures based on the doctrine of the Incarnation—God was made man in the flesh—will be mustered by the intellectual fathers of the Byzantine church in reaction to the absolute policies of iconoclasm thrust upon the monastic world in the eighth century by military emperors (see below, p. 128 ff.).

Just what constituted the orthodox position in Christian dogma is not clear until the great council meetings of the fifth century, when the definitions of the natures of Christ (human and divine), the Trinity, the Incarnation, and the role of Christ's mother, Mary, were debated and, for some groups, resolved at least for a time. During the first centuries it appears that the organization of the church was loose and unfocused, with volunteer administrators—the overseers (later bishops) and the stewards (later deacons)—looking after the business of the local congregation (titulus or diocese). The rituals, too, were vague and unclear.[4] It seems that the congregation (*ecclesia*) assembled at sunrise on Sunday for prayer and again at sunset for a meal (cf. the Jewish Sabbath eve meal) beginning with the breaking of the bread (*fractio panis*) and the blessing of wine—the essential elements of the more fully developed sacrament of the Eucharist. Prayers were offered and hymns were sung, and sometimes a special guest or member would deliver a sermon. There was no need for a special architecture for these humble needs. A house would do. Paul speaks of "breaking bread from house to house" (Acts 2:46). The dining room (*triclinium*) of the typical house would suffice for the small numbers participating.

Since the Christians, along with the Jews and many Romans (except for the poor classes), did not normally practice cremation, what were needed were burial grounds, and these took the form of the common open-air cemeteries or underground chambers referred to as catacombs (named after the cemetery, *ad catacumbas,* on the Via Appia, where the Church of San Sebastiano was later built). Many of the Christian cemetery grounds were the collective properties of church organizations legally registered. One of the largest to be excavated, the Catacombs of Callixtus, was, in fact, under the supervision of the deacon Callixtus, a rich banker in the early third century. Roman law protected any tomb as a *locus religiosus,* and even during periods of severe persecution, these sites "outside the walls" of the city were sanctified as inviolable and inalienable property rights.

Nineteenth-century writers of Gothic novels found in the catacombs the romantic settings for eerie tales of frightened Christians gathering in secrecy in dark and scary underground chambers to escape their persecutors, a misconception that still holds today. The catacombs, with few exceptions, were not places for secret meetings and refuge. Rather, they were underground resting places for the dead. They were not only dark, but cramped, labyrinthian, and uncomfortable, with their mephitic air. Let us visit one (fig. 2). Generally entered through a modest portal above ground, the subterranean passages were restricted by law as to size and position along the roads outside the city walls. The narrow galleries and chambers were excavated by *fossores,* members of a kind of guild of gravediggers, from the *tufa,* a rocky but soft stone composed of sand and volcanic ash.

Depending upon the quality of the soil, as many as six layers of galleries could be excavated underground, resulting in ground plans that resemble three-dimensional spider webs. Burial niches, or *loculi,* carved into the gallery walls, were closed by slabs of stone with inscriptions such as that of Kalimere discussed above. Larger chambers, called *cubicula* by archaeologists, formed crypts for family burials or for the commemoration of special sites where martyrs were buried. Some larger tombs, often distinguished by arched niches called *arcosolia,* had room for several burials side by side. The wealthier could afford a stone or lead sarcophagus (coffin), which was often ornamented and elaborately

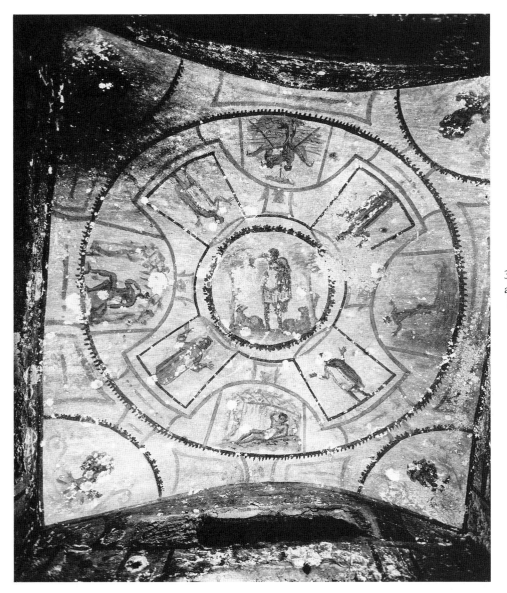

3. *Good Shepherd.* Ceiling painting of a burial chamber in the Catacomb of Saints Peter and Marcellinus, Rome. 4th century

carved. In some of the larger *cubicula* or in buildings erected above the catacombs, Christians gathered for special funerary meals (*agape,* or feast of love) and memorial banquets (*refrigeria,* or refreshments) following the practice of the pagans in honoring their dead. The service or Mass, however, was not regularly performed there.

In these diminutive and mysterious burial caverns the *fossores* and decorators worked to mark the Christian burial sites, especially if a martyr's grave were incorporated in a *cubiculum,* to distinguish them from the pagan tombs. Tertullian wrote that "it is permissible to live with the pagans but not to die with them," and while most of the Christian catacomb decorations repeat the general compositions of traditional pagan tombs—murals with little more than geometric lines to divide the walls and ceilings into boxes, circles, and rectangular compartments—the pictorial motifs added frequently indicate a Christian burial. Along with the ubiquitous "Elysian fields" or paradise garden, often with little more than a few trees, flowers, birds, and urns, one distinguishes the Good Shepherd and his flock (fig. 3), the favorite funerary motif derived from Psalm 23 (see also the parables in Luke 15:4–7 and John 10:11–16): "The Lord is my shepherd, I shall not want; he maketh me to lie down in green pastures. He leadeth me beside still waters; he restoreth my soul . . . Lo, even though I walk through the valley of the shadow of death, I fear no evil."

What is surprising about these cryptic paintings is their freshness and spontaneity of execution. While the decorators were rarely accomplished fresco painters, their quick, sketchy lines softly capture light and shadow playing across forms, and the relaxed gestures effectively repeat the normal conventions for movements and actions in pagan art. The lesser sophistication of the sketchy figures scattered about the field has led some to label them "sub-Antique" in style (a

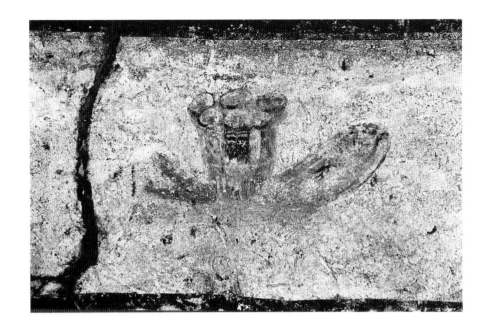

4. *Fish and Bread.* Detail of a painting in the crypt of Lucina in the Catacomb of Callixtus, Rome. 3rd century

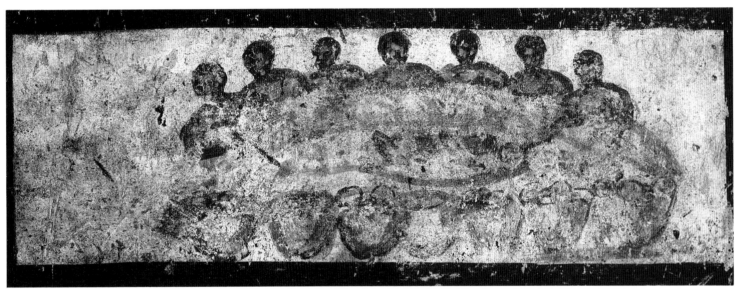

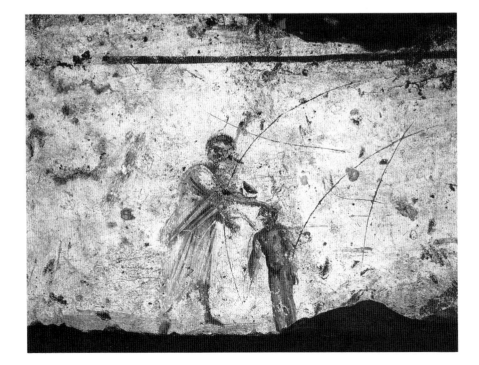

above: 5. *Refrigerium.* Painting in the Catacomb of Callixtus, Rome. 3rd century

right: 6. *Baptism.* Painting in the Catacomb of Callixtus, Rome. 3rd century

debasement of the Classical), and, to be sure, this is true, but in some of them stylistic features are imposed that suggest a conscious groping for a new expression, one that was already developing in Late Antique art, where spiritual and not physical presence was sought.

This is particularly discernible in the *orantes,* or praying figures, symbols of faith for the soul of the deceased. Generally female, they stand rigidly frontal and lift up their hands to the Lord in the ancient attitude of prayer, imploring their God for the deliverance of the dead. As a motif of faith and hope, the *orantes* with uplifted arms also personify the faith of the church in general, and as such often serve as a symbol of *ecclesia.* The same pose was repeated by the priest at the altar in the very heart of the Mass.

The *Donna Velata* (veiled lady) in the Catacomb of Priscilla (colorplate 1) is, in a way, a masterpiece of Early Christian expressionism. The huge, deeply shadowed eyes staring upward and the enlarged hands imploring God's deliverance are dramatically brushed in, conveying a sense of urgency. The praying hands and the enlarged eyes—the windows of the soul—express it all vividly. The body itself is of no consequence; in fact, it is not only hidden but annihilated by the broad vertical strokes that quickly mark out the area of the heavy mantle. In many respects the abstraction of the body to a flat pattern and the exaggeration of the dilated eyes and the distended fingers anticipate the style that we shall come to associate with the Byzantine icon. As an image of faith in prayer, the *Donna Velata* is an accomplished work of art.[5]

A number of the sign-images scattered about the walls can be interpreted as outright statements of belief in the efficacy of the sacraments of the early church. As mentioned above, the liturgical practices of the Christians before the fourth century are vague and poorly documented, but the simple rite of the *fractio panis,* the breaking of the bread, and the blessing of the wine—the body and blood of Christ—while perhaps derived from the pagan funerary *agape,* were also essential aspects of the Mass of the early Christians. The *Fish and Bread* (fig. 4) painted on the wall of the crypt of Lucina in the Catacomb of Callixtus surely was intended to evoke the association of the body and blood of the Savior. Very early on the fish was a symbol of Christ, derived from the acronym of his title in Greek, "Jesus Christ, Son of God, Savior," which became *Ichthys,* or fish. According to Prosper of Aquitaine the fish signified Christ as the food given to the disciples and to the whole world. Within the reed basket containing the breads representing the body of Christ, one can discern a transparent glass containing red wine, the blood of the Savior.

In the Catacomb of Callixtus, the sketchy figures of seven disciples seated behind an arced table (fig. 5), before which seven baskets of bread are aligned, could be interpreted as a company enacting the *refrigerium,* or celestial banquet for the deceased in pagan art, but the central figure breaks the bread, and hence the fresco could well allude to the Eucharistic sacrament, such as it was anticipated when Christ breakfasted with seven apostles by the Sea of Tiberias (John 21:1–14) with fish and bread.[6] The other major sacrament of the early church was Baptism, and numerous examples of this rite are depicted too.[7] That in the Catacomb of Callixtus (fig. 6) perhaps presents the historical scene of the baptism of Christ by John, but it could also allude to the act of general baptism, with the person administering the sacrament by extending his hand over a tiny figure, the *infans.* In Baptism we are reborn as infants.

This brings us to an interesting issue regarding early catacomb frescoes. Was there the idea of a "program" of subject matter in this early art? By program I mean to refer to a set, a cycle, or a sequence of related themes or stories selected and arranged in proximity to each other that presented a larger, more comprehensive plan to the subject matter, a central theme governing it all. Could the chapel of the catacomb with the celestial banquet have been "programmed" to explicate the doctrine of the Eucharist? Or are the scenes merely motifs randomly scattered about the walls and ceilings? This question will become increasingly interesting to study, and at least in some of the more intact chambers such an idea of multihistoriated programs unified by their position on the wall is already presented. One of the finest examples is the ceiling fresco in the Catacomb of Saints Peter and Marcellinus (fig. 3), mentioned above, where a number of familiar motifs or sign-images appear together with a narrative that has a much more comprehensive message to convey.

The slightly domed ceiling of the chamber is marked out by a huge circle within which is inscribed, in faint lines, a giant cross with another circle at its center and semicircular fields at the ends of each arm. The geometric layout thus presents a unified field for the pictorial motifs presented within each compartment. In the topmost circle stands the Good Shepherd with the lamb across his shoulders, the familiar sign-image for the Lord of salvation which we have already considered. In the rectangular areas between the arms of the cross, in the second zone of the decoration, appear *orant* figures, symbols of the prayers for the deceased; and in the cupped sections along the lower band adjoining the greater circle are four lively narratives or picture-stories relating the ordeal of Jonah and the whale, an Old Testament example of one man's salvation through faith in the Lord. Reading clockwise from the top we see how Jonah was thrown from the boat at sea and swallowed up by the whale, a certain death; next, Jonah prays for deliverance while inside the belly of the whale; then the whale spits up Jonah on the shores; and, finally, a refreshed Jonah sits under a gourd vine in a paradise garden, his salvation accomplished.

The three zones of images hang together with a remark-

7. *Three Shepherds and Vine Harvest.* Marble sarcophagus, approx. 3′6″ × 8′. Late 3rd century. Lateran Museum, Rome

able cohesion. The one to whom the prayers are directed, the Good Shepherd, appears in the summit. The images of prayer imploring the Savior on behalf of the deceased next appear in the *orantes,* while the lowest zone illustrates for us the example of one man's salvation through prayer. Not only does this rudimentary program provide a hierarchy of subject matter upward—an Old Testament history, New Testament personifications of the faithful in prayer, and the divine one, Christ, in the heavens above—but it also subtly displays certain stylistic traits that one associates with later monumental picture programming. For one thing, there is a strict centrality about the figure of the Good Shepherd as the dominating and largest figure. Thus hieratic scale governs the size and importance of the figures, the *orantes* being larger than the figures in the narrative of Jonah. Another striking difference is the juxtaposition of strictly frontal figures, such as the *orantes,* with the livelier profiles of the participants in the Jonah story.

The technique is sketchy throughout, but the changes in style here noted—what we shall later refer to as stylistic modes—are interesting to ponder further. The Old Testament, the most removed and least sanctified of the themes, is presented in a vibrant, staccato tempo and pace, and a lively story is told; it is clearly a picture cycle to be read, and it fits into what will later be more specifically described as the narrative mode or style. The *orantes,* abstractions for Christian prayers, are more iconic or hieratic. Later the bucolic portrayal of the Good Shepherd will be replaced by the stern countenance of Christ as ruler and judge, the Byzantine *Pantocrator.* Seen in this light, do not the primitive frescoes in the Catacomb of Saints Peter and Marcellinus anticipate the sophisticated mosaic decorations of the Byzantine churches such as we find them in the dome of Daphni or in the apse and choir of the Cappella Palatina in Palermo (see figs. 174, 193 and colorplate 23)?

The same funerary themes and motifs are repeated across

8. *The Story of Jonah.* Marble sarcophagus, approx. 2′ × 7′. Late 3rd century. Lateran Museum, Rome

the surfaces of the sculptured coffins or sarcophagi. The *orantes* and the Good Shepherd frequently appear as the principal motifs, sometimes placed against a decorative reference to the Eucharistic wine or vine, the blood of Christ (fig. 7). Of more interest to us are the so-called frieze sarcophagi, which have extended narratives carved across the horizontal face.

A good example is the Jonah Sarcophagus in the Lateran (fig. 8), where one will recognize the drama that was painted in the cusps of the catacomb ceiling compressed into a decorative pattern in low relief. In the lower register, from left to right, we follow Jonah on his mission of prophecy: first he pays for his journey with a sack of money (?) given to a sailor; next, while at sea, the crewmen throw him overboard and the whale, in the form of a sea serpent with a marvelous curlicue tail, gulps down the hapless Jonah; turning tail, the whale then spits forth Jonah on the shore in compliance with God's plan of salvation; and, finally, above to the right, Jonah, striking the pose of the sleeping Endymion in mythological illustrations, rests under a gourd arbor, a paradisiacal setting.

In an irregular band above the Jonah story, other salvation motifs are added as pictorial footnotes to the main theme. To the left is one of Christ's first miracles, the Raising of Lazarus, who was dead for four days and was then resurrected through his sisters' faith and prayers; next Moses strikes the rock to nourish the thirsting Israelites in the desert; and finally Peter escapes from prison (this scene is uncertain). Scattered about the reclining Jonah are three more random footnotes. At his feet, along the shore, appears a tiny box floating in the water with a figure, like a jack-in-the-box, releasing a dove: the story of Noah and the ark. Above Jonah's head stands the Good Shepherd guarding his flocks before a tiny building, and, finally, on the far right edge of the sarcophagus, a rustic fisherman casts forth his line, the familiar image of Christ as the fisher of man's soul.

The narratives are presented with the nervous rhythm and intensity characteristic of the repetitious prayers familiar in early litanies. In fact, the pace of these carvings brings to mind the rapid evocation of images found in some of the earliest prayers of the church, where examples of salvation are cited from the Old and New Testaments. One such litany for the dying and the dead reads: "Receive, O Lord, thy servant into the place of salvation. . . . Deliver, O Lord, his soul as thou didst deliver Noah from the deluge . . . as thou didst deliver Jonah from the belly of the whale."[8]

Much speculation has focused on the question of the models used for the pictorial sequences that are repeated, more or less regularly, in both frescoes and sarcophagi reliefs. The story of Jonah, for instance, is found in nearly the same sequence with identical pictures on sarcophagi and in paintings, with only minor variations. A practical answer would be that the decorators had access to standardized

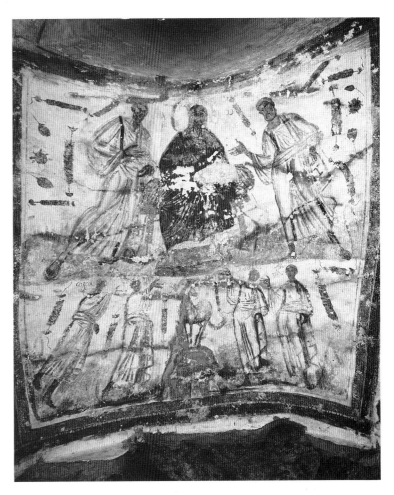

9. *Christ Enthroned Between Saints Peter and Paul* (above); *Agnus Dei Adored by Four Saints* (below). Wall painting in the Catacomb of Saints Peter and Marcellinus, Rome. 4th century

workshop models from which they culled their motifs, working much like modern advertising artists who assemble such pattern books for ready models to copy.

The funerary arts discussed so far reflect the mode of decoration found in Rome before the Peace of the Church in A.D. 313. Many of the frescoes and sarcophagi dating later in the fourth century present more ambitious and orderly compositions, suggesting that more monumental models were accessible, very likely those that were devised for the walls of the new basilicas built under the sponsorship of Constantine and his successors. Such is certainly the case with a painting in the "Crypt of the Saints" in the Catacomb of Saints Peter and Marcellinus (fig. 9). Here we find not anonymous personifications of faith and Christ in the guise of the *orantes* and Good Shepherd but actual portraits, with Christ dressed in regal robes enthroned between two standing figures, one with a short-cropped gray beard, the other with a long beard, who are identified as Peter and Paul. The orderly composition with the lower band displaying Christ a second time in the guise of the lamb (cf. Rev. 4) has a grandeur of concep-

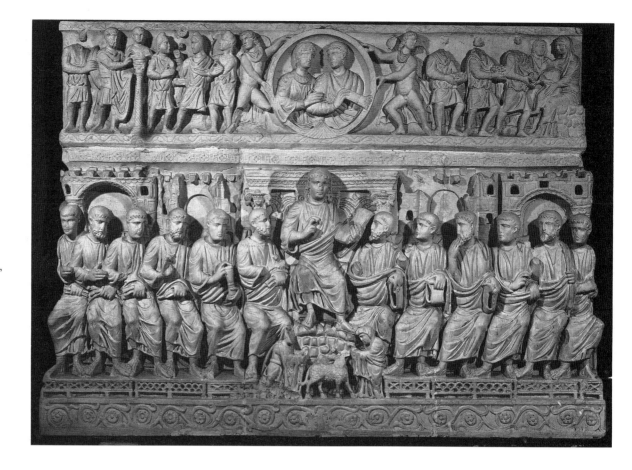

10. *Christ Enthroned Between the Twelve Apostles.* Front of a marble sarcophagus, approx. 3′9″ × 7′6″. c. 380. Sant'Ambrogio, Milan

tion that no doubt owes much to the apse decorations in the great basilicas of Rome, perhaps Saint Peter's, which it probably copies, as we shall see later.

A similar sophistication can be noted in the splendid sarcophagus in Sant'Ambrogio in Milan (figs. 10, 11). All four faces are carved with well-articulated figures of the apostles seated or standing in rows about Christ. On the front, Christ is enthroned as a teacher, much as in the catacomb painting just discussed, and on the back he stands atop a mound with his right arm raised above Saint Paul as if making a proclamation, and with the left hand he unravels a scroll that falls into the hands of Saint Peter. Five apostles on either side gesture toward Christ. They stand before architectural facades that project regularly behind them resembling a series of portals, an aspect of the composition that gives this and like sarcophagi the designation "city-gate" types. Below the groundline is a narrow frieze of tiny sheep symmetrically placed about a central lamb on a mound. They form the symbolic counterparts of the apostles and Christ above them, another feature of many apse compositions (cf. fig. 61), a kind of predella or base for the major representation.

Interestingly, the pose of Christ proclaiming and delivering a scroll, the Law, to Peter resembles a familiar pagan formula for the representation of the imperial *traditio legis,* or transference of the law, found in many Roman relief sculptures. On the sarcophagus in Sant'Ambrogio the theme is more specifically the Christian counterpart, the *Dominus legem dat,* the Lord gives the Law, which formed the central motif in representations of the Mission of the Apostles well known in later monuments. The prototype was very likely the original apse composition in the Lateran basilica, although it would be equally at home in Saint Peter's, for reasons to be discussed below (p. 61).[9]

Not only are the compositions of these last two examples impressive in their monumentality, but the general stylistic treatment is accomplished. For the present, one may ask if the wealth of the patron were not the determining factor in our judgment of quality, the richer obviously able to employ the more gifted artists. A three-dimensional sculpture of *Jonah Cast Up by the Whale,* recently acquired by the Cleveland Museum (fig. 12), displays a finesse of carving and an understanding of complex sculptural turnings that far surpass the meager patterns found on the Jonah Sarcophagus (fig. 8).[10]

This question is further complicated by other Christian objects that were commissioned by highly placed dignitaries in Rome. The splendid *Sarcophagus of Junius Bassus* (fig. 13) can be dated A.D. 359 according to an inscription on the lid, when Bassus, prefect and former consul of Rome, was baptized on his deathbed. Perhaps Bassus's hesitation in converting to Christianity was simply a judicious concession to

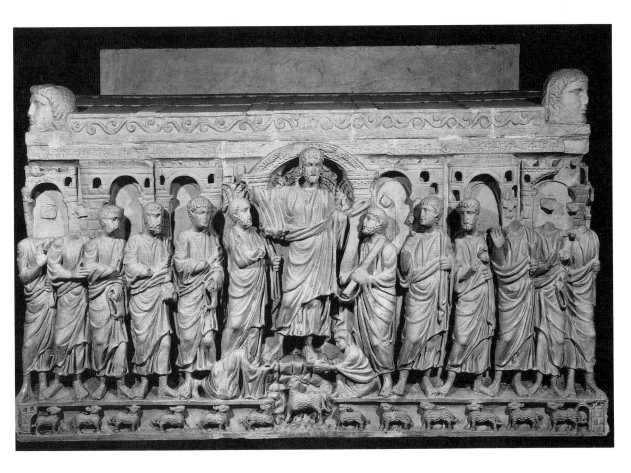

11. *Dominus legem dat.* Back of fig. 10

Roman state religion, which was still followed by the majority of the city officials. Constantine had done the same.

Whatever the facts are, the themes presented on the sarcophagus are Christian and a strange assortment at that. In two registers, four Old Testament stories are juxtaposed with scenes from the New on either side of a portrayal of Christ on the central axis (fig. 14). Above, Christ appears enthroned as the youthful Lord of the heavens with his feet resting on a personification of Caelus (Jupiter with a veil over his head). Peter and Paul stand beside him. Below, he is mounted on a donkey in the Entry into Jerusalem. Both are related to the imperial theme of *adventus,* or the coming and reception of an emperor before the people, and thus are appropriate for a patron with close ties to the state. The four Old Testament scenes are funerary subjects in that they are related to aspects of salvation: the Sacrifice of Isaac (top left), Job in his Suffering and the Fall of Adam and Eve (both lower left), and Daniel in the Lions' Den (second from the right in the lower register). The unusual selection of New Testament events has never been explained adequately. These include scenes of the arrests of Saints Peter and Paul and, expanded across two zones, the arrested Christ before Pilate. This last episode, a poignant example of Roman law tested and repudiated, was one of the stories of the Passion that received special attention in Early Christian art.

The elegant carving of the architectural details, with their

12. *Jonah Cast Up by the Whale.* Part of a sculptural group. Marble, height 16″. 3rd century. The Cleveland Museum of Art. John L. Severance Fund

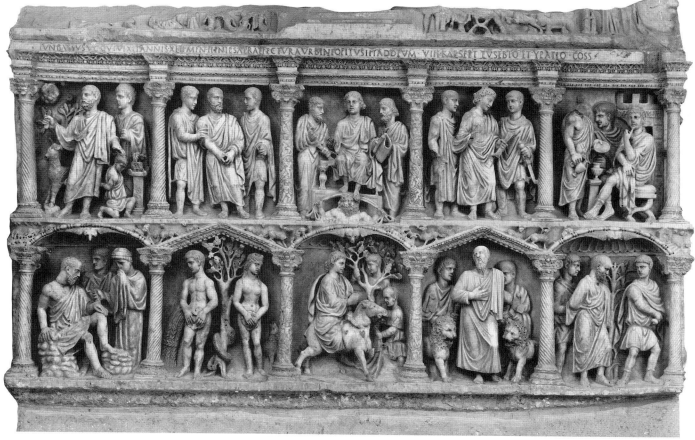

above: 13. *Sarcophagus of Junius Bassus.* Marble, approx. 3′10½″ × 8′. 359. Grottoes of Saint Peter, Vatican City

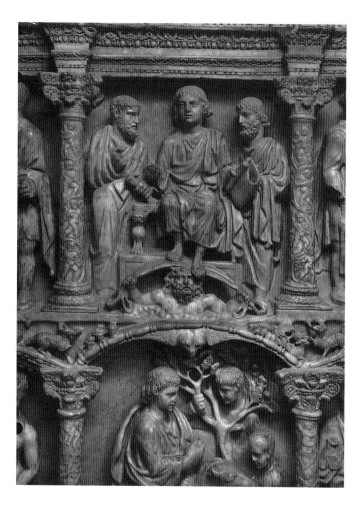

left: 14. *Christ Enthroned Between Saints Peter and Paul* (above); *Entry of Christ into Jerusalem* (below). Detail of fig. 13

below: 15. *Adam and Eve.* Detail of fig. 13

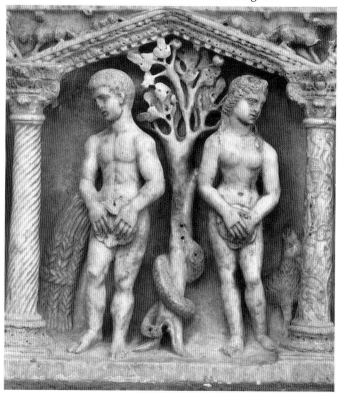

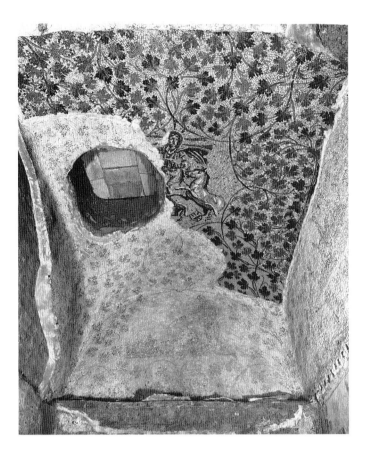

vated Christian burials in house-tombs—a type that was built above ground—along the former Via Cornelia on the Vatican Hill. In one of the chambers, an image of Helios, the sun-god, interpreted as Christ the Sun-God (?), appears in mosaics (fig. 16). One house-tomb of special interest is that in which the bones of Saint Peter were allegedly interred.[12] On one wall a two-storied shrine (fig. 17) has been reconstructed to mark the burial of Peter's remains, and this diminutive edifice, called a *memoria,* today rests directly beneath the High Altar of the great Vatican basilica.

It is known that the first churches or meeting places were simply the homes of the faithful, with certain rooms adapted and outfitted for the basic needs of the services. Such house-churches are recorded as *tituli:* churches named after the owners of the property, and they presumably displayed a plaque designating them as legal places for worship. Twenty-five are recorded in Rome in the early fourth century, some of which retained their titulus, or title, when basilicas were later built over them. It is also known that tenement apartments were often converted, but most of those excavated

left: 16. *Helios (Christ as Sun-God?).* Mosaic in the vault of the tomb of the Julii, Vatican Grottoes. 3rd century

below: 17. *Shrine of Saint Peter.* Reconstruction of the late 2nd century shrine (after Corbett). Height approx. 12′. Saint Peter's, Rome

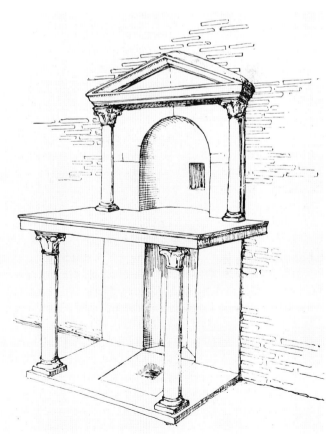

elaborate shafts, capitals, and entablatures, bespeaks an artist familiar with the finest Classical idioms. Tiny figures of lambs enacting the stories of the Three Hebrews in the Fiery Furnace, Moses Striking the Rock, the Multiplication of the Loaves and Fishes, and the Baptism of Christ fill the spandrels of the lower arches and gables like symbolic footnotes. The youthful Christ in the upper register appears Apollonic; the bearded heads of Abraham, Daniel, Job, Peter, and Paul are all noble Roman types. Adam and Eve are presented as diminutive Classical nudes posed on either side of the Tree of Knowledge (fig. 15).

Lo stile bello, or "the beautiful style," of the *Sarcophagus of Junius Bassus,* as some scholars have called it, would seem to be a contradiction of what we have seen in the catacomb arts. The pursuit of physical beauty does not seem to fit the aesthetics of the Early Christian artists, where the spiritual expression should be foremost. And yet it is now recognized that the revivals or returns to Classical norms for beauty were so frequent in Medieval art that the idea of a "Renaissance" has been applied to such periodic intrusions. In the *Sarcophagus of Junius Bassus* we have the first (at least for the present) of these revivals, the so-called Theodosian Renaissance, datable to the reign of the emperor Theodosius the Great in the second half of the fourth century.[11]

There is little evidence of Christian art above ground before the Peace of the Church in A.D. 313. Under the Constantinian basilica of Saint Peter there have been exca-

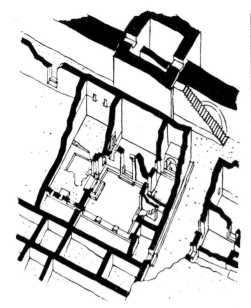

above: 18. Isometric reconstruction of a *domus ecclesiae,* Dura-Europos, Syria. Before 256

right: 19. Model of a Baptistry, detail of fig. 18. Transferred and reconstructed in the Yale University Art Museum, New Haven. Dura-Europos Collection

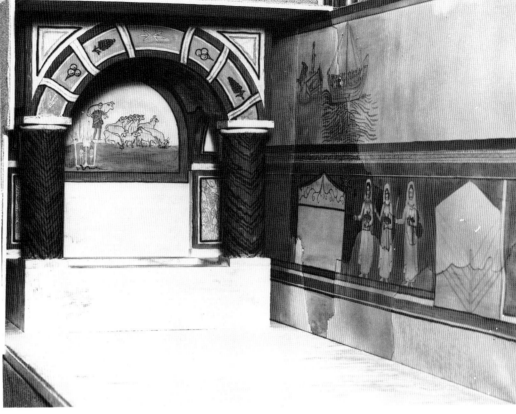

were more elaborate town houses or villas (cf. the remains under the basilicas of Saints Giovanni e Paolo and San Clemente).[13]

The *domus ecclesiae,* or house-church, needed only a hall large enough for a small assembly and a meal. The *triclinium,* or dining room, would usually be appropriate. Other rooms to the sides served the postulants (new candidates) and the catechumens (converts yet to receive baptism) when Mass was held for the members only. Essentially then, the *domus ecclesiae* was a simple domestic structure, a small community center at most, and the only special area needed would be that of the baptistry, which, of course, meant a font and access to water.

Such simple domestic quarters serving the needs of the Christians throughout the Roman world were ubiquitous, as attested by the remains of a *domus ecclesiae* in the remote frontier town of Dura-Europos on the Euphrates in Syria (fig. 18). The house was built in the proximity of the fortification walls, which subsequently were enlarged and strengthened during Persian invasions in A.D. 256, and it was buried soon after under the rubble of the destruction wrought there.[14] The house is a simple Mediterranean type in two stories. Around a squarish courtyard open to the sky were aligned rectangular rooms of various sizes. The largest, capable of accommodating roughly fifty to sixty people, very likely served as the congregational assembly room. Were it not for a smaller elongated room to the right of the entrance

on the northwest corner (fig. 19), the function of the house as a Christian church would never have been recognized. A font shaped like a large sarcophagus built into a niche on the end wall is decorated with paintings not too unlike those of the catacombs that indicate that this was a Christian baptistry.

The paintings in the lunette above the font and those in the upper part of the north wall are especially primitive in execution. On a reddish ground in the lunette the remains of a Good Shepherd are faintly discernible, and below the shepherd the tiny forms of Adam and Eve are visible. Regardless of the crudity of these random spottings, the meaning of the lunette fresco is clear: the New Adam—Christ the Good Shepherd—is sent to redeem man from the sins of the Old Adam. The rebirth of the old man was an essential image in early baptismal rites. The refreshing waters of the font washed away his sins. Below the faint miracle scenes on the adjacent wall, in the lower register of the northwest corner, appears an entirely different type of representation featuring large, monumental figures in procession toward a large gabled structure resembling a huge sarcophagus. This fragment has been interpreted as the visit of the Three Marys to the Tomb of Christ, a familiar allusion to the resurrection of Christ, and, consequently, a funerary theme very appropriate for a baptistry. Later we shall see that the iconography of the baptistry is intimately related to that of the tomb (see pp. 38–39).

CONSTANTINE AND THE EARLY CHRISTIAN BASILICA

I N MARCH A.D. 313, four months after the defeat of Maxentius at the Milvian Bridge in Rome, Constantine, the new Caesar of the West Roman Empire, issued the following decree in Milan: "We decided that of the things that are of profit to all mankind, the worship of God ought rightly to be our first and chiefest care, and that it was right that Christians and all others should have freedom to follow the kind of religion they favoured; so that the God who dwells in heaven might be propitious to us and to all under our rule."[15] Constantine, son of an earlier Caesar, Constantius, had claimed his rightful title over Maxentius, one of the tetrarchs invested by Diocletian to rule the vast Roman world.

According to his biographers, Eusebius and Lactantius, Constantine won the decisive battle over the larger army of Maxentius through the miraculous intervention of the Christian God, who appeared to him in the skies on the eve of the battle in the form of a monogram and cross, the chrismon, or *Chi-Rho* (the Greek XP, abbreviation for Christus). From the heavens thundered the prophecy: *"in hoc vinces"* (in this sign, conquer). Placing the Christian symbol on his labarum (standard), Constantine did indeed conquer the West, and by A.D. 325 he had also subdued and executed his rival Licinius, the last of the tetrarchs, to claim the East Roman Empire as his domain too. Constantine was now Emperor and Augustus, the sole and absolute inheritor of the great Augustus Caesar.

The nature of Constantine's relationships with the Christians has been an issue of considerable controversy.[16] Until he was baptized on his deathbed in A.D. 337, he remained a catechumen, perhaps out of a desire to be open to all religions, including the pagan affiliations of the majority of the Roman senate—the Edict of Milan of A.D. 313 had specifically stated that "all others" would be tolerated. However we measure Constantine's personal beliefs, it is known that for the first time Christianity and the Roman state were closely wedded politically, socially, and culturally.

As emperor, Constantine used his power to better the Christian church by sponsoring new public buildings for worship in Rome, much to the chagrin of the senate. The features of his new church, the basilica, will be discussed presently, but the state of the arts in Rome at the time of his victory, exhibited in new sculptures added to his triumphal arch (figs. 20, 21), erected shortly after his victory over Maxentius, should be briefly examined as they present one of the more controversial issues in the development of the arts in general.

Constantine's arch was a piecemeal assembly in terms of the sculptural adornments. The giant round reliefs above the two side arches are *spolia* (sculpture or architectural fragments plundered from earlier imperial monuments), as are the huge rectangular plaques in the attic; but the smaller friezes directly above the side arches and the winged victories carved in the spandrels are products of Constantine's workshop. The frieze on the seaward side (west) depicts a *congiarium*, or distribution of favors to the people, a familiar subject in Roman historical relief sculpture. But when compared to earlier representations of such scenes on the Arch of Trajan at Benevento (fig. 22) or the historical reliefs on the Arch of Titus in the Forum (fig. 23), the productions of the early fourth century seem astonishingly inept, if not crude and childlike in execution, with none of the naturalism usually associated with Antique sculpture.

How do we explain this startling divergence from the Classical norm?[17] To the defenders of the Classical tradition, beginning with Vasari and the Renaissance through early-twentieth-century authorities such as Jacob Burckhardt and Bernard Berenson, the Constantinian reliefs mark the death of the great art of the Greco-Roman past. For them, these sculptures are the prelude to a long Dark Age of no artistic merit. Much favors this interpretation. Who can deny that the incised lines for the draperies and the carved profiles are crude or roughly hewn or that the proportions are stunted, with large heads ill fitting dwarfish torsos? Moreover, the reliefs are carved across the horizontal slabs with little regard for spatial unity. But many have questioned the validity of using technical proficiency as a factor in assessing this curious new art.[18]

Similar changes in style can be found in other arts as well. The colossal head of Constantine, a fragment of a huge statue that once towered over the public in a niche of the Basilica Constantini in the Forum, displays many of the same fea-

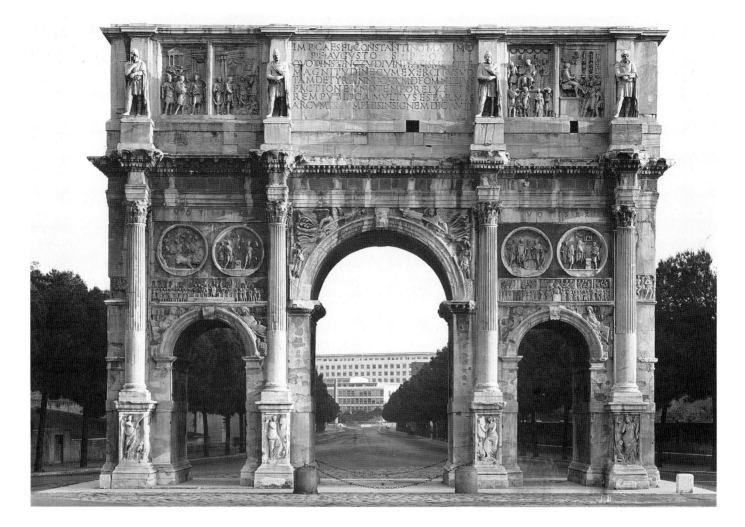

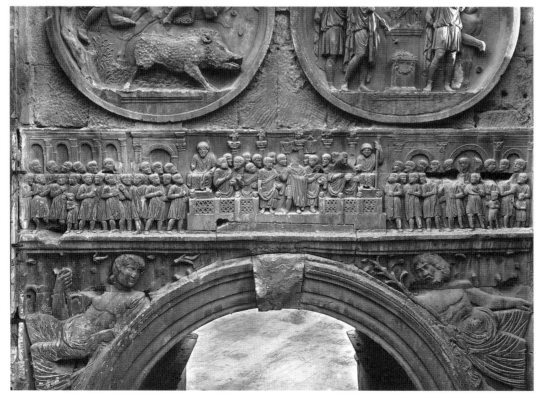

above: 20. Arch of Constantine, Rome. View from the north. 312–15

left: 21. *Constantine Distributing Favors.* Detail of fig. 20. 312–15; medallions 117–38

tures: a stiff, hieratic style with a rigid frontality; a fixed, staring upward gaze in the huge eyes carved out with deep craters for pupils; the reduction of the facial features to harsh conventions raised or submerged in the polished masklike face of smooth planes (fig. 24).

These traits in portraiture are markedly different from the lifelike countenances of earlier imperial effigies, such as that of Caracalla (fig. 25), but tendencies toward static immobility began to appear before Constantine with the stoic emperor Marcus Aurelius and continued through the reign of Diocletian. A late-third-century portrait (fig. 26) clearly projects different qualities of personality in the staring eyes fashioned with harsh outlines of the iris and hollowed-out pupils dominating the visage. It is not surprising that this haunting likeness has been identified as that of Plotinus, the ascetic philosopher who contributed much to the mystical theologies of the Middle Ages.

The abstractions in the portrait of Constantine indeed convey a terrifying sense of spiritual gravity and the overpowering presence of authority. The great eyes, the windows of the soul, are features befitting an inspired leader with a new and lofty conception of his calling by some divine being. Constantine is the divinely appointed vicar of God on earth.

The building that Constantine raised as the new house of worship for the Christians is called the *basilica,* or House of the Lord (*basilica id est dominicum,* according to Eusebius). The old meeting place, the *domus ecclesiae* (see p. 26), was much too simple and unfocused to provide the necessities of

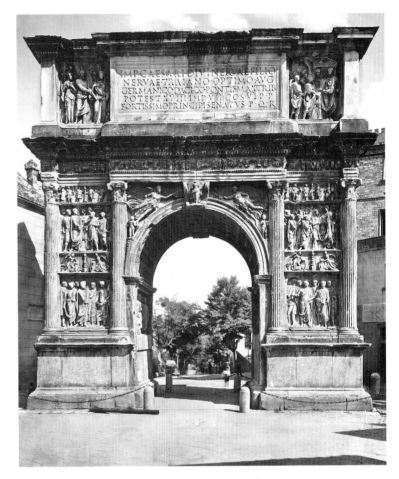

22. Arch of Trajan, Benevento. 114

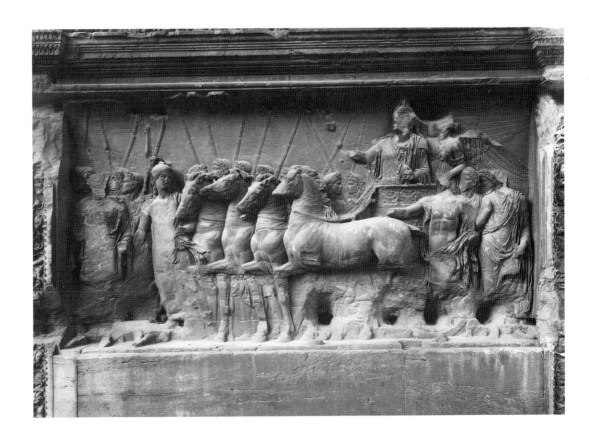

23. *Triumph of Titus.* Relief in passageway of the Arch of Titus, Rome. Marble, height 7′10″. 81

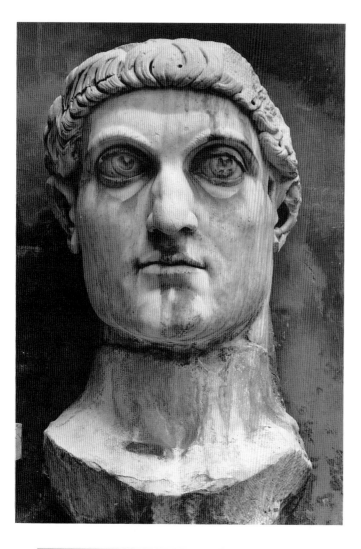

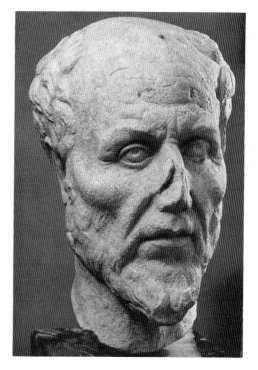

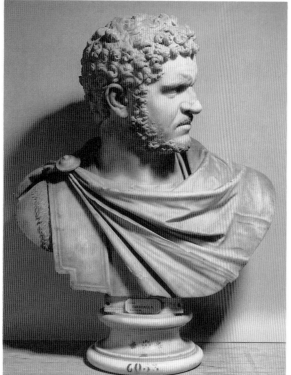

left: 24. *Constantine the Great.* Fragment of a colossal statue. Marble, height 8′6″. Early 4th century. Museo dei Conservatori, Rome

below left: 25. *Caracalla.* Marble, height 20⅛″. 211–17. Museo Nazionale, Naples

above: 26. *Portrait Head* (probably Plotinus). Marble, lifesize. Late 3rd century. Museum, Ostia

Christian worship under Constantine, although a number of the so-called *tituli* churches continued to serve communities in various parts of the city. The basilica (fig. 27) was—and this point must be emphasized—a generic building type that served numerous functions in the Roman world as a gathering place for law courts, business transactions, stock and money exchanges, audience halls for civic affairs, and so forth. The genus *basilica* included hall-type structures in palaces for imperial ceremonies or in the wealthier estates for gatherings in general. Essentially it was a large longitudinal hall with raised platforms or tribunes to accommodate its functions. There was no *one* basilical form, and surely the building that Constantine's builders fashioned for Christian worship must be considered one of the most innovative of Late Antique architectural forms.[19]

The stricter organization of the Christian community under Constantine made a distinct physical separation of the clergy and congregation necessary (fig. 28). One end of the basilica was enlarged and marked off as the tribune or sanctuary for the clergy and the altar. The main body of the longitudinal hall was divided into a nave (the central aisle) and side aisles for the gathering of the faithful. The entrance

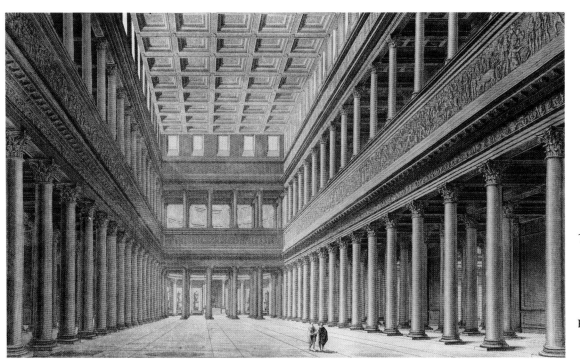

left: 27. Reconstruction drawing of the Basilica Ulpia in the Forum of Trajan, Rome (after Canina). 98–117

below: 28. Jacopo Grimaldi. Drawing of the interior of Saint Peter's, Rome. 1619. Vatican Library, Rome (MS Barberini, lat. 2733, fols. 104v–105r)

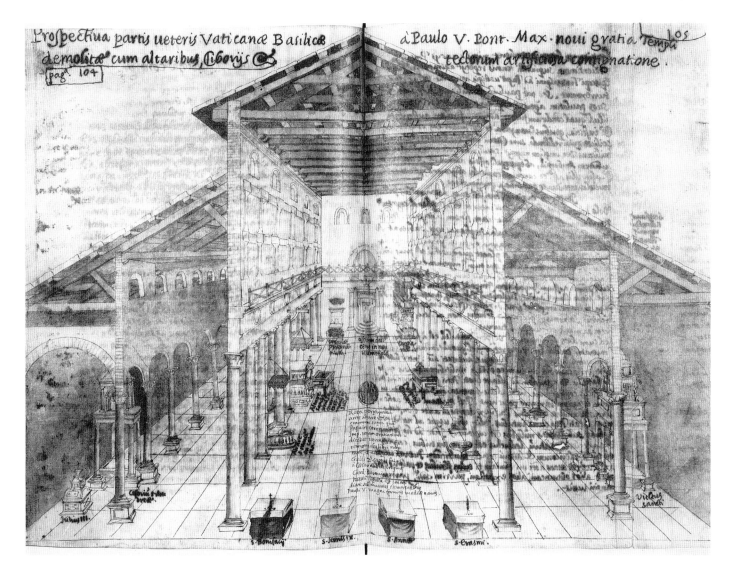

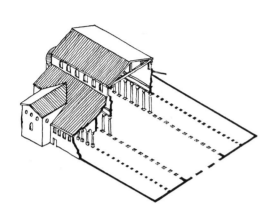

above: 29. Isometric reconstruction of the Lateran Basilica, Rome (after Krautheimer). c. 320

right: 30. Filippo Gagliardi. *Nave of the Lateran Basilica, Rome.* Fresco. Reconstruction attempt as of 1650. San Martino ai Monti, Rome (nave erroneously arcaded)

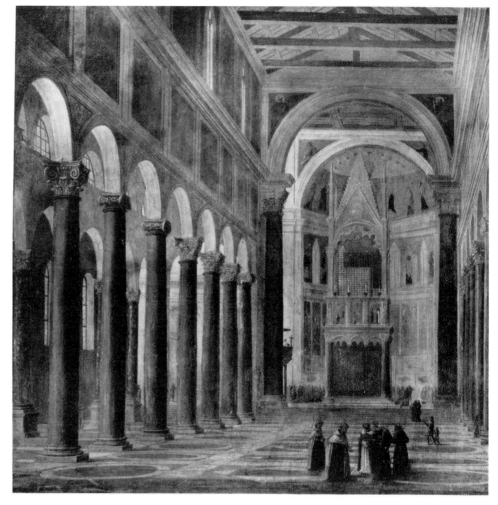

was placed at the end opposite the altar, and an atrium or open court was set before the porch (narthex) for the gathering and instruction of the postulants and catechumens. Timber roofs with flat ceilings covered the main hall, and windows in the nave above the level of the side aisles opened the interior for light. This upper zone of the nave is called the clerestory.

One result of this division of the basilica was the emphasis on longitudinal space. With the entrance at one end, the sanctuary culminating in the form of a semicircular apse at the other, and a long hallway in between, the experience of the Christian basilica was one of movement in time along a marked axis to the altar. Furthermore, it was totally an experience of interior space for the faithful. The exteriors were simple, barnlike structures of brick that formed an opaque box to enclose the space. Only the entryways were monumentalized and decorated with mosaics or paintings.

A variety of basilical forms were employed by the Christians. Vast hallways were erected for funerary banquets and assemblies that were laid out on a hairpin or *U*-shaped plan; in some instances two or three halls were added side-by-side or at right angles to form double basilicas; and one of the

most distinctive types, the cross-transept or *T*-shaped basilica, was designed for two of the major churches in Rome, the Lateran church and Saint Peter's.

The first Christian church to be considered is the Basilica of the Savior in the Lateran, now dedicated to Saint John the Baptist.[20] In a remote but wealthy district of Rome, at that time out of the jurisdiction of the senate, Constantine donated to the Christians the old imperial palace, the Lateran, to serve as a residence for the bishop, and he built alongside it the first cathedral of Rome, *ecclesia cathedralis,* as the diocesan church for the bishop, about A.D. 313.

The title of "Mother and head of all churches in the city and in the world" (*omnium ecclesiarum Urbis et Orbis mater et caput*) is still retained. Although it was rebuilt and restored by Francesco Borromini in 1649, and few remains of its foundations and walls can be found, it has been reconstructed with some authority by Richard Krautheimer (fig. 29). The huge building was double-aisled, with a projecting apse and transept (a transverse structure between the apse and the nave) that extends slightly beyond the outer walls of the aisles on either side, forming a rudimentary *T*-shaped plan. A fresco by Filippo Gagliardi in San Martino ai Monti,

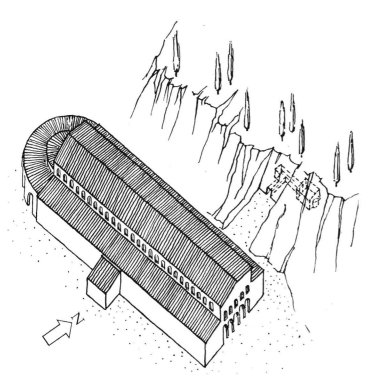

31. Isometric reconstruction of San Lorenzo fuori le mura, Rome. Basilica and underground memoria (after Krautheimer). c. 330

painted around the time of Borromini's restorations, gives us a good idea of the size and grandeur of the Constantinian interior (fig. 30).

The nave and double aisles, each with arcades of twenty-two columns, together with the transept, measured approximately 250 by 180 feet in size. The sanctuary extended some sixty feet. The vast interior was capable of accommodating a congregation of several thousand. Like most basilicas, the exterior would have been rather plain brick and unadorned in appearance, but the interior was lavishly outfitted with countless gold and silver objects, donations recorded in the *Liber Pontificalis* (Book of Popes), an important source book of papal records compiled in the ninth century.[21]

The Lateran basilica, the cathedral of the bishop of Rome, was originally dedicated to the Savior and commemorated no special hallowed ground. For the most part, however, the early-fourth-century structures were erected over or near the graves of the martyrs, the Roman equivalents of the holy sites in Jerusalem. The original basilica dedicated to Saint Lawrence built on the Via Tiburtina was raised near his tomb in the Verano catacombs (fig. 31). The present Basilica of Saint Lawrence (San Lorenzo fuori le mura) was built in the sixth century immediately next to the earlier one, dating about A.D. 330, which was called the basilica *maior* in early accounts. Few remains of the earlier structure have been uncovered, and only a tentative reconstruction of it is possible. It was a type known as a funerary basilica since it apparently functioned as both a covered cemetery for the faithful and a funerary banquet hall in the proximity of the *memoria,* or martyr's grave. A giant hallway with a roof, side aisles, and a projecting apse, its plan was *U*-shaped or hairpin in outline. The floor was, in time, lined with gravestones, and within it the faithful would gather for funerary celebrations.

A similar *U*-shaped funerary basilica was built alongside the *memoria* of Saint Agnes on the Via Nomentana (fig. 32) near the catacombs there. The famous mausoleum built for Constantine's daughter Costanza sits to the left of the entrance, and further beyond the ruined walls is the sixth-century basilica dedicated to Saint Agnes. In both cases the funerary basilica predated the martyr's church, and the exact

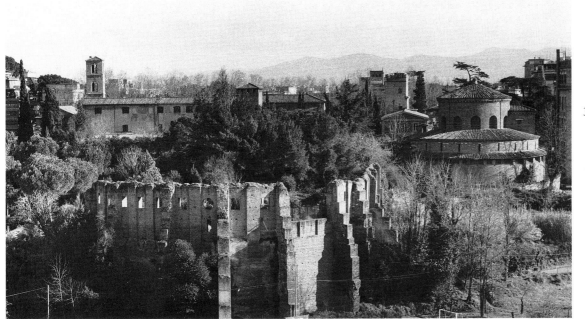

32. Ruins of the funerary Basilica of Sant'Agnese, Rome. Remains of ambulatory walls (to right, the Mausoleum of Costanza). c. 350

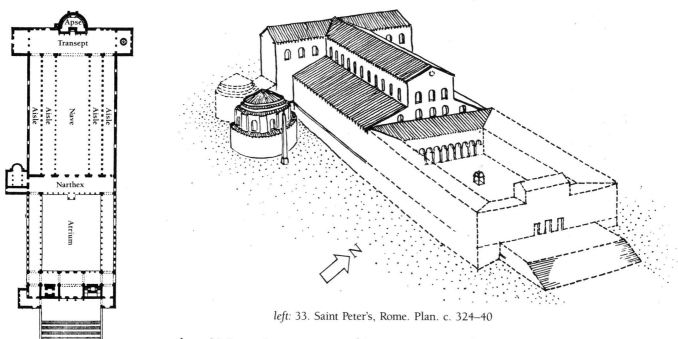

left: 33. Saint Peter's, Rome. Plan. c. 324–40

above: 34. Isometric reconstruction of Saint Peter's, Rome (after Krautheimer). c. 400

function of the former in the regular service has yet to be determined.[22]

In light of these early building types, the original Basilica of Saint Peter's (figs. 33, 34) must be seen as something of a fortuitous compromise and innovation. Sometime around A.D. 324 Constantine donated the burial grounds on the Vatican Hill to the church as a site for the erection of a major basilica commemorating the tomb of Saint Peter there. We have already mentioned the oldest *memoria* built over Peter's remains as it appeared in the second century, and with the increasing number of pilgrims visiting the site—and no doubt the demands for burial grounds there as well—it was only fitting that one of the major churches in Rome should be erected on this spot.[23]

In order to achieve this it was necessary for Constantine's builders to level the area about the tomb by building up foundations on the south side of the sloping hill and sinking the ground level on the north and west sides. As in most building campaigns, the sanctuary with the altar and, in this case, the *memoria* of Saint Peter, was raised first and presumably completed before the death of Constantine in A.D. 337. This sanctuary, however, was enlarged in an unusual manner, very likely to accommodate the hundreds of pilgrims who gathered about the *memoria* daily (fig. 35). The space before the apse was transversed by a huge hall extending far beyond the side walls of the aisles, forming great projecting transept arms. The nave was probably finished after 350 with its double aisles of twenty-two columns, as at the Lateran, but exceeding it in length and width considerably (276 by 190 feet). At some later date, about 390, a vast atrium was added before the facade.

The cross-transept and the apse were marked off from the nave dramatically by a huge archway, later referred to as the triumphal arch, which carried an appropriate inscription: "Since under Thy leadership the Empire rose once again triumphant to the stars, Constantine the victor has founded this hall church (*aula*) in Thine honor," a reference to the victory over Maxentius under the aegis of the chrismon. Beneath the great triumphal arch stood the original *memoria* of Saint Peter, where very likely the altar would be placed in the fourth century, although this is not known. The *memoria Petri* was elaborated with a baldachino, or canopy, supported by four twisted columns of porphyry carved with vine tendrils that were imported from Constantinople. Two more porphyry columns supported an extension of the architrave of the baldachino across the opening of the apse, which, when hung with curtains, would be concealed from public view. An unusual carving on an ivory reliquary box from Pola in Istria (fig. 36) is believed to be an accurate representation of the Constantinian *memoria* and its columns, with the faithful making an offering while male and female members of the church stand as *orantes* before the side screens.[24]

Insofar as the apse and transepts were built around the *memoria Petri,* the sanctuary functioned as a *martyrium,* or tomb church,[25] and the broad nave, once paved with carpets of stone tombs, served as a funerary basilica. Unlike the early funerary basilicas of San Lorenzo and Sant'Agnese, in Saint Peter's the tomb of the saint, the *memoria,* was thus incorporated directly into the church, forming a combination of martyrium-funeral hall, a unique solution in its time. The distinctive *T*-shaped plan of Saint Peter's that resulted was long believed to be typical of Early Christian basilicas,

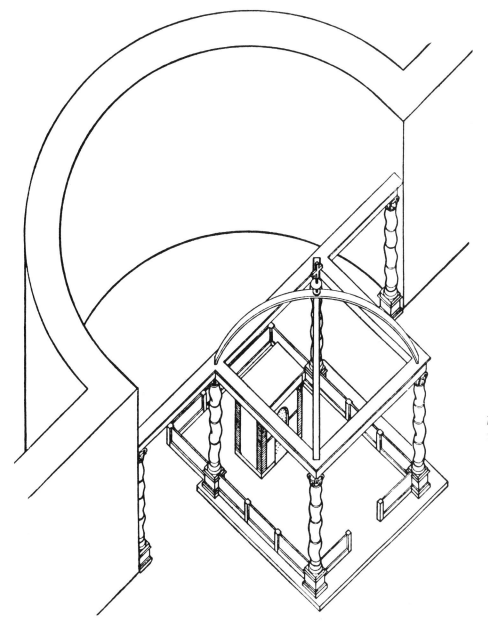

left: 35. Reconstruction of the *memoria* of Saint Peter in the sanctuary of Saint Peter's, Rome (after Toynbee). c. 324–37

below: 36. *Shrine of Saint Peter.* Ivory casket from Pola, 5⅝ × 7⅝". c. 400. Museo Civico, Rome

perhaps inspired by the symbolism of the cross, but, in fact, it is an anomaly in its time. Later this unique plan, hallowed by its associations with the "prince" of the apostles, was accepted as a standard form, as we shall see.

The Basilica of Saint Paul's Outside the Walls (San Paolo fuori le mura) is a monument of the "Theodosian Renaissance." According to the inscription on the triumphal arch, "Theodosius began, Honorius completed this church, consecrated by the body of Paul, teacher of the world." The mosaic decoration on the arch was sponsored by Honorius's sister, Galla Placidia: "The devout soul of Galla rejoices to see this foundation of her father radiant in splendor through the devotion of Bishop Leo."

Begun about 385 as a replica of Saint Peter's, equal in size and splendor, Saint Paul's remained fairly intact through the centuries until it was largely destroyed by a fire in 1823, and while the nineteenth-century restorations were ambitious and complete, many aspects of the Early Christian church

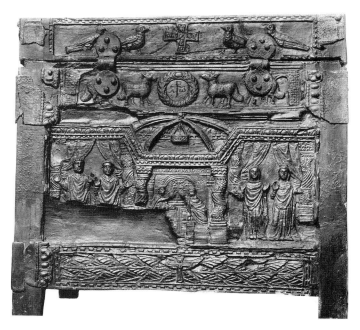

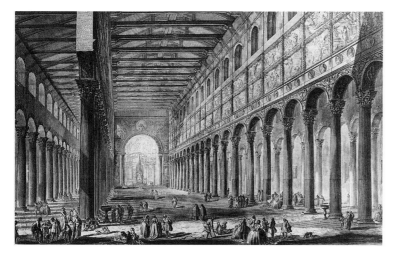

37. GIOVANNI BATTISTA PIRANESI. *San Paolo fuori le mura, Rome.* Etching. 1749

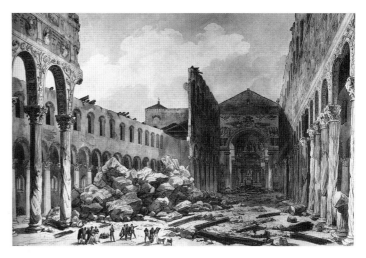

38. BARTOLOMEO PINELLI. *San Paolo fuori le mura after the fire of 1823.* Drawing

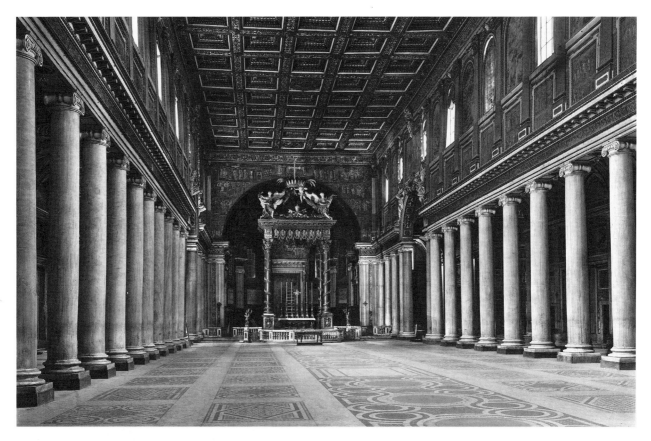

39. Santa Maria Maggiore, Rome. Interior of nave. c. 432–40

have been lost or distorted. Much of the grandeur, especially of the interior, remains, however, reminding us of how "it shines in imperial splendor . . . covered with gold leaf . . . propped with marble pillars," as Prudentius described it about A.D. 400. Giovanni Battista Piranesi made an etching of the church (fig. 37) which records the Old and New Testament pictures below the windows in the nave that were probably added about 450 by Pope Leo the Great. A drawing by Bartolomeo Pinelli made after the fire of 1823 confirms the accuracy of Piranesi's view of the interior (fig. 38).

The Classical flavor of the Corinthian arcade in Saint Paul's is majestically echoed in the interior of Santa Maria Maggiore (the major church of Mary) on the Esquiline Hill (fig. 39), where an Ionic colonnade supports the upper walls of the nave. This sumptuous church, the first dedicated to the Virgin in Rome, was erected by Pope Sixtus III between

432 and 440, and while the sanctuary and expanses of the nave have undergone drastic alterations in the course of time, the original fifth-century mosaics that lined the walls and covered the arch before the apse remain rare and beautiful survivors of Early Christian art. These will be discussed later. The plan shows a single-aisled nave with slightly projecting transepts (the latter may be the work of rebuilding about 1290). The exterior is lost beneath rebuildings of much later periods.

The finest example of what has been called the "standard" Early Christian basilica is the titulus church of Santa Sabina, high on the Aventine Hill in what was then a fashionable quarter of the city (figs. 40, 41).[26] According to an inscription inside the narthex, the basilica was founded by Pope Celestine I (422–32). This type of so-called standard basilica emerged in the fifth century and was admirably suited to serve the function of a parish church. The ground plan is simpler, with three clearly marked spatial units, an atrium,

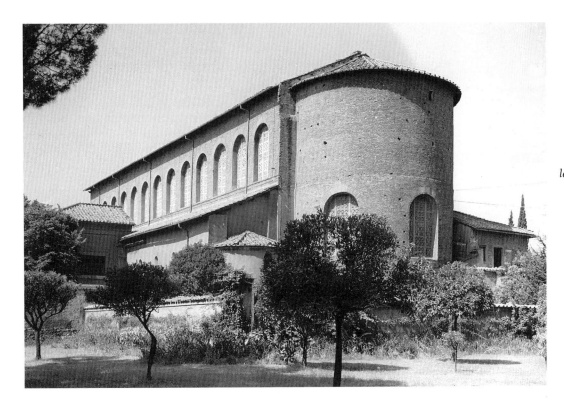

left: 40. Santa Sabina, Rome.
Exterior of apse. 422–32

below: 41. Santa Sabina,
Rome. Interior of nave

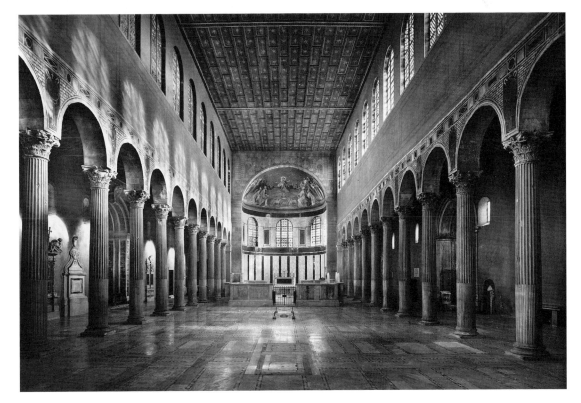

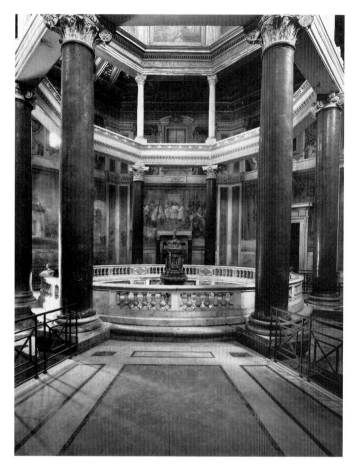

42. Lateran Baptistry, Rome. Interior. c. 315 and c. 432–40

nave, and apse, but no complex additions such as transverse transepts. The interior, with an elegant arcade of Classical columns carrying a wall with large clerestory windows, is high and narrow. The long nave directs one's focus irresistibly down toward the altar, placed before a simple apse with three windows.

Celestine's successor, Sixtus III (432–40), was, as mentioned above, the sponsor of the building and decorating of Santa Maria Maggiore. He also enlarged the old baptistry of the Lateran basilica (figs. 42, 43), which was subsequently remodeled in the sixteenth and seventeenth centuries. Throughout the Middle Ages, baptistries displayed a distinctive architectural form: centralized structures, either round, square, cruciform, or, more usually, octagonal in ground plan, capped by an imposing dome. Both the font in the center and the dome (which formed a huge baldachino for the font) were mystically associated with the number eight, hence the frequency of the octagonal shape. Eight marked the day of new creation or new birth (six days for creation in Genesis, the seventh for rest), and the "sacred eight," as Ambrose called it in the dedicatory verse for a baptistry in Milan, signified eternal life.

It is not surprising that the form of the baptistry should be derived from funerary types, since the idea of death of the Old Adam and rebirth of the New in the rite was so universal.[27] Some have argued, in fact, that such impressive

43. ANTONIO LAFRERI. Section of the Lateran Baptistry. Engraving. c. 1560

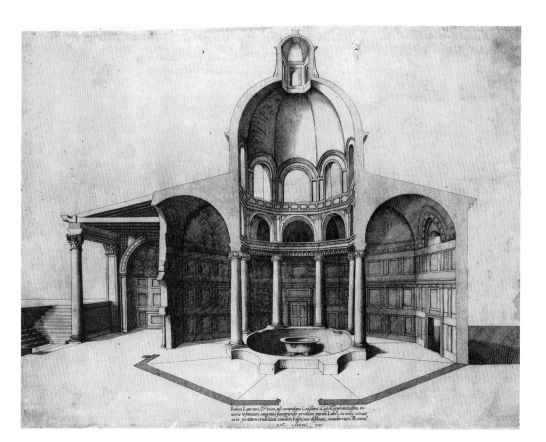

mausolea as that of Santa Costanza, the tomb of Constantine's daughter, actually functioned for a time as a baptistry for the nearby Basilica of Sant'Agnese. At Santa Costanza, a circular ambulatory with a barrel vault buttresses the dome and is richly decorated with "carpets" of mosaics lifted into the curved drum (fig. 44). Similar mosaic enrichments once covered the octagonal ambulatory in the Lateran Baptistry.

Centralized buildings with domes also characterize many of the so-called *martyria,* or tomb churches, in the Early Christian world. Santo Stefano Rotondo (the round church of Saint Stephen), 468–83 (fig. 45), is one of the most impressive of these types in Rome. Here the great cylindrical core is augmented on the four axes by projecting rectangular chapels, providing a cross and circle ground plan for the complex, possibly influenced by the architecture of the Anastasis, the tomb of Christ in Jerusalem. It is important to keep in mind these various funerary associations of mausolea, memoriae, martyria, and baptistries in Medieval architecture, particularly since another type of building, the palace chapel, often adopted the central plan but for entirely different reasons. Architectural forms have an amazing flexibility, and it is often the decorations applied to the walls that give a building specific meaning. It is to the specific meaning of the Christian basilica that we shall now turn our attention.

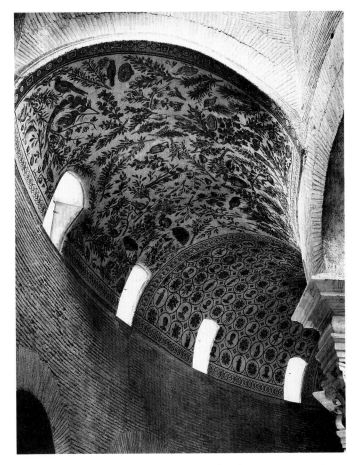

44. Santa Costanza, Rome. Portion of vault mosaics. c. 350

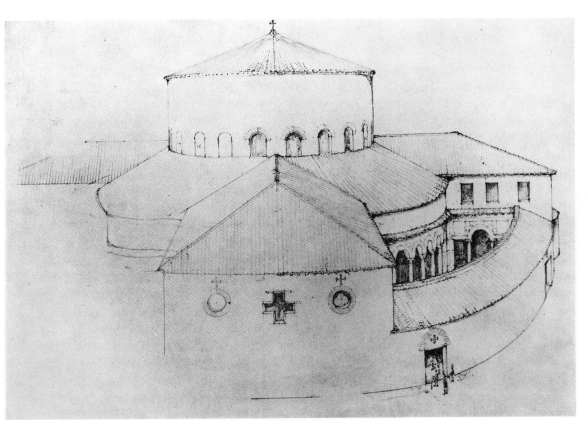

45. Reconstruction of the exterior of Santo Stefano Rotondo, Rome (after Corbett). 468–83

ECCLESIA, BASILICA, CIVITAS DEI — THE DECORATION OF THE EARLY CHRISTIAN CHURCH

THE BASILICA of Saint Paul (San Paolo fuori le mura) is one of the most impressive churches in Rome. Stepping from the spacious atrium into the main body of the basilica, we suddenly find ourselves in the refreshing twilight world of a vast and deep interior (colorplate 2). At the far end of the nave the yellow lights of the candles on the altar shimmer mysteriously in the shadowy silhouette of the niche, and high above, on the broad arch before the apse, the soft glow of golden mosaics filters through the darkness. Slowly the structure of the building emerges from the shadows: the massive polished columns, the elegantly carved capitals, the richly paneled walls, and the coffered ceiling. Here, it would seem to many visitors, the mystical experience of the Early Christian worshipper can still be appreciated. But perhaps our impressions are distorted by the romance and mystery that popular history has given the Early Christian period. For one thing, the basilica was largely rebuilt after a disastrous fire of 1823; it had undergone numerous alterations during the Middle Ages; and the mosaics have been restored. The comforting darkness, too, may be an illusion, since we know that countless tapers and candelabra lined the nave during the services. On the other hand, this enticing first-hand impression is surely more authentic than the glossy photographic prints we study in handbooks on architecture.

The architecture of the Early Christian basilica, which was discussed in the previous chapter, was foremost one of interior space, and while the generic models of the structure may be quite easy to trace in Roman architecture, the interior is wholly an Early Christian invention and one that, according to early descriptions, was constructed of "heavenly type in symbolic fashion." Unquestionably this is a vague statement, but it has often been argued that the basilica can, in fact, be seen as a reflection on earth of the New Jerusalem in heaven.[28]

Some have seen this prototype in realistic terms in the description of the City of God in the Book of Revelation: the facade is the city gate, the nave corresponds to the streets, the side aisles are porticoes that line the street, and the sanctuary is the royal throne room placed on the main avenue. Such an interpretation is not sensible in realistic terms, and yet if we consider the mosaic decoration and the elaborate ceremonials that animated this space, the interior, when filled with the congregation, becomes a gathering of souls in communion with God, the very embodiment of the idea of *ecclesia,* an assembly of the faithful. And in this light, the services on earth clearly imitate and reflect the Mass of the church of God held in heaven much as it is described in the Book of Revelation. The heavenly Mass in the Apocalypse and the rite of Christian worship have often been compared, and the parallels are striking, especially in the ceremonies related in chapters 4, 7, and 19 of Revelation and in the conclusion, where John the Evangelist witnesses the image of the holy city of Jerusalem "coming down out of heaven from God" (21:2).[29]

An important document survives to illustrate the symbolic interpretations of the Early Christian basilica: the oration of Eusebius, Constantine's biographer, delivered at the dedication of a church at Tyre.[30] For Eusebius the concept of the church as *ecclesia* is foremost. The basilica is a "living temple . . . of a living God formed out of ourselves." The hierarchy of the faithful is then seen in relationship to the parts: the foundations are the apostles and prophets, Jesus Christ is the cornerstone. While contemporary Roman architecture unquestionably played an influential role in shaping the structural form of the Christian basilica, as we have seen, Eusebius is cautious not to make any specific references to pagan buildings. The church, while not dedicated to a pagan deity, was nevertheless raised in honor of a king, and it is in this oration where we find one of the earliest designations of the new church as a *basilica,* the house of the king.

The final, eschatological image of the basilica for Eusebius was that of the *civitas dei,* the city of God. In the introductory lines of the oration, he describes the church as the "new-made city that God had builded" and the "new and far goodlier Jerusalem," and toward the end of the sermon he more emphatically states that the prototype of the church on earth is to be found in the region above in the heavens: "Such is the great temple which the Word, the great Creator of the universe, hath builded throughout the whole world beneath the sun, forming again this spiritual image upon earth of those vaults beyond the vaults of heaven." Thus Eusebius

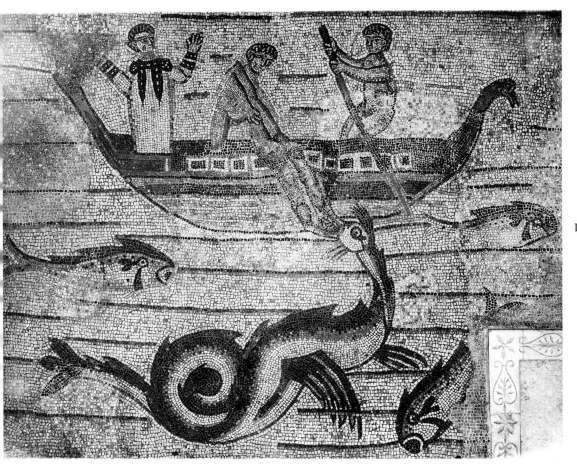

46. *Jonah and the Whale.*
Detail of floor mosaic in the
Basilica of Aquileia
(Venetia). 314–20

sums up the meaning of the church: *ecclesia, basilica, civitas dei.* It is this all-embracing concept that was proclaimed in the decorations of the Early Christian basilica.

Constantinian wall decoration survives in fragments that are little more than patterns of flora and fauna and occasional figurative representations that seem to have been rather arbitrarily applied to those parts of the architecture that normally would have mosaic or painted designs to enhance them in pagan buildings. Floor mosaics survive in appreciable numbers. Especially intact are those of the Basilica of Aquileia, ascribed to Bishop Theodore, 314–20, where amid the numerous geometric divisions of the pavements displaying conventional bucolic motifs one finds the Good Shepherd, the story of Jonah and the whale, and a type of winged Victory standing between a basket of bread and a chalice of wine, motifs common in the catacombs (fig. 46). The fourth-century mosaics in the ambulatory vaults of the mausoleum of Costanza (fig. 44) are simply pagan floor mosaics lifted into the ceilings. They display few motifs that can be considered Christian.[31] The apse mosaics below them are of a later date and reflect basilical decoration, as we shall see.

Prudentius describes floor mosaics and wall paintings in his *Peristephanon,* and he records a series of *tituli* (short, explanatory verses) for nave decorations in the *Dittochaeon,* but he offers little evidence for any extensive programmatic decorations in churches.[32] Paulinus of Nola, on the other hand, writing in the first decades of the fifth century, describes extensive mural decorations in his churches at Cimitile and Fundi (near Naples), and he advises his friend, Sulpicius Severus in Gaul, on appropriate decorations for the apses of his basilicas.[33]

Paulinus describes portals of his "new" basilica decorated with crosses and an atrium with paintings of male and female martyrs near the entrance. The side walls displayed stories of Old Testament women and men of saintly character. At the end of the atrium (adjoining the narthex?) were paintings of events from the first eight books of the Bible (Octateuch). Upon entering the basilica the worshipper could read both Testaments in pictures, apparently lining the nave walls. More lengthy are the *tituli* he composed for the apses. These verses, wholly symbolic in imagery, exalt his favorite motif, the cross, along with other familiar symbols such as the lamb, the dove, and the Hand of God. We shall return to these interesting verses later.

It was about this time, in the early fifth century, that new schemes for decorating the great basilicas in Rome must have incorporated vast picture cycles much like those described by Paulinus. Much of the evidence—such as the inscription on the triumphal arch of Saint Paul's—points to Pope Leo the Great and the empress Galla Placidia as the chief spon-

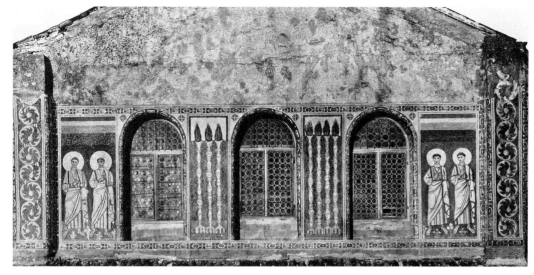

47. Facade mosaic on the Basilica Euphrasiana, Parenzo (now Poreč in Yugoslavia). 535–43

sors of the new art. It was at this time, too, that the flowering of Latin Christian culture occurs. Three of the great Fathers of the Latin church lived in the generation immediately preceding Leo. Saint Ambrose (d. 397), the eldest, not only made significant contributions to the liturgy and music of the Latin service, but he was also instrumental in the founding of churches and *martyria* in Milan, as will be seen in the next chapter. Pope Damasus, himself actively engaged in the commemoration of the martyrs in Rome, assigned to Saint Jerome, the second Father, the arduous task of translating afresh the Hebraic Old and the Greek New Testaments into authorized Latin. The Vulgate, Jerome's edition, was begun in 384, and by the middle of the fifth century it had replaced the earlier *Itala* translation of the Bible in Rome.

The third Church Father, Augustine (d. 430), in writing his monumental *Civitas dei,* or *City of God,* put down in comprehensive form the Christian philosophy of history and the meaning of *ecclesia.*[34] The extensive narrative cycles painted on the walls of the basilicas closely parallel Augustine's divisions of time and his interpretations of them.

It was also during the first half of the fifth century that the great church councils were held. At the Council of Ephesus in 431, Mary was officially entitled *dei genetrix* or *Theotokos,* the "bearer of God" and not merely the mother of a human child. The final definitions of the Incarnation, the two natures of Christ, and the exalted role of Mary *Theotokos* were established at the Council of Chalcedon in 451 and were in part the inspiration of Pope Leo, whose *Tome* of 449 on these matters was instrumental in formulating the orthodox position. And so religious art took on a new role, that of illustrating the expanding dogma and doctrine of the Catholic faith. A new mode of pictorial expression arose in the West, one that can be termed catechetical as well as narrative and symbolic, one in which the expanded mural decorations were not merely embellishments for the new church but were also instructions for those who could read their messages.

In many respects the new mosaic programs of the Roman basilica are manifestations of this rich period. But this significance cannot be easily uncovered by studying only the fragmentary remains of decorations that survive the period as individual works of art as they are generally presented. Rather, they should be studied in the context of the decoration of the church as a whole theater of the Christian drama. For our purposes the pictures can be considered in three divisions appropriate for the real and the symbolic makeup of the basilical complex: the portal, the nave, and the apse.

THE PORTAL

The symbolism of architecture in the Early Christian world was rigidly codified. The late Roman Empire had accumulated a variety of articulate architectural forms that served as symbolic settings for ceremonials ranging from the pompous pageantry of the imperial court to the secretive rituals of the numerous religious cults.[35] Foremost among these symbolic forms was the portal, which, in the broadest sense, was a major architectural structure that served as a point of division, be it a gateway, a facade, or an elaborate door. Simply stated, the portal separated one place from another: the countryside from the city, the street from the temple or palace, the assembly hall from the sanctuary. In a religious precinct the portal was multiplied, marking each important step along the *sacra via* (sacred way), and, like sections of a telescope gradually opened, each magnified the focal image, the deity or emperor. In the Christian church the portals were aligned along the longitudinal axis that led from the atrium gateway through the facade of the basilica to the great arch before the apse. It is not surprising that such a significant architectural form early acquired an impressive decorative program befitting its function.

In late Roman times the symbolic portal served purposes beyond that of a simple entrance or exit. The emperor frequently made his official appearance before the public there,

especially at ceremonials such as that of the *adventus* or *triumphus,* the reception of the lord into the city after a victorious campaign. Thus the central image on the portal of a Christian basilica was the appearance (*adventus*) of the King of Kings, Christ, in symbolic form or portrayed in the heavens at his Second Coming, when he makes a grand appearance as the *Maiestas Domini* (the majesty of the lord).[36]

The theme of the *Maiestas Domini,* one of the most impressive images in all Christian art in the West, was based on the description of the mystical appearance of the Lord to John the Evangelist in the early chapters of the Book of Revelation: "After these things I looked, and behold a *door* was opened in heaven . . . and upon the throne one sitting. . . . and there was a rainbow round about the throne, . . . And round about the throne were four and twenty seats; and upon the seats, four and twenty ancients sitting, clothed in white garments, and on their heads were crowns of gold. And from the throne proceeded lightnings, and voices, and thunders; and there were seven lamps burning before the throne, which are the seven spirits of God. And in the sight of the throne was, as it were, a sea of glass like to crystal; and in the midst of the throne, and round about the throne, were four living creatures, full of eyes before and behind. And the first living creature was like a lion: and the second living creature like a calf: and the third living creature, having the face, as it were, of a man: and the fourth living creature was like an eagle flying. And the four living creatures had each of them six wings; . . . And they rested not day and night, saying: Holy, holy, holy, Lord God Almighty, who was, and who is, and who is to come" (4:1–8).

Not surprisingly, no examples of gateways to atria of the fifth century survive, but the scant evidence that we have suggests that at least by the eighth century an abridged version of the *Maiestas Domini,* with Christ enthroned within an aureole carried by angels above standing figures, was represented in mosaics on the outer wall of the towered entrance to the atrium of Saint Peter's.[37]

More evidence remains for the decoration of the basilica facades. A sixth-century mosaic on the west front of the Basilica Euphrasiana in Parenzo with the lower zone still intact (fig. 47) retains the outlines of the spooled candlesticks (the seven lamps of fire) that appeared before the enthroned Christ in the gable above, of which mere traces are visible. Fortunately, the facade of Saint Peter's in Rome is documented in a seventh-century report—"the four beasts are depicted about Christ"—and in drawings of the archivist Jacopo Grimaldi (fig. 48).[38] Restorations of the facade are

48. JACOPO GRIMALDI. Drawing of the facade of Saint Peter's, Rome. 1619. Vatican Library, Rome (MS Barberini, lat. 2733, fol. 133)

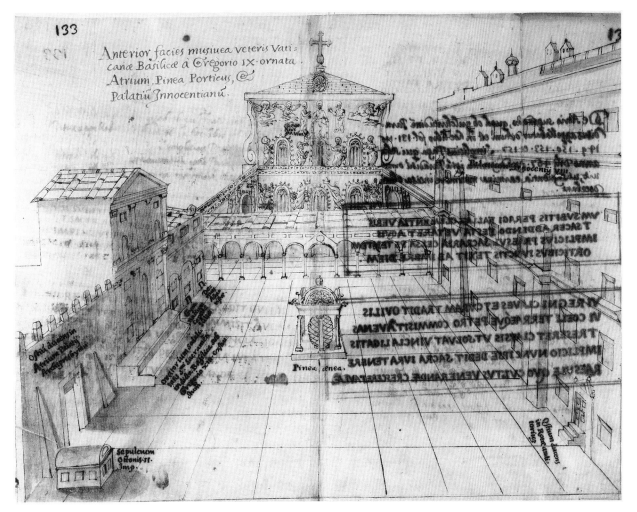

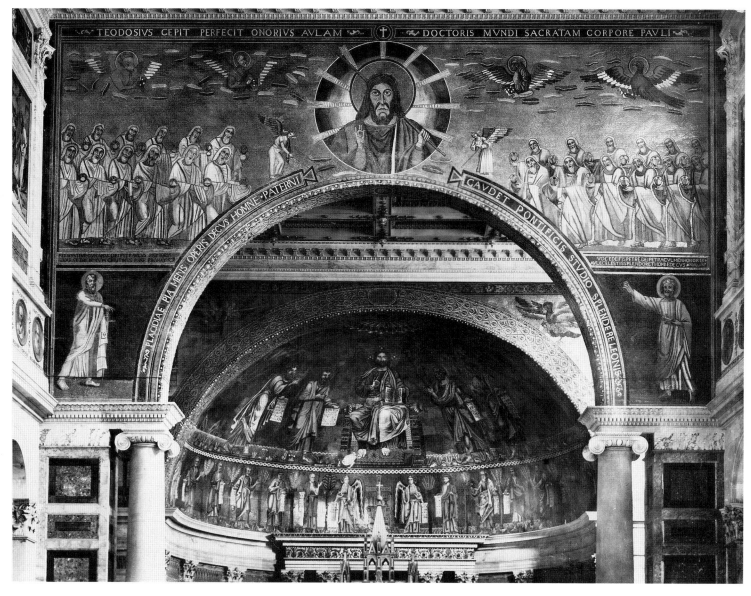

49. *Maiestas Domini.* Mosaic on the triumphal arch of San Paolo fuori le mura, Rome (restored). c. 450

recorded during the papacies of Sergius I (687–701), Innocent III (1198–1216), and Gregory IX (1227–41), but it is unlikely that the original design would have been changed appreciably (some have argued that a symbolic lamb replaced the figure of Christ in the restoration of Pope Sergius I). That the tradition of presenting the *Maiestas Domini* on the basilica facade was lasting is clearly evidenced by its repeated appearance in sculptural form in later Medieval churches, such as Moissac (fig. 332) and Chartres (fig. 473), where it constitutes the central theme in a much-expanded iconographic program.

The third major portal in the basilical complex is the enlarged arch separating the nave from the apse, the congregation from the clergy. Significantly, an early designation of this structure, a Carolingian reference, is *arcus tri-*

umphalis, or arch of triumph, and in many early basilicas it is monumentalized and set within the transepts, resembling a Roman triumphal arch with its heavy base and broad attic.[39] The restored mosaic on the triumphal arch in Saint Paul's (fig. 49), decorated for Pope Leo the Great, according to the inscription, preserves its original design with the exception of a few muddled details (the angels who seem to be playing golf should be blowing trumpets!). The attic features a dramatic *Maiestas Domini* with Christ presented in an *imago clipeata* (medallion bust-portrait) anticipating the bold Christ *Pantocrator* of Byzantine art (see pp. 151–52). The bust of Christ forms an effective keystone for the decorations, and it became the traditional motif for many later arches. To the sides are the winged busts of the Apocalyptic beasts, and below, on the sides of the arch, the twenty-four

50. *Adoration of the Lamb.* Mosaic on the triumphal arch of Saints Cosmas and Damianus,
Rome. c. 526–30

elders are aligned in two rows. Standing portraits of Peter and Paul decorate the lowest zone.

The substitution of the symbolic lamb for the bust of Christ appears in the sixth-century enframing arch in the apse of Saints Cosmas and Damianus (fig. 50).[40] The lamb rests on an elaborate throne, an altarlike structure, bejeweled and carrying a cushion and small cross. This is the "prepared throne," or *Etimasia,* a familiar motif in later Byzantine art, described in Psalm 9:8–9: "He hath prepared his throne in judgment: and he shall judge the world in equity, he shall judge the people in justice." On the suppedaneum before it lies the scroll of the seven seals that the lamb will open (Rev. 5 and 6). To complete the Apocalyptic image, the four beasts appear (partially concealed by later restorations) along with the seven candlesticks about the throne. Barely visible today in the lower zones of the arch are veiled hands offering crowns, remnants of the twenty-four elders in the original design of the mosaic.

The *Etimasia* appeared earlier on the arch in Santa Maria Maggiore about 432–40 (figs. 51–54). The unusual representations on this arch would seem to contradict our model, but, in fact, it reinforces the iconography of the *Adventus Domini,* or appearance of the Lord, so basic to portal decoration. It should be remembered that Santa Maria Maggiore was the first church in Rome to be dedicated to the Virgin, and for that reason the mosaics on the arch display not the Second Coming but the first appearance of the Savior in the flesh, the bearer of salvation being Mary herself. Curiously this Nativity cycle is unlike any other known in Early Christian art. It has been suggested that the episodes are based in

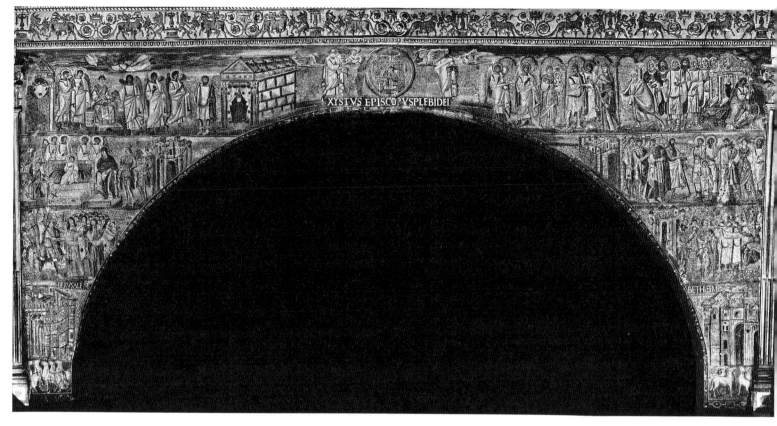

XYSTVS EPISCO VSPLEBIDEI

HIERVSALE BETHLEEM

51. Mosaics on the triumphal arch of Santa Maria Maggiore,
Rome. c. 432–40

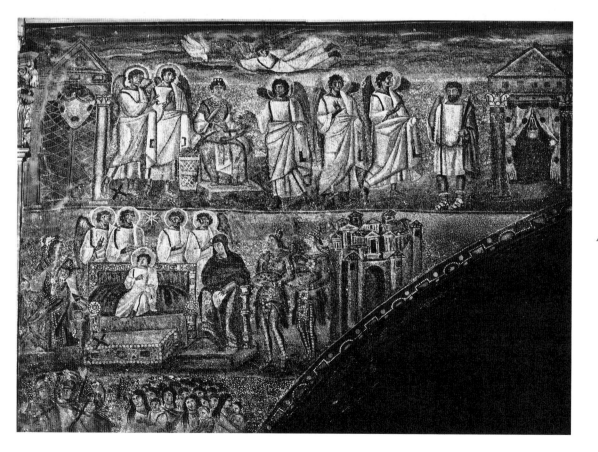

52. *Annunciation*
(above);
Adoration of the Magi
(below).
Detail of fig. 51

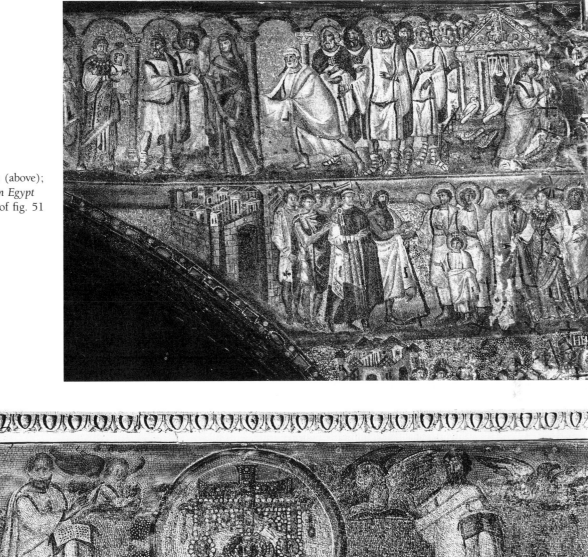

53. *Presentation* (above);
Christ Child in Egypt
(below). Detail of fig. 51

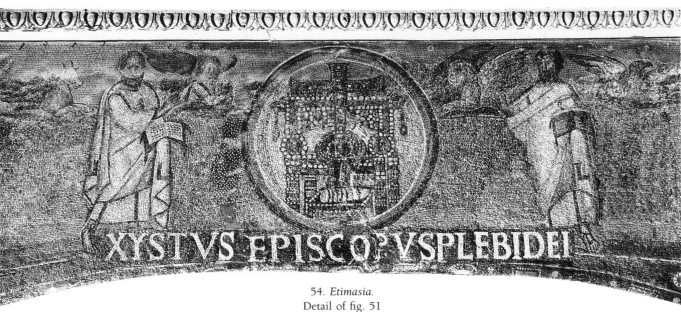

54. *Etimasia.*
Detail of fig. 51

part on apocryphal gospel accounts such as that of pseudo-Matthew, but this is not demonstrable, and, furthermore, the scenes are unique.

The scenes of the Annunciation and Presentation in the topmost register are depicted as royal events, with Mary enthroned as an elegant empress amid palace guards in the Annunciation, while the Presentation is expanded to form a ceremonial frieze of courtly figures gathered before the temple of Rome with its statue of the goddess of the city. The combined scenes of the Nativity and Adoration of the Magi in the second register on the left are even more regal. The divine Child sits on a huge, bejeweled throne as a miniature emperor making his official appearance to the kings of the world. These curious intrusions in the Infancy cycle are certainly intentional, and no doubt they were meant to underscore the role of Mary as *Theotokos,* the bearer of a divine god, such as her personality was defined at the Council of Ephesus in 431 and to whom the original dedicatory inscription on the arch was addressed.[41]

Since the "first coming" is so emphatically stated here, the

"second coming" is reduced to the representation of the empty "prepared throne" that awaits Christ's appearance in judgment. Such an idea and image can be linked to ancient council ceremonies where similar empty thrones were displayed with insignia of the imperial office to signify the divine presence of the king (for example, the Throne of Alexander the Great).[42] According to the Carolingian scholar Anastasius Bibliothecarius, the idea of the prepared throne in Santa Maria Maggiore was inspired by the tradition initiated at the Council of Ephesus, where an empty throne or cathedra was set up with the scriptures opened across it to summon the invisible presence of Christ as the divine judge presiding over the council. Thus the unusual mosaics on the arch of Santa Maria Maggiore demonstrate a double *adventus* of Christ: his divine appearance in the Incarnation as manifest in the Infancy scenes and the second advent anticipated in the throne prepared at the end of time when he will judge mankind. The hieratic nature of this presentation no doubt accounts for the more abstract style that characterizes the arch mosaics.

THE NAVE

One of the most distinctive features of the Medieval basilica in the West is the pronounced longitudinal character of the deep nave. The nave functioned as an assembly hall for the congregation and as an avenue for liturgical processions and ceremonies. Why should such a church type persist? It could be argued that the prestige of Saint Peter's, where one of the earliest longitudinal halls was combined with cross-transepts—the formidable Latin cross or *T*-shaped plan—established a fast tradition, one that was so hallowed that not even the renown of Bramante or Michelangelo, both of whom designed centralized ground plans for the new church, could influence the churchmen of the Vatican to abandon it.

Like some great tunnel, the nave evoked a dramatic, almost magnetic, attraction for movement. There was a constant focus on the altar at the far end, thus contributing to a sense of continuous and measured progression with a clearly marked beginning, middle, and end. The decoration devised for the walls of the nave made this experience more dramatic and meaningful. An impressive sequence of pictures illustrating the pilgrimage of the city of God unfurled before the eyes of the worshipper and led him down the nave toward the awesome portrayal of the godhead in heaven hovering in the apse. This concern for history, for the progression of *ecclesia* through the Old and New Testaments to the New Jerusalem, constitutes one of the basic tenets of Latin worship. In fact, the keen sense of history that the Latin church had inherited from Judaism and Rome—the same historical consciousness that Augustine so clearly explicated—was one of the reasons why the nave provided an appropriate gallery for their arts.

The elevation of the nave was divided into three well-defined zones for decoration. The highest, that formed by the wall strips between the windows in the clerestory, was treated as a portrait gallery for the earliest authorities of the church, the most honored citizens: the patriarchs, prophets, and apostles. In the blank wall below, a very different mode of decoration was employed, with individual mosaic or fresco panels, side-by-side, narrating the sacred histories. The lowest register along the architrave of the nave colonnade or arcade presented medallion portraits of the popes, the descendants of the apostles.

Portraits, whether full-standing as if in niches or *imagines clipeatae* (medallion busts), were common in pagan mural decoration, but panels with narrative illustrations present a more complicated ancestry. Such histories belong to the mode of illustration known as cyclical narration that had its development in Hellenistic book illustration and Roman historical painting and relief sculpture. Following in sequence down or up the nave, they are to be read as some cinematographic presentation of Christian history, just as miniatures were to be read along with the texts, and the addition of short, explanatory verses beneath them often made this resemblance more striking. At any rate, the idea that the nave mosaics are comparable to a giant illustrated Bible placed before the eyes of the congregation is certainly apt.

From the evidence, it seems that such picture programs were already put into the naves of Saint Peter's and Saint Paul's at an early date,[43] although, as we have seen, these areas were frequently restored or rebuilt. In both churches the right wall of the nave, viewed from the entrance, was decorated with a double register of episodes from Genesis and Exodus, with such stories as the creation, the flood, and the miracles of Moses. The left wall carried a corresponding series of New Testament scenes. These latter episodes illustrated the life of Christ in Saint Peter's, but in Saint Paul's, where Pietro Cavallini later worked as restorer, the cycle was devoted to the life of Saint Paul, the patron saint (figs. 55–57a, b). At Santa Maria Maggiore, where the only extensive remains of fifth-century mosaics with narratives survive, the events on both sides of the nave were drawn from the Old Testament, while at Sant'Apollinare Nuovo in Ravenna, the sixth-century nave mosaics are restricted to scenes of the miracles and the Passion of Christ, for reasons to be explained later (see pp. 115–16). For the most part, however, later basilicas repeat the juxtaposition of the Old and New Testament stories that very likely was initiated at Saint Peter's.

The opposition of Old and New Testament events across the nave in Saint Peter's brings to mind the familiar juxtaposition of *type* and *antitype* so common in Christian literature and later Medieval art. According to this typology, an Old Testament event prefigured one in the New opposite

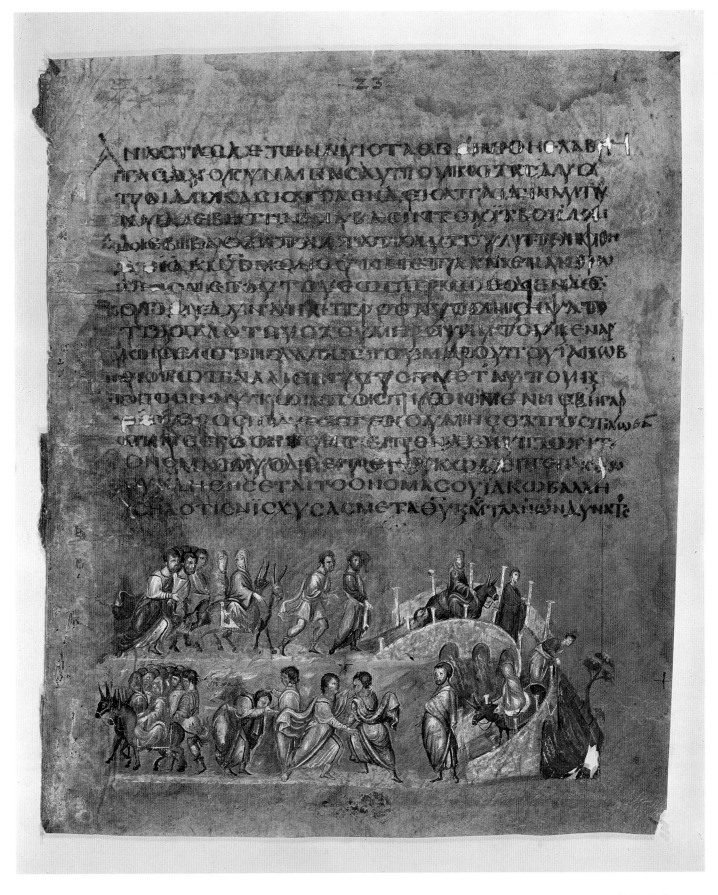

Colorplate 6. *The Story of Jacob.* Miniature in the Vienna Genesis. 13¼ × 9⅞″. 6th century. Oesterreichische Nationalbibliothek, Vienna (Cod. theol. gr. 31, fol. 12v)

Colorplate 7. *The Story of Adam and Eve*. Miniature in the Ashburnham Pentateuch. 14½ × 12⅜″. 6th century (?).
Bibliothèque Nationale, Paris (MS nouv. acq. lat. 2334, fol. 6)

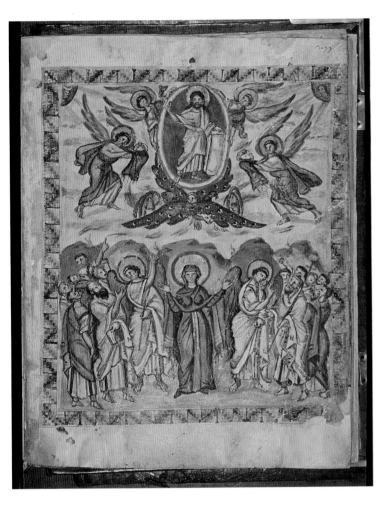

Colorplate 8. *Ascension*. Miniature in the Rabbula Gospels.
13 × 10½″. Completed at Zagba, Mesopotamia, c. 586.
Biblioteca Laurentiana, Florence (MS Plut. I, 56, fol. 13v)

Colorplate 9. Scenes from the Life of Christ. Painted box for
pilgrims' mementos of the Holy Land. Wood, 9⅞ × 7⅛″.
Late 6th century. Museo Sacro Cristiano, Rome

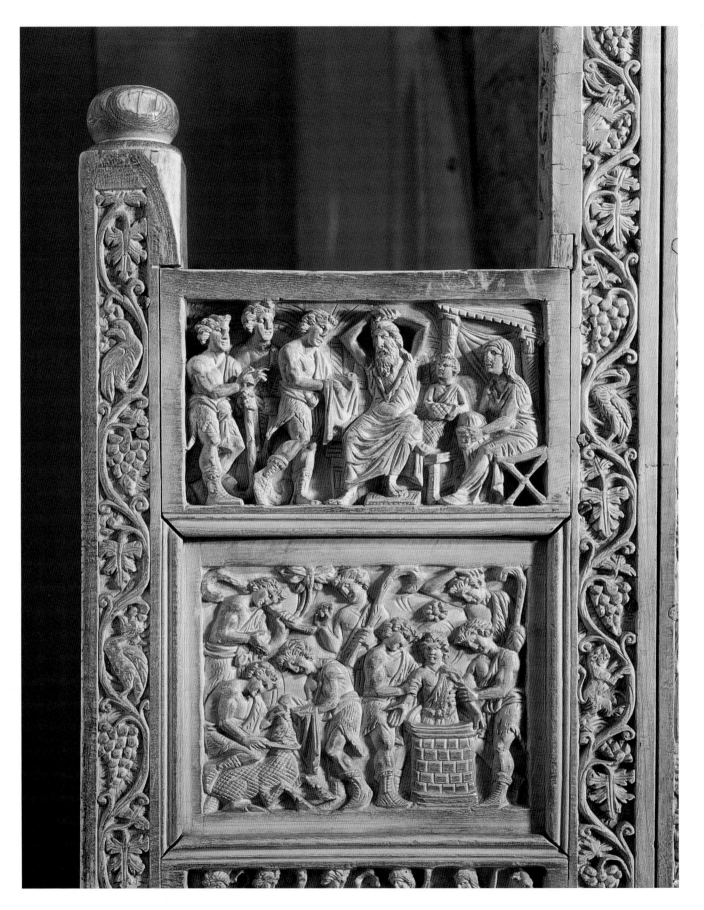

Colorplate 10. *Joseph's Brethren Tell of His Death* (above); *Joseph in the Well and the Killing of the Kid* (below).
Ivory plaques on the side of the Throne of Maximian. c. 547. Detail of fig. 112

55. Jacopo Grimaldi. Drawing of the right (north) wall of the nave of Saint Peter's, Rome. 1619. Vatican Library, Rome (MS Barberini, lat. 2733, fol. 109)

56. Jacopo Grimaldi. Drawing of the left (south) wall of the nave of Saint Peter's, Rome. 1619. Vatican Library, Rome (MS Barberini, lat. 2733, fol. 114)

it—for example, the Sacrifice of Isaac paired with the Crucifixion, the Meeting of Abraham and Melchizedek with the Last Supper—and while there is some hint of such an ordering in the forty-nine verses in Prudentius's *Dittochaeon,* which apparently reflect such a nave program, there is little evidence to ascribe such a rigorous parallelism to Early Christian nave cycles.

Jacopo Grimaldi's drawings of the remaining eastern portions of the nave of old Saint Peter's (figs. 55, 56) preserve the state of the decorations after numerous restorations and, hence, can serve only as reflections of the iconography of the fifth-century decorations. The drawings of the right wall show the remains of the clerestory figures that Grimaldi labeled "prophets," although one appears to be an angel. The

57. *left:* (a) *Sacrifice of Isaac; right* (b) *Deception of Isaac.* Drawings of nave paintings in San Paolo fuori le mura, Rome. 1634. Vatican Library, Rome (Cod. Barberini, lat. 4406, fols. 38, 39)

narrative scenes along the wall below record superimposed scenes that can be identified as the stories of Noah and the flood, Abraham and the three angels, the deception of Isaac by Jacob, above, and in the lower register events from the life of Moses, including the seven plagues in Egypt and the crossing of the Red Sea. The entablature, finally, featured a double row of medallion portraits of popes (obviously added to in time). The decorations of the left wall are too fragmentary for us to discern a program. An enlarged Crucifixion appears; a Baptism, Descent into Limbo, and Christ among the apostles can also be identified, but no scenes of the Infancy or Ministry appear. A number of details in the Old Testament stories indicate an Early Christian iconography for them, while those of the New appear to be mixed in types.

Much attention has been given to the restorations of the Early Medieval paintings in the nave of Saint Paul's by Pietro Cavallini about 1300. While the upper walls of the nave were nearly destroyed by the fire of 1823, detailed watercolor copies of the pictures in the nave, made in 1634 (Vatican Library, Cod. Barberini, lat. 4406, 4407), record the subjects. They include forty-three standing figures from the clerestory, seventy-eight narratives from the nave walls, and numerous *imagines clipeatae* of popes that once adorned the arcade. Here the Old Testament wall was disposed much as at Saint Peter's, and many of these are clearly Early Christian in style and iconography, indicating that Cavallini restored his models carefully where he could (figs. 57a, b). Some are definitely products of the late thirteenth century and were no doubt new compositions added by Cavallini where necessary. It is important to note that Cavallini's work in Saint Paul's was part of a greater project of Pope Nicholas III to renovate the Early Christian monuments in Rome, a reform and restoration that we shall return to later in this study (see chapter XXV).

The surviving mosaics in the nave and arch of Santa Maria Maggiore were commissioned by Pope Sixtus III (432–40).[44] Perhaps Leo, then the archdeacon under Sixtus, had a hand in planning the pictures in the nave, which, as remarked above, are wholly devoted to Old Testament events. The lives of Abraham and Jacob appear on the left, those of Moses and Joshua on the right. The close bond between Mary and the Old Testament, so familiar in later Medieval art, thus is stressed here in the earliest major memorial to the Virgin in the West. As the mother of Christ in the New Testament, Mary was also the final member of the Jewish ancestry inherited by Christ, and this is the foremost theme presented in the *historiae,* or historical narratives, of the nave. Themes alluding to marriage, legitimate birth, and inheritance of the covenant are stressed as much as the dramatic liberation of Israel recorded in the Pentateuch. This emphasis further underscores the role of the son of the *Theotokos* as the legitimate heir of Jewish patriarchy and priesthood.

The idea of presenting Old Testament types for the mysteries of the church is also apparent in many of the panels. The first mosaics on the left wall, which are out of chronological order, were chosen because of their proximity to the priest officiating at the altar. In the first (fig. 58) the high priest and king Melchizedek offers bread and wine to Abraham after his victory. This is one of the most frequently cited prefigurations of the institution of the Eucharist in Christian art. The rigid alignment of the offerings, bread and wine, beneath the bust of Christ as the Lord, makes the association all the more emphatic.

In the next mosaic the meaning of the Eucharist is unveiled further (colorplate 3). The feast of Abraham and the three men in the valley of Mambre is illustrated in three distinct scenes crowded into a landscape setting (this compression of two or more episodes within a single field is

called conflation). Abraham, who is portrayed three times, is foremost the image of the priest who celebrates the Eucharist at the altar. In the upper part he kneels before the three men of the Lord, a prefiguration of the Trinity. In the *City of God* Augustine wrote, "While seeing three, Abraham worshipped but one."

One of the earliest examples of the oval aureole in Christian art appears in this mosaic to make the point clear. As a sign of divine presence, the transparent mandorla surrounds the central figure and overlaps the other two. The three men were sent to Abraham to announce to him and his wife Sarah the forthcoming (and miraculous) birth of a son, to be named Isaac. Sarah stands to the left before their modest dwelling. The final episode, the presentation of the feast to the three about the table, once again prefigures the Christian Mass. Cakes of bread, marked with crosses, are on the table. Abraham holds a platter with a toy calf, and directly below the table, where only fragments remain, the lip of a wine crater has been discerned. Thus the bread and the wine, the body and blood of Christ, are elements of the feast.

Across the nave, *Moses Crossing the Red Sea* (fig. 59), a popular type for baptism, is followed by other deeds of Moses that anticipate the miracles of Christ. The painterly illusionism of the scene of the Crossing transforms the panel into a confettilike carpet of tesserae (cubes of stone or glass) that render the mosaic difficult to identify. What can be said about the style here?

In this and other nave mosaics the illusionist values are enhanced by the vibrancy of the tiny colored cubes of tesserae that shimmer unevenly, suggesting gradations of light across the strong outlines of the figures. Varicolored streaks of colored glass form drifting clouds against the blue skies that fade at the horizon into the "rosy-fingered dawn" of Antique atmospheric perspective. The lively figures stand clearly in space and cast shadows as they move in and about miniature buildings convincingly rendered in rudimentary perspective schemes. Often gold zones appear between the sky and the ground, but more than having iconographic significance, these abstract areas help to silhouette the moving figures. The tiny actors are more casually arranged and more animatedly disposed than their counterparts in the hieratic compositions on the arch in Santa Maria Maggiore where, as we have seen, the rigid regimentation, the frontality, and the measured cadence of a frieze predominate.

These stylistic differences are due to different modes of illustration. The arch mosaics fit the mold of Roman tri-

58. *Abraham and Melchizedek.* Nave mosaic in Santa Maria Maggiore, Rome. c. 432–40

59. *Moses Crossing the Red Sea.* Nave mosaic in Santa Maria Maggiore, Rome. c. 432–40

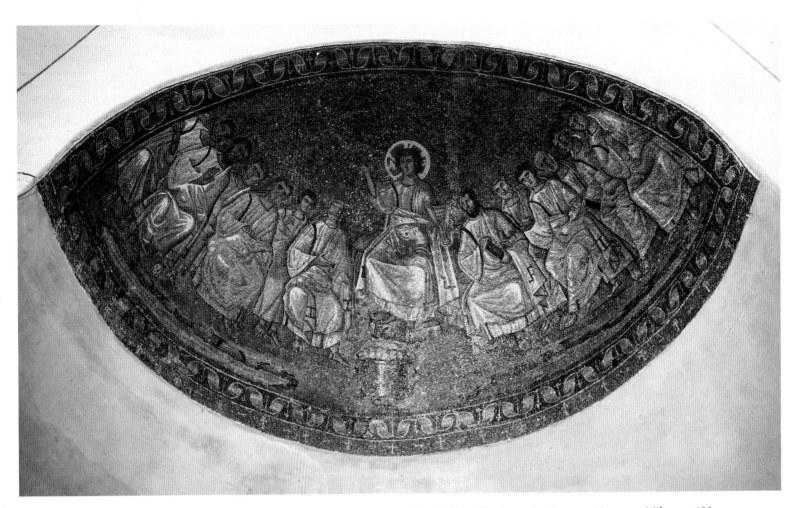

60. *Christ Teaching, Seated Among Apostles.* Apse mosaic in the Chapel of Sant'Aquilino, San Lorenzo Maggiore, Milan. c. 400

umphal ceremonials such as those found in the relief sculptures of the Arch of Galerius in Constantinople, while the livelier nave scenes evoke memories of the dynamic narratives unraveling on the triumphal Column of Trajan in the Roman Forum. In turn, it has been argued that these column reliefs, resembling lengthy scrolls wrapped about a column, are dependent on the illustrated scrolls of Antiquity (see below, p. 136). That the more animated and illusionistic style of the nave histories points to the art of continuous narration seems irrefutable.

THE APSE

The mosaics that adorned the apse of the presbyterium completed the program of decorations in the Early Christian basilica. Passing under the triumphal arch, one left the domain of the terrestrial *ecclesia* and the unfolding of its history and arrived in the sanctum of the heavens, where Christ and his saints reign eternally. The designation of this part of the church as the apse (*apsis*) is somewhat vague, but for the Late Antique world, *apsis* (meaning hoop or arch) would have evoked associations of an entry into a radiant heaven, and the imagery of the Christian sanctuary appropriately portrayed the One in heavenly paradise.[45]

Pagan representations of paradise settings provided the

Christians with a number of familiar motifs. The stretched tent or canopy of the cosmos that appears in pagan vaults and domes of heaven found a place in the very summit of the apse (a semidome), and the fields of Elysium, its verdant meadows accentuated by bright flowers, served as a stage for the figures. Also the exotic pagan riverscapes with putti fishing were taken over by the Christians to represent the refreshing waters of paradise that flow beneath the throne in heaven.[46]

The intimate relationships between the imagery of the apse and that of the liturgy performed at the altar below were conspicuous. The divine service in heaven above reflected the Mass below. Hence, the architectural decoration served as a giant stage set for the liturgical drama.[47] Numerous legends testify to the belief that the portrait of Christ in the apse was miraculously conceived. According to one legend, the face of the Savior magically appeared in the apse of the Lateran basilica during the consecration services before Bishop Sylvester, the emperor Constantine, and the startled congregation.

In the simplest representations, Christ is depicted as a youthful teacher or philosopher with the apostles gathered about him (fig. 60).[48] A leather case, or *scrinium,* lies on the ground filled with the scrolls that represent the teachings of the Bible. This type derives from pictures of pagan sym-

posia, common in Hellenistic art, where learned friends are seated about their mentor. In Christian terms, the philosopher theme could easily be seen as a type for the Sermon on the Mount (Matt. 5), and, as such, it was widespread in Italy by the fifth century, one of the finest surviving examples being the mosaic in the apse of the Chapel of Sant'Aquilino in Milan. The composition also appears in later catacomb paintings and on sarcophagi, such as that in Sant'Ambrogio (fig. 10), discussed above, where it is elaborated with new features. Christ and his apostles appear before city gates or portals, symbolic of the New Jerusalem in heaven, and below them, in a predellalike fashion, a lamb or frieze of lambs is added as the symbolic counterpart to those above. Interestingly, this elaboration appears in one of the earliest apse paintings in Rome, the mosaic in the sanctuary of Santa Pudenziana (colorplate 4).

The mosaic in the Church of Santa Pudenziana, dating about 400, has been partially obscured by later rebuildings, but drawings help us reconstruct the original design.[49] Enthroned between the apostles, led by Peter and Paul, the bearded Christ stares out and makes the familiar gesture of teaching or proclamation (also called the benediction). In the colorful skies above are busts of the four creatures described in Revelation: the man, lion, ox, and eagle, each with six wings, as the text specifies. Hence the elderly Christ is envisioned as the One on the "throne set in heaven" presiding over the Divine Mass in the Apocalypse (Rev. 4).

Two veiled female figures, heavily restored, stand behind Peter and Paul and offer wreaths. They are personifications of the churches of Gentiles, behind Paul, and the Circumcision (the Jews), behind Peter on the right. According to a drawing, a lamb standing on a mound originally appeared directly below the throne, as it does on the sarcophagus in Sant'Ambrogio. The open court behind the figures resembles the city-gate facades on the same sculpture. The complex cityscape in the distance, however, is unprecedented. In the midst of the city, directly behind Christ, rises a hill surmounted by a tall cross bedecked with gems. This is meant to reproduce the famed *crux gemmata* placed on Mount Golgotha in Jerusalem in the fourth century, and it is tempting to identify the other structures with topographical features of the Holy Lands as the counterparts of the New Jerusalem.[50]

The second apsidal theme with Christ and the apostles is that of the transference of the Law, more specifically the *Dominus legem dat Petro,* or the Lord gives the Law to Peter.[51] The frequency of its appearance (Santa Costanza apse, San Giovanni in Fonte in Naples, the sarcophagus in Sant'Ambrogio, and elsewhere) suggests that the impressive theme originated in a major basilica in Rome. Christ stands in a frontal position atop the hill of paradise (the new Sinai?) between Peter and Paul. In his left hand he holds a scroll, often inscribed *Dominus legem dat,* which is received by Peter in veiled hands.

61. JACOPO GRIMALDI. Drawing of the apse mosaic in Saint Peter's, Rome. 1619. Vatican Library, Rome (MS Barberini, lat. 2733, fol. 158v–159)

In the broader sense, the *Dominus legem dat* can be interpreted as the Mission of the Apostles (Matt. 28:16–20; Acts 1:8). At the very moment of the Ascension of Christ, he charged the apostles with powers "given to me in heaven and in earth. Going therefore, teach ye all nations, baptizing them in the name of the Father, and of the Son, and of the Holy Ghost. Teaching them to observe all things whatsoever I have commanded you."[52]

Where are we to look for the prototypes for these impressive apse compositions? Some have suggested that the second, the *Dominus legem dat,* was devised for the apse in Saint Peter's, certainly a plausible location concerning the role of Peter, but the Grimaldi drawing of the apse there indicates that at the time he recorded it, the representation had an enthroned Christ teaching between Peter and Paul in paradise (fig. 61), a reduced version of the earlier apse theme. The other possibility would be the Lateran basilica, the original cathedral of Rome founded by Constantine.[53]

Numerous variations on these basic themes were possible. The impressive mosaic put into the giant semidome of Saints Cosmas and Damianus in the Roman Forum by Pope Felix IV (526–30) displays iconic features, with Peter and Paul serving as patrons for the two Persian physicians before a huge Christ coming in the clouds (fig. 62). To the far left and right stand the founder, Pope Felix, and the soldier martyr, Theodorus Tiro. Here the import of the transference of the Law to Peter has been compromised by the theme of the presentation (*praesentatio*) of patron saints of the church, resulting in a pronounced stiffness, frontality, and abstraction of the figures and setting.[54]

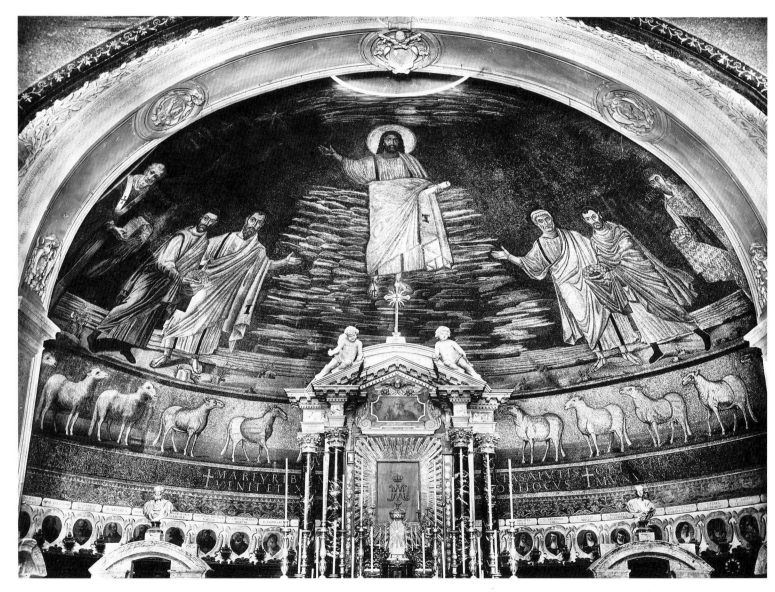

62. *Christ Acclaimed by Saints Peter and Paul with Saints Cosmas and Damianus, Saint Theodorus Tiro and Pope Felix IV.* Apse mosaic in Saints Cosmas and Damianus, Rome. c. 526–30

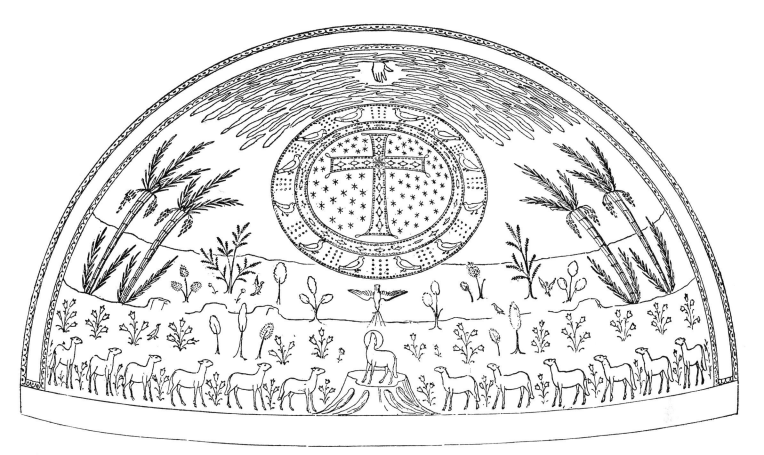

63. Hypothetical reconstruction of the apse in the Basilica Apostolorum, Cimitile (after Wickoff). c. 400–402

The familiar symbol of Christ, the cross, also made an early appearance in place of the figural portrayal of Christ in apse decorations. Such would seem to be the case with the apse described by Paulinus of Nola in verses that accompanied the decorations in the Basilica Apostolorum in Cimitile about 400–402: "The Trinity glistens in full mystery: Christ stands as a lamb, the voice of the Father sounds from the heavens, and the Holy Spirit flows out through the dove. A crown encircles the cross like a bright sphere, and on this crown are the crowns of the apostles who are represented by a choir of doves. The Holy Trinity meets as one in Christ, himself having Trinitarian signs: the voice of the Father and the Spirit reveal the divine, the purple and the palm indicate his kingship and triumph. He, himself the rock of ecclesia, stands on a rock from which issue the four sonorous streams, the Evangelists, the living waters of Christ."[55] Much of the imagery of Paulinus's verses is clear and provides the essential elements of an apse representation (fig. 63).

The exalted role of Mary as *Theotokos* had an immediate influence on her portrayal in Rome, especially at Santa Maria Maggiore, where she appears on the arch as a queen, garbed in a purple *palla* (loose outer garment) and wearing a crown. The present apse mosaic there was executed in 1296 by Jacopo Torriti and presents a Coronation of the Virgin that conforms to later Medieval iconographic types, but the original fifth-century portrait was assuredly the type known as the *Maria Regina* (Mary as Queen) that we see on the arch. Such a type appears in the enigmatic Church of Santa Maria Antiqua in the Forum (figs. 64a, b), dated usually in the sixth century.

Another, lesser-known church in the Forum, known today as Santa Francesca Romana, was originally entitled Santa Maria Nova (the "New"), and the apse there features a splendid mosaic portrait of the Virgin seated on a lyre-backed throne within a walled arcade with two apostles on either side (fig. 65). The mosaic is a twelfth-century work, a restoration of an earlier composition, but it retains many features of an Early Christian design. Not only is the Madonna an elegant queen, but the apostles within the arcade assume postures well known in fourth- and fifth-century mosaics. The conventional canopy of the heavens with the Hand of God appears above her, and the verdant fields of Elysium form the setting. As an example of the revival of Early Christian art in the later Middle Ages, it very likely is a fairly reliable copy of the apse in the most hallowed of churches dedicated to the Virgin in Rome, Santa Maria Maggiore.[56]

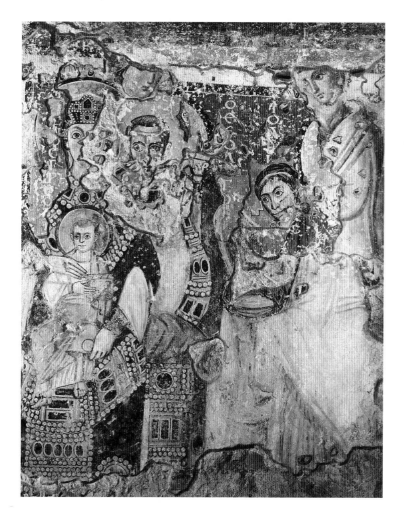

A final type of Early Christian apse decoration was that of the *praesentatio,* or display of the martyr of the church alone without the benefit of Christ or Mary. The more hieratic treatment and severe frontality of Saints Cosmas and Damianus in the apse of their church (fig. 62) clearly announced this new veneration. A famous example of this type is found today in the apse of the Basilica of Sant'Agnese on the Via Nomentana in Rome (fig. 66). The mosaic was allegedly put in by Pope Honorius I (625–38) for the church he rebuilt over the martyr's grave.[57] Here Saint Agnes, standing between the original sponsors of the church, assumes the pose and style of Early Byzantine icons, and very likely Eastern influences are to be reckoned in such portraits (cf. fig. 132). Agnes is dressed as a bride of Christ wearing a courtly costume and a crown. At her feet the instruments of her passion appear in the form of two flames and a sword, and in the summit the Hand of God issues from a starry heaven holding her crown of martyrdom.

The spirit of revival and reform, initiated by the popes in the ninth century and again in the twelfth, was accompanied by the restorations of the great mosaic programs of the Early Christian basilicas of Rome. These revivals had much to do with the surprising continuity of Christian art in the Latin West. As we shall see, the grand schemes for church decoration begun under Sixtus III and Leo the Great in the fifth century became the archetypal programs throughout the Middle Ages, culminating in the great sculptural decorations of Gothic cathedrals in the Ile-de-France.

64. *above:* (a) *Virgin and Child Enthroned Between Angels.* Section of "palimpsest" wall fresco in Santa Maria Antiqua, Rome. 6th–7th century; *right:* (b) reconstruction of the composition (after Wilpert)

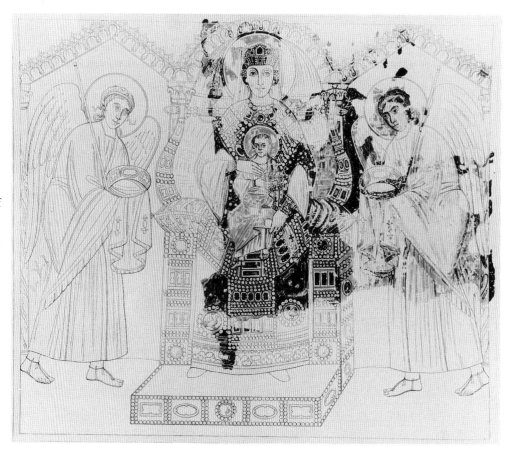

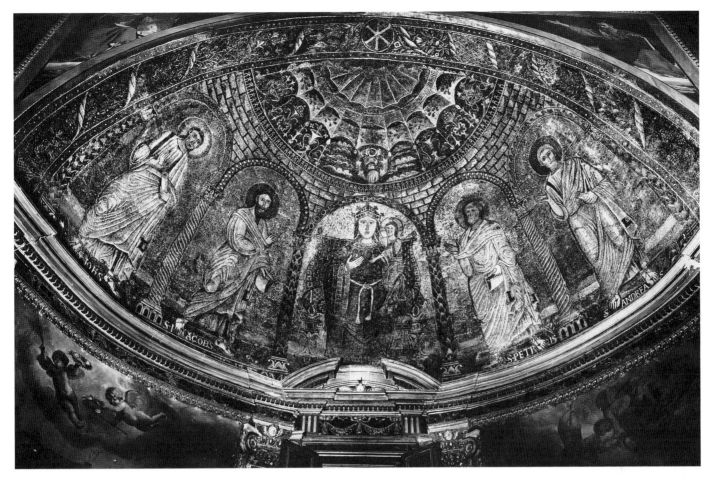

65. *The Virgin and Child Enthroned Between Saints.* Apse mosaic in Santa Maria Nova (Santa Francesca Romana), Rome. 12th century

66. *Saint Agnes Between Pope Honorius and Pope Symmachus.* Apse mosaic in Sant'Agnese fuori le mura, Rome. c. 630

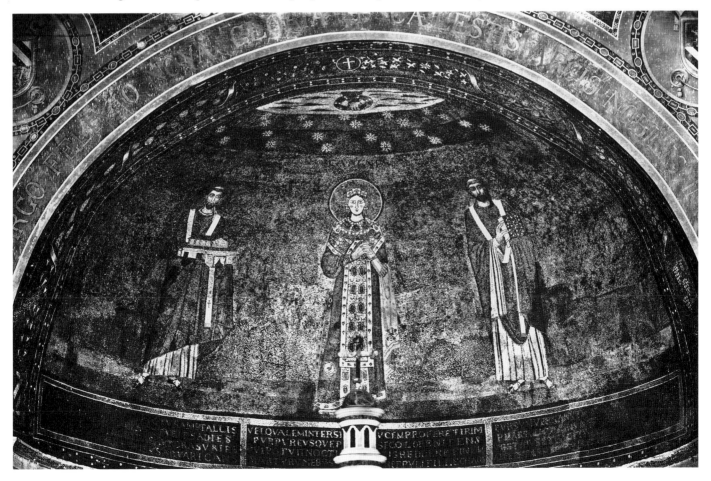

CHURCHES IN OTHER CAPITALS AND IN CENTERS IN THE EAST

CONSTANTINOPLE

CONSTANTINE THE GREAT overcame his last formidable rival, Licinius, at the battle of Chrysopolis in A.D. 324 and with that victory claimed the entire Roman Empire, East and West, as his domain. The emperor rarely resided in Rome for long periods, and partly to bolster his eastern and northern frontiers, partly to avoid the politics of the senatorial families in Rome, he decided to establish a "New Rome," a new capital, in the East. For the site he selected the old Greek town of Byzantium, so named after the original colonizer in the seventh century B.C., Byzas of Megara.

Located in the attractive and defensible peninsula called the Golden Horn, Byzantium had served as an independent port for Rome until it sided with the rival of Septimius Severus, one Pescennius Niger. After a three-year campaign (A.D. 193–96), Byzantium fell to the army of Septimius Severus and was razed. The Roman emperor, realizing its strategic position, soon rebuilt the city, adding a huge complex with baths and a hippodrome, and Byzantium once more prospered. After the defeat of Licinius, Constantine chose this attractive site for his new capital, and it was officially renamed Constantinople on May 11, 330.

Constantine's plans for the "New Rome" were ambitious (fig. 67). Following the model of Rome, distinctive promontories were marked out in the terrain as the "seven hills"; the

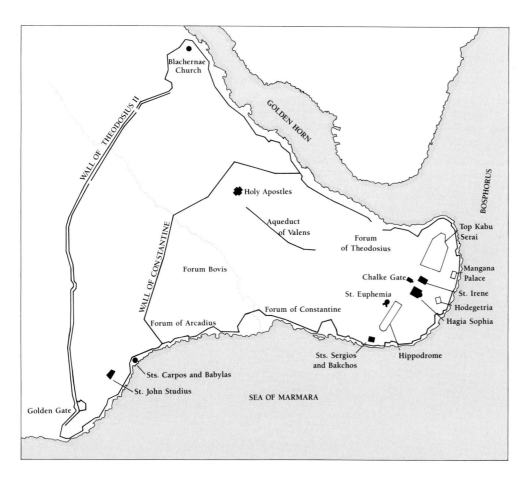

67. Constantinople.
Map of the city
(after Grabar)

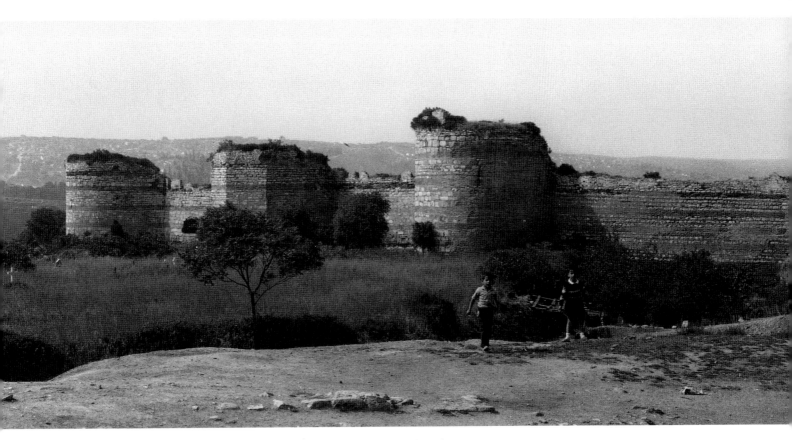

68. City walls, Constantinople. 5th century

city was partitioned into fourteen regions; and an impressive palace, a palace church, senate house, circuses, and other civic and ecclesiastical buildings were erected to enhance Constantinople as an imperial capital. Eusebius, in his *Life of Constantine,* described the building program in considerable detail. Aside from the huge palace complex and the churches that Constantine founded, Eusebius tells us that he also "filled the city which bore his name everywhere with bronze statues of the most exquisite workmanship" that were removed from various cities and sanctuaries in the Empire, including Rome.[58]

Very little survives of the fourth-century city, and we must make the most of the literary accounts in assessing its grandeur. Eusebius describes the great palace, but unfortunately the foundations presently visible are those of later rebuildings and extensions of the massive complex of rooms and ceremonial corridors.[59] We are told of the magnificent palace church of Hagia Sophia, completed in 360, which was razed during the Nika riots of 532 and rebuilt by Justinian (to be discussed in Part II). Constantine also founded the Church of the Holy Apostles, the Apostoleion, in the form of a huge Greek cross (arms of equal length) with a wide court. The church had a conical roof over the crossing of the arms, marble revetment on the walls, and costly furnishings. Nothing remains of the Apostoleion. It, too, was rebuilt by Justinian in 536, remodeled again in the Middle Byzantine period, later converted into a mosque by the Turks, and subsequently destroyed.

The Apostoleion was an impressive addition to the repertory of Christian church types, as we shall see.[60] The central plan with a dome was to become the basic formal core of many later Byzantine churches and *martyria.* With the services held in the very center of the cross structure, the arms serving the congregation, accommodations and changes in the liturgy and processional ceremonies were necessitated. Furthermore, it seems that the Apostoleion was more than a church for congregational services. It served also as a martyrium-mausoleum for the relics of the apostles and for Constantine himself, who was sometimes likened unto the "thirteenth apostle."

All that remains of the great city are the foundations and ramparts of its massive defensive walls (fig. 68) that encircled the city, some metalwork, coins, and fragments of mosaics and sculptures. One of the sculptures, a marble base for the obelisk that served as a marker in the hippodrome (c. 390), carved with portraits of Theodosius and his court, deserves special attention (fig. 69).

Even in its weathered condition, the Theodosian base is an impressive monument. The emperor and his court are portrayed presiding over the games in the hippodrome on one face and receiving the offerings of conquered barbarians on the other. The hieratic treatment of the figures and suppression of space bring to mind the abstract friezes on the Arch of Constantine (cf. fig. 21). Aligned in rigid, frontal positions, Theodosius—the central and tallest figure—and his two sons, Honorius and Arcadius, stand within the *kathisma,* or royal box, flanked by members of the imperial family, magistrates, soldiers, and bodyguards. Below them, in a second shallow plane, are two rows of citizens watching the entertainers, the tiny figures in the lowest zone, perform at the

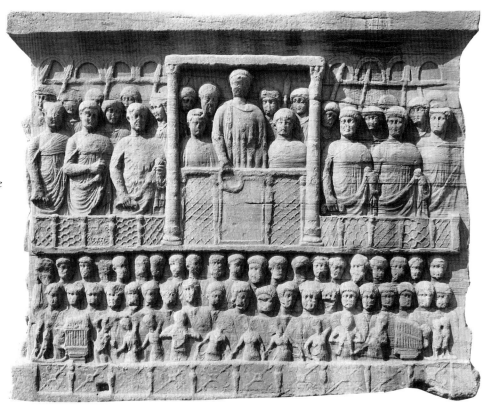

69. *Theodosius and Court Presiding at the Hippodrome*. Base of the Obelisk of Theodosius, Constantinople. Marble, height of obelisk base 7'10". c. 390

chariot race. The severe denial of space, the shallow carving with simple, closed contours, the unusual inverted perspective and hieratic scale (with the lower figures smaller), and the suppression of movement among all but the tiny musicians and dancers mark an even further departure from the canons of style of Antiquity.

MILAN

When the emperor Diocletian (284–305) retired to his palace on the Dalmatian coast at Spalatum (Split), four Caesars succeeded him in capitals in Rome, Trier, Milan, and Thessaloniki. This confusing interlude, known as the Tetrarchy, left the empire weakened, and it was from the impending chaos that Constantine, champion of the Christians, emerged as an absolute ruler, the Augustus. During the last years of Constantine's reign and during the period known to historians as that of the Epigones (337–79) serious conflicts between the church and the state precipitated a muddy flow of political, religious, and, to a degree, cultural affairs. The main religious issue emerged at the First Church Council and concerned the wording of the Nicene Creed (325), which stated that the Son (Christ) was of the very same substance as God, "begotten of the Father before all ages." This formulation had been disputed by the Alexandrian presbyter Arius, who argued that the Son was only of similar substance as God the Father and, furthermore, that the "Son has a beginning, but God is without beginning."

The ensuing philosophical arguments may seem obscure

to us today, but in the fourth century the matter of precise meaning and translation of a few words held great weight. Issues ultimately concerning the "divine" and "human" natures of Christ—the Incarnation—were at stake. Arius and his followers repeatedly attempted to force their beliefs on the churchmen through imperial sympathizers, and while they ultimately failed to sway the spirit of the councils, there resulted a dangerous schism within the church of the state and the church of the orthodox bishops, known as the Arian heresy.

Milan played a crucial role in the struggles between the Nicene (orthodox) and the Anti-Nicene (Arian and other) factions within the church and state. It remained an affluent capital for Constantine's successors from about 340 to 402, and it was during this time that one of the great Latin Church Fathers, Ambrose (d. 397), former governor of Aemilia elected bishop of Milan in 374, rose to support the cause of orthodoxy and to win the sympathies of Valentinian I (364–75) and Theodosius the Great (379–95), the last absolute ruler over both the East and West Roman Empire. Ambrose, renowned for his contributions to church administration, liturgy, sermons, and hymns, was also a builder of churches, and while much of Early Christian Milan has vanished under Medieval and modern rebuilding, evidence of Ambrose's churches can be recovered in part.

One thing seems clear: the ecclesiastical buildings in Milan differed markedly from the basilicas in Rome.[61] They exhibit widely differing architectural styles, grandiose in

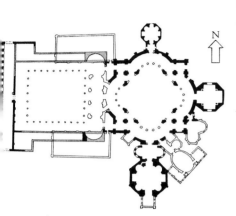

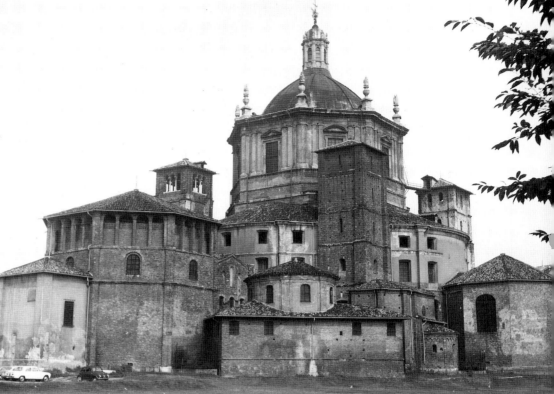

above: 70. San Lorenzo Maggiore, Milan. Plan (after Krautheimer). c. 355–75

right: 71. San Lorenzo Maggiore. Exterior from the southeast

below right: 72. San Lorenzo Maggiore. Interior

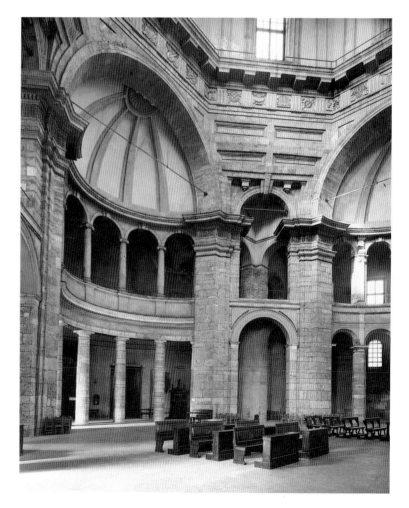

scale and innovative in design. The Church of San Tecla, built about 350, was comparable to the Roman basilical types, if one can trust the scant evidence provided in recent archaeological excavations (1943, 1961). It apparently had a huge longitudinal nave with side aisles, a chancel, and projecting apse. In scale and importance it would have been analogous to the Lateran in Rome. Likewise, the basilica erected by Ambrose, today known as Sant'Ambrogio (see fig. 412), was an ordinary hall type.

The conflicts between the Arians and the orthodox Nicenes amid the fluctuating allegiances of the emperors have been cited as impetus for the building of one of the most impressive churches in Milan, San Lorenzo Maggiore (also known as the Basilica Portiana?), the only well-known Early Christian structure in Milan that retains its original walls and elevation, although the cupola has been rebuilt (figs. 70–72). The huge court of the atrium is approached through an ancient street colonnade, the original propylaeum to an area that proclaimed its close ties to the state. The huge church is a compact, centralized structure, a type that evokes the name "palace church" in the Early Middle Ages; indeed, it resembles the elaborate tetraconchs (four-lobed structures) in Roman palace architecture.

In ground plan San Lorenzo is a great quatrefoil of a double-shell type, that is, the inner core of columns and piers supporting a dome is enveloped by an outer quatrefoil comprising ambulatory and galleries. Four towers rise from the corners of the outer quatrefoil, a feature of later palace

churches. The inner walls were originally lined with marble revetment articulated by stucco friezes and moldings. On the eastern hemicycle of the main tetraconch an independent octagonal structure was added that probably served as a *martyrium* for the relics of Saint Lawrence; and on the southern axis a larger octagonal annex, today known as the Chapel of Sant'Aquilino, with remnants of fourth-century mosaics (fig. 60), is believed by some to have functioned originally as an imperial mausoleum.

While San Lorenzo is generally described as a palace church, there is little agreement as to whom the foundation should be attributed. According to the more traditional theory, the impressive structure is pre-Ambrosian, perhaps the donation of Constantius II to the Arian bishop Auxentius (355–74); others have argued with good reasons for the patronage of Theodosius, about 388, erected as a commemoration of the victory of Ambrose over the Arians at the Council of Aquileia in 381 and the subsequent triumph of the orthodoxy in Milan.[62]

One of the first churches believed to have been founded by Ambrose is the Holy Apostles or Apostoleion, known today as San Nazaro (begun c. 382).[63] In plan (fig. 73) the Holy Apostles is a huge Latin cross with four aisleless arms (the western arm or nave is approximately 120 feet long) that focus on the center, where the altar was presumably placed. Very likely Ambrose had in mind a copy of the Apostoleion in Constantinople, if only in symbolic form, because here,

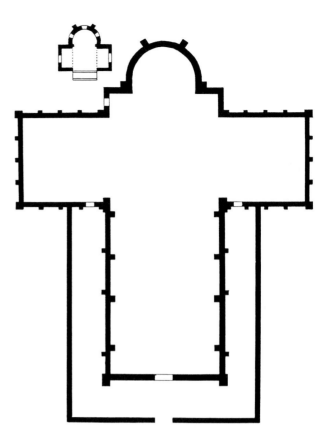
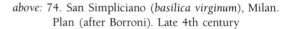

below left: 73. Holy Apostles (Basilica Apostolorum), Milan. Plan (after Villa). Begun c. 382

above: 74. San Simpliciano (*basilica virginum*), Milan. Plan (after Borroni). Late 4th century

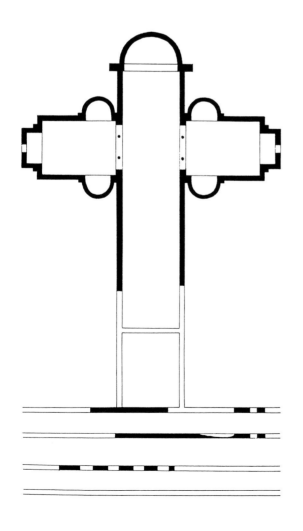

too, were enshrined the relics of the apostles Andrew, Thomas, and John the Evangelist. In a famous dedicatory inscription composed by Ambrose, it is stated that the "church in the form of a cross is a church dedicated to the victory of Christ," or *forma crucis templum est templum victoria Christi,* just as the cross shape of the Apostoleion in Constantinople was later described by Gregory of Nazianzus.

In 397 Ambrose died, and his successor, Bishop Simplicianus, completed and adorned another huge church, the *basilica virginum* (dedicated to virgin saints), which had been planned by Ambrose for a cemetery north of the city walls (figs. 74, 75). The church stands today (known as San Simpliciano) encased in later Romanesque rebuildings, but its ground plan and elevation for the most part have been preserved. Here Ambrose designed another large Latin cross, but one important change in the plan was the shifting of the altar from the crossing of the arms to the apse in the shallow eastern choir, thus effecting a longitudinal focus much as the Roman basilicas had.

The huge, spacious interior—the nave is nearly two hundred feet in length—is impressive in its sturdy construction and brickwork, with eight large windows in the clerestory of the nave framed on the exterior by curious double blind

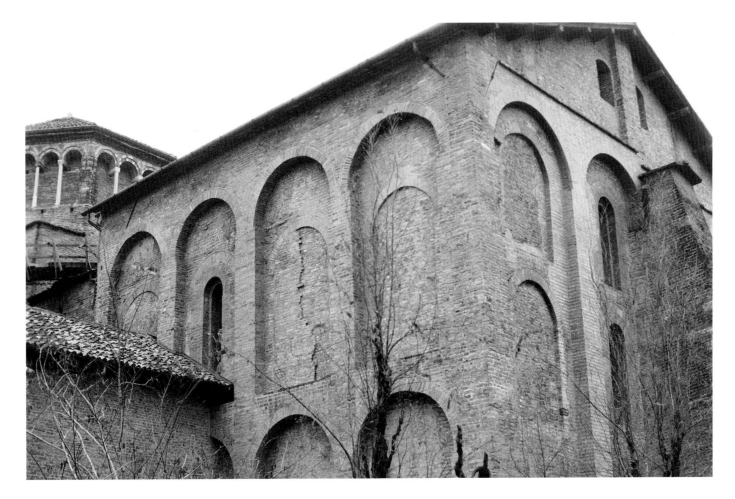

above: 75. San Simpliciano (*basilica virginum*). North transept

left: 76. Isometric reconstruction of the North Basilica, Trier (after Krautheimer). c. 380

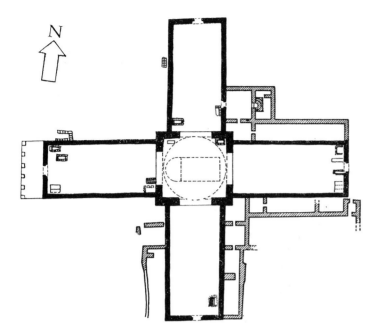

77. Saint Babylas, Antioch-Kaoussié. Plan (after Krautheimer). Begun c. 378

arcades, a type of construction we shall return to later (see p. 328). In its majestic proportions, the *basilica virginum* resembles the huge imperial basilica in Trier (fig. 76) rebuilt by the emperor Gratian about 380, when he made his residence in the Rhineland. The similarities are indeed striking, and it has been suggested that teams of masons traveled from Milan north to modernize the earlier "double cathedral" of Trier, composed of two enormous halls that had served as a palace church from Constantinian times in the northern capital.[64]

ANTIOCH ON THE ORONTES

During its history as a Roman colony, Antioch (Antakya), the old Seleucid capital on the Orontes River, had become a favored site for elaborate imperial receptions and ceremonies. Interestingly, Christianity spread to Antioch almost immediately from the mother church in Jerusalem. "At Antioch the disciples were first named Christians" (Acts 11:26), and by the end of the third century Antioch was known as a "Christian city" throughout the Roman world.[65]

The most famous of Antioch's churches was the Golden Octagon built by Constantine next to the imperial palace and dedicated to the "harmony" of church and empire. No trace of the huge octagon, situated on the Orontes island in the center of the city, remains today, but it is described by Eusebius as an elaborate structure with a double-storied narthex and gilded roof. He further mentions great niches and an ambulatory with galleries on the interior. Very likely the Golden Octagon was domed, although Eusebius does not mention it. Of special interest is the curious dedication to

"harmony"—the divine power that unites the world—an appropriate abstract title for a palace church in contrast to one dedicated to a martyr. It should be recalled that the palace church erected by Constantine in his capital on the Bosphoros was named Hagia Sophia, or "divine wisdom."[66]

That the central-type church was favored over the basilica in the eastern provinces is attested to by the major Early Christian *martyrium* in the area, Saint Babylas, erected in 378 at Antioch-Kaoussié just outside the walls of the ancient city. Built over the tomb of Babylas, heralded as the first bishop of Antioch, it forms a huge Greek cross with four great arms extended from the central core, where the saint's remains were enshrined under a giant baldachino (fig. 77). The inspiration for the cross plan has, once again, been attributed to the original Apostoleion in Constantinople.

JERUSALEM

During Constantine's reign, the most hallowed *martyria* for pilgrimages were built on the very sites where the divinity of Christ had been revealed in his life and passion. Tradition has it that the empress dowager Helena, Constantine's pious mother, made an extensive pilgrimage to Palestine about 326 and had memorials and churches erected over these holy places. Near the most sacred sites of the Crucifixion (Golgotha) and the Entombment (Holy Sepulchre) she had excavated the ground where the very wood of the True Cross was found (fig. 78a). Also Helena ordered structures to be built commemorating the place of Christ's Ascension (Mount of Olives), the ground where he taught the disciples at Mambre, and the grotto of his birth in Bethlehem.[67]

From scant remains and the descriptions of Eusebius, the buildings erected on Golgotha at this early date can be recovered in part. Just outside the walls, the rocky grotto that served as the tomb donated by Joseph of Arimathea for Christ's burial was fashioned into a small conical structure with twelve exterior columns in a circle supporting a domical baldachino, the Holy Sepulchre.[68] The ground about the tomb was leveled and surrounded by a paved court, open to the sky, semicircular on the west end. In the southeastern corner of the court the rock of Golgotha was isolated and cut into the form of a giant cube marking the site of the Crucifixion, and to the east of the court, adjoining the main street, a large basilica "more beautiful than any on earth," according to Eusebius, was erected over the place where the relics of the True Cross were discovered by Helena (fig. 78b).

The basilica—also called the *martyrium* in early times—was begun in 326 and consecrated in 336 by an assembly of bishops (fig. 78c). Because of its cramped location, the building was somewhat short and wide in proportions and was preceded on the street side by a colonnaded propylaeum and a squat, open atrium.[69] The wide nave was separated from the double side aisles by great columns. A pitched roof covered the aisles, eliminating the clerestory area for win-

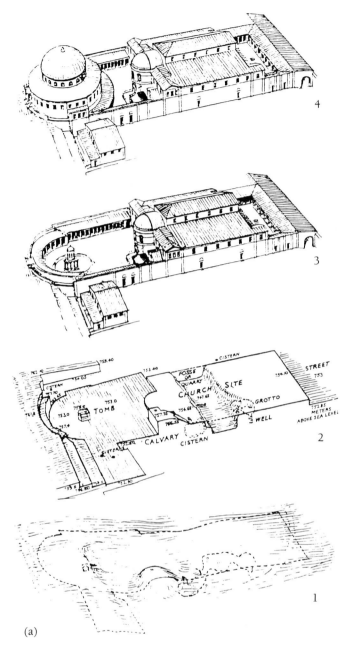

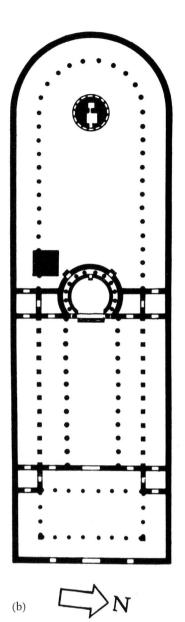

(b)

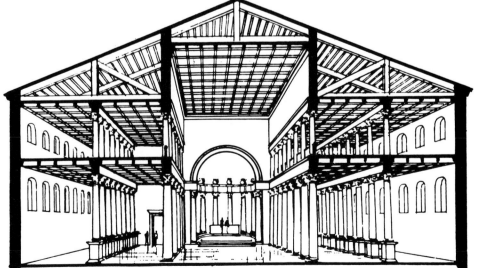

78. *above:* (a) Hypothetical reconstruction of the site of the Crucifixion, Jerusalem: 1. the site as of A.D. 29 or 30; 2. as of 326; 3. as of 335; 4. as of c. 348 (after Conant); *above right:* (b) plan of site as of c. 335 (after Conant); *right:* (c) reconstruction of the Basilica (martyrium), Jerusalem (after Krautheimer). c. 326

(c)

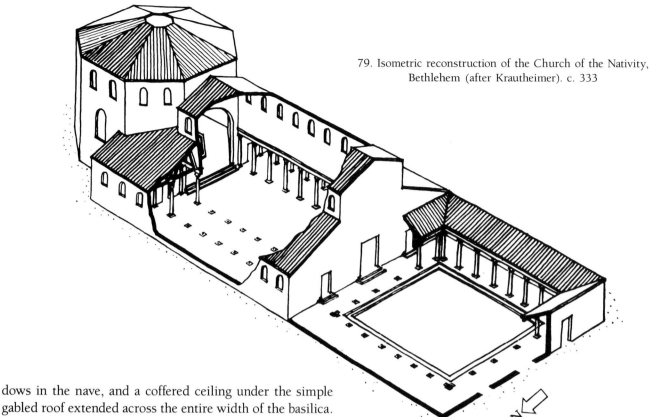

79. Isometric reconstruction of the Church of the Nativity, Bethlehem (after Krautheimer). c. 333

dows in the nave, and a coffered ceiling under the simple gabled roof extended across the entire width of the basilica. According to Eusebius, the richness of the ceiling coffers, the gilded capitals, and the stone revetment on the walls contributed to an overwhelming effect on the congregation. At the western end a quasi-domed apse (*hemisphairion,* according to Eusebius) was encircled by twelve columns, the number of the apostles. About the middle of the fourth century a domed rotunda was built over the tomb shrine to accommodate the countless pilgrims who visited the sacred site. This structure was known as the Anastasis Rotunda (from the Greek for resurrection).

Saint Jerome relates the journey of Paula to Jerusalem and Bethlehem in the fourth century—typical of many pilgrimages—and how "casting herself down before the Cross [the memorial erected on Golgotha] she prayed as though she saw the Lord hanging there. When she entered the Tomb in the Anastasis [another name for the Holy Sepulchre] she kissed the stone which the angel had rolled away from the entrance and with the ardor of true faith touched with her mouth the place where Our Lord had lain."

In Bethlehem Paula visited the Basilica of the Nativity, also erected by Constantine. Entering the grotto, "she swore—as I myself have heard—that with the eyes of faith she beheld the Child, wrapped in swaddling clothes and lying in the manger, the Magi adoring God, the star that shone above, the Mother who was a Virgin, the revered foster-father [Joseph] and the shepherds who came in the night to see the Word which had come to pass" (Jerome, *Letters,* 108, 8–10).[70] Paula's vision may have been inspired, in fact, by pictures at the site depicting the birth of Christ (cf. fig. 80).

The Constantinian basilica at Bethlehem—rebuilt by Justinian—displayed unusual architectural elements (fig. 79).

A broad colonnaded atrium, open to the sky, led into a squarish nave with double aisles. In place of the apse, however, there was a curious octagonal construction with a wide circular opening in the floor that gave a view into the grotto below. Some believe the octagon was covered by a pyramidal roof with an aperture for sunlight, much as the building to the right in the mosaic of Santa Pudenziana appears.

80. *Adoration of the Magi.* Pilgrim's flask from Palestine. Silver, diam. 5⅞". Late 6th or early 7th century. Cathedral Treasury, Monza

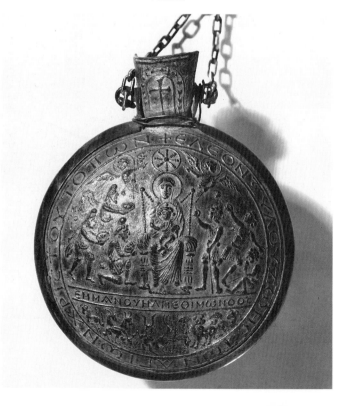

The atrium and nave of Constantine's basilica were retained in the rebuilding of Justinian in the sixth century, but the curious octagon was replaced by a chancel in the form of a trefoil. The grotto was elaborated and made accessible for the pilgrims, and both the facade and the apse of the grotto were decorated with mosaics. It is very likely that the Early Christian representation of the Adoration of the Magi, such as that on the Monza pilgrimage phials (see fig. 80) with the shepherds placed opposite them about the enthroned Madonna and Child, filled the gable on the facade of the basilica.[71]

The decoration of the grotto most likely would have been a Nativity (remains of a much later restoration still exist), and it is highly possible that at this time the bathing of Christ made its first appearance in Nativity scenes. The seventh-century pilgrim Arculphus (and others after the rebuilding) remarked on a new feature at the site incorporated into Justinian's church: the spot where the star shone down and from which a well sprung forth, the place, we are told, where the Child was first bathed (cf. colorplate 27). Thus it appears that features of the sites in the Holy Lands themselves provided many details for the iconography of illustrations for those wonders in Early Byzantine art.

FIFTH-CENTURY BUILDINGS IN THE EAST MEDITERRANEAN

Considerable evidence survives for the fifth-century churches built in Syria, and one in particular, Qal'at Si'man, east of Antioch, remains in great part intact in ruinous splendor (figs. 81–84).[72] The giant *martyrium,* built about

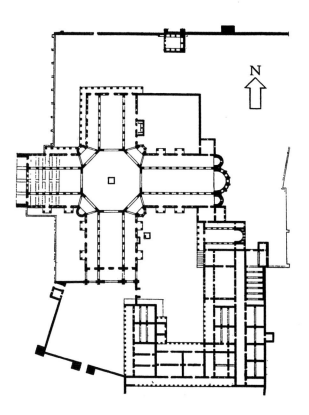

above: 81. Martyrium of Saint Simeon Stylites, Qal'at Si'man, Syria. Plan (after Krautheimer). c. 470–90

below: 82. Isometric reconstruction of the Martyrium of Saint Simeon Stylites, Qal'at Si'man (after Krautheimer)

470 around the venerated column of Saint Simeon Stylites (atop which the hermit spent the last thirty years of his life in meditation), is in the form of a huge cross (260 by 295 feet). The column, of which the base still survives, stood in

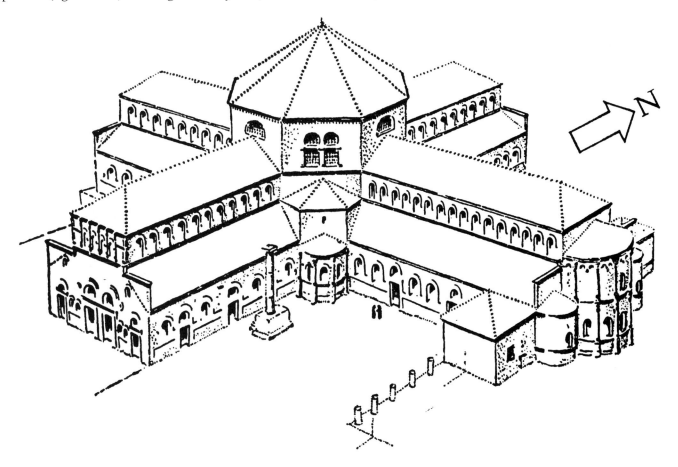

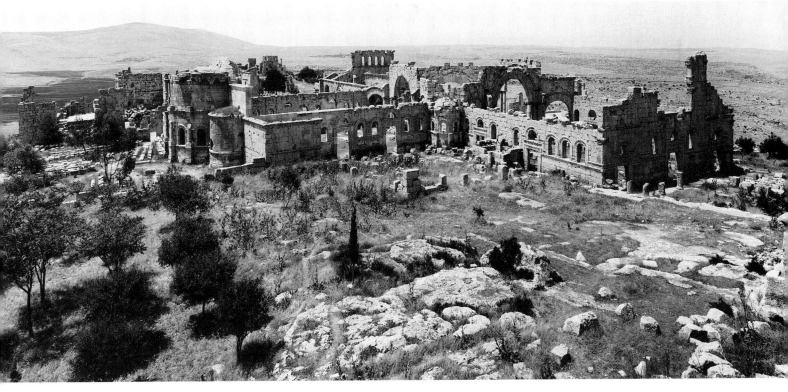

83. Qal'at Si'man. Church and monastery from the northeast

84. Qal'at Si'man. Interior

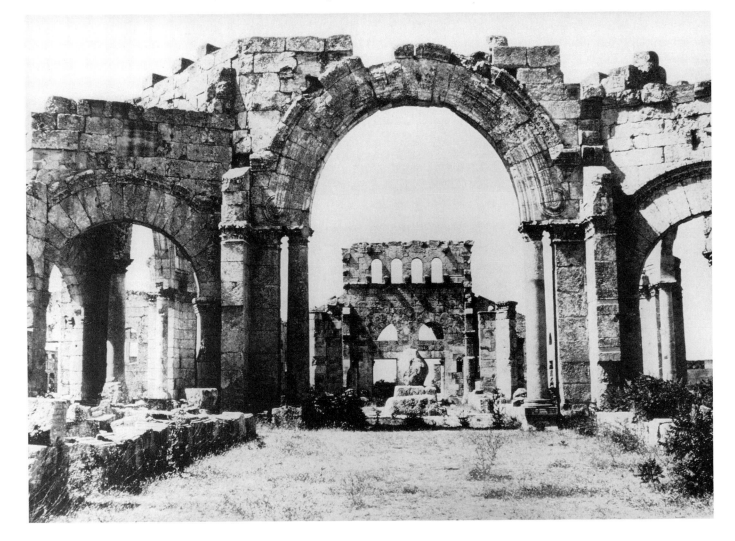

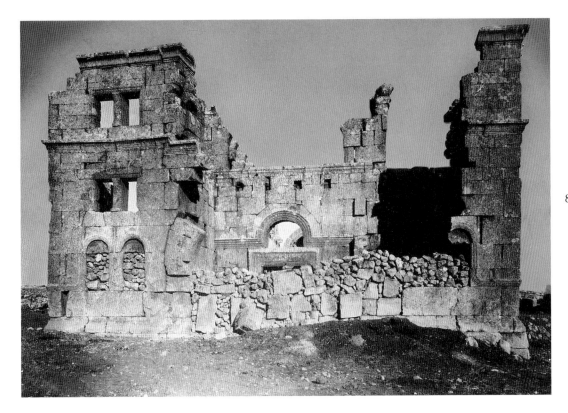

85. Church, Qalb Louzeh, Syria. Exterior. c. 500

the very center of the cross within an octagonal precinct that was either open or covered by a timber dome. Each of the four arms forms a full basilica; that on the east terminates in a trebled apse. The other arms with their narthexes (on the southern and western arms) resemble giant transepts with aisles.

The sense of grandeur and monumentality of Qal'at Si'man is still striking from the exterior. The great tripartite facades resemble triumphal arches with engaged columns and piers crowned by elegant Corinthian capitals and leaf friezes. Hybrid classical stringcourses decorate many of the architectural members. One distinctive Syrian variation is the continuous profile that runs over the windows in the clerestory of the facade and those of the apses on the east. It is important to note that Qal'at Si'man was essentially a pilgrimage center, with a caravansary of sorts that included chambers for pilgrims and monks incorporated into the complex. The significance of such elaborate monastic communities will soon become evident.

The same sense of bigness and refinement of detail characterizes numerous later churches built in Syria. Some, such as the church at Qalb Louzeh (fig. 85), dating about 500, feature low towers rising on either side of the porch, forming a two-towered facade. It has been argued, but not convincingly, that these handsome "cathedrals"—as they have been called—were the inspiration for Western churches of the Carolingian and later periods (see below, Part III).

For the most part, the churches in Asia Minor constructed in the Early Christian period were not so monumental or innovative as the structures in Syria. The standard basilical form with the dominant longitudinal nave terminated by an apse, preceded by a narthex and atrium, is the norm. One exception is the large cross-plan *martyrium* erected over the tomb and earlier memorial shrine of Saint John the Evangelist at Ephesus (fig. 86), dating about 450. Here four arms, resembling aisled basilicas, radiate from the square core

86. Church of Saint John the Evangelist, Ephesus. Plan of the first church (after Krautheimer). c. 450

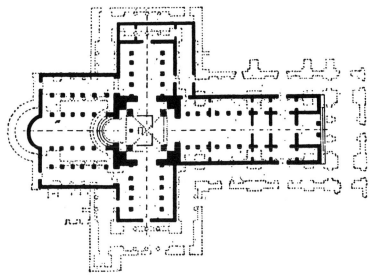

with the shrine in the center (the major nave, to the east, was slightly longer and preceded by one or two narthexes).

Alexandria, a large commercial port as well as a major center for Christian learning, was undoubtedly much favored by the Roman imperium, but practically nothing remains of its Christian topography to provide us with models for later Medieval architecture in Egypt. Monastic building had a special role in the development of the Thebaid in the

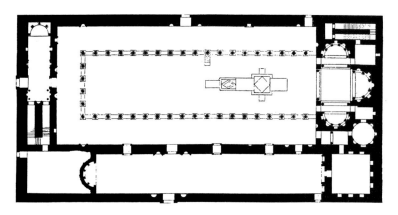

above: 87. White Monastery, Deir-el-Abiad, Egypt. Plan (after Krautheimer). c. 440

below: 88. White Monastery. Exterior

desert regions of the Upper Nile, where Saint Anthony dwelt and where his followers assembled in small colonies. Pachomius, Anthony's disciple, founded the first monastic community on the Nile as early as 320, and from there the model for the anchorite or hermit life spread rapidly throughout the Christian world, although the Antonines fostered no special monastic architecture, as the later orders were to do.[73]

An example of such secluded monastic communities can still be seen at Deir-el-Abiad, far to the south in the desert. In elevation and ground plan, the White Monastery, as it is called (figs. 87, 88), displays a long nave with side aisles adjoining a triumphal arch that opens into a chancel forming a trilobe with three semidomed apses. Two stories of columns in the nave support galleries that continue about the entrance wall. A long hall runs along the south side of the church, and all is then enclosed by massive, sloping walls of stone that form an impenetrable structure concealing everything within. With its stark, plain surfaces boldly rising in the desert, the White Monastery recaptures something of the mysterious grandeur of ancient Egyptian temples. It was in this lonely environment that the strange, inbred art of the Coptic church later was nourished and where centuries-old traditions in religious art were preserved into the later Middle Ages.

THE NARRATIVE MODE—THE ILLUSTRATED BOOK AND OTHER PICTURE CYCLES

LL SCRIPTURE, inspired of God, is profitable to teach, to reprove, to correct, to instruct in justice, that the man of God may be perfect" (2 Tim. 3:16). Like many religions, Christianity is a "book religion" that is based on the Word as transmitted in the scriptures through the inspiration of the Holy Ghost: "They have God for author."[74] For the Christians the canonical or accepted books of scripture were the Old and New Testaments. Taken together, the Testaments constitute a comprehensive encyclopedia of history, revelation, and instruction ranging from the shadowy beginnings of man created in God's image in Genesis through the long chronicles of the Jews and the brief life of Christ.

The Bible (*biblos* means book in Greek) also contains texts that can be described as ordinances of law and manuals of instruction (Leviticus, Deuteronomy), poetry (Psalms), proverbs, prophecies, and philosophical discourses (Job). But history is foremost, and like many ancient epics, it was illustrated at an early time with pictures comprising lengthy narrative cycles. As we have seen, the more hieratic images of godhead, such as those described in the visions of Ezekiel, Isaiah, and in the Book of Revelation, were given iconic picture form as well, especially in sacred settings such as the basilica apse, but pictures in the narrative mode—repeated images that tell a story in cartoon fashion to be read with the text—were just as significant for the development and transmission of Christian art.[75]

Book illustration had developed through a number of stages before it was inherited by the Christians. The simplest form was a tiny picture inserted into the column of the text of a papyrus scroll at the appropriate place. The minuscule figures were sketched in a few strokes with no elaborations such as background or settings (fig. 89). Sometimes these "column-pictures" were gathered at the top or the bottom of the text to form a frieze consisting of repeated groups of actors added simply one after the other in a time sequence (cf. fig. 95). With the introduction of the codex, the paginated book form, the illustration was often enhanced as a work of art by the addition of a frame to isolate it from the text. These framed miniatures (in effect tiny paintings within the text) could, in turn, be elaborated by squeezing two or more episodes—iconographic units—into each frame, a process called conflation. A further elaboration was to extract the picture from the text and place it alone in the form of a large frontispiece or full-page illustration, where it assumed an independent existence from the script and, sometimes, an independent meaning from the text as well.

The frieze format is difficult to trace, although it would seem a natural extension of narration in any media, as, for instance, in ancient sarcophagi with broad horizontal fields

89. *Alexandrian Romance.* Fragment of papyrus scroll. 7½ × 15¾". 3rd century (?). Bibliothèque Nationale, Paris (Cod. suppl. grec. 1294)

and, perhaps more revealing, in such monuments as the sculptured scroll that winds about the Column of Trajan in the Roman Forum (fig. 90). It has been argued that the bas-reliefs illustrating the campaigns of the Roman army against the Dacian tribes that spiral around the column, with the soldiers and their leaders repeated in the individual events that follow one another, overlapping at times, copy the illustrations of a scroll. Perhaps they illuminate the memoirs of Trajan himself, which were deposited in the Latin library that flanked his commemorative column.[76]

The idea is a good one, but it can hardly be proved, and more controversial for this theory is the priority of the painting over the sculpture medium in this translation. Many scholars have assumed that all such continuous narration, whatever the medium, derives from book illustration since it constitutes a natural, portable model book for artists. But the issue is certainly more complex, and the intervention of pattern or model books especially composed by and for artisans must be considered, since it hardly seems possible that valuable and fragile scrolls would be accessible in the workshops for direct use.

Even more restricting for scholarship is the corollary idea that once the cycle or set of pictures was established in the illustrated book, all subsequent illustrations would copy it and, in turn, serve as models for later artists to follow. Thus arises the concept of the archetype, or the original source for any given cycle of pictures. To be sure, the idea of plagarism did not exist in the arts of the ancient world in the modern sense, and the practice of following faithfully an early, hallowed model would be especially appealing to the Christians, but the obsessive search for the original iconographic source, the archetype and its recension, has stifled much of the scholarship in Early Christian art. The question cannot be avoided, as we shall see.

One of the finest examples of an illustrated Classical text is the Codex Vergilius Vaticanus, usually called the Vatican Vergil and dated no earlier than the fourth century, although it is generally thought to be an accurate copy of a much earlier illustrated edition.[77] The codex contains a number of framed miniatures illustrating passages of the *Aeneid* and the *Georgics* (it has been estimated that the original contained more than 245 painted scenes) in a variety of events. Well-proportioned, lively figures, fully modeled in delicate, painterly shades, are casually placed in elaborate interiors with sophisticated perspectives or landscapes with grottoes, seas, and cities. These scenes are illusionistically rendered with

90. *Trajan's Campaigns Against the Dacians.* Detail of the reliefs on the Column of Trajan in the Forum of Trajan, Rome. Marble, height of each relief, approx. 50″. 113

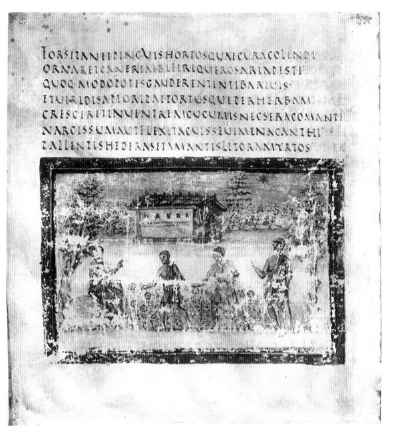

91. *Death of Dido*. Illustration to Virgil's *Aeneid* in the Codex Vergilius Vaticanus. 8⅝ × 7¾″. 5th century. Vatican Library, Rome (MS lat. 3225, fol. 41)

92. *Instructions for Gardening* (the old gardener of Corycus). Illustration to Virgil's *Georgics* in the Codex Vergilius Vaticanus (fol. 7v). 8⅝ × 7¾″

the atmospheric tonalities of Homer's "rosy-fingered dawn" (a frequently repeated cliché) with green-brown grounds fading away into a blue sky along a fuzzy horizon of pink or lilac.

The dramatic suicide of Dido following the sudden departure of Aeneas (IV. 663) is especially instructive (fig. 91): "Death be it. Thus, thus it is good to pass into the dark . . . [and] the house resounded with lamentation and bitter crying of women." With her sword unsheathed, Dido casts herself on a pyre, while about her maidens tear their garments and wave their arms in despair within the confines of a chamber that projects backward along the converging lines of the ceiling beams. Essentially this is a kind of "stage-space" or "dollhouse" perspective. The miniature is placed directly above the text it illustrates. An illustration on farming and gardening from the *Georgics* (fig. 92) presents a fine Classical landscape with a sun-drenched villa set back in a receding field of flowers executed with a soft, fleeting, impressionistic application of paint.

Another Classical manuscript usually discussed with the Vatican Vergil is the slightly later (?) *Iliad* in the Biblioteca Ambrosiana in Milan (fig. 93) with its dynamic battle scenes presenting frantic soldiers scattered and packed in groups about a broad, sketchy landscape. The panoramic qualities of

93. *Battle Scene of the Trojan Wars*. Illustration in the *Iliad*. 7 × 9¾″. 5th century. Biblioteca Ambrosiana, Milan (MS F. 205, fol. 44v)

94. *Visions of Ezekiel*. Wall fresco in the Synagogue of Dura-Europos. Before 256. Museum, Damascus

many of these miniatures suggest some monumental source, such as wall painting, and the figure groups with their colorful armor and vivid gestures remind one of the busy Roman battle sarcophagi of the second and third centuries A.D.[78]

A famous set of illustrations for the Herbal of Dioscurides (*De Materia Medica*) in the National Library in Vienna, dated A.D. 512, seems to have been of special Byzantine patronage (the princess Juliana Anicia is portrayed in one miniature) and was very likely produced in the Eastern capital. Indeed, the portrait of Dioscurides (colorplate 5) welcoming the personification of Discovery carrying a mandrake root is executed with the sophistication of an Antique author portrait. Soft modeling appears in the toga, and the rugged facial features of the elderly doctor are vividly captured in flecks of light and dark. Such seated portraits were very common in Greek and Roman cities, usually in sculptured form, where they could enhance architectural settings such as gymnasia, libraries, and other civic buildings. It was very likely from such public statuary that the portraits of the Evangelists so familiar in Gospel books were derived.[79]

The earliest illustrations that are found in Christian books date roughly from the same time—late fifth and sixth centuries—and the miniatures retain the same Antique illusion-

ism and vivid color of their pagan counterparts. It should be noted that the earliest are not complete Bibles. Not only was the Old Testament too vast, but there were serious questions as to just which books were authentic and canonical, and what we find are sets of illustrations corresponding roughly to the major divisions of the Bible. Genesis was very popular as the introductory text and often appears alone throughout the Middle Ages. The stories of Moses and the Law—Exodus, Leviticus, Numbers, Deuteronomy—together with Genesis formed an independent unit called the Pentateuch, or first Five Books; another set comprised the first eight, the Octateuch, and was particularly popular in Byzantium; while such parts as Kings, Psalms, Prophets, and Job were usually treated as independent volumes.

Could there have been any Jewish sources for Old Testament illustration? It is now generally believed that the rigid strictures that governed Jewish iconoclasm and the abhorrence of pictures might have been considerably relaxed in the more liberal Jewish communities located in the Hellenized centers of the Near East during the Greek and Roman occupations. Good evidence appears in the decorations of a synagogue in the frontier town of Dura-Europos, a site discussed in chapter I with reference to the early *domus ecclesiae* unearthed there.[80]

The synagogue, which abuts the city walls, as does the nearby Christian chapel, is only partially preserved, but there remains a handsome Torah shrine on the end wall decorated with the seven-branched menorah, a diminutive architectural shrine, and the figures of Abraham and Isaac with their backs turned to the viewer to avoid outright portraiture. The side walls, half-demolished, are covered with broad horizontal bands or registers of frescoes that illustrate in continuous fashion various stories from the Old Testament. They include extensive narratives of the events in the lives of Moses, Joseph, the kings, and the prophets. Some curious intrusions suggest that more popular Jewish legends served as the textual sources and not the Torah itself. But they do decorate a synagogue.

Typical is the band that illustrates the vision of Ezekiel in the Valley of the Dry Bones (Ezek. 37:1–14), where four distinct episodes, repeating Ezekiel each time, flow one into the other (fig. 94).[81] This repetitive, cartoonlike mode of illustration was certainly not invented for monumental wall decoration. The compact sequence of pictures of Ezekiel belongs to a more discursive, narrative manner of representation. The repeated pictures for every few lines of the text suggest an art that we would associate with book or scroll illustration. Some such model perhaps provided the curious sequence of pictures to be read in time that we see here. This raises an important issue: Could there have been early Hellenistic-Jewish illustrated versions of the Septuagint, the famous Greek translation of the Hebrew Old Testament, which was compiled in Alexandria about 270 B.C.?

Two well-known manuscripts for Christian usage attest to the popularity of Genesis for illustration at an early date. The more complete and better-preserved is the so-called Vienna Genesis, a deluxe picture Bible with an abbreviated Greek text written in silver on parchment stained purple. Purple is the color of royalty, and this suggests that the manuscript was commissioned by an imperial patron, perhaps in Constantinople, although the provenance and date are much debated.[82] While the antiquity of the miniatures is demonstrated by the exciting illusionistic style, the Vienna Genesis has usually been considered a copy made in the sixth century.

The illustration for Genesis 24:10–20, the story of Rebecca at the Well (fig. 95), is typical of the finer miniatures. Rebecca appears twice. At the left she is shown carrying a pitcher on her shoulder and walking near a low colonnade toward a spring of water personified as a half-nude female figure comfortably reclining on an urn. On the lower groundline, directly to the right, Rebecca appears again, this time offering water from her pitcher to the servant of Abraham, who stands before a trough with his ten camels. At the top right a diminutive representation of the walled city of Nahor appears suspended against the purple background.

In many miniatures the figures are simply aligned in rows along a groundline, but in one, the curious story of Jacob's encounter with his brother Esau (Gen. 32:22–30), the episodes are presented consecutively from left to right in the upper register. Jacob leads his two wives, maidservants, and eleven sons toward the ford at Jabbok, which they pass over to enter the register of illustrations below along the curving bridge foreshortened to connect the upper with the lower level (colorplate 6). Jacob is again repeated with the "man who wrestled with him till morning," and finally his meeting with Esau is illustrated on the same ground in the lower left. Surely our talented miniaturist was no slave to his model here.

Another early illustrated Genesis with framed miniatures was unfortunately destroyed in a fire in 1731, and only a few charred fragments and two drawings made for the French archaeologist Nicolas-Claude Peiresc in 1618 survive. Known as the Cotton Genesis after the English owner, Sir Robert Cotton, the manuscript was highly valued and is of considerable importance for Latin book illustration.[83] Significant departures from the text make this cycle easy to identify. In the illustrations of the creation, the usual Hand of God is replaced by a standing figure of a youthful Christ

95. *Rebecca at the Well*. Illustration in the Vienna Genesis. 13¼ × 9⅞". 6th century. Oesterreichische Nationalbibliothek, Vienna (Cod. theol. gr. 31, fol. 7)

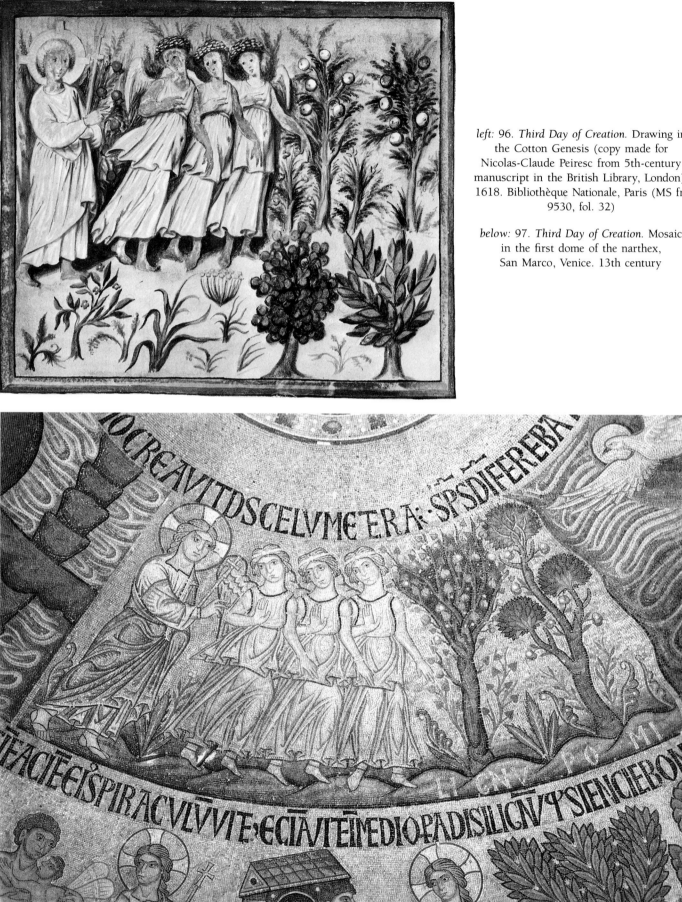

left: 96. *Third Day of Creation.* Drawing in the Cotton Genesis (copy made for Nicolas-Claude Peiresc from 5th-century manuscript in the British Library, London). 1618. Bibliothèque Nationale, Paris (MS fr. 9530, fol. 32)

below: 97. *Third Day of Creation.* Mosaic in the first dome of the narthex, San Marco, Venice. 13th century

dressed in a tunic and marked by a cruciform halo. He is Christ *logos* as the creative principle, a philosophical concept of godhead elaborated in Platonic terms by Clement of Alexandria, a proponent of mystical interpretation of scripture.

Peiresc's drawing for the third day of creation (fig. 96) will suffice for our discussion. Christ *logos* appears in the upper left gesturing toward his creation of plants and trees as three angels or spirits clad in flowing chitons proceed him as personifications of the inspiration on the third day. This unusual manner of presenting the days of creation (perhaps inspired by Augustine's *Hexaemeron*) appears in the same fashion some eight hundred years later in the narthex mosaics of San Marco in Venice (fig. 97), and surely some copy of the Cotton Genesis cycle must have supplied the models for pattern books serving the mosaicists in the church. The occurrence of the same Christ *logos* in Carolingian Bibles of the ninth century also provides evidence for the influence of the Cotton Genesis recension in the West much earlier (see p. 220).

The Greek texts of the Vienna and Cotton Genesis manuscripts suggest that the scriptoria that first produced these illustrated books are to be located in some Greek-speaking center, perhaps Constantinople, Antioch, or Alexandria. Common sense would further lead one to assume that the miniatures were painted there, too, but the issues of provenance remain thorny problems for scholars.

Even more perplexing is the impressive but enigmatic Ashburnham Pentateuch in Paris with a Latin Vulgate text (colorplate 7). Nineteen full-page pictures illustrate the stories in Genesis from the Creation to the departure of the Israelites from Egypt, including startling representations of the flood and Noah's ark. The Ashburnham Pentateuch has been variously dated between the fifth and the eighth centuries. As for the location of the scriptorium that produced the unusual miniatures, theories have ranged from North Africa and Spain to Dalmatia, Armenia, Italy, and France.[84]

Many pages have tiny, agile figures scattered within undulating registers which are given vivid and colorful backgrounds of blue, green, red, yellow, and brown. These provide settings for contoured hills, jagged cliffs, exotic towered structures, and primitive huts and sheds. The drawing of the fauna is based on keen observation, and a spirited animation is conveyed in the sprightly movements of the horses, sheep, and cattle. The figures are well-proportioned and articulated with an energy and intensity not found in Greek manuscripts. Their costumes, whether the simpler garb of the peasant farmers in the story of Cain and Abel or the more exotic regalia of the higher classes, are rendered in exacting detail. Plants and trees are vividly differentiated—note especially the date palm, the field of wheat, and the furrowed pasture—and there is a surprising balance between the scale of the figures and the landscape settings, considering the early date.

The earliest illustrated New Testament books—the Gospels according to Matthew, Mark, Luke, and John—display an even greater diversity. It should be noted that the other New Testament texts—Acts, the Letters, and Revelation—were conceived as independent books apart from the Gospels. Generally the Gospels are introduced individually with an author portrait of the Evangelist, either seated or standing, placed within or before an architectural frame.

Two closely related sixth-century Gospels with illustrations are painted on purple-stained parchment and written in Greek, indicating some aristocratic patron in the East Christian capitals, possibly Constantinople. The one known as the Sinope Gospels (after the site on the Black Sea where the book was discovered), today in Paris (Bibliothèque Nationale, supp. grec. 1286), contains only a fragment of the text of Matthew; the other, the Rossano Gospels, has selections from all four.[85] Only one Evangelist portrait is preserved in the Rossano codex and that is Saint Mark (fig. 98), seated in a wicker chair writing down his account in a scroll. A nimbed muse stands before him as the personification of inspiration (not to be confused with the beast symbols). The frame is fashioned in the form of a draped facade, perhaps

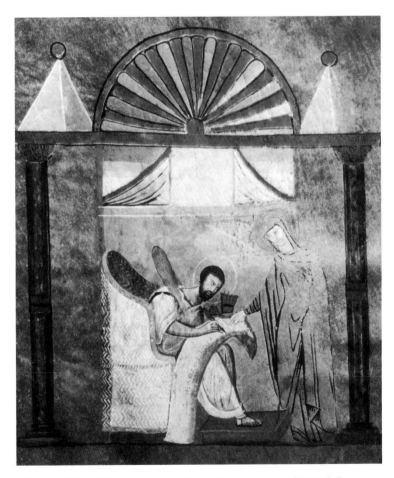

98. *Saint Mark.* Miniature in the Codex Rossanensis. 12⅛ × 10¼″. 6th century. Archepiscopal Treasury, Rossano (fol. 121)

99. *Parable of the Wise and Foolish Virgins.* Miniature in the Codex Rossanensis (fol. 2v). 12⅛ × 10¼″

100. *Trial of Christ Before Pilate.* Miniature in the Codex Rossanensis (fol. 8v). 12⅛ × 10¼″

derived from the theater fronts (*scenae frons*) or the royal portal (*porta regia*) of Roman theaters, an indication that the author portrait type probably repeats an earlier Classical model.

The narrative illustrations appear in an unusual fashion on pages before the Gospels, with liturgical readings for Passion week. The iconographic units are painted above the abbreviated texts on scroll-tablets held by prophets. Thus the idea of the Old Testament prophecies underlying the mysteries in the life of Christ, a parallelism so familiar in later Medieval art, appears here in a striking manner. Among the lively narratives, a number—the Raising of Lazarus, the Entry into Jerusalem, the Last Supper—are represented according to iconographic formulae that occur in much later cycles, indicating the persistence of a single recension of New Testament scenes transmitted through book illustrations, as we shall see. Other stories are elaborately expanded beyond the account given in the Gospel text. In the illustration of the Five Wise and the Five Foolish Virgins, a parable on the Last Judgment in Matthew, the artist elaborated the details in a most interesting fashion, indicating that he was following other sources (fig. 99).

The virgins are aligned in a row: the five wise carrying flaming torches are dressed in white chitons signifying their purity, the five foolish are grouped outside the golden gate of the marriage chamber and clad in varicolored mantles indicating their tainted personalities. The bridegroom's chamber, moreover, is a verdant orchard recalling the Garden of Eden, with four rivers flowing from a mound: the beatific vision of heaven as the reward for the wise at the Last Judgment. More striking is the portrayal of the bridegroom as Christ with a cruciform halo and dressed in a golden mantle. His gesture is emphatic, as he bars the foolish from his bridal garden, and the strained intensity suggested by the lines in the downcast eyes of the rejected virgins imparts an element of expressionism to the parade of charming, doll-like maidens.

Two unusual illustrations in the Rossano Gospels are full-page miniatures. They depict Christ brought before Pilate by the high priests Annas and Caiaphas and the trial of Jesus in which the murderer Barabbas was released at the insistence of the Jews. Both miniatures show the enthroned Pilate in a semicircular setting above Christ and his tormentors. In the *Trial of Christ* (fig. 100) a monumentality is achieved

through the symmetrical placement of the figures about the frontal Pilate on the central axis. To the sides, the Jews, who cry out "Crucify him, crucify him," are tightly gathered and cramped to fit the circular boundary of the upper zone. Below are the accused. To the left Christ, dressed in gold, is flanked by court officials. To the right a writhing Barabbas, naked to the waist with his hands tied behind him, is presented like a dangerous criminal by two guards.

How unlike the sketchy, quick-paced narratives this hieratic representation seems. The accoutrements of the tribune chamber are carefully added, with the high-backed, cushioned throne of judgment for Pilate complete with flanking standards bearing portraits of the emperors; the table is spread with writing instruments on a cloth with two more imperial portraits embroidered upon it; a clerk-scribe stands to the right taking notes on a wax tablet. All of this offers us a strikingly realistic portrayal of an actual Roman court of justice, with Pilate radiating authority. Pilate gestures to the accusers as he seemingly questions them, "Why, what evil has he done?"

Because of the elaboration and monumentality of the trial miniature, so different from the other narrative versions such as that on the *Sarcophagus of Junius Bassus* (fig. 13) discussed above, it is generally believed that some special source inspired the artist. André Grabar suggests that it was derived from an illustrated lawbook, perhaps a copy of the Code of Justinian. William Loerke offers a more imaginative solution. He argues that the miniature is a copy of a mural once decorating the *domus Pilati,* the praetorium in Jerusalem where the trial was believed to have taken place and which was an important pilgrimage site by the fourth century.[86] Clearly, the sources of Early Christian book illustration are much more complex than simply recensions of archetypal cycles transmitted by the illuminated book.

The provenance and dates of the manuscripts so far discussed are matters of fierce debate, but there are no such problems with one of the most remarkable illustrated New Testament codices, the Rabbula Gospels, written by the monk Rabbula in the monastery of Saint John of Zagba, Mesopotamia, and dated A.D. 586.

The first pages—nineteen in all—are handsome canon tables (fig. 101). These constitute a harmony or concordance of the Gospel texts as devised by Eusebius for Constantine. Eusebius drew up ten basic lists or canons, the first containing episodes (indicated by the number of the passage in the text) common to all four Gospels; the second canon included those passages repeated in the first three, and so on.[87] The canon tables are in the form of painted arcades, with the equivalent passages relating the life of Christ cited within each intercolumniation marked in parallel: Matthew, Mark, Luke, and John. The borders of many of the canons are enhanced with small vignettes illustrating in an abridged fashion the major events in the life of Christ or portraits of

101. *Canon Table.* Miniature in the Rabbula Gospels. 13 × 10½". Completed at Zagba, Mesopotamia, c. 586. Biblioteca Laurentiana, Florence (MS Plut. I, 56, fol. 9v)

the Evangelists, seated or standing. A spontaneity and directness can be perceived as if the tiny pictures were meant to be colorful footnotes for the passages cited.

Large, full-page miniatures inserted in the text are astonishingly sophisticated, although similar in execution. These include a remarkable Crucifixion, a hieratic Ascension, a statuesque Madonna standing on a pedestal, and a courtly dedication picture with Christ enthroned between two bishops and two monks. The *Crucifixion* (fig. 102) is one of the earliest fully "historiated" types in which many of the narrative details described in the Gospels are illustrated, including the eclipsed sun, the two thieves hanging on crosses beside Christ, the soldiers casting lots for Christ's robe, the lance bearer named Longinus, the man lifting the sponge soaked in vinegar to Christ's lips, and the three women who witnessed the tragedy along with the Virgin and John the Evangelist.

Below this magnificent Crucifixion is a horizontal band with two more scenes: two Marys (including the Virgin) visit the empty tomb guarded by an angel and the *Noli me tangere,* where the resurrected Christ warns the Magdalene (and curiously his mother) not to touch him. Mary's pres-

102. *Crucifixion.* Miniature in the Rabbula Gospels (fol. 13).
13 × 10½″

It is obvious that the miniature is no direct illustration for this short text. More than a cloud receives him: a huge aureole surrounds the ascending Christ. Below this glory a curious chariot with fiery wheels, scarlet wings filled with eyes, heads of four creatures (lion, ox, eagle, and man), and a mysterious Hand of God appear directly over the head of a standing female *orant* figure. The inspiration for this impressive *Maiestas Domini* is not that of John's Revelation as we found it in Roman mosaics but rather the prophecy of Ezekiel (1:3–28), where the seer experienced the vision of the "likeness of the glory of the Lord" in the midst of winged tetramorphs and flaming wheels from whence thundered the voice of God. That the image of God (theophany) is here based on the vision of Ezekiel and not that of John the Evangelist should come as no surprise when we remember that the Book of Revelation was considered spurious at an early date by the Eastern churches while the prophecies of the Old Testament, especially those of Ezekiel and Isaiah, were authority.[88]

Such a picture certainly merits a place in the apse of an

103. *Ascension.* Pilgrim's flask from Palestine. Silver, diam. 5⅞″.
Late 6th or early 7th century. Cathedral Treasury, Monza

ence in these latter scenes is not mentioned in the Gospels and surely indicates a more complex iconographic source. One unusual detail stands out even more: in the Crucifixion, Christ is not covered by the traditional loincloth but wears instead a long purple tunic or robe with two golden clavi or bands, a garment known as a royal *colobium.* Thus the double composition has a grandeur and complexity about it that go far beyond the requirements of simple narration. Indeed, its striking symmetry and integrated design bespeak a monumental prototype.

The *Ascension* (colorplate 8), also composed in two zones, is even more monumental in conception. In the opening lines of the Book of Acts the apostles are given their commission to be witnesses of Christ in the uttermost corners of the world, "And when he had said these things, while they looked on, he was raised up: and a cloud received him out of their sight. And while they were beholding him going up into heaven, behold two men stood by them in white garments. Who also said: Ye men of Galilee, why stand you looking up to heaven? This Jesus who is taken from you into heaven, shall so come, as you have seen him going into heaven" (Acts 1:9–11).

104. *Ascension.* Apse painting from the Monastery of Apollo at Bawit, Egypt. Coptic. 6th century. Coptic Museum, Cairo

Eastern church, and there are good reasons to believe that it copies a famous mosaic or fresco in a major Palestinian shrine (perhaps the Eleona, where the Ascension took place).[89] More than a site or liturgical commemoration, however, the picture also serves a catechetical role in demonstrating one of the basic mysteries in the personality of Christ as defined in the great church councils held in Ephesus in 431 and Chalcedon in 451: the doctrine of the Incarnation and the two natures of Christ, human and divine. This lesson is underscored when we focus on the lower zone of the Ascension, where the prominent figure below the Hand of God, the *orans,* is surely the Virgin Mary. She is not mentioned in Acts—recall her unusual presence in the Resurrection miniature—nor is she normally associated directly with the *Maiestas Domini* at so early a date.

It will be remembered that Mary was proclaimed *Theotokos,* the bearer of God, the vehicle for the Incarnation (the divine made human), at these same councils. While the female figure has been identified as the personification of *ecclesia,* the church, she is also Mary-*Theotokos,* who received from the Hand of God the Holy Spirit that overshadowed her and conceived the Child in her womb. This

same *Ascension* composition is stamped on leaden phials from the Holy Lands collected by pilgrims as site commemorations (fig. 103). There it includes a dove, the Holy Ghost, between the Hand of God and the halo of the Virgin, thus emphatically proclaiming the act of Incarnation as well as the fact of the Trinity: the Father, the Son, and the Holy Ghost. Perhaps the reader will find such an analysis too involved and tedious, and, to be sure, it is; but it does open our eyes to larger visions and complexities in Early Christian art even if the details may still be out of focus.

The idea that the Rabbula *Ascension* reflects a monumental painting in some Eastern church is more convincing when we realize that this same unusual representation appears on other pilgrimage objects associated with Jerusalem. The same type of "Chalcedonian" Ascension not only appears on numerous flasks but it is painted—along with the historiated Crucifixion—on the lid of a famous pilgrimage box of the sixth century, today in the Museo Sacro Cristiano in the Vatican (colorplate 9). Finally, a closely related version of the Ascension frequently appears in the apses of Coptic chapels at Bawit in Egypt, and there can be little question that the provincial painters there imitated the decorations of

the great basilicas of Palestine (fig. 104). In the apse of the Monastery of Apollo, the figure of Ezekiel, in fact, is added to the row of apostles about Mary, confirming our interpretation of the *Maiestas Domini* in the Rabbula Gospels.

The illustrations in the manuscripts so far considered clearly reveal that a complex overlapping and fusion of the narrative and iconic modes of representations were commonplace. To the miniatures in the manuscripts and the murals in the churches another source for Christian iconography should now be added to our discussion of narration, namely, the sign-symbols of the early funerary arts. Such means of communication through abbreviated pictures were inherited from the pagan world, but the question remains of just how these mini-narrative cycles were transmitted from shop to shop.

In many of the small, portable religious objects that are enriched with ivory, gold, or wooden plaques and encrusted with precious gems and enamels—the so-called sumptuary arts—one often finds the pictorial modes side-by-side with a

more iconic representation serving as the centerpiece about which narrative cycles or sign-symbols are clustered. A fine example is the *lipsanotheca* (reliquary casket) preserved today in the Museo Civico Cristiano in Brescia, Italy, dated about 360–70 and assigned by most authorities to a North Italian workshop (fig. 105).[90]

The four sides are formed of ivory plaques with upper and lower horizontal strips framing a broader central panel. The lid is composed of two plaques and a rim with roundel bust-portraits (*imagines clipeatae*) of Christ and the apostles; the four corner posts have vertical strips of ivory that carry single salvation or Passion signs (a fish, rooster, column, cross, etc.). The larger central plaques on the faces illustrate episodes from the ministry of Christ, while the narrower bands display diminutive Old Testament narratives and sign-symbols of salvation, including representations of Susanna and the Elders, Daniel in the lions' den, Jonah and the whale (on the front), and stories of Moses, Jacob, David, and others (along the sides and back). Like the scenes on the *Sar-*

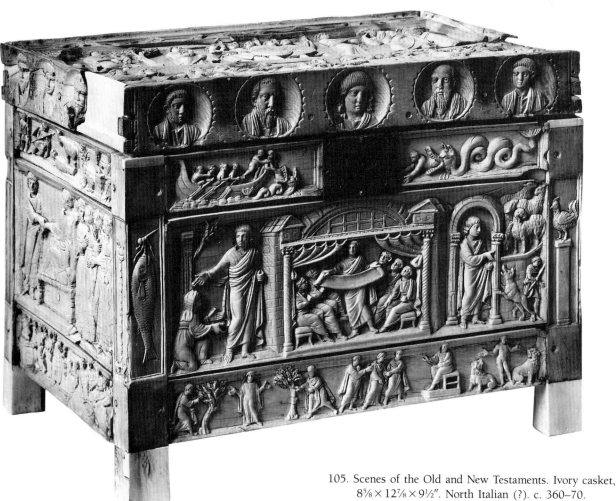

105. Scenes of the Old and New Testaments. Ivory casket,
8⅝ × 12⅞ × 9½". North Italian (?). c. 360–70.
Museo Civico Cristiano, Brescia

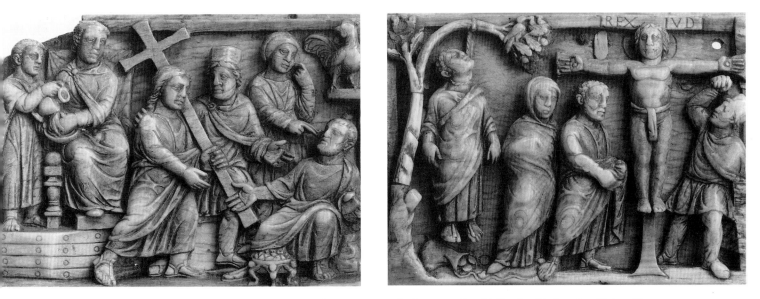

106. *left:* (a) *Pilate Washing His Hands; Christ Carrying the Cross; Denial of Peter; right:* (b) *Death of Judas; Crucifixion.* Plaques on an ivory casket, each 3 × 3⅞". c. 420. British Museum, London

cophagus of Junius Bassus (fig. 13), there is little correlation between the Old and New Testament stories illustrated.

The figures carved in low relief display the elegant and refined sculptural qualities found in the sarcophagi of the so-called Theodosian Renaissance in their polished surfaces, relaxed postures and poses, bland Classical head types, and simplified draperies. Christ is a youthful Apollo, the apostles resemble philosophers, and the narratives display a sedate, quiet pace with muted gestures, unlike the feverish staccato of those on earlier sarcophagi.

Stylistic changes in relief sculpture on a small scale are difficult to trace because of the paucity of remains, but a few major shifts in expression may be noted. A splendid ivory box, a "Passion Casket" in the British Museum (figs. 106a, b), dates approximately a half-century later, about 420, and is also attributed to a North Italian atelier. Seven compact narratives of the Passion are presented on the four faces with solid, well-articulated figures carved in deeper relief. These stockier actors, while still refined in the manner of the Brescia casket reliefs, are energized and squeezed tightly into their fields so that the stories have a dramatic immediacy enhanced by a rich pattern of light and shadow. This tight compression and the bold display of tactile qualities announce a shift from the quiet serenity of classicism to the expressionism of the Medieval period.

Of approximately the same date are the famous wooden panels of the doors of Santa Sabina in Rome (figs. 107–109a, b).[91] Probably commissioned by Pope Celestine I (422–32), the eight large and ten small cypress panels that survive from a larger ensemble offer those entering the church a different example of some loosely conceived Old and New

Testament parallelism, although the exact arrangement of the panels can no longer be determined. Carved doors were no novelty. Ambrose's church in Milan had an earlier set of wooden doors that unfortunately are too fragmentary for our discussion, and these early examples of narration on doors became the models for a lasting tradition in Medieval and Renaissance church arts.

The small plaque of the Crucifixion provides us with an opportunity of comparison with other Early Christian representations. In what has been considered a misunderstanding of the manner of crucifixion as a means of execution, the wood-carver naively placed the frontal nude figures wearing loincloths in a row, in *orans* positions, before a brick or stone wall with posts and gables marking their places. There are no crosses. Compared to the London ivory (figs. 106a, b), this Crucifixion seems sadly lacking in effect and execution.

A few of the larger panels present unusual iconographies. Two that are generally considered to form a pair, an "Ascension" and an imperial *adventus* of sorts (figs. 109a, b), have been the subjects of diverse interpretations. The so-called *Ascension* curiously resembles the elaborate type in the Rabbula Gospels, discussed above, with a *Maiestas Domini* hovering over figures of Peter and Paul flanking the Virgin (see colorplate 8). The Santa Sabina panel has been identified more precisely as the "Triumph of the Roman Church," the *orant* figure more specifically as *ecclesia*. The second panel has been variously identified as the pronouncement of Zacharias regarding the birth of his son John the Baptist, the prophecy of Malachi concerning the coming of the King of Hosts, and, more generally, the *adventus* of a Christian emperor (Constantine or Theodosius).[92]

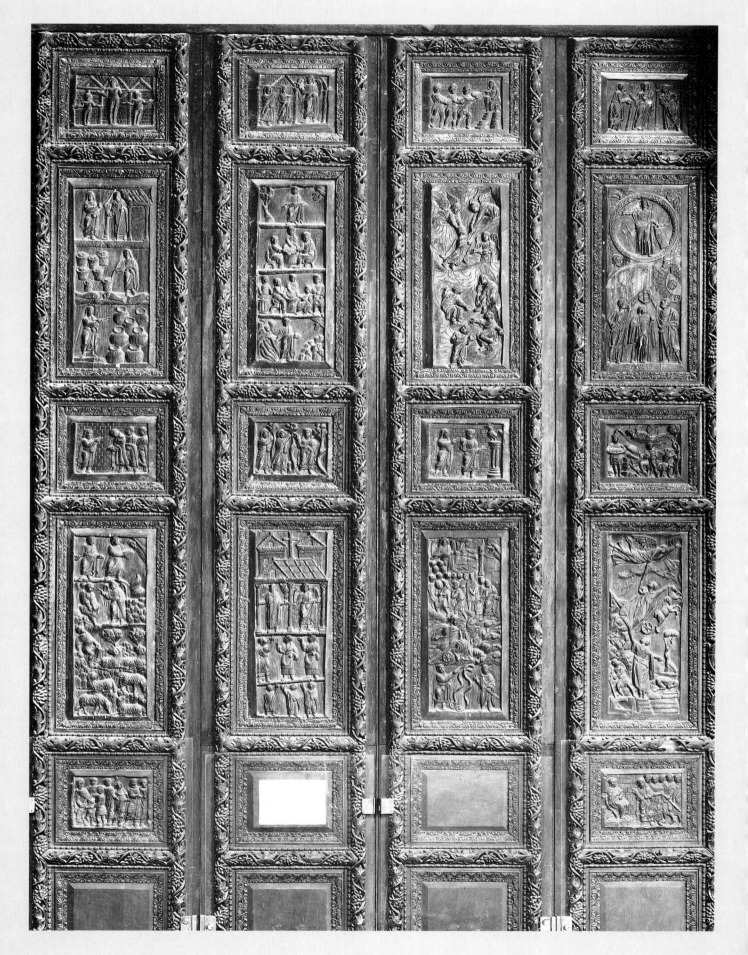

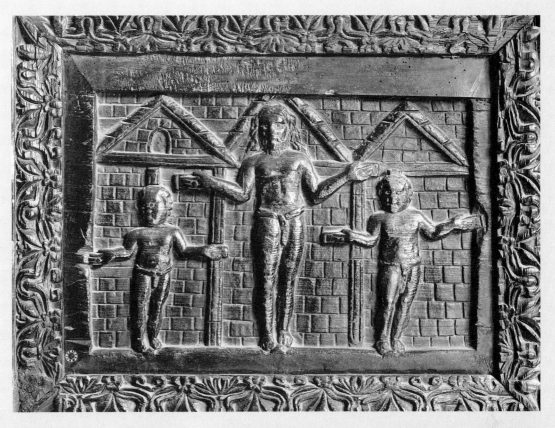

opposite: 107. Scenes from the Old and New Testaments. Doors of Santa Sabina, Rome. Cypress wood, larger panels 33½ × 15¾"; smaller panels 11 × 15¾". 422–32

right: 108. *Crucifixion.* Detail of fig. 107

109. *below left:* (a) *Ascension; below right:* (b) *Triumph of the Roman State Under Christ* (?). Details of fig. 107

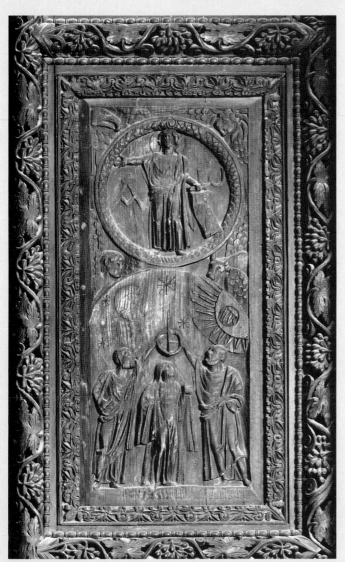

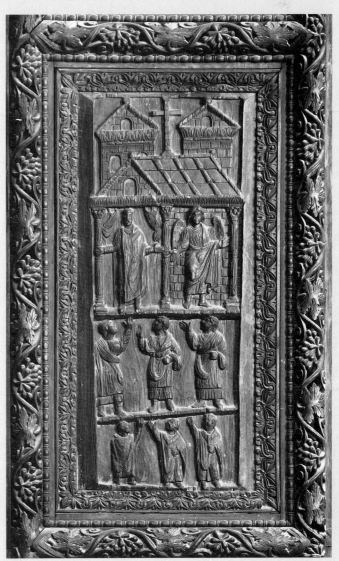

The relief is divided vertically into four registers. In the two lower, unadorned zones, officials and citizens dressed in togas and *paenulae* (sleeveless cloaks) acclaim with uplifted arms the two major figures in the third tier: a prince clad in the royal robe and an angel. In the uppermost register, marked by the entablature of the temple, rises a gabled roof surmounted by a gemmed cross. Two towers complete the elevation. As we shall see later, such two-towered facades became the symbolic and real architectural forms designating a palace church. Considering the significant role assumed by the emperor in the foundation of the Christian church, could this hieratic representation not be interpreted as the "Triumph of the Roman State" in Christian history? If so, the two enigmatic panels would form a meaningful concordance: the harmony of the church and the state in the triumph of Christianity, much as Eusebius had extolled it, "By the express appointment of the same God two roots of

blessing, the Roman Empire and the doctrine of Christianity, sprang up together for the benefit of men."[93]

Typical of the state of confusion concerning the style and provenance of these works are the descriptions of an ivory diptych, a book cover for the Gospels, in the Cathedral Treasury in Milan, usually dated in the later fifth century (fig. 110). Each side is made up of five ivory plaques. The large central fields are decorated with applied symbols of Christ in silver *cloisonné*. The left, illustrated here, is adorned with a lamb—Christ as the sacrificial victim— while the right has a cross—Christ as victor. In the four corners are bust portraits of the Evangelists in strict frontal poses and their symbols: the angel and the ox, above, the heads of Matthew and Luke, below. The upper plaque displays a curious Nativity with Joseph, dressed as a shepherd or workman, holding a carpenter's saw, seated opposite Mary before a flimsy shed with a crib, the Child, the ox and the ass.

The rather aggressive demeanor of the ass may be intentional. At an early date the donkey symbolized the Jews present at Christ's birth, stubbornly reluctant to recognize Him, while the protective ox represented the Gentiles. Taken from the words of Isaiah, "the ox knows his master, the ass his master's crib," the two beasts often figure as protagonists in a little drama about the stall, with the ass sometimes kicking up and eating the hay from the trough.[94]

Each side plaque is decorated with three framed scenes to be read from top right to left and down: the Virgin in the temple with an angel pointing upward at the miraculous star; the Annunciation curiously placed in a landscape where Mary, attired as a princess, fetches water from a stream; the three Magi following the star; the twelve-year-old Jesus before the doctors in the temple; the Baptism of Christ (which usually initiates the ministry cycle); and the Entry into Jerusalem (the beginning of the Passion events). In the lower plaque a dramatic Massacre of the Innocents is enacted before Herod with the soldiers literally smashing the babes to the ground before their wailing mothers. Scenes illustrating the miracles of Christ dominate the iconography of the back cover (not illustrated here).

The unusual iconography of the Infancy scenes can be traced to an independent textual source—the apocryphal gospels—that was popular in North Italy and elsewhere. By Apocrypha are meant the spurious books of the Bible that were not accepted as true or canonical by the early Church Fathers. Usually attributed to some famous author, these legendary testimonies, dating roughly between the first and third centuries, colorfully filled in the sparse Gospel accounts of the childhood of Christ and the life of Mary and had a lasting influence.[95]

Especially popular was the Syriac Proto-evangelion of James (and the later Latin version of it, the Gospels of pseudo-Matthew) with stories of the Virgin and the angel in

110. Scenes from the apocryphal Infancy cycle and the life of Christ. Ivory book cover, 14¾ × 11⅛". North Italian (?). Late 5th century. Cathedral Treasury, Milan

patterns. This advanced abstraction portends important stylistic features that one associates with the development of Byzantine icons from the sixth century on. Hellenistic illusionism as a primary mode of visualization here gives way dramatically to an art based on surface sensation and pattern; the real world is displaced by the abstract; the historical event by the timeless ritual.

The most impressive monument of ivory carving of the sixth century is the large episcopal chair or cathedra of Maximianus, archbishop of Ravenna from 546 to 556 (figs. 112–14; colorplate 10).[96] The body of the throne is completely covered with large ivory plaques fitted to the structural armature of wood. The legs and posts are lined with ivory strips with intricate vine rinceaux peopled by tiny animals and birds. Across the front are five vertical panels portraying John the Baptist flanked by standing figures of the four Evangelists squeezed into arched niches, their alert and expressive heads cupped within conches forming haloes. Their stances are subtly varied, and ripples of movement are created by the shifting of their weight, the raising of arms, the large whorls of drapery spinning across their torsos, and the richly textured patterns of the arched niches that hold them to the surface. There is, in fact, a certain mannerism in the exaggerated turnings of the lines and the contrived gestures.

The sides of the throne are bedecked with rectangular panels, alternating in size, that relate the story of Joseph in Egypt. In these narratives a surprisingly rich, flickering texture predominates, too. In the episode where Joseph is put into the well by his brothers (Gen. 37:23–35), a sense of *horror vacui* leads the carver to add a star, a tree, another shepherd wherever space is left over within the frame. The nervous shepherds are vigorously modeled, and they move and turn with a brisk energy that adds more vibrancy to the surface pattern.

The vertical reliefs on the back of the throne are of special interest to the iconographer, for here one of the most complete presentations of the Infancy cycle based on the Protoevangelion of James precedes the narratives of Christ's ministry. These include representations of the suspicion of Joseph, Mary submitting to the test of the bitter waters, Joseph reassured of Mary's purity in a dream, and the birth of Jesus with the midwife Salome testing the virginity of the mother (fig. 114). The harsh resonance of the design vibrates with the jarring juxtaposition of the coarse-grained fabric of the bedding, the angular brickwork of the high crib, and the large rosette boldly placed between the heads of the ox and ass.

The craftsmen who carved the ivory panels on the throne were talented artisans, and the expressive and rhythmic style they display bespeaks a major center of production, very likely Constantinople. With the ivory cathedra of Maximianus we move into the world of Early Byzantine art.

111. *Adoration of the Magi.* Ivory plaque, 8⅜ × 3⅜″. Coptic. 6th century. British Museum, London

the temple, the Annunciation at the well, the Magi following the star, that are not found in the canonical Gospel accounts. This, in itself, is interesting since the Milan ivories covered a Latin Gospel book, but its carvings followed an independent Infancy recension. A number of authorities have argued that the Milan book cover was inspired by Eastern models, possibly from Constantinople or Antioch, but there are no convincing reasons to propose such a place of origin.

A good example of an Eastern ivory, possibly of Coptic manufacture in or near Alexandria, is a plaque in the British Museum with the Adoration of the Magi (fig. 111). A number of closely related ivories of the sixth century linked to the East Christian world display the same striking stylistic features in the advanced state of abstraction that annihilates any sense of figures in space. A compacted pattern of hieratic and conventionalized emblems results. The Virgin is huge, central, and rigidly frontal as if pressed out with an iron that flattens her body and pose into linear creases and angular

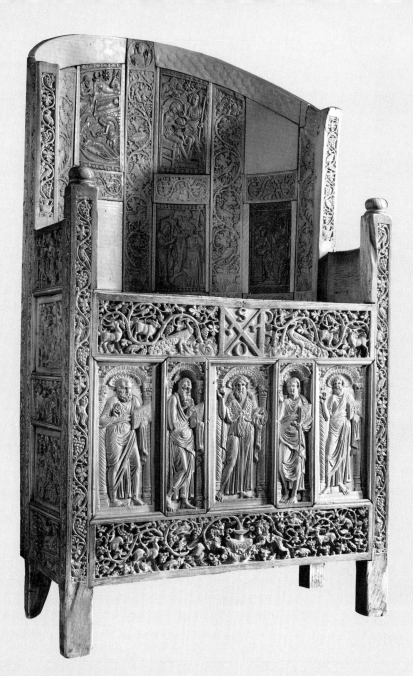

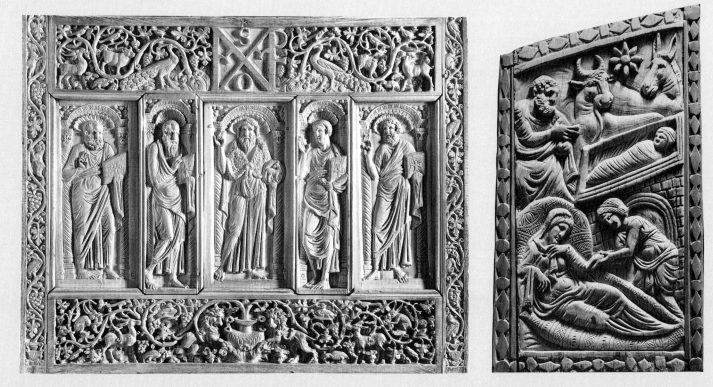

left: 112. Throne of
Maximian. Ivory, 59 × 23½″.
c. 547. Archepiscopal
Museum, Ravenna

below left: 113. *Four
Evangelists and John the
Baptist.* Detail of fig. 112

below right: 114. *Birth of
Christ.* Detail of fig. 112

PART TWO

BYZANTIUM

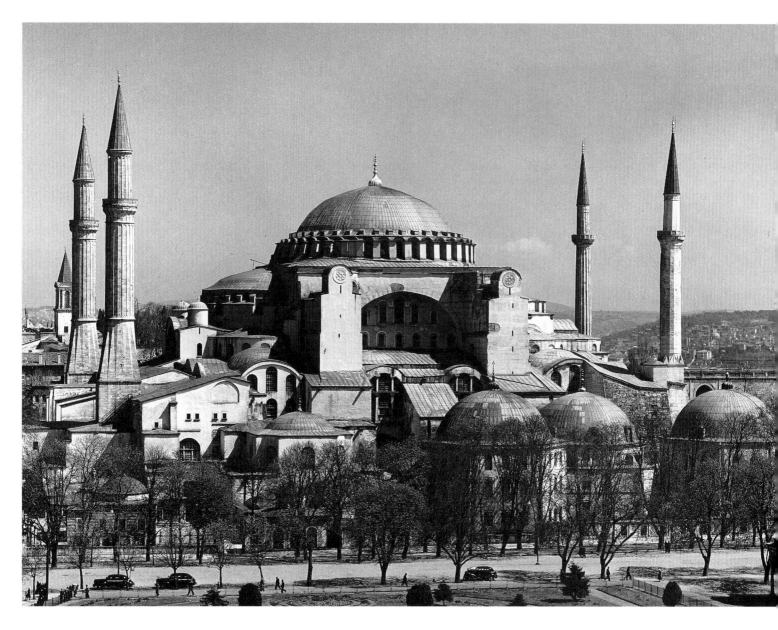

above: 115. ANTHEMIUS OF TRALLES AND ISIDORUS OF MILETUS.
Hagia Sophia, Constantinople. Exterior from the southwest. 532–37

below: 116. Hagia Sophia. Plan (after Schneider)

below right: 117. Hagia Sophia. Interior, view into the dome.
Height of dome 184′

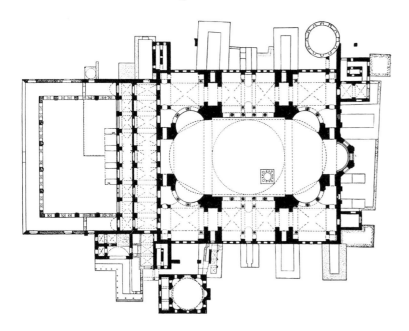

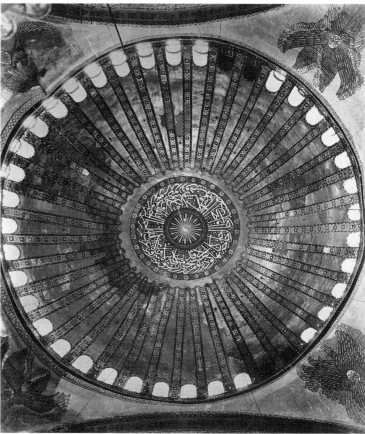

CONSTANTINOPLE IN THE AGE OF JUSTINIAN

ONSTANTINOPLE, the "New Rome" consecrated by Constantine in A.D. 330, was devastated by civil riots in 532. Two opposing factions in the city, the Greens and the Blues, not only massacred each other, but they destroyed nearly half of the imperial city as well. The imperial palace, the Constantinian cathedral of Hagia Sophia, and the *martyrium,* the Holy Apostles (Apostoleion), as well as other religious structures were razed. Justinian, emperor from 527 to 565, put down the revolt, and the restoration of the city and its famed churches commenced immediately. The new buildings erected by Justinian represent some of the most original and ingenious architectural accomplishments in Byzantine history.

Justinian was a shrewd administrator and a devout defender of the orthodoxy in Constantinople.[1] Convinced of his divine calling as leader of church and state as the co-regent of Christ on earth, Justinian instituted a policy that combined temporal and religious spheres into one, whereby the emperor ruled with absolute authority as a sacred monarch, a policy known as caesaropapism (emperor-pope). With his powerful military state sanctioned by the church, Justinian sent out his armies to reconquer all Christian lands lost to invading barbarians and Persians on the fringes of the empire.

An ivory plaque, known as the Barberini Diptych (colorplate 11), is believed by some to be a portrait of Justinian as defender of the faith, and while this identification is not certain, the elegant piece clearly displays Justinian's policies.[2] In the center, the triumphant leader, wearing a crown and posed in a lively manner on a rearing steed, plants his lance in the ground before a startled barbarian. Seated at the right is a goddess (Gaea or Terra) representing Earth. A tiny winged personification of Victory flies in at the top right. In the narrow plaque to the left, a military officer offers the emperor another trophy of triumph (the missing panel on the right presumably featured a second such figure). Below, in the horizontal plaque, appear the agitated figures of the conquered heathen and barbarians bearing gifts of tribute and accompanied by exotic animals that distinguish their territories, the lion and elephant of Africa and the tiger of Asia. Another winged personification stands amid them and gestures upward to the conquering emperor.

Justinian secured the territories bordering the Mediterranean Sea. His armies drove the Goths out of Italy; they forced the Vandals to surrender North Africa; and they pushed Persian invaders into the hinterlands of Asia Minor. The topmost panel of the Barberini Diptych illustrates the divine authority that appointed the emperor his special regent on earth. Two angels support an *imago clipeata* of Christ blessing the leader. In 554, after reclaiming the Mediterranean Sea as part of the Roman empire, Justinian issued a decree announcing, "We believe that the first and greatest blessing for all mankind is the confession of the Christian faith. . . . to the end that it may be universally established . . . we have deemed it our sacred duty to admonish any offenders."

A complex bureaucracy administered Justinian's new empire efficiently, and the old code of Roman law, which had become encumbered and inefficient since the time of the Caesars, was studied and rewritten by capable scholars at court in a new form, a body of civil law (*corpus jurus civilis*) known as the Justinianic Code that provided a model for legal systems throughout Europe. But it is Justinian's grandiose building programs that concern us. No less impressive than his institutions in administration and victorious military campaigns were the highly original structures that his architects created for the Christian church in Constantinople. Indeed, church and state were both glorified and fused in his most astonishing undertaking, the rebuilding of the imperial cathedral, Hagia Sophia (figs. 115–17; colorplate 12).[3]

Hagia Sophia dominates the landscape of Constantinople much as the great Parthenon does the skyline of the Acropolis. From the exterior it resembles a giant mass of interlocking geometric blocks rising rhythmically to a huge domed apex. But, unlike ancient Greek temples, this House of God overwhelms the viewer. There is no sense of human scale to comfort our confrontation with the huge building, and, furthermore, an even more awesome experience awaits us when we enter the structure.

The building of Hagia Sophia commenced immediately after the riots of 532 were quelled, and the final consecration

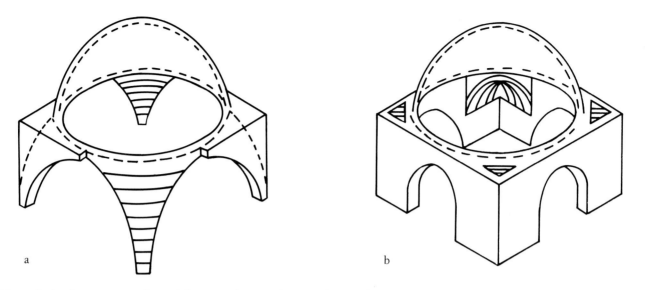

a b

118. Methods of supporting a dome: *left:* (a) *Pendentive.* The curved triangular section in the corner of a square bay that supports the dome. *right:* (b) *Squinch.* The half-conical niche built into the corner of a square bay, transforming it into an octagon suitable for supporting a dome

took place only five years later, on December 27, 537. It seems clear that Justinian had in mind a grandiose project for his palace church from the start. Hagia Sophia was to be a monument to the glory of church and state that would surpass all earlier churches, including the former basilica on the site, and was to outdo in grandeur even the famed Temple of Solomon, the Old Testament archetype of all Christian temples.

To accomplish this, Justinian appointed two learned scientists, *mechanopoioi,* to design and supervise the building. Anthemius of Tralles was an expert in geometry who specialized in theories of statics and kinetics. Isidorus of Miletus taught physics at the universities of Alexandria and Constantinople and was the author of commentaries on vaulting techniques. They were not builders but theoretical scientists, and this is unusual, considering the building practices of the time. The project was an extremely costly one. Thousands of workmen were brought in from all parts of the empire to labor in the brickyards; marble revetments and capitals were shipped in from workshops in the nearby Proconnesian islands, and marble columns were appropriated from Rome, Ephesus, and other Greek sites.

In plan Hagia Sophia is a huge squarish rectangle (230 by 250 feet) augmented by two narthexes and a broad atrium (only a few foundations remain today) on the west and a single projecting apse on the east. Aside from this rudimentary alignment of parts, however, it little resembles the basilicas of earlier times. The nave, in fact, is totally dominated by the soaring dome over its center, a dramatic feature

that interrupts the longitudinal flow of space commonly experienced in Christian basilicas. The directional focus toward the altar with the closed, tunnel-like projection of space is overwhelmed by the vast openness of spaces that rise and swell out and upward to the summit of the lofty dome (165 feet) in the very center of the building. Hagia Sophia has been described as a fusion of a hall basilica and a centralized double-shell structure, but this explains little.

Four giant piers, forming a square in the center approximately one hundred feet on each side, are joined by sweeping arches to create the base for the giant dome. The transition from a square plan to a circular base for the dome is accomplished by pendentives, great curved triangular sections built into the corners that rise from the arches of the square, upon which the dome rests (fig. 118a). To the east and west the space descends from the central axis in scooped-out hollows formed by semidomes of exedrae, which, in turn, enclose the smaller half-domes of the diagonally placed conchs on the corners. This sequence of spherical spaces culminates in the apse on the east and a vaulted passageway abutting the inner narthex on the west.

The north and south flanks are screen walls penetrated by arcades that open into the side aisles (three vaulted bays on each side). Galleries and a high clerestory with two rows of windows fill the arched shape of the upper walls. Any sense of solid wall on the north and south sides is thus lessened by the various openings—the nave arcade, the galleries, the windows in the clerestory—which are rhythmically articulated in units of 3-5-7 throughout. The lofty dome, pen-

etrated by forty arched windows along its base, seems not to rest solidly on the pendentives but to hover above an aureole of lights as if it were suspended from heaven. Even the giant piers seem to dissolve into the fabric of the aisles, which in turn are amorphous and difficult to clarify spatially when viewed from the center of the nave.

How does one describe the dynamics of such an astonishing construction? Many theories have been proposed to explain the complex system of buttressing in Hagia Sophia. It has been suggested that the rippling semidomes on the east and west and the solid exterior piers on the north and south form the buttressing that holds up the dome. A clear solution evades the architectural historian, however. It has been argued more recently that the central core of Hagia Sophia is raised like a giant, freestanding baldachino and that the lateral spatial units, including the aisles, the narthexes, the galleries, conchs, and apse, are essentially unconcerned with the structure of the inner core and stand as independent architectural units. And yet there is no sense of an additive assembly of parts when we stand in the nave. The whole seems indivisible and organic, leading us slowly through space from the summit downward in a centripetal fashion, so that we seem enclosed in an immense, floating canopy of the heavens.

The enigma of Hagia Sophia can be partially answered if we turn to the building techniques employed. The weighty stone and concrete vaults and domes raised by the Romans over their giant structures would have required an entirely different disposition of foundations and walls. By the sixth century it was common practice to construct lighter vaults and domes with thin bricks embedded in mortar, thus reducing the problems of thrust and support considerably, and this type of construction was employed by Justinian's builders. The walls, vaults, and domes of Hagia Sophia were constructed of thin bricks forming a skin held up by four piers of sturdy ashlar construction. This allowed for greater flexibility in shaping the spaces to be enclosed. A variety of interlocking volumes expand outward from the inner shell— exedrae, conchs, and apse—resulting in a daring interplay of interior spaces.

To add radiance to the interior, colorful materials lined the walls and vaults. Porphyry and marble slabs—white, green, yellow, and blue—served as revetments for the walls. The great dome was enriched with gold mosaics, and the windows were filled with colored glass. A new type of capital was employed that radically transformed the appearance of the architectural supports. The sculptural character of Classical capitals was discarded for one of patterned surfaces with deeply undercut acanthus leaves sprouting lacy tendrils that impose an organic quality on the simple blocky shape and spill over into the architraves as colorful friezes. Thus we enter an exotic, brightly colored world culminating high above with the splendor of a golden heaven. With the myriad

shafts of light pouring through the windows at the base of the dome, an incredible sense of mystery is evoked. Hagia Sophia becomes a heaven under the heavens. It is not difficult to accept the report that Justinian, at the dedication of Hagia Sophia on December 27, 537, exclaimed, "Solomon, I have surpassed thee."

More than the quest for grandeur and celestial symbolism shaped Justinian's palace church, however. The complex liturgies of the Eastern church necessitated more clearly marked stations for the clergy, the emperor, and the laity.[4] Two impressive processions marked the opening of the services and, after the dismissal of the catechumens, the beginning of the Mass of the Faithful: the Lesser Entrance and the Great Entrance. In the former, the Lesser Entrance, the celebrant (bishop or patriarch) and members of the clergy assembled in the narthex, where the emperor awaited them. The procession then moved through the royal door into the inner narthex and down the nave, passed the ambo or pulpit in the center, along the solea (a path with low walls in the middle of the nave) to the door of the sanctuary. The emperor walked beside the celebrant into the sanctuary and presented his gift of gold, usually a paten or chalice, and then retreated to a special loge in the south aisle. The patriarch took his place high on the semicircular steps that formed the *synthronon,* or benches in the apse.

After readings from the scriptures by the deacon in the ambo and a sermon (homily) by the patriarch on the meaning of the words, the catechumens were dismissed. The Great Entrance (the Entrance of the Mysteries) followed, with a solemn procession led by the deacon, who brought the Eucharistic bread and wine to the altar from a small building outside the church. The clergy first received communion, then the faithful who gathered before the sanctuary (men and women apparently were segregated during the service, the women in the north aisle and gallery, the men in the south). The emperor left his "royal box" and entered the sanctuary to receive communion directly from the patriarch. In later Byzantine rites, the Great Entrance was restricted to the interior of the church itself, which necessitated the addition of a special side chapel on the north side of the apse, the *prothesis,* where the Eucharistic elements were prepared and stored. A second chamber, the *diaconicon,* on the south side, was used for vesting the bishop. Thus the typical Middle Byzantine church featured the familiar tripartite plan on the eastern end. At Hagia Sophia, however, a single apse projected from the sanctuary.

Justinian's building campaigns extended from the desert lands in the Near East to northern Italy, but it was primarily in his capital, Constantinople, that innovations in architecture are to be found. His historian, Procopius, describes more than thirty churches in Constantinople (*The Buildings*), and of these, four seem to be related to Hagia Sophia in that they were domed and centrally planned. The famed

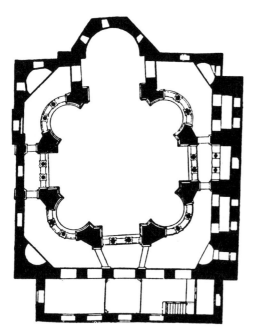

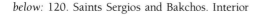

above: 119. Saints Sergios and Bakchos, Constantinople. Plan (after Dehio/Bezold). Completed before 536

below: 120. Saints Sergios and Bakchos. Interior

Apostoleion was rebuilt in 536. The Greek-cross plan of the Constantinian structure was retained, with domes raised over the center and over the four arms of the cross, establishing a handsome building type that was frequently copied (cf. San Marco in Venice, fig. 185).

Saints Sergios and Bakchos (figs. 119, 120), built in 525 alongside an earlier basilical church in the private residential area where Justinian lived before he was named Caesar, has been considered to be an experimental and miniature version of Hagia Sophia.[5] It features a double-shell plan with a dome, an octagonal core, and an ambulatory and galleries within a slightly irregular square. Very likely it was built as a private palace church alongside a congregational basilica since the dedicatory inscription names Justinian and Theodora as founders. The construction is like that of Hagia Sophia, with vaults and dome built of light, thin bricks embedded in mortar. The capitals, too, are similar to those in Hagia Sophia.

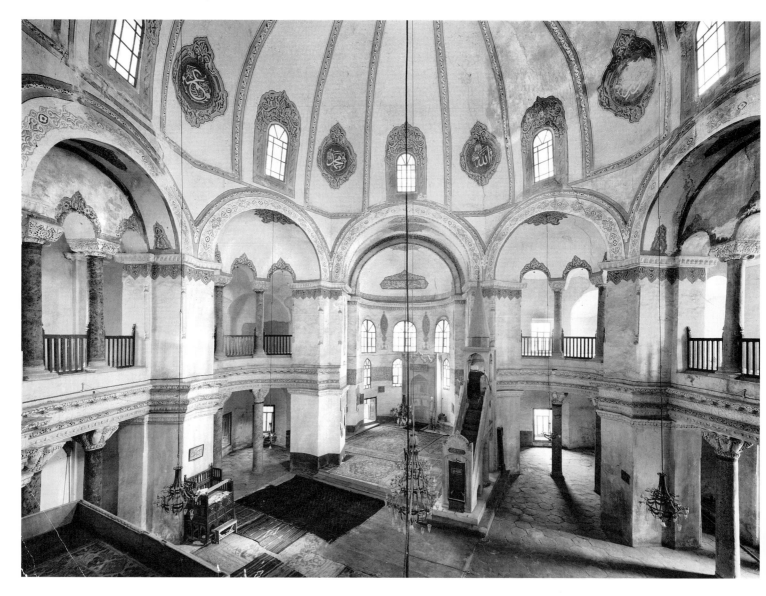

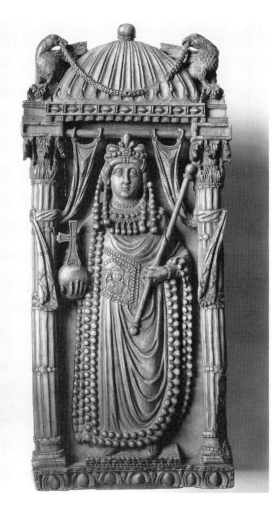

121. *Portrait of Ariadne*. Ivory panel of an imperial diptych, 14⅜ × 5⅜″. Early 6th century. Museo Nazionale, Florence

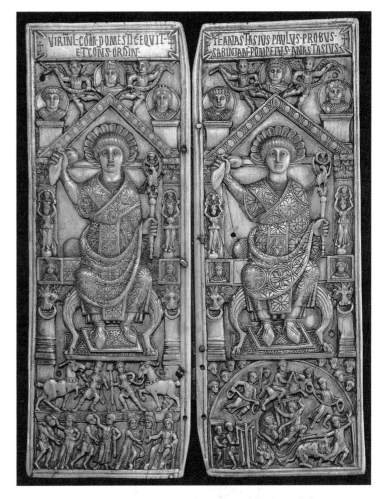

122. *The Consul Anastasius*. Ivory diptych, each 14⅛ × 5⅛″. 517. Bibliothèque Nationale, Paris

Were there figurative mosaics in Justinian's churches in Constantinople as there were in Rome? It has been assumed that any mural decoration would have been aniconic, that is, only floral or abstract ornamentation, but this may be an extreme judgment. Recently a ninth-century mosaic of the *Virgin and Child Enthroned* (fig. 155) was uncovered in the apse of Hagia Sophia with an inscription informing us that "the images which the imposters [the iconoclasts of the eighth century] had cast down here, pious emperors have again set up."[6] We shall return to this mosaic later. Other evidence of pre-iconoclastic figurative decoration is found in a room of the patriarchal palace adjoining the church, where medallion portraits of saints appear (their faces replaced by crosses and their names erased) and in a mosaic of the *Presentation of Christ in the Temple* discovered in a walled-up area of the Mosque of Kalenderhane, originally a pre-iconoclastic church in Constantinople.[7] The latter, although only a fragment, displays stylistic affinities with mosaics in Thessaloniki dating in the seventh century. The possibility of figurative mosaics in Constantinopolitan churches of Justinian's reign should not be ruled out.

That Constantinople was a major center for figurative arts is indeed demonstrated by the wealth of sumptuary arts, both secular and religious, that survive in the form of ivories and metalwork with portraits and narratives. Ivory was a precious medium highly valued for its fine grain that allowed for exquisite and minute detail in carving. A number of ivories with figurative designs served as covers for state and church documents in the form of diptychs.[8] Such, no doubt, was the handsome equestrian portrait discussed above (colorplate 11). Of similar high quality is the *Portrait of Ariadne* (fig. 121), an empress who died in 515. Here the abstraction is so advanced that Ariadne appears as a cult image, placed within an ornate baldachino. She holds a scepter and an orb surmounted by a cross, and her body is overwhelmed by beads, jewels, and other details of her precious imperial regalia.

Even more abstract are the portraits on the ivory diptychs that were made to commemorate the appointment of the consul of the year, a practice documented by the ivories from 406 to 539, thus providing the art historian with an absolute chronology for stylistic developments (fig. 122). On such

occasions the consul presided in a special box in the hippo-
drome, where games were held in his honor (and at his
expense). Anastasius, consul in 517, appears twice in hiera-
tic isolation on a huge throne adorned with many attributes
of his office. On the right-hand side, the arena below the
throne is a diminutive arc crammed with heads of spectators
and tiny, agitated performers battling lions. The surface is
overloaded with symbolic paraphernalia, including heraldic
lions, personifications of victory, and imperial scepters. The
consul's face is an oval mask with huge, staring eyes, and his
elaborate costume is a rich pattern of rosettes and diamond-
shaped ornaments.

Aside from the unusual hieratic scale, other anti-Classical
traits are apparent, too. There is practically no suggestion of
spatial projection so that all elements are pressed into a
coplanar organization, and the carving is harsh, imparting a
metallic hardness to the forms with an extreme stylization
and schematization to the setting. The consul obviously is no
portrait likeness but rather a frozen emblem of his short-
lived office.

A different style, a mode that seems astonishingly Classi-
cal when compared to the abstraction of the consular dip-
tychs, also appears in many ivories. An ivory plaque portray-
ing the *Archangel Michael,* today in the British Museum (fig.
123), has a refreshing exuberance about it even though the
placement of the lithesome angel in the elaborately carved
porch is somewhat ambiguous. Michael's face is youthful
and fleshy; his stance is casual; and his well-proportioned
body is draped with softly falling folds of the tunic and

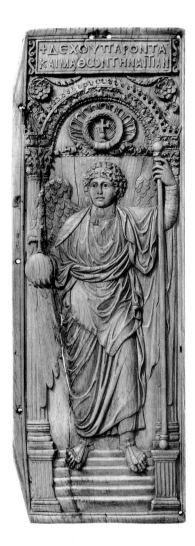

above right: 123. *Archangel Michael.* Right
panel of an ivory diptych, 16⅞ × 5⅝″. Early
6th century. British Museum, London

right: 124. *Silenus.* Fragmentary silver plate,
diam. 11½″. 527–65. Byzantine Visual
Resources, © 1987, Dumbarton Oaks,
Washington, D.C.

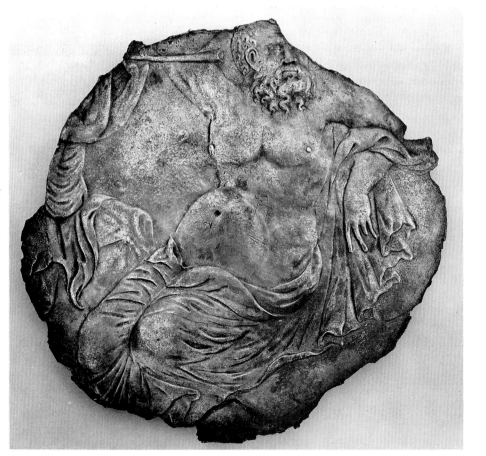

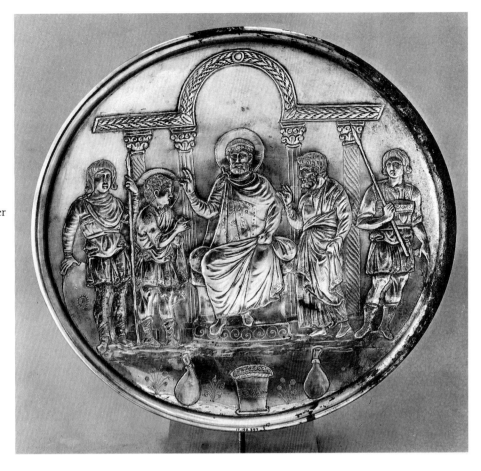

125. *David Before the Enthroned Saul.* Silver plate from Cyprus, diam. 10½″. 610–41. The Metropolitan Museum of Art, New York. Gift of J. Pierpont Morgan, 1917

pallium. A Hellenic radiance and grace distinguish this ivory figure from that of Anastasius, and the carefully modeled drapery, the delicately engraved lines of the hair and wings, and the well-defined facial features suggest that the carver was a court artist of the highest caliber.

This second style, referred to by Ernst Kitzinger as "perennial Hellenism" in Byzantine art, is especially characteristic of many of the silver plates made in the capital as imperial gifts, and control stamps on their backs enable us to date them fairly accurately.[9] A number of them display mythological scenes executed in *repoussé* (a technique of raising a design on metal by hammering the reverse side) with incised details. A large fragment of a heavy plate dating from Justinian's reign (527–65) is decorated with a sprawling Silenus (fig. 124) falling into a drunken slumber. There is a remarkable rendering of the flabby undulations of his corpulent body. The naturalism is reminiscent of Antique metalwork, and the question remains as to whether it signals an outright revival of Classical style or a continuing tradition for such genre.

A similar liveliness and precise delineation of anatomy appear in the scenes from the life of David decorating a set of nine silver plates with the stamps of the emperor Heraclius (610–41). The *Combat of David and Goliath* (colorplate 13), the largest of the set, has three episodes from the story aligned in registers. Above, David confronts Goliath; across the center, David prepares to hurl a stone at the charging giant; and below, the young hero decapitates his adversary. The fine articulation of the muscular bodies, especially evident in the sinews of their legs and arms, and the lively gestures are striking when compared to the stumpy figures on the consular diptychs.[10]

The fact that the plates illustrate the life of a courageous Old Testament hero has prompted some scholars to suggest that they were meant to extol the military prowess of Heraclius himself, and, as products of court art, they bespeak a conscious revival or renaissance of Antique style promoted by the emperor. Another explanation recommends itself, however. The action-packed scenes of combat contrast markedly with the more ceremonial presentations such as that of the young *David Before the Enthroned Saul* (fig. 125). To be sure, the details of the costumes are highly refined in both, but the harsher frontality of Saul and his larger scale, together with the strict symmetry of the composition, are not stylistic traits that one normally associates with the Antique. Perhaps the more naturalistic style of the *Combat of David and Goliath* is due to the fact that it is a narrative scene and not an iconic presentation. As we shall see later, it was in Byzantine book illustration that such a mode of representation was maintained through a number of centuries.

THESSALONIKI, RAVENNA, AND MOUNT SINAI

THE EVIDENCE for figurative mosaic decoration in the early Constantinopolitan churches is scant, as we have seen, but in other important Early Byzantine centers the remains are abundant and display an astonishing development of style. These range from pre-Justinianic mosaics at Thessaloniki, through sixth-century mosaics at Ravenna and Mount Sinai, to early seventh-century wall decorations, again at Thessaloniki.

THESSALONIKI

Situated on the northeast coast of Greece, Thessaloniki was an important Aegean port and urban center in Hellenistic times. A Christian church was founded there in the first century, but after the emperor Galerius redeveloped the city in the early fourth century, building a hippodrome, a vast palace complex that included a huge circular mausoleum and a triumphal arch, Christians were severely persecuted (c. 303–11). During the course of the fifth century, after Christianity had been restored as a state religion, Thessaloniki assumed an important role as a provincial capital, the seat of the prefect of Illyricum. At this time, too, the bishop of Thessaloniki served as head of the churches in that area of the Balkans, but it is important to note that he was subject to the patriarchy of Rome, not Constantinople, until 732, when the Isaurian emperor Leo III annexed all bishoprics of Illyria to the patriarch of Constantinople. In the late sixth century Thessaloniki was gravely endangered by roving tribes of Slavs and Avars. A plague devastated the city in 586, and these misfortunes created a spiritual atmosphere that was instrumental in the rise of the cult of saints, particularly that of Saint Demetrios, a third-century martyr.

Among the numerous churches built in Thessaloniki during the fifth century, two remain with substantial mosaic decorations intact. The rotunda that was to serve as the mausoleum or throne room of Galerius was converted into a church now known as Hagios Georgios (figs. 126, 127), dating from about 450.[11] To the imposing domical structure were added chancel and apse with an ambulatory and a towered narthex that opened to the triumphal arch and palace of Galerius just beyond. The mosaic decoration that filled the huge dome, nearly one hundred feet in diameter, was unprecedented in Christian churches of the period. Three concentric zones lifted the viewer's eyes into the summit, where Christ appeared posed frontally with arms outstretched within an elaborate garland medallion carried by four angels against a gold background. Below, in the second register, were twenty-four figures (the twenty-four elders of the Apocalypse?) standing in various poses on a green ground. Although very fragmentary, these upper zones most likely represented the Second Coming of Christ, a *Maiestas Domini* not unrelated to that theme in Western basilical decoration (see p. 43).

The lowest zone, which forms a sort of wainscoting or drum for the heavens above, is better preserved. It is divided into eight sections, with magnificent mosaics of fantastic architectural sets resembling great palace facades or theater fronts (*scenae frons*) with intricate niches, exedrae, aedicules, canopies, and towers serving as symbols of heavenly mansions. The gold light of the background shines through the giant elevations, imparting eerie qualities of weightlessness and transparency to them. Before each facade stand two or three tall saints posed frontally as *orantes*. Inscriptions identify them and record the dates of their martyrdom. While flat, frontal, and weightless, the martyrs are delicately stylized with fine lines to give faint patterns to their costumes, and their faces are slightly modeled. They seem to be idealized types of handsome young men.

Hellenistic models can be found for the general disposition of the "Dome of Heaven" in Hagios Georgios, but a strange new world is shaping up here. Any sensation of illusionism, whether in the perspective of the architecture or the modeling of the figures, is overwhelmed by the uncanny glow of the bright gold background filtering through the fine lines that describe the colorful settings and figures.

Equally impressive but on a much smaller scale is the apse mosaic in a small chapel, known today as Hosios David, attached to the monastery of Latmos in Thessaloniki (fig. 128).[12] Here, in another variation of the *Maiestas Domini* theme, a youthful Savior appears enthroned on a rainbow within a radiant aureole. The partial figures of four winged

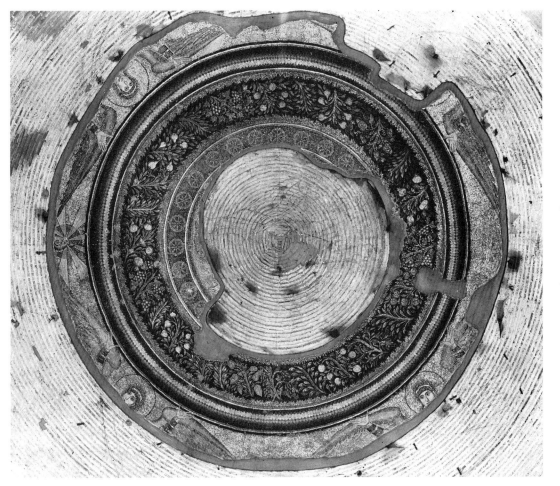

left: 126. Hagios Georgios, Thessaloniki. View into the dome showing mosaics. 5th century

below: 127. *Saint Onesiphoros and Saint Porphyrios.* Mosaic frieze in dome in Hagios Georgios, Thessaloniki

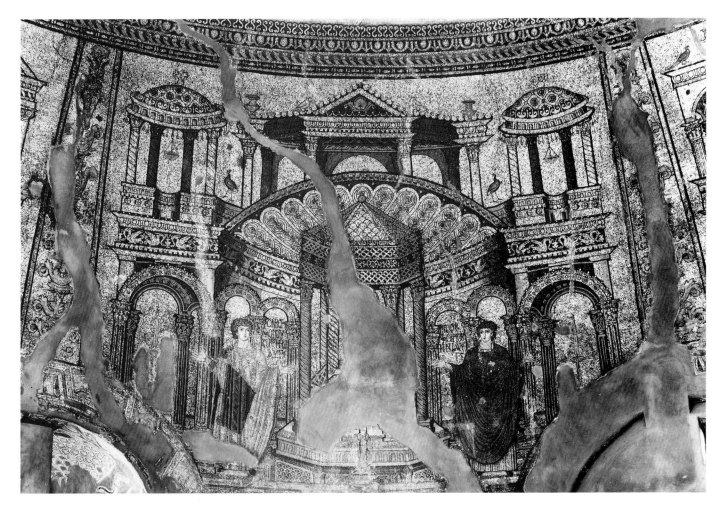

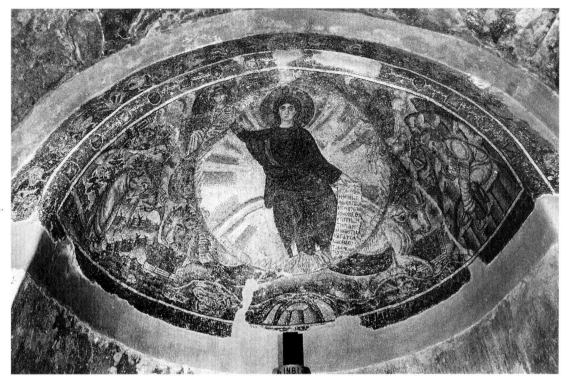

128. *Maiestas Domini.*
Apse mosaic in Hosios
David, Latmos
Monastery, Thessaloniki.
5th century

creatures—the angel, lion, ox, and eagle (symbols of the four Evangelists, Matthew, Mark, Luke, and John, respectively)—issue from the bright glory, and below the feet of Christ rises a mound with the four rivers of paradise. An inscription on the scroll held by Christ informs us, "I am the spring of living water."

In the rocky terrain to either side appear two figures. One, to the right, sits comfortably holding the Gospels open on his lap as he gazes across the curvature of the apse to the apparition of Christ. Although traditionally identified as Habakkuk the prophet, this witness must be Saint John the Evangelist, whose text (Rev. 4) describes the vision. The other figure, turning away and standing in a cringing posture to the left, has been identified as Ezekiel, the prophet who had a similar vision of the *Maiestas Domini* except that the animal guardians were tetramorphs (four-headed creatures) as they were represented in the *Ascension* miniature of the Rabbula Gospels (colorplate 8). The mosaic seems to proclaim that the vision of godhead described by the Old Testament prophets, on which the Byzantine church relied, was the very same as that experienced by the New Testament Evangelist John, the favored source for the Latin church. The former hides his eyes from the glory; the latter views it contemplatively.

A third church in Thessaloniki, Hagios Demetrios, presents us with mosaics of a very different style and content in the form of *ex-voto* portraits of patron saints protecting the donors, who vowed to make donations to the church in times of need.[13] During the course of the sixth century, Thessaloniki suffered a number of disastrous setbacks, as mentioned above, and it was the intercession of Saint Demetrios that saved the city, according to local legend.

The life of Demetrios is difficult to reconstruct, but it is generally believed that he was a member of a senatorial family and an officer in the army who was martyred by Galerius because of his Christian faith. During the troublesome years of the sixth century, with the Slavs and Avars pressing near the city walls of Thessaloniki by land and sea, Demetrios was adopted as protector of the city, and, according to a seventh-century text, *The Miracles of Saint Demetrios,* his popularity promoted an enthusiastic cult-following among the citizens. This, in turn, spurred on a new type of personalized devotion that had been gradually developing in the Byzantine world (see below, chapter VIII). A subtle transformation of the imagery in the church resulted, one in which the role of the picture was not to educate the worshipper but to offer him a direct confrontation with mysterious powers of protection and healing embodied in the image of the saint.

The Church of Hagios Demetrios was a large pilgrimage basilica with double side aisles, galleries, projecting transept arms, and a complex assembly of chambers flanking the apse (figs. 129–31). The relics of Demetrios were presumably preserved in a crypt. The fifth-century basilica burned in 620 and was immediately restored. It burned again in 1917, and while it was again fully restored, the chronologies of surviving mosaics are problematical. Fragments on the west walls of the inner aisles, believed to have been executed

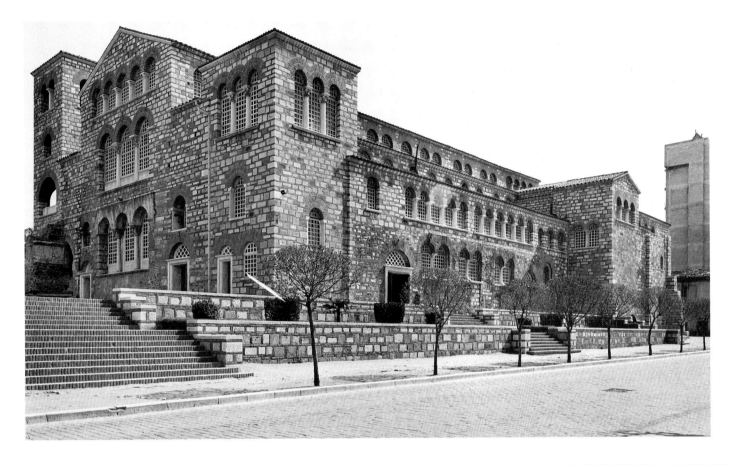

above: 129. Hagios Demetrios, Thessaloniki. Exterior.
Late 5th century; rebuilt after fire of 1917

below: 130. Hagios Demetrios. Reconstruction and plan
(after Krautheimer)

below right: 131. Hagios Demetrios. Interior of nave
(rebuilt after fire of 1917)

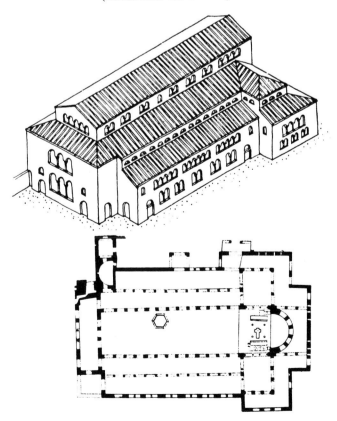

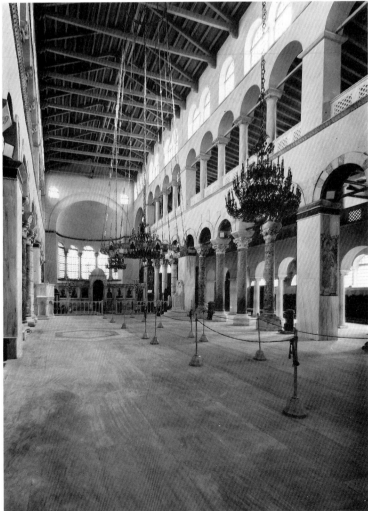



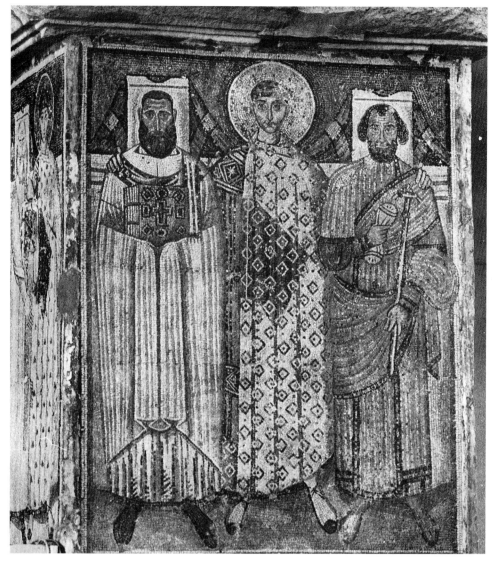

132. *Saint Demetrios with Bishop Johannes and Prefect Leontius.* Mosaic on chancel pier in Hagios Demetrios, Thessaloniki. c. 650

before the fire of 620, portray Demetrios in the presence of an angel blowing a trumpet and again with a donor presenting his son. Far better preserved are the commanding iconic portraits that appear on the piers of the sanctuary (fig. 132; colorplate 14). Because of stylistic changes these mosaics have been dated after the fire of 620.

One of the better preserved mosaics portrays Demetrios embracing Bishop Johannes (left) and a city governor, Leontius (right). All three men stand rigidly frontal, and below them an inscription records the mosaic as a donation (made after the fire?): "You see the donors of the glorious house on either side of the martyr Demetrios, who turned aside the barbarous wave of barbarian fleets and was the city's salvation." On another face of the chancel pier appears a companion saint (Bakchos?) standing between two boys who were presumably the sons of a donor placed in the protective custody of the martyr through eternity. The advanced abstraction in these images reminds us of the development of the hieratic portraits of saints in the apses of Roman basilicas

(for example, Sant'Agnese, fig. 66). The tall proportions, the reduction of the bodies to flat carpets of surface patterns, the rigid frontality, and the imposing presence of these large figures who fill the borders completely with little indication of a spatial setting induce a mysterious response on the part of the worshipper.

How does one account for the startling abstractions in the portrait of the saint? Surely there is something more than inherent stylistic developments involved here, something that has created a new meaning for the image of man that these icons embody. In the writings of a sixth-century theologian, the so-called Pseudo-Dionysius the Areopagite, we can find an interpretation of the relationships between nature, man, and god that provides us with a partial answer. In his treatises (*The Ecclesiastical Hierarchy, The Celestial Hierarchy,* and *Mystical Theology*), all matter and being are described as forming a ladder of essences that reaches from the most mundane and earthly through the animals, man, and angels of various categories, culminating in the pure

spirit and essence of God. This image of the hierarchy of matter and spirit is basic to mystics of all ages and is ultimately derived from Plato's analogy of the cave.

The pure spiritual light of godhead shines forth at the top of the ladder of being, while lifeless, inert matter lies in darkness at the bottom. Man appears at the midpoint in this chain of being, a spirit imprisoned in an earthly body. But a saint is different. He is more spiritual in form, and to render the likeness of a saint, the artist must search for an image higher on the ladder of being than his human form provides. In one of his treatises, *Mystical Theology*, the Pseudo-Dionysius writes: "This is my prayer. . . . in the earnest exercise of mystical contemplation, abandon all sensation and all intellectual activities, all that is sensed and intelligible . . . thus you will unknowingly be elevated, as far as possible, to the unity of that beyond being and knowledge. By the irrepressible and absolving ecstasis of yourself and of all, absolving from all, and going away from all, you will be purely raised up to the rays of the divine darkness beyond being."[14]

The mosaic portrait can be interpreted in an analogous manner. The artist is to discard the physical and sensuous appearance of the saint. He is to reject the illusionistic devices of natural lighting, perspective, and modeling of the saint as an object in space by refining all fleshy matter until the saint becomes a transparent, weightless shell, until the body is distilled into a pure form to contemplate. The stillness and transparency of the portrait will then induce a quiet, hypnotic trance in the beholder.

The Pseudo-Dionysius does not discuss art, but we know that his mysticism was steeped in the writings of the pagan philosopher Plotinus (A.D. 205–270) and his school of thinking known as Neoplatonism, a philosophy derived from the writings of Plato. In the *Enneads* Plotinus provides us with an aesthetic basis for the arts in this mystical world of hierarchies.[15] The artist is not to create copies of natural objects but seek to portray the higher images: "How are you to see the virtuous soul and know its beauty? Withdraw into yourself and look alone . . . act as does the creator of a statue that is to be made beautiful: he cuts away here, he smoothes there, he makes this line lighter, this other purer, until a lovely face has grown upon his work. . . . [You must] bring light to all that is overcast . . . until there shall shine out on you from it the godlike splendor of virtue, until you see perfect goodness . . . in the stainless shrine" (I. 6.9).

Not only should the artist strive for an abstraction of matter and light but also of space. Distance dims colors and blurs details. The artist should reject spatial illusionism and depict the object close at hand and in its fullest dimensions. Forms should not overlap or conceal one another, and their colors must be pure and bright, not shaded or diminished as forms seen in space and natural light. The eye should see pure color: "The eye, a thing of light, seeks light and colors which are the modes of light, and dismisses all that is below

the colors and hidden by them as belonging to the order of darkness, which is the order of matter" (II. 4.5).

Plotinus further informs us that beauty of color is enhanced through symmetry of parts: "In visible things, as indeed in all else, the beautiful thing is essentially symmetrical, patterned" (I. 6.1). Finally, Plotinus writes that the viewer must participate intimately with the image and not merely observe it as a work of art indifferently. He should strive to identify with the image and go up the ladder of essence with it and participate in its world. The mosaic portrait of Demetrios engages the viewer directly and stares hypnotically at him. Be silent, be still, lift yourself out of your body through the image: When you perceive this image, when you find yourself attuned to "that only veritable Light which is not measured by space, not narrowed to any circumscribed form nor again diffused . . . when you perceive that you have grown to this . . . you need a guide no longer" (I. 6.9).

Thus Plotinus provides us with four stylistic means for establishing the aesthetics of the Byzantine icon portrait. First, bring the object close to the viewer so that he may contemplate it unobstructed and fully; second, employ pure color to portray pure form, one that is not subjected to the breakdown of forms seen in the natural light of this lower world; third, order the pattern of pure color and the transparency of light into a symmetrical composition to assure its stability and permanence; and, finally, place the image in a frontal position so that it regards the viewer directly, inviting him to participate in its goodness and purity. The icon portrait, in contrast to those of Antiquity (or the Renaissance of the fifteenth century), displays an imposing frontality and regards us directly. We shall return to some of these ideas in the next chapter.

RAVENNA

Situated in an inlet on the Adriatic coast below Venice, Ravenna has, from earliest times, impressed visitors as a strange and exotic city. In the fifth century Gaius Apollinaris Sidonius described Ravenna as "a marsh where all the conditions of life are reversed, where walls fall and waters stand; where towers float and ships stand still; where invalids walk and their doctors take to bed . . . where merchants shoulder arms and soldiers haggle like hucksters, where eunuchs study the arts of war and barbarian mercenaries study literature."[16]

For the art historian, too, Ravenna presents a baffling picture, and a brief historical sketch is necessary. In A.D. 402 Honorius, son of Theodosius the Great, moved the capital of the western empire from Milan to Ravenna. Following his death in 423, his sister, Galla Placidia (r. 424–50), the benefactor of Pope Sixtus III in Rome it will be recalled, initiated an ambitious building program in Ravenna centered about the palace church of Santa Croce that included a

mausoleum (and chapel dedicated to Saint Lawrence) that stands intact today (figs. 133–35).[17] The mausoleum is laid out on a Greek cross plan with barrel vaults over the arms and a central dome on pendentives. The exterior design with blind arcades framing the windows and the masonry with thick bricks and narrow mortar joints point to Milanese workmanship, as is to be expected. The decoration of the interior, on the other hand, is unprecedented and surprising in its lavishness.

The floor of the small building has been raised some five feet since the fifth century, and the intimacy one feels in being so close to mosaics in the vaults and dome is deceptive. But it is a wonderful deception. The mausoleum is a glistening box, with blue and gold mosaics covering the entire interior above the walls (which are sheathed in marble), including the lunettes that terminate the arms. The vaults on the north-south axis are decorated with splendorous golden stars shining out from a rich, deep-blue background; those on the east-west axis have elegant golden tendrils against the

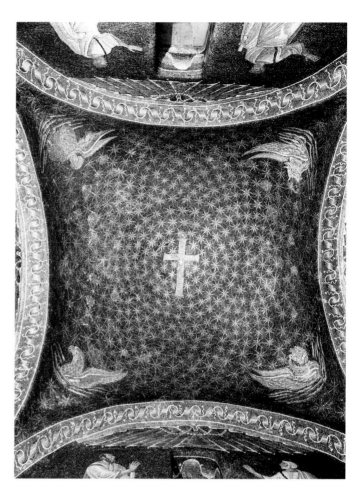

below: 133. Mausoleum of Galla Placidia, Ravenna. Exterior. c. 425–50

above right: 134. Mausoleum of Galla Placidia. View into dome

opposite: 135. *The Good Shepherd.* Lunette mosaic in the north arm of the Mausoleum of Galla Placidia

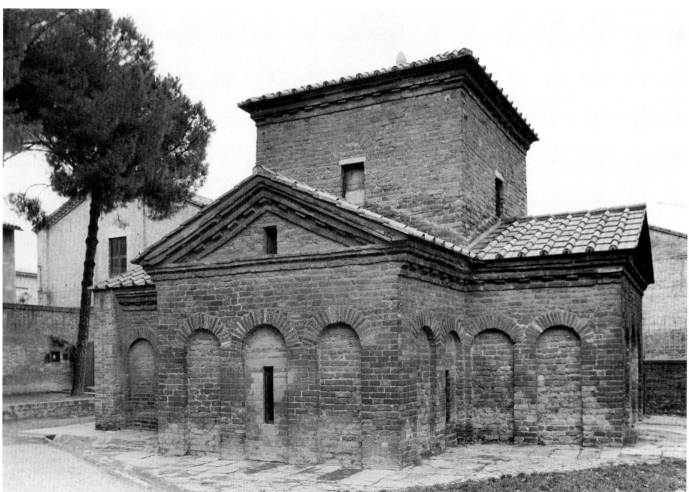

blue. A golden cross and busts of the Apocalyptic symbols appear in the deep blue of the dome, while four pairs of apostles, flanking alabaster windows, decorate the upper walls of the central bay. The lunettes in the arms display scenes that carry us back to the repertoire of Early Christian funerary arts with two (east and west) decorated with stags, standing amid rich overgrowths of tendrils, drinking from the life-giving waters of paradise. That over the entrance in the north arm has the Good Shepherd tending his flocks; that in the south presents a curious representation of Saint Lawrence, his grill aflame, and an open bookcase at the left displaying the four Gospels.

The Good Shepherd, however, is not to be confused with the ordinary bucolic figures whom we find in the catacombs. He is garbed in brilliant gold and purple and holds a tall golden scepter, reminding us that we are in the company of royalty.

The so-called Orthodox Baptistry (San Giovanni in Fonte) in Ravenna was built at the end of the fourth century in the form of a high octagonal structure with four shallow niches (figs. 136, 137). After Ravenna was elevated to an imperial residence, a remarkable transformation took place in the remodeling of the interior by Bishop Neon, sometime between 450 and 460.[18] The timber roof was replaced with a light dome constructed of hollow tubular tiles set in concrete, and the entire superstructure was lavishly lined with mosaics and stucco niches. One is immediately aware that this is a baptistry. The font is huge, and the summit of the dome is brightened by a scene of the Baptism of Christ set against a golden background.

Much like the decoration in the dome in Hagios Georgios in Thessaloniki (figs. 126, 127), that of the Orthodox Baptistry rises in concentric bands with a similar combination of solid architectural foundations, serving as a base for the heavens above, and figures of saints placed in a terrestrial landscape. There are major differences in the conception of figures in space, however. The lower zone is partitioned into eight divisions with alternating representations of altar tables carrying Gospels and jeweled thrones resembling the "prepared thrones" for Christ's Second Coming that we first encountered in Early Christian Rome (see p. 45). Elaborate candelabra grow from the lower pendentives into this band, further marking the eight divisions.

Instead of portraying frontal saints before the architectural base, as at Hagios Georgios, the Ravennate mosaicist lifted the figures into the upper register and placed them on a shallow landscape stage against a blue background. The twelve apostles are depicted as figures moving in procession about the dome. They are isolated by the alternating colors of their mantles, white and gold, and more emphatically by the floral candelabra that rise between them. The disjunction between the eight spokes of floral divisions in the lower zone

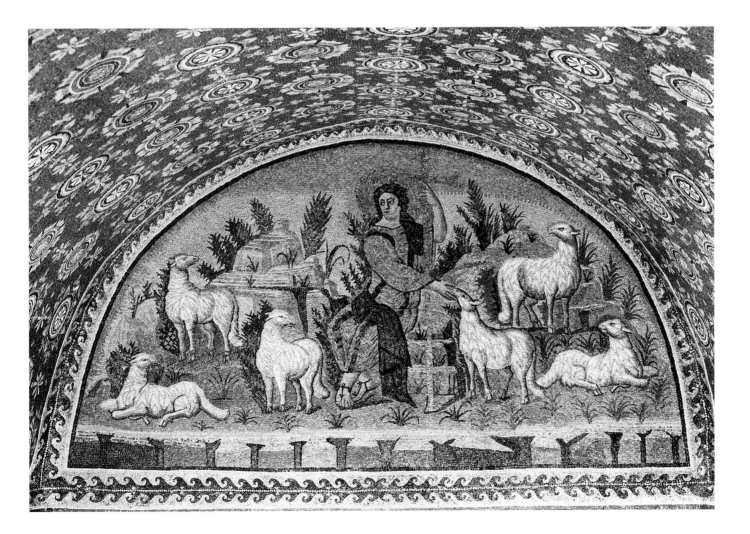

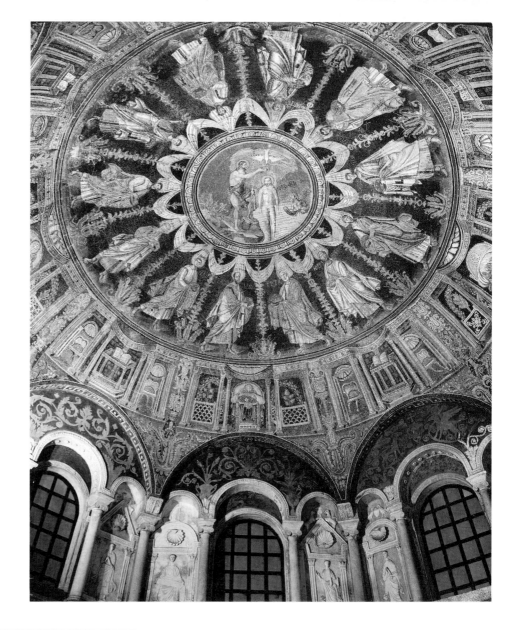

below: 136. Orthodox Baptistry, Ravenna. Interior. 450–60

right: 137. Orthodox Baptistry. View into the dome

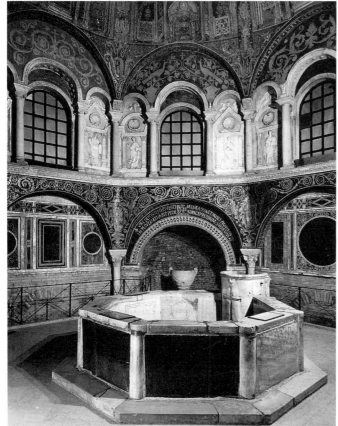

and the twelve in the upper disturbs any sense of spatial continuity or illusionism, however. Unlike the majestic rise of the transparent mansions with saints into the summit of the dome at Hagios Georgios, that of the Orthodox Baptistry develops in three distinct and unrelated zones.

A further change of style can be seen in the procession of apostles in the dome of the Arian Baptistry (fig. 138), dating about 500, that was built by the Ostrogothic king Theodoric. The figures, flattened and frozen in their poses, are mechanically aligned against a stark golden background. The colorful and complicated pattern of the decorations in the Orthodox Baptistry is reduced to a simple repetition of white silhouettes separated by palm trees against the expanse of gold. The lower register with altars and thrones is eliminated. This heightened abstraction has been attributed to the tastes of the new patrons, the Arian Ostrogoths, but the matter is more complex.

The disintegration of the Roman empire in the West during the later fifth century is difficult to assess. Theodoric the Great (454–526), king of the Ostrogoths (eastern Goths), is the principal actor in this drama for Ravenna. Taken as a

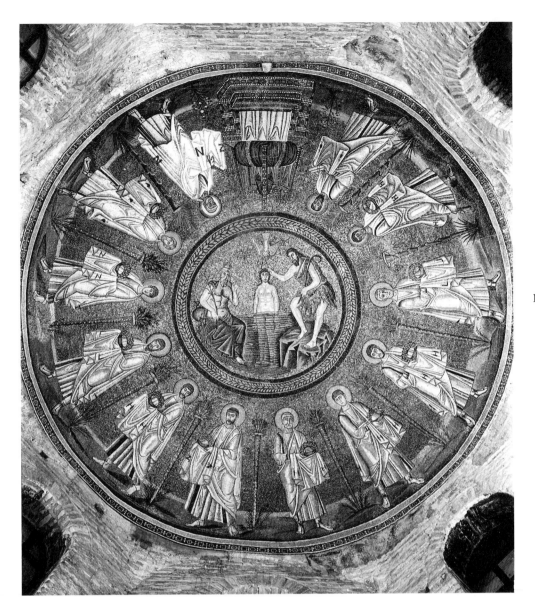

138. Arian Baptistry, Ravenna.
View into the dome. c. 500

hostage in his youth, Theodoric was educated in Constantinople. At the age of eighteen, he was sent back to his people, in the area north of the Black Sea, to rule over them. The Byzantine emperor Zeno next sent Theodoric and his restless tribes on a campaign to quell barbarian encroachments on the frontiers. Between 487 and 493 Theodoric led hordes of Ostrogoths into North Italy to drive out the usurper Odoacer. Odoacer capitulated at Ravenna in 493, and Theodoric set up his newly won empire there.

Some historians have seen Theodoric's short-lived reign as a blessing for the West, and in terms of economic recovery, religious tolerance, and cultural revival in Italy, this is true. In some respects Theodoric acted as a vice-regent of East Rome, Byzantium, but it is clear that he wanted to establish the autonomy of his western empire. Aside from the dangers posed by his political ambitions, Theodoric's rule had a serious flaw in the eyes of the empire. He was an Arian Christian, and while Theodoric himself was very tolerant of the beliefs of others, he could never reconcile his Arian faith with the orthodoxy of the Roman and Byzantine churches, and he established his own Arian churches in Ravenna.

The palace church of Theodoric in Ravenna was originally dedicated to "Our Lord Jesus Christ" (rededicated to Saint Martin after the Byzantine occupation in 539, and then to Saint Apollinaris in the ninth century). Presently known as Sant'Apollinare Nuovo, it is one of the most memorable monuments in Ravenna (figs. 139–42; colorplate 15).[19] The structure is a simple basilica in plan and elevation without projecting transept arms, and the building techniques conform to Milanese practices.

The entire elevation of the nave above the arcade is filled with rows of figures seen against golden backgrounds (fig. 140). As in Christian basilicas in Rome, these decorations are arranged in three horizontal zones, but the selection of themes in each departs considerably from the norm and reflects Theodoric's Arian interests. The walls between the windows in the clerestory form a portrait gallery of white-robed authorities of the Old and New Testaments, thirty-two in all, who stand in frontal positions. They hold either books (apostles) or scrolls (prophets and patriarchs). This follows the program of Roman basilicas, but in the blank zone between the clerestory and the nave arcade, where Biblical

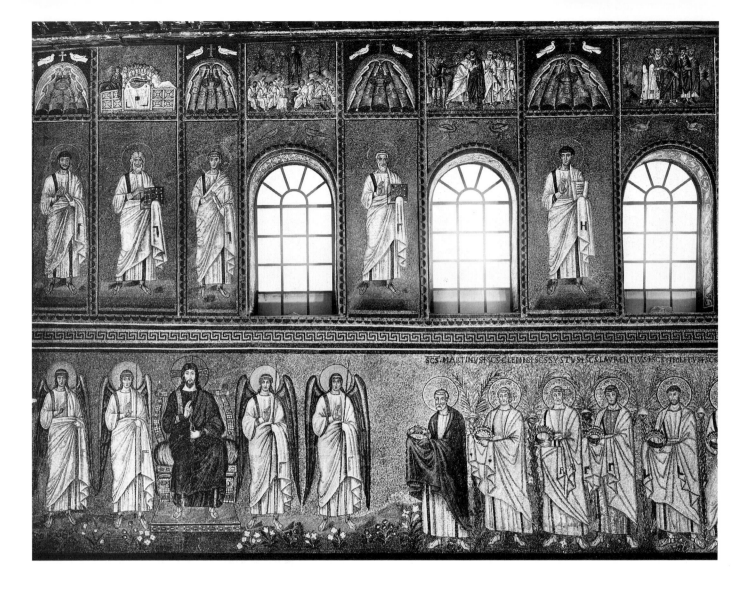

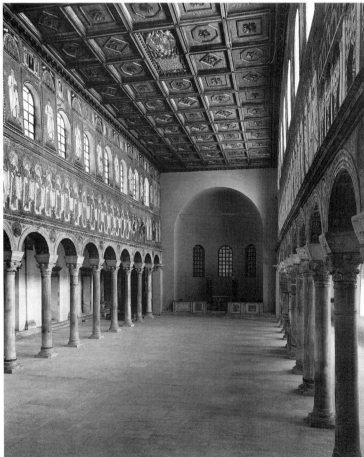

narratives usually appear, a stunning procession of male and female martyrs, slightly taller than the figures in the clerestory, moves from the entrance toward the altar on either side. On the left, twenty-two female martyrs, elegantly attired, proceed rhythmically from diminutive representations of the port of Classe to the enthroned Virgin and Child (with the three Magi) near the altar. On the right, twenty-five male martyrs in white march slowly from the *Palatium* (palace) of Theodoric to Christ enthroned between angels opposite the Virgin (fig. 141). Curiously, the narrative scenes—all New Testament stories—are lifted to a narrow band between the clerestory and the ceiling, where they alternate with decorative panels of shell canopies that serve as frames for the apostles and prophets below.

When the Byzantines took Ravenna from the Ostrogoths in the middle of the sixth century, remodelings were carried out in order to convert Theodoric's "Arian" mosaic programs to ones acceptable to the orthodox church. To what extent this meant replacing large expanses of the earlier mosaics is a matter of some debate. The figures of Theodoric and his court that formerly appeared in the portals of his *Palatium* (outlines of some figures are still visible) were surely expunged by the Byzantines, but would it have been necessary for them to replace the two processions of martyrs? It has

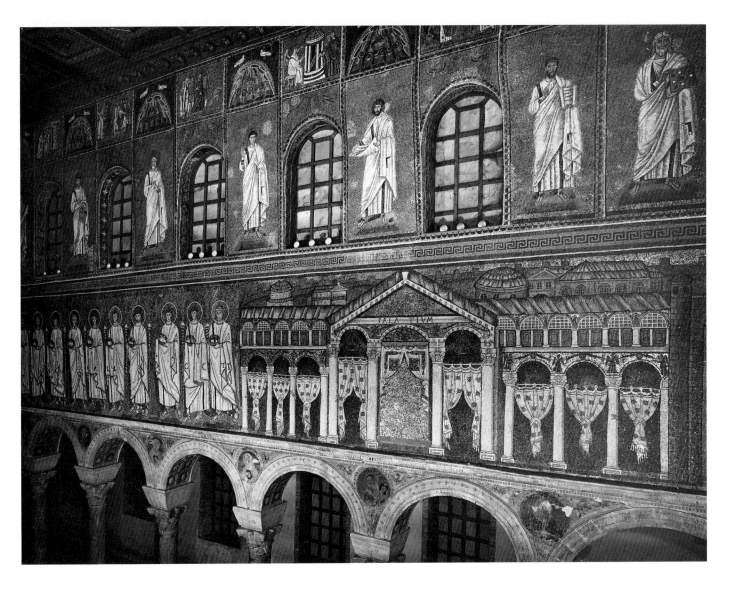

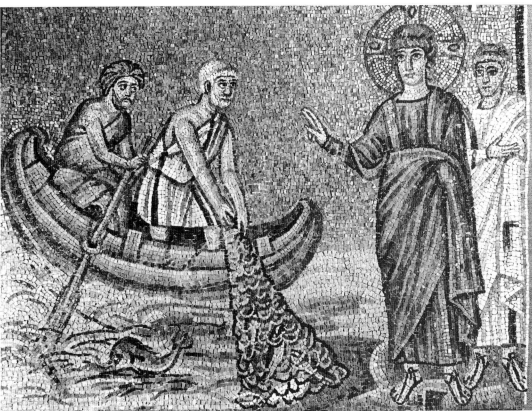

opposite below: 139. Sant'Apollinare Nuovo, Ravenna. View of nave toward the east. c. 500

opposite above: 140. *Christ Enthroned Between Angels and Procession of Saints* (below); *Prophets and Apostles; Gospel scenes* (above). Mosaics on the east end of the south wall of the nave of Sant'Apollinare Nuovo. c. 500 (alterations c. 550–60)

above: 141. *Theodoric's Palace*. Mosaic on west end of the south wall of the nave of Sant'Apollinare Nuovo. c. 500 (alterations c. 550–60)

right: 142. *Calling of Peter*. Mosaic in upper register of the north wall of the nave of Sant'Apollinare Nuovo. c. 500

been argued that the present rows of saints are Byzantine and should date about 550–60. The leader of the male martyrs, Saint Martin (who was not a martyr but a popular warrior against the Arians in northern Europe), is clearly a replacement made for the rededication of the church to him.

But are these handsome figures Byzantine in style? They are very like the apostles in the Arian Baptistry, and if one compares them to figures in mosaics in Byzantine churches in the East, a number of significant stylistic differences are apparent. To be sure, they show a similar state of abstraction with their bodies reduced to weightless patterns of color, but these martyrs are not icons in the strict sense of the term. They are not individualized, nor are they placed in rigid frontal poses. Only the inscriptions give them identities (Agnes, however, is accompanied by a lamb), and they simply form a melodic sequence of anonymous saints that fill the House of the Lord as they bear their gifts, crowns of martyrdom, to Christ at the altar.

The beautiful abstraction of these weightless saints floating against a brilliant gold background of the heavens can best be studied in the female martyrs. They are all sisters of one family with nearly identical facial features and coiffures. Only subtle variations are introduced to establish a cadence in their movement. Every third or fourth figure slightly tilts her head; the right hands are alternately veiled and free; the linings of the crowns they carry change from red to green to red. Even the rudimentary paradise landscape partakes of this subtle rhythm. The palm fronds form a pattern of green-blue-green, then one of blue-green-blue; below, white lilies alternate with red roses. There is something oriental in these dazzling shapes and bright colors, but nowhere, other than in Ravenna, do we find such magnificent assemblies of holy women.

The New Testament narratives in the topmost register, alternating with conchs, present other problems.[20] Those on the left illustrate thirteen individual episodes from the ministry of Christ (see fig. 142); those on the right thirteen scenes from the Passion. Surprisingly, in neither the ministry nor the Passion sequences are there any events that constitute a major epiphany, an episode in which the divinity of Christ is announced. The Baptism and the Transfiguration are missing in the ministry cycle. In the Passion sequence, the Entry into Jerusalem, the Crucifixion, and the Ascension are omitted. Rather, the Passion scenes concentrate on the failings of those nearest to Christ—the Betrayal of Judas, the Arrest of Christ, the Denial of Peter, the Doubting of Thomas. Only the mosaics nearest the altar on either side of the nave display Eucharistic themes—the Miracle of the Wine at Cana, left, and the Last Supper, right. Could there be something "Arian" in this selection of themes wherein a suppression of divine revelation seems intentional? Alas, we know too little about Arian art of the period to pursue this issue further.

The treatment of the figures and space in the narratives is similar to that of the saints and prophets below. There is little movement or drama in the stories. Only slight variations appear in the poses and postures. The compositions are reduced to simple designs often displaying a symmetrical grouping of the figures, who are static and frozen, forming simple color shapes. The draperies, with their bold outlines, are devoid of modeling, and instead of illusionistic landscape settings there are gold backgrounds. While the inspiration for the cycles may have been book illustrations ultimately, it seems clear that the manner of presentation here departs dramatically from the narrative mode that we studied earlier (chapter V). Here again, we are confronted, I believe, with a style that can only be characterized as Ravennate, neither Roman nor Byzantine in spirit. What can be said then about the Byzantine influences in Ravenna? The most famous and, in many respects, the finest examples of Early Byzantine mosaic work are found in San Vitale, but even here curious problems in iconography and style confront us.

San Vitale (figs. 143–49; colorplates 16, 17) was founded by Bishop Ecclesius in the last years of Theodoric's reign (d. 526).[21] The construction was delayed, however, and the monograms on the capitals of the ground floor indicate that under Bishop Victor (538–45) the building was raised. Furthermore, mosaics in the sanctuary inform us that the sumptuous decorations there were completed about 546–48, when Maximianus was archbishop and Ravenna was the exarchate of the Byzantine world under Justinian. The ground plan is closely related to that of Saints Sergios and Bakchos in Constantinople (c. 525–35), and column shafts and capitals were imported from the marble workshops of the capital in the Proconnesian islands. Like its Constantinopolitan model, San Vitale is raised on an octagonal, double-shell plan with ambulatory, galleries, and semicircular niches on the sides. The apse projects from a square chancel.

Local craftsmen were employed, and the building techniques are those of northern Italy. The dome is constructed of hollow tubes inserted into each other and set in mortar (cf. Orthodox Baptistry). Other features that suggest indigenous building practices are the clarity of the polygonal units when viewed from the exterior and the rather lofty proportions of the interior with large windows in the ambulatory, galleries, and dome, creating an aureole of bright light about the central core. A long, shallow narthex, terminating in towers, is set off axis on a side of the octagon and serves as the entrance.

While the interior of San Vitale is light and airy, the chancel and apse form a closed inner sanctum glowing with colorful mosaics (fig. 149). The lower walls are reveted with marble, and above the elegant columns and basket capitals, mosaics like huge luminous tapestries cover the walls and

vaults. In the summit of the chancel vault the *agnus dei,* the sacrificial Lamb of God, appears as the leitmotif for the Eucharistic program of the mosaics below. In the lunette on the south side of the chancel appears a representation of the sacrifices of Abel and Melchizedek on either side of a huge altar on which hosts and a chalice are displayed. Abel offers a lamb to the Hand of God, the bloody sacrifice of the Old Testament, while Melchizedek extends a host. As in the nave mosaic in Santa Maria Maggiore (fig. 58), Melchizedek is the type for the New Testament priest who gives the bloodless offering in the Mass.

In the left spandrel Moses appears twice, tending his flocks and removing his sandals before the burning bush, while on the far right stands Isaiah, the prophet of the Incarnation. These themes are elaborated in the lunette on the north side of the chancel, with Abraham offering the meal to the three men seated beneath the oak at Mambre

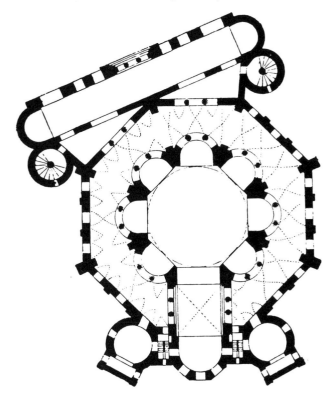

below: 143. San Vitale, Ravenna. Exterior. Completed 546–48

right: 144. San Vitale. Plan (after Dehio/Bezold)

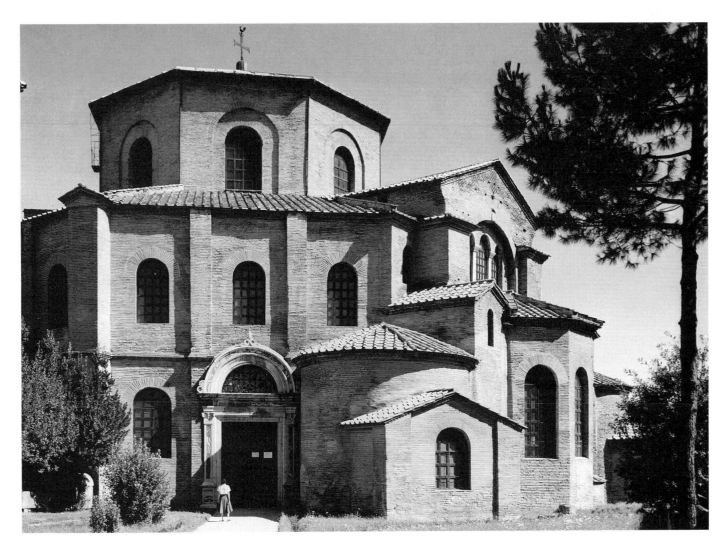

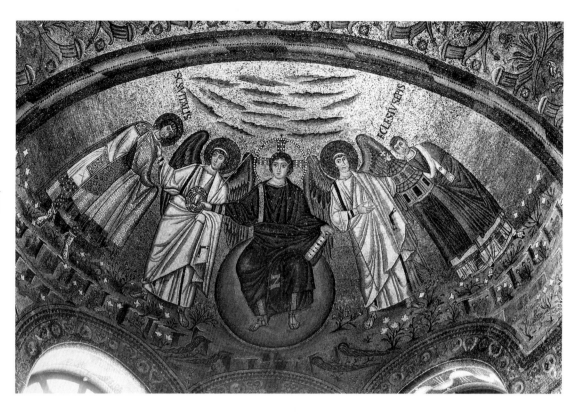

145. San Vitale. View into apse. Completed c. 546–48

(colorplate 16), and, to the right, the Sacrifice of Isaac. In the right spandrel Moses appears receiving the Law (in the form of a scroll) from the Hand of God, and to the far left the prophet Jeremiah stands with an open scroll.

Above the lunettes, flanking the openings in the galleries on either side, are portraits of the Evangelists. They are seated in rocky landscapes with their books open before them, and above, in a stepped, clifflike setting, stand their respective symbols, taken from the imagery in the Book of Revelation (see p. 43). The typological concepts involved here, the Old Testament anticipating the New and the depictions of the Evangelists with their beasts in a landscape, are Latin, not Byzantine, in origin, but the placement of these scenes within architectural spaces brings to mind the cyclical disposition of later Byzantine mosaic programs (see pp. 150–51).

The mosaics in the chancel thus present clearly defined narratives, with landscape settings under cloudy skies, and the pervasive tonality is a rich green, suggestive of a terrestrial rather than a celestial setting. While the figures move gracefully in these scenes, there is an emphasis on strong linear silhouettes with little modeling in the drapery. The landscapes, too, are pressed out with flora scattered about to fill the shallow ground, and the furnishings — the banquet table and the altars — are rendered in inverse perspective and tilted upward.

If one compares the scene of Abraham's banquet (colorplate 16) to the same episode in Santa Maria Maggiore (colorplate 3), the advanced stage of abstraction in the Ra-

vennate mosaic is immediately evident. The early fifth-century representation retains much of the illusionism of Antique painting with three-dimensional figures placed clearly in space about a table in an atmospheric landscape. At San Vitale the illusionistic qualities are diminished. The table before the three men who visit Abraham is not only tipsy but it unfolds precariously. The men's feet seem to project arbitrarily, the braces of the table legs are askew, and the bench for the visitors apparently has no legs. This disregard for perspective and naturalism characterizes the landscape as well. The shading of the oak of Mambre, for instance, is reduced to a series of peppermint stripes; the rolling hills beyond are transformed into lacy patterns of overlapping scallops; the clouds display herringbone striations; and the floral motifs are simply pinned to a groundline. Thus a curious compromise between the illusionistic qualities of earlier narration and the more iconic tendencies toward flat patterns is encountered in the chancel mosaics of San Vitale.

The warm green world of the Old Testament in the chancel is suddenly transformed into one of a radiant golden heaven in the apse. In the semidome, the youthful Christ is enthroned on a giant globe that hovers above a mound with the four rivers of paradise nourishing a strip of landscape with scattered flowers (fig. 145). With his left hand he holds the seven-sealed scroll on his knee, while with his right he extends a crown of martyrdom to the Ravennate saint, Vitalis, standing on the far left. To the right stands Bishop Ecclesius, the builder of the chapel, offering Christ a diminutive model of his church. The background is solid gold with

only a few colored strips of clouds floating in the summit.

The most famous mosaics in San Vitale are the two court portraits that appear on the walls of the apse directly beneath the enthroned Christ. Justinian did not attend the ceremonial dedication of the chapel, but he is portrayed there as the principal actor in the drama of the Great Entrance (cf. p. 101), offering a costly paten to the church (fig. 147). He is attended by the archbishop Maximianus, the only participant identified by an inscription, the banker Julianus Argentarius (who financed the building), standing just behind them, and the general Belisarius to Justinian's right.

The individualized features of these four figures indicate that they are true portraits based on likenesses available to the mosaicist. Justinian is blessed with a halo and wears a bejeweled crown and a royal robe to distinguish him as the regent of Christ on earth. The characterization of Justinian is vivid and brings to mind the vituperative description of the emperor found in the *Secret History* of Procopius (a historian of the period): "In person he was . . . rather moderate in stature; not thin, just slightly plump. His face was round and not uncomely and even after two days fasting his complexion would remain ruddy."[22]

Maximianus, the notorious archbishop hated by the citizenry, is portrayed as lean, fanatic, and grim. With a few tesserae of orange, the artist imparts a nervous quiver to his lower lip. His eyes seem to twitch. Julianus Argentarius, who served as Justinian's promotor in Ravenna, appears as a stout, fatheaded strong man with a double chin and scraggly hair. Belisarius, Justinian's able commander, is the most bland personality of the foursome. For the rest, types, not true portraits, are presented. To Justinian's right stand youthful members of the army representing the power of the state; to his left, two deacons accompany Maximianus, the authority of the church. Their features are somewhat emaciated and drawn.

Although the mosaic displays obvious hieratic characteristics in the symmetry, frontality, stiffness of pose, coplanar organization, and lavish use of gold for the background, the designer underscores the preeminence of Justinian and Maximianus by placing them centrally and having them overlap the other attendants slightly. Their feet also ride atop the others in what seems at first to be a spaceless void framed by pillars and a roof. The bodies are flat, vertical blankets marked by the emphatic vertical lines of the drap-

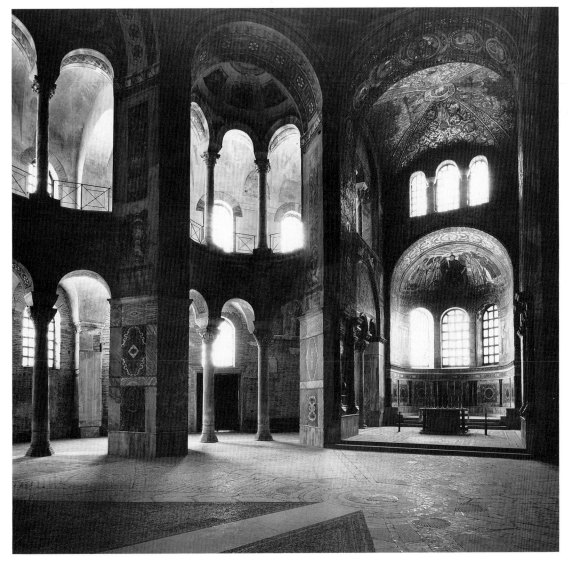

146. San Vitale. Interior

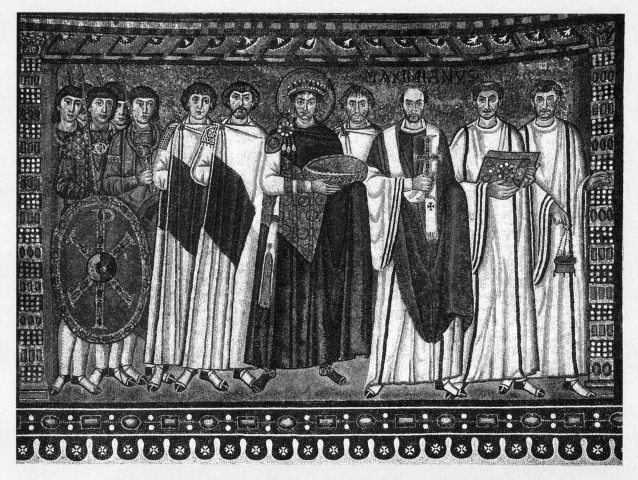

above: 147. *Justinian and his retinue.* Mosaic in the apse of San Vitale

below: 148. *Theodora and her court.* Mosaic in the apse of San Vitale. See colorplate 17

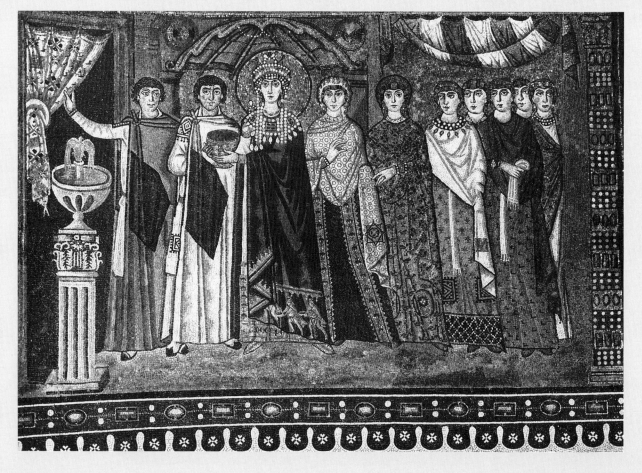

149. San Vitale. View of south wall of the chancel, with *Abel and Melchizedek* in the lunette, *Moses* and *Isaiah* in the spandrels, portraits of Evangelists in the gallery, and the Lamb of God in the vault

ery. The emperor stares out relentlessly at the spectator in the fashion of the portraits in Thessaloniki, and no doubt some such iconic elevation of Justinian's person was intended here. He is portrayed as a saintly emperor eternally present at the celebration of the Mass in San Vitale.

Directly opposite Justinian is the colorful portrait of Theodora with her retinue (fig. 148). They have gathered in an outdoor annex (the atrium?) with a fountain and curtained doorway. The harsh, hieratic qualities are somewhat relaxed, with the elegantly clad empress placed off center and slightly back in the composition before an elaborate niche or exedra. She offers a chalice as her donation to the church. The representation of the three Magi embroidered on the hem of her robe makes the act of offertory explicit. The stunning patrician lady standing next to Theodora is probably the cunning Antonia, wife of Belisarius and close friend of the empress.

Theodora was known for her ravishing beauty as well as her ruthless manner and haughty disposition. Framed in a huge, towering tiara with emeralds, pearls, diamonds, and sapphires, Theodora peers out amid a fireworks of riches (colorplate 17). Procopius tells us that "Theodora was fair of face and of a graceful, though small, person; her complexion was moderately colorful, if somewhat pale; and her eyes were dazzling and vivacious."[23] Here she seems aged—she died the year after this portrait was made—but still the elegant and proud queen who, according to one biographer, burst into Justinian's chamber as he was packing to flee the city during the Nika riots of 532 and shouted, "If you wish to flee, flee. Yonder is the sea; there are the ships. As for me, I

stay. . . . May I never put off this purple or outlive the day when men cease to call me queen."[24]

In 549 Maximianus consecrated Sant'Apollinare in Classe (Ravenna's port town), an exceptionally beautiful basilical church founded under the Ostrogothic rulers (see fig. 150). The relics of Saint Apollinaris, the first bishop of Ravenna martyred during the reign of Vespasian, were enshrined there, and he figures prominently in the mosaic in the conch of the apse (colorplate 18).[25] The mosaic dates only a few years after those in San Vitale, but a surprising modification in style and content is evident. For one thing, the broad landscape setting is now abstracted to the point where it forms a flat green backdrop with no indications of spatial illusionism. All details are isolated and treated as individual motifs—plants, sheep, and rocks—lined up in rows symmetrically about the central axis. Even more astonishing is the abstraction of the subject matter. Two overlapping themes are presented, one in iconic, the other in symbolic, form.

The central figure is Saint Apollinaris. Dressed in bishop's vestments and posed as an *orans,* he reflects the priest who stands behind the altar directly below the mosaic. The apotheosis of the bishop-saint is thus analogous to later Roman apse representations such as that in the Church of Sant'Agnese (fig. 66), where the patron saint looms above the altar in a similar fashion. The sheep to the sides refer to the role of the bishop as the protector of the flock.

Above Apollinaris appears a huge aureole of blue, studded with stars and containing a great gemmed cross with a tiny bust portrait of Christ at its center. The Hand of God issues from clouds in the summit of the apse, and to the sides appear half-length portraits of Moses and Elias. Directly below the aureole, to the right and left, are three lambs attending the vision. The Hand of God, the cross, and the lambs bring to mind the apse composition described by Paulinus of Nola in verse some 150 years earlier (p. 63, fig. 63), but here the iconography is more complex.

One of the main theophanies of Christ—when his divinity was revealed on earth—was the Transfiguration: "And after six days Jesus taketh unto him Peter and James, and John his brother, and bringeth them up into a high mountain apart: And he was transfigured before them. And his face did shine as the sun: and his garments became white as snow. And behold there appeared to them Moses and Elias talking with him. And Peter answering, said to Jesus: Lord, it is good for us to be here: if thou wilt, let us make here three tabernacles, one for thee, one for Moses, and one for Elias. And as he was yet speaking, behold a bright cloud overshadowed them. And lo, a voice out of the cloud, saying: This is my beloved Son, in whom I am well pleased: hear ye

150. Sant'Apollinare in Classe, Ravenna. Air view. c. 549

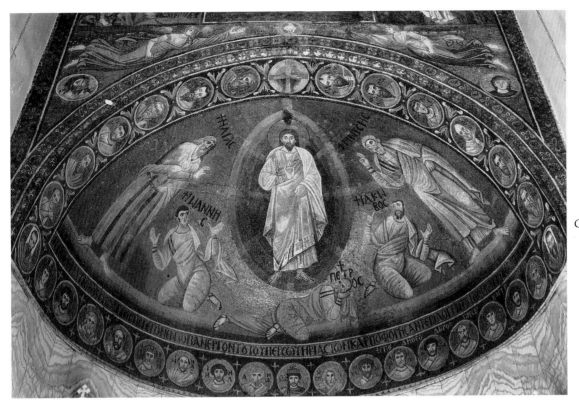

151. *Transfiguration.* Apse mosaic in the church of the Monastery of Saint Catherine, Mount Sinai. c. 550–65

him. And the disciples hearing, fell upon their face, and were very much afraid. And Jesus came and touched them: and said to them, Arise, and fear not. And they lifting up their eyes saw no one but only Jesus" (Matt. 17:1–8).

It is interesting to note that the major figures in the theophany—the transfigured Christ, the voice of God, and the three apostles—appear as symbols, while the two Old Testament figures in the vision, Moses and Elias, are presented as humans. This deliberate restriction of New Testament figures to symbolic forms is, in some respects, a conscious return to aniconic representation in art, an issue that will be treated in the next chapter.

MOUNT SINAI

A different kind of abstraction appears in the apse mosaic that Justinian had placed in the church in the Monastery of Saint Catherine on Mount Sinai (fig. 151).[26] As with many churches in the distant provinces, Justinian's building program was primarily focused on providing fortifications to secure them. To the Monastery of Saint Catherine he added massive walls and installed housing for a garrison of soldiers to protect the isolated monastery from desert nomads. The church itself, dedicated to the Virgin, according to Procopius, was of local, provincial construction, and to enrich the basilica Justinian sent artisans from Constantinople or some other Byzantine center (Gaza?) to provide it with a sumptuous apse mosaic.

The mosaic in Mount Sinai is of the same subject matter and approximately the same date as that of Sant'Apollinare in Classe, but it bears little relationship to it in style. The theme of the Transfiguration had special meaning for Mount Sinai since it was on this very site that Moses received the tablets of the Law from the Lord—when divinity was revealed to him.

In some respects, the general design of the mosaic brings to mind the slightly earlier *praesentatio* in the apse of Saints Cosmas and Damianus in Rome (fig. 62). Unlike the Transfiguration in Ravenna, the corporality of all the figures is vigorously presented. Indeed, the bodies of the gesticulating apostles, who "fell on their face" before the vision of the divine Christ, are given considerable bulk through modeling. The full-bodied Christ fills the blue mandorla, and the attending Moses and Elias are tall, pillarlike forms with a weighty presence. Yet abstractions are clearly evident in the setting and general arrangement of the figures. Where, one might ask, is the "high mountain apart," an important aspect of the iconography? The background is solid gold, with only thin bands of green and yellow at the base to serve as a vague ground for the figures, who, much like the symbolic forms in Sant'Apollinare in Classe, resemble giant cutouts placed symmetrically on the gold with little regard for their actual positions in space.

Among the other treasures of the monastery on Mount Sinai are hundreds of icons painted on panels, dating from the sixth through the nineteenth century. It is to this new form of religious art that we now turn.

VIII

ICONS AND ICONOCLASM

THE ICONS of Mount Sinai were first systematically published by Georges Sotiriou in 1939,[27] and before this important study appeared, few pre-iconoclastic (before the eighth century) icons were known to scholars. The term *icon* (*eikon* in Greek) has been loosely applied to almost any painting on panel in the Byzantine style, but in the strict sense *icon* implies portraiture and more specifically portraits of Christ, Mary, and saints. The origins of the icon lie in ancient portraiture, especially that of royal personages, and its basic functions were those of the pagan effigies as well: to serve as a remembrance of a dear one or to evoke the presence of authority. Yet the meaning of the Christian icon is complex insofar as it was a special image for veneration in times of need, and because of this, special problems arose concerning the confusion of icon and idol, which was a major issue for the early church (see pp. 15–16).

One of the finest of the Early Byzantine icons is that of the *Virgin and Child Enthroned with Angels and Saints* (fig. 152), dated variously between the late sixth and the mid-seventh century. It is believed that it was executed in some major Byzantine center, perhaps Constantinople, and brought to the Monastery of Saint Catherine at an early date. The icon is painted on a relatively large wooden panel in an encaustic medium, that is, the pigments have been fused with a wax matrix so that the surface has the rough texture of a painting in impasto. As an example of Early Byzantine painting, it is an excellent piece to study since different basic styles are exhibited in the three groups of figures portrayed. The Virgin and Child are presented with a definite sense of bulk and naturalism, especially evident in the posture of the Child and the fleshy modeling of the Virgin's head. Although posed in frontal positions, the Mother and Child display little of the harsher linear conventions and stylizations so familiar in later Byzantine icons of Mary.

Another style appears in the two pillarlike saints, the warriors Theodore and George (?), flanking the Virgin, who stand in rigid frontal poses and stare out at the viewer. They wear the flat robes of imperial bodyguards, which hide their bodies underneath. There is no indication of movement of body parts beneath their closed silhouettes save the stiff protrusion of their right hands holding crosses. The youthful Saint George, in fact, closely resembles the mosaic portraits of Saint Demetrios in Thessaloniki (fig. 132).

A third style is evident, finally, in the heads of the two angels behind Mary, who glance dreamily upward toward the heavens. The difference in technique between the angels and the saints before them is so astonishing that some scholars have argued for different artists at work here. This style is reminiscent of the impressionism found in many Antique paintings (for example, wall frescoes in Pompeii and Herculaneum) with thick, sketchy highlights brushed in quickly, imparting a fleeting and more ethereal characterization to the celestial creatures. Surely, this juxtaposition of styles indicates that we are dealing with icon painting in its infancy, at a stage before the styles crystallized into the unified mode that we meet in later Byzantine icons.

Another early icon at Mount Sinai is that of *Christ* (fig. 153), a work that can be dated about 695–700. The facial type departs significantly from earlier portraits of the Savior that we have seen. He is, in fact, portrayed in the guise of Zeus with the idealized features that we know from sculptures of the Greek father-god attributed to Phidias, the famed artist of the fifth century B.C. Christ has a full, fleshy face, heavy beard, and a sharply tapering mustache. The same frontal Christ appears for the first time on the coins of the emperor Justinian II about 692–95 and perhaps reflects the famous icon of Christ that was displayed on the Chalke Gate that led into the imperial palace in Constantinople (fig. 154).[28] In the Mount Sinai icon the style seems close to that of later Byzantine paintings, with very fine brushwork delineating the features over the subtle modeling of the planes of the face.

We know from literary sources that the production and veneration of icons developed rapidly during the course of the late sixth century,[29] and the reasons for the sudden popularity of the painted icon are instructive to note. It has been pointed out, mainly by André Grabar, that the veneration of icons came to replace that of the relics. They were much more accessible as objects of devotion, both public and private, and from literary reports we know that prescribed rituals were followed for their veneration, including *pros-

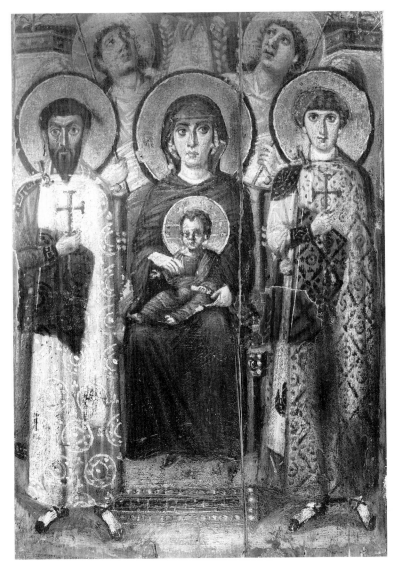

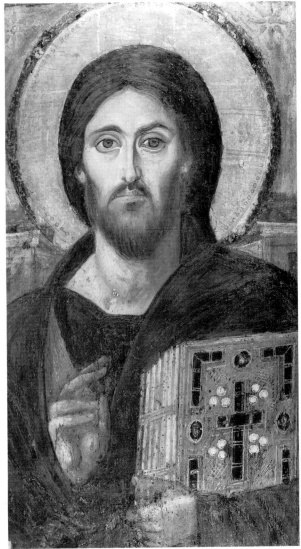

152. *Virgin and Child Enthroned with Angels and Saints.* Encaustic painting on panel, 27 × 19⅜″. Early 7th century. Monastery of Saint Catherine, Mount Sinai

153. *Christ.* Painted icon, 34 × 17⅞″. c. 700. Monastery of Saint Catherine, Mount Sinai

kynesis (prostrating oneself before the image) and the placing of candles about the base of the icon.

It is also evident that many of the icons were thought to be *acheiropoietai,* images not made by human hands. In some cases they were impressions miraculously left on cloth or stone that came in contact with the holy person. One such legend records the imprint of Christ's features on a cloth that, in turn, was transferred mechanically onto the cloth in which it was wrapped, thus duplicating itself.[30] Other legends inform us that Saint Luke was the first artist to paint a portrait of the Virgin from life, and that it was the prototype for later icons of Mary holding her child. It is no wonder, then, that the goal of the icon painter was to duplicate the prototype as faithfully as possible. To do otherwise would dilute the true image. Hence copies of copies result throughout Byzantine history.

There is also abundant evidence that the worshippers believed in the magical qualities of the icon, that it could protect or heal in times of need. Indeed, it could serve as a *Palladium,* an image that provided security for a whole community when placed above the city gate (so named after the ancient statue of Pallas Athena on which the safety of Troy depended). Clearly, such veneration of a painted portrait easily blurred the barrier between a simple likeness and an idol to be worshipped, and it was this issue that constantly was raised by those churchmen who opposed the use of icons in churches in general. Such veneration of an image violated the "spirituality" of worship, the belief that the divine presence of Christ could only be evoked in the mystery of the Mass. The second commandment given unto Moses (Ex. 20:4), "Thou shalt not make to thyself a graven thing," was often cited, too. Simply put, painted images too

154. *Christ.* Gold coin of Justinian II (obverse), diam. ¾".
Constantinople. 692–95. Byzantine Visual Resources, © 1987,
Dumbarton Oaks, Washington, D.C.

closely resembled pagan idols, and their veneration transformed worship into idolatry.

The defenders of icons (iconodules, iconophiles) repeated the old argument that pictures simply served a didactic role as visual aids for the illiterate: "An image is, after all, a reminder; it is to the illiterate what a book is to the literate, and what the word is to hearing, the image is to sight" (John of Damascus, *Oratio 1*).[31] This defense could no longer suffice, however, given the rapture that often accompanied popular veneration of icons. More philosophical justifications were needed.

One apology contended that the icon, as an image of its prototype, while not partaking of its true substance, did provide a channel by which the faithful could demonstrate his love and honor for the one depicted.[32] In Genesis we read that "God created man to his own image" (1:27). It follows, therefore, that God could be envisioned as a human form, or, to put it another way, the image of man was a reflection of the deity. Thus the painter of the icon was partaking in the divine act of creation, although he reproduced only the reflection.

This point was further underscored by the fact of the Incarnation of Christ. Mary was the vehicle by which the divine was given human form, and, as argued by Theodore the Studite (759–826), "How, indeed, can the Son of God be acknowledged to have been a man like us—he who was deigned to be called our brother—if he cannot, like us, be depicted?" Much earlier, at the Quinisext Council called by Justinian II at Constantinople in 692, many of these arguments had already been mustered: "Now, in order that perfection be represented before the eyes of all people, even in paintings, we ordain that from now on Christ our God . . . be set up, even in images according to His human character, instead of the ancient Lamb."[33] Thus, sponsored by the state, the cult of images reached an apogee under Justinian II, the same emperor, it will be recalled, who had stamped the imprint of the new Christ-*Pantocrator* (world ruler) on his coins (fig. 154).

Opposition to the cult of images in the form of an imperial policy called iconoclasm (image-breaking) flared on the scene when Leo III assumed rule in 717. Leo III had grown up in Isauria in southeastern Anatolia, near the Arab frontiers, and it is believed by some that his oriental background had much to do with his abhorrence of the representational arts in general. Indeed, iconoclasm can be seen as a broader Semitic movement that affected the policies of the church and state in Constantinople. It was with Leo's son, Constantine V (r. 741–75), that the policies of iconoclasm were most stringently enacted, and icons were destroyed, mosaics torn from churches, and monks and others who supported the cult of images persecuted.

The first edict against the veneration of icons apparently was issued as early as 726, although it is not known to what extent it was accepted by the church authorities. At the so-called Iconoclastic Council held in 754 at Hiereia all figurative imagery in churches was banned: "The divine nature is completely uncircumscribable and cannot be depicted or represented by artists in any medium whatsoever."[34]

There are other reasons why Leo III and his son so vehemently opposed the veneration of icons. Justinian II had proclaimed on his coins that Christ was *Rex Regnantium,* the king of kings. By thus raising the authority of the church over the state, the fine balance of caesaropapism so vital to the absolute authority of the Byzantine monarch was upset. The military emperors, beginning with Leo III, wished to reset the balance, so to speak, by proclaiming their authority over the church and the monasteries. Iconoclasm was a means of sapping the wealth and popularity of the monasteries, which had virtually become museums for icons, drawing thousands of pilgrims and the faithful to their shrines.

The persecution of monks who defended the veneration of icons was part of the campaign of Constantine V, especially between 762 and 768. Icons were no longer produced in Constantinople, and those on display were destroyed. Mosaic icons of Christ, Mary, and the saints were torn out and replaced with ornamental decorations or crosses, the one symbol that was allowed by the iconoclasts. The famed icon of Christ on the Chalke Gate leading into the imperial palace was destroyed and replaced by a cross, and it seems that the apse mosaic in Hagia Sophia was removed.

The son of Constantine V, Leo IV (775–80), continued the iconoclastic policies in the face of growing opposition on the part of the monastic communities. When he died in 780, Empress Irene discontinued the prohibition, and there occurred a lull in iconoclastic policies. At the Seventh Ecumenical Council held in Nicaea in 787, the veneration of icons was restored. In the same year the icon of Christ on the Chalke Gate was set up again.

The restoration was short-lived. In 813 Emperor Leo V the Armenian reinstated iconoclastic policies. The icon on the Chalke Gate was again removed, and following the new

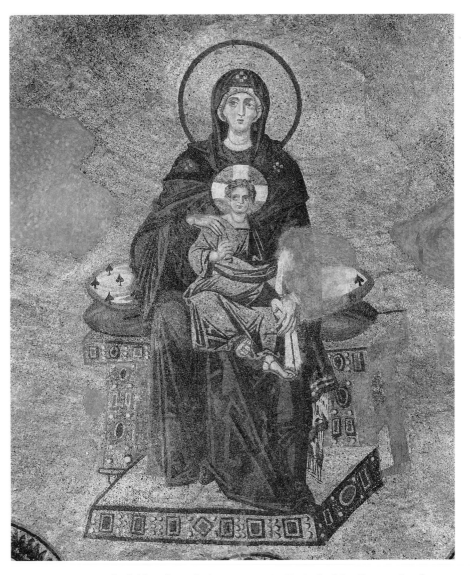

155. *Virgin and Child Enthroned.* Apse mosaic in Hagia Sophia, Constantinople.
Before 867

prohibition of art, monastic craftsmen fled in numbers to western Christian lands, especially Italy. A series of military disasters in Crete, Sicily, and Amorion sapped the power and prestige of the emperors at home, however, and the iconodule empress Theodora was instrumental in the final restoration of the veneration of icons in Constantinople on March 11, 843. This date is still known as the "Feast of the Orthodoxy." The icon of Christ on the Chalke Gate was again restored.[35] Two women, Irene and Theodora, were thus important figures in the suppression of the "Dark Age" of iconoclasm in Byzantine art history.

Theodora's pious act initiated the second golden age of Byzantine art. Among the important restorations was the image of the Virgin enthroned in the apse of Hagia Sophia (fig. 155), which was accompanied by an inscription reading, "The images which the imposters had cast down here, pious emperors have again set up." In a homily delivered in Hagia Sophia on March 29, 867, the patriarch Photius addressed the mosaic of the Virgin and Child in the following words: "Christ came to us in the flesh, and was borne in the arms of His Mother. This is seen and confirmed and proclaimed in pictures . . . Does a man hate the teaching by means of pictures? Then how could he not have previously rejected and hated the message of the Gospels? Just as speech *is transmitted* by hearing, so a form through sight is imprinted upon the tablets of the soul, giving to those whose apprehension is not soiled by wicked doctrines [iconoclasm] a representation of knowledge concordant with piety. . . . it is the spectators rather than the hearers who are drawn to emulation. The Virgin is holding the Creator in her arms as an infant. Who is there who would not marvel, more from the sight of it than from the report . . . ? For surely, having somehow through the outpouring and effluence of the optical rays touched and encompassed the object, it too sends the essence of the thing seen on to the mind, letting it be conveyed from there to the memory. . . . Has the mind seen? Has it grasped? Has it visualized? Then it has effortlessly transmitted the forms to the memory."[36]

THE SECOND GOLDEN AGE OF BYZANTINE ART

THE END of iconoclasm was announced publicly by the installation of the icon of Christ on the Chalke Gate of the imperial palace in 843, and henceforth there would be no ban on icons in the orthodox church. The restoration of churches and religious images proceeded as an official policy under the Macedonian emperors who succeeded Theodora (regent from 843–56) and her son Michael III (842–67). Basil I the Macedonian (867–86) is generally credited with initiating a renaissance of Byzantine art and architecture, and under him and his successors, Leo VI (886–912) and Constantine VII Porphyrogenitus (912–59), the prestige and culture of the East Roman Empire reached its zenith.

Through trade, military conquests, and shrewd diplomacy, Byzantine influence spread throughout the western Mediterranean and as far north as Kiev in the Ukraine. The Italian republics—Pisa, Genoa, and especially Venice—turned more and more to Constantinople for models in statecraft and the arts. The Muslim Caliphs of Cordova in Spain held the Byzantine emperor and his capital in highest esteem and employed Byzantine mosaic workers to decorate their palaces. Nor were the "barbarians" in northern Europe untouched. The Saxon emperor Otto I petitioned for a Byzantine princess, Theophano, as wife for his son, Otto II.

The high level of culture that developed during the dynasty of the Macedonians was due, in part, to the reopening of the University of Constantinople (closed during the reign of the iconoclasts). Efficient and progressive curricula were instituted to train the civic and diplomatic personnel, and much education was based on reading of the Greek classics in ancient philosophy, drama, poetry, mathematics, and the sciences. Indeed, the role of the educational program clearly affected the developments in the arts, especially book illustration.

In the religious sphere, Constantinople asserted its authority in the Christian world, too. Photius, the powerful patriarch of Constantinople (858–67, 877–86), no longer recognized the supremacy of the Roman See, establishing a church policy that led to the final schism between Rome and Constantinople in 1054, when the pope in Rome was excommunicated by the Byzantine patriarch.[37] By the end of the eleventh century, the Byzantine emperor and the patriarch of Constantinople were the temporal and spiritual leaders of the world in Byzantine eyes.

Some idea of the luxurious conditions that surrounded the emperor and patriarch can be gleaned from reports of court ceremonies (recorded in the *Book of Ceremonies* of Constantine VII Porphyrogenitus)[38] and other descriptions of the great imperial palace complex. It covered acres of sloping land from the hills behind Hagia Sophia to the southern coast of the peninsula. Few remains of the palace exist today, but sources inform us that the complex was a vast maze of telescoped palace chambers that featured some type of grand entranceway, broad courts, reception rooms, audience halls, chapels, and throne rooms added one to the other. The various ceremonial units were connected by colonnaded corridors, and the whole area was enhanced with ponds, gardens, and grottoes.

The tenth-century complex was thus a magnified Hellenistic palace, and some idea can be formed of its extent and richness if we turn to later reflections of grandiose residences such as the Alhambra in Granada. The main stateroom, the Magnaura, was a vast reception hall where the emperor sat at one end on the "Throne of Solomon," flanked by bronze lions and gilded birds in a gilded tree. The animals were automata, or mechanized creatures, and upon the visitor's entry, the lions roared and flapped their tails, the birds chirped, and the emperor, dressed in exotic costume, was raised on high like a living icon by a mechanical contrivance.

CHURCHES IN CONSTANTINOPLE

Within the sprawling complex of ceremonial halls and rooms, Basil I built a palace church, the Nea, or "The New," situated on a terrace. The Nea, completed in 880, was destroyed, but descriptions give us some idea as to its plan and construction. In plan it was based on one of the most popular and innovative variations of the central church in Middle Byzantine architecture, the cross-in-square with five domes (*quincunx*). The Greek cross-in-square plan divides the church into nine square and rectangular bays (fig. 156). The central bay, the largest square, is domed; the smaller square corner bays are usually domed or groin-vaulted, while the

four arms of the cross are rectangular with barrel vaults. An apse and two lateral chambers, the *prothesis* and *diaconicon,* are built into the east end of the square, while a narthex and an atrium are added to the west. Often porticoes were built into the flanks of the structure. In the Nea the narthex extended from the west front along the north and south sides, forming a *U*-shaped addition that virtually enclosed the cross-in-square.

The Nea did not rival Hagia Sophia in size. Its spaces were concentrated and compressed, resulting in a pronounced steepness in elevation. The interior was richly decorated with marbles and mosaics, the latter displaying scenes of the life of Christ with the *Pantocrator* and angels filling the central dome. The north church of the Monastery of Constantine Lipps (an admiral in the Byzantine navy), dedicated in 907, is considered to be a small version of the Nea (fig. 157) and gives us an idea of its general structure and proportions.

The hallowed Apostoleion, the Greek cross-plan church with five domes built by Constantine the Great (see p. 67), was renovated and redecorated by Basil and his successors. It, too, was subsequently destroyed, and we must rely again on descriptions of the tenth and twelfth centuries by Constantinus Rhodius and Nikolaos Mesarites for a reconstruction of the church and its decoration.[39] The large central dome displayed the bust of Christ-*Pantocrator* in the summit with the Virgin and apostles standing below, while the mosaics in the other domes and walls in the arms of the

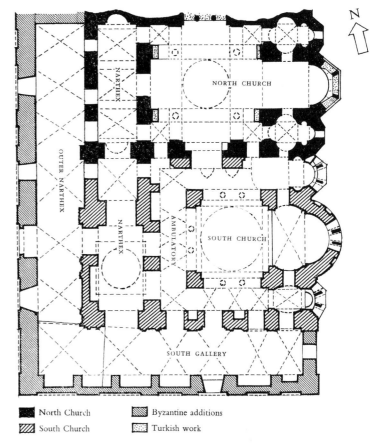

157. Monastery of Constantine Lipps (north church), Constantinople. Plan (after Krautheimer). Dedicated 907

156. *Quincunx* church type. Cross-in-square with five domes (after Krautheimer)

cross presented a sophisticated scheme of subjects from the life of Christ, including the Transfiguration, the Anastasis (Christ rescuing the souls from Limbo), the Ascension, and Pentecost.

While it would be hazardous to reconstruct the iconography of these pictures in detail, the descriptions of Mesarites do indicate that the mosaic program in the Church of the Holy Apostles was carefully conceived and, in many ways, anticipated the superb decorations in such monastic churches as those at Chios, Hosios Lukas, and Daphni, to be discussed below, where the major church festivals (feasts) of the life of Christ rotate above the heads of the worshippers, culminating in the awesome *Pantocrator* in the summit of the central dome. Perhaps the learned patriarch Photius was the mind behind this new program of church decoration.

Mosaics were gradually restored and added in Hagia Sophia as well. The evidence of pre-iconoclastic figurative decoration is indeed slim, but remains of several mosaics added by the Macedonian and later emperors have come to light in the cleaning of areas hidden by whitewash painted over the walls and vaults after the Turkish occupation in 1453.[40] We have already discussed the enthroned Virgin and Child, eloquently described by Photius, recovered in the

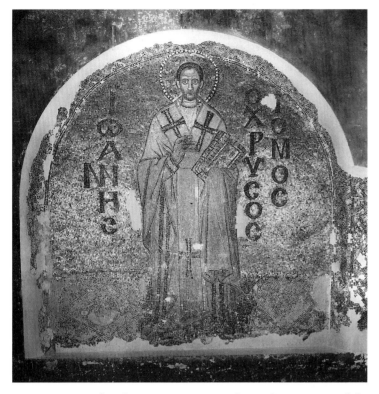

158. *Saint John Chrysostom.* Mosaic on the north tympanum of the nave of Hagia Sophia, Constantinople. Late 9th century (?)

apse. The summit of the dome was decorated with a Christ-*Pantocrator,* and huge winged heads of cherubim filled the pendentives below. The upper walls of the nave served as a portrait gallery with saints and prophets, standing in rigid frontal poses, filling the walls between the windows (fig. 158). These tall, rather heavyset figures remind us of the votive icons in Thessaloniki (fig. 132), but the general tonality is somber, with white and blue tesserae predominating. The heads and hands are out of scale with their broad bodies, and the modeling of their vestments is rigid and ponderous.

Hagia Sophia was too vast to lend itself to an intricate iconographic program such as that in the Church of the Holy Apostles. Most of the Middle Byzantine mosaics recovered are individual panels located in the peripheral areas such as the galleries, narthex, and vestibules leading into the church. They are of a type known as *ex-votos,* or pictures that commemorate a vow or donation of a member of the imperial family in recognition of divine favors bestowed. The earliest, dating at the end of the ninth century, appears in the lunette over the "imperial door," or main entrance in the narthex, and depicts Leo VI receiving the investiture of

159. *Leo VI Making Proskynesis Before the Enthroned Christ.* Mosaic in the lunette over the imperial doorway in Hagia Sophia, Constantinople. Late 9th century

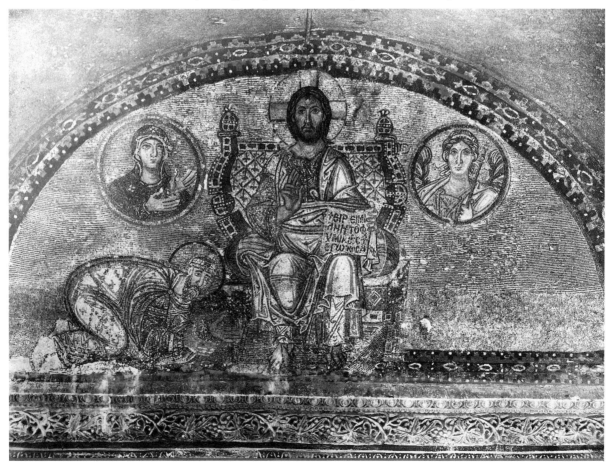

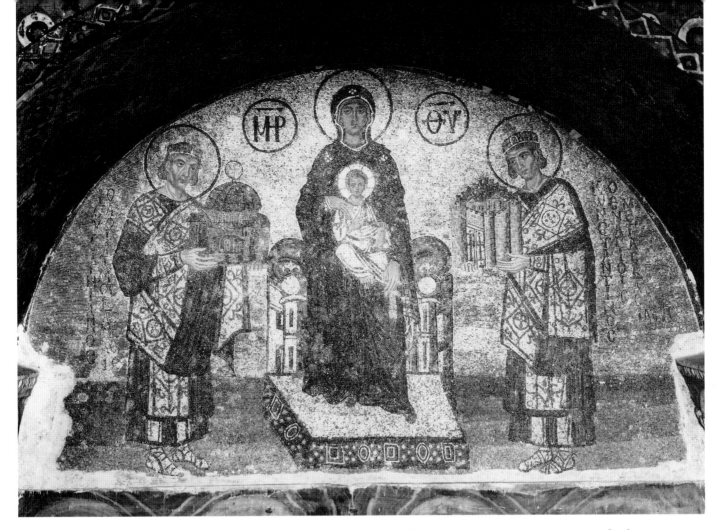

160. *Virgin and Child Enthroned Between Emperors Constantine I and Justinian I.* Mosaic in tympanum over the door leading into the narthex from the south vestibule in Hagia Sophia, Constantinople. Late 10th century

Divine Wisdom (Hagia Sophia) in the form of Christ (fig. 159).

Leo prostrates himself (*proskynesis*) before Christ, who sits on a lyre-backed throne, to either side of which appear medallions with busts of the Virgin and the archangel Gabriel. In a homily composed by Leo VI for the feast of the Annunciation, the relationships between Christ as Holy Wisdom and the emperor, as vice-regent on earth, are elucidated, hence accounting for the curious additions of the Virgin and the angel of the Annunciation.[41] The execution of the mosaic is somewhat coarse. The lines describing the body and drapery of the kneeling emperor are bold and schematized, and the gradations in colors of the tesserae, like those in the figures in the nave, are few and meager, with mostly white, blue, and gray-green tonal areas seen against a bright gold background.

Approximately a century later, the lunette over the door of the south vestibule was decorated with a mosaic presenting the enthroned Virgin as protectress of the church and city between standing figures of Constantine I, on her left, and Justinian I, on her right (fig. 160). As an *ex-voto,* this mosaic functions quite differently, however, since it commemorates the memory of the long-deceased benefactors of the church,

one of whom, Constantine, had been canonized. Constantine offers the Virgin a model of the city he had founded in her honor, Constantinople, while Justinian presents a diminutive representation of the Church of Hagia Sophia, which he rebuilt in 532. Hence this mosaic honors the meritorious donations of the two principal emperors in the history of the site.

Some changes in style are evident. More colors are employed in the variety of tesserae laid in, giving the lunette a much brighter tonality than that over the imperial door in the narthex, and the lines that model the draperies are delicate, although the silhouettes remain closed and the bodies flattened. The emphasis is on the imperial regalia, the bejeweled stole (*loros*), crown (*stemma*), and scarlet boots. The refinements in technique can be seen particularly in the heads. While they are not based on authentic portraits of the emperors (they closely resemble one another), the diverse colors of the cubes, including touches of orange, and the gray-green lines that model the contours of the cheeks and jaw, impart a curious saintly mien to their gaunt features.

A room at the east end of the southern gallery, the so-called imperial box, was reserved for members of the royal family, and here more *ex-votos* have been uncovered. That of

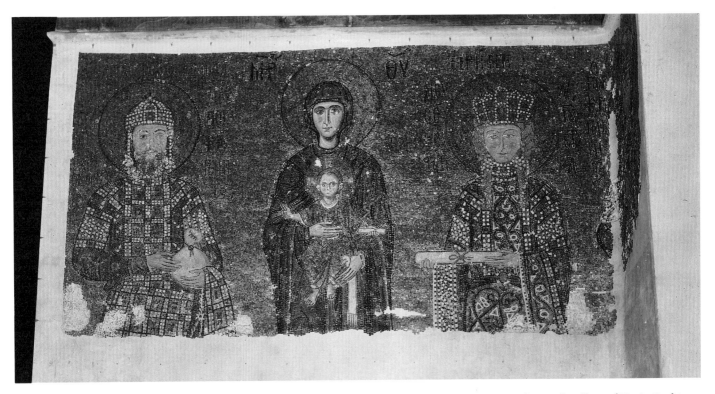

161. *Virgin and Child Standing Between Emperor John II Comnenus and the Empress Irene.* Mosaic in the south gallery of Hagia Sophia, Constantinople. Early 12th century

162. *Coronation of Emperor Romanus II and Eudocia by Christ.* Ivory relief, 9½ × 5⅞″. 945–49. Cabinet des Médailles, Paris

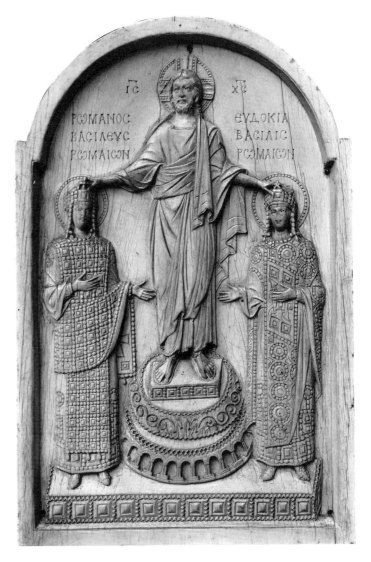

the Virgin and Child standing between the emperor John II Comnenus (1118–43) and the empress Irene is particularly instructive for the study of stylistic development, with further refinements in the use of rich colors and a more meticulous application of the fine tesserae (fig. 161). A sense of weightless serenity resides in these imperial figures, whose bodies are lost behind the flat expanse of their stunning regalia. Irene was the daughter of a saint, King Ladislaus of Hungary, and the delicate treatment of lines and colors in her pale face seems to impart something of an oriental charm to the visage of the young empress. The curious coiffure with pendant braids framing the delicate oval face also adds a distinctive touch to her personality.

In contrast, the figure of the Virgin is more three-dimensional. Her deep blue mantle is subtly modeled with darker shades of tesserae, and her head is given those distinctive features found in most later icons of the Virgin. An ideal beauty is established with the final crystallization of a number of conventions for her face: the *Theotokos* has a long, oval face with large, almond-shaped eyes, a small pinched mouth, a long arced nose, and dark shading along the contours of her right cheek and upper eye sockets.

The *ex-voto* of John II Comnenus typifies a number of Byzantine court portraits. A static, iconic presentation re-

sults, with the symmetrical placement of frontal figures offering donations about a taller holy person. In the mosaic, John II gives a bag of silver, Irene extends a roll of parchment. Such ceremonials were ritualized and obligatory at the imperial court, and the compositional formula—a kind of triptych—is followed in various media. Dedicatory miniatures in illustrated books often display this type of court portrait, and book covers, too, frequently feature similar hieratic groupings.[42] The ivory with the coronation of Emperor Romanus II and Eudocia by Christ, dating between 945 and 949, is a handsome example (fig. 162). The elongated proportions of the thin figures, the delicate carving of their sumptuous regalia, and the static composition in general anticipate those very qualities of elegance noted in the Comnenian mosaic.

THE IMPERIAL SCRIPTORIA

In contrast to the gradual crystallization of iconic features in mosaic figurative compositions, a very different style developed in the narrative illustrations in books produced in Constantinople during the course of the ninth, tenth, and eleventh centuries. Not only was the livelier narrative mode of Early Christian miniatures revived, but surprising enrichments were frequently added in the form of sumptuous Antique frames or backgrounds and Classical personifications. These classicizing tendencies are so predominate that the period has sometimes been called the Macedonian Renaissance,[43] but the term "Renaissance" should be applied cautiously. As we have seen, the continuity of the Hellenistic heritage can be traced from early times in Christian art, and we are frequently faced with the question of survival or revival of ancient styles in various periods. Secondly, with some exceptions, the blatant classicizing features are found only in book illustration and related narrative arts.

That there was a conscious return to ancient models can hardly be questioned, however. With the reopening of the University in Constantinople following iconoclasm, a renewed interest in ancient Greek texts occurred. Not only were the more practical works on engineering, science, medicine, horticulture, and mathematics restudied, but the literary masterpieces of the past in philosophy, drama, poetry, and mythology were also resurrected. The texts were copied and edited by the scribes of the court scriptoria, and often illustrations were repeated as well. In fact, this wave of humanism, if it can be called such, preserved many ancient texts, including the works of Euripides, Sophocles, and others, providing Europe with the basic body of Classical writings that are still studied today.[44]

The eloquence and refined style of the classics rubbed off on the theologians as well. It seems clear that the learned patriarch Photius neither feared nor ignored the ancients. In his *Myriobiblion,* Photius commented on the contents of his own library, and Classical texts are almost as numerous as

Christian writings. Among others, Photius had a copy of the *Bibliotheke,* a popular mythological handbook attributed to Apollodorus, an Athenian of the second century B.C. These interests in the classics were shared by the enlightened Macedonian emperors as well. The scholar-emperor Constantine VII Porphyrogenitus wrote encyclopedic treatises on early Greek texts dealing with military tactics, agriculture, and medicine. According to his biographers, Constantine VII even practiced painting and designing enamels in the court workshops.

One of the earliest products of this "Renaissance" is an illustrated book of the Homilies of Gregory of Nazianzus made for Basil I about 880. A variety of miniatures appears for the sermons, and among them a large, full-page painting of the vision of Ezekiel in the Valley of the Dry Bones (Ezek. 37:1–14) is one of the most stunning (colorplate 19). Within a lavish golden frame appear three figures in a colorful landscape. In the lower right a youthful angel leads Ezekiel through a valley filled with bones and skulls, and in the upper right the prophet appears a second time receiving the command from the Lord to prophesy the resurrection. The miniature painting looks like nothing we have seen before. The artist clearly attempted to create a work of fine art and not merely an illustration of a text.

The most eye-catching aspect of the miniature is the filmy landscape painted in fluid, impressionistic strokes against a blue and pink sky, reminding us of the "rosy-fingered dawn" in the Vatican Vergil illustrations of the fifth century (fig. 92). The highlights on the ridges of the basalt rocks and the craggy mountain peaks are carefully brushed in, and the effects of atmospheric perspective are captured in the subtle tonal gradations.

While the figures are clearly Medieval in their gestures, a Classical flavor is achieved in their poses, which are relaxed and graceful, and in the soft highlights of white applied to the draperies, the hands, and facial features. The well-proportioned Ezekiel seems more a pensive philosopher than a starved prophet, and the angel's face has a dreamy expression about it.

The classicism in the vision of Ezekiel is a matter of style, but in another court manuscript, the Paris Psalter, dating in the early tenth century, the revival of Antique forms and motifs is so apparent that the miniatures appear as elaborate composites made up from various sources. The introductory miniature, *David Composing the Psalms* (colorplate 20), is an excellent example of a "Renaissance" production.[45] The full-bodied figures and the rich colors remind one more of a mural painting than something designed for the confines of a book. In the center is the shepherd seated among his flocks, a bucolic motif that perhaps owes its inspiration to Hellenistic representations of Orpheus playing to the animals in a landscape. Here it functions as an author portrait, since David was considered to be the composer of the psalms.

163. *Combat of David and Goliath*. Illustration in the Paris Psalter.
14 × 10¼″. 10th century. Bibliothèque Nationale, Paris
(MS gr. 139, fol. 4v)

Eight full-page miniatures with episodes from his life introduce the psalms and have nothing to do with the text. These compositions were very likely borrowed from an earlier illustrated Book of Kings in the Old Testament, where David's life is related. The Macedonian painter has much elaborated the core motif of David playing the harp in the first miniature, however. A corpulent female, a personification of musical inspiration identified as Melodia, sits in a relaxed posture next to him. In the top right, behind a sacred column (?), a nymph, perhaps Echo, listens intently as David's song fills the air in the woodland clearing. More surprising is the swarthy figure reclining in the fashion of an ancient river or mountain god in the lower right. Labeled "Bethlehem," he personifies the site where David spent his youth, the village itself appearing in the top left background.

Like the miniature of Ezekiel, that of David is striking in the illusionistic effects achieved by the rich colors and fluid brushwork. The figures are idealized types who do not move or gesture dramatically but are embodiments of the ancient Greek idea of beauty in repose. Classical, too, is the centripetal design of the compositional elements about David. Abandoned are the iconic features of symmetry, hieratic

scale, and rigid frontality. The painting remains, however, a blatant pastiche of motifs rather clumsily arranged, and the obsession for filling the field with details, reminiscent of the *horror vacui* in Early Christian art, marks this as a Medieval and not a Classical work.

Another episode in the life of David, the *Combat of David and Goliath* (fig. 163), is closely related to the representation on the seventh-century silver plate discussed earlier (color-plate 13). Two narrative scenes are conflated. David and Goliath battle in much the same fashion as they do on the plate, but the artist of the Paris Psalter adds a female personification, Dynamis, spurring the young shepherd into combat, while another, Alazoneia (boaster), flees behind Goliath. The decapitation is depicted below. Curiously, on the silver plate, a third scene is added at the top, the confrontation of David and Goliath, and a personification of the site, the river Elath, appears between them. Obviously, the interest in enriching a narrative with Classical motifs was not the invention of the Middle Byzantine period.

A unique document of the Macedonian Renaissance is the Joshua Roll, with the story of Joshua's military campaigns illustrated in a continuous frieze in a scroll format (fig. 164).[46] With very few exceptions, the scroll had ceased to be used as a book since the second century A.D. Its appearance here underscores the idea of a conscious revival of Antique forms, and it may be significant that one of the more familiar pictorial scrolls in Antiquity was the sculptured triumphal column that commemorated military victories (for example, those of Trajan and Marcus Aurelius in Rome, Theodosius and Arcadius in Constantinople—see fig. 90). With its abridged text, limited to the chapters in the Book of Joshua in the Old Testament devoted to the military feats, the Joshua Roll could hardly function as a service manual for the church. Very likely it was specially made up for some contemporary military hero, an imperial commander of the Byzantine armies, a "New Joshua," to commemorate his victories.

Fifteen sheets of parchment are joined to form the scroll. The artist employed a drawing technique with faint tints of red, yellow, blue, and brown washed in, since gold and thick tempera would have cracked when rolled up. The section illustrated here presents the story of Joshua and the emissaries from Gibeon in three distinct narrative episodes (Josh. 9:6–15; 10:6; and 10:10–11). In the first, two messengers approach Joshua at his camp in Gilgal (note the personification on the hill beyond) announcing, "We are come from a far country, desiring to make peace with you." In the second scene, two more emissaries from Gibeon report to Joshua that the Amorites have besieged their city and it will surely fall if his mighty army does not save it; finally, to the far right, one can see how the armies of Joshua "slew them [the Amorites] with great slaughter in Gibeon."

In cartoon fashion, the three episodes are illustrated one

Colorplate 11. *Justinian (?) as Defender of the Faith* (The Barberini Diptych). Leaf of an imperial ivory plaque, 14¼ × 11″.
Mid-6th century. The Louvre, Paris

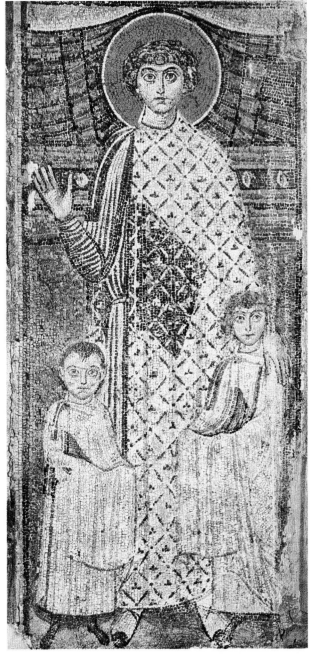

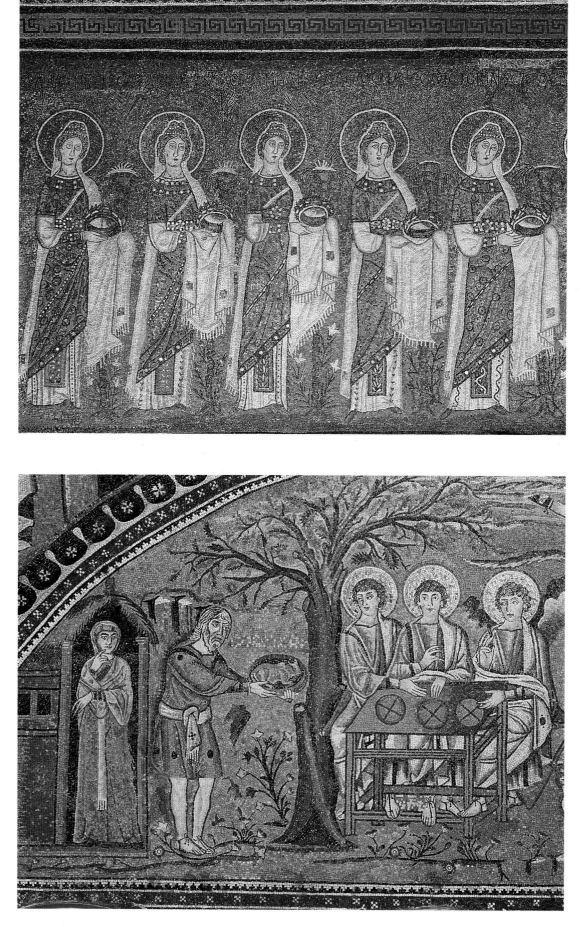

Colorplate 15. *Procession of Virgin Martyrs.* Mosaics on the north wall of the nave of Sant'Apollinare Nuovo, Ravenna. c. 500 (?)

Colorplate 16. *The Feast of Abraham and the Three Men.* Mosaic on the north side of the chancel of San Vitale, Ravenna. c. 547

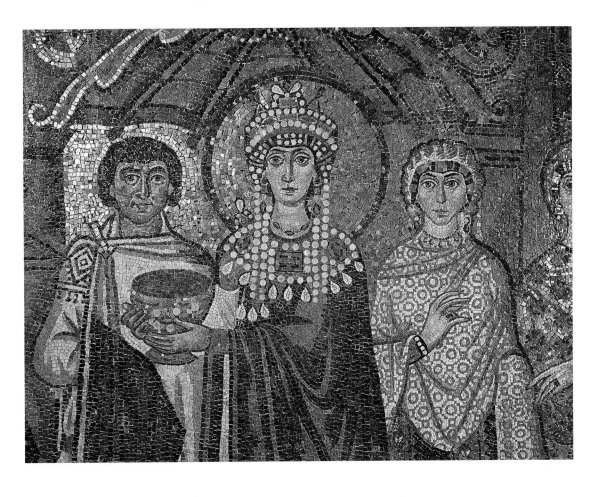

Colorplate 17. *Theodora and her court*. Detail of the mosaic on the south side of the chancel of San Vitale, Ravenna. c. 547. See fig. 148

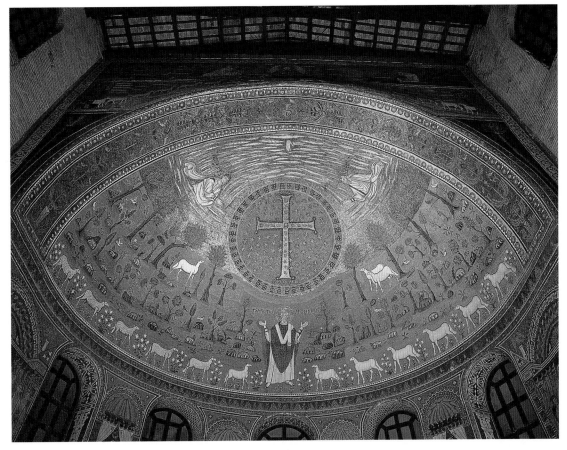

Colorplate 18. *Transfiguration*. Apse mosaic in Sant'Apollinare in Classe, Ravenna. c. 549

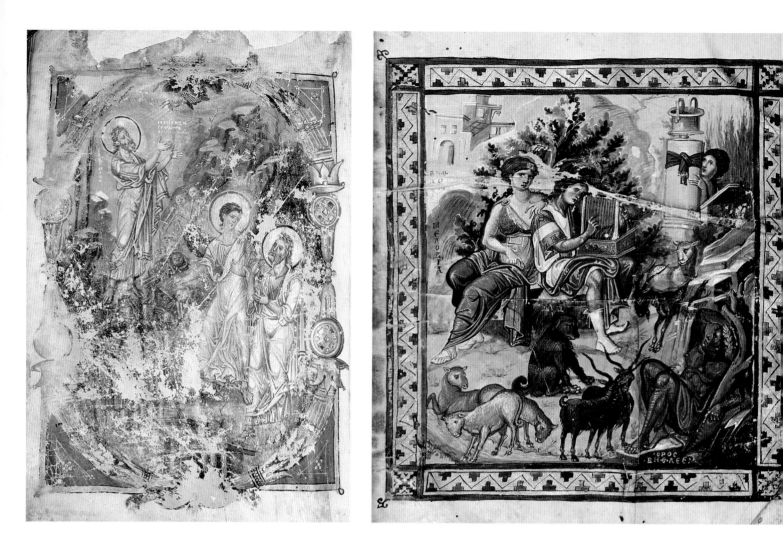

above: Colorplate 19. *Ezekiel in the Valley of the Dry Bones.* Illustration in the Homilies of Gregory of Nazianzus. 16 × 11⅜″. c. 880. Bibliothèque Nationale, Paris (MS gr. 510, fol. 438v)

above right: Colorplate 20. *David Composing the Psalms.* Illustration in the Paris Psalter. 14 × 10¼″. 10th century. Bibliothèque Nationale, Paris (MS gr. 139, fol. 1v)

below: Colorplate 21. *Archangel Michael.* Illustration in the Menologion of Basil II. 10 × 14½″. c. 1000. Vatican Library, Rome (MS grec. 1613, p. 168)

below right: Colorplate 22. *Ascension.* Illustration in the Homilies on the Virgin by Jacobus Kokkinobaphos. 9⅝ × 6⅝″. 12th century. Bibliothèque Nationale, Paris (MS gr. 1208, fol. 3v)

Colorplate 23. *Pantocrator*. Mosaic in the summit of the dome in the Church of the Dormition, Daphni. c. 1080–1100. Byzantine Visual Resources, © 1987, Dumbarton Oaks, Washington, D.C.

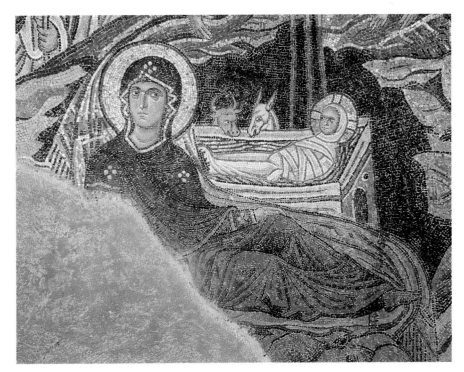

Colorplate 24. *Nativity*. Detail of the mosaic in the northeastern squinch in the Church of the Dormition, Daphni. c. 1080–1100. Byzantine Visual Resources, © 1987, Dumbarton Oaks, Washington, D.C. See fig. 176

Colorplate 25. *Virgin and Child Enthroned*
(The Mellon Madonna). Icon, 32⅛ × 19⅜". c. 1290.
National Gallery of Art, Washington, D.C. Andew W.
Mellon Collection

Colorplate 26. *Maiestas Domini.* Plaque in the center of the
Pala d'Oro. Silver gilt and enamel. Height of central figure,
approx. 17". 12th century. San Marco, Venice. See fig. 178

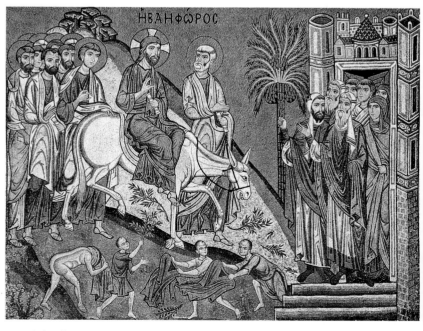

Colorplate 27. *Nativity.* Mosaic on the wall above the
apse of the south aisle in the Cappella Palatina, Palermo.
Mid-12th century

Colorplate 28. *Entry into Jerusalem.* Mosaic on the lower wall of the south
transept in the Cappella Palatina, Palermo. Mid-12th century. See fig. 196

164. *Joshua and the Emissaries from Gibeon*. Illustration in the Joshua Roll. Height of scroll 12¾". 10th century. Vatican Library, Rome
(Cod. Palat. grec. 431, sheet 12)

after the other, but rather than resorting to line frames to separate the scenes, the artist created the illusion of a continuous panorama of action by linking them with landscape motifs, especially the sloping hill, and by inserting personifications of sites and cities. To the right, the battle before the

165. *Saint Mark*. Illustration in the Stauronikita Gospels.
10th century. Stauronikita Library, Mount Athos (Cod. 43, fol. 11)

walled city of Gibeon is introduced by the *Tyche* (a personification of a city), who wears a crown in the form of a city gate. The artist used a similar Classical model for this seated figure, as did the painter of Melodia in the Paris Psalter.

The appropriation of Classical motifs can also be found in portraits of the Evangelists in Byzantine Gospel books. In the handsome Gospels in the Monastery of Stauronikita at Mount Athos, another product of a Constantinopolitan atelier of the tenth century, the conventional Early Christian Evangelist portrait (cf. fig. 101) has been elaborated by adding motifs from ancient portraits of philosophers and dramatists (fig. 165). Mark's meditative and relaxed pose, even his costume and bearded head, are clearly derived from some such Classical figure.[47] And in contrast to the tradition in the West of placing the Evangelist in a landscape with the appropriate Apocalyptic symbol (a lion for Saint Mark), derived from John's Revelation and Jerome's commentaries, the Macedonian painter places Mark in a niche before the proscenium wall of a Hellenistic theater or library, much as sculptures of literary giants in the ancient world would have been displayed before the public as monumental author portraits.

During the course of the eleventh and twelfth centuries, a number of new directions in Byzantine painting at the imperial court can be noted. The illusionism that characterized the Macedonian Renaissance productions gives way to a highly refined iconic style wherein more hieratic features are restored along with the abstract gold backgrounds. Secondly, there is a return to the diminutive "column-picture" format; and, finally, colorful borders and headings of delicate abstract ornamentation are more and more incorporated into the miniatures, reminding one of the luxurious embellishments in Islamic illuminated manuscripts.

An example of the first tendency is found in the Men-

166. *Magi Before Herod and the Nativity.* Illustrations in the Gospels of Saint John Studius (?). 10 × 8″. 11th century. Bibliothèque Nationale, Paris (MS grec. 74, fol. 4r)

ologion of Basil II in the Vatican Library, dating between 976 and 1025 (colorplate 21). A *menologion* is a general service book for each day of the year, with readings of some notable event such as a martyrdom, an episode from the life of Christ, and so forth, appropriate for the day. In the Vatican manuscript, only the readings and illustrations for September through February are preserved, but more than 430 miniatures appear. Eight different artists signed the paintings, an unusual practice in Byzantine art, and therefore it is not surprising that a variety of styles are present.

The miniature portraying Saint Michael is typical of many of those that present a single saint standing before a simple architectural or landscape setting with a rich gold background. The Archangel Michael is tall and slender and stands in a proud frontal position as he vanquishes little blue and green demons (the fallen angels) placed symmetrically about him. His blue and gold costume is drawn in hard, straight lines with sharp angular pockets. Sprays of gold model the blue mantle as if pure light were shining through the saint's

body. The setting is simplified: hills of green and blue rise symmetrically as compositional props, with little indication of atmospheric illusionism or naturalism. The background is a brilliant gold. Taken alone, Saint Michael would nicely complement the hieratic *ex-voto* mosaics in the galleries of Hagia Sophia.

Very popular with rich connoisseurs in the capital were small Gospel books filled with tiny miniatures elegantly painted in bright colors with touches of gold. One of the finest of these deluxe editions is the Gospels of Saint John Studius in Paris.[48] Illustrated here (fig. 166) are scenes of the Magi before Herod and the Nativity in Bethlehem in the fashion of Early Christian column-pictures with no backgrounds or frames. Simple groundlines with trees or diminutive buildings serve as stages for the wispy, elfin figures who move agilely on frail legs. The execution is masterful, although the tempo of the lengthy stories can become monotonous due to the repetition of many of the same compositional schemes and figures. But this is exactly what the column-pictures were intended to do: to illustrate the text line-by-line if possible.

It is interesting to speculate on the degree to which these profuse cycles of illustrations copy or reflect earlier Gospel manuscripts. Nowhere in Early Christian art do we encounter such vast numbers of New Testament illustrations. Could these Middle Byzantine Gospels copy or reflect some rich pre-iconoclastic model? If so, they would be invaluable sources for iconographic studies. A similar density of column-pictures is found in several Middle Byzantine Old Testament Bibles, called Octateuchs because they contain the first eight books of the Bible (Genesis through Ruth), and it has been demonstrated that these productions preserve Old Testament cycles that originated in the Early Christian period.[49] In the illustration of the Nativity in the Paris Gospels, the representation goes far beyond the simple textual account, however. The bathing scene, the ox and ass, and the adoration of the shepherds and angels are all interpolations derived from more monumental representations of the Nativity that grew over the centuries.

A highly imaginative artist of the twelfth century painted the sumptuous miniatures that illustrate the Homilies on the Virgin written by a monk, Jacobus Kokkinobaphos (colorplate 22). Bright colors, especially blues, reds, and golds, verge on the garish in many miniatures, but the execution is meticulous and elegant throughout. Many of the pictures display original compositions to illustrate the mystical content of the monk's sermons, but even in those that present more conventional narratives, such as the *Ascension* illustrated here, the elaborations of the frames and backgrounds are startling. In the lower center of the painting, we find a composition as old as that in the Rabbula Gospels (colorplate 8), with Mary standing amid the apostles witnessing the ascending Christ. The frame dominates the miniature. An

architectural facade rises in three well-marked zones to form a structure with five domes. In a lunette at the base of the central dome, a diminutive representation of Pentecost appears. Could the artist have intended to reproduce the elevation and mosaic program of one of the major churches in Constantinople—the Apostoleion—in this fashion?

THE MONASTERY

Monasticism in Byzantium served as an organization for the pious who wished to live in retirement from the mundane affairs of the world, but it was also an influential authority in the balance of power between the church and state in the empire. The spokesmen for the orthodox church were traditionally drawn from the ranks of the monastery, and, indeed,

metropolitan and parish churches were subordinated to the monastic system. Byzantine monasticism, following the Rule of Saint Basil (c. 330–49), was loosely organized around individual communities of monks. The hermitage, known as the *lavra,* was simply a cluster of cells built about a church within protective walls, but this basic unit could multiply or divide itself, often resulting in sizable monastic villages with several independent churches.

One of the most dramatic of the extant monastic communities is the Great Lavra of Mount Athos, situated high above the sea on a rocky promontory in northern Greece (figs. 167, 168). It is enclosed by a rectangle of fortified walls lined with storerooms, stables, workshops, and multistoried cells fronted by porticoes for the monks. In the center of the

167. Great Lavra, Mount Athos. View from the southwest

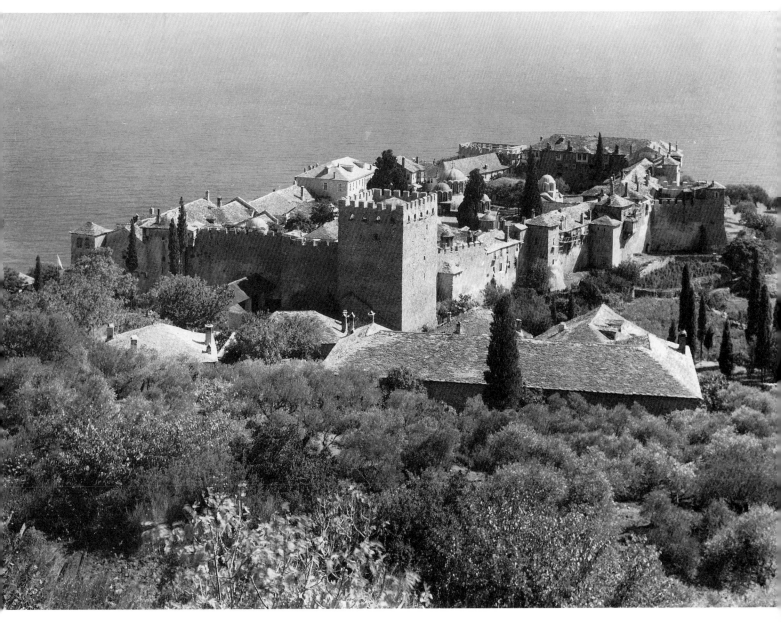

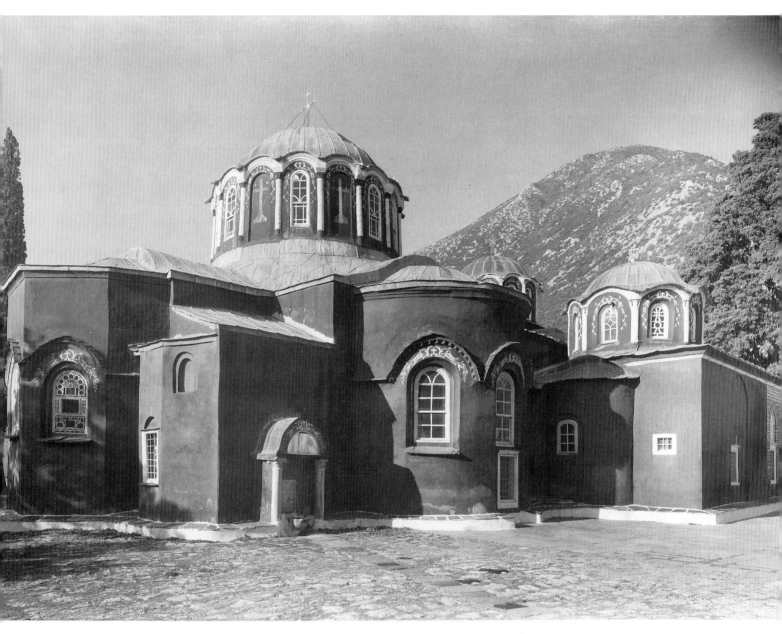

168. Katholikon, Great Lavra, Mount Athos. Exterior. 10th century

rectangle, within a large cloister, rises the church, and adjoining it are the refectory and kitchen. The simple plan, lacking any ceremonial stations or processional avenues, was the outgrowth of traditional fortified monasteries of the Early Christian period such as that on Mount Sinai (p. 125). The main church at Mount Athos, the Katholikon, dating from the tenth century, is cross-in-square in plan with apses added to the crossarms, a deep narthex with two chapels on the west, and a dome over the crossing.[50]

Because the monastic congregations in the Middle Byzantine period were relatively small—frequently less than twelve monks—their churches were small, and yet, during the period, it was the monastic church, not the great metropolitan cathedral, that established the norm for religious architecture: the Greek cross-in-square plan with a dome over the crossing. The four arms of the cross (connecting the inner core to the outer walls) and the bays in the corners of the square were vaulted. The apse was usually augmented with flanking chapels, the *prothesis* and the *diaconicon,* and the side facing west was fronted by a vaulted narthex. Due to the development of the service in Byzantine liturgy, the nave, or *naos,* was restricted to the clergy even in metropolitan churches, and the ancillary spaces were concentrated about the central dome, which was lifted high.

Looking into the *naos* of the Katholikon of Hosios Lukas in Greece (Phocis), one can sense the clarity and nobility of this compacted dome and cube construction, yet, due to the small scale, a comforting intimacy is effected by the concentration of spaces about the beholder standing in the very center of the church (figs. 169–71).[51] The unity of parts here—the great circular dome rising from the center of the Greek cross, which, in turn, is encased in a cube—creates a

perfect image of the cosmos to which the church was compared in contemporary descriptions (panegyrics), a point to which we shall return.

Hosios Lukas is more complicated in elevation than most Byzantine churches of the period, however. A secondary dome rises before the apse, and the *naos* has high, open galleries that accentuate the vertical lift of the central bay. Furthermore, the dome rests not on a square bay but on one that is transformed into an octagon by squinches (half-conical niches built into the four corners of the bay; see fig. 118b). From these eight segments pendentives rise to form the circular base for the dome. The exterior is also elaborated with richly textured courses of stone and brickwork.

The Middle Byzantine cross-in-square churches have sometimes been considered little more than modifications of the huge cross-domed structures of earlier architecture, but this view ignores the dynamic inventiveness born of the restraints imposed by such simple plans. For one thing, Hosios Lukas is an intricate skeletal structure of interlocking spatial units and not merely a massive hollowed-out cube. Due to the complex interplay of the nine-bay plan with open galleries and double and triple windows that pierce the west wall and the four corners, the experience of space is unusual in the magnetism that draws us to the center of the church. We are invited to turn and explore its intricacies and nuances of changing illumination in the various stereometric parts. The darker shadows of the marble revetment lining the walls and piers, the bright glitter of the mosaic pictures that fill the vaults and dome above, seem to revolve about us.

The church at Daphni in Greece (near Eleusis) is one of

169. Katholikon, Hosios Lukas, Greece. Interior. c. 1020

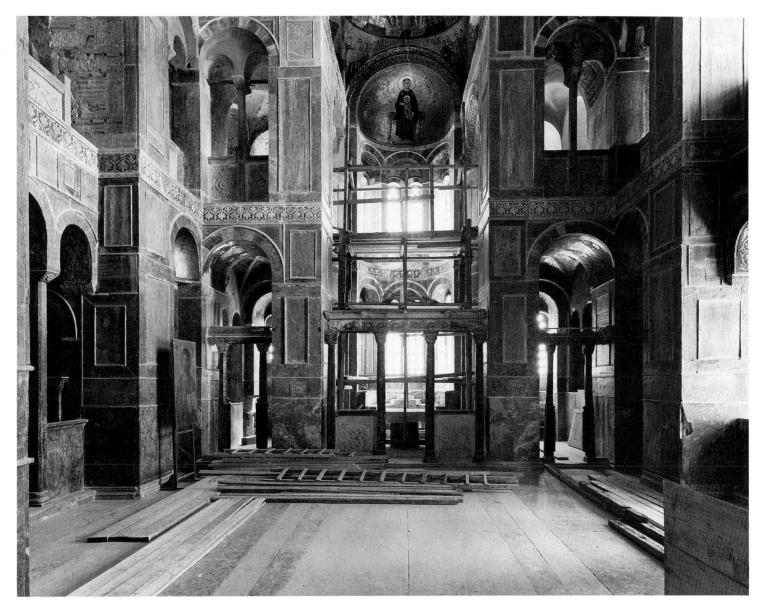

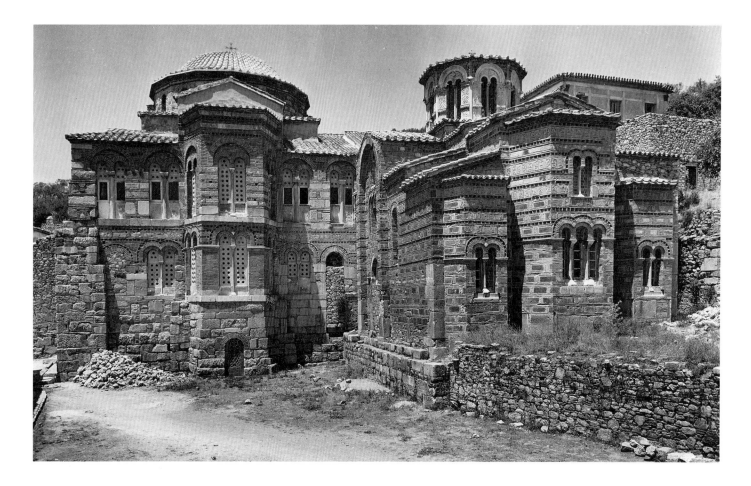

above: 170. Katholikon, Hosios Lukas (c. 1020), and Church of the Theotokos (10th century). Exterior from the south

below: 171. Katholikon, Hosios Lukas, and Church of the Theotokos. Plan

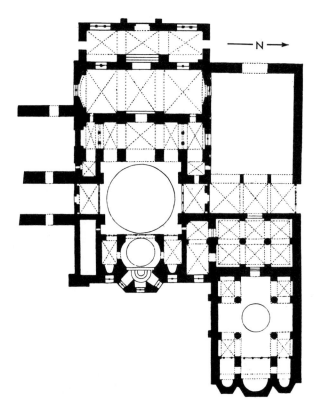

the most famous Middle Byzantine churches due to the extensive remains of the mosaic decorations there (figs. 172–77; colorplates 23, 24). Built about 1080, Daphni, like Hosios Lukas an imperial foundation, is simpler in elevation. The galleries are omitted so that the high dome rests directly on the tall piers of the *naos*. A comforting balance of dome and cube thus replaces the complex interpenetrations of space that we experience in Hosios Lukas. Because of this concentration, the mosaics in the central bay seem more dominating and crucial to our experience of the church and its meaning as a house of worship.

Otto Demus, in his fine book on Byzantine mosaic decoration, has likened the Middle Byzantine church to an "icon in space," and while such a characterization may seem extreme, the symbolic meaning he finds in the domed cross-in-square structures certainly enriches our responses to them.[52] For Demus the meaning of the church is threefold. Citing various *ekphraseis* and interpretations (in particular the *Historia mystagogica* attributed to Germanus, patriarch of Constantinople between 715 and 730), Demus describes the church as an image of the cosmos with the dome symbolizing the heavens, the squinches and vaults representing the paradise of the Holy Lands, and the piers and walls constituting the terrestrial world. The mosaics clarify this interpretation. The higher the painting, the more sacred is the image, an idea analogous to the Neoplatonic ladder of being which,

as we have seen, served as the aesthetic basis for the icon in general.

The architecture is divided into discreet zones to accommodate the imagery of this Neoplatonic universe. The summit of the central dome is the exclusive domain of the *Pantocrator* (see fig. 172); the mosaics lining the curved surfaces below—the squinches and vaults—present the major events in the life of Christ on earth (a sort of topographical symbolism allows the worshipper to make a pilgrimage to the Holy Lands); and the rank and file of the saints on the lower walls and piers commemorate those among us who have attained sainthood. Standing below, the worshipper occupies the lowest rung in this hierarchy.

Let us step into Daphni. Standing in the center of the *naos,* one first looks upward into the dome at the awesome portrait

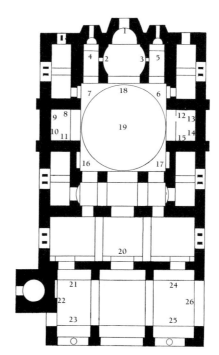

1. Madonna with Child
2. Michael
3. Gabriel
4. John the Baptist
5. Nikolaos
6. Birth of Christ
7. Annunciation
8. Birth of Mary
9. Crucifixion
10. Entry into Jerusalem
11. Lazarus
12. The Three Magi
13. Resurrection
14. Thomas
15. Presentation
16. Transfiguration
17. Baptism of Christ
18. The Sixteen Prophets
19. Pantocrator
20. Dormition
21. Last Supper
22. Washing of the Feet
23. Judas Betrayal
24. Presentation of the Virgin
25. Prayer of Joachim and Anna
26. Benediction of a Priest

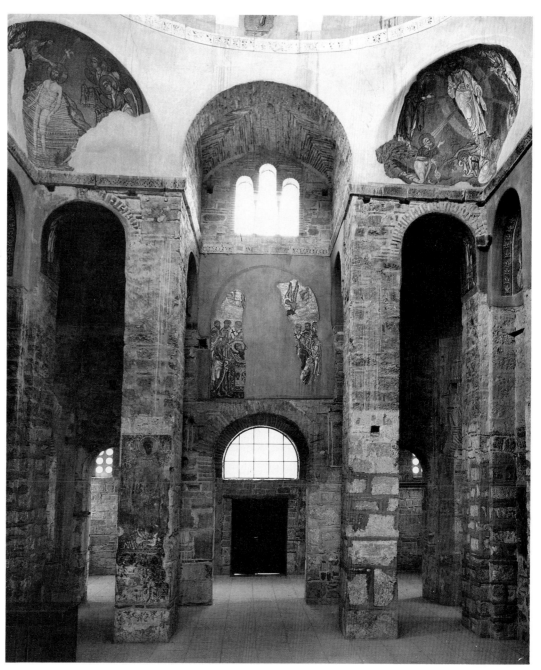

above: 172. Church of the Dormition, Daphni. Plan with mosaics indicated (after Demus and Diez). c. 1080–1100

right: 173. Church of the Dormition, Daphni. Interior facing west

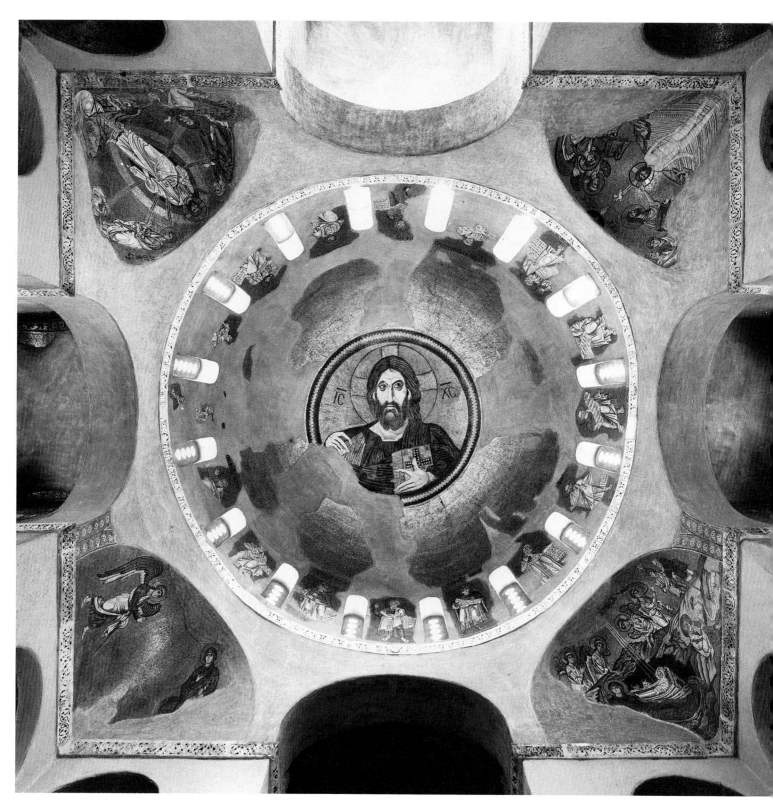

174. Church of the Dormition. View into central dome

of Christ *Pantocrator* (fig. 174). Gradually, as if pulled by
some magnetic force, we begin a spiraling descent, with the
building slowly rotating about us. In his description of a
Middle Byzantine church, Photius wrote, "The sanctuary
seems to revolve round the beholder; the multiplicity of the
view forces him to turn round and round, and this turning of
his is imputed by his imagination to the building itself."[53]
How different this cyclical experience of space seems when
compared to the longitudinal pull of the Western basilica,
where one is drawn down the nave and moves along the deep

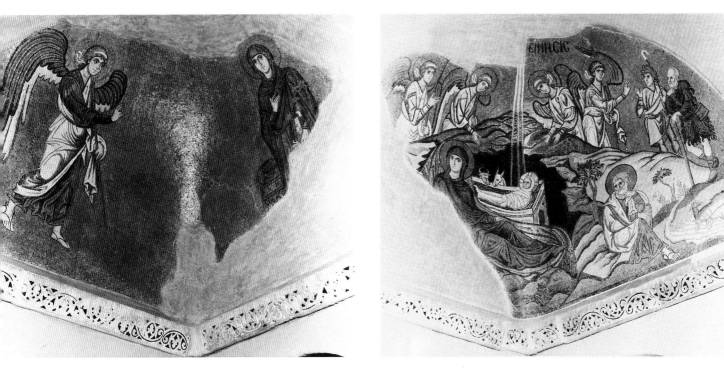

175. *Annunciation.* Mosaic in southeast squinch in the Church of the Dormition, Daphni

176. *Nativity.* Mosaic in the northeastern squinch in the Church of the Dormition, Daphni. See also colorplate 24

hallway while attending the pictures as an unfolding chronicle of Christian history. The timeless, repetitive, and cyclical world of the Byzantine church, where one turns but does not move from the center, is a wholly different experience from that of the progressive movement of the beholder in the Latin basilica.

The *Pantocrator* is presented as a huge bust portrait within an oculus or medallion (colorplate 23). His facial features are those of the pre-iconoclastic icon of Christ discussed earlier (fig. 153), but this ruler is stern if not menacing, and in his rigid left hand he carries a heavy book, signifying the "Word": "In the beginning was the word, and the word was with God, and the word was God" (John 1:1). Christ, the second person of the Trinity, embodies all three in one—the Father, the Son, and the Holy Spirit. How different this personality is from the comforting shepherd of the Early Christian period or the benevolent teacher of the Gothic (cf. figs. 3, 491).

The mosaics in the squinches next engage the beholder's eyes. Turning clockwise from the northeast corner, we see the Annunciation, the Nativity, the Baptism of Christ, and the Transfiguration. Other narratives that make up the Christological cycle are placed on the walls of the crossarms, north and south, and they complete the series of the *Dodekaeorta,* or Twelve Feasts of the Byzantine calendar (the major festivals of the life of Christ celebrated during the year). The mosaics in the squinches are not narratives in the traditional sense, however. They are like staged performances of actual events, with real actors performing in the space before the beholder. In the *Annunciation* (fig. 175), Mary and Gabriel hover as bright forms projecting from the abstract gold background of the niche as if standing in the real space of the *naos*. By virtue of the deep curvature of the squinch, they confront each other directly; Mary stands in a frontal position, but at the same time she faces Gabriel across the way much as she looks down at the worshipper.

In a like manner, the curvature of the squinch provides a three-dimensional stage for the *Nativity* (fig. 176; colorplate 24). The dark grotto where the Child lies is in the deepest part of the niche, and the concave landscape moves out and around it. Mary reclines to the left, her body turned to a near frontal position as she regards the viewer, while Joseph, pondering the mystery of the Incarnation, sits off to the right and glances across the space at the Virgin. The star shines down from the summit of the squinch, its rays descending along the curved surface of the grotto, and the angels above appear to be grouped in a semicircle about the crib. The gold background is highly effective in sealing off any illusion of representational space, and this abstraction imparts a timeless ambience to the stories. The mosaics present a never-ending cycle of the feasts of the year, not as history but as true mysteries. As Demus points out, they invite the worshipper to make a symbolic pilgrimage to the holy sites to witness the mysteries of Christ's life on earth as testimonies of the Incarnation.[54]

The *Crucifixion* at Daphni is one of the finest examples of

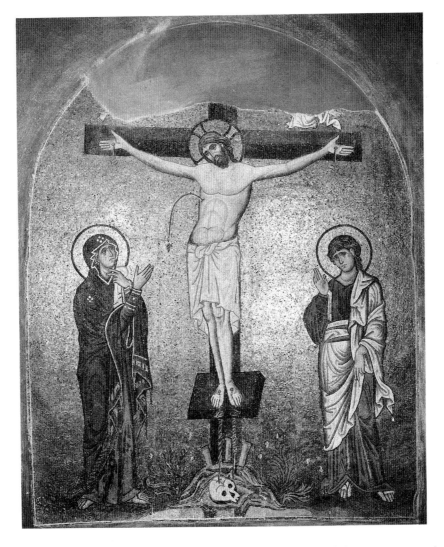

177. *Crucifixion.* Mosaic on east wall of north arm in the Church of the Dormition, Daphni

an "iconic" calvary picture ever created (fig. 177). It appears on the east wall of the northern crossarm and is difficult to see from the center of the *naos.* Perhaps the *Crucifixion* was relegated to this secondary position because a representation of the body of Christ on a vertical cross would not lend itself easily to a curved surface. Here we find an amazing blend of the iconic and the narrative requirements of the story. The setting is reduced to a simple groundline with a mound and the skull of Adam. The background is solid gold, and the numerous figures usually presented under the cross (cf. figs. 102, 582) are eliminated. Only the two major mourners, the Virgin and John the Evangelist, are placed symmetrically about Christ. They are not reduced to flat carpets, however, but appear as well-modeled bodies covered by articulated draperies. The frontal corpus sags a bit off axis, and Christ's eyes close as his head falls to his shoulder. The Classical qualities of the figures and the symmetrical balance create an image wherein a truly spiritual ideal of human beauty is attained. A timeless Crucifixion is presented to us, a death that was ordained for man's salvation, and the Virgin and Saint John seem to accept that fact quietly without displaying the pangs and contortions of the despair they suffered.

The conch of the apse, the most sacred area in the Latin basilica it will be recalled, was the second most sanctified place in the hierarchy of the Byzantine program, and it is here that icons of the Virgin, standing or enthroned, were presented (cf. fig. 155). The lowest zone, the walls and piers, received no scenic mosaics. Over fifty single figures are arrayed at Daphni, forming choirs of saints—apostles, martyrs, prophets, bishops—who fill the House of the Lord. These appear as full-standing or bust portraits posed frontally and standing upright with respect to the floor of the *naos.* As true icons they represent the faithful who attained sainthood and thus are elevated above the common worshipper. Finally, in the areas outside the *naos,* such as the narthexes and lateral chambers abutting the outer walls, various programs could be devised.

At Hosios Lukas, an echo of the interior scheme is found in the narthex, while at Daphni, mosaics of the Passion, the Infancy of Mary, and the Death of the Virgin (*Koimesis*) are presented there. It is important to note that Old Testament stories have no place in this world, unlike that of the Latin church, and when they do appear, as in the side chapels of the sanctuary of Hosios Lukas, they are clearly typological allusions that belong to a much earlier age of Byzantine mural decoration.

Monasteries were like museums of art in the Middle Ages. Everywhere rich gold and silver objects greeted the eyes, augmenting the splendor of the glowing mosaics overhead. The *iconostasis,* a screen wall of wood or stone separating the

naos from the sanctuary on the east, was the main place for the display of icons. The *iconostasis* usually consisted of three tiers. At eye level, the first of these was the carrier of larger, hieratic icons of *proskynesis*. With oil lamps and candles burning before him, the worshipper approached, knelt, and embraced the icon while offering prayers. Generally the focus of the *proskynesis* icons was on a group of three, featuring Christ between the Virgin and Saint John the Baptist, a triptych known as the *Deësis*. The two side figures served as intercessors for the faithful when Christ appears at his Second Coming to judge mankind.

The second row of icons featured an assortment of smaller portraits of standing saints, and above them appeared scenic icons with representations of the twelve feasts of the church year commemorating the major events in the life of Christ. There were many variations, and the icons were of various media. If the *iconostasis* had a door, the Annunciation (the introduction to the mysteries of the Incarnation) would be painted on it, and frequently a large Crucifixion was displayed above.

Icons of the Virgin figured prominently on the *iconostasis,* as indeed they did almost anywhere that devotions were held. These appear in various media ranging from paintings on wood to costly *cloisonné* enamels and miniature mosaics. A splendid example of such icons is the so-called Mellon Madonna in Washington (colorplate 25).[55] Much controversy remains concerning the provenance of the painting, but it is generally agreed that the icon or its prototype reflects a Constantinopolitan work of the late thirteenth century, about 1290.

The enthroned Virgin is the familiar *Hodegetria* type, so named after an original in the Church of the Hodegoi, the "pointers of the way," in Constantinople that was believed to have been painted by Saint Luke.[56] The *Hodegetria* Virgin can appear enthroned, standing, or in half-length, but she always holds the Child to the side on her left arm while "indicating" or "pointing the way to Salvation" (the Child) with her right hand. The Child is characterized as a miniature philosopher, holding a scroll in his left hand and raising his right in benediction or proclamation.

The Virgin in Washington is seated on an unusual throne, reminiscent of the Colosseum. It encompasses her glowing body and forms a definite spatial niche. Small Archangels appear in medallions in the upper corners (cf. fig. 152) against the gold background. The execution of the flesh parts, the heads and hands, is extremely delicate and soft, conveying a lyrical, sweet-sad expression in the Virgin's face. Her facial features have by now been clearly established: the narrow, tapering eyes, the long arcing nose, the small pinched mouth, and the heavy shading along the contours of the cheek and eye sockets. It is this type that passed into Sienese painting of the late thirteenth century (see p. 451).

What is surprising about the painting is the lavish use of color. Gold dominates. It glows from the background through the tiered throne and explodes in a shower of lines that shine through Mary's mantle, proclaiming the purer light of her being. The colors of her mantle are bright blues, reds, and gold (yellow), the primary colors, while the Child is garbed in bright green and orange, the secondary colors. Thus pure color suggests pure form, but there are other mystical associations at work in the style here. The upper half of the panel is dominated by circular forms: the throne that encloses the Virgin, the perfect circles of Mary's head and halo, those of the Child, and the circular medallions with the angels. This repetition of perfect circular forms evokes a gentle hypnotic response in the more sensitive worshipper and leads him slowly into a trancelike meditation.

It is clear that Byzantine artists spared no expense in creating these religious images. The materials are costly in the painted icons, and mosaic as a medium for mural decoration far surpasses any other in richness and labor involved. Among the sumptuary arts, that of *cloisonné* enamel leads the way in preciousness (figs. 178, 179; colorplate 26). The matrix of the enamel is powdered glass or gems heated to a molten state and then poured into a cavity, where it fuses to the gold or silver surface. In the *cloisonné* technique (from the French "partition"), the cavities or cells are carefully welded and partitioned with tiny strips of metal that form the golden lines of the finished design. The molten enamel is then poured into the appropriate cellular divisions and allowed to set. Later, the finished enamel is polished. The result is something between a stained-glass design and a mosaic, but on a miniature scale. Enameled objects were usually enriched with frames or borders of encrusted jewels or cameos, but mounted alone they could beautify a chalice, a tiara, or vestments.

The Pala d'Oro in San Marco, Venice, is one of the richest ensembles of Byzantine enamel work that survives, and while the present makeup of the "golden altarpiece" dates from the fourteenth century, the general composition reflects a type of Byzantine *iconostasis* in its assembly of miniature icons of *cloisonné* enamels in a luxurious golden frame.[57] The original Pala for San Marco was ordered from Constantinople by Doge Pietro I Orseolo (976–78) and apparently consisted of golden plaques nailed on wood. About 1105 a new Pala was ordered or received from Constantinople by Doge Ordelaffo Falier (1102–18) which was to serve as an antependium (a screen) for the High Altar. Whether or not this was an imperial gift on the part of the Byzantine emperor Alexius I and the empress Irene is a controversial issue, but portraits of the two (along with one of Doge Falier) appear among the enamels.

The second Pala was altered in 1209, when booty from the Fourth Crusade brought the rich sumptuary arts of Constantinople to Venice. An even more impressive shrine was

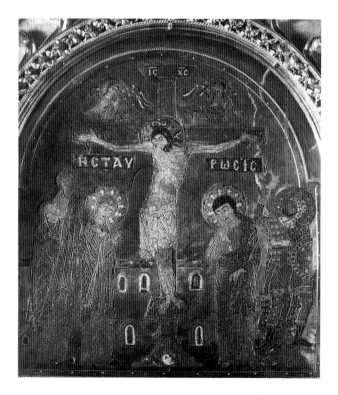

then designed. To the central plaque, which featured a *Pantocrator,* were added a tier of enamel feast icons taken from an *iconostasis* in Constantinople (Hagia Sophia or the Church of the Pantocrator). Other enamels of Venetian workmanship were also added, including the four Evangelists, the life of Saint Mark, and the life of the Virgin, which are of inferior quality. The whole was reconstituted again under Doge Andrea Dandolo in 1342–45, when Byzantine enamels of various dates, tenth through the twelfth century, were added to the gold, pearl, and gemmed setting. In spite of its makeshift history, the Pala d'Oro remains one of the most impressive deposits of this fine Byzantine art, and it had influence on later Italian painted polyptychs.

X

BYZANTINE ART IN ITALY

FROM the last years of the sixth century through the end of the eighth, the political power and prestige of the West Roman Empire suffered a calamitous decline as a result of the Lombard invasions. Even the Byzantine exarchate in Ravenna was threatened and ultimately fell to the Lombards in 751. The heroic Church Father Gregory the Great (590–604) was, however, able to maintain the authority of the papacy in western Europe, and this he did largely through the promotion of the Benedictine Order, the monastic organization founded by Benedict of Nursia (d. 543) at Monte Cassino (see p. 313 ff.).

Little art was produced in Rome during these years, and even in Byzantium the Muslim invasions in the provinces and the threat of iconoclasm in Constantinople itself drove Greek artists and monks into exile, many of whom settled in Italy. Between 606 and 741 no fewer than thirteen popes were Greek or Syrian, and the small number of notable works of art produced in Rome were variations on Byzantine themes executed in a provincial Byzantine style mixed with the local Roman idiom.

The iconic figure of Saint Agnes in the apse of her church on the Via Nomentana (fig. 66), dating about 630, is an example of Roman mosaic work that reminds one of the votive pictures in Hagios Demetrios in Thessaloniki (fig.

180. *Virgin orans amid Apostles and Saints.* Detail of apse mosaic in the Oratory of San Venanzio, Lateran Baptistry, Rome. 640–42

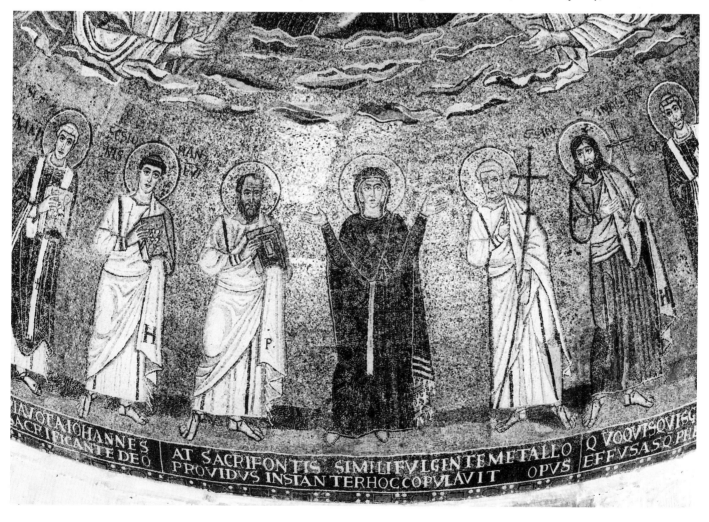

132; colorplate 14). The same severe style characterizes the apse mosaic in the Oratory of San Venanzio in the Lateran Baptistry (fig. 180), about 640–42; a mosaic portrait of Saint Sebastian in San Pietro in Vincoli, about 680; and in the mid-seventh-century frescoes painted in the Church of Santa Maria Antiqua in the Roman Forum (fig. 181), where Greek inscriptions testify to the presence of Byzantine artisans or advisors.[58] This latter church must have been a veritable museum of Byzantine art before its devastation by an earthquake in 847. Although difficult to study in its present condition, the church has numerous picture cycles and portraits that can still be discerned. These images display a confusion of styles ranging from the more sophisticated Byzantine figures to stockier types painted boldly with labored modeling techniques, such as that of the angel of the Annunciation (fig. 182).

In 1944 a remarkable find in North Italy in the small Church of Santa Maria di Castelseprio, twelve miles north of Milan, presented surprising problems for historians of Early Medieval art. The structure itself is crudely built in the fashion of other seventh-century churches in Lombardy, but the apse and choir are decorated with a double frieze of frescoes of astonishing beauty and freshness (fig. 183).[59] Hardly larger than miniatures, the paintings illustrate the Infancy of Christ according to Apocryphal sources (see p. 94). Executed with a startling spontaneity, the wispy figures move agilely in sketchy landscapes and architectural settings. Dynamic highlighting is achieved with quick, sure strokes, and the delicate hues, although considerably faded, still retain something of the fleeting blond tonalities of their original state. Compared to the ponderous provincialism of other works in Italy of the period, these frescoes seem to transport us back to the paintings of ancient Rome or Pompeii.

How does one account for the appearance of such accomplished art in this remote village, and what is the style anyway? The frescoes have been variously dated from the sixth century through the tenth (a graffito of 938–45 gives us a *terminus ante quem*), and because of the Greek inscriptions, they have been considered to be creations of an itiner-

181. *Saint Anne.* Fresco in Santa Maria Antiqua, Rome. Mid-7th century

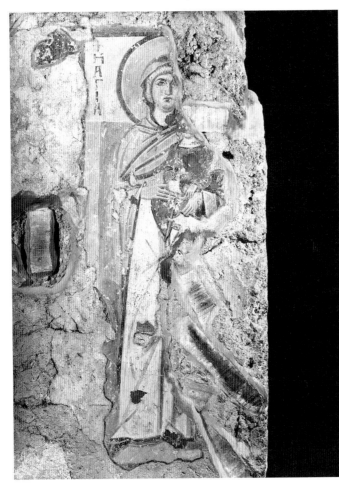

182. *Angel of the Annunciation.* Fresco in Santa Maria Antiqua, Rome. c. 700

183. *Presentation in the Temple.* Fresco in the apse of Santa Maria in Castelseprio. c. 700

ant Byzantine artist. It has also been argued that they are works of a Western painter following Byzantine models and, as such, represent the initial impulse for the development of the Carolingian "Renaissance" style found in such manuscripts as the Utrecht Psalter (see pp. 217–19) and therefore should be dated in the eighth century. Along totally different lines, the Castelseprio frescoes have been described as related to manuscripts of the so-called Macedonian Renaissance, discussed earlier, and should be dated in the ninth or tenth century. The problem has not been resolved, but most authorities today date the paintings about 700 and consider them Byzantine.

VENICE

Aside from the sixth and seventh century mosaics in Ravenna, important remains of Byzantine art can be found in other North Italian centers, and foremost among these is Venice. The famed lagoon city had grown from a Byzantine settlement on the island of Rialto in the seventh century into one of the most powerful city-states in the Mediterranean by the ninth. In order to claim its preeminence as an ecclesiastical center as well as a commercial port, Venice needed an imperial church of distinction, an apostles' shrine, as hallowed as those of Rome, Milan, or Constantinople. Rome, of course, not only had abundant relics but also the bodies of

Peter and Paul, and it will be remembered that Ambrose had acquired relics of the apostles to enshrine in his copy of Constantine's Apostoleion in Milan (see p. 70). Venice could claim no apostle, but the evangelist Mark, patriarch of Upper Adria and founder of the apostolic Sees of Grado and Aquileia nearby, had supposedly preached there. As the protectors of Grado, the Venetians took it upon themselves to "rescue" the remains of Saint Mark from his *martyrium* in Alexandria, then under Muslim control, and this they did in 829.

A noble shrine was needed for their newly acquired patron saint, and they erected the first church of San Marco with a cruciform ground plan, very likely meant to copy the illustrious sanctuary dedicated to the founders of the faith, Justinian's renovated Apostoleion in Constantinople.[60] The first church burned in 976 and was quickly rebuilt. This second San Marco was, in turn, pulled down in the eleventh century, and upon its foundations the present church was raised (figs. 184–88). Again the five-domed Apostoleion (it had been renovated in the tenth century) served as the model, and the construction was speedy. Begun in 1063, it was consecrated in 1073, and by the turn of the century the interior walls were lined with marble.

An ambitious program of decoration in mosaic was planned under Doge Domenico Contarini about 1100, but

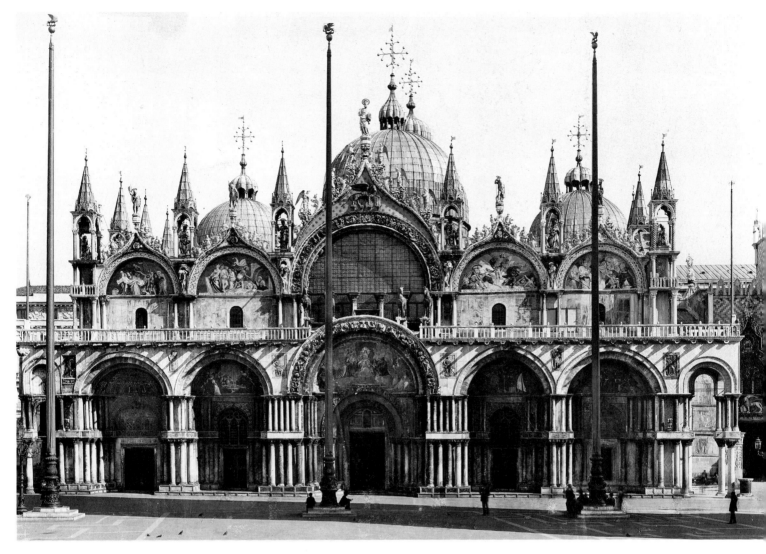

above: 184. San Marco, Venice. Exterior. Begun 1063

right: 185. San Marco. Plan

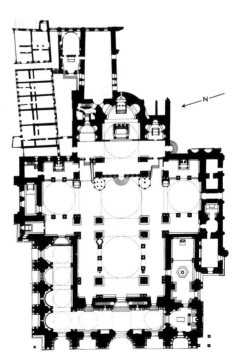

the work dragged on for two centuries. Today the mosaics of San Marco present the student with a baffling ensemble of pictures as far as chronology and iconography are concerned, but they remain the most impressive Byzantine decorations in western Europe. The earliest mosaics are the portraits of the four saints on the wall of the apse—Saints Peter, Mark, Nicolas, and Hermagoras (the first patriarch of Aquileia)—and the figures of the frontal apostles in the main entrance on the west. Their style displays a mediocre translation by Venetian workers of Middle Byzantine art.

The decorations of the five main domes and the vaults of the galleries in the arms of the cross were added during the course of the later twelfth century in accordance with a plan loosely related to the cosmic schemes found in Middle

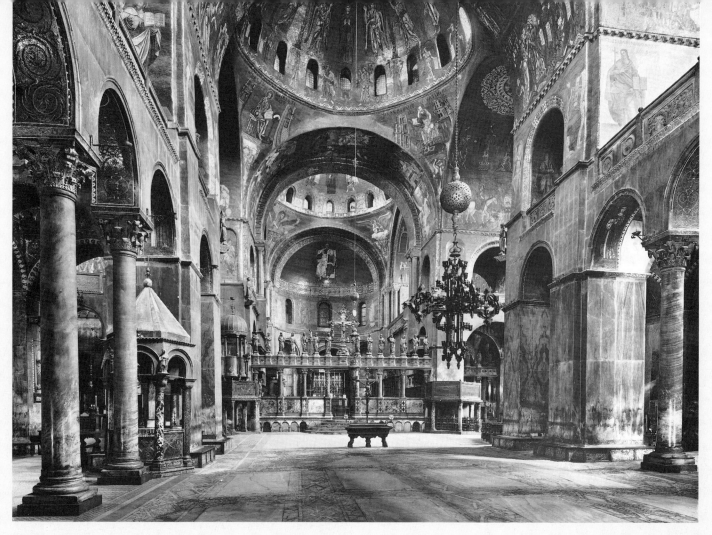

186. San Marco. Interior of nave

187. San Marco, Venice. Scenes from Genesis in the first dome of the narthex. 13th century

188. San Marco, Venice. View into the central dome with the mosaic of the Ascension. 12th century

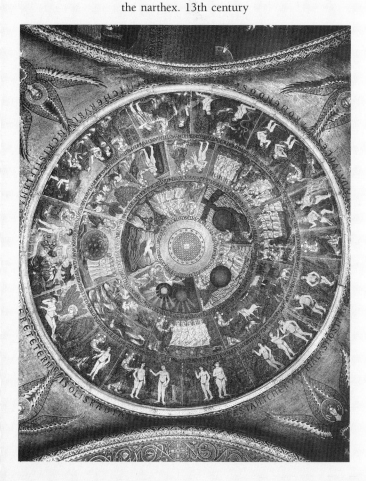

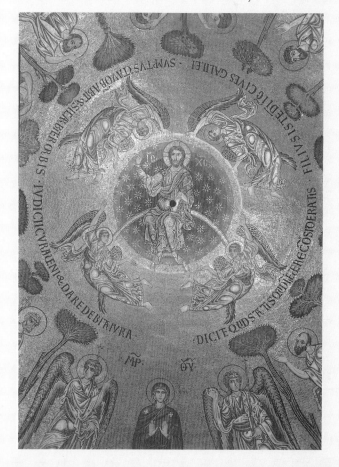

Byzantine churches. The mentality of the Western artist, however, is everywhere apparent. The dome with the *Pantocrator* is in the east, near the apse and altar, and includes the figures of the *orans* Virgin and prophets between the windows of the base of the dome. The central dome features an impressive Ascension (a theme closely related to that of the *Pantocrator*)[61] that follows Byzantine iconography except for the addition of personifications of the Virtues placed between the windows, which is a Western touch (fig. 188).

The western dome was decorated with another Byzantine feast picture, Pentecost, but the domes over the north and south arms of the cross depart surprisingly from the Byzantine norm. That on the north has the frontal figure of Saint John the Evangelist between diminutive narratives of his life spotted on the curvature of the dome with no figurative representation in the oculus. The southern dome is even more disappointing, with simply four Venetian saints posed frontally on the axes of the dome. Much restoration obscures the original appearance of many of these mosaics.

An extensive cycle of scenes from the life of Christ covers the arches and vaults of the galleries in the arms of the cross. These, for the most part, are weaker echoes of Comnenian mosaics. Certain manneristic devices are displayed in the draperies (for example, the coils and swirls about the pivotal points of the body) and in clumsy groupings of the figures in the more complex compositions.

Early in the thirteenth century a *U*-shaped narthex was added to the church (cf. that of the Nea in Constantinople). In the western and northern passages of the narthex are six domed bays lavishly decorated in mosaics with scenes from Genesis. The first of these, near the main entrance, has stories of the first days of creation and is of special interest to us (fig. 187). The narratives are arranged in three concentric circles of boxed compositions, starting in the center, that are closely related to the fifth-century illustrated Bible, the Cotton Genesis, discussed in chapter V (p. 83 ff.).[62]

A youthful Christ appears as the Creator in each of the uppermost compositions, and many of the colorful details, such as the angels representing the days of creation, are nearly identical to those in the miniatures of the Cotton Genesis recension (cf. figs. 96, 97). It seems clear that the builders and decorators of San Marco were determined to place their church into a grand tradition that reached back to Early Christian times. Even the capitals in the nave copy those of the sixth-century Apostoleion, and a number of relief sculptures embedded in the exterior walls are either Early Byzantine works or copies of them.

The exterior of San Marco is an exotic combination of Byzantine, Islamic, and Gothic features added gradually over centuries (fig. 184). The columns lining the five portals are spoils brought back from Constantinople in 1204, during the Fourth Crusade, and Venetian artisans, copying Byzantine and North Italian Romanesque sculptures (see p. 330

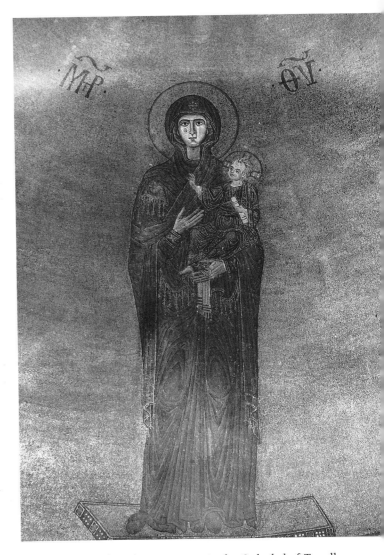

189. *Virgin and Child.* Apse mosaic in the Cathedral of Torcello, Venice. Late 12th century

ff.), carved large relief plaques that are set into the walls of the west and north facades. The lanterns crowning the outer shells of the domes display the ribbed, bulbous contours of Islamic types. French Gothic gables and tabernacles were added above the portals in the fifteenth century, and seventeenth-century mosaics replace early decorations on the upper walls of the facade. Finally, one finds the famous bronze horses of the Hellenistic age prancing over the central doorway (copies of these are placed there today), another reminder of the rich booty taken from Constantinople.

The huge basilical Cathedral of Torcello, an island in the Venetian lagoon, was built in the eleventh century and decorated with frescoes which were later covered by mosaics in the twelfth. In the center of the apse, an elegant *Hodegetria* Virgin holding her Child stands in haunting isolation as if floating in a sea of gold (fig. 189).[63] The mosaic is one of the most stunning in all Byzantine art. Secondary figures such as angels and saints are omitted so that the tall form of the Virgin commands our attention, with flickering golden lines filtering through her rich blue mantle. Viewed from a high vantage point, as the camera gives us in the reproduction,

Mary seems ten feet tall, but this distortion is simply an aspect of the subtle refinements found in Middle Byzantine mural decoration.

The image is conceived as an object in our space, before the golden background of the concave apse, and seen from below she appears in normal proportions. Similar adjustments are found in the inverse perspective of the base upon which she stands. Below her appear the twelve apostles in frontal positions, but they are not so tall since, once again, a staggering of scale is employed to accommodate the actual distance between the beholder and the image. The higher the image is placed, the larger and more sacred it is.

A curious concession to Western and, more specifically, Romanesque programming appears in the huge mosaic of the *Last Judgment* that fills the inner facade wall at Torcello (fig. 190). This theme was favored in the Latin west as the major subject for the entrance to a basilica (see p. 287 ff.),

but it was not part of Byzantine church decoration until very late. The iconography, however, is Byzantine and is found in miniature paintings of the Middle Byzantine period. Judgment takes place with Christ seated amid the apostles in the upper zone. From his throne flows a sea of fire that forms a lake subdivided into rectangular and squarish sections that mark out the divisions of Hell. Trumpeting angels announce the resurrection of the dead, and in the bowels of Hell, Lucifer is portrayed as a blue-skinned demon holding the Antichrist on a dragon throne engulfed in a fiery lake. Heads of the damned—they include various ranks of people from both the Christian and Islamic world—are bounced about like balls by little blue demons, while two elegant angels with spears attack an emperor and a monk. Above the tiered ensemble appears the Crucifixion of Christ and the Anastasis. The curious iconography is based on some compilation of various commentaries on the Second Coming of

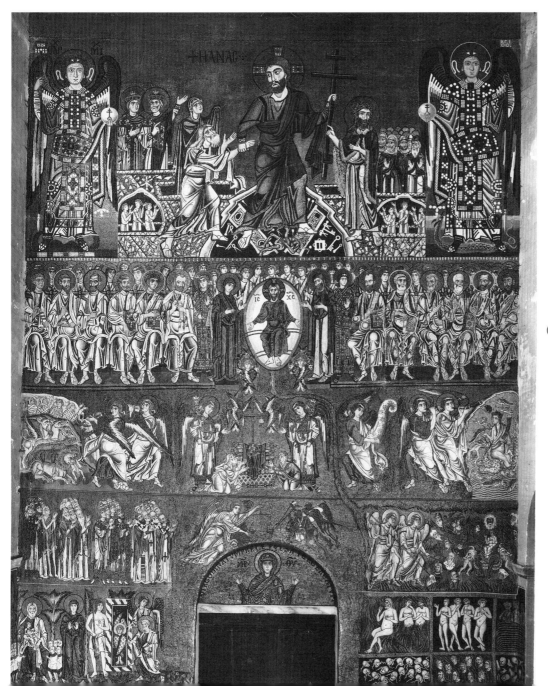

190. *Last Judgment.* Mosaic on the inner west wall (entrance) in the Cathedral of Torcello (restored). Late 12th century

Christ as yet unidentified. The Latin counterpart, as seen at Autun (fig. 358), is a far more gruesome Last Judgment.

SICILY

The history of Sicily, the largest island in the Mediterranean, is one of an exotic mixture and conflict of Mediterranean cultures. Greek, then Roman in the Hellenistic period, Sicily became a battleground between Byzantine and barbarian armies during the Early Christian period, the former dominating until the gradual occupation of the island by Muslim invaders from the mid-seventh through the mid-eleventh centuries. In 1060 Roger of Normandy, brother of Robert Guiscard, led his troops from Calabria across the straits of Messina into Sicily, and by 1091 the island was occupied by Normans. The conqueror's nephew, Roger II d'Hauteville, was crowned king of Sicily, Apulia, and Calabria in 1130 and, from his capital at Palermo, proclaimed the Norman

empire of the "Two Sicilys" the equal of that of the Western emperor, Lothair, and the Byzantine basileus, Manuel.

There is no question as to which of the two Roman empires Roger most wanted to emulate in building his domain. His portraits on coins and seals are clearly based on those of the Byzantine emperors; he petitioned Manuel for a Byzantine princess to be his wife; and he fashioned the culture of his court on the model of the Byzantine state. His ambitions were so bold that after the Second Crusade in 1147, Roger planned an invasion of the city on the Bosphorus and the ousting of the Comnenian basileus. While the political dreams of Roger were not realized, the enrichment of his kingdom in Sicily along Byzantine lines is quite another story.

The dedicatory mosaic in a domed church, the Martorana, built by Roger II for one of the Greek communities in Palermo, served as a political manifesto for the Normans (fig. 191). Roger II, garbed in Byzantine court costume, stands tall and slightly bends his head to receive the crown (the Byzantine *stemma*) from Christ directly. Furthermore, his claim to be the one chosen by Christ to govern the Roman world is underscored by his actual identification with Christ. Roger's facial features are nearly identical to those of the Savior; his long hair, thin face, mustache and mouth make him the earthly counterpart of Christ. The bold proclamation, *Rex Messiah est,* the "King is the Messiah," that can be read in an anonymous Norman political tract of 1100, is thus echoed in the mosaic portrait.[64]

The syncretic character of Roger's world is displayed in the magnificent palace chapel, the Cappella Palatina, that he erected between the palace residence and the administrative offices in Palermo between 1132 and 1140 (figs. 192–96; colorplates 27, 28).[65] The structure is a curious combination of a Latin basilica and a Greek cross-in-square *naos* with a dome. The mosaic decoration on the walls and dome is Comnenian in style, executed in part by artisans called in from Constantinople, but the iconographic program is a combination of the Byzantine image of the cosmos (in the sanctuary and transepts) and a Latin pictorial chronicle of the history of *ecclesia* from the Old Testament to the New (in the nave). The wooden ceiling of the nave, finally, is an exotic work of hanging honeycombs of interlocking cells created by Islamic craftsmen brought in from Fatimid Egypt.

The Greek-cross sanctuary built into the transept is domed and carries a lavish mosaic scheme based on the programs of Middle Byzantine churches such as Daphni. In the summit of the dome is the bust of the *Pantocrator* (fig. 193). Angels and Archangels stand in a circle directly below. In the curious stepped squinches are the four Evangelists, and on the walls between them are prophets. The scenes of the life of Christ are then placed on the walls of the transepts and on the arches and vaults that connect them to the apses and piers of the central bay. Medallion portraits of warrior

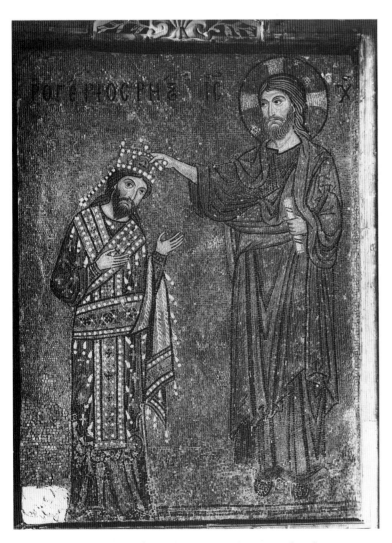

191. *Christ Crowning King Roger II of Sicily.*
Dedicatory mosaic in the Martorana, Palermo. c. 1148

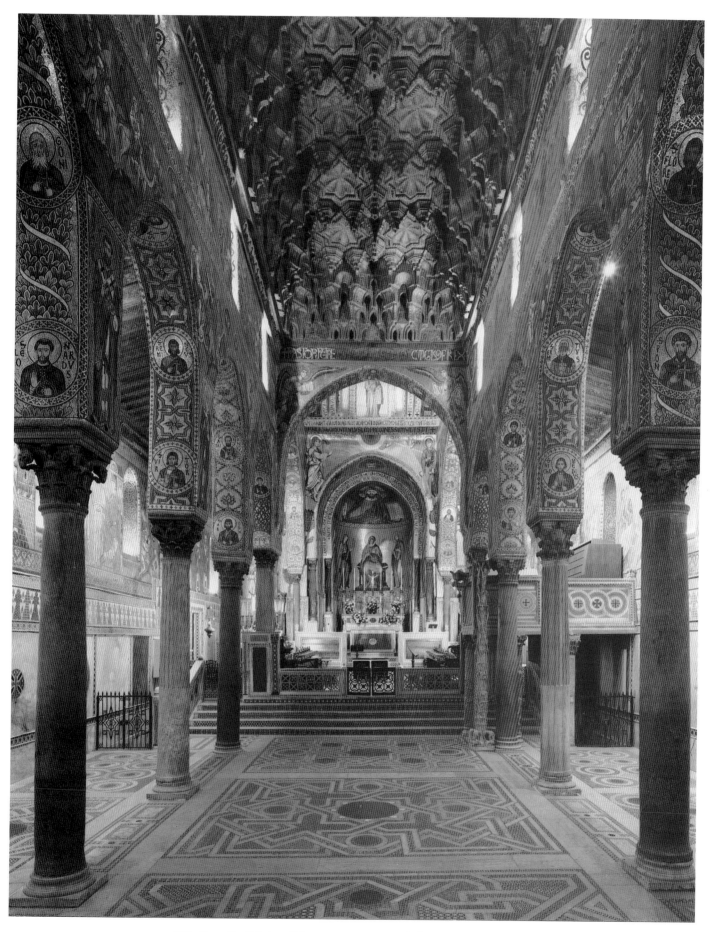

192. Cappella Palatina, Palermo. Interior toward altar. Mid-12th century

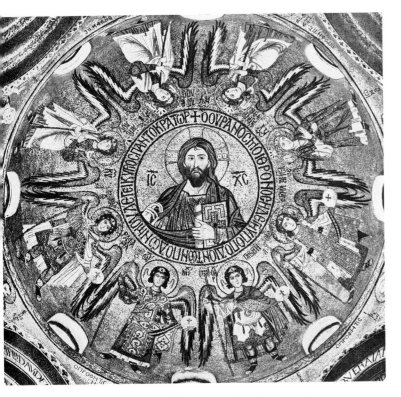

193. Cappella Palatina. View into the dome
with the *Pantocrator*. 1143

saints line the soffits of the arches, while the lower register of the end walls of the transepts, north and south, display full-length portraits of the Church Fathers and other saints, much as in a Byzantine *naos*. The mosaic in the dome is dated by an inscription to 1143, and the other pictures in the sanctuary were added shortly thereafter (the extensive restorations in the Cappella Palatina make it difficult to determine the chronology precisely). The basilical nave and aisles were decorated with mosaics by local artisans, trained by Greeks, during the reign of Roger's son, William I (1154–66).

In the *Nativity* (colorplate 27) one can recognize the essential features of Middle Byzantine style easily (cf. fig. 176). One departure from the austere presentation at Daphni is the more discursive nature of the narrative. The designer has crammed in extra details, including the diminutive figures of the Magi traveling in the upper left and, a second time, adoring the Child in the middle right. Hieratic scale is exaggerated, too, and the conventions employed for drapery are mechanically rendered and disconnected. Unlike the Daphni mosaics that are carefully composed in pockets or cells of well-defined architectural spaces, those of the Cappella Palatina flow across the corners of the wall divisions and, as in the *Nativity,* invade the zone of the mosaics on the adjacent walls. More significant, however, is the lack of concern for space. The figures are treated as flat silhouettes

that float against the stylized landscape with heavy, scalloped contours. The magic realism of the staged festivals at Daphni is thus lost in the patterns of figure groups in the Sicilian mosaic.

The figure of Saint John Chrysostom on the lower wall of the north transept, on the other hand, is a splendid example of Comnenian style (fig. 194). The abstract patterns of the drapery are carefully integrated into the quiet movement of this gaunt figure. The delicate lines of the tesserae are shaped to echo the slight protrusion of the knee or the bend of the elbow, and thin red outlines describe the elegant fingers. The high, domed head of the saint, the sunken cheeks, and the

194. *Saint John Chrysostom*. Mosaic on the lower wall of the north transept in the Cappella Palatina. Mid-12th century

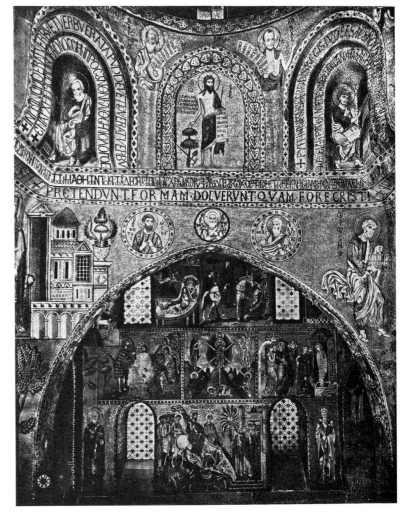

195. *Abraham's Hospitality*. Mosaics in the spandrels of the nave arcade of the Cappella Palatina. Second half of the 12th century

196. Cappella Palatina. View into south transept

pursed mouth are indicated by minuscule lines in white tesserae forming abstract patterns of circles, arcs, and ovals that lend the countenance a pristine, ascetic quality. Compared to the stockier figure of the same saint in the upper walls of Hagia Sophia (cf. fig. 158) — the inscriptions as usual in Byzantine art assure us that these are meant to be specific portraits — that in the Cappella Palatina presents us with the learned Byzantine scholar of the fourth century as we might imagine him to look.

The inscriptions in the sanctuary are in Greek, those in the nave are in Latin, and the subject matter there shifts from the Byzantine model to one familiar in the Latin west, an Old Testament cycle related to the Cotton Genesis pictures (fig. 195). There was no place in the Byzantine cosmos for these histories, but, as we have repeatedly seen, Old and New Testament stories were juxtaposed in the decoration of the Latin basilica to serve as didactic examples of the pilgrimage

of *ecclesia* in time (cf. chapter III). The nave mosaics seem to be the work of local craftsmen, probably trained and supervised by Greek masters, and are inferior in style. Mechanical repetitions of figure types appear, and the stylized backgrounds merely echo their positions without actually serving as space settings. Between the windows of the clerestory and the spandrels of the nave arcade, the lengthy cycle reads from left to right in two registers with episodes illustrating the first days of creation, starting in the upper eastern corner of the nave, through the history of Jacob on the opposite wall.

The program of the mosaics in the Cappella Palatina is more than a mechanical juxtaposition of Byzantine and Latin iconographies, however. A distinctive Norman character appears in the arrangement of the scenes in the sanctuary. In fact, the "feast" cycle is curiously out of balance, with the three tiers of mosaics on the south wall of the transept

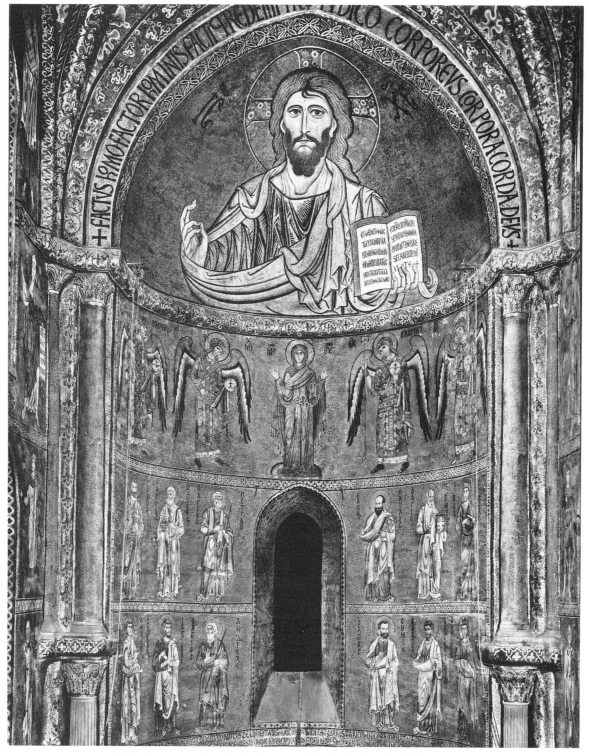

197. *Pantocrator.* Mosaic in the apse of the Cathedral of Cefalù. c. 1148

clearly predominating. The original "royal box," or balcony for the king, was located on the north transept wall (later moved to the west end of the nave), directly opposite the mosaics on the south wall.[66] This axial deviation, north and south, explains the unusual emphasis on the themes dis-played to the emperor during the services, for they allude to imperial *adventus* and reception ceremonies wherein the *christomimesis* (identification with Christ) of Roger II, much as in his portrait in the Martorana, is emphatically pro-claimed.

In the top register, opposite the throne, the *Flight into Egypt,* a rare scene in the feast cycle, appears as the *adventus* of the young Christ before the city gates of Egypt, personified by a standing female (see fig. 196). The largest mosaic, the *Entry into Jerusalem* in the lowest tier, is the example *par excellence* of the triumphal *adventus* of Christ before the two-towered gate of Jerusalem (colorplate 28). Thus two *adventus* ceremonies, in Christ's infancy and in his triumph at the beginning of the Passion sequence, confront the king and allude to his royal reception in foreign lands. What better reminder of Roger's role as a triumphant basileus could be placed before his eyes? The divine authority of the Normans, not religious mystery, is thus the ideology proclaimed in the Cappella Palatina.

A purer form of Comnenian style appears in the apse mosaic in the Cathedral of Cefalù (fig. 197), which Roger II founded in 1131 as a royal burial church (his body was later moved to Palermo Cathedral).[67] The Cathedral of Cefalù is basically an Italian Romanesque basilica with a wooden roof, transepts, and a partly vaulted presbytery. In the main apse appears the majestic Christ *Pantocrator* with the Virgin *orans* and Archangels below and the twelve apostles lined frontally in the lowest zone. Since there is no dome in Cefalù, the decoration, completed by 1148, is an abridgment of the mosaic schemes for the *naos* in Middle Byzantine churches.

The Greek artists who executed the mosaics graduated the height of the figures to compensate for their distance from the beholder. The Virgin and Archangels thus are taller than the apostles below them, and in the conch of the apse the bust of Christ looms out as some super icon, completely dominating the sanctuary, with his right arm sweeping outward as if to embrace the worshipper. The open book in his left announces, in Greek and Latin, "I am the Light of the world," and the delicately curved lines of the tesserae in his

198. Cathedral and Monastery of the Virgin, Monreale. View of the nave toward the east. 1174–83

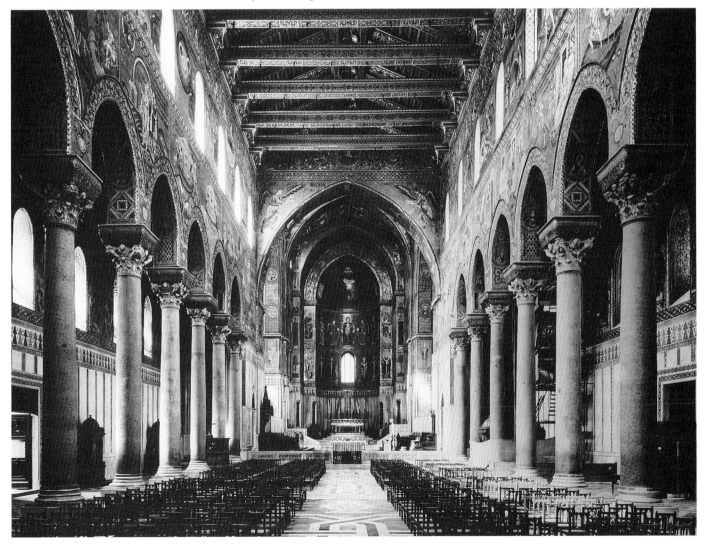

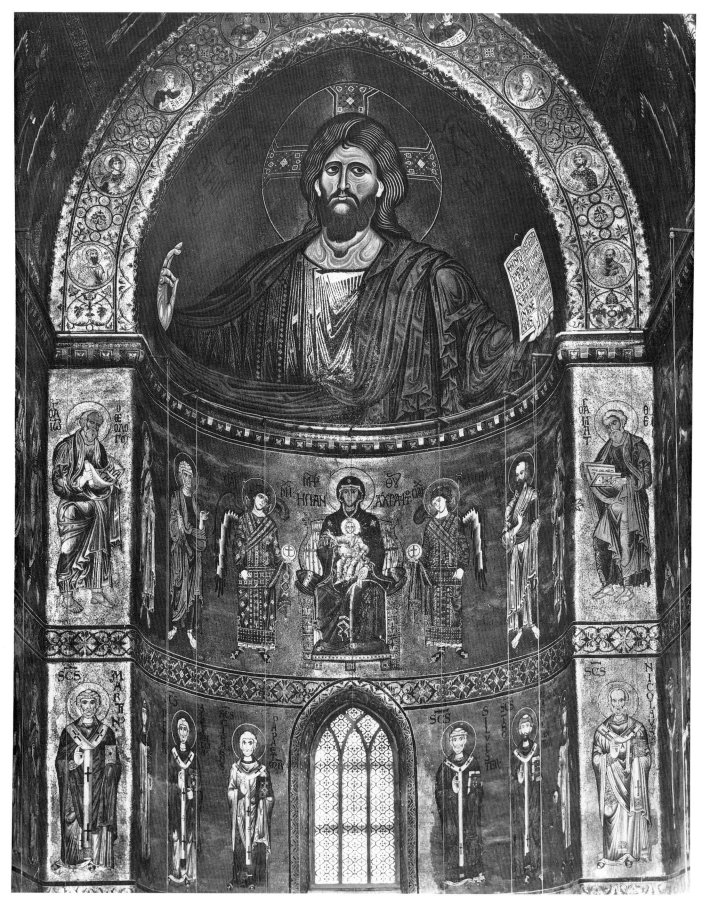

199. *Pantocrator*. Apse mosaic in the Cathedral of Monreale. c. 1183

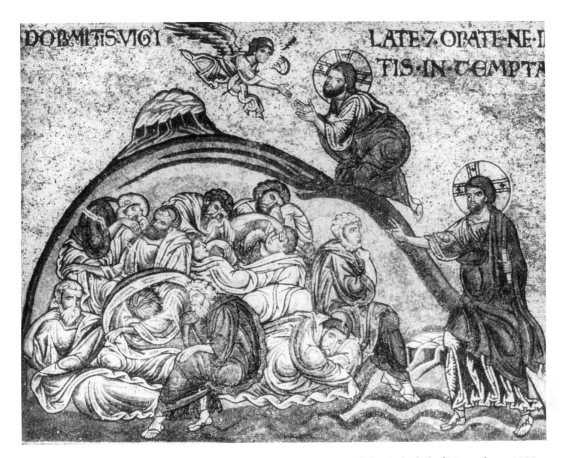

200. *Christ in the Garden of Gethsemane*. Mosaic in the transept of the Cathedral of Monreale. c. 1183

face, especially those in his eye sockets and cheekbones, describe the drawn features of a truly ascetic leader. Less corporeal and imposing than the world ruler who stares down angrily from the dome at Daphni, the Christ of Cefalù is more compassionate, and his gaze is more comforting.

In the "royal park" of Roger II, high on a hill overlooking Palermo, his grandson, William II (1166–89), founded the Cathedral and Monastery of the Virgin, known as Monreale, in 1174 (figs. 198–201).[68] Built directly over the site of Hagia Kyriaka, the cathedral center for the Greek community during the Muslim occupation, the new cathedral was sanctioned to rule over the See of Palermo and the clergy of Palermo Cathedral in the city below. The latter much opposed the authority of the Norman rulers. Monreale was granted complete independence by a papal bull of 1176, and its abbot, a Cluniac monk, was appointed archbishop of Palermo, answerable only to the king and the pope.

The huge basilica was built and decorated rapidly, enabling William II to exert the authority of his new church as a *fait accompli* before his death. In keeping with Norman traditions, an imposing two-towered facade also signaled his authority (see p. 291), and a splendid cloister with sculptured capitals, some of which were executed by French artisans, adjoined the church (fig. 201). Much of the present structure was completed by 1183, and in the following decade an intense campaign for decorating the church was carried out. New teams of Greek mosaicists were brought in, and it is surprising how they adapted their techniques of decoration to the immense basilica, with no *naos* or dome, and how they accommodated the standard Byzantine program to Western interests.

Following the example of Cefalù, the central figure in the sanctuary is the *Pantocrator* in the conch of the apse above the Virgin between Archangels and, in a lower register, the apostles (fig. 199). In keeping with Benedictine traditions, the conchs of the two side apses received mosaic icons of Saints Peter and Paul with legends of their lives below on the walls. The square marking the crossing, lifted high with a lantern, and the side walls of the transept arms were decorated with a vast cycle of Christological scenes with no particular emphasis given to the major feast events as in a Byzantine church. History, not liturgy, dictated the subject matter, and extensive narratives completely dominate the scheme. Episodes from the ministry of Christ line the walls of the aisles of the nave, and in two registers, much as in the Cappella Palatina, those of the Old Testament unfold above

the nave arcade from the days of Creation to the story of Jacob. Originally in the narthex there were more pictures of the infancy and life of Mary.

In spite of the vast wall spaces covered, the mosaics of Monreale display a homogeneous style. They constitute, in fact, the largest expanse of Comnenian mosaic work to survive, and dating some decades later than those of the Cappella Palatina, they are significant examples of the developments in later Byzantine art. Aside from the general disposition of the decoration with regard to the architecture—they are like huge tapestries covering and concealing the divisions of the church structure, which is wholly un-Byzantine—the style of the individual compositions clearly anticipates a later phase of Byzantine art called the "dynamic style."[69] The emphasis on line over volume is accentuated by complex turnings of the drapery, often resulting in swirls and eddies about the hips, knees, and other pivotal parts of the body and in arbitrary zigzag linear contours in the garments that flutter free from the body. All features of the anatomy are clearly defined by lines, not modeling, and gestures and facial expressions are dramatically emphasized. Individual figures and, in some cases, entire compositions thus display a curious agitation and restlessness, characteristic of manneristic traits in later Byzantine art (see fig. 200).

Such developments nicely accommodate the faster pace of the narratives, the main concern for Western eyes, but much of the Classical sublimity in the fine balance of abstract line and painterly, three-dimensional effects that we find in the mosaics of Daphni is lost. The draped figures become composites of linear conventions with little bulk; the settings are little more than abstract patterns. It is not surprising that Romanesque art in France, especially that of the Cluniac Order, found much inspiration in the Byzantine style that filtered through the mosaics of Monreale. It is to the developments in Christian art north of the Alps that we now turn.

201. Cathedral of Monreale. View of cloister

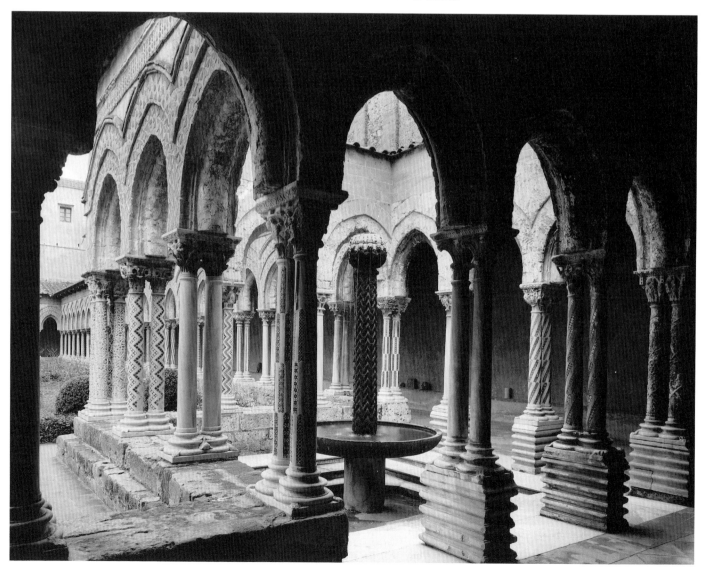

THE EARLY MIDDLE AGES IN THE NORTH

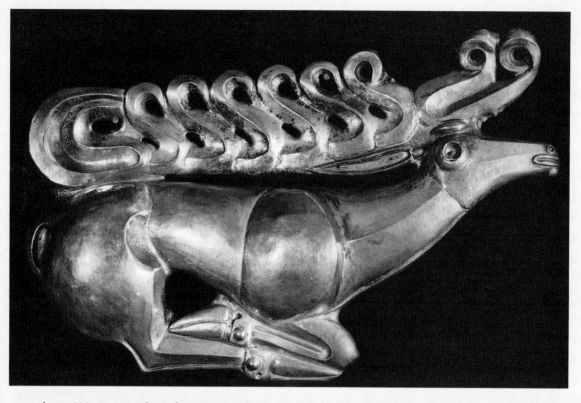

above: 202. *Stag*. Scythian, from Kostromskaya, Russia. Chased gold, length 12″. 7th–6th century B.C.
Hermitage Museum, Leningrad

below: 203. *Lion-Griffon Attacking a Horse*. Chased gold, length approx. 5″. 2nd century B.C.
Hermitage Museum, Leningrad

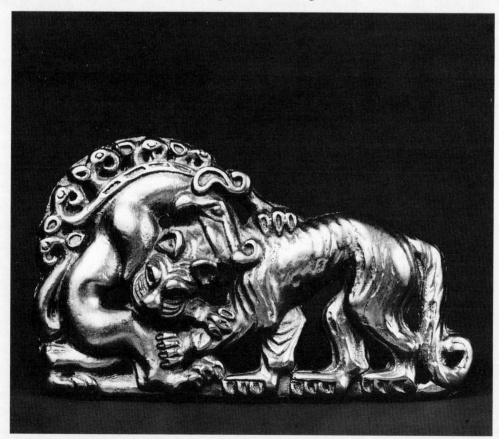

THE NORTH

FAVORITE passage in the Venerable Bede's *Ecclesiastical History of the English People,* written in the early eighth century, relates a touching parable employed by one of the chieftains of Edwin the Saxon, king of Northumbria, when considering his own conversion from paganism to Christianity: "This is how the present life of man on earth, King, appears to me in comparison with that time which is unknown to us. You are sitting feasting with your ealdormen and thegns in winter time; the fire is burning on the hearth in the middle of the hall and all inside is warm, while outside the wintry storms of rain and snow are raging; and a sparrow flies swiftly through the hall. . . . For the few moments it is inside, the storm and wintry tempest cannot touch it, but after the briefest moment of calm, it flits from your sight, out of the wintry storm and into it again. So this life of man appears but for a moment; what follows or indeed what went before, we know not at all. If this new doctrine brings us more certain information, it seems right that we should accept it."[1]

Geography and climate were the factors that conditioned the spiritual, social, economic, and cultural expressions of these Northern peoples. It is not a matter of racial constants, as some in the past have argued; it is clearly the weather and habitat that shaped the business, the comradeship, the religion, and the arts of ethnic groups, who for centuries roamed westward in scattered tribes from the windswept plains of Asia into the cold, icy crags and fearsome mountains that separated the north from the south, the west from the east.

Our knowledge of Nordic religions is limited to a few late written records, but it seems clear that life in a cold, troubled world was man's fate from the cradle, that the valor of the heroic warrior and his obedient family was the only virtue, and that life after death was a nothingness in which darkness and the raw forces of nature ultimately triumphed in their Last Judgment, their *Götterdämmerung,* the twilight of the gods. The terrifying elemental forces were always at hand, if not in icy winds, frozen ponds, and bottomless depths, then in the fierce monsters, both seen and imagined, that haunted the dark forests and lay in wait for their human prey behind matted veils of wild copses intertwined with dense undergrowth: "In the darkness dwells a demon whose heart is filled with hate" is the leitmotif in *Beowulf.*

Is it surprising, then, that the first arts of these wandering peoples glorified the battle in nature — animal against animal, monster against man — cast in a dark turbulence of frantic motion accented with flashes of eerie colors? Theirs was a culture of the hunter and the hunted, the victor and the victim, overwhelmed in a world that was mysterious and incomprehensible. Furthermore, nomadic tribes cannot carry about elegant temples or polished marble sculptures; their only mural decorations were heavy woven rugs and hangings that could be rolled up and packed away for the next move.

Because of their nomadic existence, the only arts that could be highly developed were those of the warrior on the move: decorations for a helmet, a sword hilt, a clasp to secure one's cloak, the trappings of a harness. Gold was the richest medium in the fashioning of the taste of the barbarians, and these small portable objects of gold were tokens of power and authority, of excellence and superiority, in the culture of the wandering tribes.

The earliest distinctively North European arts are closely related to, and derived from, the portable arts of the nomads in the central steppes of Asia and, more specifically, those of the Scythian hunters who came to settle between the Don and the Danube rivers in south Russia about the Black Sea. Much controversy has raged over the sources of Scythian art. The metal-casting techniques seem to be closely related to, if not inspired by, the Iranian craftsmen with whom they traded; their skills and forms were perhaps quickened by the neighboring Ionian Greeks; and their animal motifs have been linked by some authorities to the bronzeware of the Chou dynasty in ancient China, especially the Chinese who occupied the far western reaches of the broad continent.[2] Whatever the origins, the fact is that a Scythian *objet d'art* distinguishes itself immediately from others when confronted in a grave find. It is not Iranian, or Greek, or Chinese in expression; it is uniquely Scythian, an obvious artifact of a

wandering culture distinct from the arts of its neighbors and the centuries of stable artistic traditions behind them. Let us look at a few of these objects carefully.

The leaping *Stag* (fig. 202), perhaps a breastplate decoration, was found in a funerary tumulus at Kostromskaya in the Kuban River basin on the north shore of the Black Sea. Over a foot long, the elegant golden object, dating from the sixth century B.C., is executed in *repoussé*. In some respects, the animal reminds us of the massive yet agile bison and deer that were painted more than ten thousand years earlier in the caves of Altamira, but the Scythian stag is highly sophisticated and stylized compared to the naive naturalism of the prehistoric creatures. The sections of the body are smooth and rounded, and the rhythmic flutterings of the repeated *S*-shaped or scroll antlers along the entire length of the back enhance the forward thrust of the animal. Anatomical details and textures are omitted, and natural lines are abstracted to form a powerful, streamlined machine.

Numerous other types of portable art, comprising mostly horse trappings and jewelry, reflect the more-fearsome aspects of the hunt. Sometimes referred to as *plaques de combat,* these feature real and imaginary animals locked in battle to the death amid a racing network of lines. The *Lion-Griffon Attacking a Horse* (fig. 203) is typical, with swirling lines of necks and torsos, sharp arcs of jaws and teeth, interlocked in a choking maze of lines that are twisted and contorted to express the brutal ferocity and writhing agony of the pathetic struggle. The victim is often the tamed horse, while the killer is usually a composite dragon, epitomizing the evil forces of raw nature. Energized line is the primary element of its design, so much so, in fact, that Wilhelm Worringer found in this dynamic linearism the latent "will to form" of all later Gothic art.[3]

But dynamic linearism is not the only element of style in Northern art. Deeply rooted in the past was the love for sparkling gems and translucent enamel inlay in such objects. The *cloisonné* technique that was employed involved filling a metallic cavity, usually partitioned with threads of gold, with molten glass and semiprecious stones which, when hardened, formed a permanent part of the metal article. In some Nordic cultures the lines were controlled and contained within strict geometric divisions of circles, triangles,

rectangles, or repeated angular designs for the inlay. Such objects made handsome pins and brooches. The *Eagle Fibulae* illustrated here (colorplate 29) are a product of the Gothic tribes in Spain about A.D. 500.

This more static style had a lasting appeal even after the Christianization of these wanderers. The *Crown of Recceswinth* (fig. 204), a king of the Visigoths who had settled in Spain, dating between 649 and 672, served a commemorative purpose as a votive crown to hang over an altar or a tomb. The elegant object typifies this refined jewelry. Its large uncut gems and inlaid letters dangling from golden threads spelling out the king's name are a forecast of the familiar animal alphabet in Merovingian art, such as we find it in the Sacramentarium Gelasianum "page with a cross" (fig. 205) produced in northern France in the mid-eighth century.

Another development of Northern ornament is found in the refined metalwork of the Celtic tribes. Inlays of coral and enamel together with graceful linear motifs that ultimately derive from Classical palmettes and Greek key patterns characterize much Celtic art. The earliest remains (fifth to fourth century B.C.), called La Tène (the "Shallows") after an excavation site near the eastern end of the Lake of Neuchâtel in Switzerland, display a number of very distinctive motifs. These motifs later developed into the more familiar Celtic vocabulary of spirals, trumpets, peltas, or triskelions (three legs or spirals spun from a central hub) that we find in the early arts of Ireland, where the Celts had settled by the fourth century B.C.[4] These dynamic designs often turn into chains of flying commas resembling the flamboyant turnings characteristic of nineteenth-century Art Nouveau. A handsome example is the elegant back surface of a bronze mirror from Desborough (Northants), a work of the first century A.D. (fig. 206). Decorative motifs were incised or engraved on the surface, and enamel inlays or *niello* (a sulphorous metallic substance) filled the grooves, enhancing the fleeting movement of the design. *Millefiori* glass inlays, a kind of mosaic made of the cross sections of fused multicolored glass rods, also appear.

Another distinctive element of style in these early Northern arts is the ribbon interlace, a pattern derived from Roman ornament frequently found in floor mosaics. The interlace is a complex interweaving and braiding of thick lines resembling some uncontrolled warp and woof in a fanciful woven fabric. Yet even here there is an important distinction to note. Whereas the Mediterranean interlace remains a geometric abstraction, the ribbons in Northern art are frequently animated or given life by turning them into squirming serpents or attenuated animals and birds.

A fine example of animated interlace is the great *Golden Buckle of Sutton Hoo* (fig. 207), a hollow golden belt buckle over five inches long that was found among the regalia of an Anglo-Saxon king, identified as Raedwald (d. 624/25). The Sutton Hoo treasures were found buried within a warship in a tumulus near the sea in Suffolk, England.[5] Ship burials are recorded in *Beowulf* (where the ship is set afire and adrift in the sea). It is not certain that the king's corpse was interred with his prize possessions at Sutton Hoo. Some have argued

opposite left: 204. *Crown of Recceswinth.* Visigothic Spain. Gold, sapphires, and pearls, diam. 8½". 7th century. Museo Arqueologico, Madrid

opposite right: 205. *Page with a Cross.* Illustration in the Sacramentarium Gelasianum. Merovingian. 10¼ × 6⅞". Mid-8th century. Vatican Library, Rome (Cod. Regina, lat. 316, fol. 13v)

left: 206. *Bronze Mirror.* Celtic (Desborough). Bronze and niello, length 8¾". 1st century. British Museum, London

below: 207. *Golden Buckle of Sutton Hoo.* Gold, length 5¼". 7th century. British Museum, London

that the site was a cenotaph, or commemorative monument. The hollow buckle is of a type known to have served as a portable reliquary box, and the fact that it was found among other trappings for a warrior's wardrobe suggests that the burial was the focus of a grand pagan rite. The surface of the buckle is covered with a continuous interlacing pattern of zoomorphic forms that intertwine in a seemingly haphazard fashion. Three golden bosses, parts of the locking device, form the hubs about which serpents turn.

Among the finds at Sutton Hoo were a variety of articles, including a Byzantine silver dish of the fifth century, bowls, coins, spoons inscribed "Saul" and "Paul" in Greek (Christian items?), an elegant Anglo-Saxon purse lid with garnet inlays, and ornaments from a great shield, among them a splendid gilt bronze winged dragon with a sharply tapering body (fig. 208). Such strange creatures are much like those described in early Irish poetry: monsters encountered in seafaring tales, strange dragons and demons that lurk on islands as weary voyagers seek out the happy lands (paradise) hidden far out in the western ocean. In the *Voyage of Maelduin* a wild beast as indescribable as these interlaced

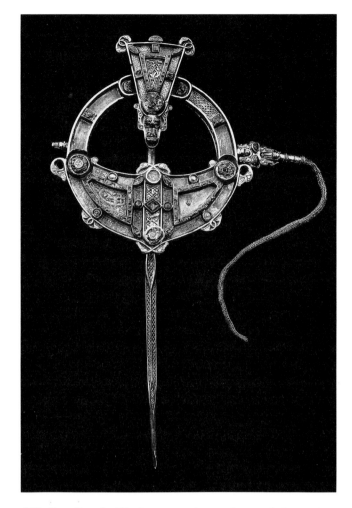

209. *Tara Brooch.* Gilt, bronze, amber, and enamel, diam. 3⅝".
c. 700. National Museum of Ireland, Dublin

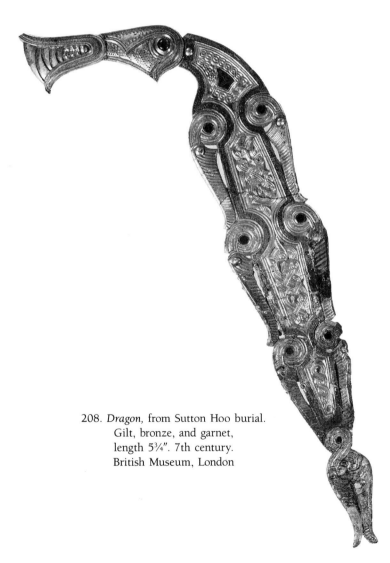

208. *Dragon,* from Sutton Hoo burial.
Gilt, bronze, and garnet,
length 5¾". 7th century.
British Museum, London

ribbon creatures suddenly menaces the travelers: "They came then to another island and a wall of stone around it. And when they came near, a great beast leaped up and went racing about the island, and it seemed to Maelduin to be going quicker than the wind. And it went then to the high part of the island, and it did the straightening-of-the-body feat, that is, its head below, its feet above . . . it turned in its skin, the flesh and the bones going around but the skin outside without moving. And at another time the skin outside would turn like a mill, and the flesh and the bones not stirring."[6]

Just such fantastic animals swirl about parts of the magnificent *Tara Brooch* (fig. 209), a cast-bronze fastener of startling refinement, with fierce reptiles coiled about the circumference and then wrapped into intricate golden wires twisted and plaited like exotic metallic embroidery. The glowing gilt surface with its stunning amber bands is accented with studs of blue and deep red enamels. The simple safety pin comes alive on its owner's mantle, biting and snapping like a savage but beautiful pet tethered there.

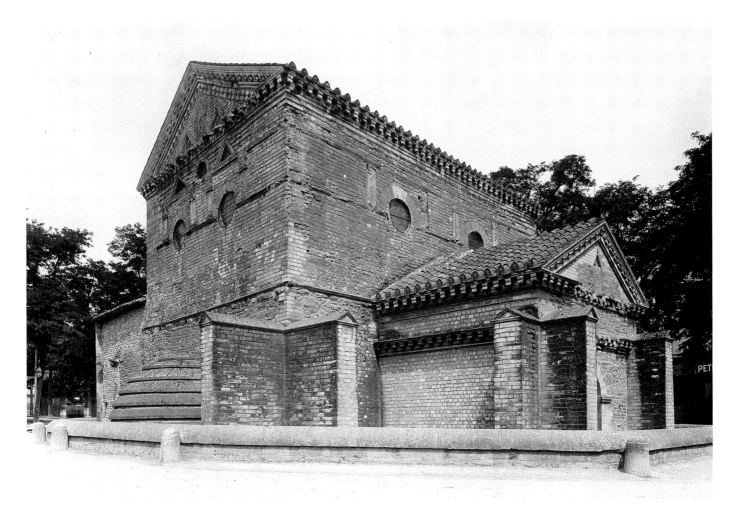

210. Baptistry of Saint John, Poitiers. Exterior from the west. 7th century

The migrations of the wandering tribes followed circuitous routes across Europe. The Visigoths settled sporadically in southern France and then in Spain; the Ostrogoths, under Theodoric, occupied northern Italy, followed later by the Lombards. By the fifth century, these tribes were largely Christian of the Arian faith. More indigenous groups, such as the Celts and the Angles and Saxons, settled in the northern territories of France, Germany, and Scandinavia and then moved westward to Ireland and England in waves. The Franks and the Burgundians in turn rose to power with the Frankish kings, establishing what today is known as the Merovingian dynasty of Christian rulers. Their defeat of the hordes of Muslim invaders at Tours in 732 was a momentous date in history for the Christian world and a prelude to the rise of the powerful Carolingian empire established by Charlemagne, himself a Frankish ruler.

Gregory of Tours (573–93), in his *History of the Franks,* lavishly praised a number of basilicas in his homeland, including the imposing Church of Saint Martin at Tours,[7] but scant remains of any churches earlier than the seventh

century survive, and little of the Early Christian splendor is reflected in the one modest structure that is often cited, the so-called Baptistry of Saint John in Poitiers (fig. 210). Featuring a stunted central plan, Saint John's is built from reused stones and bricks and decorated with debased Classical capitals, ponderous cornices, and embedded pilasters and pediments resembling simulated embroideries in stone. There is little relationship of ornament to structure. The walls were further enriched with patterns of terra-cotta inlays and modillions, making the church a rather coarse piece of architectural jewelry of dubious ancestry.

As we have seen (Part II, pp. 114–115), the first notable barbarian occupation of Italy was that of the Ostrogoths in 487 under Theodoric the Great, a king who followed the Arian faith and built a splendid capital at Ravenna, employing builders and craftsmen from Rome and perhaps from Byzantium. The arts of Ostrogothic Ravenna displayed not a weakening or barbarization of Antique style, it will be recalled, but a subtle shift toward a more hieratic and iconic mode of representation. The Lombards, a Teutonic tribe also

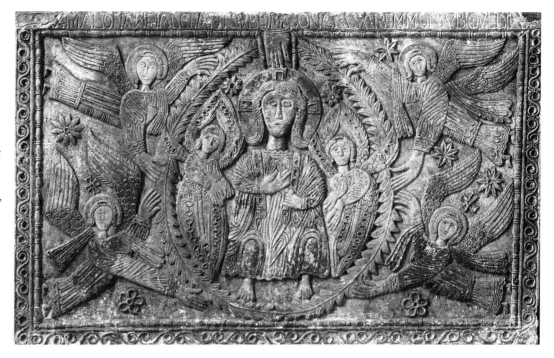

211. *Maiestas Domini*. Altar Frontal of Duke Ratchis. Marble, approx. 3′ × 5′. 731–44. Museo del Duomo, Cividale

committed to the Arian faith, invaded Italy in 568 and settled in the valley of the Po River (roughly the area today known as Lombardy), establishing their capital at Pavia, south of Milan.

The stone Altar Frontal of Duke Ratchis (fig. 211) was donated to the Church of Saint John in Cividale, the seat of his dukedom of Friuli (north of Trieste) between 731 and 744.[8] The side panels have crude representations of the Visitation and the Adoration of the Magi, while the front has a more monumental relief of the *Maiestas Domini,* with a beardless Christ enthroned between seraphim in a mandorla circumscribed with leaf patterns and carried by four strange, insectlike angels. The iconography of the Christ in Majesty conforms to the general type such as that in the Rabbula Gospels *Ascension* miniature (colorplate 8), and the simple compositional devices of hieratic scale, symmetry, and frontality (the bodies of the angels are carved in profile) comply with the traditional iconic mode of the theme. The provincial qualities of the carving, on the other hand, are apparent.

This so-called provincialism raises some thorny problems for the art historian. In response to those who decry this "barbarization" of the Antique style are the counterarguments of many Medievalists who claim that what we see here is not so much the death of an ancient art but the exciting beginnings of a new, abstract art for the Christians (much the same controversy as provoked by the sculptured friezes on the Arch of Constantine—see p. 27). One thing seems clear: the artisans were not schooled in the traditions of the earlier ateliers if, indeed, they were rigorously trained in any representational crafts at all.

The miniatures in the so-called Roman Vergil demonstrate

that the lack of trained miniaturists was not limited to Christian scriptoria but, indeed, was commonplace by the sixth century. Interestingly, paleographers have dated the fine rustic script of the Roman Vergil to the third or fourth century, while art historians have usually placed the miniatures in the fifth or sixth.[9] The scene of the *Shepherds Tending Their Flocks* (fig. 212) certainly strikes one as a debased adaptation of a much earlier model (cf. the Vatican Vergil, fig. 92) with its harsh isolation of stumpy figures mounted like cutouts on a flat background with bold outlines that deprive them of any modeling.

More instructive for our purposes are the miniatures in the Gospels of Saint Augustine (fig. 213) in Cambridge, allegedly brought to England by the apostle of the English himself in the late sixth century.[10] The text has been identified as sixth-century Italian, and the miniatures are generally considered to be of the same date. In the portrait of the evangelist Luke, elements of Classical illusionism are preserved beneath the dry stylizations that confront us. The elaborate frame that forms an alcove for Luke retains aspects of perspective behind the author—the half-length animal symbol also has precedents in Early Christian art—but these features are reduced to pale reflections of the model that served the sixth-century miniaturist. The scenes that fill the boxes in the intercolumniations on either side are so simplified and abridged that some would be impossible to identify were it not for the inscriptions that accompany them.

The earliest illustrated manuscripts produced in the North in which we find Italian types copied are those of the Merovingian period.[11] Two basic styles appear. On the one hand, many Merovingian miniatures appropriated the indig-

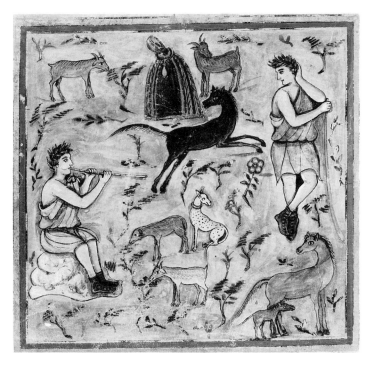

left: 212. *Shepherds Tending Their Flocks.* Illustration in the Roman Vergil. 8½ × 8¾″. 6th century(?). Vatican Library, Rome (Cod. lat. 3867, fol. 44v)

enous Animal style, such as the cross page in the Sacramentarium Gelasianum (fig. 205), discussed above, where only the outlines of the architectural frame preserve an earlier Mediterranean prototype. On the other hand, the figurative scenes were often copied with a wild, imaginative vigor. In the Gellone Sacramentary, the Animal style appears in many of the initials, but in the larger representational images it is apparent that the illuminator attempted to emulate the figured codices of the Early Christian period. The *Crucifixion* (fig. 214), serving as the *T* for the *Te igitur* of the Canon, is unquestionably crude, but its spontaneity and wild expression forcefully convey the pathos and suffering of Christ. A striking compromise of these various styles appears in the early arts of the British Isles.

213. *Saint Luke.* Illustration in the Gospels of Saint Augustine. 9⅝ × 7⅛″. 6th century. Corpus Christi College Library, Cambridge, England (Corpus MS 286, fol. 129v)

214. *Crucifixion.* Illustration in the Gellone Sacramentary. 10¼ × 6½″. 8th century. Bibliothèque Nationale, Paris (MS lat. 12048, fol. 143v)

IRELAND AND ENGLAND—HIBERNO-SAXON ART

THE ORIGINS of Irish art are as mysterious as the history of the Emerald Isle itself. The remoteness of the island with its windswept crags and damp fens made its prehistoric inhabitants and the early Celts who settled there relatively secure from the colonizing Romans and the later Saxon invaders who settled in Britain during the course of the fifth and sixth centuries. The Celts had brought with them their sophisticated decorative arts. With the Christianization of Ireland by Saint Patrick in 432, the arts began to emerge from the dense fog that veiled Irish prehistory.

For nearly two centuries the Irish church was a lonely outpost growing sporadically from the scattered seeds of early missionaries who found the eremitic life of Saint Anthony proper for their calling and mode of living. With a silent fervor for solitude and asceticism in their remote retreats perched on craggy precipices overlooking the windy ocean, the Irish monks dwelt like human amphibians or crustaceans between land and sea, so that, as one early poet reflects, "I may see its heavy waves over the glittering ocean as they chant a melody to their Father on their eternal course."[12]

215. Skellig Michael. Monastery remains, Ireland. 6th–9th century

Slowly the Irish monks emerged from their solitude and built small monastic communities, humble wooden and roughhewn stone structures at first, little more than beehive dwellings of modest proportions, such as the stone cells perched on the cliff overlooking the sea at Skellig Michael (fig. 215). According to tradition, the See of Armagh was established in the center of the island about 550 as the successor to the authority of Saint Patrick, but nothing remains of the buildings there. Later the saintly Columba founded communities at Derry, Durrow, Swords, and on the island of Iona to the north; and in 635 the coastal island of Lindisfarne in Northumbria was settled by Saint Aidan. Already by the end of the sixth century, Saint Columbanus, "desirous to live as a stranger and pilgrim for the Lord's sake," spread the Irish missions to the continent, to the lands of the heathen Burgundians and Franks and into the wilderness of North Italy (Luxeuil, Saint Gall, Bobbio).

The Saxons in England were semi-Christianized by the sixth century, and the missionaries sent to England by the Roman church—Augustine in 597—found the Irish rites mysterious and barbaric, with even the hallowed date of Easter misconstrued in their calendar. Over the next century the Irish gradually came to accept Roman practices—Iona submitted only in 716—as further contacts with Rome brought service books and works of art to the islands. Bede tells us that the Northumbrian Benedict Biscop, founder of Saint Peter's at Wearmouth and Saint Paul's at Jarrow, had been to Rome and returned with every kind of manuscript, including one of the earliest authorized versions of Saint Jerome's Vulgate Bible.

Biscop's new texts made it possible to introduce proper ordering in chanting, singing, and other parts of the service as well as the manner of administering the church affairs according to Roman practice. He also brought paintings "which he might encompass about the whole church . . . shewing the agreement of the Old and New Testaments, most cunningly ordered: for example, a picture of Isaac carrying the wood on which he was to be slain, was joined to one of the Lord carrying the cross on which He likewise was to suffer"—a *dittochaeon* (parallelism) of sorts.[13] Moreover, from Gaul Biscop brought back "masons to build him a church of stone *after the Roman fashion* which he always loved."

For the most part, the lingering archaisms of the Irish church were finally suppressed at the Synod of Whitby in 663, and it is about this time, too, that Latin forms begin to emerge in Irish arts and architecture. Large stone churches were raised, freestanding crosses of stone with carved symbols and human figures begin to appear, and the indigenous Celtic spiral and trumpet motifs were framed, intermeshed, and interwoven with Mediterranean interlace into beautiful patterns in their book illuminations.

How marvelous and uncanny these first contributions of

216. *Carpet Page.* Illustration in the Book of Durrow. 9⅝ × 6⅛″. c. 660–80. Trinity College Library, Dublin (MS 57–A.4.5, fol. 192v)

the Irish appear! Upon seeing for the first time an illustrated manuscript in Ireland, a twelfth-century Welsh historian, Giraldus Cambrensis, enthusiastically noted: "Look more keenly at it and you will penetrate to the very shrine of art. You will make out intricacies, so delicate and subtle, so exact and compact, so full of knots and links, with colours so fresh and vivid, that you might say that all this was the work of an angel, and not of a man."[14] The uncommon beauty and spontaneous effervescence of color in Irish illuminated pages, "veiled in ornaments as if in clouds of incense," to quote one scholar, distinguish them as ultimate achievements of what might be viewed as a totally anti-Classical style in art history.

One of the earliest Irish Gospel books with illuminations is the Book of Durrow (Codex Durmachensis), today in the Library of Trinity College in Dublin. Presumably produced

in the ancient scriptorium of the monastery at Durrow in Ireland sometime around 660–80 (Lindisfarne and Iona have also been suggested), the text, according to a later colophon, was written by none other than the hallowed Saint Columba (d. 597): "I implore your benedictine, holy priest Patrick, that whosoever holds this little book in his hands remembers Columba the scribe who has written this Gospel book in the space of twelve days by the grace of God."[15]

The colophon is probably a pious forgery since what we find in these earliest illuminations seems to be a fully developed style. Executed in four colors—yellow, red, and green within brown-black outlines—on parchment of suedelike texture that is especially receptive to ink and color, the illuminations in the Book of Durrow consist of allover "carpet" designs, symbols of the Evangelists, and large initials for the beginnings of the Gospels. Some carpet pages have swirling spirals and trumpets of the Celtic type, one has a magnificent cross that seems to be based on oriental Christian motifs, while others seem more like sectioned metal plates filled with interlaced patterns like those on the Sutton Hoo belt buckle (fig. 216).[16]

Each Gospel has a carpet page paired with another displaying the symbol of the Evangelist (the carpet page of Matthew is missing). The symbol for Matthew, the first Gospel, is a man (fig. 217), but aside from the carefully drawn circular head, the doll-like body, lacking even arms, resembles more a metallic buckle adorned with inlays of colored glass. Vestiges of two feet, both pointing to the right of the frontal body, testify to the illuminator's disinterest in Classical symmetry, even in such a rigid, conventionalized representation. Isolated against the white ground of the parchment, Matthew's symbol thus appears as a piece of Irish metalwork affixed to the page.

Dating slightly later, about 690, the striking symbol of Saint Mark, the rampant lion labeled *imago leonis,* in the Gospels of Saint Willibrord (also known as the Echternach Gospels), is one of the masterpieces of early Irish art (colorplate 30). This book, according to most authorities, was the very Gospel presented to Saint Willibrord for his long journey to convert the heathen in the Low Countries and Frisia, since its provenance can be traced to Echternach in Luxembourg, a monastery he founded.[17] The free, flamboyant form of the heraldic beast sweeps diagonally across the page in a prancing leap (cf. the Scythian leaping reindeer, fig. 202), placed like a giant jeweled pin against a fragile network of thin rectilinear lines of red and violet which form an elegant abstract pattern.

Some specialists have argued that both the Book of Durrow and the Gospels of Saint Willibrord were executed not in Ireland but in the Irish colony established on the island of Lindisfarne in Northumbria, southeast of the Scottish coast.[18] Lindisfarne was founded by Aidan of Iona about 635 and played a key role in the exchange between the Irish and the Roman Catholic church after the Synod of 663 at nearby Whitby. The vicissitudes of history, however, do not diminish the Irish character of the arts produced at Lindisfarne, although it has become customary to refer to them as Hiberno-Saxon to allow for some influences of local Anglo-Saxon traditions.

The masterpiece of Northumbrian art is the Lindisfarne Gospels, usually dated before 698 on the basis of the colorful colophon in the manuscript written by the priest Aldred in the early tenth century: "Eadfrith, bishop of the church of Lindisfarne [698–721], first wrote this book for God and Saint Cuthbert and all the saints in general who are on the island."[19] Much larger than the Book of Durrow, the Lindisfarne Gospels repeat the general pattern of illuminations with the addition of elaborate canon tables. The Evangelist pages are expanded to include full portraits of the authors that are clearly dependent on Mediterranean models. In general, the Lindisfarne decorations strike one as being ma-

217. *Symbol of Saint Matthew.* Illustration in the Book of Durrow (fol. 21v). 9⅝ × 6⅛″

218. *Saint Matthew.* Illustration in the Lindisfarne Gospels. 13½ × 9¾″. c. 700. British Library, London (MS Cotton Nero D. 4, fol. 25v)

realistic curtain rod is drawn across the top right corner from which hangs a heavy, undulating drape, partially concealing a second bearded figure who seems to be eavesdropping. Both heads are haloed. The identification of the additional witness to the Gospel is uncertain. Perhaps he is meant to be Christ, the object of Matthew's genealogy, as some have argued. Could he be Moses, the Old Testament prophet of Christ's coming as he is described in the popular prefatory verses to the Gospels by Sedulius (*Carmen Paschale*) and in Bede's own homily on the text of Saint Matthew?[20]

Directly above Matthew appears the bust of his symbol, a winged man identified as *imago hominis,* who blows a tapering trumpet. Curiously, Matthew's name, in the top center, is introduced with the Greek *O Agios* (saint). How does one account for this unusual miniature? No doubt the artist had before him an early model that preserved the illusionism and modeling of Late Antique author portraits. The carefully

219. *Ezra Restoring the Bible.* Illustration in the Codex Amiatinus. 20 × 13½″. 8th century. Biblioteca Medicea Laurenziana, Florence (Amiatinus MS I, fol. 5)

jestic in the architectonic ordering and elegance displayed in the treatment of traditional Irish ornamental motifs. Yet within the delicate and restrained compositions there flows a myriad of Celtic motifs with exceedingly fine lines of well-balanced turnings and delicate colors of gold, dark red, pale blue, green, mauve, yellow, purple, and pink.

In the carpet page with a cross (colorplate 31), countless dog-headed serpents and long-beaked birds with *cloisonné* wings performing acrobatics are fantastically elongated, their forms lost in the maze of knots and loops forming floating *S* and inverted *C* patterns of interlace. But an orderly division and symmetry govern the entire page, imposing a kind of frozen pattern and muted rhythm upon the usually wilder exuberance of Irish ornamentation.

The portrait of Saint Matthew (fig. 218) comes as a complete surprise within the folios, since here we see a naturally proportioned elder comfortably seated on a cushioned bench writing in his book. The background is not painted, but a

drawn red arcs that describe the folds of the green mantle, the misunderstood rendering of perspective in the bench and unhinged suppedaneum, the spatial implications of the curtain rod, and the fractional figures of the symbol and the extra male witness—both intended to overlap in space—are nowhere to be found in earlier Irish illuminations.

It will be recalled that Bede wrote of the numerous books, some illustrated, that Benedict Biscop brought to England from Rome, ultimately to be kept in Northumbria. It has long been believed that the miniatures in the famous Codex Amiatinus, written in Northumbria about 750—its text is of paramount importance to students of the Vulgate—copy those in books procured by the Benedictine reformer. The miniature of *Ezra Restoring the Bible* in the Codex Amiatinus (fig. 219) appears to be another version of the same model that served the Lindisfarne artist for Matthew, although it is a more slavish (and faithful?) copy (note the cast shadow of the inkpot).[21]

The surprising introduction of the Mediterranean style into insular art was by no means limited to Northumbria, however. In Canterbury the creative copying of Italian models was even more evident by the eighth century. It will be remembered that Saint Augustine of Canterbury, a Benedictine, was sent to Kent by Pope Gregory to reform the English church. The Benedictines were the major monastic order in Italy, and they enforced their strict rule as it was formulated by the founder of the order, Saint Benedict. In fact, the antagonism between the more severe Benedictines and the Columban Irish monks lasted throughout the seventh and eighth centuries, and this confrontation is possible to discern in their arts to a degree.

The illuminated manuscripts brought to Canterbury by the earlier Roman missions stimulated the production of illustrations in a more Classical flavor. A good example is the portrait of Saint John in the Canterbury Codex Aureus today in Stockholm, dated to about 750 (fig. 220), which clearly reflects compositions like that of *Saint Luke* in the Gospels of Saint Augustine (fig. 213) that was discussed earlier.[22] The vivid face of the youthful Evangelist staring out at the reader, the bold lines that describe the sharply contoured folds of his mantle, and the rotundity of the grained column shafts forming the frame that supports the colorful lunette with the symbolic beast all point to an Italian source. Only the Celtic spirals and trumpets above the heavy capitals betray the Hiberno-Saxon ancestry of the miniaturist. It has also been noted that the Evangelist portraits in the Codex Aureus are related to Carolingian illuminations of the so-called Palace School (see below, pp. 207–8). With this new style in mind, we now turn to the most outstanding Irish manuscript that survives, the incomparable Book of Kells.

"The great Gospel of Columkille [the Book of Kells], the chief relic of the western world" (*Annals of Ulster,* 1003), is a vast and sumptuous production with elaborate initials (fig.

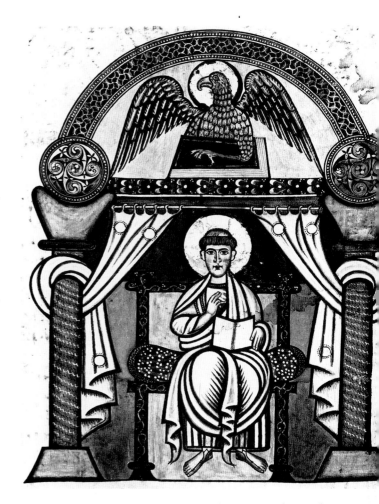

220. *Saint John.* Illustration in the Codex Aureus of Canterbury. 15½ × 12½". c. 750. Royal Library, Stockholm (MS A. 135, fol. 150v)

221) and numerous full-page miniatures of holy personages, narratives of the life of Christ (Arrest of Christ, Temptations), carpet pages, and exuberant canon tables. Indeed, it is a relic insofar as it survived the devastating Viking raids that left Iona island in ruins in 804–7, when, as some believe, it was carried off unfinished by the monks to Kells in County Meath in Ireland.[23] The unprecedented wealth of the manuscript's decorations indicates that it had some commemorative role as a showpiece for the Columban monks and their artists over a number of years.

The elaborate canon tables (fig. 222) that incorporate Evangelist symbols and other unusual animal motifs within their colorful spandrels seem to be influenced by a continental manuscript, very likely a courtly Carolingian Gospel book. Other pages suggest diverse Mediterranean models.[24] One striking example of such foreign intrusions is the *Virgin and Child* (colorplate 32) enthroned among four angels that is placed appropriately opposite the first list of chapters (*breves causae*) beginning with the words *Nativitas Domini* (the birth of the Lord). The throne and the lower torso of the Virgin are rendered in profile with delicate black lines trac-

ing the folds of the violet tunic that covers her legs. Mary is dressed in a Byzantine costume and assumes a pose not unlike that of the familiar *Hodegetria* type (see p. 155) in east Christian art, suggesting that the hieratic Virgin and Child may reflect a liturgical icon.

While such icons were common in Byzantine and Coptic chapels of the sixth and seventh centuries, it is likely that the direct inspiration for the Kells artist was a painting brought north from Italy by Benedict Biscop, perhaps one like that recorded in his trip of 678: *imaginem beatae Dei genetricis semperque virginis Mariae* (similitude of the blessed Mother of God and ever virgin Mary).[25] At the lower right, near the Madonna's knees, the interlace border is cut by a small box in which the heads of six bearded monks (?) appear. Perhaps they are meant to represent members of the artist's congregation.

Epitomizing the Irish ornamental style is the incredible *Chi-Rho* page (colorplate 33) that faces the beginning of Matthew's genealogy. Here the name of Christ appears for the first time in the Bible (*Christi autem generatio*) and is magically transformed into a huge sweeping *Chi* (X) that engulfs the illumination with its gaping jaws and descending tendril tail, overwhelming the smaller *Rho* (P) and the word *generatio* in the lower right corner. Indeed, to agree with Giraldus Cambrensis, the shimmering mass of ornamental motifs growing and subdividing across the unframed page is so fine and minute that it is truly difficult to believe that it is a design fashioned by human hands and not the beautiful spidery fabric of some delicate tapestry woven by angels.

The powers of concentration required for such infinitesimal execution must have hypnotized the miniaturist. In such a state of total artistic involvement, the hand, it would seem, could be led by mystical forces beyond the reasonable constraints of craft, and in producing such labyrinthine microscopic worlds, the very act of tracing the tiny lines would take on some superreality for the artist. Some scholars have suggested that the fusion of animal and letter in the name *Christus*, with the great living cross form of the *Chi*, is

221. *Text with Initials.* Illustration in the Book of Kells. 13 × 9½″. Late 8th–9th century. Trinity College Library, Dublin (MS 58, A.1.6, fol. 183v)

222. *Canon Table* (Canons VI, VII, and VIII). Illustration in the Book of Kells (fol. 5). 13 × 9½″

223. *Cats and Mice with Host.*
Detail of colorplate 33

a veiled allusion to the Incarnation of the Word as well as to the supreme sacrifice of Christ on the cross.[26]

Curiously, human heads can be discerned here and there. Three angels appear along the descender of the *Chi,* a monk's head emerges from the end of the *Rho,* and surprisingly lifelike animals appear elsewhere. Two cats are crouched behind mice tugging at a round wafer (fig. 223), a black otter catches a fish directly below the *Rho,* and two moths are pinioned in the upper extension of the *Chi.* The fish captured by the otter (cf. the legends of Irish monks miraculously treated to fish each day by an otter) has been interpreted as a symbol of Christ (cf. p. 19), while the wafer taken by the mice has been likened to the host of Communion in the Mass. Since the cats, mice, and otter are creatures of the earth and the moths belong to the air, these mysterious animals have been further interpreted as symbols of Christ's resurrection. But these are only marginal associations at best—if, indeed, we accept such interpretations—that are lost amid the grandiose fireworks of forms. It is the astonishing growth of these beautiful motifs that commands our attention.[27]

The obsession with continual change and transmutation—a magical metamorphosis—brings to mind the unruly imagination that characterizes early Irish poetry, where animals turn inside out, seas change into clouds, streams suddenly stop and begin again, where Saint Finan can boast: "A

hawk to-day, a boar yesterday, Wonderful instability! . . . Though to-day I am among bird-flocks; I know what will come of it: I shall still be in another shape."[28] And one is reminded of a fascinating riddle of the Medieval Irish: "[Who am I?] An enemy ended my life, deprived me of my physical strength: then he dipped me in water and drew me out again, and put me in the sun, where I soon shed all my hair. After that, the knife's sharp edge bit into me and all my blemishes were scraped away; fingers folded me and the bird's feather often moved over my brown surface, sprinkling meaningful marks; it swallowed more wood-dye and again travelled over me leaving black tracks. Then a man bound me, he stretched skin over me and adorned me with gold; thus I am enriched by the wondrous work of smiths, wound about with shining metal." Answer: I am a Gospel book, illuminated and written on prepared vellum leaves and bound in a fine golden cover![29]

Irish and Northumbrian manuscripts were frequently bound in exceedingly rich covers encrusted with precious gems. Fortunately, a fine example of such sumptuary art survives in the famous (lower) cover for the Lindau Gospels in the Pierpont Morgan Library in New York (colorplate 34), generally described as a continental work of the Carolingian period, about 800, because the small *cloisonné* enamel inlays with busts of Christ about the center of the huge cross resemble Italianate types not commonly found in Ireland or

Northumbria.[30] Perhaps this is so, yet the allover pattern of dynamic interlace with serpents and dragons in silver gilt that forms the background for the sweeping arms of the cross closely resembles the intricate designs of the carpet pages in books such as the Lindisfarne Gospels (colorplate 31), and, like them, the Lindau cross has a symbolic meaning as well as a decorative role. The subjection of the wild creatures to the commanding cross dominating the surface proclaims the order and authority of the church over the natural world, the sign of the victory of Christ over the chaos of nature with its menacing beasts and monsters, a theme to which we shall now turn.

Typical of much Irish metalwork is the *Crucifixion* plaque from Rinnagan (fig. 224), which very likely served as an adornment for a book cover. Even in treating such a familiar theme as Christ on the cross, however, the craftsman's dis-

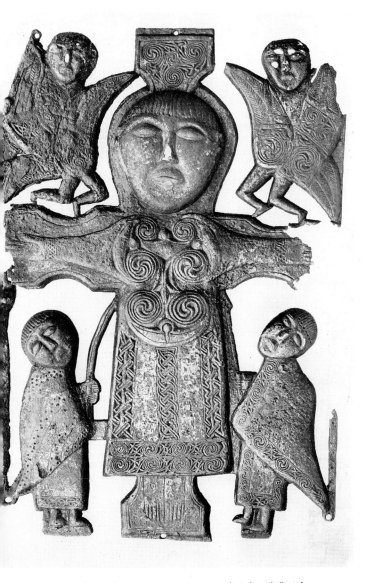

224. *Crucifixion from Rinnagan.* Bronze, height 8¼". 8th century. National Museum of Ireland, Dublin

taste for realistic representation is striking. Many of the necessary narrative elements are present, but from the rendering of the flat torso of Christ on the stunted cross to the odd figures added symmetrically above and below the arms, the intent was to emulate a piece of abstract jewelry.

Hiberno-Saxon sculpture on a grander scale is well represented by the great monolithic stone crosses that marked the countryside from the seventh century on. The earlier Irish stone crosses display the familiar Celtic abstractions, but in some of the later ones another spirit emerges. The surprising solemnity of the triumphant Savior standing on the main face of the *Ruthwell Cross* (figs. 225, 226), from the northwestern coast of England, seems almost Romanesque in conception. Even the ornamental touches, such as the vine and animated scroll borders, imitate Antique types rather than Northern interlace. Dated usually in the seventh century, the *Ruthwell Cross* anticipates in its style the Mediterranean character of later Saxon art in England.

As trophies or standards of victory, the symbolism of these stone crosses reaches as far back as the legend of Constantine and his victory over Maxentius in 312 (see p. 27). This colorful legend, much embellished in the course of the Middle Ages, was put into Northumbrian verse form in the *Dream of the Rood,* where the vision of the cross raised on high, ablaze with light and glittering with gold and gems, is exalted. The *Ruthwell Cross,* originally standing on the shores of the Solway, would have majestically evoked the image of the cross on Golgotha as it was erected in Jerusalem. Along the narrow flanks of the cross, inscriptions from the *Dream of the Rood* in Northumbrian dialect state that this cross suffered and bled, clearly referring to the sacramental meaning of the Crucifixion as well as to its symbolism of triumph.[31]

Below the feet of Christ are two animals that symbolize the forces of evil, as the inscription informs us: "Jesus Christ: the judge of righteousness: the beasts and the dragons recognized the savior of the world in the desert." It should be noted that the *Ruthwell Cross* and others like it were not funerary monuments but pillars that marked centers for outdoor worship and commemorations of the monastic or ascetic way of life. In the life of Saint Kentigern (c. 518–603), an anchorite monk in the region of Strathclyde, where the *Ruthwell Cross* was placed, we are told that the missionary saint erected many such stone crosses in the countryside to mark his triumphs in the conversion of the heathen.[32]

It has been suggested that the *Ruthwell Cross* was set up as a sign of the triumph of the Roman church over the Irish at the Synod of Whitby (663) and that its style displays the victory of the Mediterranean representational arts over the wildly imaginative Irish. But the victory hardly seems one of ecclesiastical authority if we attend the subject matter more carefully. The little scenes that border the "Christ of Righteousness," above and below, illustrate the eremitic or an-

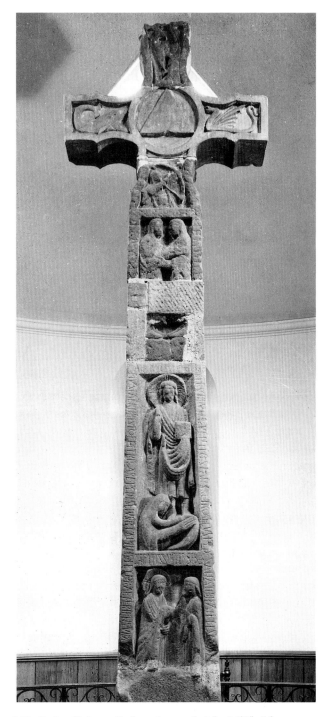

225. *Ruthwell Cross*. Red sandstone, height 16'6". 7th century. Ruthwell (Dumfriesshire), Scotland

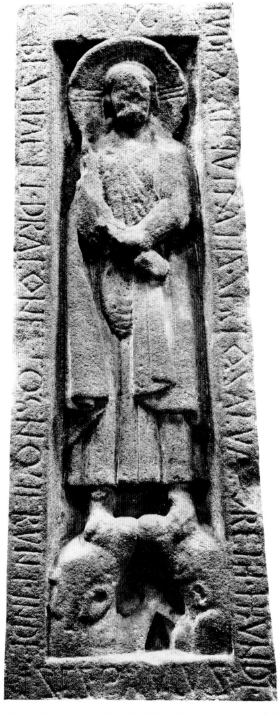

226. Christ Triumphant. Detail of fig. 225 (main panel of shaft, north face)

chorite way of life in seclusion and in harmony with the beasts of the natural world that dwell there: Saint John the Baptist stands with the lamb as a hermit in the desert, and Saint Anthony and the hermit Paul, the founders of the anchorite orders in the deserts of Egypt, meet and break bread brought by the raven in their story.

What, in fact, the curious legends on the *Ruthwell Cross* celebrate is the victory of the ascetic Christian monk over the raw forces of nature, like the beasts who, tamed by Christ's presence, yield and live in harmony under him. Rather than proclaiming the new authority of the Roman church and the Benedictines, these carvings more strongly celebrate the monastic ideals of the Irish, and while the sculptures can be analyzed formally as being basically Anglo-Roman in style, the meaning of the cross echoes the calling of the Columban Irish.[33]

CHARLEMAGNE: *RENOVATIO IMPERII ROMANI*

O<small>N DECEMBER</small> 25, 800, while attending the third Christmas Mass in the Basilica of Saint Peter in Rome, the king of the Franks, Charlemagne, kneeling before the Tomb of the Apostle in the apse, was approached by Pope Leo III. When Charlemagne rose, the pope placed a crown on his head, and an auspicious acclamation was chanted by the congregation about them: "To Charles, the most pious Augustus, crowned by God, the great and peace-giving Emperor, life and victory!" Much controversy obscures the actual events that happened — Einhard, Charlemagne's biographer, tells us that the king was unaware of the pope's plan and would have avoided the ceremony had he known — but the fact remains that a chieftain of barbaric origin and speech from across the Alps was officially crowned emperor of the Romans, an act that was to have a lasting tradition in the history of the Holy Roman Empire and an honor that gave new dignity to Northern rulers and affirmed close church-state unity henceforth in the Latin West. Furthermore, it was a revival of the ancient Christian empire of Constantine, one based on the forged "Donation of Constantine," a document allegedly issued by the first Christian emperor submitting his crown and authority to the Roman church.[34]

All of this is announced in a mosaic that filled the apse in the state hall of Leo III (*aula Leonis*) in the Lateran Palace, apparently put there the year before, 799, in anticipation. Leo's mosaic displayed the hallowed Early Christian theme of the *Dominus legem dat,* or Mission of the Apostles to teach all nations, baptizing them in the name of the Father, the Son, and the Holy Ghost, as the inscription proclaims. More significant were the mosaics on the walls immediately framing the apse, right and left, with state portraits. To the left the enthroned Christ gives the keys of authority to a kneeling Saint Peter and the banner of the church to Constantine, and, on the right (fig. 227), Saint Peter transfers his authority to Pope Leo and Charlemagne, the two latter portraits having square nimbi to indicate that they were still living.[35]

The papacy had petitioned the Frankish rulers once before. In 754 Pope Stephen II had personally crowned Pepin, Charlemagne's father, king of the Franks in a ceremony at Saint Denis outside Paris, but the grandiose affirmation in 800 of the alliance was truly a pivotal point in history. Henceforth Charlemagne openly pursued a policy of reviving the emperorship of ancient Rome, instituting an outright *renovatio imperii romani* and stamping it so on his coins.

Unlike other so-called renaissance movements in the Medieval world, the program of Charlemagne does, in fact, present us with a conscious revival of the ancient state, and it manifested itself in two forms: the alliance of church and state and the florescence of a renaissance in the arts, a cultural endeavor that may have missed the mark at times but that nonetheless was a conscious turning back to Antiquity for models. With the death of his brother Carloman in 771, Charlemagne had inherited all of Francia (a territory that included France, western Germany, and the Netherlands), and it seems clear that he first set about to reorganize the administration of his domain, formerly identified with the "mayor's palace," into a far-reaching organization of states. The court was at first itinerant, with the king and his family, together with councillors and aides, moving from one capital to another frequently. Now a system of vassalage was adopted with counts (*comitati*) or companions of the court controlling defined territories or counties, anticipating in some respects later Romanesque feudal systems.[36] The clergy, always powerful in the government in the North, were incorporated as the *capellani,* or court clergy.

Admittedly, the Carolingian administration was loosely organized, and the domain lacked a central capital until Aachen was established in 794, but it is apparent from numerous sources that Charlemagne had in mind a means of universal education for the peoples of his empire. The "academy" that Charlemagne established at his court was very likely an informal circle of learned clerics and scholars who gathered about him from time to time. The monastic schools spread the new education throughout the North, engendering an enthusiasm for ancient learning.

Aside from the religious texts that were collected in the libraries, pagan literature was also much revered. Car-

In Patriarchio Lateranensi q in aula tooromana.
A PP. Leone iij. fadm exopere nevomicular
extat .S. Petrus Pallium tribuens Leoni
3. et imponu Carolo magno, qui
insignia getilitia Leonis iij.
manu in vexillo gestat.

SCS PETRVS

✦ D N CARVLVS

R E X

SCSSIMVS .D.N. LEO PP.

DONAS VICTO EA

Onuphrius Panuinig de Septem
Ecclesis perpora legit, Carolo
Regi. Et infra male legit,
Beate Pete, Leoni papa biroia
Carulo Regi-

vide mea adversaii fol. 302

227. *Saint Peter Presenting the Papal Pallium to Pope Leo III and the Banner to Charlemagne.* 18th-century watercolor copy of mosaic in the Hall of Leo III in the Lateran Palace, Rome. Vatican Library, Rome

olingian copies of early illustrated books of the comedies of Terence (fig. 228) are valuable today for our knowledge of the Roman theater of the second and third centuries A.D. and retain the earlier column-picture format of ancient illustrated books.[37] Numerous other Classical texts were copied, including the *Carmina* of Fortunatus, the *Psychomachia* of Prudentius, *De Consolatione philosophiae* and *Aritmetica* of Boethius, astrological poems of Aratus, herbals and bestiaries, surveyors' manuals, calendars, and so forth. We know that a copy of Vitruvius's *De Architectura* existed at Fulda since Einhard wrote to a young monk there requesting information concerning the terminology of the ancient Roman authority.

Einhard also referred to a reliquary at Fulda that imitated an ancient building in its form. In fact, he designed a triumphal arch of ancient form as a base for a reliquary shrine

for Saint Servatius at Maastricht (fig. 229). Einhard's base was lost in the French Revolution, but drawings of it survive. Clearly inscribed as a trophy of victory, the base included an enthroned Christ with the twelve apostles in the attic; a second tier displayed the four Evangelists with their symbols in the spandrels and the Annunciation and the *Ecce Agnus Dei* on the ends; and the lower walls of the arch formed portrait galleries with standing soldiers holding spears and shields, court attendants with standards (*vexilla*), and two emperors on horseback trampling dragons.[38]

Perhaps we should consider these examples of Antique revival as "miniatures" in conception and limit the renaissance movement to the domain of book illustration and other minor arts, but this would be wrong. To evaluate the Carolingian Renaissance properly, we must first consider architecture, the primary manifestation of church and state alliance, and then turn to the scriptoria. Fortunately much survives of Charlemagne's new capital at Aachen.[39]

Extensive excavations and studies of the site were carried out and published in five volumes recently (1965–68), and, furthermore, the major building, the palace chapel, survives nearly intact, although it is somewhat smothered under later additions. Originally the chapel was part of a large complex of palace structures (fig. 230). From its huge courtyard— over 650 feet broad—a long gallery led to the royal hall, the *aula regia*, resembling the *aula Leonis III* in the Lateran Palace complex, where official state business would be conducted.

Much of this is obscured today, but the sturdy and rugged palace chapel, the *cappella palatina*, of Charlemagne remains (figs. 231–34). This handsome structure was the emperor's private chapel, and its spiritual models were the palace churches in Rome (the Lateran—Einhard referred to it as Charlemagne's "Lateran") and in Constantinople. Much speculation has been devoted to its actual physical model or models in both plan and elevation, but it is apparent that the *cappella palatina* of Charlemagne owes much to the palace church of Justinian in Ravenna (fig. 143), a building that Charlemagne knew well and from which he removed marble columns and panels for the construction of its counterpart in Aachen, as Einhard himself admits.

The ground plan features a central octagon supporting a dome, a projecting apse, and an impressive two-towered entrance. Charlemagne employed a Frankish builder, Odo of Metz, and Einhard was the general supervisor of the entire complex. Thus the imprint of the North is not lacking, especially in its solid walls. San Vitale is light and airy with its brick construction; the *cappella palatina* at Aachen is ponderous and well-hewn in stone. The attached entranceway is tall but compact, with a deep exedra carved from its plain front and a giant "window of appearance" (an opening where the emperor could view the atrium and be visible to the people there) penetrating its second level. Two cylindri-

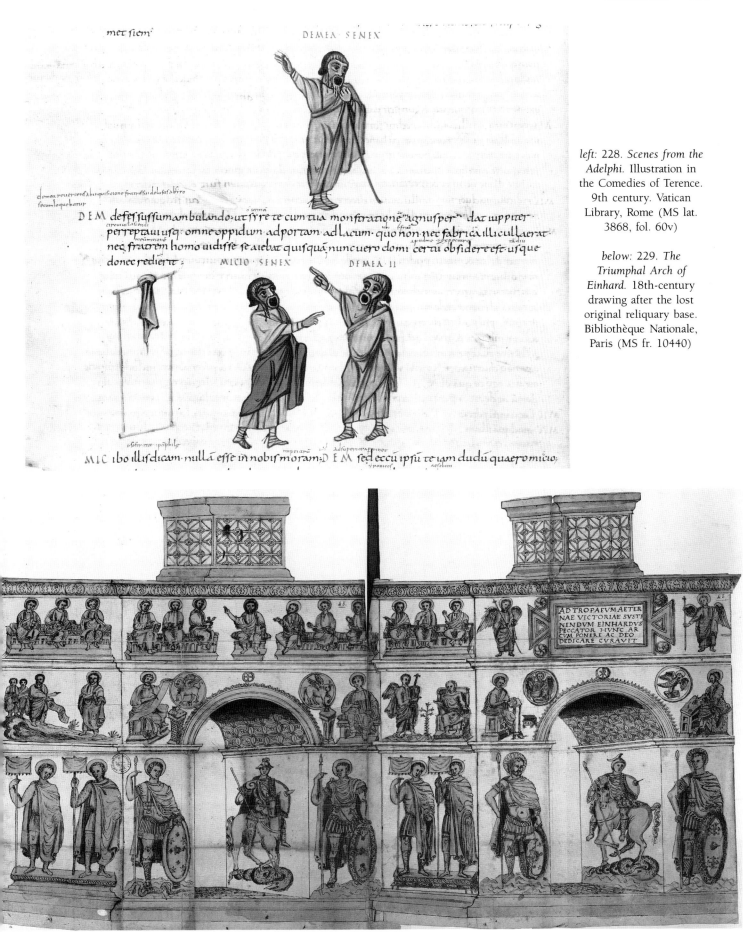

left: 228. *Scenes from the Adelphi.* Illustration in the Comedies of Terence. 9th century. Vatican Library, Rome (MS lat. 3868, fol. 60v)

below: 229. *The Triumphal Arch of Einhard.* 18th-century drawing after the lost original reliquary base. Bibliothèque Nationale, Paris (MS fr. 10440)

230. Royal Hall and Palace Chapel of Charlemagne, Aachen. Plan of the 9th-century complex (after Conant)

cal towers squeeze in the portal, symbolizing its function as a fortress as well as an imperial foundation.

On the second level, directly behind the window above the entrance, is a broad platform on which sits the marble throne of Charlemagne, serving as his royal loge with a view down to the altar dedicated to Mary in the apse (fig. 233). Directly opposite Charlemagne's throne and above the altar of Mary was a second altar (on the first level of the galleries) dedicated to the Savior, and this in itself is significant. The Lateran, too, was originally dedicated to the Savior. The throne of the emperor thus mirrored the altar-throne of Christ; Charlemagne, chosen by God, was the co-regent of

Christ on earth, and at Aachen their dual presence is emphatically stated.

Across the octagonal space that separates the domain of the secular ruler—the two-towered facade—and that of the divine—the sanctuary—the powers of church and state interpenetrate and reflect one another. According to a ninth-century description of the coronation of Charlemagne's son Louis the Pious, the emperor, dressed in royal robes and crowned, stepped before the upper altar dedicated to Christ and placed there a golden crown just like the one he wore. And according to a panegyric addressed to Charlemagne (*De sancto Karolo*), dating from a later period, this identification was still remembered: "Oh King, triumphator of the world, Co-ruler with Jesus Christ. Intercede for us, Our Holy Father Charlemagne."[40]

The identification of the emperor as co-ruler with Christ was further proclaimed in the impressive mosaics that filled the dome (fig. 234). Although the present decoration is a replacement—the dome itself has been rebuilt—the general iconography is surely true to the original scheme. There, in keeping with Early Christian triumphal displays, the appearance of the One enthroned in heaven amid the four beasts and surrounded by the twenty-four elders (Rev. 4) is seen dramatically against a star-studded background of gold. The enthroned Christ, his right hand raised in blessing, appears directly above the altar dedicated to the Savior and opposite Charlemagne's throne. It is as if the invisible presence of Christ in the altar opposite the emperor were made manifest in the mosaic in the dome.

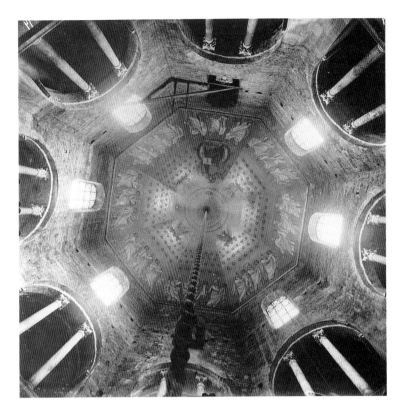

A new chapter in the history of Medieval architecture was written following excavations of French and German sites after World War I. It was formerly assumed that the Carolingians had contributed little; the few buildings that were known and studied were described as provincial and debased imitations of Late Antique or Ravennate structures, and the palace chapel at Aachen was considered a wondrous

opposite left: 231. Palace Chapel of Charlemagne, Aachen. Entranceway. Late 8th century

opposite right: 232. Palace Chapel of Charlemagne. Lateral view

right: 233. Palace Chapel of Charlemagne. Interior with the throne in the royal loge

above right: 234. Palace Chapel of Charlemagne. View into the dome with the mosaic of the *Maiestas Domini* (restored)

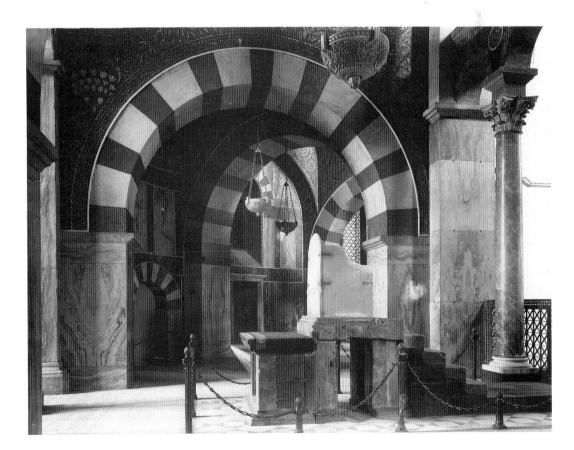

anomaly. That has all changed, and the architecture of the Franks is now recognized as an important link between Antiquity and the Romanesque and Gothic. Aachen fits into the pattern in a special way.

Two important discoveries have been made that reinforce the idea of a Carolingian Renaissance in architecture. In an article published in 1942, Richard Krautheimer demonstrated that many of the basilical plans of Carolingian churches were outright revivals of the layout of Saint Peter's in Rome.[41] Secondly, it was also discovered that one unusual but consistent feature of the major Carolingian basilicas was the independent structure that emphatically marked the western or entrance end of the church, an independent "westwork" (*Westwerk* in German). Since basilicas with westwork additions were also imperial foundations, it seemed clear to most historians that the strange annex was, in fact, an abridged palace chapel welded to the congregational hall basilica. It functioned as a special room for the emperor, where, during his visitations, he could participate in the services and other ceremonies.[42]

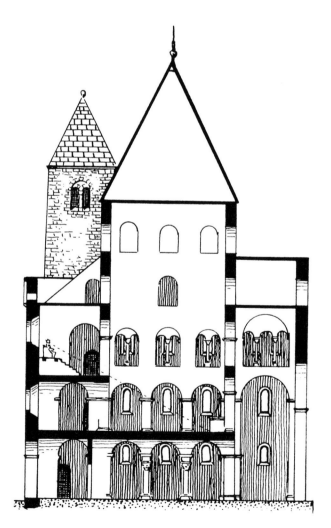

235. Abbey Church, Corvey (Westphalia). Cross section of the westwork (after Fuchs). Late 9th century

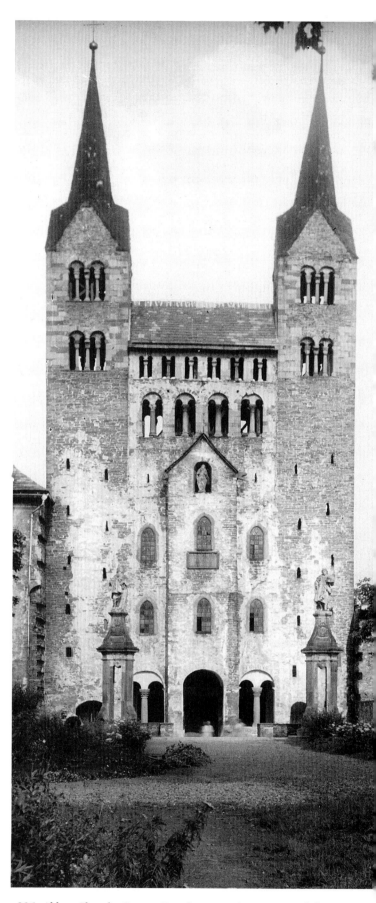

236. Abbey Church, Corvey. Facade. Late 9th century with later additions

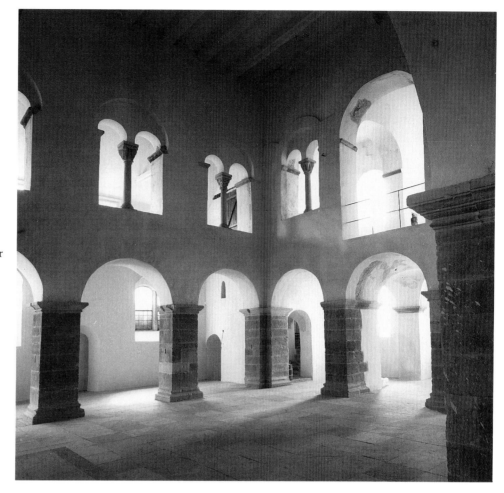

237. Abbey Church, Corvey. Interior
with view into western tribune.
Late 9th century

The essential elements of the westwork are clearly presented (fig. 235). The structure was usually of a central plan with a domed tower over the center; on the interior, well-marked galleries distinguished three or more levels for the participants—a kind of celestial-terrestrial hierarchy implied—with the imperial loge on an upper floor having an unobstructed view into the nave and the sanctuary below; finally, it featured a symbolic facade with a great doorway or doorways, a large window of appearances on the level of the emperor's loge, and two towers framing the portal like bookends.

This form, in essence, is a type similar to the two-towered structures of ancient Rome that marked an edifice as an insignia of imperial power and domain, whether it be a city gate, a triumphal arch, a palace facade, or a throne room. Carolingian westwork assumes an important role in the evolution of the familiar two-towered facades of Medieval cathedrals in France. With its two towers and its impressive portals, its rose window and king's gallery, the Gothic facade was, in effect, simply the aggrandizement of the Carolingian westwork.

While this interpretation of Carolingian westwork churches may seem extreme, there is good evidence to support it. Interestingly, one of the first Gothic structures in France, the royal abbey church of Saint Denis, was very likely one of the first Carolingian churches to have what can

be termed a westwork. Saint Denis was founded as the palace church of Charlemagne's father, Pepin, who was allegedly buried before its entrance. Its role as a royal church was continued under Charlemagne and his sons, and, in fact, Saint Denis remained the burial church of the French monarchy until recent times.

In his book on the rebuilding of the ancient Saint Denis in 1142–44, Abbot Suger leaves us much important information concerning its original appearance. He tells us that "in the front part at the principal doors the arched doorway was squeezed in on both sides by twin towers.... We began therefore at the entrance tearing down the addition which, it is related, was built by Charlemagne for a worthy occasion."[43] The Carolingian basilica, according to the most recent excavations, revived the *T*-shaped ground plan of Old Saint Peter's; the portals of the new construction added by Charlemagne thus would have transformed the church into a westwork structure, an appropriate building for conducting Christian services in the company of imperial visitors.

A number of variations on the basic plan were possible, and only gradually have the remains of westwork churches been identified and classified as to regional types. One fine example, Corvey in Westphalia (figs. 236, 237), founded in 882, remains surprisingly intact and will serve as our example. While upper stories have been added to the facade, the handsome westwork still displays much of the strength and

austerity of these early imperial churches, with its plain volumetric masses and clearly stated elements: the central plan (the central cupola has been submerged in the later rebuildings), the projecting main portal with twin towers, the window or windows of appearance at the level of the *Kaisersloge,* or king's gallery.[44] The interior of the westwork, sometimes referred to as a tribune, also is marked by the large opening for the imperial throne in the western gallery, offering an open view into the nave and sanctuary.

The famous Torhalle of Lorsch (fig. 238), originally standing within the atrium of the towered basilica there, was erected as an independent station for imperial ceremonials. Modeled loosely on the Arch of Constantine in Rome, the Torhalle (porch or gateway) served as a kind of waiting room during the visit of the emperor. The colorful masonry patterns on the exterior, which seem to be concessions to Northern taste, were inspired by a type of Roman construction (*opus reticulatum*), and remains of fresco decoration in

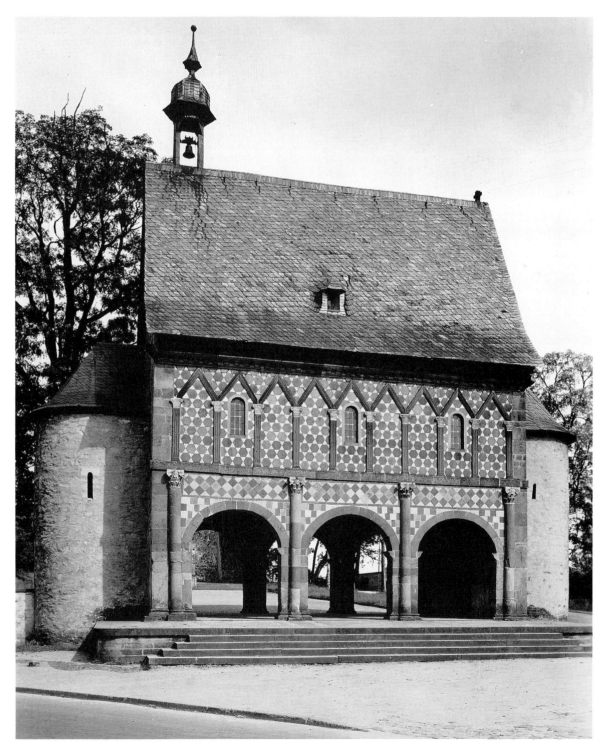

238. Torhalle of the Monastery, Lorsch. c. 800

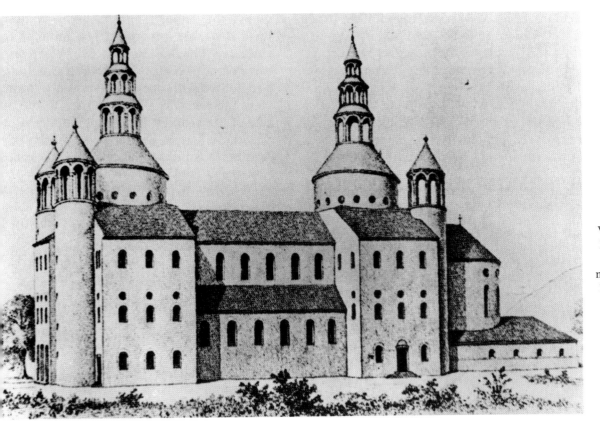

the interior of the upper chamber also have ancient anteced-ents. The two towers fused to the end walls of the gate-way underscore its imperial role, paralleling that of the westwork.

An impressive example of an imperial monastic com-munity is that of Centula in the northwestern corner of France, founded by Abbot Angilbert in 790.[45] Angilbert, one of the poet-scholars attached to Charlemagne's academy, was a close friend of the royal family—so close, in fact, that it is alleged that he had a child by Charlemagne's daughter Bertha. The illustrious abbot built an entire holy city at Centula with a complex of three churches and other monas-tic buildings forming the core of a sprawling community of seven villages, symbolic of the seven stations of the cross.

More than three hundred monks resided at Centula along with one hundred novices and a large lay staff. The major church, dedicated to the Trinity, Mary, and Saint Richarius, was vast and complex, accommodating several altars (fig. 239). It apparently had monumental additions at both ends, anticipating the "double-ender" churches of Ottonian and Romanesque times in Germany (see pp. 236, 334). An-gilbert's church was restored in 881 after it had been razed by Norse invaders, and the present site has been further changed by much rebuilding in the thirteenth and fourteenth centuries. However, an eleventh-century drawing of the ear-lier monastic complex (here copied in an engraving of the seventeenth century) preserves it in part (fig. 240).

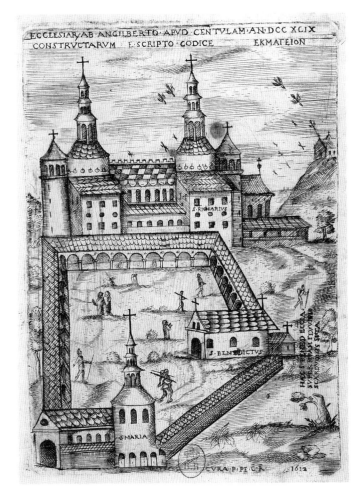

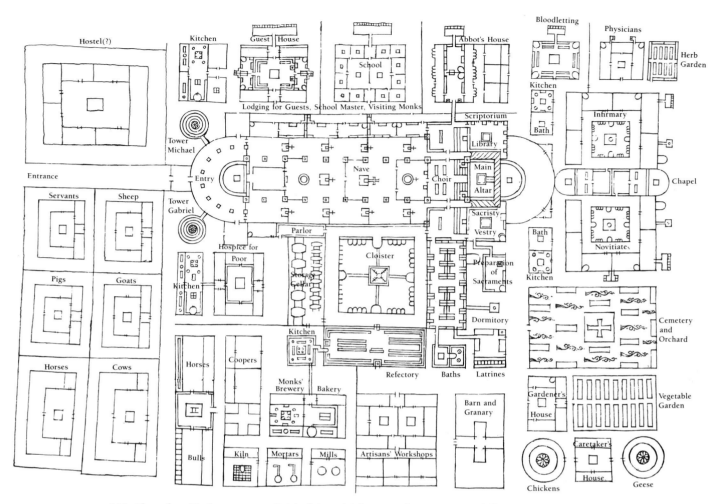

241. Plan of an ideal monastery. Original in red ink on parchment, 28 × 44⅛". c. 820. Stiftsbibliothek, Saint Gall, Switzerland (inscriptions translated into English from Latin)

While an accurate reconstruction of the imperial monastery of Centula is not possible, a complete ground plan for a Benedictine community of the ninth century comes down to us in the form of five sheets of vellum preserved in the abbey library of Saint Gall (Switzerland), here reproduced in a redrawing for clarity (fig. 241). The ambitious plan was presumably drawn up as a utopian Benedictine community. At synods of 816 and 817 held at Aachen, the Benedictine Order was adopted as the official monastic system, and the Saint Gall plan provided the model for the physical layout. We know further that the plan was sent by Abbot Haito of Reichenau, a leading ecclesiastical figure at the Carolingian court, to Abbot Gozbert of Saint Gall (816–36) with the accompanying note: "I have sent you, Gozbert, my dearest son, this modest example of the disposition of a monastery, that you may dwell upon it in spirit. . . . We drew it through the love of God out of fraternal affection, for you to study only."[46]

The Saint Gall plan is laid out according to a simple grid system with axes roughly marking off four major areas about the huge church in the center. Numerous buildings are

named, including the most menial sheds, the rooms for guests, the hospital for the infirm, the quarters for the monks, the wine cellar, and even the trees in the orchard are designated. Four basic quarters about the church are clearly marked. First is the closed monastic core—the monastery within the monastery, so to speak—adjoining the cloister on the south side of the church. This area is the sacred claustrum, or enclosure, reserved for the monks, who pursue their devotions there uninterrupted by outside distractions.

Opposite this sacred core, on the north side of the church, is the residence for the imperial guests and the abbot's house. Here, too, are the schools, the library, the scriptorium, and the larger kitchen. To the south, beyond the monks' refectory and kitchen, is the area for the lay workmen, the craftsmen, their kilns, mills, stables, brewery, and bakery. The final arm, to the east beyond the apse of the church, is lined with rooms for the monastic physician, the infirmary, the chapel for the sick, and a cloister. In the southeastern corner is the area for the cemetery and the orchard along with the gardener's house. Saint Gall's ideal monastery was thus envisioned as a self-sufficient city of its own, closed to the

outside world and yet accommodated to receive amiably pilgrims and royal guests, as was the Benedictine practice.

The great church in the plan is impressive in scale and complexity. The western entry facade is marked by a curious semicircular atrium, labeled the "Paradise," flanked by two great round towers dedicated to the militant saints, the archangels Michael and Gabriel, as protectors of the community. The elevation of the church remains questionable, but it no doubt would be a meaningful symbolic structure since the ground plan is laid out in very precise measurements. All dimensions are governed by a "mystical" harmony of numbers, a sort of Golden Mean, with the basic module being the church crossing. From this inner core all other parts follow a symbolic geometric and arithmetic progression based on the trinitarian triangle and the form of the cross. The thorough and meticulous studies of Walter Horn,

involving the measurements and module of the entire complex, have made a reasonable reconstruction of Saint Gall possible (fig. 242).[47]

Evidence of monumental mural decoration in Carolingian times is scant. The poet Ermoldus Nigellus describes extensive fresco cycles in a church(?) at Charlemagne's residence in Ingelheim on the Rhine with Old Testament scenes painted on one wall of the nave and New Testament episodes on the other. In the nearby palace quarters, in the *aula regia,* secular histories provided a profane testament with stories taken from the fifth-century *History Against the Pagans* by Paulus Orosius and legends of more contemporary "fathers, who were already closer to the faith," including Constantine, Theodosius, Charles Martel, Pepin, and Charlemagne conquering the Saxons. Nothing remains of the buildings or paintings at Ingelheim.[48]

242. Hypothetical reconstruction of the ideal monastery for Saint Gall (model by Walter Horn)

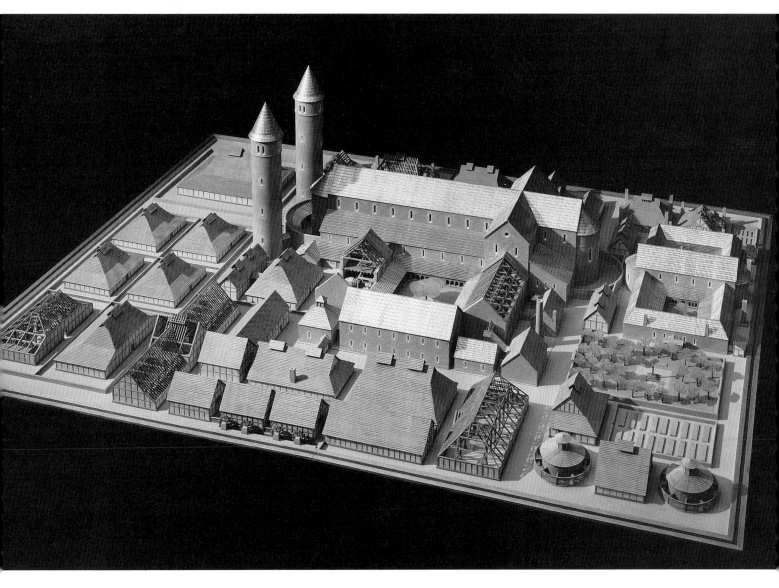

Theodulf, another famous court poet, was bishop of Orléans and abbot of Saint-Benoît-sur-Loire (Fleury). He built a comfortable villa retreat between his two benefices at Germigny-des-Prés on the Loire, and the walls formed a kind of gallery of special secular paintings, including those of the seven liberal arts, the four seasons, and a *mappa mundi,* or map of the world. The villa of Theodulf has vanished, but a small oratory erected nearby still stands (fig. 243). The curious central structure has been poorly restored, but apparently a domed tower covered the crossing with four smaller cupolas at the corners. Apses projected on all four sides, the eastern or main end being trebled.

The lavish decorations in mosaic and stucco on the interior survive only in fragments, except for the surprising mosaic that fills the main apse (fig. 244).[49] An inscription along the lower border informs us to "Heed the holy oracle and the cherubim, consider the splendor of the Ark of God, and so doing, address your prayers to the master of thunder and join with them the name of Theodulf." In the center, against a golden background, rests the Ark of the Covenant as described in the first Book of Kings (8:4). Two tiny angels in gold hover above the Ark, while two larger ones, dressed in purple, their wing tips touching, stand to the sides. These creatures are meant to represent the cherubic and seraphic guardians of the Ark.

The style of the heads of the two larger angels is Byzantine, but the craftsmanship does not warrant an attribution to Eastern artists, and, furthermore, such a representation is unprecedented in Byzantine church decoration. The tabernacle with the Ark of the Covenant does appear in early

243. Oratory of Theodulf, Germigny-des-Prés. Interior. Consecrated 806

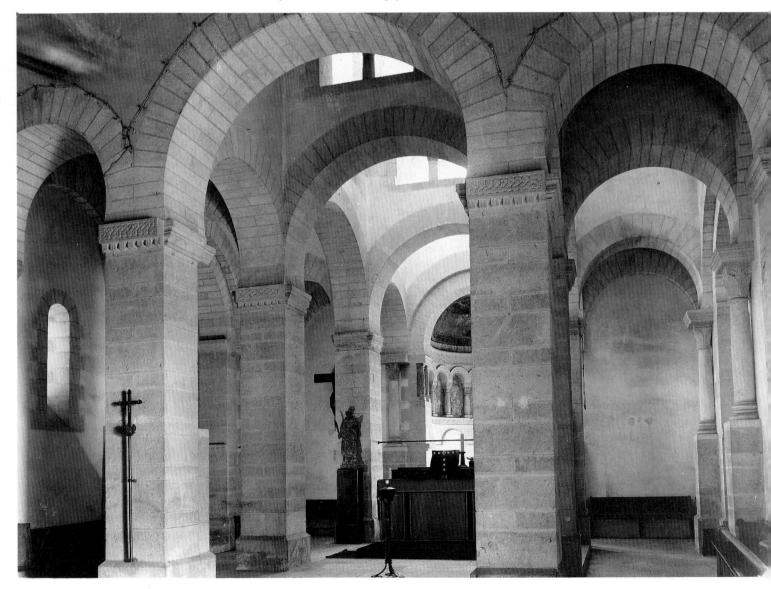

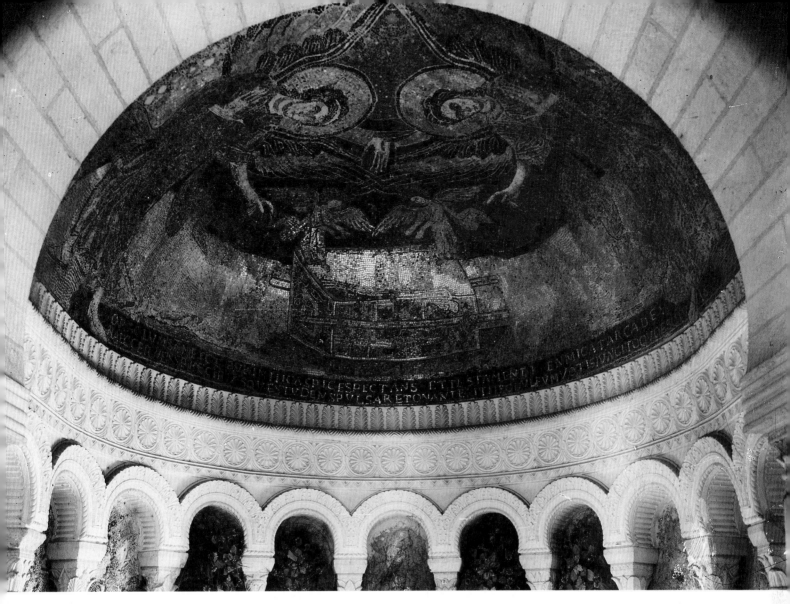

244. *Ark of the Covenant*. Apse mosaic in the Oratory of Theodulf, Germigny-des-Prés. Early 9th century

Jewish art and in early Spanish Bibles, and the fact that Theodulf was a Spaniard may account for the unusual iconography here. When we remember that this same Theodulf was very likely the composer of the *Libri Carolini,* a Carolingian aniconic treatise, an even more engaging solution presents itself. In keeping with the prohibition of representing godhead in portrait form, the Jewish Ark of the Covenant, as a substitution for the likeness of Christ the Lord, would serve as a powerful evocation of divine presence above the altar.

Extensive remains of mural painting were recently uncovered in the Church of Saint John at Müstair (figs. 245, 246) in eastern Switzerland.[50] The paintings in the nave are in registers, with scenes from the Infancy and Ministry of Christ. A Last Judgment covered the west wall behind the entrance, while the north apse presented a *Dominus legem dat* with the enthroned Christ handing the keys to Saint Peter and a book (?) to Paul. Overpainting has obscured much of the figure style at Müstair, but the iconography

appears to be similar to that of the cycles in Early Christian basilicas. That such programs of decoration were models for the Carolingians is also suggested by the early description of paintings in the ninth-century abbey of Saint-Faron at Meaux: "In the vault of the apse appears a figure painted on a star-spangled ground, the figure of Christ the Lord. Following each other on the walls are Bible stories, fine windows and pictures of the Fathers and the Popes."[51]

Considering the paucity of architectural remains, it is not surprising that Carolingian mural decorations are rare and fragmentary. That extensive picture cycles originating in Early Christian Rome became available to the Northern artists is, however, clearly demonstrated by the rich variety of subjects that appear in Carolingian illuminated manuscripts.

Carolingian book illustration presents an exciting history. Charlemagne's personal ties with the papacy were initiated nearly twenty years before the momentous coronation of 800, when in 781 he escorted his son Pepin to Rome to be

245.
Church of Saint John,
Müstair, Switzerland.
North aisle apse.
9th century

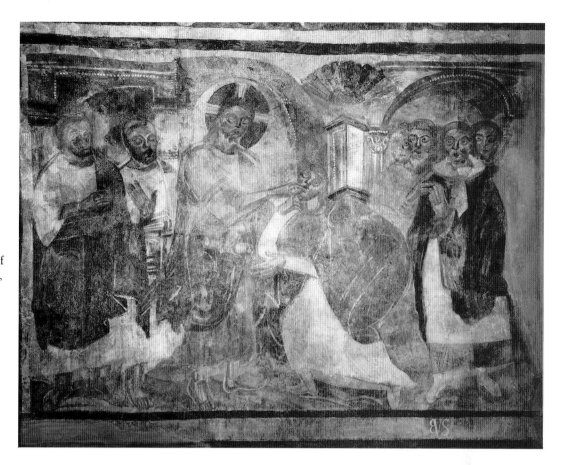

246.
Christ Healing the Blind Man. Fresco in the nave of the Church of Saint John, Müstair. 9th century

baptized by Pope Hadrian. He returned to Francia with many gifts, including books. One of the earliest Carolingian court manuscripts with illuminations, the Godescalc Gospels (fig. 247; colorplate 35), commemorates this significant journey, and the full-page miniatures that adorn its pages are startling. The text, which is actually that of a lectionary with selections of the Gospels, signed by the monk Godescalc, is dedicated to Charlemagne and his wife Hildegarde (d. 783) and contains references to the baptism of Pepin in Rome.

In the beginning of the manuscript a handsome frontispiece for the vigils of Christmas presents an unusual *fons vitae,* or fountain of life, with a font covered by a conical dome resting on a huge, arched entablature carried by eight columns. A large cross surmounts the ensemble. The fountain is placed within a garden enlivened by plants and various fauna. Peacocks are perched on the roof, and other colorful birds are scattered about the font. A grazing hart appears in the lower right. The symbolism of the large font is clear: it refers to Pepin's baptism in 781. The Lateran Baptistry was of such a form in the fourth century (see p. 33), and, in fact, we know that golden statues of harts were placed about the columns, illustrating the lines of Psalm 41 in the Vulgate Bible (42 in the King James): "As the hart panteth after the fountains of waters; so my soul panteth after thee, O God."

The miniature is no Carolingian invention, however. It is undoubtedly a copy of an Italian picture, perhaps one brought back from Rome in 781. Whatever illusionism the model may have displayed is compressed into a bold surface design by the Carolingian miniaturist. The columns of the font are merely flat strips, and the garden does not recede but rises vertically like a tapestry with flora and fauna strewn from top to bottom. A sense of *horror vacui* characterizes the bright surface pattern, with the architecture filling the page to the margins and flora and fauna filling every available space. The ornate border, too, is elaborated with various metal-colored sections joined by variegated shafts. And how bright the colors are! Shining blues, radiant oranges, and dark wines accented with touches of gold give the miniature a sparkling richness. This is no slavish or meek copy of a Mediterranean miniature.

The portraits of the four Evangelists and their beasts are similarly transformed into radiant color patterns, and perhaps the most instructive miniature to study is the portrait of *Christ Enthroned* (colorplate 35). Here again, spatial illusion is of little concern, and the figure of Christ completely fills the page. The garden and the architectural backdrop are reduced to rich bands of metallic blue and wine sprinkled with floral motifs. Christ is draped in a deep purple tunic and a wine-colored mantle, and the black lines that are vigorously traced across his knees and along the drapery folds are the only concessions made to convey the modeling effects of the Italianate prototype. How refreshing this portrait appears when compared to the inept rendering of Saint Luke in the Gospels of Saint Augustine (fig. 213).

Illustrated Carolingian manuscripts present numerous problems, and to place them properly into schools or lines of chronological development is difficult. The most accepted

247. *Fountain of Life.* Illustration in the Gospels (Lectionary) of Godescalc. 12⅜ × 8¼″. 781–83. Bibliothèque Nationale, Paris (MS nouv. acq. lat. 1203, fol. 3v)

manner of organizing this study has been to locate the manuscripts in specific court or monastic centers, usually traceable through traditions of their patronage.[52] These schools, briefly stated, are (1) the so-called Ada Group, named after a manuscript allegedly made for a putative sister of Charlemagne and located at Aachen about 780–830; (2) the Palace School, a slightly later group of imperial manuscripts also located at Aachen that display a more concerted effort to capture the illusionistic qualities of the models; (3) the Reims School, located in a monastery near Reims, where unusual illustrated books were produced for the archbishop Ebbo between 816 and 835; and (4) the Tours School, established at the Abbey of Saint Martin on the Loire after Alcuin moved there in 796 to revise the Vulgate text of the Bible. Later schools are very loosely defined.

The Ada Group is initiated by the Godescalc Gospels, dating 781–83. That the scriptorium was actually located in

Aachen is questionable since, it will be remembered, it was not until the mid-790s that Charlemagne settled permanently in his new capital. Furthermore, later manuscripts assigned to the Ada atelier—the Ada Gospels, the Lorsch Gospels, and particularly the Soissons Gospels—are in a style not easily reconciled with that of the Godescalc miniatures. The masterpiece of this group is the luxuriant Soissons Gospels (figs. 248, 249; colorplate 36), given by Louis the Pious, Charlemagne's son, to the monastery of Saint-Médard in Soissons in 827.

The miniaturist or miniaturists of the Soissons Gospels had a model similar to that followed in the Godescalc manuscript. The same unusual fountain of life appears at the beginning of the book. It is also apparent that the younger generation of artists was greatly attracted to the illusionism of the Italian models. Their interest in reproducing the subtle details of perspective and even atmospheric effects considerably tempered their innate desire to force all of the pictorial elements to the surface, as if the page were a metallic object. The font now tilts in space, and the background is partitioned into a lower grassy field and a backdrop with a receding exedra. The animals, too, are more carefully rendered, with the birds occupying the upper zone and the harts and waterfowl placed in the meadow below. Together with this more accurate representation of space and naturalistic detail, a more orderly balance through symmetry governs the placement of the fauna.

The curious introductory frontispiece with the *Adoration of the Lamb* seems to reproduce a Roman architectural facade with curtains. Resembling a triumphal arch or ancient *scenae frons* (a theater front), the colonnaded portico opens to a view of a tiered sanctuary, perhaps symbolic of the New Jerusalem. The high entablature is adorned with four medallions decorated with symbols of the Evangelists. The cornice is a curious band decorated as a riverscape with fishes, waterfowl, and fishermen, reminiscent of the "waters of life" or "sea of glass" beneath the throne in heaven in Early Christian apse compositions (cf. fig. 61); the attic of the structure, finally, presents the twenty-four elders (unbearded) singing praises to the One worthy of opening the book of seven seals, the Lamb, placed in the summit. It would be too venturesome to interpret the miniature as a copy of a specific Roman mural program, but it seems obvious that it was inspired by an Early Christian triumphal arch or facade decoration.[53]

The stylistic changes that occurred in the thirty years separating the Godescalc and the Soissons Gospels are strikingly demonstrated in the portraits of the Evangelists (see colorplate 36). For one thing, a change in the palette can be noted immediately. Bright oranges and light blues replace the deeper, metallic hues of the earlier miniatures. The rudimentary architectural backgrounds are now articulated behind elaborate frames, the body of Saint John the Evangel-

ist is actually modeled with white strokes in his pinkish mantle, and the throne is tilted in space. Yet, even with these accomplishments in illusionism, the innate concern for surface pattern and the manipulation of objects affixed to it override the naturalism.

Upon closer study we see that the artist has thought in terms of four separate planes of representation and not one unified expanse. The outer border of gold with simulated gems forms the initial plane and seems to project from the surface like a metal strip. The shallow setting for the enframing arch comes next with its elaborate cusps. Painted cameos in blue and red are affixed to the intrados, while silver letters—the Alpha and Omega—hang on chains from the abaci of the capitals. The Evangelist appears floating in the third plane as if he were a large cutout pasted in place with its own perspective scheme. This third plane is clearly at odds with that of the background, the fourth planar surface,

249. *Adoration of the Lamb*. Illustration in the Gospel Book of Saint-Médard de Soissons (fol. 1v). 14 × 10½"

248. *Fountain of Life*. Illustration in the Gospel Book of Saint-Médard de Soissons. 14 × 10½". Early 9th century. Bibliothèque Nationale, Paris (MS lat. 8850, fol. 6v)

which is painted to resemble a multistoried facade projecting in an eerie fashion as if quickly glimpsed on a roller coaster.

This blunt confrontation of styles is partly resolved when we turn to the manuscripts illuminated in the Palace School. These are grouped about the famous Coronation Gospels in Vienna (also called the Schatzkammer Gospels) that, according to legend, were found on Charlemagne's knees when Otto III opened his tomb in the Palatine Chapel at Aachen in the year 1000 (fig. 250). The purple-stained parchment and the silver text point to a special royal function for the precious manuscript.

The Palace group is distinguished by bold, illusionistic Evangelist portraits rendered in a painterly technique that admirably captures the spirit of Antique poet and philosopher portraits. The bodies and draperies are fully modeled with highlights and shadows brushed in, and the heads

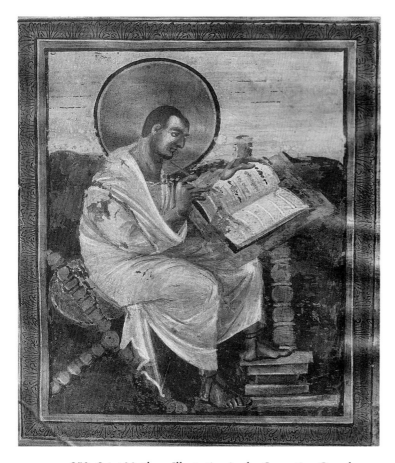

250. *Saint Matthew.* Illustration in the Coronation Gospels. 12¾ × 10″. Early 9th century. Schatzkammer, Kunsthistorisches Museum, Vienna (fol. 15r)

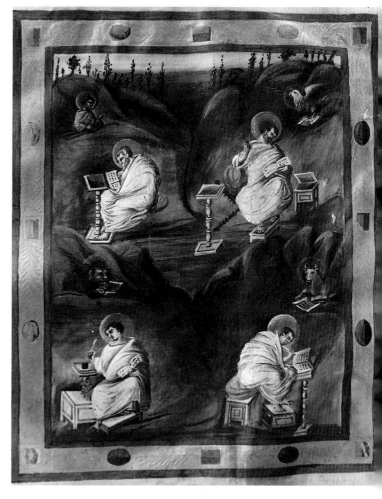

251. *The Four Evangelists.* Illustration in the Aachen Gospels. 12 × 9½″. c. 810. Cathedral Treasury, Aachen (Evangeliar, fol. 13r)

strike one as true likenesses. Surface elaborations and mannerisms have disappeared, and the bulky Evangelists fill the space with a vivid presence. No decorative beasts interrupt the serene portrayals; no complex arches or simulated gems detract from the monumentality of the portraits. Matthew brings to mind the author portraits of ancient Pompeii or that of Dioscurides in Early Byzantine art (colorplate 5). Indeed, it has been suggested that the artist here followed a Byzantine model and perhaps even that a Greek craftsman was employed.

The surprising technique of modeling with color rather than line is even more apparent in a closely related manuscript, the Aachen Gospels (fig. 251), dating about 810. Here the four Evangelists are gathered together in a sweeping landscape of bluish-green hillocks terraced along an inclined plane that rises to the "rosy-fingered dawn" which was seen in the much earlier Vatican Vergil (fig. 92).[54]

A very distinctive group of illustrated manuscripts forms the Reims School—usually located at the monastery of nearby Hautvillers—since one of the chief manuscripts, the Ebbo Gospels, contains dedicatory verses in praise of Abbot Ebbo, archbishop of Reims from 816 to 835. Ebbo had been

the court librarian at Aachen until he was elevated to his new position by Louis the Pious, and the Evangelist portraits in his Gospels echo the more illusionistic types of the Palace School, copies of which he presumably brought with him to Reims in 816. *Saint Mark* (fig. 252) closely conforms to his counterpart in the Aachen Gospels, with the author draped in a bulky mantle and seated frontally in a sketchy landscape. But amazing transformations of both style and iconography are immediately apparent in the Reims miniature. Mark turns his head abruptly upward toward the tiny lion unrolling a scroll in the top right. This is no simple author portrait; it is a type known as the "inspired Evangelist." Mark responds dramatically to the vision of the lion as if experiencing a mystical revelation.

This heightened animation conveying the psychological state of excitement is new, but it is an idea that soon passed into the repertory of the Northern artists. And how is this excitement so vividly expressed? Notable are the distortions of the facial features—the heavily arched eyebrows, the large staring eyes, the pointed lashes—and the nervous twitch in the fingers and torso. Even more expressive are the racing lines that replace the modeling in color found in the Palace

Colorplate 29. *Eagle Fibulae*. Visigothic Spain. Gilt, bronze, and gems, height 5⅝″. 6th century. Walters Art Gallery, Baltimore

Colorplate 30. *Symbol of Saint Mark*. Illustration in the Gospels of Saint Willibrord (Echternach Gospels). 12¾ × 10⅜″. c. 690. Bibliothèque Nationale, Paris (MS lat. 9389, fol. 75v)

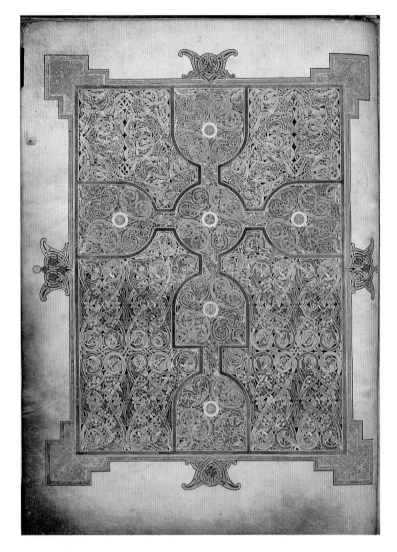

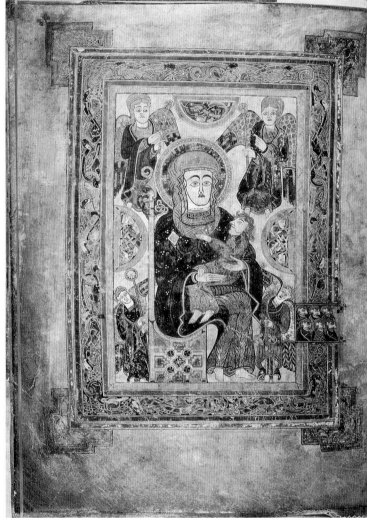

Colorplate 31. *Carpet Page with a Cross*. Illustration in the Lindisfarne Gospels. 13½×9¾". c. 700. British Library, London (MS Cotton Nero D. 4, fol. 26v)

Colorplate 32. *Virgin and Child*. Illustration in the Book of Kells. 13×9½". Late 8th–9th century. Trinity College Library, Dublin (MS 58, A.1.6, fol. 7v)

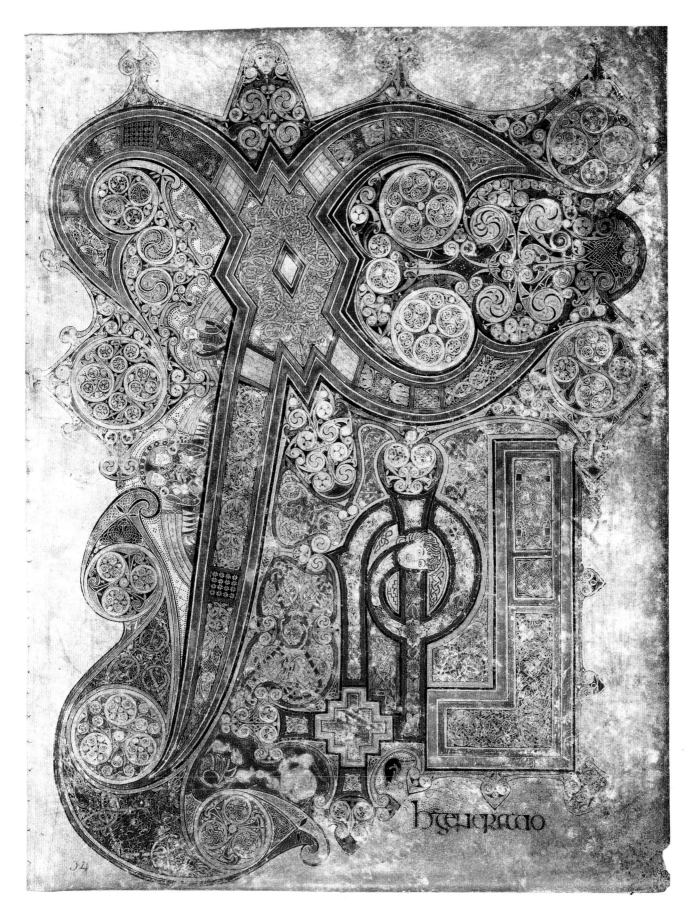

Colorplate 33. *Chi-Rho Monogram Page*. Illustration in the Book of Kells. 13 × 9½″. Late 8th–9th century. Trinity College Library, Dublin (MS 58, A.1.6, fol. 34v)

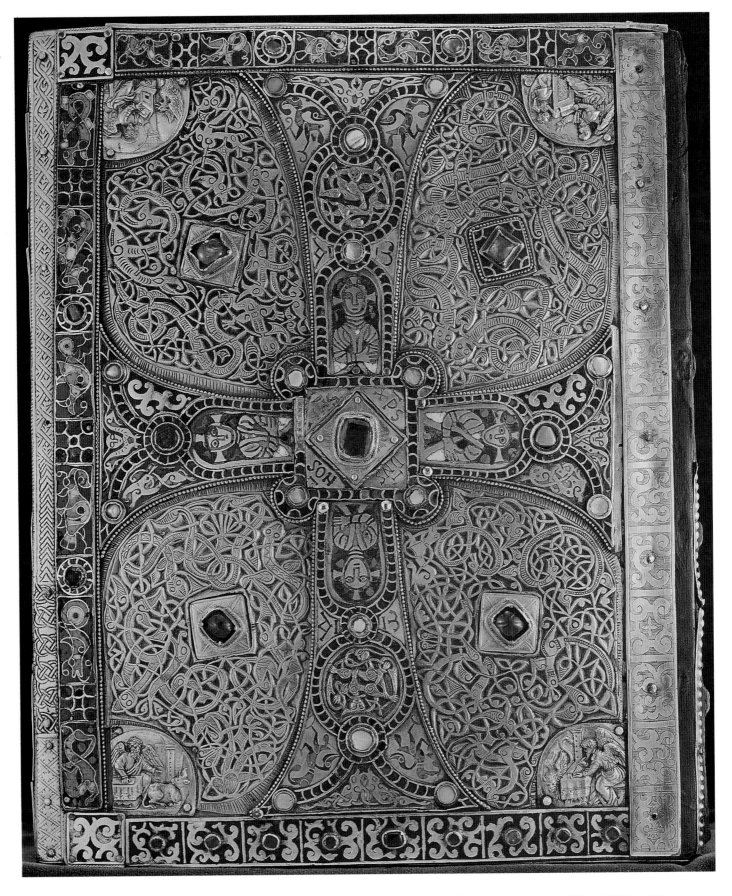

Colorplate 34. Book cover of the Lindau Gospels (lower or back). Silver gilt with enamels and gems, 13⅜ × 10⅜″. c. 800.
Pierpont Morgan Library, New York (MS 1)

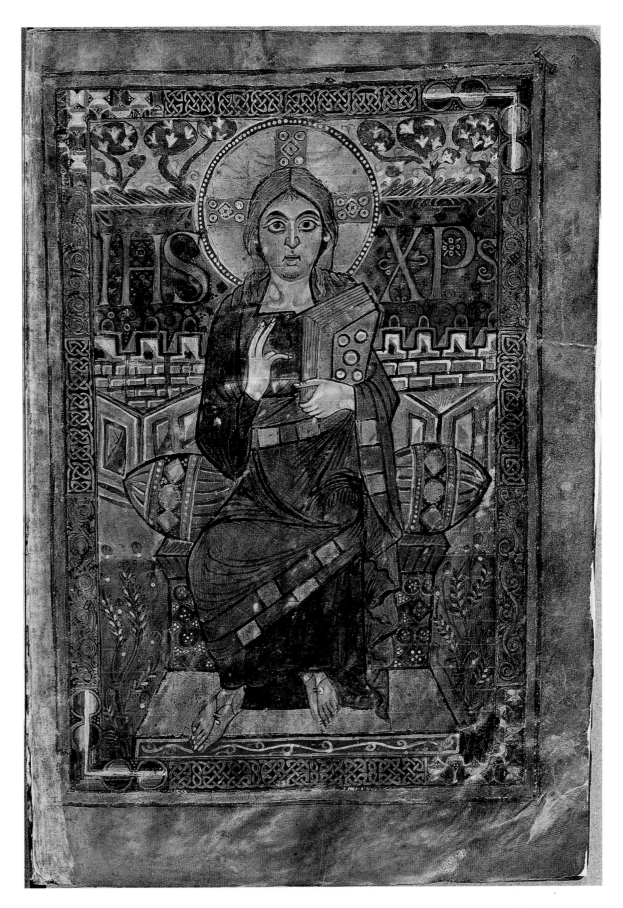

Colorplate 35. *Christ Enthroned*. Illustration in the Gospels (Lectionary) of Godescalc. 12⅝ × 8¼″. 781–83.
Bibliothèque Nationale, Paris (MS nouv. acq. lat. 1203, fol. 3r)

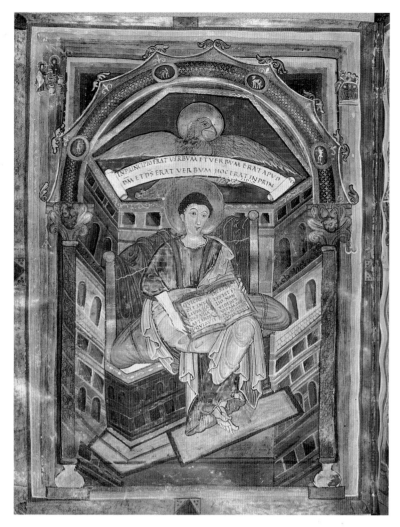

Colorplate 36. *Saint John the Evangelist.* Illustration in the Gospel Book of Saint-Médard de Soissons. 14 × 10½″. Early 9th century. Bibliothèque Nationale, Paris (MS lat. 8850, fol. 180v)

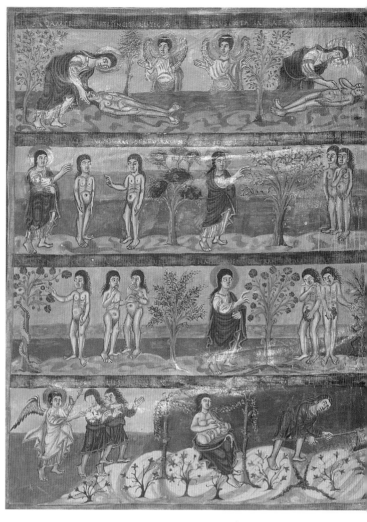

Colorplate 37. *Scenes from Genesis (1:27–4:1).* Illustration in the Moûtier-Grandval Bible. 20 × 14¾″. c. 840. British Library, London (MS Add. 10546, fol. 5)

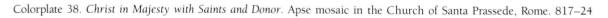

Colorplate 38. *Christ in Majesty with Saints and Donor.* Apse mosaic in the Church of Santa Prassede, Rome. 817–24

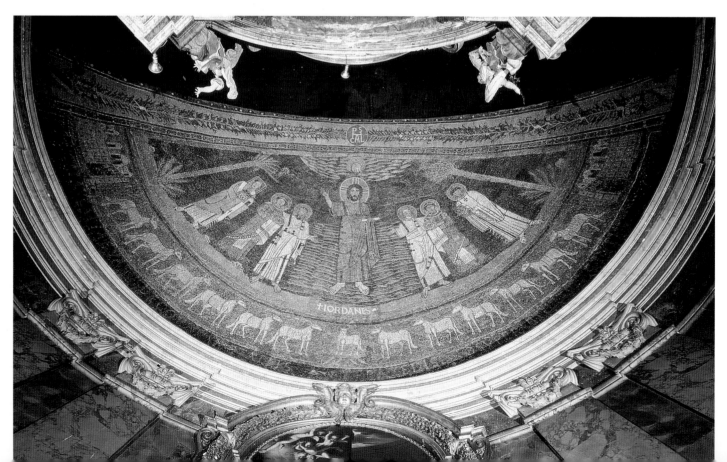

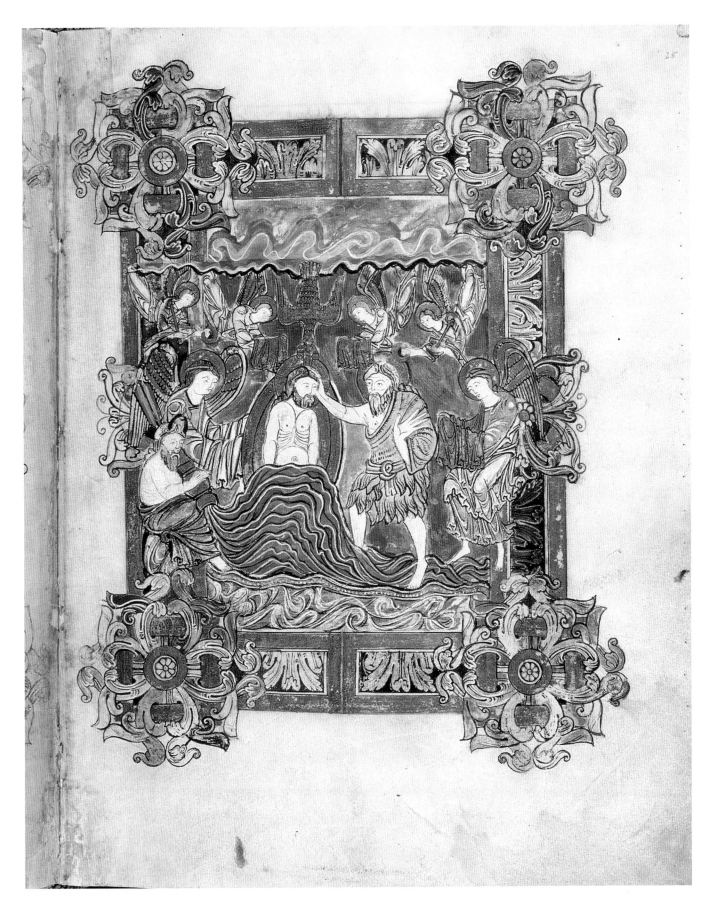

Colorplate 39. *Baptism of Christ*. Illustration in the Benedictional of Saint Ethelwold. 11½ × 8½". 971–84. British Library, London
(MS Add. 49598, fol. 25)

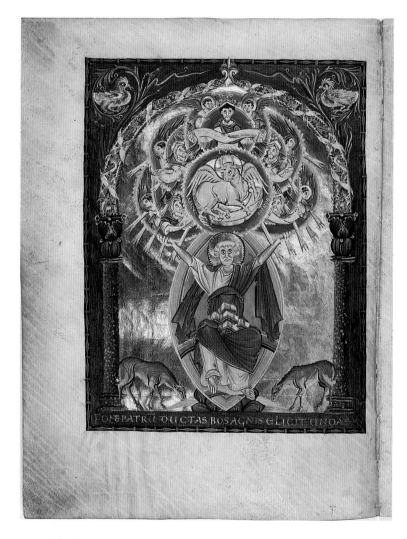

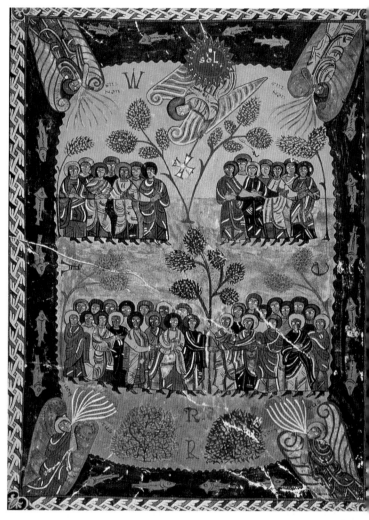

Colorplate 40. *Saint Luke*. Illustration in the Gospels of Otto III. 13 × 9⅜". c. 1000. Staatsbibliothek, Munich (Clm. 4453, fol. 139v)

Colorplate 41. MAGIUS. *The Four Angels Holding the Four Winds*. Illustration in the Morgan Beatus of Liébana, *Commentaries on the Apocalypse*. 14¾ × 11". 922 or mid-10th century. Pierpont Morgan Library, New York (MS 644, fol. 115)

School portraits. To be sure, the arms and legs are highlighted and darkened illusionistically, but the opaque qualities of the paint are dissolved and energized by swirling lines, like whirlpools spinning about the arms and legs. Gold flecks in the hair electrify Saint Mark's features, and the illusionistic landscape background is transformed into a surging waterfall of cascading lines. A new style is in the making before our eyes, a style that can be more appropriately termed "expressionistic," and it is no wonder that some scholars have seen the Reims School as the fountainhead of the dynamic linearism of later Romanesque art. These qualities are even more captivating in the masterpiece of the Reims School—the Utrecht Psalter (figs. 253–57), illustrated entirely with pen drawings.[55]

The psalter was one of the most important books in the service of the church, and while illustrated psalters are plentiful in Byzantine art, there are no apparent models for the unusual illustrations produced at Reims. The conventional Byzantine psalter displays allusive illustration, as we have seen (pp. 135–36), since the imagery of the psalms is so poetic and imaginative. The artists of the Utrecht Psalter follow a similar pattern but only in part. The far greater number of illustrations are not allusive but literal and direct. They depict objects, figures, and actions just as they are described in the words of the psalmist. Furthermore, for

252. *Saint Mark.* Illustration in the Gospel Book of Ebbo. 10¼ × 8¾″. 816–35. Bibliothèque Municipale, Epernay (MS I, fol. 60v)

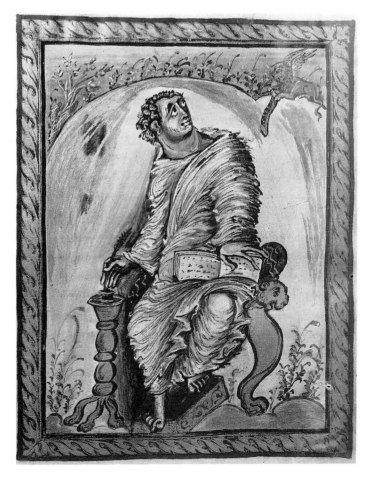

many psalms the lines of the song are illustrated one after the other in a continuous fashion and then sprinkled over a broad panoramic landscape above or below the text. The illustrations thus become something like tableaux of pictorial riddles or charades, a form of play and instruction that was always popular in the North (especially in Ireland, as we have seen) that the reader must decipher. Let us take a familiar example, Psalm 22 (Vulgate Bible; Psalm 23 in King James version), the "Lord is my shepherd" (fig. 253), and play the game.

"The Lord is my shepherd": "He maketh me to lie down in green pastures" (the psalmist reclines among his flocks in a bucolic setting); "He leadeth me beside still waters" (a stream flows beneath the figure); "Lo, even though I walk through the valley of the shadow of death" (below, to the right, is a shallow pit with writhing demons hurling arrows); "Thy rod and thy staff, they comfort me" (behind the shepherd another figure holds a rod and a small vial); "Thou anointest my head with oil, my cup runneth over" (the chalice held in the psalmist's hand spills over its lip); "Thou preparest a table before me" (to the left a small table with food stands before the psalmist); "Surely goodness and mercy shall follow me all the days of my life; and I shall dwell in the house of the Lord forever" (in the upper left is a small basilica with an altar before which tiny figures kneel).

The composers of the tiny vignettes often exhibit a remarkable inventiveness. For Psalm 43 (44), which is a lament for the afflictions of Israel, cast out, oppressed, humbled, abused, and disgraced, the panoramic landscape features a broad city under siege with details of the text such as "Thou hast made us like sheep for slaughter" illustrated by a number of slain sheep heaped before the city gate (fig. 254). For the last verses of the Psalm, "Arise, why sleepest thou, O Lord," the illustrator added the figure of Christ comfortably reclining within a mandorla upon a canopied bed. Earlier, in Psalm 11 (12), "For the oppression of the poor, for the sighing of the needy, now will I arise, said the Lord," the miniaturist actually depicts the figure of Christ rising up and stepping forth from the confines of his aureole (figs. 255, 256). Below, "the wicked walk round about" by holding on to a turnstile or forming a circle which reminds one of Saint Augustine's commentary on this Psalm: "The ungodly walk in a circle . . . which revolves as a wheel."

Often the miniaturists appropriated familiar motifs out of context, for example, Evangelist portraits, Classical personifications, labors of the months, zodiac signs, or bestiaries. The scattered pictorial motifs for Psalm 1, the only full-page illustration, give us some insight into this procedure (fig. 257). The top half of the sprawling landscape illustrates the first verses: "Blessed is the man who hath not walked in the counsel of the ungodly . . . nor sat in the chair of pestilence. But his counsel is in the law of the Lord, and on his law he shall meditate day and night." For the blessed man con-

above: 253. *Psalm 22 (23).* Illustration in the Utrecht Psalter. 13 × 9⅞″. 816–35. University Library, Utrecht (MS script. eccl. 484, fol. 13r)

right: 254. *Psalm 43 (44).* Illustration in the Utrecht Psalter (fol. 25r). 9⅞ × 13″

templating the law day and night we find a typical Evangelist portrait (cf. those in the Ebbo Gospels) with the sun and moon personified above. Directly below the studious blessed man, another portion of the landscape features a river-god, a stream issuing from his jug, and a flowering tree, illustrating the lines, "And he shall be like a tree which is planted near the running waters, which shall bring forth fruit in due season."

Thus the Utrecht Psalter is, in many ways, a glorious pastiche, but one should not deny the artists their keen sense of humor and inventiveness. In many instances the scattered vignettes have pointed theological meanings, but often they seem more like clever pastimes, like pictorial riddles, for the artists and for those who will peruse these pages.

Formerly it was thought that the Utrecht Psalter was an original production of the fourth or fifth century because of the fact that the script is in rustic capitals and the headings are in ancient uncials. The arrangement of the texts of the Psalms in three narrow columns on each page is also an Antique practice long abandoned by Christian scribes. It is no wonder then that paleographers were confused. The question posed is thus fascinating: Were the scribes and artists aware of the Antique features of their production? Were they consciously reviving earlier Classical forms?

Any early models employed by the artists very likely would have been painted, and the wispy figures with fluttering draperies and twitching fret-folds cascading across wildly gesticulating arms were born from innate impulses

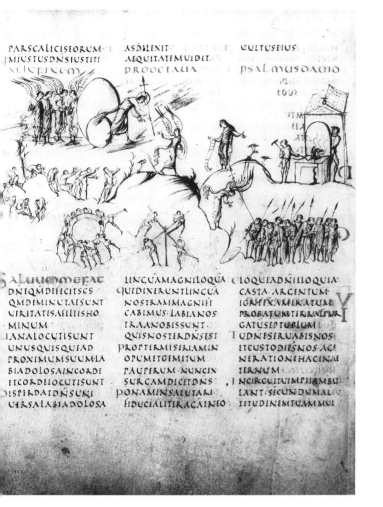

above left: 255. *Psalm 11 (12).* Illustration in the Utrecht Psalter (fol. 6v). 13 × 9⅞"

above right: 256. *Psalm 11 (12).* Detail of fig. 255

right: 257. *Psalm 1.* Illustration in the Utrecht Psalter (fol. 1v). 13 × 9⅞"

for dynamic linearism. The tiny sprites with their frail bodies and hunched shoulders dance on tiptoe across the filmy landscapes, evoking the world of elfin creatures in woodland settings. The artists had little concern for anatomical detail since their fleeting actors are put down in a few quick strokes. Legs are barely sketched in, and nervous zigzags suffice for fluttering garments. Furthermore, the artists seem at times to scatter the narrative motifs across the vellum with little regard for balance or other principles of Classical composition. How like the Irish illuminations in a way!

Alcuin, Charlemagne's brilliant court scholar and theologian, retired to the venerable Monastery of Saint Martin at Tours in 796. There he set about to edit single-volume Bibles (called pandects) for Charlemagne and to establish an authentic Vulgate text, an issue of much concern in the

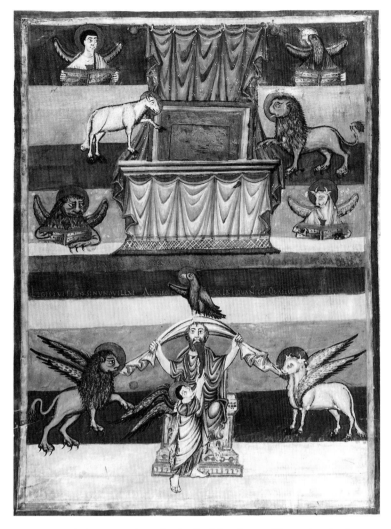

258. *Scenes from the Book of Revelation.* Illustration in the Moûtier-Grandval Bible. 20 × 14¾". c. 840. British Library, London (MS Add. 10546, fol. 449v)

North.[56] The pandects attributed to Alcuin are not of the highest quality, however, nor are they illustrated; but succeeding abbots at Tours, perhaps inspired by the impressive illustrated codices of the Palace and Reims schools, established a tradition of producing giant illustrated Bibles of astonishing beauty.

The famous Moûtier-Grandval Bible in the British Library, one of the earliest of these, was produced under Abbot Adalbard (834–43) and contains four full-page frontispieces for the basic divisions of the Old and New Testaments: one folio for Genesis has registers illustrating the story of the creation of Adam and Eve and their fall (colorplate 37); a frontispiece for Exodus has two enlarged narratives, one over the other, depicting Moses receiving the Law on Mount Sinai and Moses preaching to the Israelites; a full-page *Maiestas Domini* illustrates the beginning of the New Testament; and a final page is devoted to a pair of enigmatic scenes for the last book of the Bible, Revelation (fig. 258).[57]

It seems clear that the scriptorium at Tours had numerous illustrated models to draw upon. The Genesis page depends on an early cycle related to the Cotton Genesis (see p. 83 ff.). The most distinctive feature of this cycle is the depiction of the creator in the form of Christ *logos* (he lacks the cross-nimbed halo, however). Surprisingly, the more painterly qualities of the early style are also retained. Some attempt is made to model the nude bodies of Adam and Eve, and the heavily draped Christ, repeated like an exclamation mark between the scenes, stands in a continuous landscape ground with zones of deep blue, red-pink, and light blue indicating the atmospheric haze.

The frontispiece for the last book of the Bible, Revelation, is exceptional and difficult to interpret (fig. 258). In the upper half appears the great book of seven seals on a throne that initiates John's visions in the Apocalypse (5:2–6) with the lamb (Christ) opening one of the seals. Opposite the lamb is the "lion of the tribe of Judah" that "prevailed to open the book," but did not. In the corners are the four symbols of the Evangelists, the "four living creatures" in the midst of the throne.

Below is a curious representation of an elderly man enthroned and lifting a veil above his head with outstretched arms. The four "living creatures" appear to assist in the unveiling. This enigmatic elder has been variously identified, but he is most likely Moses, who veiled his face after his encounter with the Lord on Mount Sinai, as recorded in Exodus. It has been noted that the image of Moses here may rely on words of the prophet Isaiah (40:22): "He stretched out the skies like a curtain," and that the figure is based on pagan representations of the sky god who carries the canopy of the heavens over his head (cf. the breastplate of the *Prima Porta Augustus* and the figure beneath the enthroned Christ on the *Sarcophagus of Junius Bassus*—fig. 14). The meaning here is clearly that of unveiling, however, and to find an appropriate textual source we turn to the letters of Saint Paul (2 Cor. 3:12–18): "It is not for us to do as Moses did: He put a veil over his face to keep the Israelites from gazing on that fading splendor, until it was gone. . . . Only in Christ is the old covenant abrogated . . . and because there is no veil over the face, we all reflect as in a mirror the splendor of the Lord."

The two curious images in the Apocalypse frontispiece thus form a diptych of sorts, a kind of harmony of the Old and New Testament visions of the Lord: the Lord veiled by Moses in Exodus is the same whose vision John experienced in Revelation. Just such a parallelism (cf. that of the apse mosaic in Hosios David—p. 106 ff.) can be found in Early Christian writers, especially in the commentaries on the Apocalypse by Victorinus of Pettau (third century). Such a reading would also provide an interpretation for the frontispieces for Exodus and the Gospels in the Moûtier-Grandval Bible, where Moses receives the law on Mount Sinai and the New Law is revealed in the *Maiestas Domini*. Wilhelm

Köhler has brilliantly argued that the model for the set of four frontispieces was an illustrated Bible made especially for Leo the Great in the fifth century.[58] Although Köhler's argument for the unity of meaning in the Grandval illustrations has been seriously challenged and rejected by some, his theory is very convincing and perhaps near the truth. However, it is clear that the miniaturists of the Tours scriptorium had many early models at hand.

Illustrated frontispieces for the books in a large Bible executed for Count Vivian, lay abbot of Tours from 844 to 851, today in the Bibliothèque Nationale in Paris, are very closely related to those in the Moûtier-Grandval manuscript, and no doubt they copy the same model with minor variations. However, three new pictures together with an elaborate dedication page are added to the earlier foursome. A portrait of David and his musicians serves as a frontispiece for the Book of Psalms; the story of Saint Paul's conversion introduces the Book of Acts; and an unusual narrative il-

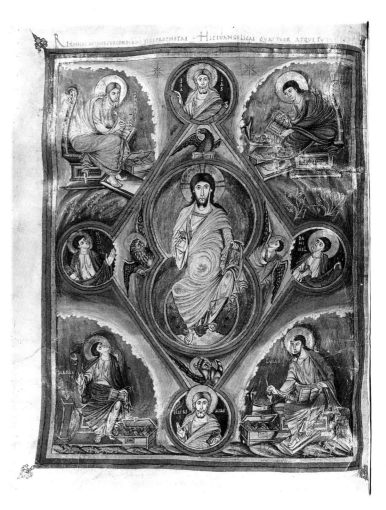

260. *Maiestas Domini.* Illustration in the Vivian Bible (fol. 329v). 19½ × 13⅝″

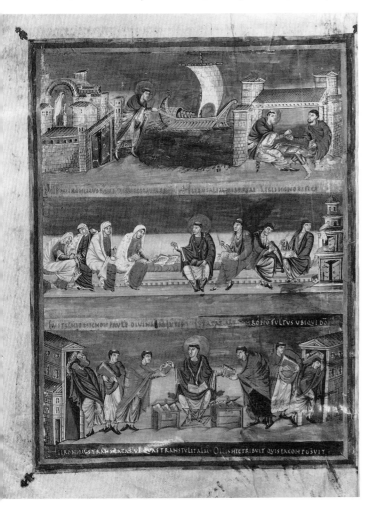

259. *Story of Saint Jerome's Translation of the Bible.* Illustration in the Vivian Bible (First Bible of Charles the Bald). 19½ × 13⅝″. c. 845. Bibliothèque Nationale, Paris (MS lat. 1, fol. 3v)

lustrating the translation of the Bible by Saint Jerome precedes Jerome's prefaces to the Bible (fig. 259).

The story of Jerome's Vulgate translation would, of course, have special meaning at Tours, where the quest for an accurate Latin text was promoted by Alcuin, but it would be equally at home, if not more so, in an Early Christian copy of Jerome's new translation. The vivid descriptive detail—note especially the Antique appearance of the ship and the statue of *Roma* within the city walls—and the lively action of the tiny figures against a semi-illusionistic background suggest that we are again dealing with a Carolingian copy of an Early Christian cycle of illustrations, in this case perhaps an illustrated *Vita Hieronymi* appended to an early Vulgate edition.

The *Maiestas Domini* page for the Gospels (fig. 260) is based on the type in the Moûtier-Grandval Bible, but it is much elaborated. Here the One in heaven is surrounded by a figure-eight-shaped aureole, a form that divides the divine and human components of his body: his head and shoulders in the upper heaven, his torso below, with his feet resting on

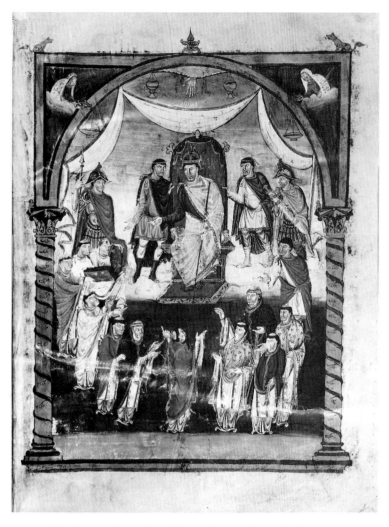

261. *Presentation of the Bible to Charles the Bald.* Illustration in the Vivian Bible (fol. 423). 19½ × 13⅝″

ing the miniature name the emperor as Charles the Bald and the abbot as Vivian (d. 851), who has sometimes been identified as the figure with his back turned, in the lower center of the circle of monks. This is not likely. Vivian was a lay abbot, and he should be identified as the sole prince among the ecclesiastics standing to the far right introducing them.

Somehow the miniatures in the Tours Bibles or their models were made available to the artists who illustrated the giant pandect known as the Bible of Saint Paul's Outside the Walls, produced about 869–70 for Charles the Bald and his wife Hermintrude. The twenty-four full-page miniatures — one for nearly every book of the Bible — constitute the final expansion of the Carolingian Bibles, and it has been estimated that numerous models from the fifth through the seventh centuries, from Italy, France, and Byzantium, must have been available for these artists.[59] Pictorial enrichments with more discursive narratives distinguish the Old and New

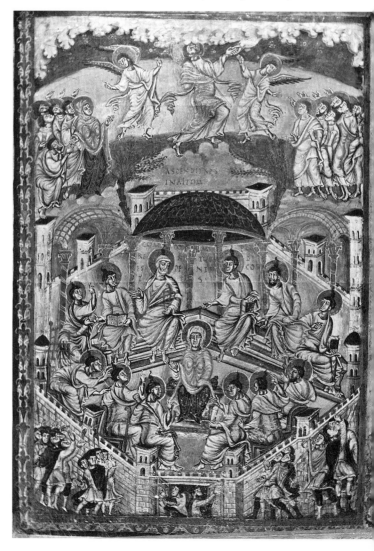

262. *Ascension and Pentecost.* Illustration in the Bible of Saint Paul's Outside the Walls. 15½ × 12″. c. 870. Library, St. Paul's Outside the Walls, Rome (fol. 292v)

the earth that serves as a footstool (cf. Isa. 66:1). He holds a tiny waferlike orb — the *mundus* — in his right hand, the book in his left. The four creatures are placed within the confines of the tetragon, and the prophets appear in the four circles that mark its corners. Outside the tetragon, in the four corners, the miniaturist has added full-bodied portraits of the Evangelists in the traditional poses found in Carolingian Gospel books. The harmony of the Old and New Testament witnesses, the prophets and the Evangelists, dominates the image of Christ in Majesty.

The dedication page portraying the emperor Charles the Bald is inserted near the end of the Bible (fig. 261). Enthroned in the center of the upper zone and somewhat larger than the others is Charles the Bald flanked by two princes and two bodyguards dressed in armor. The Hand of God issues from the summit of the arch to bless the event. Below, in a loose semicircle, are arrayed various monks, three of whom present the Bible to the emperor. Verses accompany-

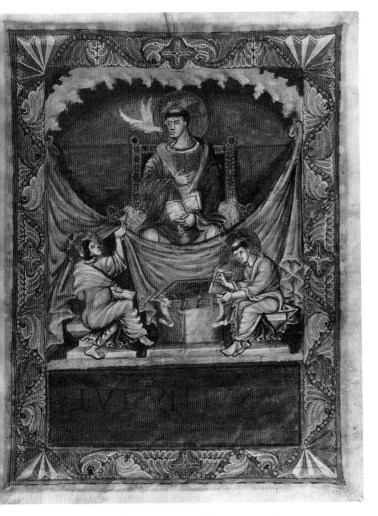

263. *Portrait of Saint Gregory*. Illustration in the Coronation Sacramentary of Metz. 10½ × 7¾″. c. 870. Bibliothèque Nationale, Paris (MS lat. 1141, fol. 3r)

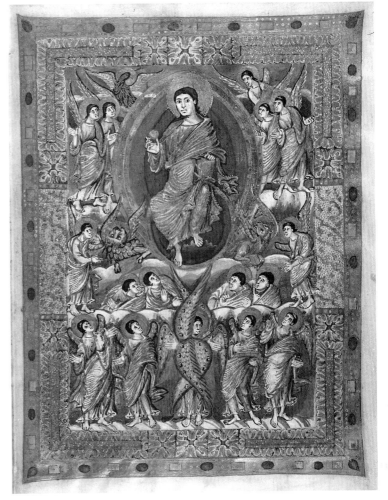

264. *Maiestas Domini*. Illustration in the Sacramentary of Metz (fol. 5v). 10½ × 7¾″

Testament illustrations, and the handsome miniature for the Book of Acts in which the Ascension of Christ is merged with the scene of Pentecost (fig. 262) presents us with a combination of iconographies that anticipates the complex program presented in the great tympanum sculpture at Vézelay, a key monument of the Romanesque period (fig. 352).

Closely related in style to the miniatures in the Saint Paul's Bible are those in the sumptuous Sacramentary of Metz (figs. 263, 264).[60] Facing each other at the beginning of the sacramentary are the *Coronation of a Prince* (variously identified as Clovis, Charlemagne, Charles the Bald) and an "author" *Portrait of Saint Gregory,* who compiled the sacramentary. The figure style resembles the vivid characterizations of the Tours Bibles, but the miniature is greatly enriched with an elaborate frame and exaggerated linear stylizations throughout—the feathery clouds above Gregory, the sharp, nervous pleats of the curtains and the drapery folds—that add a sparkle to the composition.

An elaborate *Maiestas Domini* (fig. 264) before the preface of the Canon of the Mass depicts Christ seated within an aureole and adored by a throng of angel types seldom seen together in a single representation. According to one authority, A. M. Friend, Jr., the elaboration of angels in the Metz Sacramentary is due to the influence of a new source book for angel lore. It is recorded that a Latin translation of the influential, ecclesiastical and celestial hierarchies of Pseudo-Dionysius the Areopagite—the mystical treatise of the sixth century discussed earlier (pp. 110–11)—was available in the library of Saint Denis by 858. Since it is also known that the venerable abbey church was patronized by Charles the Bald in his later years—he became lay abbot in 876—Friend believes that the workshops that produced the Metz Sacramentary and closely related works rich in angel types should be located at Saint Denis.[61]

The historiated initial wherein narrative scenes are incorporated into the floral decoration of the letter is found in the Drogo Sacramentary (fig. 265), presumably produced in the

265. *Initial D with the Three Marys at the Tomb.* Illustration in the Sacramentary of Drogo. 10½ × 8¼". c. 850. Bibliothèque Nationale, Paris (MS lat. 9428, fol. 58r)

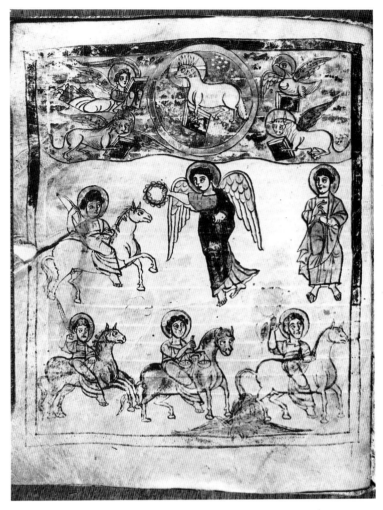

266. *The Four Horsemen of the Apocalypse.* Illustration in the Trier Apocalypse. 10⅜ × 8½". End of 9th century. Stadtsbibliothek, Trier (MS 31, fol. 19v)

court scriptorium of the archbishop Drogo of Metz.[62] The initial *D* (*eus*) for the opening of Easter Mass is typical of the insertions of narratives into the elegant golden tendrils, bars, and trellises of the initial. Below is the familiar scene of the Three Marys at the Tomb, and along the curving bar of the *D* two more tiny episodes are hidden amid the twining flora, *Christ Appearing to Mary Magdalene* and *Christ's Appearance to His Mother* following the resurrection. We have seen how animals invade the initials of Merovingian and Irish manuscripts, but this interest in marginal narration is more complex. The harmonious integration of picture and decoration such as we find in the Drogo Sacramentary anticipates by a full century the sculptured historiated capitals that are so characteristic of the Romanesque period.

Not all Carolingian illustrated manuscripts were so luxurious or sumptuous as the court productions. A number of them served monasteries—herbals, astronomical treatises, calendars, chronicles, commentaries—and had less-am-

bitious illuminations, frequently little more than line drawings. One important example is the Trier Apocalypse (fig. 266), produced in northern France in the mid-ninth century.[63] This manuscript, like another very closely related to it in Cambrai, has eighty-six full-page miniatures for the text of Revelation. Such extensive cycles of illustrations are not uncommon and were responsible for the transmission of much iconography to later ages.

Carolingian workshops were not exclusively devoted to manuscript illumination. Bronze-casting and metalwork were traditional crafts in the North, and often the spirit of antiquarianism pervades these arts as well. A frequently cited example is the small bronze statuette usually identified as Charlemagne (fig. 267) that obviously copies some Antique equestrian portrait (one source suggested is the bronze *Portrait of Marcus Aurelius* in Rome, considered to be one of Constantine in the Middle Ages). It should be remembered that Charlemagne had carted such a statue of Theodoric, his

spiritual ancestor, from Ravenna to Aachen, presumably to be set up in the courtyard of his palace.

More significant are the numerous ivory carvings that were executed in ateliers attached to the scriptoria and served as covers for the richly illuminated manuscripts. Because of the close association with the scriptoria, it is assumed that many of the ivory carvers were guided by miniaturists, if not illuminators themselves.[64] The cover for the Lorsch Gospels (fig. 268), dating about 810, has long been attributed to a workshop attached to the Ada school manuscripts. A number of Carolingian ivories display a more dynamic style, with tiny figures bending and swaying in rhythmic friezes that resemble illustrations in the Utrecht

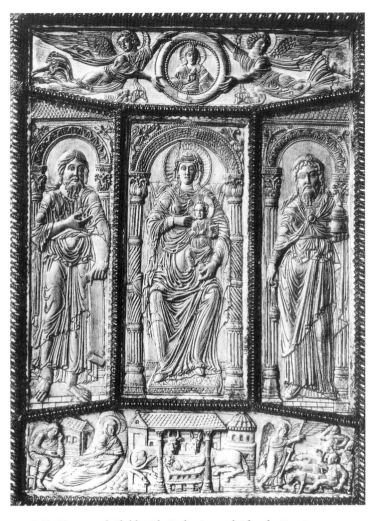

268. *Virgin and Child with Zacharias and John the Baptist.* Book cover of the Lorsch Gospels (back). Ivory, 14⅞ × 10¾″. c. 810. Victoria and Albert Museum, London

267. *Equestrian Portrait of a Carolingian Emperor* (Charlemagne?). Bronze, height 9½″. 9th century. The Louvre, Paris

Psalter. These ivories, called the Liuthard group (after a scribe), have generally been located at Reims, although other Frankish centers have been proposed. The inner cover of the Pericopes of Henry II, dating about 870 (fig. 269), is a good example of these ivories. The representation of the *Crucifixion* is typical of the inordinate passion for narrative detail found in many of these works.[65] The elaborate outer border with Byzantine *cloisonné* enamels and gems has been dated later, to 1007–12, as an addition made when the Ottonian emperor Henry II presented the reset cover to the Cathedral of Bamberg.

This same dynamic style characterizes some of the goldsmiths' work of the ninth century. Because of their splendid richness and certain iconographic peculiarities, the finest of these have been assigned to the imperial workshop of Charles the Bald, perhaps to be located at Saint Denis, as mentioned above. The Crucified Christ in gold *repoussé* in the gem-studded second (upper) cover of the Lindau Gospels in the Pierpont Morgan Library (fig. 270) is one of the

left: 269. *Crucifixion.* Cover for the Pericopes of Henry II. Central panel: ivory, 11 × 5″; frame: Byzantine enamels, gold, pearls, and gems, height 17⅜″. c. 870 (ivory); c. 1014 (frame). Staatsbibliothek, Munich (Cod. lat. 4452)

opposite left: 270. *Crucifixion with Angels.* Second (top) cover of the Lindau Gospels. Gold, pearls, and gems, 13⅜ × 10⅜″. c. 870–80. Pierpont Morgan Library, New York (MS 1)

opposite right: 271. *Maiestas Domini, Four Evangelists, Scenes of Christ's Miracles.* Book cover for the Codex Aureus of Saint Emmeram. Gold, pearls, and gems, 16½ × 13″. c. 870–80. Staatsbibliothek, Munich (Cod. lat. mon. 14000)

opposite bottom: 272. WOLVINIUS. Front of the Altar of Saint Ambrose. Gold with enamel and gems, 2′9½″ × 7′2⅝″. 824–59. Sant'Ambrogio, Milan

finest examples of such delicate gold work; another is the sumptuous golden cover of the Codex Aureus of Saint Emmeram of Regensburg (fig. 271), today in Munich. Both have been dated about 870–80.

The refined linear style displayed in the floating angels of the Lindau cover and those of the figures in the miracle scenes beneath the arms of the cross in the Munich book cover was anticipated by a quarter of a century in the great golden Altar of Saint Ambrose in Milan (fig. 272), one of the most ambitious artworks to survive from the early reign of Charles the Bald.[66] The patron, Angilbert II, archbishop of

Milan from 824 to 859, and the court artist Wolvinius are portrayed in medallions on the back, paying homage to Saint Ambrose. The elaborate front of the *paliotto* (altarpiece) has the form of a fixed triptych with Christ in Majesty in the center.

The two sides are divided into six fields each with representations of events in the life of Christ in gold *repoussé*. A number of these are clearly related to Byzantine feast pictures—note especially the Transfiguration and the post-Passion episodes—but the thin, agitated figures with dramatic gestures and intense stares are very much in the style

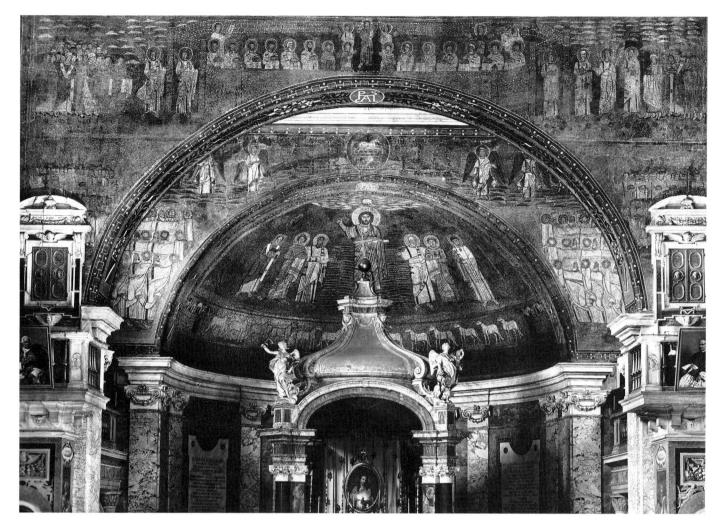

273. Santa Prassede, Rome. View of triumphal arch and apse. 817–24

of Reims School illumination. The fact remains, however, that the Altar of Saint Ambrose was executed for a Milanese patron and very likely executed by Italian craftsmen headed by Wolvinius. These exchanges between the North and South are too complex to describe here, but they do inform us that Milan, and very likely other Italian centers, were important contributors to the Carolingian Renaissance.

This spirit can be seen in Rome, too. Under the pontificates of Hadrian (772–95), Leo III (795–816), and Paschal I (817–24), a resurgence of building on a grand scale took place as part of the attempts of the papacy to repair and restore Rome's ancient glory and prestige. The fervent artistic activity in Rome reflected the renewed confidence and optimism of the Roman church. It must be remembered, however, that colonies of Byzantine monks and craftsmen had migrated to Rome and south Italy during the period of iconoclasm, and their presence is to be reckoned with in any study of ninth-century art in Rome.

The mosaic installed in the triclinium of Leo III before the coronation of Charlemagne in Saint Peter's, discussed ear-

lier, was one of the first fruits of the renaissance spirit with its blatant proclamation of the *renovatio Romanorum* under the aegis of the Frankish emperor, the "New Constantine." Leo's successor, Paschal I, took a more personal interest in the restoration of Early Christian Rome. He not only built and restored a number of churches but he also commissioned some of the finest mural decorations for their walls, among them Santa Cecilia, Santa Maria in Domnica, and Santa Prassede. This last church has often been cited as the finest monument of the Carolingian Renaissance in Rome. Built by Paschal to replace a religious center that had grown up in the vicinity of Santa Maria Maggiore, Santa Prassede became a major receptacle for the new relics transferred from the catacombs.[67]

For the building itself, Paschal turned directly to Saint Peter's and its *T*-shaped plan, just as the builders in the North had done. Indeed, Santa Prassede is a miniature copy of Saint Peter's. A triumphal arch marks the juncture of the nave and the sanctuary (fig. 273; colorplate 38).

The decoration of the tiny Chapel of Saint Zeno (fig. 274)

in the north aisle of Santa Prassede has received much attention. In the tight confines of the cross-in-square chapel, some of the finest post-iconoclastic mosaics are preserved with a hieratic program that in some ways anticipates or parallels the new schemes of mosaic decoration in Middle Byzantine churches. The lavish mosaics that fill the sanctuary, to the contrary, owe little to Byzantine examples.

Precedents for the decoration of the triumphal arch and apse were many in Early Christian Rome. It will be recalled that the basilical triumphal arches, such as that of Saint Paul's Outside the Walls (fig. 49), displayed a reduced *Maiestas Domini* with the adoration of the twenty-four elders. At Santa Prassede the outer arch presents a transformation of this Apocalyptic imagery into the Adoration of the Multitude of Saints in heaven (Rev. 19)—an All Saints' picture—which no doubt reflects the policy of the restoration of relics that Paschal pursued, especially in regard to this church. Within the sprawling city walls of the New Jerusalem stands Christ surrounded by the Virgin, John the Baptist, and the apostles.

In a verdant meadowland outside are assembled the rank and file of saints venerated at Santa Prassede.

On the inner arch that frames the apse the representation of the Adoration of the Lamb by the twenty-four elders finds its place much as it appears in apse of Saints Cosmas and Damianus (fig. 62), which it obviously copies. The apse, sheathed in glowing marble revetment, is decorated with a resplendent mosaic that repeats the apse composition of Saints Cosmas and Damianus with a tall Christ floating in the clouds of a deep blue heaven. To either side, Peter and Paul stand on a floral carpet and present Praxedis, her sister Pudentiana (in place of Cosmas and Damianus), the brother, and the founder Pope Paschal (with a square nimbus to indicate that he alone is among the living). With Santa Prassede we come full circle and return to the golden age of Christian Rome, and this renewed pride and concerted effort to aggrandize Rome's position was the impetus for a far-reaching program of the papacy that was to be more fully realized in the twelfth century.

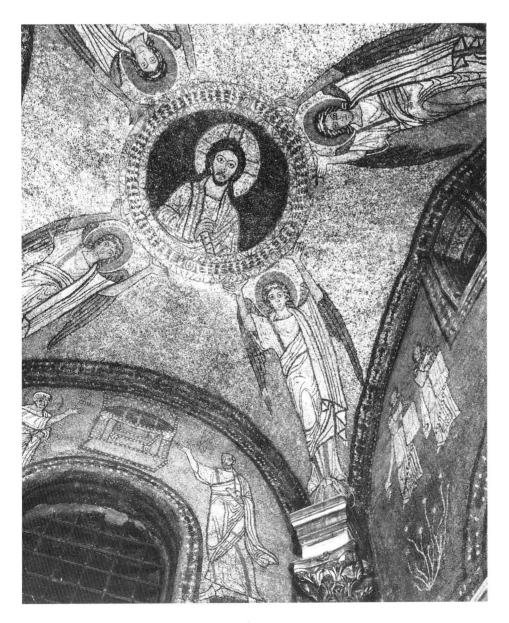

274. *Christ and Four Angels.* Dome mosaic in the Chapel of Saint Zeno, Santa Prassede, Rome. 817–24

DIFFUSION AND DIVERSITY IN THE TENTH CENTURY

ANGLO-SAXON ART

During the course of the ninth century, the great monasteries of England fell prey to the invading Danes, and if one can take the good King Alfred (871–99) as the spokesman for this dark age, learning and the arts suffered immensely. During Alfred's reign the Danes were contained, and in time cultural intercourse with the continent was renewed. By the middle of the tenth century, the reclaimed monasteries were reformed under strict Benedictine rule, particularly with Dunstan, archbishop of Canterbury (960–88), and Ethelwold, bishop of Winchester (963–84). Under Ethelwold, direct contacts were made with the monastery of Fleury in France, which was itself reformed by the Cluniac abbot Odo (927–44), to be discussed below (p. 274 ff.).

Anglo-Saxon art of the tenth and eleventh centuries has recently been the subject of intense study, and the complexities and varieties of its forms and styles are gradually being sorted out.[68] One cannot deny the importance of illustrated manuscripts in these developments, and it is to these exciting monuments that I will devote this brief review.

One of the finest "painted" Anglo-Saxon manuscripts to survive is the Benedictional of Saint Ethelwold, dated between 971 and 984 and produced at Winchester (New Minster?).[69] The dedication poem in the manuscript informs us that "a bishop, the great Ethelwold, whom the Lord had made patron of Winchester, ordered a certain monk subject to write this present book. . . . He commanded also to be made in this book many frames well adorned and filled with various figures decorated with numerous beautiful colors and with gold."

The benedictional is a special book made up for the use of the bishop that contains the solemn blessings given during the Mass in preparation for Communion. Although some miniatures are missing, it seems that each major feast was accompanied by two full-page pictures appropriate to the blessing. For the feast of the Epiphany (January 6), for

275.
Illustration to Psalm 43 (44).
Anglo-Saxon Psalter.
12⅜ × 15″.
Early 11th century.
British Library, London
(MS Harley 603, fol. 25)

276. *Illustration to Psalm 43 (44)*. Eadwine Psalter. Miniature 4 × 7¼″. c. 1150.
Trinity College Library, Cambridge, England (MS R.17.1, fol. 76)

277. *Illustration to Psalm 43 (44)*. Canterbury Psalter. Miniature 11⅝″ wide. c. 1200.
Bibliothèque Nationale, Paris (MS lat. 8846, fol. 57r)

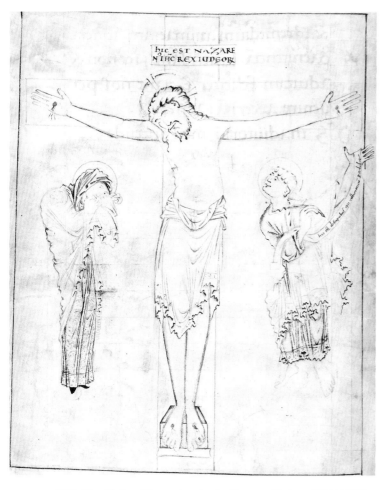

278. *Crucifixion.* Illustration in the Ramsey Psalter. 13⅛ × 9⅞".
c. 990. British Library, London (MS Harley 2904, fol. 3v)

instance, the *Baptism of Christ* (colorplate 39) is paired with
the *Adoration of the Magi.* Especially striking are the broad
frames that form elaborate trellises over which the leaves of
the "Winchester acanthus," as they are called, clamber and
intertwine, spiraling out from giant golden bosses that punc-
tuate the corners and the centers of the borders. The figures
overlap and merge with the lush growth around the page. In
the *Baptism,* the Jordan, issuing from a river-god's urn,
swells upward to cover Christ's loins and then tapers off in
undulating waves about the wading Baptist and the angel to
flow naturally into the border of flowers. The bright colors
are laid on in lines, not areas, and the overall effect is not too
unlike that of the vibrant portraits in the Ebbo Gospels (fig.
252) of the Reims School, discussed in the last chapter.

Sometime around the year 970, the masterpiece of the
Reims School, the Utrecht Psalter, was brought to the scrip-
torium of Christ Church in Canterbury where, during a
span of 150 years, it served as the inspiration for at least three
creative copies (figs. 275–77; cf. fig. 254). In the earliest of
these copies, the Psalter in the British Library (Harley 603),

dated to the early eleventh century, the facility of the English
artists in duplicating the model is astonishing. If one did not
notice the Anglo-Saxon script of the text, the illustrations
could be mistaken for those in the Utrecht Psalter. The
drawings are carried out in colored inks instead of the
monochrome of the Reims psalter, and there is a slight
tendency toward a more patterned and precise treatment of
the fleeting figures scattered about the illusionistic land-
scapes. The lines are shorter, points of spears are sharper,
and faint arabesques emerge in details of the landscape. The
Harley 603 Psalter is clear testimony to the overwhelming
impact of the dynamic linearism of the Reims School in early
English art.

The second variant, the Eadwine Psalter in Trinity College
Library at Cambridge (fig. 276), dates to about 1150 and
informs us of the Romanesque style in England. Now a
border is added to contain the restless movement and subor-
dinate the agile figures to the fixed framework of a boxed
composition. The city walls and the hillocks are schematized
into surface patterns that divide the horizontal field into
three distinct bands. A groundline anchors the horsemen
and sheep along the lower border; the canopied bed of Christ
hangs from the crenelations of the upper frame; and the
apostles sit along scalloped contours of the flattened terrain.
Even the sketchy quality of the tiny figures gives way to
sharper linear conventions and bold outlines.

The conflict between freedom of movement and constric-
tions of the frame and field, so basic to the Romanesque
style, is resolved in the Gothic version of about 1200 (fig.
277), today in Paris. Here the later Medieval obsession with
clarity of parts through compartmentalization completely
obscures the original design. Had we not the two earlier
copies before us, the comparison of this Gothic manuscript
with the Carolingian Psalter would never come to mind.
This rare opportunity to study the drastic transformations of
a model through two centuries is very revealing, and we shall
return to these points later.

The linear style of the Utrecht Psalter was the impetus for
an important body of Anglo-Saxon art of the tenth and
eleventh centuries. One of the most impressive examples is
the *Crucifixion* in the so-called Ramsey Psalter that has been
dated to the last quarter of the tenth century and attributed
to the Winchester scriptorium (fig. 278). The delicate ren-
dering of an iconic Christ on the cross between Mary and
John the Evangelist superbly displays the sensitivity of the
English artist. The long, graceful outlines of Christ's limbs
and torso contrast with exciting contrapuntal accents of
vibrating calligraphic motifs that mark the border of his
loincloth. The irregularly hooked outline of Mary's mantle,
rendered as if a magnetic force were attracting the frets like
metallic filings, adds a frenzied touch to her body, which
dramatically tapers from broad shoulders to tiny feet. The
artist conveys the sense of her shower of tears by having the

Virgin fervently embrace the jagged ends of her mantle as if she were sobbing over a dead child.

The Utrecht Psalter style is further developed in a number of later manuscripts with diminutive outline drawings. Attributed to the scriptorium at Winchester, the drawings in the New Minster Prayer Book, dating from about 1023–35, display a pronounced expressionism in the sharp outlines of the fluttering folds, the enlargement of hands, the twisting of the bodies, and the delicate heads that seem to poke outward from narrow shoulders.

The *Quinity* (fig. 279) is a particularly engaging drawing. Within a circular aureole above the cramped figures of earthly despair, Arrus (Arius) and Judas—two archetypal traitors to the church—the Trinity, in the form of four human figures and the Dove, is aligned on a rainbow. The two enthroned figures—God the Father and Christ the Son—are bearded and have cross-nimbed haloes, while Mary, holding the Christ Child and serving as a perch for the Dove, stands at the left. Hence, a "quinity" is actually presented. How does one account for this unusual aberration?[70] One wishes that Thomas Aquinas had had occasion to study and comment on the miniature!

Precocity of a very different order characterizes the stunning drawings in the Psalter of Bury Saint Edmunds, produced for the abbey in Suffolk (or for Canterbury?) about 1040. Over fifty seemingly spontaneous sketches are scattered about the margins of the psalms, illustrations that have no direct link to the Utrecht Psalter cycle but are, nevertheless, highly imaginative and varied in their derivations from New Testament pictures, bestiaries, and other sources, with some fresh inventions such as that for Psalm 82 (83), a prayer against the enemies of God's church: "O my God, make them like a wheel; and as stubble before the wind" (fig. 280).[71] The directness of the illustration is surprising, and while the effect is by no means sinister or terrifying, the quick hand of the artist has superbly conveyed the evil one upended like "stubble before the wind" and cast backward with the rotary movement of the giant wheel, his skirt tossed forward in melodic accordion pleats along a sweeping arc.

The beauty of the Bury Psalter lies mainly in the elegance and grace of the drapery patterns, a refinement and sophistication of the Reims style carried far beyond the wants of a fleeting illusionism. Here, the calligraphic beauty, almost akin to that of oriental art in its delicacy, announces the new aesthetics of Romanesque abstraction in its elegance and sensitive expression fashioned by a sure hand that does not err. The wheel, an inviolate man-made object, is mechanically drawn with a compass, but it will turn, and the figure, which attracts our attention with its graceful backflip, brings to mind the falling figures on a wheel of fortune, here illustrating the fate of the enemies of the church as well. The marginal illustrations in the Bury Psalter provide us with evidence for the transformation of the dynamic linearism of

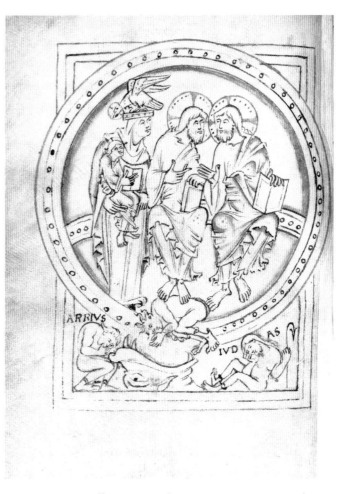

279. *Quinity*. Illustration in the New Minster Prayer Book. 5 × 3⅜". c. 1023–35. British Library, London (MS Cotton Titus D.xxvii, fol. 75)

the Utrecht Psalter into the beautiful and expressive abstractions of what is generally called Romanesque style. Here we can see the refinements of moving line reach an almost mannerist phase if, indeed, that word can be applied to such art.

The anticipation of the Romanesque style in England is announced in a harsher manner in another psalter that was made, according to its calendar, for the New Minster in Winchester, dated to about 1050–60. The *Crucifixion* (fig. 281) presents a more static and hieratic image, with the energies of the lines quelled beneath heavy bars painted as contour lines for the draperies and silhouettes. The figures loom larger by virtue of their material weight; the lines of the drapery are hardened into regular metallic ridges. The all-over effect is that of an engraved design for an enamel plaque rather than of the calligraphic gymnastics of pen drawing. These, too, are Romanesque traits, and the significance of the stronger stylization of the Arundel *Crucifixion* is that it gives evidence of the natural evolution of an English Romanesque art without the direct intervention of the conti-

right: 280. *Illustration to*
Psalm 82 (83). Psalter of Bury
Saint Edmunds. 12¾ × 9⅝″.
c. 1040. Vatican Library,
Rome (MS Regina 12, fol.
90v)

below: 281. *Crucifixion.*
Illustration in the Arundel
Psalter. 12 × 7½″. c. 1050–60.
British Library, London
(MS Arundel 60, fol. 12v)

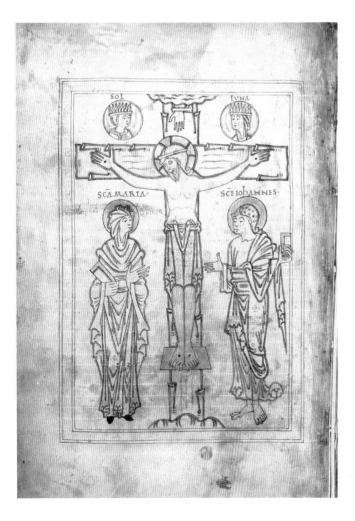

nental styles that are sometimes claimed to have been introduced only after the conquest of William of Normandy in 1066.

THE OTTONIANS

The empire of Charlemagne, once divided among his heirs, gradually weakened and shrank into small principalities with little central authority or power. And as in much of western Europe, the waves of marauding infidels from the fringes of the Christian world—the Vikings, the Magyars, the Slavs—sapped the energies for the cultural programs that Charlemagne had so magnificently initiated. The far-flung monastic centers had defensive walls, not oratories, to build; the scribes had few costly models on hand to inspire them. It was as though all of Europe went into a deep freeze for nearly a century.

Then in the early years of the tenth century, in the eastern territories across the Rhine, in Saxony, there emerged a powerful family of rulers—the Ottos—who had the means and determination to establish a kingdom and maintain channels of communication between east and west, north and south. An impressive victory for Otto I, "The Great" (936–73), was won over the Hungarians on his eastern frontiers in 953. The dream of Charlemagne was revived, and in 962, in Rome, Otto was crowned Augustus and Emperor of the Latin Christian world, henceforth known in history as the Holy Roman Empire. The imperial lineage now linked Augustus to Constantine to Charlemagne to

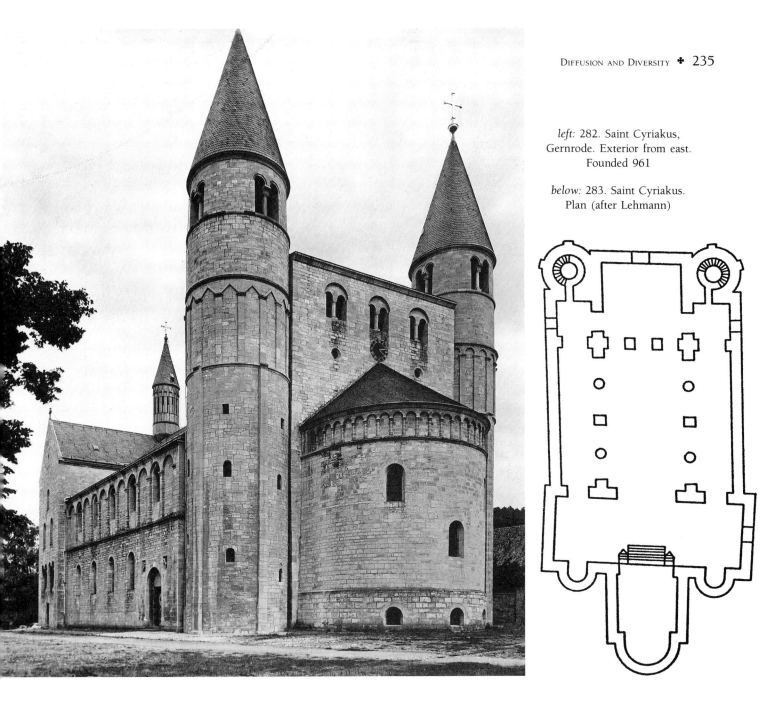

left: 282. Saint Cyriakus, Gernrode. Exterior from east. Founded 961

below: 283. Saint Cyriakus. Plan (after Lehmann)

Otto the Great, and the impact of this symbolic genealogy was to have lasting significance throughout Europe until very recent times.

The Saxon house of the Ottos revived the Carolingian idea of *renovatio,* and while they frequently resided in Rome, the Rhine and the Meuse (Maas) river valleys became their chief avenues of communication, and their immediate models were those about them in the North, Aachen in particular. It was also during this period that the first reverberations of the reform movements of the Cluniac Order in France, to be discussed below, were felt across Europe, heralding the reestablishment of the powers of the monastic world in the delicate balance of church-state power in the North.

The revival of Carolingian art was by no means a slavish and empty aping of the past.[72] In architecture, Carolingian westwork churches were taken as models for imperial pres-

ence in the ecclesiastical communities, but their outward forms were refashioned to make them imposing and majestic. The finest architectural remains are to be found just south of Magdeburg at Gernrode, where the Church of Saint Cyriakus was founded by the margrave Gero (960–65) to serve as a royal convent (fig. 282).[73] The Ottonian structure is intact and well preserved, except that the apse built into the flat entrance wall is believed to be a later, twelfth-century addition.

In plan (fig. 283) Gernrode displays a simple nave with side aisles, a square chancel and apse raised over a crypt, slightly projecting transept arms, and a westwork with a high tribune flanked by two round towers. The exterior is plain but imposing in the clarity of its cubic and cylindrical massing of elements, and the divisions of the elevation on the exterior are subtly marked by changes in pilaster strips on

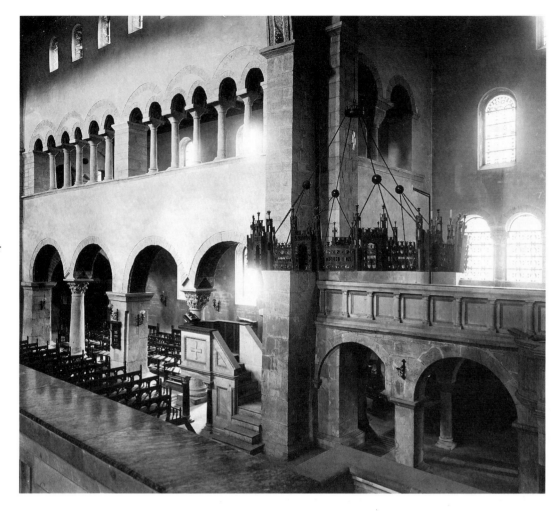

284. Saint Cyriakus. Interior from southeast

the towers and blind arcades over the nave windows. The interior (fig. 284) is equally imposing in its austerity, with the nave divided into two large bays by great rectangular piers carrying arches that rest midway on columns between them. A new feature appears in the gallery of six arches over each bay above the triforium (for the nuns?). The nave is covered by a timber roof.

The simple volumes of Gernrode were elaborated into a complex assembly of stereometric forms in the great Church of Saint Michael in Hildesheim, begun about 1000 by the learned court bishop Bernward (figs. 285, 286). As though a major chord had been struck on an organ, the building rises majestically, with the crossing establishing the proportions throughout. It is doubled in the transept arms and trebled in the nave. In the elevation, the height is approximately twice the width. Thus the simple beauty of the square, doubled and trebled, with apses and towers anchoring the extremities, presents a tightly knit assembly of austere volumes on the exterior.

The interior of Saint Michael's (fig. 287) features a more complex elevation in the transepts, with galleries in the arms (called "angelic choirs"). The nave, with three square bays and the so-called Saxon alternation of pier and columns, is

more severe. The high triforium wall rises to the clerestory without galleries. Heavy, cubical capitals contribute to the severe geometric nature of the elevation. No doubt along the high expanse above the nave arcade colorful murals depicting Biblical stories were painted originally, much as mosaics lined the naves in Early Christian basilicas. Few remains of such fresco decoration survive in Saxony, but the paintings in the nave of the Church of Saint George at Reichenau-Oberzell on Lake Constance (fig. 288), dated to the late tenth century, have frequently been cited as examples of this Ottonian art, particularly in the more expressionistic style of thin figures swaying and gesticulating against a plain background.

Bernward of Hildesheim, the builder of Saint Michael's, is a remarkable figure in Ottonian history.[74] Born of a noble Saxon family, he was educated in the best cathedral schools (Heidelberg and Mainz) and traveled extensively through France and Italy. In 987 he was elected chaplain at the imperial court and appointed tutor of the young Otto III by the empress-regent Theophano, the Byzantine widow of Otto II (d. 983). When studying the association of the learned theologian and his aspiring secular ruler, one is reminded of the influence of Aristotle on the young Alex-

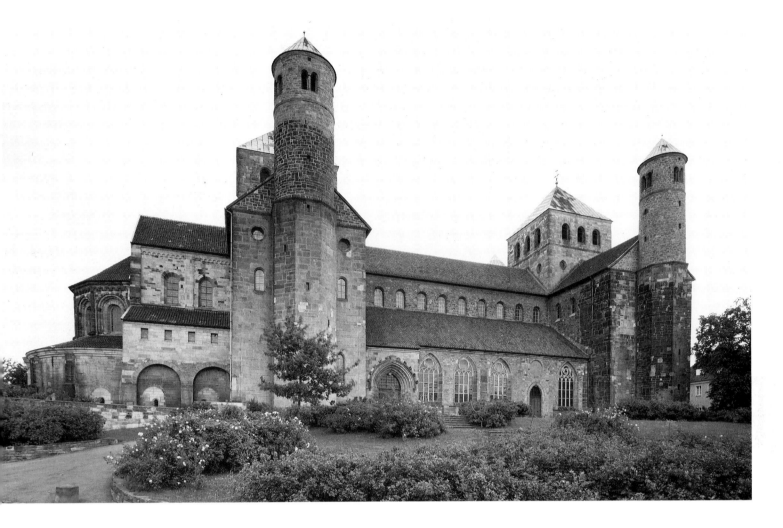

285. Abbey Church of Saint Michael, Hildesheim. Exterior from south. 1010–33

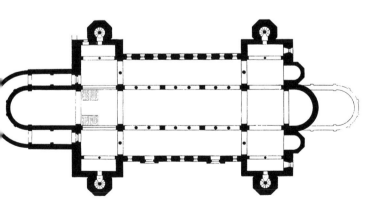

above: 286. Abbey Church of Saint Michael. Plan

right: 287. Abbey Church of Saint Michael. Interior

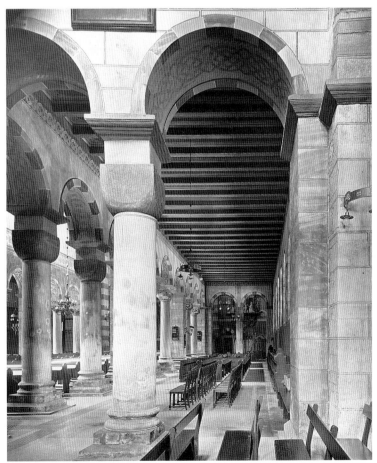

288. *Healing of the Leper*. Fresco in the nave of the Church of Saint George, Reichenau-Oberzell. Late 10th century

289. *Miracle of Christ*. Detail of Bronze Column of Bishop Bernward. Height of column 12′5½″. 1015–22. Cathedral, Hildesheim (originally made for Abbey Church of Saint Michael)

ander. Indeed, it may be that some of the grandiose ideas of the "boy wonder of the world," as young Otto III was called, were instilled and articulated in the monarch's mind through the teachings of the powerful ecclesiastic.

But Bernward had more interests than political to occupy his energies, and, according to his biographer, Thangmar of Heidelberg, he excelled in the arts and crafts, frequenting the workshops of his artisans and actually assisting them in their crafts. A number of elegant gold and bronze objects are attributed to Bernward's patronage, including a great golden cross and two elaborate candelabra that survive. On a larger scale he had cast a tall bronze column with a spiraling band of sculptured reliefs carrying episodes from the life of Christ, much as if a metal scroll were wound about it (fig. 289). It has been suggested that the inspiration for Bernward's column was one of the triumphal columns of ancient Rome that he had undoubtedly seen.

More impressive are the huge bronze doors cast for Saint Michael's at Bernward's behest about 1015 (figs. 290, 291).[75] As tutor to Otto III, Bernward had spent time at the royal palace in the neighborhood of Santa Sabina in Rome, where he would have seen the famed wooden doors discussed in Part I (pp. 91–94), and it was perhaps there that the inspiration for such multifigured narratives for doorways came to him. The great doors were cast in two solid valves, an incredible feat of foundry work, an art in which the casters of the Rhine and Meuse valleys had always excelled. The huge monolithic casts stand some sixteen and one-half feet high, and each valve is divided into eight registers with narratives in each field.

The left door has scenes from Genesis reading from top to bottom, beginning with the shaping of Adam in the first days of creation and concluding with the murder of Abel by Cain. Scenes from the life of Christ are ordered from bottom to top on the right valve, from the Annunciation to the Resurrection. It would seem that some type of parallelism was meant to be presented here that harmonized Old and New Testament events, and indeed some such reading seems appropriate in the pairing of scenes such as the Fall of Adam and Eve with the Crucifixion in the third row and the lively story of the Admonition to Adam and Eve with the Judgment of Christ before Pilate.

The style of these dramatic reliefs indicates that the artist had recourse to models familiar in book illustration. In fact, the so-called passing-the-buck scene, with God condemning Adam, Adam passing the blame to Eve, and Eve cowering and indicating the serpent as the true culprit, corresponds remarkably well with the same episode as presented in the Cotton Genesis recension (for example, the Tours Bibles and the San Marco narthex mosaics), suggesting that the designer had at hand a model book with illustrations derived from that source.

Ottonian narrative style as presented in the bronze reliefs

290. Scenes from Genesis (left) and the Life of Christ (right). Doors of Bishop Bernward. Bronze, height 16′6″. 1015. Cathedral, Hildesheim (originally made for Abbey Church of Saint Michael)

291. *Adam and Eve Passing the Blame Before God.* Detail of fig. 290

displays a distinctively expressionistic trend vaguely related to the vibrancy of Anglo-Saxon miniatures and no doubt partly indebted to the dynamic style of the Reims School. The *cire perdu,* or lost-wax, method of casting the delicate figures allowed the artists to vary the height of the relief so that background details—plants and trees—are little more than engraved floral designs, while the animated figures gradually project from the feet upward until their heads appear in three dimensions. The doors of Hildesheim represent an initial phase in the tradition of bronze-casting for portals that can be followed through the famous *Gates of Paradise* by Ghiberti and, indeed, to the *Gates of Hell* by Rodin.

Bernward's scriptorium at Hildesheim excelled in manuscript illumination, as did a number of court and monastic scriptoria throughout the Ottonian kingdom. Unlike the monastic workshops in England, however, the Ottonian illuminations were mainly produced in royal foundations, and there has been much controversy over the location of these ateliers. Formerly it was assumed that the Benedictine Abbey at Reichenau on Lake Constance, famed for its liturgical codices, was the major center for the illuminators, but this has been seriously challenged in recent years.[76] It is now believed that the main center for the illustration of elegant manuscripts, mostly destined for royal patrons, was the old Carolingian capital of Trier (Trèves) on the Moselle. Other major centers were Echternach and Cologne. Without pursuing this complex problem further, it should be pointed out that the Ottonian style represented in the finest manuscripts is relatively homogeneous.

Indicative of the problems of provenance are the illuminations in the splendid Gospel book known as the Codex Egberti, named for its owner, Archbishop Egbert, who was the imperial chaplain to Otto II at Trier. The frontispiece, depicting the archbishop between two diminutive monks named Keraldus and Heribertus, establishes the ownership at Trier, while the monks who present the book to Egbert are identified as being from Augia, the old Latin name of Reichenau. In any case, the style of the miniatures—portraits of the Evangelists, fifty New Testament scenes, several

illuminated initials—introduces the distinctive Ottonian mode for the first time. The Gospel book includes a selection of stories—all New Testament—that seems to have been of special interest to the Ottonian scriptoria, where basic service books, not Bibles, were produced (it will be recalled that the narratives in Carolingian Bibles were predominately Old Testament).

Furthermore, the iconography of the New Testament scenes in the Codex Egberti points to new sources, namely, Byzantine models, for the illuminators, and it comes as no surprise that direct links with the East were now openly negotiated. Otto II married the daughter of the Byzantine emperor Romanus II, one Theophano, who was a staunch regent after her husband's death. There is much evidence for the importation of Byzantine ivories, enamels, silks, and manuscripts at this time; indeed, it seems certain that Eastern craftsmen were sometimes employed in the court ateliers.[77]

The fifty New Testament illustrations in the Codex Egberti range from the Infancy through the Passion of Christ, and the compositions of many of the miniatures suggest a certain indecision on the part of the painters in following their models. The *Annunciation* (fig. 292) is a good example.

Framed within the text by a simple band decorated with gold lozenges (an Early Christian convention), the two figures, Gabriel and Mary, are placed irregularly to the left on a bumpy groundline as bright silhouettes seen against an abstract background. The figures are described in heavy outlines with long arcs and straight lines and little shading to indicate the modeling of the body. They seem ironed out into flat silhouettes. Many details, such as the sharp facial features, the costumes, and the pinions of Gabriel's wings, remind us of the conventions employed in Byzantine art, but to speak of Byzantine influence here beyond these vague generalizations would only obscure the issues of style. Qualities of immediacy and vividness through intense colors and sharp lines are traits that are uniquely Ottonian and mark the temperament of a talented artist responding to the vigorous tenor of his time and place.

The crystallization of the Ottonian style into an art of expressive abstraction can be studied in two Gospel books made for Otto III. The earlier(?) is in Aachen today and is generally dated about 1000, an ominous year in the church calendar, as we shall see later. The dedication page (fig. 293) presents the youthful Otto enthroned on high within a mandorla representing the heavens; his throne is supported

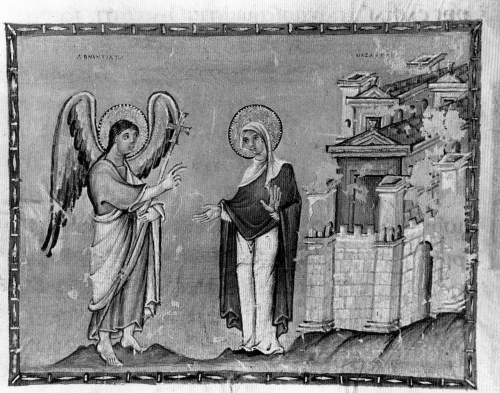

292. *Annunciation.*
Illustration in the Codex Egberti.
9⅜ × 7½". 977–93.
Stadtbibliothek, Trier
(Cod. 24, fol. 9r)

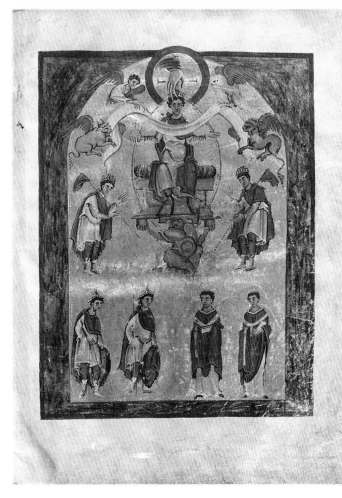

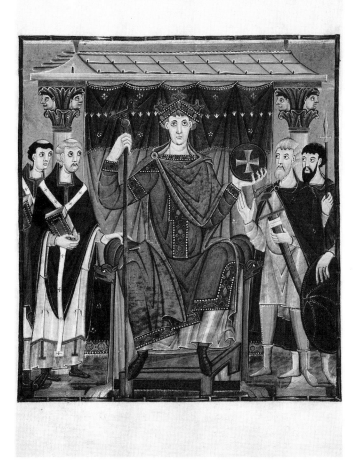

293. *Otto III Enthroned amid Church and State.* Illustration in the Aachen Gospels of Liuthar. 10⅞ × 8½". c. 1000. Cathedral Treasury, Aachen (fol. 16r)

294. *Otto III Enthroned Between Church and State.* Illustration in the Gospels of Otto III. 13 × 9⅜". c. 1000. Staatsbibliothek, Munich (Clm. 4453, fol. 24r)

by a straining atlantid (Earth or Tellus in the form of Atlas supporting the world); he is flanked by two emperors wearing identical crowns (the other Ottos?); and the four symbols of the Evangelists fly about his head carrying a long scarf or scroll-like cloth that breaks across his shoulders. From a circle above, the Hand of God places a crown, against a cross, on the head of Otto III.

The emperor, dressed in the same regalia as the two in obeisance beside him, opens his arms to receive the divine favors bestowed upon him. "May God invest your heart with this book, Otto Augustus," reads an inscription on the opposite page, commanding the ruler to establish his empire on the wisdom of the Gospels. With the four creatures about his head—the four Gospels—and the Hand of God above, the inference that he is invested heart and soul is clearly marked by the scroll that bisects his body. This, as one historian has pointed out,[78] illustrates the idea of the king's two bodies: his heart and soul (shoulders and head) signify his divine investiture, while his torso, here resting on Tellus or the Earth, represents his earthly role as a secular ruler. Below Otto, in the terrestrial world, are two soldiers and two clerics representing the unity of state and church in his domain.

The second Gospel Book of Otto III (fig. 294) is also dated about 1000 but exhibits a more advanced stage of Ottonian abstraction of space, scale, and frontality. Otto, the "boy wonder," looms large in the center of the page enthroned before a temple that represents the palace(?). All details of his regalia are enlarged and emphasized, including the eagle on the scepter in his right hand, the lion heads on the imperial throne, and the huge gemmed crown. A rich border adorns his purple mantle. To his right, in smaller scale, stand the representatives of the church holding Gospel books, attending him alertly as they touch his throne; to his left are the soldiers of state with sword and shield, making gestures of acclamation. Compared to the Carolingian portrait of Charles the Bald (fig. 261), the image of Otto is one of commanding authority, an icon of a divinely appointed monarch, a powerful statement of church and state united in the awesome Augustus.

A better comparison for such imperial portraiture would, in fact, be the mosaic panel of Justinian and his retinue at Ravenna (fig. 147), where the glaring statement of caesaropapism was superbly fashioned. It should be recalled that Otto III was the son of a Byzantine princess and was educated at court by the sagacious Bernward, councillor to his

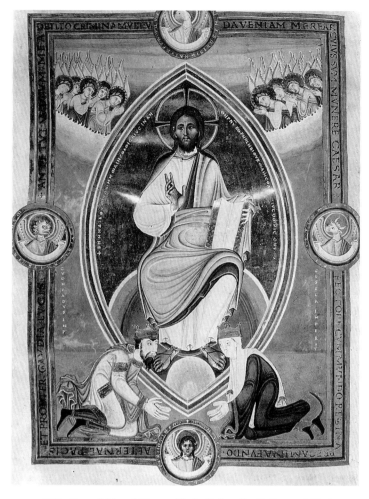

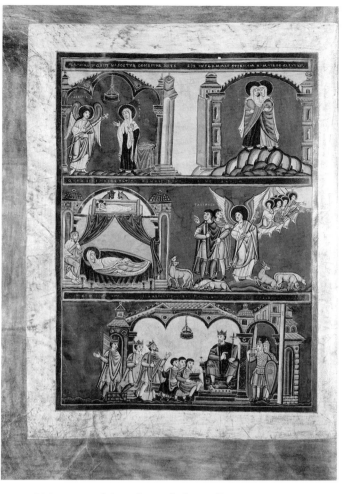

295. *Conrad II and Queen Gisela Before the Enthroned Christ.*
Illustration in the Codex Aureus of Speyer Cathedral.
19⅝ × 13¾″. 1043–46. Library, Escorial (Cod. Vitr. 17, fol. 2v)

296. *Scenes of the Infancy of Christ.* Illustration in the
Codex Aureus of Echternach. 17¼ × 12⅜″. 1053–56. Germanisches
Nationalmuseum, Nuremberg (MS 156142, p. 19)

mother. It is not too bold to suggest that perhaps similar Byzantine ideas of caesaropapism filled the mind of the young ruler. Crowned successor to Charlemagne at Aachen in 983, he later received the crown of the church from the pope in 996. Otto thus was divinely appointed, and our miniaturist pays him a splendid tribute in this portrait in his own Gospel book.

"Divinely inspired" is also a fitting characterization of the Evangelist portraits in Otto's Gospels (colorplate 40).[79] The astonishing representation of the seated Evangelist writing his text is here transformed into an image of mystical revelation with the writer lifted into the heavens. Luke, identifiable by the ox directly above his head, is transfixed and stares out frighteningly as if lost in an hypnotic trance. He has been inspired by the prophets, whose heads emerge from the fiery wheels that turn about them.

The intense colors and the jagged circles of light make Luke's vision spin like an exploding fireworks display. The palette is dissonant, as is often true in Ottonian miniatures. Cool blues are placed against greens and purples, but it is the thrusting lines and swirling edges that bring vitality to the image. Perhaps there is even something mystical in the overlapping of revolving circles of light, caught up in and

reverberating with the harmonies of the spheres, just as the Gospels resound sonorously with the prophecies of the Old Testament.

The attraction of Byzantine art manifests itself in a curious way in certain manuscripts produced in Echternach (or Trier?) for Henry III, the Holy Roman emperor from 1039–56, that mark the end of our period. In the sumptuous Codex Aureus dated 1043–46 that was presented to Speyer Cathedral by Henry III, the dedicatory frontispiece displays the parents of the emperor, Conrad II and Gisela, kneeling before a great *Maiestas Domini* (fig. 295). Here the vigor of Ottonian line has been quelled somewhat, and the faces of Christ and the angel in the lower medallion have been added by a Greek artist at the court, as can be seen in their distinctive Byzantine features when compared to the other heads on the page.

In another manuscript, the large Codex Aureus of Echternach, dating 1053–56, a full-page frontispiece is painted in imitation of a Byzantine silk pattern and serves appropriately as a carpet page for the beginning of Matthew's text, recalling the use of geometric decorations in Irish manuscripts of the seventh and eighth centuries. The numerous miniatures illustrating the Gospels are organized in registers much in

right: 297.
Doubting Thomas.
Ivory plaque, 9⅝ × 4″.
Early 11th century.
Staatliche Museen, Berlin

below: 298.
*Christ Between Archangels
Michael, Gabriel, and
Raphael and Saint Benedict.*
Altar Frontal of Henry II.
Silver with gilt and niello,
47 × 70″. c. 1019.
Musée de Cluny, Paris

the fashion of those in the Tours Bibles (cf. colorplate 37). The story of the Incarnation (fig. 296), associated with the genealogy of Matthew, is presented with stories of the Annunciation, Visitation, Nativity, and Adoration of the Magi, the first two scenes being related only in Luke's Gospel. Obviously, the pictures here depend on a set that constituted the Infancy cycle independent of the Gospel text.

Anticipations of the Romanesque are also found in many of the ivory carvings attributed to Ottonian workshops. The highly expressive *Doubting Thomas* (fig. 297), perhaps produced at Trier, announces the exaggerated elongation and twisting of torso and limb that we find in later French trumeau figures of the twelfth century. It is in metalwork, however, that some of the most accomplished large-scale pre-Romanesque sculptures appear. As we have noted, Bishop Bernward employed bronze-casters for his monumental doors and triumphal column, and in the craft of metalwork in *repoussé,* the Ottonians also excelled. Emperor Henry II presented Basel Cathedral with a magnificent antependium (altar frontal) of gold plate with *niello* inlays (fig. 298), dated about 1019, that exemplifies these elegant metal sculptures.

299. *Virgin of Essen.* Gold over wood, enamel, filigree, and gems, height 29½". 973–82. Cathedral Treasury, Essen

In a broad arcade are *repoussé* figures of the archangels Michael, Gabriel, Raphael, and Saint Benedict standing symmetrically about a tall figure of Christ holding an orb. At his feet kneel the diminutive figures of the emperor and his queen, Kunigunde.

Attempts at monumental sculpture in the round are also found.[80] The controversies over icons and imagery had not yet subsided, and large, fully modeled statues of Christ, the Virgin, or saints on an altar, serving an iconic presence, would still be considered dangerously close to idolatry. Yet the cult of relics, which enjoyed a renewed popularity in the North, could not be denied objects of veneration. The first

sculptures in the round, often incorporating a reliquary cavity, come surprisingly close, in fact, to fetish images. The *Virgin of Essen* (fig. 299), standing about two and one-half feet high, is at first sight a bit frightening, with her huge paste eyes staring out from the glistening orb of her golden head. Made of gold plate affixed to a wooden core and enriched with filigree, gems, and enamels that accent the stark planes of the mantle, the statue has a remote and unreal appearance. The *Virgin of Essen* was probably given to the cathedral there by Abbess Matilda, sister of Otto I, sometime around 973–82.

The earliest known example of such monumental sculp-

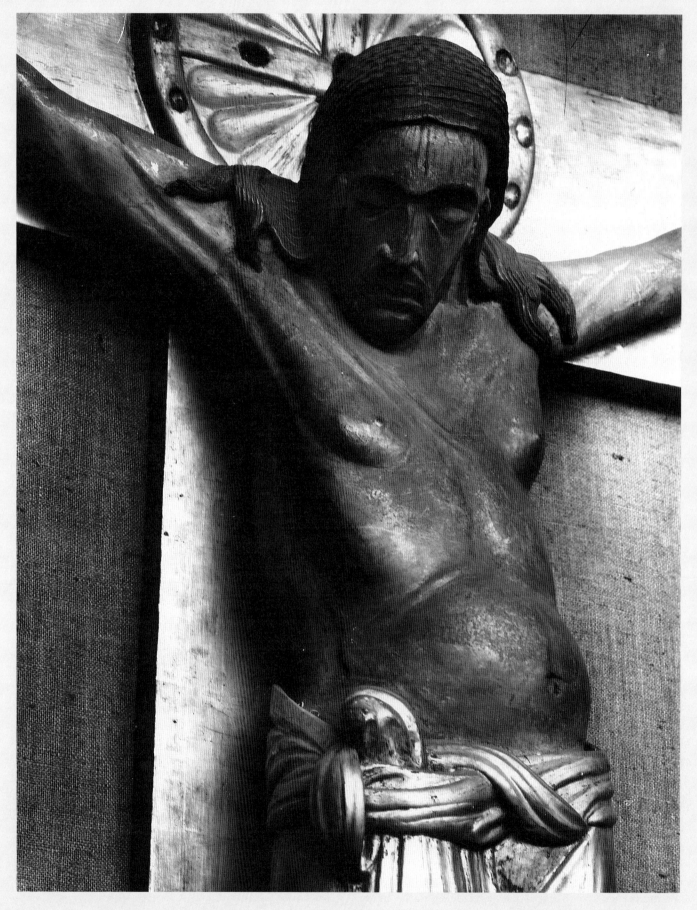

300. *Cross of Archbishop Gero* (detail). Painted wood, height of figure 6′2″. c. 970. Cathedral, Cologne

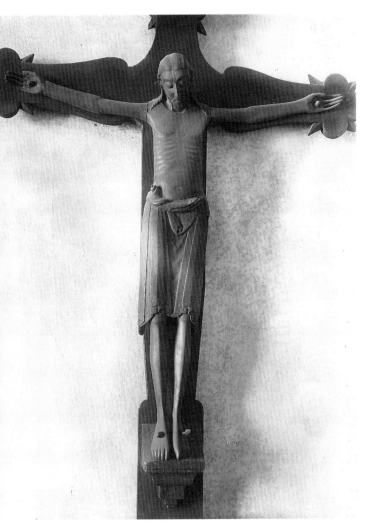

301. *Werden Crucifix.* Bronze, height 3'8". c. 1070. Abbey Church; Werden (formerly in the Abbey of Helmstedt)

ture in wood, the Gero Crucifix (fig. 300), was commissioned by Gero, archbishop of Cologne, for his cathedral about 970. The impressive figure is over six feet high. A cavity in the back of the head received the host. Covered with gesso and then painted, the wooden corpus displays an amazing modernity. The heavy weight of the dead body is conveyed by the grooves of stretched and sagging skin in the shoulders and chest, while the stomach is swollen and bulges outward. Christ's face is superbly modeled to express a lonely, withdrawn somberness. The lips are contorted and twisted down at the corners above the cup of the chin, while deep craters form the eerie sockets for the closed lids of the eyes capped by harshly contoured brows. The Gero Crucifix, a striking image of human suffering and death, is the work of a superior sculptor who appears far ahead of his time.

The crucifix was a popular object in early German sculpture, although most were of small scale and cast in bronze. Many are impossible to date, but one is distinguished by its huge scale and extreme refinement in casting technique—

the *Werden Crucifix* (fig. 301). The tall, lean form of Christ is made up of five cast pieces flawlessly assembled into a streamlined image of quiet pathos. The narrow planes are smoother and the contours sharper than those of the crucifixes in wood. The conventions for the body parts—note especially the eye sockets and the beard—are pronounced and very stylized, but the elegant abstraction of the torso into geometric planes resembling a polished breastplate and the slight inclination of the head and neck effect a timeless characterization of the dignity of Christ even in death. The *Werden Crucifix* is one of the finest sculptures of the Ottonian period.

"MOZARABIC"—LEONESE ILLUMINATIONS IN SPAIN

"A man who knows not how to write may think this no great feat. But only try to do it yourself and you shall learn how arduous is the writer's task. It dims your eyes, makes your back ache, and knits your chest and belly together—it is a terrible ordeal for the whole body. So, gentle reader, turn these pages carefully and keep your fingers far from the text. For just as hail plays havoc with the fruits of spring, so a careless reader is a bane to books and writing."[81] This touching admonition appears at the end of the text of a richly illustrated Apocalypse manuscript traditionally called the Silos Beatus. The colophon is signed by Prior Petrus, who also contributed to the enchanting miniatures; the scribes were Dominicus and Nunnio; and the scriptorium was the monastery of San Sebastian (later Santo Domingo) at Silos in north central Spain. The illustrations belong to a late phase of the so-called Mozarabic style that developed in the Asturias around León during the course of the tenth century.

The term Mozarabic, derived from the Arabic *mustarib,* meaning "Arabized," is something of a misnomer since very little Arab or Islamic influence can be found in this curious style no matter how hard we try. The term does have historical relevance, however, insofar as this art was produced by cloistered monks who took refuge in the Christian kingdom of the Asturias during the long Muslim occupation of the Iberian peninsula (from 711 for roughly three centuries). Spain was virtually cut off from the currents of Western culture in Italy and the North during this period. In fact, all land south of the Pyrenees belonged to Africa rather than to Europe, and thus severely isolated, the Christians in Spain withdrew and sealed themselves off from the flux of international intercourse. An inborn, mutant culture germinated in seclusion, and it should not be surprising that the arts that flowered in such an estranged environment unfold as primitive, even barbaric, expressions of weird beauty.

The sources of Mozarabic style have been traced in part to Visigothic and Merovingian Animal styles, to Early Christian manuscript illuminations, and to some Carolingian models, but these influences explain little.[82] The stylistic or formal elements of these strange pictures cannot be so easily

302. MAGIUS AND EMETERIUS(?) *Scribe and Miniaturist at Work in the Tower Workshop of Tábara.* Illustration in the Beatus of Liébana, *Commentaries on the Apocalypse.* 14¼ × 10⅛″. 970. Archivo Historico Nacional, Madrid (Cod. 1240, fol. 139r)

dissected. One must analyze them in psychological terms as features of an art misplaced in time, displaying a primitivism that is not wholly a decorative language of signs, as we normally consider folk art, but also an emotional expressionism that mysteriously conveys the fears and longings of a closed monastic society in dire times. That the scribes and illuminators took deep pride in their work is not only the sentiment of Prior Petrus, quoted above, but that of the entire monastic community as illustrated in the bell tower of a monastery (fig. 302) painted in a famous Mozarabic manuscript, the Tábara Apocalypse, dated 970, where the atelier of the illuminators and scribes is given special prominence.

Prior Petrus's allusion to "fruits of spring" with reference to the pages is particularly apt, since Mozarabic miniatures

resemble strange bouquets of wild flowers gathered on a page, and, furthermore, the vellum is treated with a special wax that emits a slightly astringent odor that enhances the primeval sensations evoked by the manuscripts' appearance (see colorplate 41). The compositions are bursts of rich colors—bright reds, sulphurous yellows, blues, greens, and violets; the shapes are insectlike and scattered in a seemingly haphazard fashion but in fact are held mysteriously within definite patterns and symmetries. Space is totally abstract and visionary, often divided into multicolored bands or concentric circles.

The figures are reduced to cookie-cutter silhouettes with a few conventional marks—double arcs, curlicues, and frets—suggesting the lines of drapery, the protrusion of shoulder or thigh, the feet, the hands, the head. The round faces have big bulging eyes, and with a shorthand of quick strokes the nose, mouth, and chin are marked out. Enlarged hands appear here and there as if stuffed into the carpet-bodies; even the haloes display a variety of colors. This is an

303. VIMARA AND JOHANNES. *The Symbol of Saint Luke.* Illustration in the León Bible of 920. 9¼ × 8⅝″. 920. Cathedral, León (Cod. 6, fol. 211r)

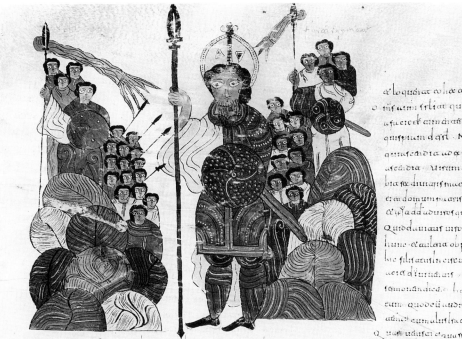

304. FLORENTIUS. *Goliath Challenges David.* Illustration in the León Bible of 960. 12⅜ × 19½″. 960. Colegiata San Isidoro, León (Cod. 2, fol. 116v)

art born of basic instincts working through the faded memories of sophisticated models and resembling those eerie kaleidoscopic sensations that float against a dark nothingness created when we close our eyes tightly.

While Christians were tolerated under Islamic rule, it seems clear that they sensed a threat of death through suffocation and isolation, and gradually many monks migrated from Muslim territories northward to the kingdom of Alfonso III (866–911), centered in León in the Asturias, where they established monastic communities. One of the earliest illustrated books in the Mozarabic style is the León Bible of 920.[83] Fortunately, Mozarabic manuscripts provide us with much information in their colophons. The León Bible was commissioned by Abbot Maurus for the monastery of San Martin de Albelda (Albeares) near León; it was written and illuminated by the monks Vimara and Johannes. The date in the colophon, 958, must be rectified to the year 920, since Spanish chronology was off by thirty-eight years. The illustrations include a favorite motif, the Cross of Oviedo (a familiar sign of resistance to Muslim rule), canon tables with Evangelist symbols, and full-page frontispieces for the Gospels with symbols of the Evangelists supported by angels within huge circles (fig. 303). The execution is childlike and folksy with only colorful outlines and candy stripes of red, green, yellow, and blue lending a feathery lightness and transparency to the image. No attempts at modeling can be discerned, and indications of space are totally ignored.

A later Bible of 960, signed by the monk Florentius, in San Isidoro in León, is remarkable for the vast number of narrative pictures that appear in the margins and in the text, many unframed, like column pictures (fig. 304). Again, the naive treatment of the figures, the suppression of gestures, and the lack of any illusion of space make these colorful illustrations difficult to read at times, but if one studies the configurations closely, as if they were flat cutouts pasted to the margins, the rudiments of the narratives become discernible.[84]

It is to the illustrations of the Beatus Apocalypse manuscripts that we must turn to study the true spirit of Mozarabic art, however. These densely illustrated codices outnumber all others in the Mozarabic style. Why should such a compilation of commentaries on the Book of Revelation be so popular? We know that in Spain from the earliest times, the Book of Revelation was considered as canonical as the writings of the Evangelists themselves. In fact, at the Fourth Council of Toledo (633) it was decreed that "the Apocalypse is a canonical book and should be read in the church from Easter to Pentecost."

But more important than its liturgical significance was the millenarian message of the ultimate triumph of the church over the false prophets and enemies of the faith, with the establishment of the New Jerusalem at the end of time. This message, wrapped in colorful allegory in the Book of Revelation, was dear to the hearts of the Spanish Christians, who had frequently been embroiled in issues involving heresy. Were not the Muslims, the followers of Muhammad, the

most threatening of the false prophets occupying their very land? If the popularity of the Beatus Apocalypse swelled as the real millennium—the year 1000—approached, perhaps their vision of the Apocalypse became something of an obsession, something truly awaited and very imminent for them. We will return to the question of the millennium in Part IV.

As an encyclopedia of doomsday, the contents of the Beatus commentaries are rich and varied, as are the illustrations. The books begin and end with large initials of the Alpha and Omega. In the more complete editions, there are genealogical tables for the descendants of Adam through Christ, a fanciful *mappa mundi,* a depiction of Noah's ark (commemorating the Flood as the first destruction of the world), illustrations of Jerome's commentaries on the Book of Daniel and its Apocalyptic visions, portraits of the Evangelists, and numerous double-page and full-page miniatures as well as column pictures of the episodes narrated in the text of Revelation.[85]

It is in illustrating the more mystical visions described by John that the Mozarabic artists truly excelled (colorplate 41). For "the four angels holding the four winds" (Rev. 7:1–2), the earth is presented as a splendid oval with bands of bright yellow, violet, and pink and trees and bushes scattered here and there. Enframed by a border of deep blue waters with fishes, it forms the setting for the multitude of the elect from "every tribe of the children of Israel," standing hand-in-hand like so many paper dolls. In the corners the four angels, like giant butterflies pinned there, hold on to antennae that represent the forces of the winds, while in the upper center,

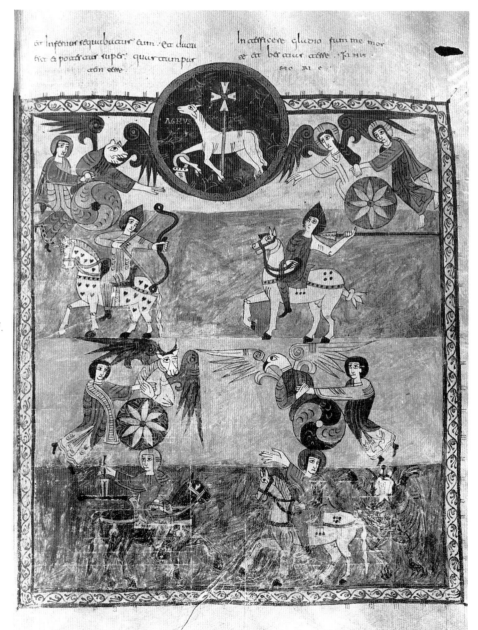

305. Emeterius and Ende. *The Four Horsemen of the Apocalypse.* Illustration in the Gerona Beatus of Liébana, *Commentaries on the Apocalypse.* 16 × 10″. 975. Cathedral Library, Gerona (MS 7, fol. 126v)

the angel with the seal blossoms from a red disc labeled SOL. This colorful image of the world is just one of the many enchanting full-page miniatures in the Apocalypse in the Pierpont Morgan Library in New York, one of the earliest Beatus manuscripts known. The Morgan Beatus is signed by one Magius and dedicated to the Monastery of Saint Michael, very likely San Miguel de Escalada near León.

Magius later settled in the Monastery of San Salvador de Tábara, north of Zamora, where he established an important atelier that produced several Beatus Apocalypse manuscripts with illustrations. We know further that the *archipictor* Magius, as he was known, died at Tábara in 968. The intriguing representation of the bell tower at Tábara (fig. 302) features the rooms of his atelier located in a side chamber on the second level. The cross section shows the walls lined with colorful tiles, a horseshoe-shaped doorway, and ladders giving access from one floor to the next. Magius died before the completion of the Tábara Beatus, leaving the task to his disciple Emeterius, who tells us that in this "lofty tower" he sat "for three months, bowed down and racked in every limb by copying."

Elevated to the rank of master *pictor*, Emeterius continued his mentor's work at Tábara, employing an assistant, one Ende, a *pinctrix*, a nun who lived in a convent annexed to the monastery. Together they produced the beautiful Beatus Apocalypse, today in the Cathedral of Gerona and dated 975, with many new enrichments that were clearly copied from Carolingian models. The sequence of pictures follows closely that established in the Morgan Beatus. The page with the *Four Horsemen* (fig. 305) is typical of these narratives,

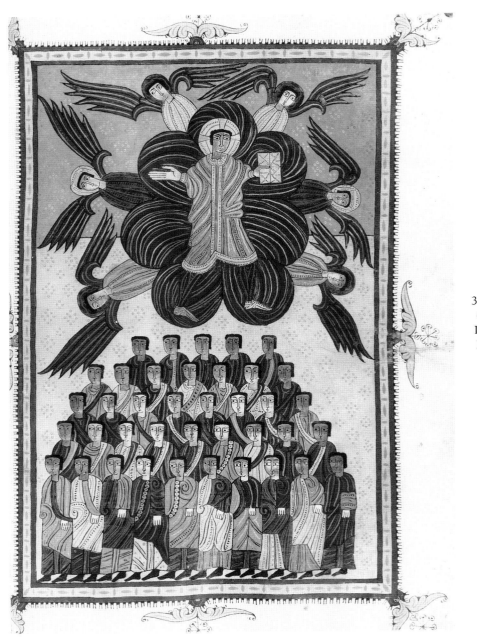

306. PRIOR PETRUS. *Christ Appearing in the Clouds.* Illustration in the Silos Beatus of Liébana, *Commentaries on the Apocalypse.* 15¼ × 10″. 1109. British Library, London (Add. MS 11695, fol. 21r)

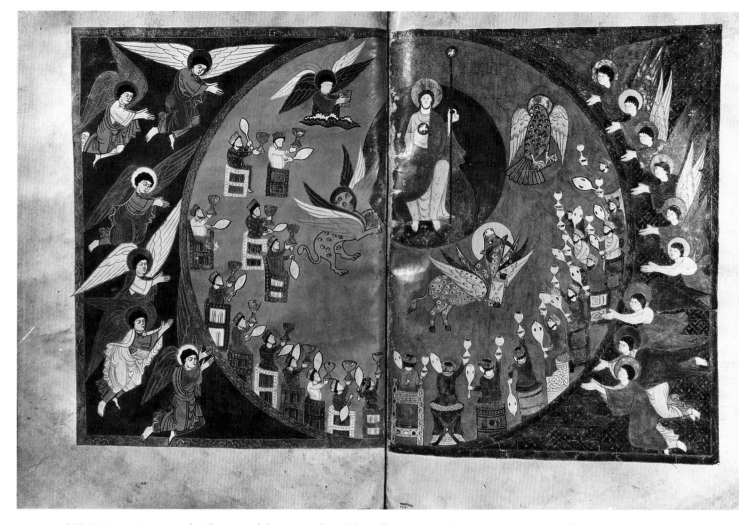

307. *Maiestas Domini with Adoration of the Twenty-four Elders.* Illustration in the Saint Sever Beatus of Liébana, *Commentaries on the Apocalypse.* Each page 14⅜ × 11″. Mid-11th century. Gascony(?). Bibliothèque Nationale, Paris (MS lat. 8878, fol. 121v–122r)

with the mounted destroyers added one after the other against glowing bands of color (cf. the Trier Apocalypse, fig. 266).

Considered the last great monument of Mozarabic art is the famous Silos Beatus in London (fig. 306), written by Dominicus and Nunnio between 1091 and 1109 and illustrated in part by Prior Petrus, who left us the plea to treat his manuscript with care that was quoted above. This scriptorium was located in Castile at the Monastery of San Sebastian (later Santo Domingo) de Silos, where some of the finest examples of monumental sculptures in the Early Romanesque style are found (see Part IV, p. 260). Meyer Schapiro has argued that the style of the Silos manuscript leads us from Mozarabic to Romanesque, and in many ways his observations are convincing.[86] Yet such a colorful page as *Christ Appearing in the Clouds* (Rev. 1:7–8) can hardly be dissociated from the Mozarabic style that we have studied in the Leonese manuscripts.

However one describes the introduction of the Roman-

esque style—and we have observed many anticipations of it in tenth-century art—the one famous Beatus manuscript that clearly shows the transition from Mozarabic to Romanesque is the Saint Sever Apocalypse in Paris, a lavish production made for Abbot Gregory Muntaner (1028–72) of the Gascon monastery in the western Pyrenees.[87] Here the models behind the Morgan and the Gerona Beatus cycles were followed faithfully, but the figures are normally proportioned and articulated with draperies that are more functional than patterned (fig. 307). Pockets of folds flare up at the ends in Romanesque fashion, the heads are more carefully drawn, and the gestures and movements are less conventionalized. It is clear that a new style is announced here, one that portends the dynamic line of French Romanesque art. This transformation took place in the larger context of the sculptural enrichments of a new architecture in a broader international movement of style no longer bound to isolated regions and patrons but to the spread of the church, a development we will follow in Part IV.

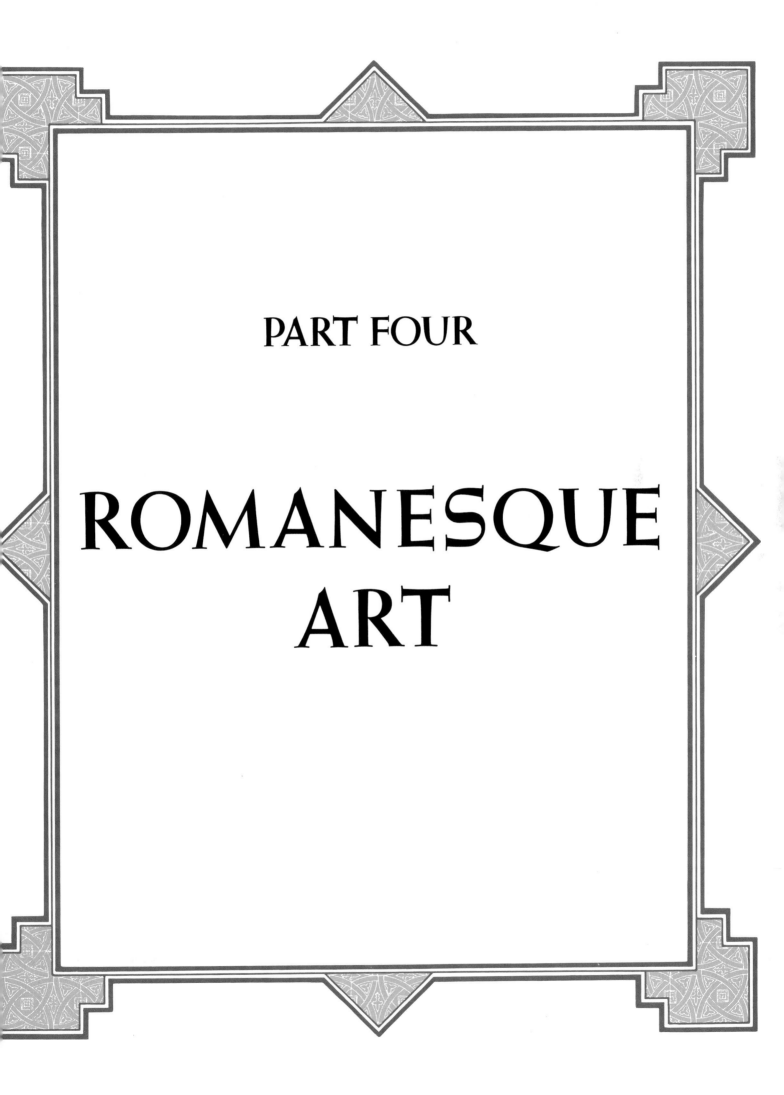

PART FOUR

ROMANESQUE ART

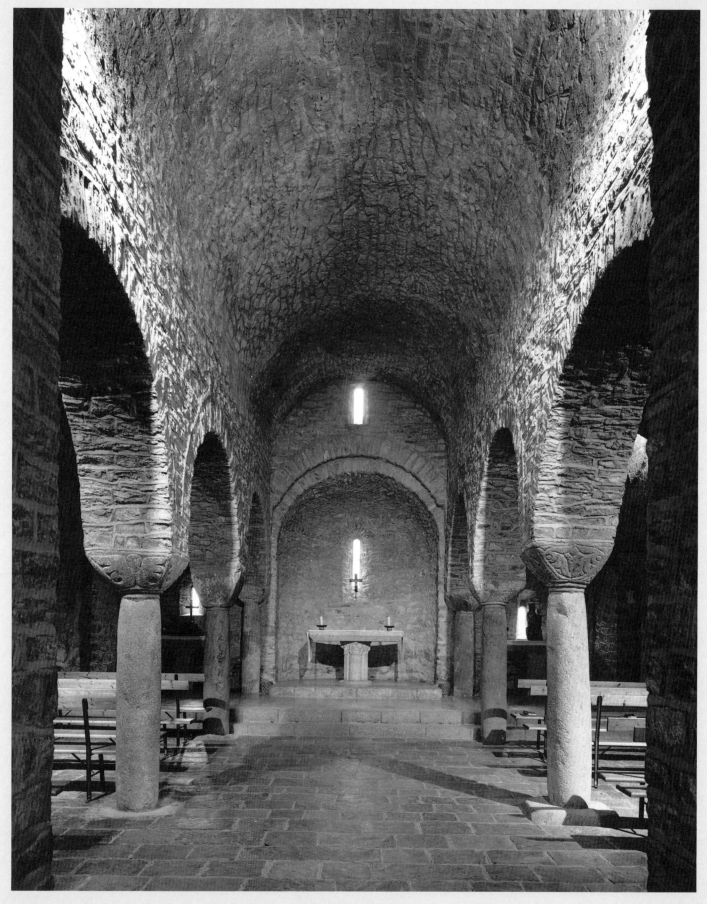

308. Saint Martin-du-Canigou. French Pyrenees. Nave, upper church. 1001–26

THE TRIUMPH OF LATIN CHRISTENDOM

HE IDEA of Latin Christendom as a spiritual and temporal power presiding over the affairs of the world was announced in Carolingian lauds of the eighth century: "Christ is victor, Christ is king, Christ is emperor."[1] The world in the Middle Ages was a very limited one by our perceptions. It included the lands bordering the Mediterranean Sea (the *occidens*) and the vast areas east of the Caucasus (the *oriens*), and the *mappa mundi,* or map of the world, was envisioned as a circle divided into three parts: Asia, Europe, and Africa. Pope Urban II, rallying the faithful for the First Crusade at Clermont in France (1095–96), decried the condition of the world. The enemies of Christ had seized control of Africa and Asia, and "There remains Europe, the third continent. How small a portion of it is inhabited by us Christians!"[2]

It was the Christian mission—beginning with that given to the apostles by Christ—to recover these lands for the *imperium christianum,* the kingdom of Christ. A mythology was born from the stories of the crusading campaigns of Constantine and his mother Helena in the fourth century, tales of the emperor Heraclius's efforts to recover the site of the Holy Cross in Jerusalem in 628, and those of Charlemagne to free the Christians from the Moors in Spain (the *Song of Roland*) in the eighth.[3] The world of the crusading knights of Christ is born again in the Romanesque era, and there are a number of factors to be considered in evaluating its impact and success in history. In a Europe that was still basically agrarian in makeup, two systems emerged for organizing the vast wilderness in the North: feudalism and monasticism.

Feudalism, a pyramidal system of polity developed from the relation of lord to vassal and the ownership of land in *feud* (*feod, fief*), or land held from a lord in return for service, had roots in old Roman, Carolingian, and Germanic landholding practices. By the end of the tenth century it was institutionalized in the North. Thousands of fiefs were scattered across Europe, and the confusions resulting from such a system are obvious when one traces, for instance, the evolution of the Capetian lords in France, as we shall later see. Monasticism, founded as a mode of life in retirement or seclusion from the world, became the major organization

within the church. The Rule of Saint Benedict held the favor of the papacy, and Benedictine monastic houses spread rapidly throughout Europe. Viewed in the broadest sense, the warlords of feudalism epitomized the *vita activa* in Christendom, the monks, the *vita contemplativa,* but all was not so simple.

Unifying links in these sprawling chains of authority were forged by pilgrimages and crusades, with the pilgrimage roads forming the avenues that connected France to Spain and Italy. The idea of a pilgrimage to the holy sites was, of course, important in Early Christian times, when travelers spent lifetimes wandering from one hallowed shrine to another, usually converging on Rome and its great basilicas or, for the more ambitious, the Holy Lands in the East, especially Jerusalem. There were only brief interludes when Christians could safely visit the Holy Lands after they fell to the Persians in 614, and during the course of the tenth and eleventh centuries, two major shrines became distinguished for the Latin pilgrim: Rome and Santiago de Compostela.

A psychological factor has also been frequently cited when tracing the emergence of the new Romanesque world. For many historians the birth of the Romanesque should be placed about the year 1000, the end of the first millennium. Fears of the holocaust coming with the Apocalyptic Last Judgment, considered imminent, together with the joys at the establishment of the New Heaven on earth that was to follow were emotions that quickened the pulsebeat of Europe, it has been argued. It is true that numerous commentaries with dire warnings of the Second Coming of Christ appear (recall the illustrated Beatus Apocalypse), but the reckoning of the final hour was usually muddled. It is even reported that peasants and nobility gathered on hillsides on the eve of the second millennium to await the Apocalyptic fireworks, but generally today these factors are downplayed by Medieval historians. Who can tell? A Cluniac monk, Raul Glaber, writing about 1003, has often been cited as an authority for the advocates of the millenarians: "Therefore, after the above-mentioned year of the millennium which is now about three years past, there occurred, throughout the world, especially in Italy and Gaul, a rebuilding of church basilicas. . . . each Christian people strove against the others

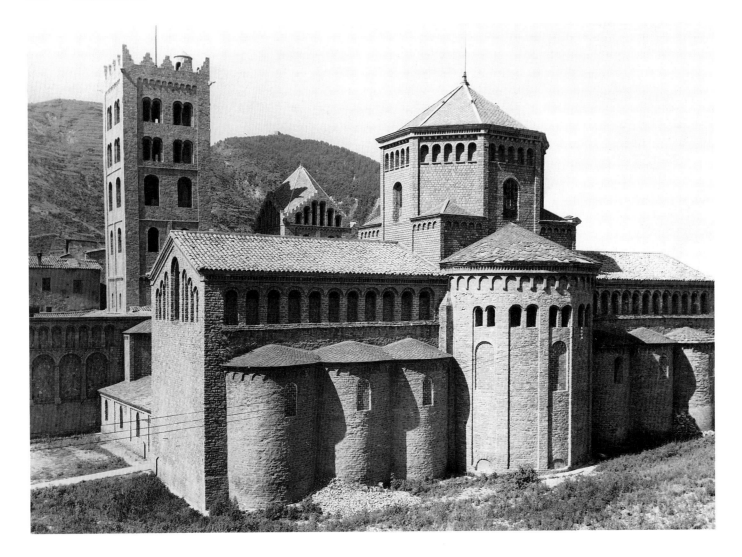

to erect nobler ones. It was as if the whole earth, having cast off the old by shaking itself, were clothing itself everywhere in the white robe of the church."[4]

The term Romanesque—meaning "in the Roman style"— is a fairly recent invention in art history. Formerly considered a primitive phase of Gothic, the architecture of the eleventh and twelfth centuries was not given its name or presented systematically until 1871, when Arcisse de Caumont published his "geography of styles," dividing the earlier buildings into seven regional groups.[5] Later, Caumont's schools of architecture were extended to include sculpture as well, especially the great tympanum decorations.

Special attention was then given to chronologies and origins of the new style. For some, the scholarly battle concerned the preeminence of northeastern Burgundian churches over the southern Languedocian in the beginnings of Romanesque. Others claimed the impetus was to be found in the churches in Provence, bordering Italy, where the idea of monumental stone sculpture, in the "Roman manner," would have evolved naturally. Others argued for Spanish origins. The role of Cluny as the sponsor of the new art was

also emphasized, and finally the theory of the pilgrimage roads as the conduits of the new style was introduced to relieve the rigidity of the categories imposed by the spokesmen for regional schools.[6] These various arguments will be reviewed below, but attention should be given to the theory of a "first" (*premier*) Romanesque art that offers an interesting transition from the arts of the Early Christian and Carolingian periods to those of the eleventh and twelfth centuries.

THE "FIRST" ROMANESQUE

The definition of the "first" Romanesque was introduced in 1928 by José Puig i Cadafalch (*Le premier art roman*).[7] While a somewhat vague concept, the "first" Romanesque concerns a phase of building, about 950 to 1060, that occurred on an east-west axis, stretching from Lombardy in Italy across lower France and into Catalonia. The Catalonian churches are the best preserved, and Puig described these structures as bridging the gap between the earlier (Visigothic, Carolingian, and Mozarabic) buildings in Spain and those of the Romanesque. This phase was marked by the

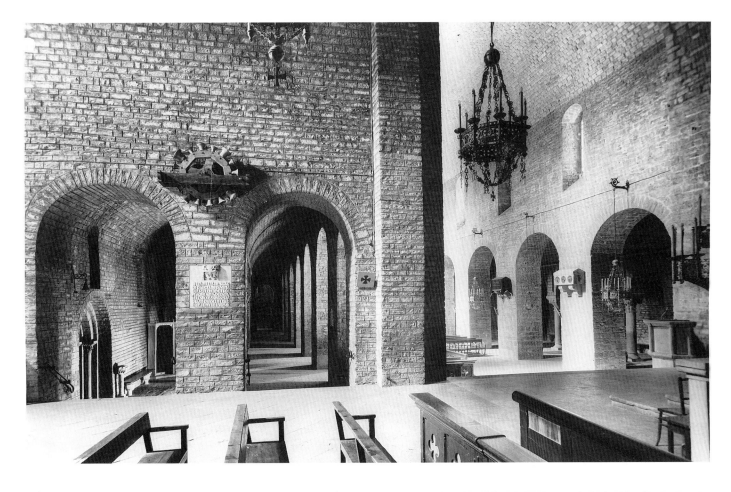

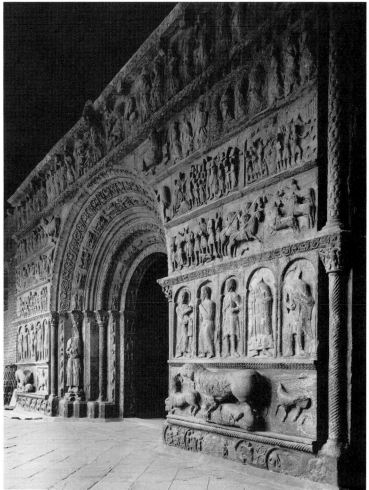

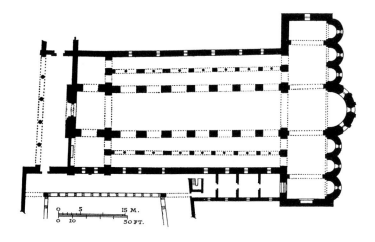

opposite: 309. Santa Maria, Ripoll, Spain. Exterior from north (restored after fire of 1835). c. 1020–32

above: 310. Santa Maria. Interior, view of nave and side aisles

above: 311. Santa Maria. Plan (after Conant)

right: 312. Santa Maria. View of portal

introduction of solid stone construction in the nave with a heavy tunnel vault carried on massive piers or columns. The "will to vault" has been traced to Lombard workmen (the *comacini*), who were masters of scaffolding techniques used in vaulting crypts and side aisles with small, split stones used as bricks (*petit appareil*), a technique presumably introduced from Byzantium in the sixth century.[8]

As for decoration, the familiar Lombard corbel tables together with pilaster strips on exteriors formed a simple but effective accent to the austere surfaces of stone. In time, figurative sculptures appeared in the capitals and on the portals. Puig i Cadafalch isolated three or four major plans, two of which interest us here. One consisted of a triple-aisled nave with tunnel vaults, without transepts, terminating in three apses opposite the entrance. The other featured the *T*-shaped basilical plan of Saint Peter's in Rome with a dome over the crossing of the nave and projecting transept arms.

A more romantic setting can hardly be imagined than the one for the monastery of Saint Martin-du-Canigou (French Pyrenees), nestled comfortably in the mountainous slopes above Prades (fig. 308; colorplate 42). As one visitor noted, the "rooms command a lovely view," looking out over rocky masses that descend about the buildings of the double church, the bell tower (rebuilt), and the dormitories squeezed about a spacious open cloister. The church, restored in the nineteenth century, has been dated between 1001 and 1026. It was built on two levels. The upper church is particularly impressive. Three long tunnel vaults are carried on ten heavy supports consisting of two sets of columnar shafts separated by huge piers. The piers strengthen the middle of the nave, which is marked by a sturdy transverse arch across the vault. The problems of thrust and support are thus simply resolved by this sturdy arcade and the massive exterior walls. There is no clerestory, and hence the only illumination is provided by small windows at either end of the nave.

The history of Saint Martin-du-Canigou is of interest. The first abbot, the monk Scula, apparently supervised the building of the church. The founder was Guifre, count of Cerdagne (later a monk at Canigou) and brother of the famous churchman Oliba, abbot of one of the leading cultural centers in the West, Santa Maria at Ripoll (figs. 309–312).[9] The plan of Oliba's church at Ripoll reminds us at once of the Basilica of Saint Peter in Rome, which it undoubtedly is meant to copy, with the addition of three apses on either arm of the transept. A view of the exterior (restored after a fire of 1835) dramatically changes this impression, for here we find massive walls of small stones with rhythmic pilaster strips and corbel tables applied to the elevation and a great cupola over the crossing. Even more surprising is the interior with its ponderous tunnel vaults resting on great thick piers. Windows pierce the clerestory above the intercolumniations

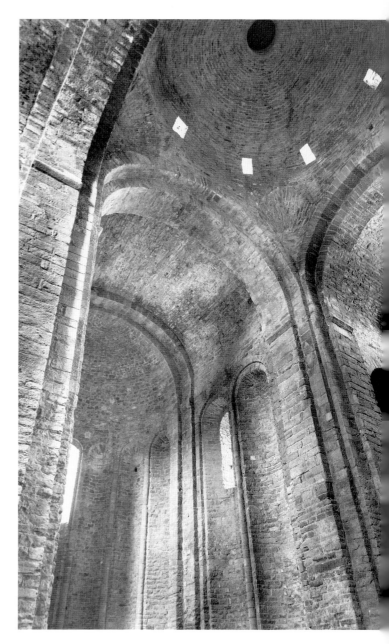

313. Saint Vicente, Cardona Castle, Spain. Interior. c. 1029–40

of the nave arcade, but its austerity remains forbidding and cold. However, one must imagine the barren expanses of walls brightly decorated with frescoes, the floors glistening with marble, and lavish furnishings accenting the deep space.

In the hills some forty miles southwest of Ripoll is the elegant Church of San Vicente at Cardona Castle (Barcelona). Begun about 1029 and consecrated in 1040, it is raised on a simpler plan with no projecting transepts. However, the building techniques employed are so advanced that it is difficult to imagine the rapid strides in masonry that occurred in the early eleventh century. The interior (fig. 313) is especially impressive with its keen articulation of

parts. The great tunnel vault of the nave is divided into bays by transverse arches. For each vaulted bay of the nave three groin vaults are employed in the side aisles, and over the crossing rises a dome on squinches. What is especially interesting for us is the early use of the articulated pier here. The giant supports have a complex cross section made of trebled rectangular projections from the basic square, each of which corresponds to some element in the rising elevation of the interior. These piers form, in their cross section, a kind of working ground plan for the masons, and from their profiles the various aspects of the interior can be visualized in three dimensions.

The articulated pier is one of the major innovations in Romanesque architecture; it introduces a sophistication of building techniques and a process of thinking in architecture—the stone mason's concept—that have revolutionary implications for later Medieval buildings in the North. The articulated pier imposes a strict division of the nave into bays, which are added one to the other longitudinally and are clearly marked by transverse arches. Later Gothic architects will transform this mathematics of addition into one of division.

Some of the earliest examples of figurative sculptural decoration in architecture are found in the "first" Romanesque churches of Catalonia and the Pyrenees. Not surprisingly, these early experiments appear in marginal areas such as capitals, cloister piers, and portals. Small figures, often merely incised, appear like badges affixed to the face of a floriate capital. Sometimes a narrative is involved, but more frequently these carvings seem to be whimsical footnotes of a missing text. At Saint Genis-des-Fontaines in the Pyrenees a marble lintel (fig. 314), two feet high, spans the central doorway with a representation in relief of a squat Christ in Majesty within a figure-eight-shaped mandorla carried by angels. Aligned on either side are three doll-like figures of the apostles squeezed tightly within an arcade of horseshoe arches, resembling the childlike friezes of figures found in Beatus Apocalypse illustrations in the Mozarabic style. The curious *Maiestas Domini* at Saint Genis, dated to 1020–21, clearly belongs to the tradition of Early Christian portal decoration (see Part I, pp. 42–43), but the direct source for the representation seems to have been a Mozarabic manuscript or carving.

The close dependence of early monumental sculpture on the minor arts is demonstrated in the impressive twelfth-century portal of Santa Maria at Ripoll (fig. 312). Above the keystone of the doorway appears Christ enthroned amid the symbols of the Evangelists, flanked by two friezes of angels and the twenty-four elders (Rev. 4). Below this Apocalyptic image are friezes with Old Testament stories, some of which are closely related to earlier Spanish Bible illustrations, such as those in the eleventh-century *Farfa Bible*.[10] Below, on the

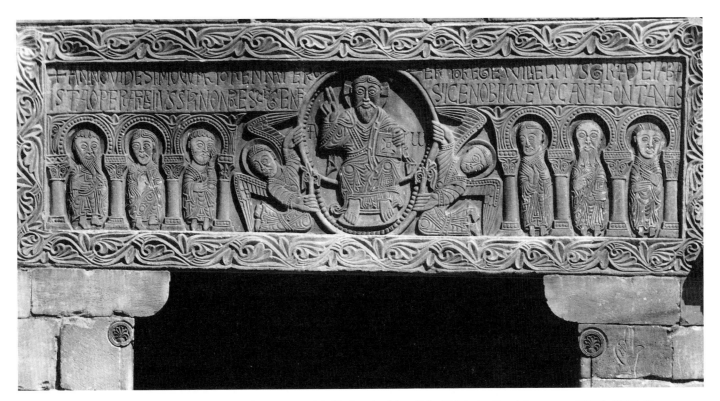

314. Saint Genis-des-Fontaines. French Pyrenees. Marble lintel with relief of *Maiestas Domini,* approx. 2′ × 7′. 1020–21

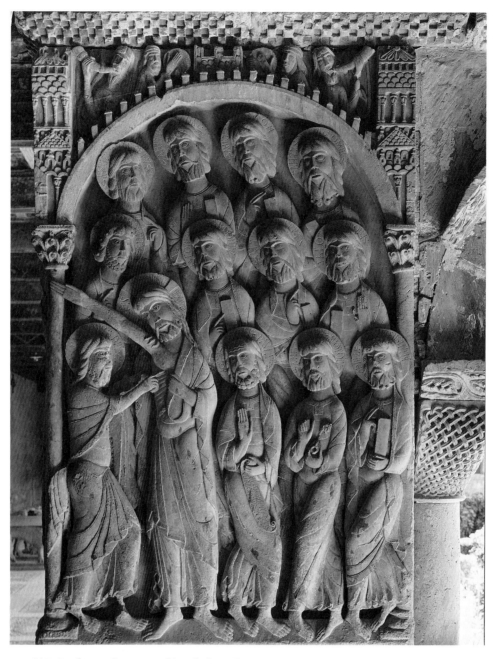

315. *Doubting Thomas.* Marble relief on cloister pier of Santo Domingo de Silos, Spain.
Late 11th century

door jambs, taller figures stand in regimentation much in the fashion of the carved column-figures in mid-twelfth-century French churches (cf. fig. 478). Unfortunately, these fascinating sculptures were seriously damaged in a fire in 1835 and have disintegrated too much to serve a meaningful discussion of style.

Among the finest preserved are the pier reliefs in the cloister of Santo Domingo de Silos (fig. 315), usually dated about 1088. The relief of the *Doubting Thomas* is superbly carved with broad, smooth surfaces and extremely delicate lines describing the flowing draperies of the tall, weightless figures. A more sophisticated style appears in the Silos reliefs, and while some features are clearly related to Mozarabic art,[11] the complex overlapping of forms in shallow planes and the expressive accents, such as the thrusting arm of Christ, anticipate the complex designs of later tympanum sculptures in France. It is not surprising, therefore, that some French scholars have dated the Silos sculptures much later (mid-twelfth century) and see them as dependent on French models. The cross-fertilization of Early Romanesque art, whichever way it may move, introduces us to one of the major issues in any consideration of twelfth-century sculpture, namely, the role of the pilgrimage roads in the development of regional styles.

THE PILGRIMAGE ROADS AND REGIONAL STYLES

THE RAPID developments in Romanesque architecture and sculpture in the last decade of the eleventh century appeared almost simultaneously in Spain and France. Four roads or avenues linking various religious centers in France led southward to the Pyrenees, where they joined and continued westward to the hallowed Church of Saint James in the "field of stars" in Galicia (see map III). We are fortunate that a twelfth-century handbook for pilgrims, written by the priest Aymery Picaud (preserved in an encyclopedic account of Saint James, the *Liber Sancti Jacobi*), survives as a firsthand description of these routes.[12] The southernmost road started in Arles at the column memorial to the martyr Saint Genes. It led westward through churches built over tombs, including that of Saint Gilles, on to Toulouse, where the relics of Saint Sernin were enshrined, then south into the Pyrenees, crossing into Spain, where it initiated the major avenue across northern Iberia to Santiago de Compostela.

The second route described in the guide led from Burgundy through Notre Dame of Le Puy and Sainte Foy at Conques, which preserves the charming scale of these centers and where one can still see the miraculous reliquary of the child saint in all its primitive and frightening splendor (colorplate 43). The road continued to the magnificent church of Moissac and onward to Ostabat at the foot of the Pyrenees. Another, somewhat rambling route, also started in Burgundy at the Church of the Madeleine in Vézelay, led south to the tomb of Saint Front at Périgueux, and finally joined the second road near Ostabat. The fourth, beginning at Paris and Chartres, followed the Loire from Orléans to the age-old sanctuary of Saint Martin at Tours, then southward through Poitiers, Saintes, to Bordeaux, and finally converged with the other roads at Ostabat. Once across the Pyrenees, the routes formed a single road that led through the battlefield of Roncevaux, famous in the Charlemagne legends, and across the treacherous country of the Basques. This final, long leg of the journey led from Puente la Reina via Burgos and León to Compostela. The first in the group of pilgrims to sight the towers of the church of Santiago was proclaimed *roi*, or king.

The "Way of Saint James" was thus a challenging journey through the heartland of the major Romanesque churches and, like tourist centers today, the various communities vied with each other to attract the donations of the weary travelers who trudged for months from one station to the next. Let us begin our journey at the goal, Santiago de Compostela, and slowly return northward. The chronology of Romanesque art is perhaps not best served this way, but it makes more sense for our broader understanding of the culture.

The towers of Santiago seen by the *roi* of the pilgrims in the twelfth century are not those that greet the modern visitor. The exterior of the famous cathedral has changed considerably over the centuries. The imposing west facade is an ornate and frivolous Baroque frontispiece masking the original two-towered entranceway, and while the flanks of the building retain something of their original massiveness, several parts have been rebuilt, restored, or added to down through the years. The south transept portal is still Medieval in appearance. The Puerta de las Platerías (named after the nearby shop of the silversmiths), begun in 1078, today displays a strange assortment of sculptures with disorderly and confusing representations of the Temptations of Christ and the Transfiguration (fig. 316), that Aymery Picaud describes in his guide as decorations on the west and north porches. The *"Adulterous Woman"* with flowing hair (fig. 317), according to Aymery, portrays a notorious figure in local legend, an adultress who sits forlornly with the skull of her husband in her lap. The sculpture of the portal in the vestibule to the great crypt at the west end, the Pórtico de la Gloria (fig. 318), is a masterpiece by Master Matthew and belongs to a later phase of Romanesque art (c. 1168–88).

The Romanesque cathedral, built over an earlier ninth-century church (now beneath the huge choir), was begun about 1077–78 under Bishop Diego Peláez and completed by 1124 or 1128 by his successor, Diego Gelmírez (figs. 319, 320). The sculptural decoration was gradually added to enhance its role as the principal monument of the pilgrimage roads.[13] The interior, entered through the Pórtico de la Gloria, with its deep, dark nave (250 feet long) and shadowy tunnel vaults marked off regularly by the round transverse arches, is well preserved. The solemn cadence of the handsome piers of brown granite and their colonnettes rising into

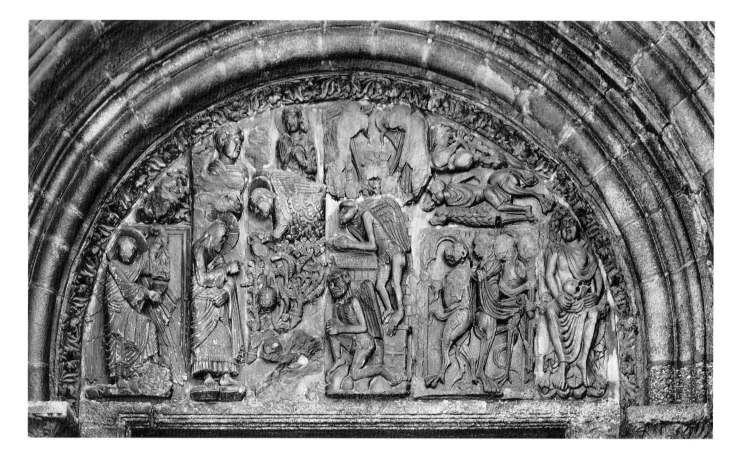

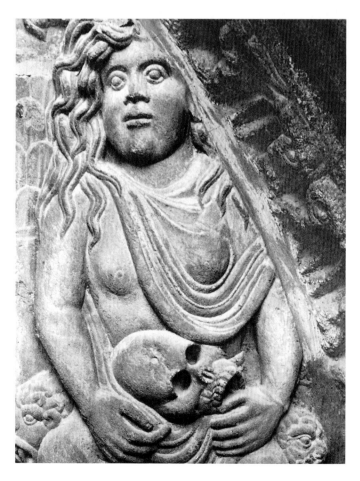

above: 316. Puerta de las Platerías. South portal of Cathedral, Santiago de Compostela. c. 1078–1103

right: 317. *"Adulterous Woman" with a Skull.* Detail of fig. 316

transverse arches mark off the nave rhythmically into square bays that lead us slowly toward the altar—the focus of pilgrims for more than a thousand years.

Santiago de Compostela is a typical pilgrimage church. In ground plan we at once recognize the bold restatement of the *T*-shaped design of Saint Peter's in Rome, but now the complexities are multiplied, with great western foundations for the original two-towered facade. Apsidioles are attached to the transept arms and seem to sprout from the huge semicircular aisle with groin vaults that encircles the apse. This passageway, known as an ambulatory, together with the additional apses with altars constitute what is called a pilgrimage choir, an innovation of earlier pilgrimage churches (for example, Saint Martin's at Tours) and a division of the basilical structure that will continue to grow and expand until the body of the church is nearly engulfed by it.

The additional altars were necessitated by the proliferation of relics displayed for the pilgrims—each altar housed a different relic—and the ambulatory gave the visitor access to

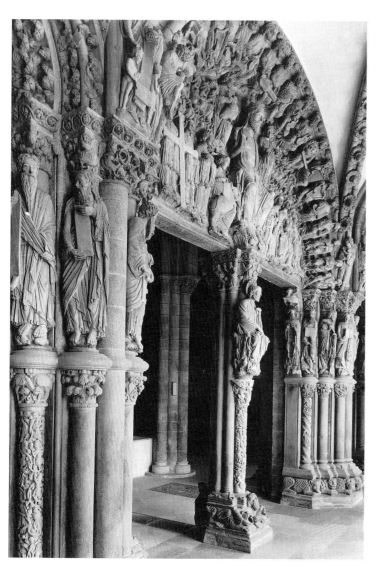

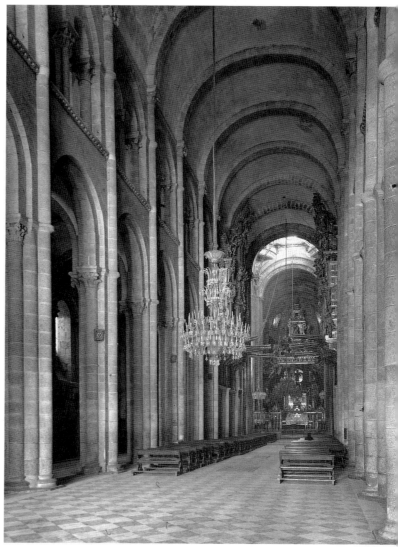

above left: 318. MASTER MATTHEW. Pórtico de la Gloria. West portal of Cathedral, Santiago de Compostela. 1168–88

above right: 319. Cathedral, Santiago de Compostela. Interior toward east. 1075–1120

right: 320. Cathedral, Santiago de Compostela. Plan (after Dehio)

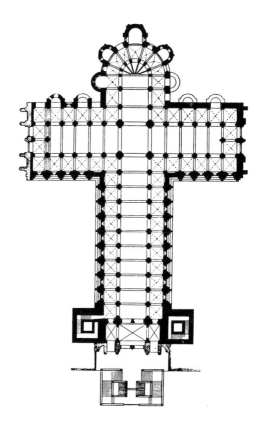

those shrines behind the main altar. Furthermore, reforms in the church required priests in residence (canons) to perform at least one Mass daily to accommodate the crowds. To provide even more space, the aisles of the nave were continued about the transept arms. In the twelfth century a huge wall, called a *coro,* marked off the choir from the nave, separating the canons from the milling crowds of pilgrims.

From the ground plan one can see how the cross section of the piers led the masons in the construction of the church. A columnar shaft is attached to each face of the square pier. The

inner colonnette rises the entire height of the nave (sixty-eight feet) to mark the spring of the transverse arch in the vault; the lateral shafts mark the arcades between the piers down the nave; while the fourth supports the transverse arch of the side aisles. Groin vaults are employed in the bays of the side aisles, and the cross-ribs that mark them into quadrants rest on the corners of the piers. Thus the piers and their shafts bind the divisions of the interior into a coherent whole as well as articulate its elevation with the repeated round arches that rise from them. Here we can see why the term Romanesque is so appropriate. Great walls of stone masonry, simple geometric forms, define massive volumes of space that emphasize the gravity and austerity of the structure, much as in ancient Roman buildings. It is not simply a huge barn with a wooden roof but a complex assembly of space modulators organically interlocked.

The nave elevation of Santiago is also typical of one major group of pilgrimage churches. It builds up majestically in three giant steps: the sturdy nave arcade; the solemn open gallery (each bay has another round arch divided into two smaller arches between elegant shafts); and, finally, the broad contour of the tunnel vault spanning the nave. There is no clerestory, as there often appears in Romanesque churches, and the lighting is achieved through the fenestration at either end of the nave—the facade and the apse—and whatever filters in from the windows in the outer walls of the side aisles. The great octagonal lantern that covered the crossing of the transepts and the nave also had windows to spotlight the beginnings of the great choir.

The beauty of pilgrimage architecture can be more fully experienced today at Saint Sernin in Toulouse (figs. 321–27).[14] Here the scale is grander, and double side aisles

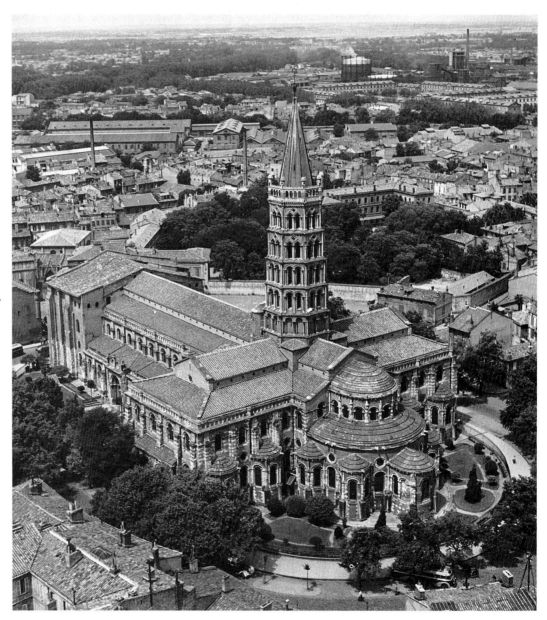

321. Saint Sernin, Toulouse. Air view. 1070; altar consecrated 1096

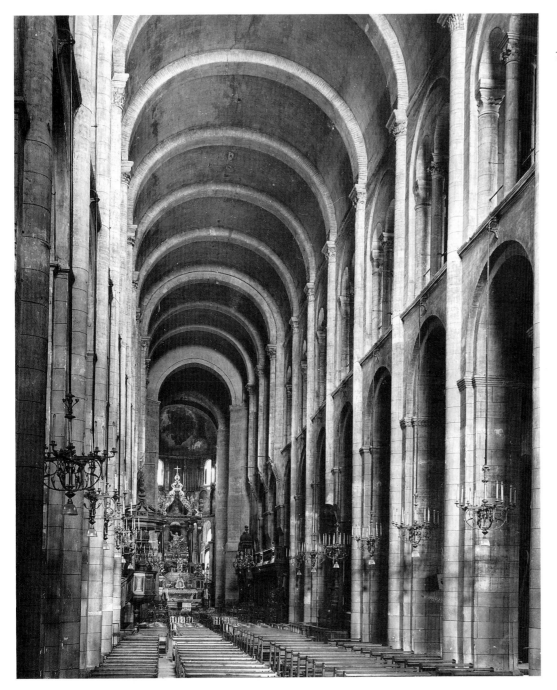

322. Saint Sernin, Toulouse. Interior

appear. Otherwise, the interior duplicates that of Santiago (the *petit appareil* has been painted to simulate larger building blocks). The exterior preserves its original twelfth-century appearance—the two towers of the facade were never completed—and offers us a view of the stately splendor of Romanesque architecture in the great massing and integration of cubic volumes, including cylinders and cones, like the simple harmonics and rhythms of a Medieval plainsong (the analogy with music is particularly appropriate for Romanesque architecture, as we shall see). Pilaster strips on the exterior, marking the internal structure of the bays, relieve the overpowering austerity of the huge unadorned geometric forms in space; a coursing of blind corbel tables accents the roof lines; while heavy round arches carried on half-columns articulate the windows in the apsidal chapels and the upper walls. A towering octagonal spire, added in the thir-

teenth century, built in elegant stages, provides an emphatic focus for the pilgrimage choir.

Saint Sernin was built (the foundations date about 1060) as a collegiate church for Augustinian canons, and in 1082–83 Cluniac monks were installed for purposes of reform. The high altar was consecrated by Pope Urban II in 1096 (a date that has been used too generously for dating Romanesque structures), and the original marble altar table survives, with tiny angels carrying a medallion portrait of Christ carved along its rim. The style of these minuscule sculptures, surely dating about 1096, corresponds with that of the more famous stone plaque reliefs that presently are set into the ambulatory wall behind the altar with monumental representations of a *Maiestas Domini* flanked by standing apostles and angels in arched niches (figs. 323, 324). It is unlikely that the present location of these sculptures is

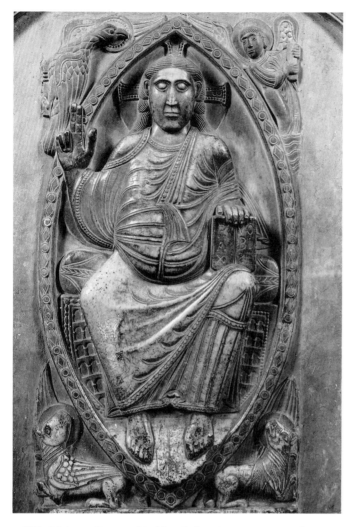

323. *Maiestas Domini.* Marble relief in Saint Sernin, Toulouse, height 50″. c. 1096

mulae, and all forms are conceived as coplanar with the surface as if pressed between panes of glass so that the bodies are flat, frontal, and static with closed contours squeezed within the tight confines of the arched frame.

The sculptures that make up the tympanum of the south portal, the Porte Miégeville (*media villae;* figs. 325–27), are slightly later in date, about 1110–18. Although restored, the portal is here intact, and three major areas for decoration are to be noted: the jamb-columns with sculptured capitals, the spandrels with tall statues of Saints Peter and James, and the tympanum with its impressive representation of the Ascension of Christ. Five huge slabs of stone make up the tympanum, each carved with individual figures so that no forms overlap in the composition. The lintel block below is a slab

324. *Angel.* Marble relief in Saint Sernin, Toulouse, height 72″. c. 1096

original, and it has been suggested that the five stone reliefs formed part of an exterior, probably portal, decoration or part of a shrine of Saint Sernin in the crypt of the church.[15]

For the present, it is the style of these imposing sculptures that merits our attention. In our reproductions they appear as enlarged ivory plaques, and by virtue of the fact that the individual figures are carved independently on single stone slabs, I would like to refer to this early phase of Romanesque sculpture as the "plaque style."[16] Stylistic traits reminiscent of Carolingian and Ottonian ivories, metalwork, and miniatures further justify this description, suggesting that the first monumental sculptures in stone were, indeed, indebted to the so-called minor arts more so than the statuary of Antiquity, as is often surmised. The sharply incised contours that describe the outlines of the drapery, the smooth facial features, and the abstract ornamental motifs about the aureole of Christ all bring to mind the metallic traits of Ottonian representations. Conventions are reduced to geometric for-

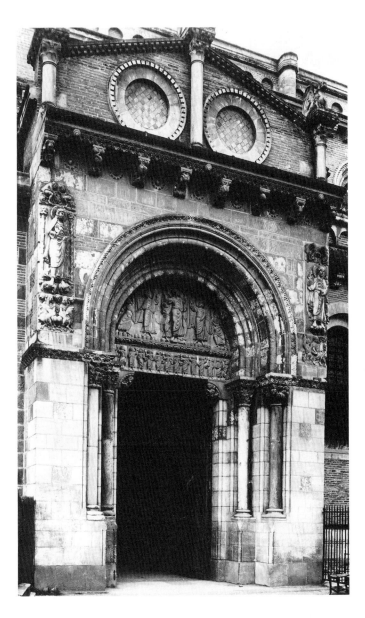

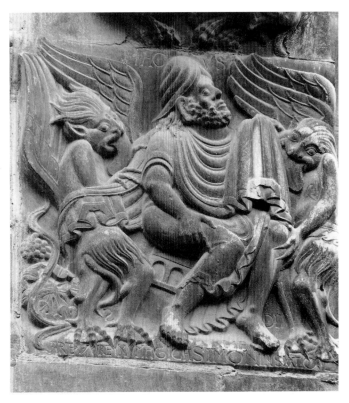

left: 325. Porte Miégeville, Saint Sernin, Toulouse. c. 1110–18

bottom: 326. *Ascension.* Tympanum of the Porte Miégeville, Saint Sernin, Toulouse

below: 327. Base of the statue of Saint James on the Porte Miégeville, Saint Sernin, Toulouse

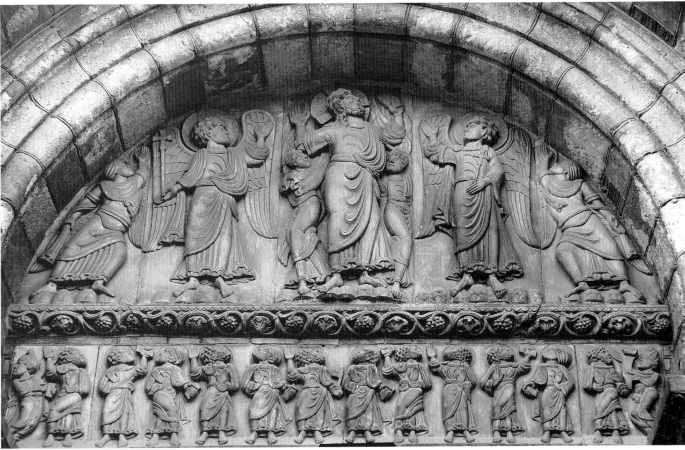

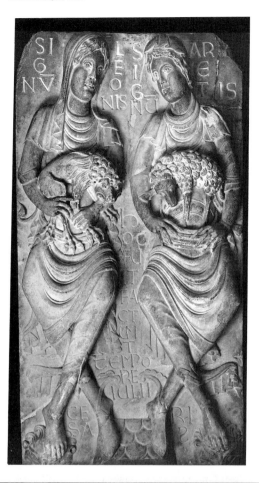

frieze with apostles and angels (and an Old Testament prophet on each end) viewing the ascending Christ. All are carved in low relief and exhibit the same harsh conventions of the "plaque style." One sign of the growing desire to break from these conventions appears unobtrusively in the crossing of legs in some of the figures on the lintel, a feature that adds a sense of agitation and restless movement to the figures.

Even more dynamism appears in the smaller carvings on the capitals of the jambs and the consoles of the spandrel figures. One (fig. 327), in fact, seems to be by the same hand that carved the expressive figure of the *"Adulterous Woman"* on the Puerta de las Platerías at Santiago (fig. 317). This same spirit pervades the impressive relief plaque today housed in the Augustinian Museum in Toulouse (fig. 328), known as the *signum leonis* relief. Two women sit cross-legged side-by-side and hold on their laps a lion and a ram. According to an inscription on the stone slab, they commem-

left: 328. *Signum Leonis.* Marble relief, height 53⅛".
Early 12th century. Augustinian Museum, Toulouse

below: 329. Saint Pierre, Moissac. View of cloister. c. 1100

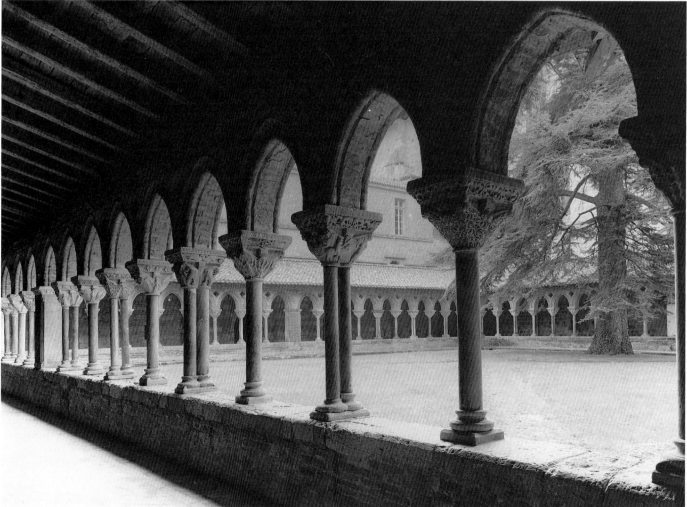

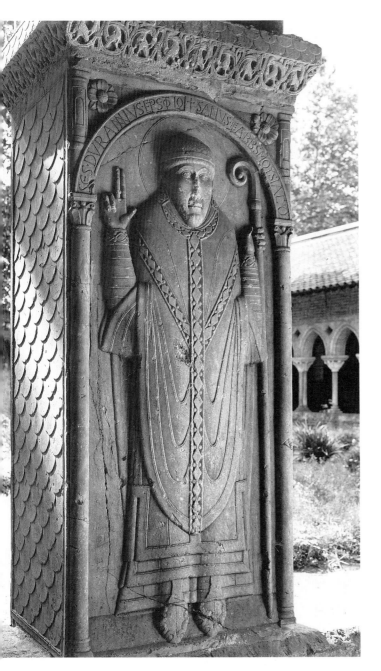

330. *Durandus.* Marble relief on cloister pier, Saint Pierre, Moissac, height approx. 6'. c. 1100

orate a miracle that occurred at the "time of the birth of Christ" when, according to local legend, two women gave birth, one to a lion, the other to a ram, animals symbolic of Christ's appearance as both king and sacrificial victim.

Lying some forty miles northwest of Toulouse is the famous pilgrimage church of Saint Pierre at Moissac (figs. 329–35), a major stopping point on the road leading from Le Puy.[17] Legend has it that the original shrine at Moissac dated from the time of Clovis, the Merovingian ruler. It was razed by the Saracens in the eighth century, rebuilt by Louis the Pious, and destroyed by fire again in 1042. With the second

rebuilding, the community was guided by the famous reformer of Cluny, Odilo, who appointed as abbot the Cluniac monk Durandus (1047–72), an illustrious churchman who also served as bishop of Toulouse. Much of the rebuilding is attributed to Durandus, but his name is not associated with the famous sculptures at Moissac. According to an early chronicle, a succeeding abbot, Anquêtil (1085–115), built the cloister and commissioned the tympanum sculptures for the church. Under Abbot Roger (1115–31) the decorations were completed. Two distinct workshops were involved, that of the cloister and that of the south portal sculptures.

The attribution of the cloister and its sculptures to Anquêtil seems certain (figs. 329, 330) since the same workshop that executed the ambulatory reliefs at Toulouse was employed to execute the giant pier sculptures in the cloister. The inner sides of the corner piers have over-lifesize figures of standing apostles in shallow relief nearly identical in style to those at Toulouse. The most impressive figure, however, is the fully frontal portrait of Abbot Durandus (fig. 330) on the inside of the central pier on the east side of the cloister. No doubt it was the desire to honor the builder of the new church that led the later abbot to commemorate the Cluniac churchman in this monumental fashion.

The name "Durandus" is inscribed on the halo about the head, but aside from his ecclesiastical vestment, the abbot is treated in the same style as the apostles. One early scholar claimed that the "portrait" was a realistic likeness, arguing that the slight smile on the lips (actually a blemish created by chipped stone) properly characterized Durandus as the "jesting abbot," as he allegedly was. This cannot be considered a true likeness, however; his rigid stance, his elaborate vestments and crosier serving as attributes of office, and his masklike face all stamp this as a symbolic portrait, as was the custom in the art of the period.

The glory of Moissac is the south portal (figs. 331–35), where a new workshop, active about 1115–30, introduced a totally revolutionary style in sculpture, a style, moreover, that is much akin to the developing Romanesque art in Burgundy (see below, chapter XVII), although no convincing lines of influence north and south have been traced. A complete program of portal decorations lies before our eyes. The major field, the great tympanum over the doorway, displays one of the most impressive *Maiestas Domini* representations ever created; the immediate door jambs and trumeau (central door post) below have extraordinary reliefs of two apostles and two prophets carved into them; the lateral walls carry complex narratives and moralizing stories. That to the right has a double register and frieze of figures devoted to the Infancy of Christ. The left illustrates the story of the Rich Man and Lazarus with personifications of Luxuria and Avaritia. Finally, the outer spandrels have portraits of Saint Benedict, the founder of their order, and Abbot Roger, under whom the church was completed.

The giant overlord—nicknamed *Re clobis* (King Clovis) by local inhabitants in memory of the legendary benefactor—looms from the center of the tympanum with awesome majesty like an apparition (fig. 332). All relevant details described in chapter 4 of the Book of Revelation are here. Angels and the beasts of the Apocalypse crowd about the enthroned one; the sea of glass ripples across the tympanum below his feet; and the twenty-four elders are seated irregularly in three tiers in the margins of the field. Emile Mâle suggested that the immediate source of inspiration for the design was the representations in Beatus Apocalypse manuscripts (cf. fig. 307),[18] but the presence is so majestic that it must have been designed from the start as a special composition for this church.

A new style presents itself here with an abstraction conveyed through dynamic linearism, the culmination of stylistic tendencies traceable to the exciting lines of the Utrecht Psalter. Irregular patterns of vibrating lines flicker across the surface as drapery edges dance and swell arbitrarily about the attenuated figures. Meandering ribbons along the outer border merge with the ruffled draperies of the impatient elders seated on the perimeter, reminding us of the fusion of animal and ornament in Irish art. In contrast to the plaque

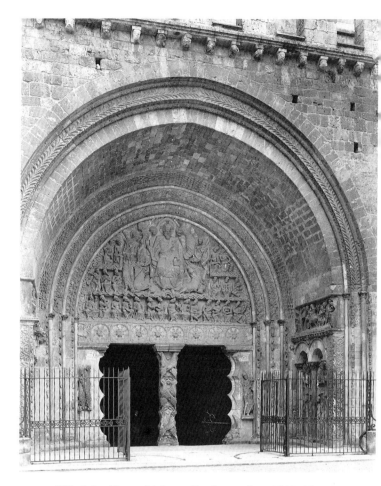

331. Saint Pierre, Moissac. South portal. c. 1115–30

332. *Maiestas Domini.* Tympanum of south portal, Saint Pierre, Moissac. c. 1115–30

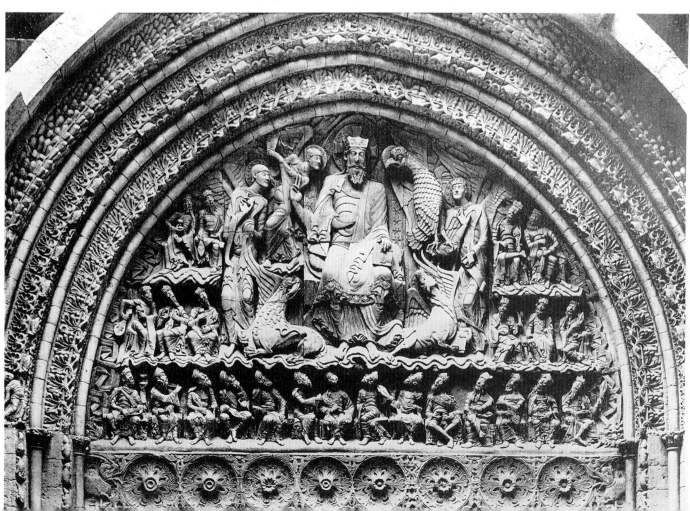

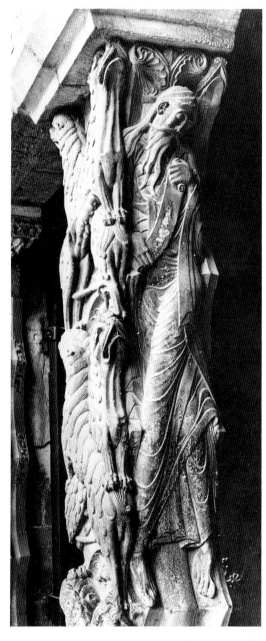

333. Prophet and lions. Trumeau of south portal, Saint Pierre, Moissac. c. 1115–30

334. *Saint Peter*. Jamb relief sculpture on south portal, Saint Pierre, Moissac. c. 1115–30

style, this mode obeys no rigid frame. The design, in fact, is carved across twenty-eight blocks of stone with little regard for their junctures or structural integrity.

Within the throbbing patterns of lines there emerges a careful organization, however. Hieratic scale and centrality clearly govern here. The largest figure, the frontal Christ, is the central element, and he is the most rigid in pose, the least affected by the vibrancy of the racing lines about him. The scale decreases, the agitation increases, as we move out in concentric circles from the center. The smallest and most numerous figures, the twenty-four elders, carved nearly in the round, squirm restlessly on their benches, disturbing the symmetry of the hieratic organization as they cross and uncross their legs nervously.

An important feature of this developed Romanesque style is the complete subordination of the carved figures to the architecture. They are imprisoned in the stone, and their agitation only heightens the claustrophobic effect of complete subordination. Unlike later jamb figures (cf. fig. 472), which can at least claim the rotundity of the column for their own space, these figures are carved into the stone and can enjoy no such individuality. They neither complement nor echo the structure; they are, in fact, at violent odds with it. This is a basic feature of Romanesque art, and such an imprisonment creates a striking impression of instability and struggle between the building and its decoration.

This anti-Classical relationship of architecture and decoration is even more emphatically expressed in other areas.

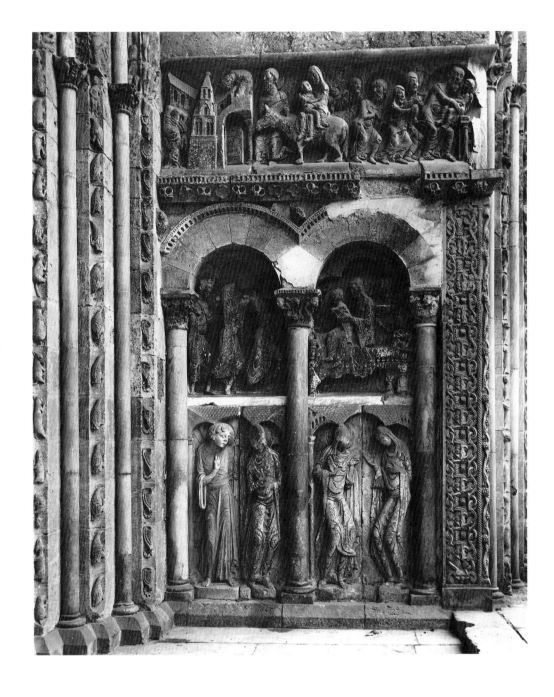

335. Scenes of the
Infancy of Christ.
East wall of south portal,
Saint Pierre, Moissac.
c. 1115–30

The heavy tympanum rests precariously on scalloped jambs and a writhing trumeau post (fig. 333). Three superimposed lions and lionesses confront each other on the outer face of the trumeau; on the sides, marvelously elongated figures of Saint Paul and a prophet, their emaciated torsos twisted and crisscrossed, serve as exhausted caryatids for the *Maiestas Domini* weighing down heavily on them.

On the lateral wall, to the right, scenes of the Infancy are dominated by the Adoration of the Magi offering gifts (fig. 335). The sculptures on the left wall, in contrast, vividly serve as a warning for those who transgress the moral teachings of the church. Above the twisted personifications of Luxuria and Avaritia and their satanic companions, the lesson illustrated is that of the rich man (Dives) and Lazarus,

the parable in Luke (16:19–31) that teaches that avarice and the accumulation of riches in this earthly life will not be condoned at the Last Judgment. Dives is claimed by demons on his deathbed while the poor and humble Lazarus is lifted to the bosom of Abraham, the image of heaven in the parable. The lesson is clear: Give your riches to the church just as the Magi gave theirs to the infant Christ.

Another vivid explication of the evils of avarice, the major deadly sin for the Romanesque period, appears at Souillac, just north of Moissac (fig. 336). Giant reliefs—originally part of the lateral walls of the major portal—illustrate the story of the avaricious Sicilian vicar Theophilus, a kind of Medieval Faust figure, who sold his soul to the devil in return for riches and a high station in the church. Below,

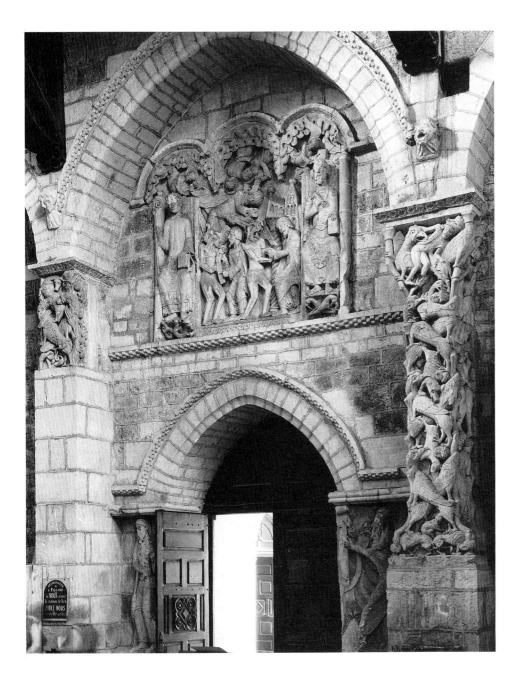

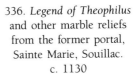

336. *Legend of Theophilus* and other marble reliefs from the former portal, Sainte Marie, Souillac. c. 1130

Theophilus appears twice with a grotesque demon, taking a feudal oath of fealty with satan. But the erring vicar will be saved by Mary, to whom he prays in the second register. Aside from serving as an admonition against avarice and heresy, the legend of Theophilus introduces us to another aspect of the Romanesque age, namely, the sudden proliferation of the popular miracles of the Virgin, which ushered in a vast new repertory of subject matter. The church at Souillac, furthermore, was dedicated to the supreme intercessor for mankind, Notre Dame.[19]

The sculptor of the Theophilus relief consciously violated all major rules governing Classical composition. There is no uniform symmetry or centrality in the ordering of the actors in the tragic melodrama. In fact, the larger and more hieratic figures are those of Saints Peter and Benedict placed on the sides. Like giant bookends they press in on the errant Theophilus and his satanic adversary, forcing them into violent, contorted postures as they struggle to break free from the imprisoning frame. Discordant trefoil arches weigh down on them from above, and the strange chapel is twisted off axis as if about to topple. A disturbing and distracting pattern results, appropriate for the diabolic nature of the story. In one of the more memorable reliefs from the ensemble at Souillac, the "dancing" prophet Isaiah (colorplate 44), these same dissonant contortions convey a sense of excitement and exuberance in the twisting seer who announces to the world that "a virgin shall conceive and bear a son, and his name shall be Emmanuel" (Isa. 7:14).

CLUNY AND BURGUNDY

I N 909 Duke William of Aquitaine presented a farmland with an old Roman station, Cluniacum, in the valley of the Grosne River, to the Benedictines. Berno of Baume, abbot of Benedictine abbeys in the area, built a modest church there (910–16). An important condition of the charter was that this new house was to be free of any local jurisdiction (the bishop or the duke) and owe allegiance only to the pope in Rome. Berno took advantage of this uniqueness and initiated an ambitious program of monastic reform with Cluny as its headquarters. Blessed with a sequence of unusually capable abbots, Cluny grew from its humble beginnings to become the largest, most powerful, and most culturally enriched monastery in all Europe.[20]

The first church, known as Cluny I to art historians, was a small barnlike structure about one hundred feet long dedicated to Saints Peter and Paul. Little is known of Cluny I or Abbot Berno, but his successor, Odo (927–44), renowned for his saintly character, followed Berno's program of reform with zeal, and the prestige of Cluny spread rapidly. From the emperor Henry I and the pope, Odo received special privileges to oversee, as a reforming abbot, other monasteries and to append them to Cluny as "daughters," thus giving rise to the establishment of a "family" or congregation of Cluniac churches independent of other Benedictine abbeys.

Odo's fame spread to Italy, and he made a pilgrimage to Rome and south Italy in 939, reforming churches along the way, among them the original Benedictine foundation at Monte Cassino (see below, chapter XIX). While not recorded as a great patron of the arts, Odo, however, was an avid musician—an important category of knowledge at Cluny—and attributed to his hand are psalms set to music and even a treatise, *Dialogus de musica,* that provides a rudimentary system of musical notation so that "one may sing at first sight without fault."[21]

Within a generation, the old church at Cluny proved to be too small for the great influx of monks who came there. Under Abbots Mayeul (954–94) and Odilo (994–1049), a new basilica, Cluny II, was raised alongside the old. Relying on the scant evidence uncovered in excavations by the Medieval Academy of America at Cluny and the description of the ideal Benedictine monastery recorded in the "Constitutions of Farfa" (*Consuetudines Farvenses*) of 1043, Kenneth Conant has elaborately reconstructed Cluny II (fig. 337).[22]

The church that Conant reconstructs resembles a number of "first" Romanesque churches built by the Benedictines in the course of the eleventh century, but one significant addition in Conant's plan is the Galilee porch that served as a sort of sub-nave for processions and other ceremonies. The name recalls the Mission of the Apostles given by Christ at Galilee (Matt. 28 and Acts 1), an important event for an age obsessed with the idea of crusades. The *descriptio* in the Farfa manuscript also states that two towers were built into the facade, suggesting that Odilo granted himself an imperial westwork in keeping with the new power the abbot exerted over both the ecclesiastical and the secular worlds. A monastic empire was being established under Odilo. A temporal as well as a spiritual kingdom emerged that made Cluny the capital of Christendom in the North.

If Abbot Odilo is to receive credit for establishing the empire of Cluny, then his successor, Hugh of Semur, who ruled sixty years (1049–1109), should be acclaimed the master builder of the order. Cluny's political role in Europe was never greater. Hugh frequently settled disputes between papal and imperial opponents, including those involving Rome and Henry III, Henry IV, Philip of France, and William the Conqueror. His greatest benefactor was King Alfonso VI of Castile. The papacy was practically controlled by Cluny. Pope Gregory VII (1073–85), the great reformer, was apparently trained at Cluny; Urban II, who preached the first crusade in the North in 1095–96, was a Cluniac monk, as was his successor, Paschal II. Numerous churches along the pilgrimage roads were absorbed by Cluny, and by 1083 the number of monks residing at Cluny had grown from the initial twelve to more than two hundred. For such numbers Hugh needed a new church, Cluny III.

Described as a place for angels to dwell should they come down to earth, Cluny III was the largest and most glorious church in Europe. Built entirely of stone, it stretched 616 feet in length; its vaults soared to an unprecedented 96 feet; its walls were over 8 feet thick at the foundations. It is truly a sad comment on the progress of Western man that this great

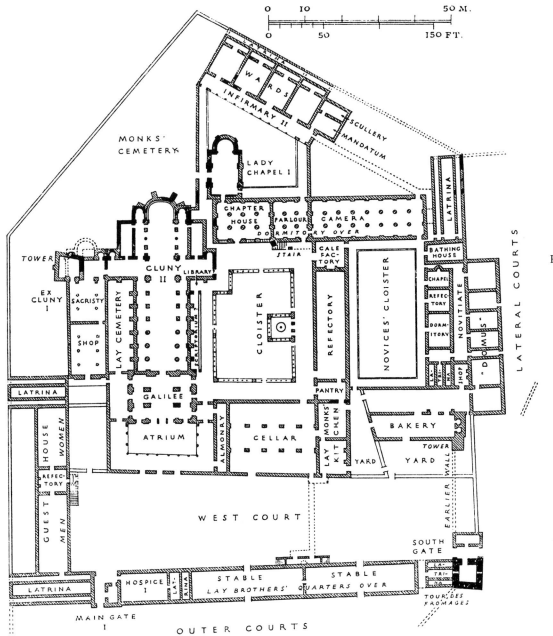

337. Abbey Church, Cluny.
Plan of Cluny II (after Conant).
11th century

structure was demolished after the French Revolution, as were many others. In 1791 the last Mass was celebrated; in 1798 the French government sold the entire complex to three citizens; in 1810 the final demolition (save for one transept) was completed; and, ironically, in 1928 costly excavations to recover and restore the great monastery were initiated (figs. 339, 340).[23]

From scant remains and a number of early drawings and prints, a reliable reconstruction of Cluny III can be made (figs. 341–44). The great church displayed a complex clustering of cubic and spherical volumes, accented by six great towers, along the axis of the huge nave. The plan (fig. 338) features double transepts, a huge ambulatory with radiating chapels, and an impressive portal (the huge covered atrium

was added after Hugh's abbacy and finished in Gothic style). Construction apparently began in 1088. In 1095 Pope Urban II consecrated the high altar; transept altars were dedicated in 1104; and the nave was constructed between 1107 and 1121 (completed under Hugh's successor, Abbot Pons). Peter the Venerable (1122–56), the last great abbot of Cluny, was largely responsible for finishing the basilical complex and its decorations. The final dedication was made by Pope Innocent II in 1130.

Conant's study has revealed that a complex harmony of parts based on the "perfect" numbers of the ancients as well as on the musical relationships of Pythagoras (as then understood) governs the measurements of the great basilica. Cluny is, in effect, solid music, a concrete embodiment on

earth of the harmonies of the spheres in the heavens. Music theory was important in the education of the monk, and, in fact, one of the architects of Cluny III, Gunzo, was a learned musician. One senses this instinctively when first viewing the reconstructed elevation. The sequence of geometric forms seems to develop one from the other like the expansion of a musical composition, with the long nave culminating in a multisectioned choir rising and descending in towers and chapels like crescendos.

A similar concord echoed through the giant nave, with the elegant arcade and pilaster strips accented by Corinthian capitals rising through trebled arches in the triforium gallery and clerestory into the slightly pointed transverse arches in the lofty tunnel vault (fig. 342). The huge choir had a circular tunnel vault in the ambulatory with transverse arches resting on eight tall, freestanding columns (fig. 343). The facade, masked behind the later narthex (fig. 344), had three wide portals and featured a sculptural program of special interest to us, although it can be reconstructed only hypothetically from early prints and drawings.

Fortunately, ten capitals that adorned the ambulatory arcade survive (see figs. 345–47). Eight have carvings on all four faces, indicating that they originally capped the freestanding columns. Even in their damaged condition, these

338. Abbey Church, Cluny.
Plan of Cluny III (after Conant).
12th century

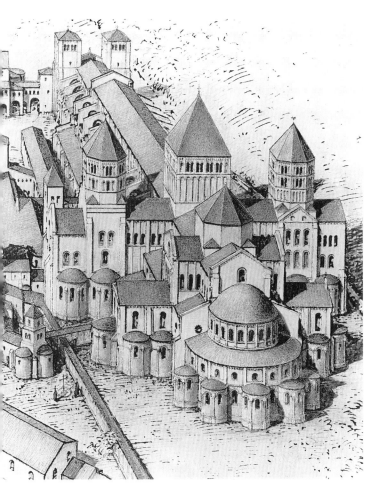

339. Abbey Church, Cluny. Reconstruction of Cluny III, from east (after Conant). 1088–1130

entire extent of the lower walls was built in one campaign and the upper walls were added gradually, hence the capitals would be part of the later construction. Yet when one views such carvings as the Fall of Adam and Eve (fig. 345), a surprising freshness of conception seems at work. The tiny, doll-like figures of the nudes cringing within the delicate sprays of foliage are carved with an immediacy and directness that bespeak an original idea working itself out and not a slavish copy of some established representation. These are creations of the highest artistic merit.

If the style of the Cluny capitals strikes one as being fresh and original, the iconography of the set, when viewed as a

340. Cluny III. South transept. 1088–1130

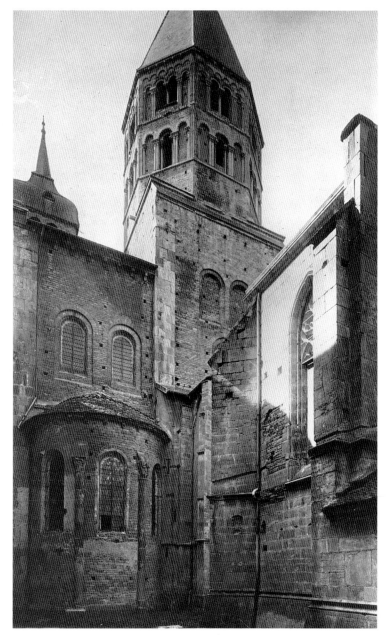

sculptures are startling, and the most vexing problem has been dating them. Three dates have been proposed: 1088–95 (when Urban II consecrated the altar in the choir); about 1120 (under Abbot Pons); and between 1120 and 1130 (under Peter the Venerable).[24] The issue is more than academic, however. The fresh and vigorous style of the capitals introduces us to that wave of dynamic linearism that swept through the second workshop at Moissac, about 1115–30, signaling the ultimate phase of Romanesque sculpture in France.

But which came first, Moissac or Cluny? The arguments of those supporting the earliest dating of the capitals, before 1095, are strongly based on the proposition that they must have been executed on the ground before being set in place. Others have pointed out that sculptures were frequently carved *in situ* with the artisans working from scaffolding after their installation. Another argument for a later dating concerns the general building campaigns, namely, that the construction of Cluny III was continuous and *horizontal* throughout, not *vertical,* with sections added one after the other from the apse to the facade. According to this view, the

right: 341.
ETIENNE MARTELLANGE.
Cluny III (from the south).
Drawing. 1617.
Bibliothèque Nationale,
Paris

below: 342.
Cluny III, Interior.
Drawing after a watercolor
by J. B. LALLEMAND
of c. 1773.
Bibliothèque Nationale,
Paris

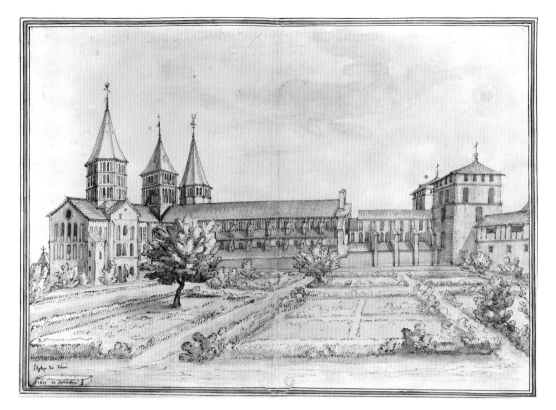

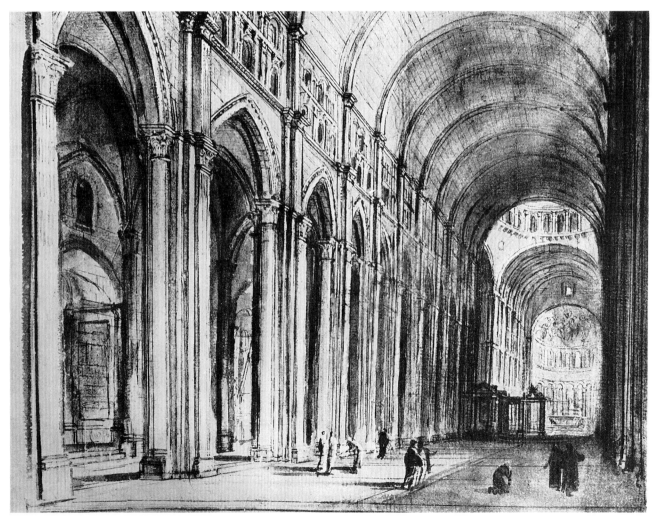

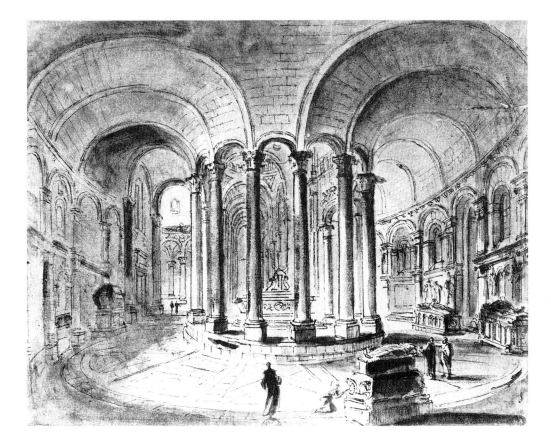

left: 343.
J. B. LALLEMAND.
Cluny III, Ambulatory.
Drawing. c. 1773.
Bibliothèque Nationale,
Paris

below: 344.
*Cluny III, Western facade
from the atrium.*
Pencil drawing, 8⅝ × 5½".
Bibliothèque Nationale,
Paris

group, is even more surprising.[25] Only rarely in Romanesque art do such marginal areas provide an integrated iconographic scheme or program as they do later in Gothic art. Rather, they seem spotted here and there like random footnotes. The Cluny capitals, on the other hand, have a definite coherence, although this is not easy to comprehend in detail. The two capitals that are carved only on three faces carry narratives—the Fall of Man and the Sacrifice of Isaac—and they have been generally located on the piers that mark the beginning of the ambulatory. The other capitals would have decorated the freestanding columns that supported the tunnel vault of the ambulatory.

Aside from one capital that has only Corinthian floral motifs, each has single figures within aureoles on the faces or emerging from foliage on the four corners. Inscriptions make their identities clear in some cases. Appropriately, these correspond to the familiar quaternities in the monks' education: the four rivers of paradise (see fig. 346), the four trees of paradise, the four seasons, the four cardinal virtues, etc. Two are exceptional for they feature, on one, personifications of the first four "authentic" modes of the plain chant sung at Cluny and the last four (or plagal) modes, on the other. Considering the significance of music and music theory at Cluny, this additional instruction for the monks seems surprisingly appropriate.

The Cluniac musician Guido of Arezzo (c. 1020) had given these eight tones emotional counterparts (*direct* as in storytelling, *happy* as in a turning dance, *sad* as in lamentation, and so forth). Even more surprising, however, is the fact

above left: 345. *Adam and Eve.* Ambulatory capital from Cluny III. c. 1088–95? Musée Ochier, Cluny

above right: 346. *Rivers of Paradise.* Ambulatory capital from Cluny III. c. 1088–95? Musée Ochier, Cluny

right: 347. *First Tone of the Plainsong.* Ambulatory capital from Cluny III. c. 1088–95? Musée Ochier, Cluny

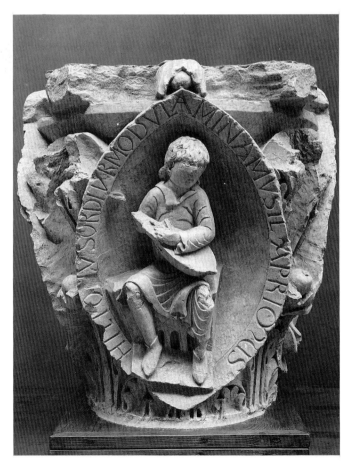

that the personifications of the modes or tones of the plainsong—always unaccompanied in the church at this period—are figures playing musical instruments! The first mode presents a tiny figure playing a lute (fig. 347), the second taps castanets (?), the third strums a lyre of unusual shape, and the fourth is a lively dancing figure carrying a pole with bells across his shoulders. The inscriptions that accompany them do not help much. The spirited bell ringer "sounds the song of lamentation," perhaps a reference to the hired mourners who accompanied funeral processions, but for the most part the *tituli* are cryptic. The performers are, in fact, closely related to similar figures in illustrated music manuscripts of the Romanesque period, suggesting that the inspiration for the new style is to be found in book illustration.

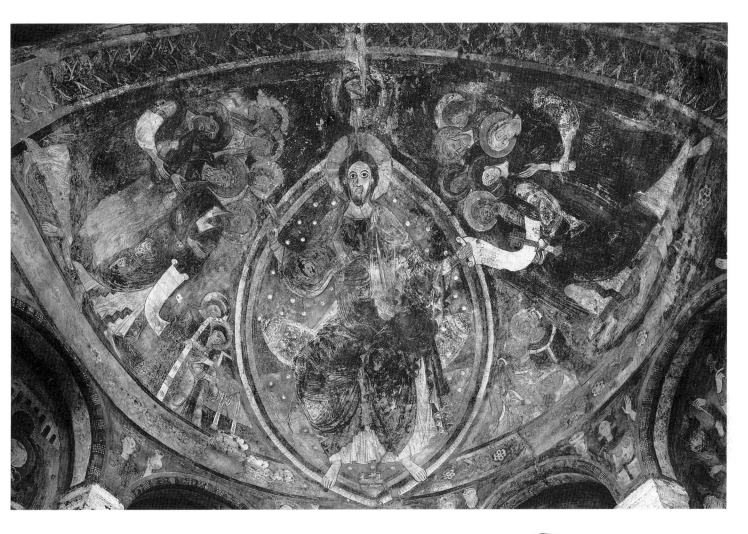

above: 348. *Maiestas Domini.* Apse fresco in the upper chapel of the Priory, Berzé-la-Ville. Early 12th century

right: 349. *Pentecost.* Illustration in the Cluny Lectionary. 9 × 5″. Early 12th century. Bibliothèque Nationale, Paris (MS nouv. acq. lat. 2246, fol. 79v). See also colorplate 45

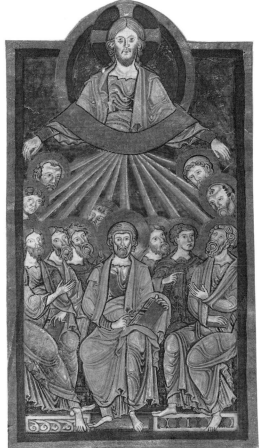

The capitals in the nave and side aisles of Cluny III were all Corinthianesque, but a major program of figurative sculpture was featured on the west facade (fig. 344). Again, there is much dispute concerning the date of these sculptures (from c. 1113 to c. 1130), but there can be no question regarding the program of the portal decorations, which included jamb capitals, portraits in the spandrels, and a great tympanum with a commanding representation of the *Maiestas Domini*. The paintings that decorated the apse are preserved in drawings (see fig. 342), with the image of Christ in the heavens hovering over the sculptured capitals in the ambulatory.

A good idea of the style of Cluny's lost frescoes is perhaps provided in the superb paintings that survive at Berzé-la-Ville, a favorite retreat of Abbot Hugh about seven miles from Cluny (fig. 348). What appears to be a *Maiestas Domini* in

the apse of the chapel is, in fact, the Mission of the Apostles with the giant figure of Christ handing a scroll to Peter. What is surprising about the paintings at Berzé-la-Ville is the sophisticated style. The thin, translucent layers of paint over red ocher underdrawing impart a rich, warm tone to the whole apse, and the highlights and cross-hatching applied to the elegant draperies are clearly derived from Byzantine conventions that are found in contemporary Benedictine paintings in Italy (see pp. 315–16), which Hugh had undoubtedly seen. The library at Cluny contained manuscripts with illuminations in this same Italo-Byzantine style. Note, for example, the delicate rendering of *Pentecost* in the Cluny Lectionary (fig. 349; colorplate 45), especially in the drapery folds that fall about the knees of the seated figures. While the sculptures are wholly Northern in style and expression, Cluniac painting reveals a strong dependence on Byzantine art.[26]

The careers of some of the "mason-sculptors" active at Cluny can be followed in other churches in Burgundy. One of the most gifted of these carved the great tympanum within the narthex of the Church of the Madeleine at Vézelay and a number of the capitals in the nave there (fig. 350). His work at Vézelay can be dated after 1120, when a campaign to restore the church following a devastating fire that year was initiated by Abbot Renaud of Semur (a nephew

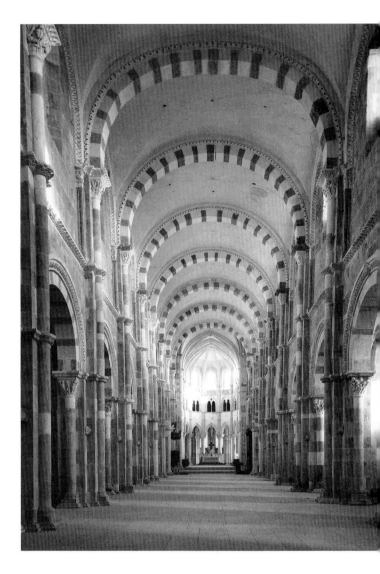

right: 350. Sainte Madeleine, Vézelay. View of nave. 1120–32; choir of later date

below: 351. Sainte Madeleine, Vézelay. View of narthex. 1120–32

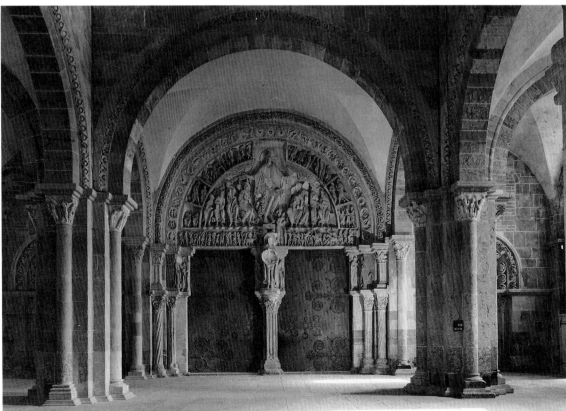

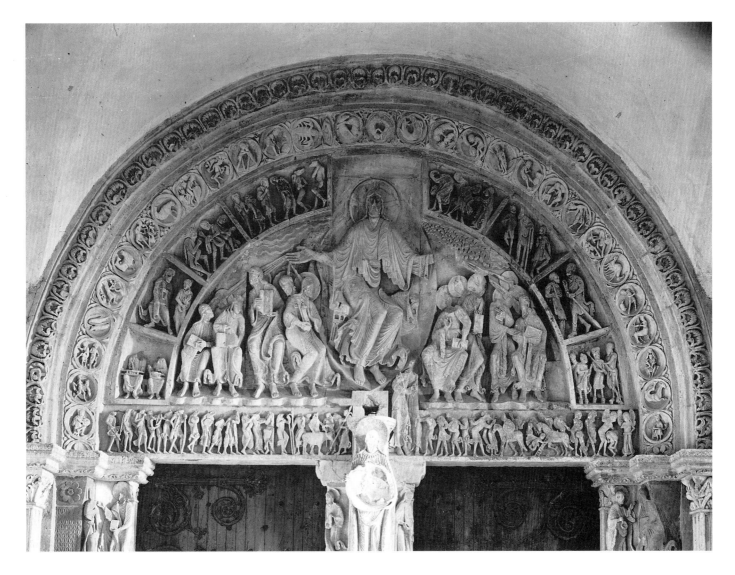

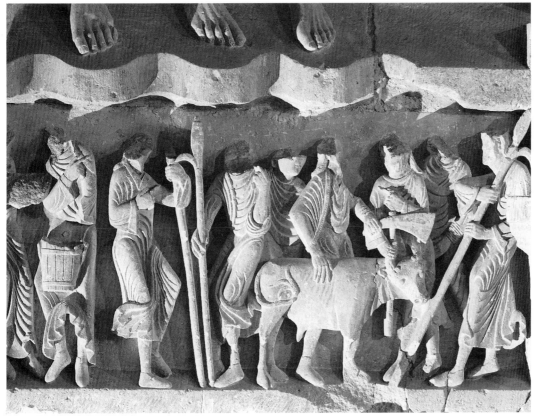

above: 352.
Mission of the Apostles.
Tympanum of
Sainte Madeleine,
Vézelay. 1120–32

left: 353.
Heathen of the world.
Detail of fig. 352

of Hugh of Cluny). The learned prior Peter the Venerable, later the abbot of Cluny, may have been the mastermind behind the ambitious program of sculptures for the new church.[27]

A new iconography appears in the narthex sculptures (figs. 351–53). The smaller doorways opening into the side aisles have tympana carved with the Infancy of Christ (south) and the Appearance of Christ to the Apostles (north), appropriate themes for a pilgrimage church, as we have seen. It is in the giant tympanum over the central portal, however, where the genius of the sculptor is displayed. Apostles stand in agitated postures with whipped pockets of drapery flaring out from their bent bodies on the door jambs. The trumeau presents Saint John the Baptist, a proper doorman for the church, since Baptism was traditionally considered the "door of the sacraments."

Above, in the broad tympanum, emaciated figures swell and vibrate within the tight confines of a heavy frame (fig. 352). Below them, on the lintel, is a colorful frieze of pup-

354. *Monstrous Races of the World.* Crusader's handbook. 12th century. British Library, London (MS Harley 2799, fol. 243r)

petlike figures. Christ, in the center, turns sideways in a cramped position with spinning patterns of drapery at his thighs resembling coils under tension about to spring free. The apostles, descending in scale as we move out, are like jerky marionettes bouncing on the strings formed by the rays of the Holy Spirit that issue from Christ's hands. No one is in repose at Vézelay, and the three courses of archivolts weigh heavily on them like a lid pressing down on a jack-in-the-box. It seems more than accidental that the sculptor provided a means of escape for Christ by breaking the inner band of archivolts directly over his head.

The exact meaning of the central tympanum has been an issue of considerable debate. Some have argued that there is no unified program, others have identified the subject matter with traditional themes such as the Ascension and Pentecost. What we have here, it seems to me, is a translation in stone of a comprehensive sermon or commentary on the role of Vézelay for the pilgrims and crusaders who gathered there. It will be remembered that Vézelay was the starting point for one of the pilgrimage roads, and it also served as a rallying place for the Second Crusade called by Saint Bernard in 1146.

Entering the church in the company of the apostles—the original crusaders for Christ—the faithful found an encyclopedic display of the wonders and mysteries of their calling, as inheritors of the original Mission of the Apostles.[28] The hallowed Early Christian theme is much elaborated, however, with numerous secondary associations, some liturgical, some educational. Two closely related feasts of the church (cf. fig. 262) are celebrated here: Ascension, which includes the Mission of the Apostles and an anticipation of the Second Coming of Christ (Acts 1:4–9), and Pentecost, whereby the apostles are given the powers of the Holy Spirit to heal and convert the peoples of the world (Acts 2:1–4). The secondary areas, the archivolts and the lintel, spell out in engaging details the tasks that will confront these first crusaders of Christ.

The favors bestowed by the Holy Spirit on the apostles at Pentecost included powers to convert the pagans and to heal the infirm. The heathen of the world are lined along the lintel (see fig. 353). Recognizable on the left are tribes of Greeks and Romans, and on the right are exotic foreigners such as the pygmies of Africa, who need ladders to mount their horses, and the Panotii, who use their huge ears as umbrellas. Descriptions of such strange peoples are found in crusaders' guidebooks of the period (fig. 354), perhaps derived from the descriptions found in the seventh-century encyclopedia of the world, the *Etymologiae* of Isidore of Seville.[29]

Within the confines of the boxes in the first range of archivolts are the cramped figures of the lame, the mute, the crippled, the insane, and other afflicted peoples from the far reaches of the world. Signs of the zodiac and the labors of the

above left: 355. *Samson and the Lion.* Nave capital in Sainte Madeleine, Vézelay. 1120–32

above right: 356. *The Rape of Ganymede.* Nave capital in Sainte Madeleine, Vézelay. 1120–32

right: 357. *The Mystic Mill.* Nave capital in Sainte Madeleine, Vézelay. 1120–32

months—the latter a favorite theme henceforth in the North—are featured in medallions in the second range of archivolts. These allude to the vast canopy of the heavens that will encompass their missions and to the anticipation of Last Judgment related in the reading for the Ascension: "It is not for you to know the *times* or moments, which the Father hath put in his own power: But you shall receive the power of the Holy Ghost coming upon you, and you shall be witnesses unto me . . . in the uttermost part of the earth" (Acts 1:7–8). The crusaders and pilgrims who gathered at Vézelay thus have a formidable mission before them.

The capitals of Vézelay are a wonder to study (figs. 355–57). Here, in the marginal areas of the church, the torments and fears of the monks, both physical and psychological, manifest themselves in carvings of moralizing stories from the Bible (including Adam and Eve, the Rich Man and Lazarus), personifications of evil (figures representing lust, avarice, infidelity, and so forth), and various temptations of

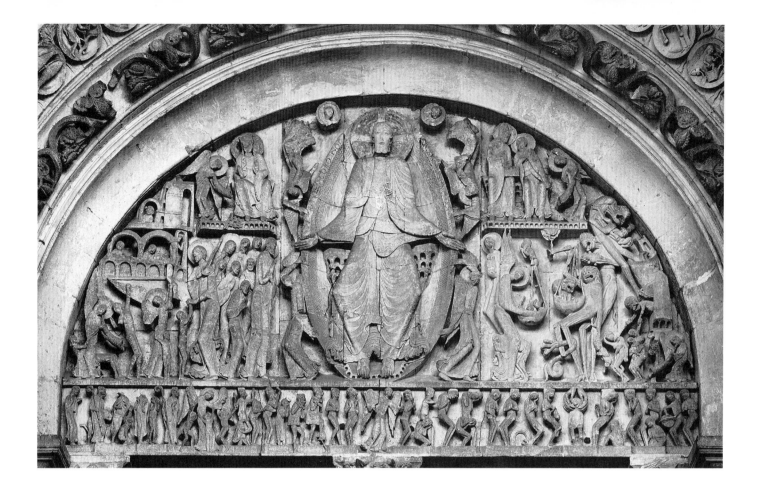

the flesh (stories of Saint Anthony and other hermit saints).

On one capital, Samson, protecting his flocks, straddles the back of a lion with a grotesque head (Judg. 14:5–9), perhaps to be interpreted as the struggle of Christ against the devil (fig. 355). On another a strange bird steals a young boy away in its beak before a satanic monster with flaming hair and a malicious grin (fig. 356). This curious scene has been interpreted as the Rape of Ganymede, the mythological tale of a handsome shepherd boy who was carried away from his flocks by Jupiter in the guise of an eagle (Ovid, *Metamorphoses* 10. 152–61), an allusion to homosexual love. This interpretation is uncertain. Often the wild vitality and grotesque distortions of these demonic creatures render them as nightmarish hybrids of evil spirits more so than identifiable personifications. A keen sense of humor is also apparent at times.

There is no order or sequence that can be detected, but the cumulative effect is telling, especially for the cloistered monks who trod the stones beneath them day after day in solitude. Saint Bernard was vehement in condeming such frivolous displays of vanities in Cluniac churches: "What profit is there in those ridiculous monsters, in that marvelous and deformed comeliness, that comely deformity? . . . So many and so marvelous are the varieties of diverse shapes on every hand that we are more tempted to read in the marble than in our books, and spend the whole day in wondering at these things than in meditating upon the law of God. For God's sake, if men are not ashamed of these follies, why at least do they not shrink from the expense?"[30]

above: 358. GISLEBERTUS. *Last Judgment.* Tympanum and lintel on the west portal, Cathedral, Autun. c. 1120–35

below: 359. *Saint Michael Weighing Souls.* Detail of fig. 358

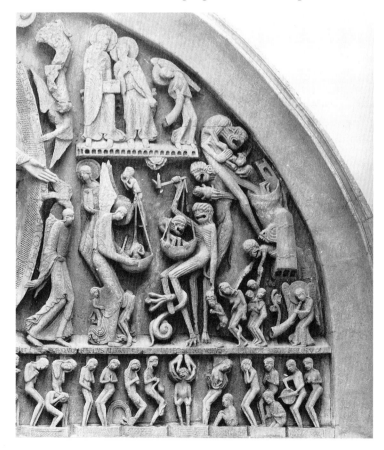

Often the interweavings of figures reveal hidden messages in the form of "disguised symbols." One such capital (fig. 357) depicts what seems at first glance to be a labor of the month with two men busy grinding wheat into flour. But this literal reading conceals others as well: allegorical, tropological (moralizing), and eschatological levels of meaning that were prescribed for reading the scripture in the Middle Ages. The two laborers can be identified as the short-bearded Moses, supplying the wheat from a sack, and the long-bearded Saint Paul, collecting the flour below. Thus the allegory: the rough stock of the Old Testament is collected by Paul in the form of the sweet flour of the New (Paul was renowned for his interpretations of Jewish scripture) to feed the pious. In instructions given to the faithful in the sixth century, Pope Gregory the Great provides us with an explanation for the "mystic mill" at Vézelay: "The letter kills as it is written, but the spirit gives life, thus the letter covers the spirit as the chaff covers the grain; to eat the chaff is to be a beast of burden; to eat the grain is to be human. He who uses human reason, therefore, will cast aside the chaff fit for the beasts and hasten to eat the grain of the spirit. For this it is useful . . . the mystery is covered in the wrappings of the letter."[31]

Another Cluniac sculptor, Gislebertus, signed the tympanum sculptures of the nearby cathedral of Autun, Saint Lazare (figs. 358, 359).[32] The new church was begun under the Cluniac bishop Etienne de Bage (1112–39) and consecrated in 1132. The magnificent interior has been described as Cluniac in construction, although the classicizing details, only marginally evident in Cluny III, are here boldly displayed in the elevation of the nave, which was inspired by the old Roman Porte d'Arroux in the city.

Gislebertus, the head master of the sculpture shop, designed and carved capitals, tympana, and other portal areas sometime between 1120 and 1135. He was a master in creating screaming monsters with spindly skeletal racks of emaciated flesh for bodies and grotesque masks with cavernous mouths and flamelike hair for heads. His blessed people, in contrast, are ethereal, disembodied specters who float weightlessly about the compositions as if buoyed by their serene holiness. In the Last Judgment tympanum, Gislebertus shows little concern for principles of composition. Scale is arbitrary, anatomical proportions are distended or distorted, and there seems to be little attention given to organizing the mélange of figures. The makeshift arrangement, in fact, suggests that Gislebertus was experimenting with his subject matter here.

Rather than presenting the traditional *Maiestas Domini* in the tympanum, Gislebertus provides us with the Last Judgment in all its gory details. Earlier scholars found the textual source for Gislebertus in the twelfth-century *Elucidarium* (Book III) by Honorius of Autun with its complex accounts of events on doomsday.[33] Honorius presents the end of the world as a terrifying drama in five acts beginning with the precursory signs, the onslaught of the four horsemen of the Apocalypse. Then Christ the judge appears in the heavens at midnight. The third act is announced by the blasts of trumpeting angels—the four angels in the corners of the tympanum—calling for the resurrection of the dead, here presented on the lintel. Judgment follows in the company of the apostles, the tall figures to the left, and the weighing of the souls by Saint Michael, to the right. The fifth and final act is the separation of the blessed and the damned to heaven and hell with the Inferno appearing as the mouth of the Leviathan (cf. Job 40:20 and 41:4, 5, 10, 11, 22), who opens the "doors of his face" to engulf the sinners who are "drawn in by hooks." Such elaborate descriptions of the Last Judgment can be found in other contemporary compilations (cf. Rupert of Deutz, *De apocalypsis*), but whatever the exact source for Gislebertus may have been, it is clear that new directions signal and anticipate in many ways the elaborate Apocalyptic schemes of Gothic tympanum sculptures (see pp. 377–78).

Fragments of the north portal sculptures, destroyed in the

360. GISLEBERTUS. *Eve.* Right half of lintel of north portal from the Cathedral, Autun. 27½ × 51". c. 1120–32. Musée Rolin, Autun

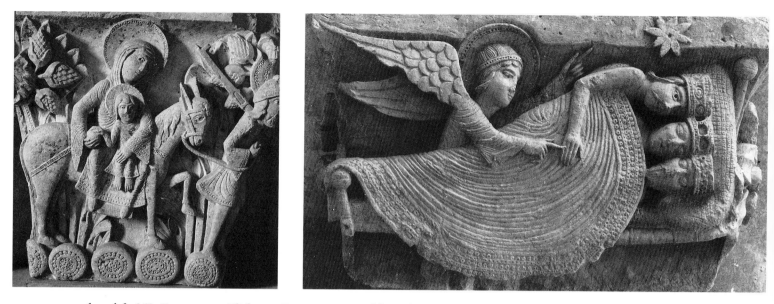

above left: 361. GISLEBERTUS. *Flight into Egypt.* Nave capital from the Cathedral, Autun. c. 1120–32. Musée Lapidare, Autun

above right: 362. GISLEBERTUS. *The Magi Asleep.* Nave capital from the Cathedral, Autun. c. 1120–32. Musée Lapidare, Autun

eighteenth century, were found in the rubble of a nearby house. The most impressive of these is the large horizontal fragment from the right side of the lintel block with a representation of Eve (fig. 360) slithering on her stomach through thick foliage, apparently in search of Adam (on the missing right half?), and calling to him with her cupped hand at her cheek. With her left hand she reaches back for the apple. While a number of interpretations have been suggested for Eve's act and personality, there can be little doubt that she is the embodiment of lust and greed, and an erotic sensuousness seems to transform her body into that of the evil serpent who betrayed man.[34]

The extraordinary capitals in the nave, carved by Gislebertus and his atelier, are as varied and fantastic as those of Vézelay (figs. 361, 362), but the most eye-catching are those that illustrate the Infancy of Christ with a joyous humor. In the Flight into Egypt the journey of the charming, doll-like figures seems accelerated by the rollers beneath the hooves of the donkey. Truly astonishing for its modernity is the depiction of the Three Magi Awakened and Warned by the Angel. A finely textured blanket serves as a warm covering for the three little kings packed into one bed, their crowns still on their heads as they sleep. A quiet angel appears and lightly touches the cheek of the third Magus, who suddenly opens his eyes. This charm and simplicity are essential aspects of Romanesque aesthetics that are too often ignored by scholars in the quest for more profound and serious meanings.

THE RIVAL OF CLUNY—THE CISTERCIANS

In the famous *Apologia* written by Saint Bernard of Clair-

vaux cited above (p. 286), the polemic was directed against the "immoderate height of [Cluniac] churches . . . their immoderate length, their excessive width, sumptuous decoration and finely executed pictures, which divert the attention of those who are praying."[35] The Cistercian Order, to which Bernard belonged, was a reform movement within the Benedictine Order, as was Cluny. The founders established their first community in 1098 in marshy lands at Cîteaux, near Dijon, in Burgundy. Their aim was to purify monastic life by rejecting the worldly riches acquired by Cluny and to return to the simple precepts of communal living as originally laid down by Saint Benedict at Monte Cassino in the sixth century. The new rules and charter, drawn up under the founders—Robert of Molesme, Alberic, and Stephen Harding—were approved in 1119 by Pope Calixtus II. Bernard, the pious son of a nobleman, requested admission to the new order, but in his new calling he found life at Cîteaux even too liberal and worldly, and so he set out with twelve monks to establish his own model house at Clairvaux, where he remained abbot for twenty-eight years until his death in 1153. It is largely through Bernard's program for the Cistercians that we have come to understand the movement.

Simply put, the Cistercian goal was to retreat from the secular world completely by living in poverty in some remote community, disengaged from all worldly and artistic affairs. The rules were laid down precisely, ranging from hourly routines to the physical makeup of the monastery.[36] At first they formed small communities (twelve monks and a prior) in the wilderness. The credo of life for the monks and the *conversi* (lay brethren who served as workers) was simple: prayer and manual labor. They were not even permitted

to read. The plan for their community was also simple (fig. 363). The monastery should be located in a hidden valley near a stream. The buildings were to be humble (wooden at first) and laid out according to a rigid axial pattern. The main building, the church and its cloister, was usually on the north flank of the plan. At exact right angles all others were aligned about this core. The dormitories for the monks joined the projecting transept arm on the east, those for the *conversi* lay on the opposite side of the cloister on the west, while other buildings such as the kitchen, refectory, forge, work sheds, and calefactorium (or warming room) were located on the south side, opposite the church.

The church itself was a simple rectangular basilica. The choir was rectangular with square apse and chapels. Simple columnar supports in the nave were screened off to form two rectangular sub-choirs, one for the monks, the other (toward the narthex) for the *conversi*. The interior was unadorned.

Saint Bernard's original settlement at Clairvaux is nearly lost to us, but early descriptions of it suggest that it resembled the ideal community described above, one that we can perhaps still experience, at least in part, at Fontenay, founded on the instructions of Bernard in 1118. The church of stone was not begun until 1139, and the layout of the complex has not changed much since then (figs. 364, 365). In order that the church be pristine and enduring, pale stone blocks were employed, superbly dressed and fitted. The measurements of the plan and elevation allegedly followed the numerical harmonics of the ancients, although, unlike

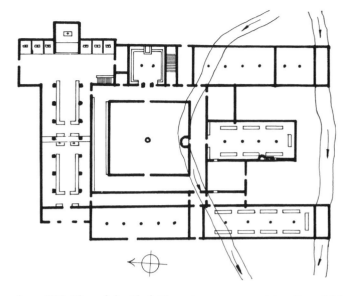

above: 363. Plan of the ideal Cistercian monastery (after Braunfels)

below: 364. Abbey Church, Fontenay. Exterior. 1139–47

Cluny, music was not included in this world, which was totally devoted to manual labor.

It is no wonder that in time the monks and the *conversi* (with a minimum of secular help at first) developed a polished and refined style of building, one that to our eyes

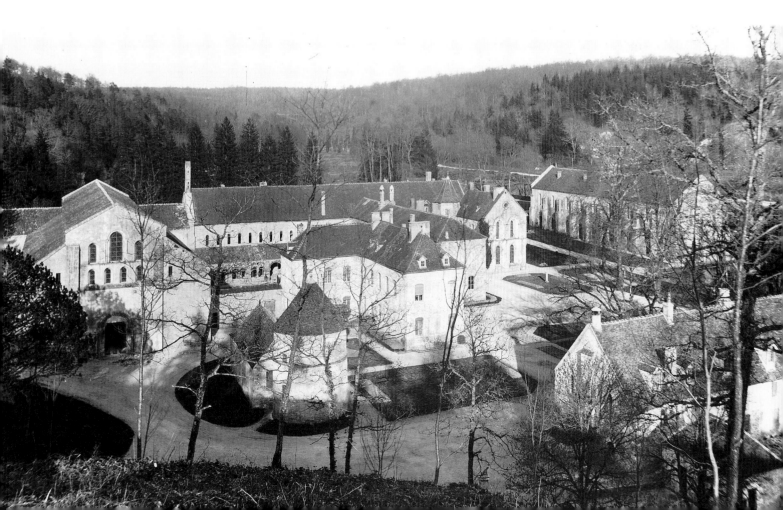

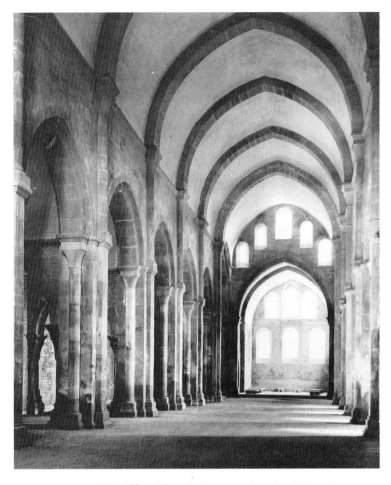

365. Abbey Church, Fontenay. Interior. 1139–47

widely from Scotland to Spain, from Germany to Italy, and the sturdy architecture of the order was to become influential in the development of regional styles of Gothic across Europe. Secondly, as the Cistercians spread, properties and donations poured in, and, as a result of their hard labor, the Cistercians became proficient in agronomy, farming, stockbreeding, wool, milling, and even mining, and with their expertise in such industries even more wealth was acquired.

The simple monastic community envisioned by Saint Bernard grew into a sprawling empire. Finally, even the puritanical iconoclasm that Saint Bernard preached so compellingly harbored serious contradictions. Bernard's absolute devotion to the Virgin, for instance, contributed to a wealth of new imagery for Mary in art. It is in illustrated Cistercian manuscripts (a contradiction to their precepts in itself) where we find the earliest representations of the Tree of Jesse, glorifying the royal ancestry of Mary and Christ through the kings of Judah, a beloved theme for Gothic artists (fig. 366).[37] And it is in his numerous sermons on the Song of Songs (*Canticum Canticorum*) where one of the richest allegories of Mary as the Bride of Christ, another favorite Gothic subject, has its origins.

366. *Tree of Jesse.* Illustration in the Legendarium Cisterciennse. 13 × 7″. Mid-12th century. Bibliothèque Municipale, Dijon (MS 641, fol. 40v)

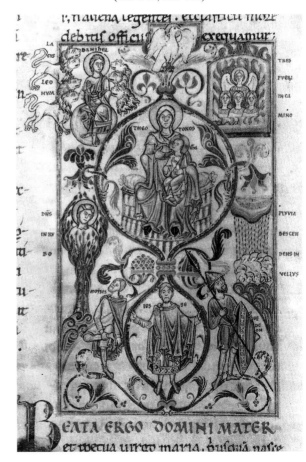

may seem at first too chaste and severe with its simple surfaces and volumes, unadorned walls, and dark twilight atmosphere. The interior was not usually provided with a clerestory or galleries, so that the only light filtered into the nave from small windows in the entrance wall and the sanctuary. The nave rose simply from the sturdy arcade, void of any capital or molding sculptures, to the smooth surfaces of the pointed tunnel vault. The side aisles were covered with transverse tunnel vaults in each bay. The austere interior thus marvelously evoked a world of silent retreat with only the muted tonalities of the stones giving it resonance.

According to the rules, there were to be no sculptures, paintings, or ornate furnishings of any kind. The exterior was also plain and austere with no sculptured portals and no towered facade to suggest worldly power. Given the picturesque nature of their settings in wooded river valleys, the Cistercian community thus established its own quiet hermitage landscape far from the noisy congestion of the rapidly developing urban world of the twelfth century.

It would seem that the Cistercians provided a final solution for the needs of Western monasticism, but many contradictions were built into this simple system as it evolved. For one thing, the Cistercian Order attracted many, and it soon grew as quickly as Cluny, establishing its remote outposts

WESTERN AND SOUTHERN FRANCE

THE NORMANS

REX *sanctus est," "Rex sacerdos est," "Rex messias est."* Thus proclaims an anonymous treatise on Norman statecraft written about the year 1000.[38] The saga of the Normans (Northmen) disrupted the flow of history in France and England as well as that of the Mediterranean world in the eleventh and twelfth centuries. Descendants of Viking pirates, the Normans sporadically settled along the western shores of France about the valley of the Sienne, and from Carolingian times they slowly grew into a powerful dynasty of conquerors and warriors who seemed to waver between their inborn aggressiveness and a reluctant submission to the authority of the church. It is a curious history indeed. William the Conqueror, son of Robert the Devil (who died in Asia Minor returning from a pilgrimage to Jerusalem in 1053), inherited the title of Duke of Normandy at the age of seven. Educated by shrewd and sagacious clergymen, William became a champion of the church but along the precepts of his ancestors as put down in the Norman Anonymous cited above: "The king is holy," "The king is priest," "The king is the messiah."

On the conditions of a papal dispensation concerning bans on marriage to a Flemish relative, Matilda, William founded two monastic communities in Caen, his favorite residence, just a few years before embarking on his famous invasion of England in 1066. Two great churches were raised. One for the men, the Abbaye-aux-Hommes, was dedicated to Saint Etienne (figs. 367, 368); the nunnery, or Abbaye-aux-Dames, commemorated the Holy Trinity. Saint Etienne boasts one of the most familiar facades in Romanesque France. It is apparent at first sight that William the Conqueror asserted his authority resoundingly with a westwork that surpasses any comparable structure of the Carolingians or Ottonians. Two great towers dramatically command the fortresslike structure, and the ruggedness of the Normans and the absolutism of William's statecraft are conveyed in the massive surfaces of its blocky walls and the bold clarity of its geometric design. There are no figurative decorations to detract from its

austerity. The huge facade is divided by harsh buttress strips and straight stringcourses into a strict tripartite division of the square. We are but a step away from the classic facade designed by the first Gothic architects, and it is believed by many scholars that such Norman structures as Saint Etienne were, in part, the inspiration for them.[39]

How majestically the interior echoes the clarity and stability of the facade. Finished by 1077, it rises emphatically in three stages. The divisions are nearly of equal height with a huge continuous gallery opening on the second level, and the walls are solid stone throughout. The austerity of the bold facade is thus reflected in the interior, and sculptural decorations are kept to a minimum, appearing only in quasi-Corinthian capitals that accent the projecting colonnettes and moldings. The present vault, about 1120, features quadripartite ribbing over two bays with an extra supporting transverse arch spanning the intermediate piers across the nave, thus forming sexpartite vaults, another anticipation of vaulting experiments associated with the Gothic (see fig. 453).

In early September 1066, William and his fleet of four hundred ships set sail from Saint Valéry-sur-Somme, above Caen, across the narrow channel for Pevensey in England. His purpose was to claim the throne of England following the death of Edward the Confessor that same year. The king's brother-in-law, Harold, who had formerly paid fealty to William, assumed the throne, and that riled Viking blood. In fact, King Hardraada of Norway also invaded England and, arriving before William, had somewhat sapped the strength of Harold's army. In the famous encounter between the Normans and Saxons at Hastings on October 14, Harold was killed, his army scattered, and William marched victoriously into London to claim the crown as king of England.

Norman chroniclers have left a number of accounts of the wondrous deeds of William the Conqueror. One of these, written between 1071 and 1077 by the court chaplain William of Poitiers, the *Gesta Willelmi ducis Normannorum et regis Anglorum,* is of special interest to us in that it records the Battle of Hastings in much the same fashion as that presented in the famous *Bayeux Tapestry,* believed to have

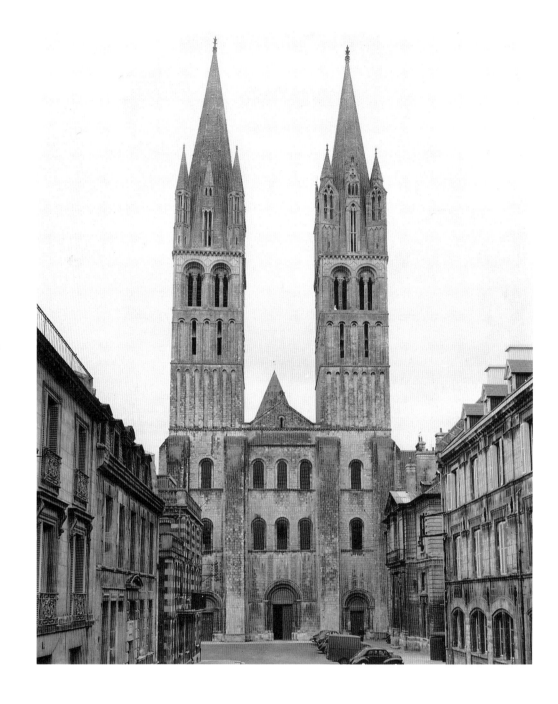

367. Saint Etienne
(Abbaye-aux-Hommes),
Caen. Facade.
1064–77

been commissioned by William's half-brother, Odo, bishop of Bayeux, to commemorate the Norman victory and justify William's claim to the throne of England (fig. 369; colorplate 46).

A work of embroidery on linen stretching some seventy-seven yards, the *Bayeux Tapestry* is a rare survivor of secular history in art, and it introduces us to a mode of pictorial narration that is intimately related to the development of literary epics and *chansons de geste,* such as the *Song of Roland.*[40] In continuous scroll fashion the events unfold with lively figures engaged in boatbuilding, sailing the channel, landing in England, and, finally, notable episodes in the Battle of Hastings. There is even an introductory proem

relating the earlier subjection of Harold to William, thus justifying the Norman claims. The embroidery is fascinating as a document of secular interests of the time. Amid the fast-paced battles, other events of contemporary concern such as the appearance of Halley's comet and a curious tale of scandal involving "a clerk and Aefgyva" are inserted. In the elaborate borders along the top and bottom are strewn various subjects of marginal interest, such as exotic animals, fables, erotic vignettes, and slain soldiers with their discarded arms.

Attempts by historians to find stylistic parallels in contemporary English book illumination—perhaps its model was an illustrated chronicle—seem futile to me, but it has

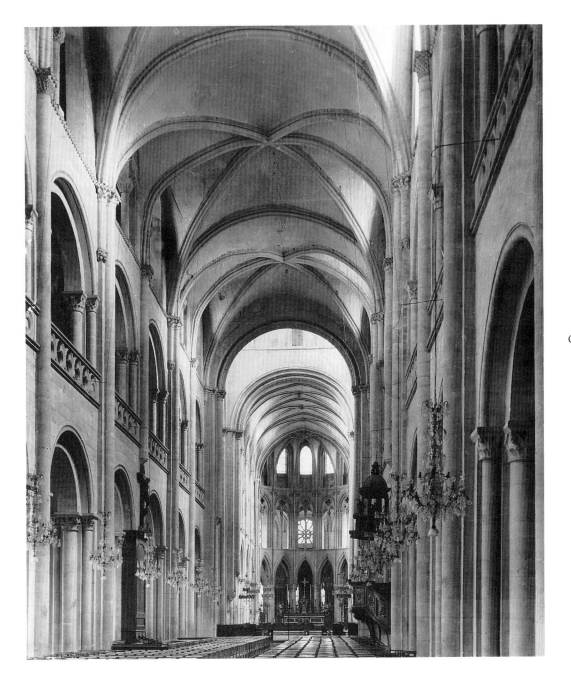

368. Saint Etienne,
Caen. Interior. 1064–77;
vaulted c. 1120

been argued that the *Bayeux Tapestry* is the work of Kentish needlewomen (evidence in the spelling of the brief *tituli* has also been cited for an English origin). To be sure, certain stylistic features of the embroidery can be found in later English illustrated manuscripts, but these same traits appear in continental books as well. What is interesting, however, is that unlike the Cluniac manuscripts of the period (cf. fig. 349), there is little evidence of any Byzantine influence in the style of the *Bayeux Tapestry*.

The Normanization of the Anglo-Saxon churches in England was immediate and vigorous. Lanfranc of Pavia, William's learned councillor, who had joined the important abbey at Bec and served the abbacy of Saint Etienne in Caen,

was a staunch supporter of the Norman acquisition of England. Acting as a vice-regent for William, he was made archbishop of the venerable Cathedral of Canterbury and led in the reform and reorganization of the Saxon churches. Following an influx of Norman monks, building activity reached a feverish pitch. Numerous old churches were torn down and replaced with impressive Norman buildings.

A number of important churches in England today have Norman foundations. The specific Norman contribution lies in the superb stonework that gives these structures their monumental proportions and stability. Norman, too, would seem to be the introduction of the two-towered facade—the priors and bishops were, in effect, lords over both secular

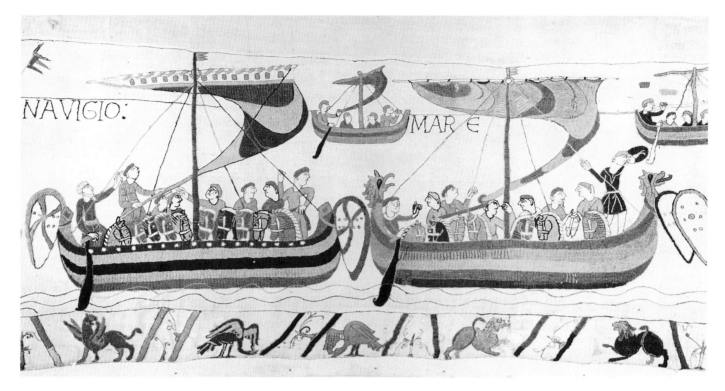

369. *Normans Crossing the English Channel.* Detail from the Bayeux Tapestry. Wool embroidery on linen, height 20″ (length of entire tapestry, 229′8″). c. 1070–80. Musée de Peinture, Ancien Evêché, Bayeux

and ecclesiastical affairs—but from Cluny III came the idea behind the double-transept plan that often appears (Canterbury and the priory at Lewes), while the distinctive English screen facade (for example, Ely) has been linked to churches in Aquitaine, to be discussed below.

Typical of Norman influence is the stately interior of Gloucester Cathedral (fig. 370), begun in 1087, with its massive walls and arcade of huge columns supporting a shallow gallery and clerestory. Gloucester was not vaulted until about 1240, but important experiments in vaulting with ribbed compartments or groins (instead of the usual tunnel vault) began much earlier at Durham Cathedral, one of the masterpieces of English Romanesque architecture (figs. 371–73). Set high on a cliff overlooking the picturesque river Wear, Durham served as a military headquarters as well as the seat of ecclesiastic authority. The familiar two-towered facade of Durham, however, dates variously with its Romanesque foundations, its Gothic towers, and the eighteenth-century battlements. An impressive Galilee porch, dating about 1175, projects from the facade, but it is the interior that interests us here.[41]

The church was begun in 1087 under Bishop William de Carilef to replace an earlier Saxon church, and the vaulting in the nave (fig. 372) was completed by 1133. The nave consists of double bays (two single bays at the entrance) with huge columns alternating with complex compound piers. Great transverse arches span the nave between the piers, dividing the expanse of the nave vault into three units. Ribs

370. Cathedral, Gloucester. Interior. Begun 1087; vaulted c. 1240

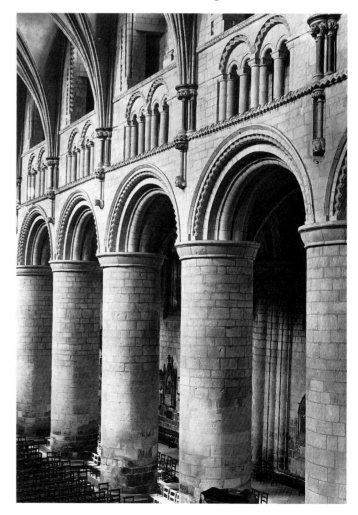

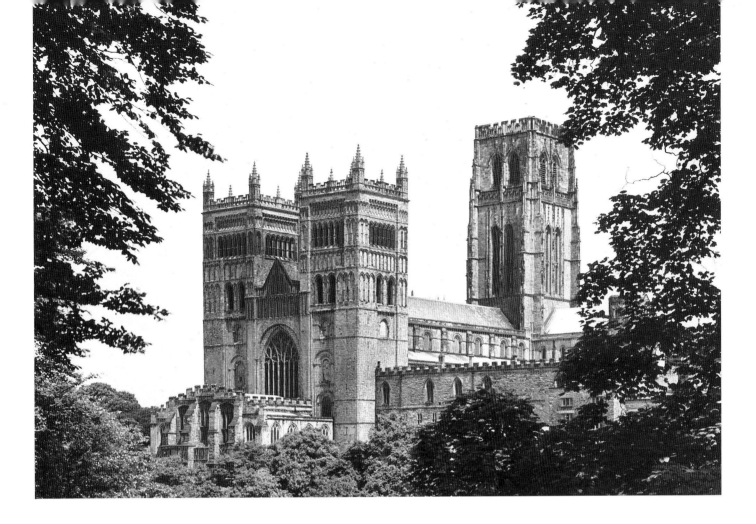

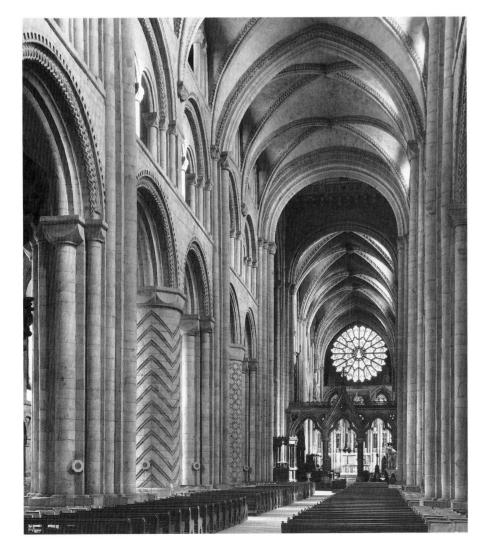

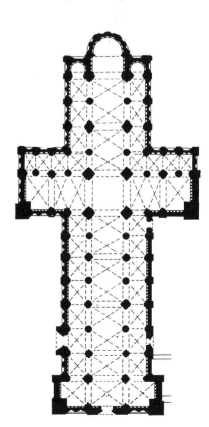

above: 371. Cathedral, Durham.
Exterior. 1093–1133 and later

left: 372. Cathedral, Durham. Interior

below: 373. Cathedral, Durham. Plan
(after Webb)

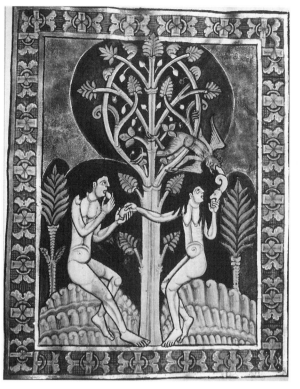

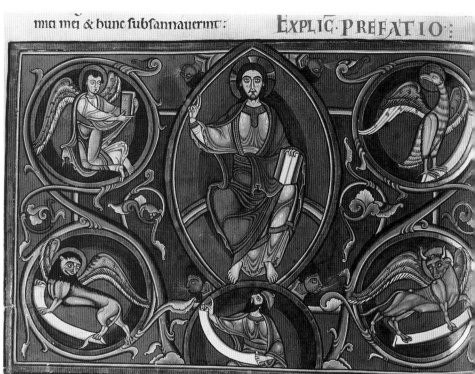

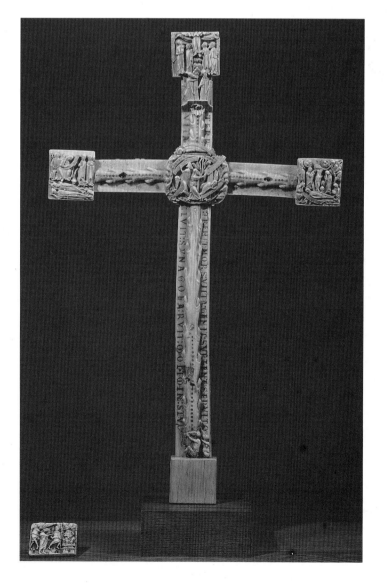

above left: 374. *Fall of Adam and Eve.*
Illustration in the Albani Psalter.
10⅞ × 7¼″. After 1120.
Library of Saint Godehard,
Hildesheim (fol. 9r)

above right: 375. MASTER HUGO.
Maiestas Domini. Illustration in the
Bible of Bury Saint Edmunds.
19⅞ × 14″. 1130–40.
Library of Corpus Christi College,
Cambridge, England
(MS 2, fol. 281v)

left: 376. Altar Cross from
Bury Saint Edmunds (front).
Ivory, height 22¾″. c. 1140.
The Metropolitan Museum of Art,
New York. Purchase, 1963, Cloisters Fund.
See also colorplate 47

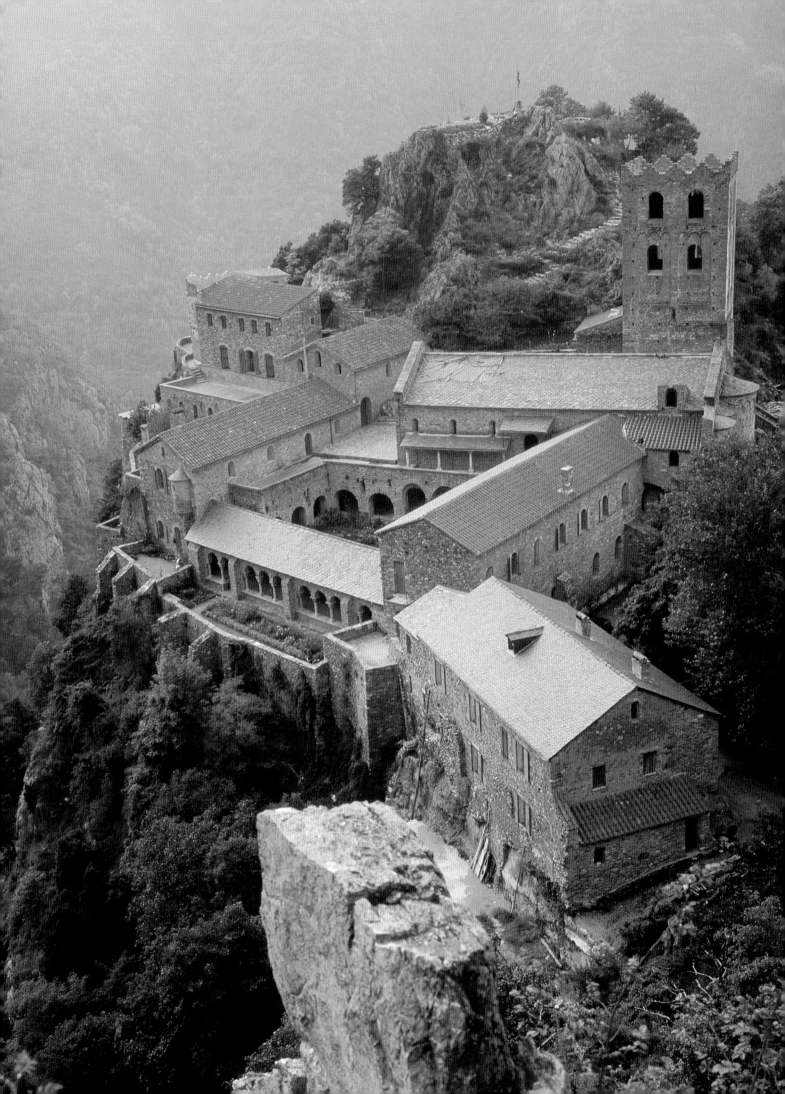

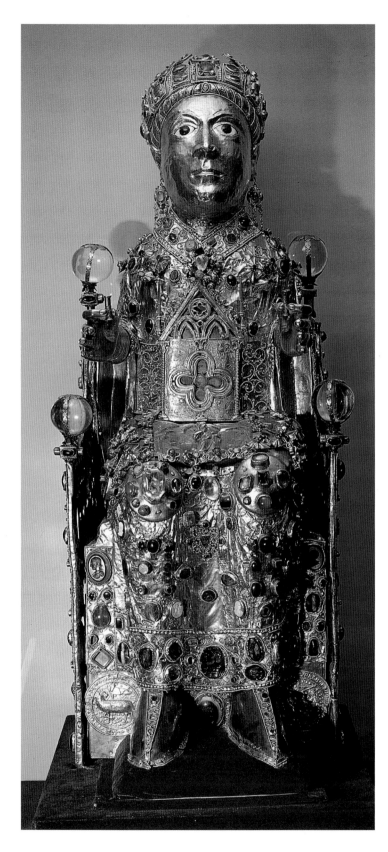

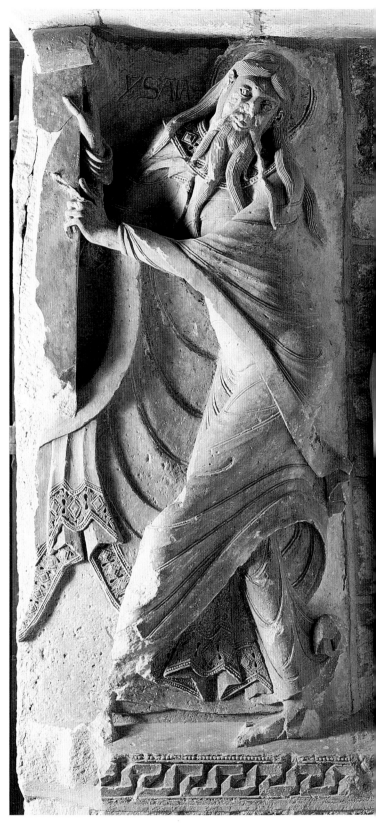

preceding page: Colorplate 42. Saint Martin-du-Canigou. Air view.
1001–26

Colorplate 44. *Prophet Isaiah.* Stone. 1125–30. Formerly on the jambs
of the Church of Sainte Marie, Souillac

above: Colorplate 43. *Sainte Foy.* Gold and jewels over wood,
height 33½". 11–12th century. Cathedral Treasury, Conques

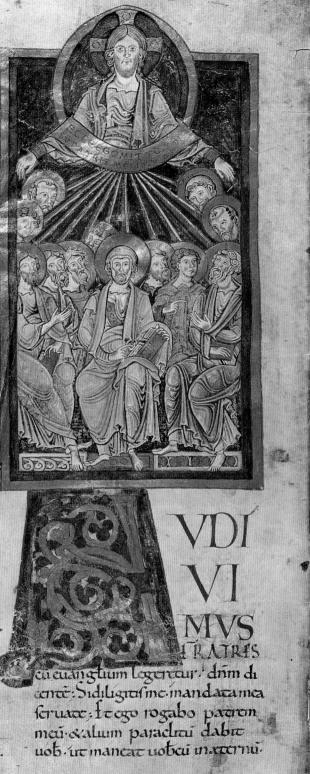

quod dñs susceptor é eā? Ds eni erat
uerbū unigenitus; gigneta co
aternus; Sed ut mediator daretur
nob. p ineffabilē grām uerbum
caro factum é & habitau in nobis;
LECTIO OCTAVA.
Hæc loquutus sū uob ut
gaudiū meū in uob sit.
& gaudium urm impleatur;
Hoc é pceptū mei ut diligatis in
uicē sicut dilexiuos. Audistis ca
rissimi dñm dicente discipulis su
is; Hæc loquutus sū uob. ut gau
diū meū in uob sit & gaudiū urm
impleatur; Quod é gaudiū xpi
in nob. nisi quod dignat gaudet
de nob. & qd é gaudiū nrm qd
dicit implendū. nisi eā habere con
sortū? Ppt qd beato petro dixe
rat. si ñ lauero te non habebis par
tē mecū; Gaudiū g eius in nobis
grā é qua pstitit nob. ipsa é utiq
gaudiū nrm; Sed de hac ille eti
am ex æternitate gaudebat.
quando nos elegit ante mundi
constitutionē; Nec recte possu
mus dicere. quod gaudium eius
plenū non erat; Non enim dñs in
pfecte aliquando gaudebat.
sed illud eā gaudiū in nob non
erat. quia. nec nos in quib; ee pos
sit iam eramus. nec quando eā ee
pimus cū illo ee cepimus. In ipso
aut semp erat. qui nos suos futu
ros certissima suæ pscientiæ ueri
tate gaudebat; EVG. Hoc est
pceptū mei. REQ. IN NT APtos.

cū euangliū legeretur. dñm di
cente; Si diligitis me. mandata mea
seruate; Et ego rogabo patrem
meū. & alium paraclitū dabit
uob. ut maneat uob cū in æternū.

AVDI
VI
MVS
FRATRES

Colorplate 45. *Pentecost.* Illustration in the Cluny Lectionary. 9 × 5″. Early 12th century. Bibliothèque Nationale, Paris
(MS nouv. acq. lat. 2246, fol. 79v)

Colorplate 46. *Messengers to King Edward and Halley's Comet.* Detail from the Bayeux Tapestry. Wool embroidery on linen, height 20″ (length of entire tapestry, 229′ 8″). c. 1070–80. Musée de Peinture, Ancien Evêché, Bayeux

Colorplate 47. Altar Cross from Bury Saint Edmunds (detail of back). Ivory, height 22¾″. c. 1140. The Metropolitan Museum of Art, New York. Purchase, 1963, Cloisters Fund

right: Colorplate 48. *Ark of Noah.* Fresco in nave vaults of the Church of Saint-Savin-sur-Gartempe. c. 1100

below: Colorplate 49. *Ascension.* Illustration in the Sacramentary of the Cathedral of Saint Etienne of Limoges. 10¾ × 6⅝″. c. 1100. Bibliothèque Nationale, Paris (MS lat. 9438, fol. 84v)

below right: Colorplate 50. *Virgin and Child* (The Morgan Madonna). Wood, height 31″. 12th century. The Metropolitan Museum of Art, New York. Gift of J. Pierpont Morgan, 1916

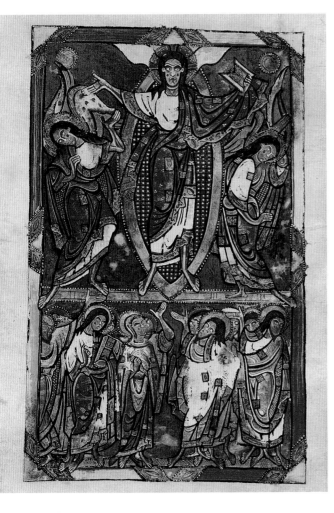

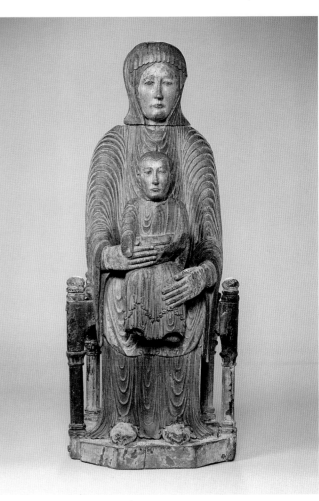

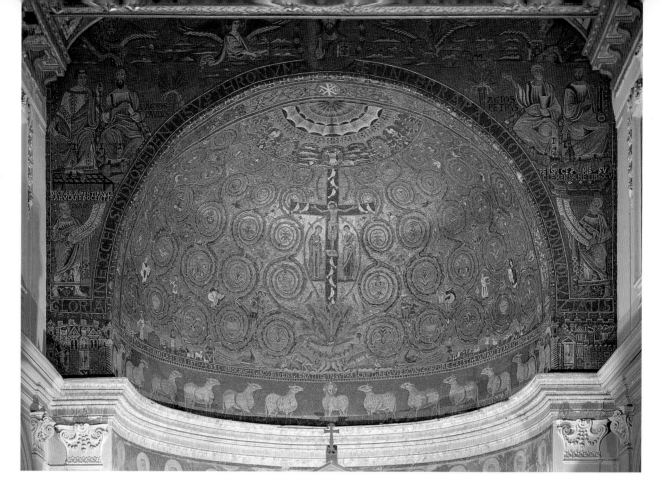

Colorplate 51. *The Cross as the Tree of Life*. Apse mosaic in the upper church of San Clemente, Rome. Before 1128

Colorplate 52. *Triumph of Maria Ecclesia*. Apse mosaic in Santa Maria in Trastevere, Rome. 1130–43

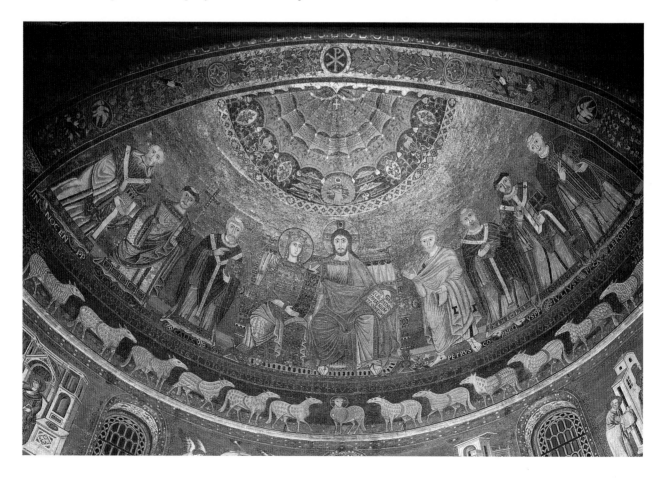

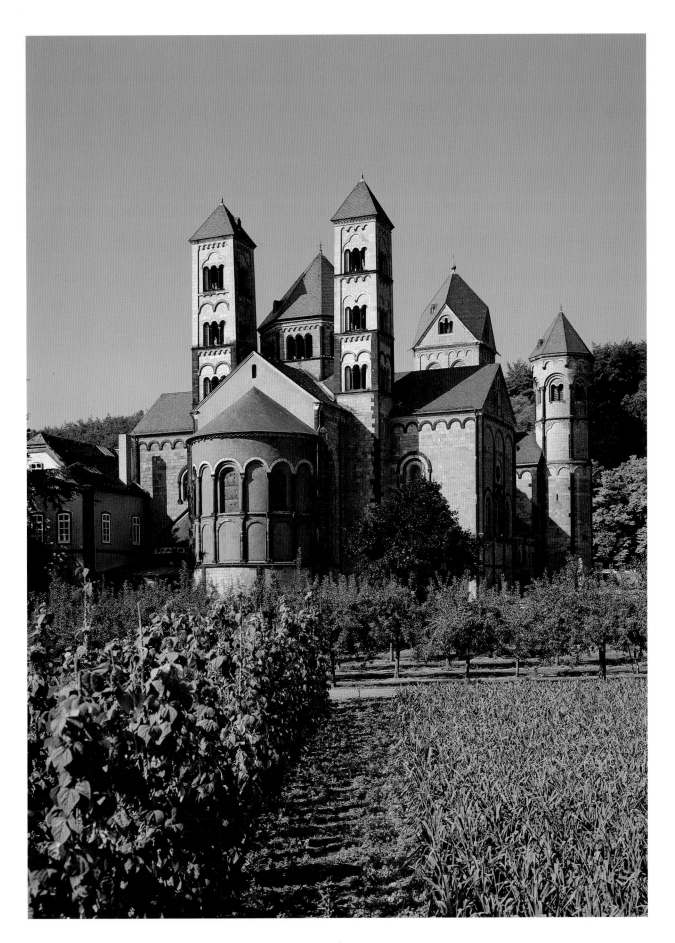

Colorplate 53. Abbey Church, Maria Laach. Exterior from northwest. Founded 1093

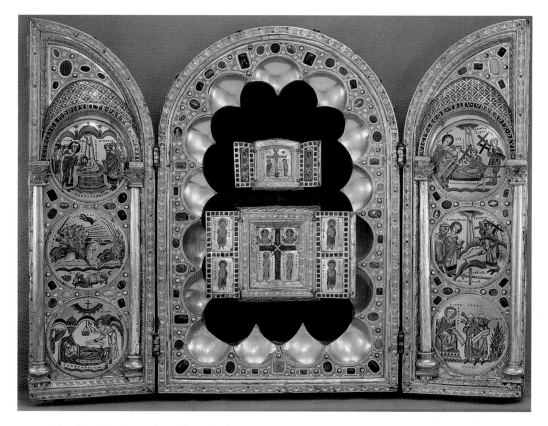

Colorplate 54. *Scenes from the Life of Emperor Constantine the Great* (Stavelot portable altar).
Champlevé and cloisonné enamel on copper gilt, 19¹⁄₁₆ × 26″. After 1154.
Pierpont Morgan Library, New York

Colorplate 55. NICHOLAS OF VERDUN AND SHOP. *Shrine of the Three Kings.* Silver and bronze, gilded;
enamel, filigree, and precious stones, 68 × 72 × 44″. c. 1190–1230. Cathedral Treasury, Cologne

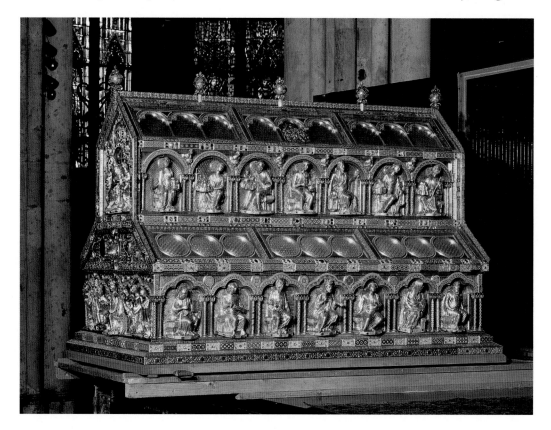

spring diagonally from the piers and from corbels in the galleries above the columns, crisscrossing the ceiling so that, together with the transverse arches, the vaults display a curious seven-part division in each unit. Such imaginative experimentation in vaulting techniques characterizes many later English churches and seems to reflect a mentality in building that prefers decorative effect over clarity of structure. This same attitude is apparent in the elaborate chevrons, diaper patterns, and spiral flutings that are incised on the massive columns, diminishing their simple structural appearance. Interlaced blind arcades decorate the lower walls of the side aisles, and a variety of molding designs throughout the elevation further express the English taste for decorative touches and embellishments.

The austerity of Norman taste would seem to have hampered the Anglo-Saxon proclivities for decoration and narration in their representational arts, and to some extent it did at first. However, in the second and third decades of the twelfth century, the love for intricate line and elaborate border embellishments returned, especially in manuscript illumination and sculptures on a small scale. The second copy of the Utrecht Psalter, the Eadwine Psalter (fig. 276), was made at this time at Canterbury. Romanesque abstractions in the figure style appear, and the ornate frame and the scalloped ridges for landscape quell the spontaneous and random flow of figures in the original.

At Saint Albans, manuscript illumination had an impressive revival. The Albani Psalter (fig. 374), executed about 1120–30, with forty full-page narratives ranging from Genesis to Pentecost in subject matter and numerous "inhabited" initials, as they are called, displays stunning designs and abstractions that no doubt owe something to Ottonian models.[42] At Bury Saint Edmunds the revival of illumination also occurred on a large scale. In the giant Bible of Bury Saint Edmunds (fig. 375), dating about 1130–40, the handsome miniatures display a compromise between the freer abstractions of Northern art and the conventions of Byzantium, especially in the drapery patterns. Saint Anselm, abbot of the abbey, came from Santa Saba in Rome, and very likely he brought examples of the huge ceremonial Bibles, so popular in Italy at the time, to serve as models in his scriptorium.[43]

The illuminator of the Bury Bible was a secular craftsman named Hugo, who is also listed in the documents of the abbey as a sculptor and metalworker. The elegant altar cross, attributed to the workshop at Bury Saint Edmunds (fig. 376; colorplate 47), is an exquisite example of the finest in English ivory carving.[44] The front of the cross is fashioned as a Tree of Life to which the corpus of Christ was affixed (perhaps the fragment now in the Kunstindustrimuseet in Oslo). Square plaques at the ends of the arms carry tiny representations of the Deposition (right), the Marys at the tomb (left), and the Ascension of Christ (top). The missing piece at the bottom presumably illustrated the Harrowing of Hell since diminutive figures of Adam and Eve appear at the base. A central medallion carried by angels displays the story of Moses and the Brazen Serpent, an Old Testament prefiguration of the Crucifixion.

On the reverse, the sacrificial Lamb, whose side is pierced by a personification of Synagoga, appears in the central medallion, while symbols of the Evangelists are in the square plaques on the arms and top. Replacing the Tree of Life are busts of prophets holding scrolls. The complex iconography has yet to be explained adequately. Some claim an anti-Jewish sentiment is expressed; others argue that a much earlier Christian tradition is at work here. Whatever the case, it is the exquisite technique of carving on such a small scale that truly impresses us.

AQUITAINE

Like a giant crescent on a map, the grand duchy of Aquitaine sweeps through the western and southern counties of modern France from the borders of Normandy in the north through Poitou, Périgord, Guienne, and Auvergne to the southern domains of the Counts of Toulouse. When one travels this circuit today, it seems that every village and city has its Romanesque church, and the varieties of regional styles, some wholly independent of the Burgundian and pilgrimage types, make classification of these structures difficult. Chronologies make little sense here, too, and it is nearly impossible to give priorities to outside influences, which are many. So our rambling survey of Romanesque in Aquitaine will be wanting in clarity and comprehension.

We begin our journey at Poitiers, capital of Poitou and favored residence of the rulers of Aquitaine. Illustrious figures in history are associated with Poitiers. Duke William IX of Aquitaine (1071–1127) is the romantic knight heralded in French history as the initiator of the colorful traditions of the chivalric romances and *chansons de geste* in the vernacular. His granddaughter, Eleanor of Aquitaine (1122–1204), wife of two kings, mother of two kings, is one of the most illustrious women in Medieval history. Her first husband was the Capetian king of France, Louis VII, whom she divorced in 1152. She then married Henry II Plantagenet, lord of Anjou, Brittany, and Normandy and later king of England. Richard the Lion-Hearted (*Coeur-de-lion*) was her son. Thus Eleanor's domain at one time covered France and England, and her reign overlapped in time the Romanesque and Gothic periods in art history.

Along with her first husband, she attended the call to arms by Saint Bernard, the spiritual leader of the Romanesque, at Vézelay in 1146 and, in fact, headed a band of women warriors, called "Amazons," who joined the ill-fated Second Crusade. On the other hand, her marriage to the French king had been negotiated by Abbot Suger of Saint Denis, the founder of the new Gothic style in the Ile-de-France. In her later years she patronized a "court of love" for artists, poets,

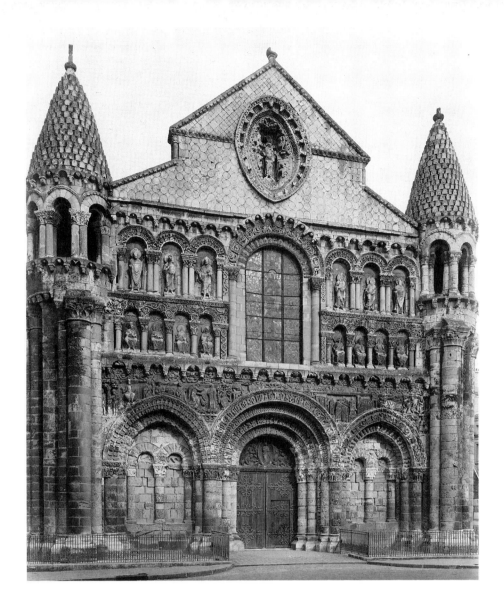

left: 377. Notre-Dame-la-Grande, Poitiers. West facade. Second quarter of 12th century

opposite above: 378. Saint Front, Périgueux. Air view. c. 1120

opposite below: 379. Saint Front, Périgueux. Interior. c. 1120

and literati at her residence in Poitiers. Eleanor was, indeed, a remarkable woman, "charming" (*avenante*), "gallant" (*vaillante*), and "of remarkable sagacity" (*admirabilis astuciae*), as a court poet described her.[45] She lies buried beside the tombs of her second king, Henry II (d. 1189) and their son Richard the Lion-Hearted (d. 1199), in the domed abbey church at Fontevrault near Poitiers.

The Church of Notre-Dame-la-Grande (fig. 377) is typical of Poitevin Romanesque architecture.[46] The ground plan and interior are simplified pilgrimage types, but the facade is distinctive. Lacking the monumentality of the Cluniac churches, Notre-Dame-la-Grande at first strikes one as an enlarged reliquary shrine, bedecked with a profusion of sculptural gems and delicate pinnacles. The ornate facade is, in effect, a screen that is unrelated to the interior. The flanking towers are reduced to cylindrical piers of bundled shafts carrying a small drum capped by a conical roof covered with fish-scale tiles. The simple gabled face is covered with tiers of sculptural decorations. The doorways have no tympana, and the courses of archivolts (voussoirs) are carved as individual elements in a radial fashion with monotonous rows of identical figures. A dog is repeated over thirty times on one range of voussoirs. In the spandrels, a frieze of

relief sculptures narrates a curious story beginning with the Fall of Adam and Eve on the left, continuing with figures of prophets, the Annunciation, the Tree of Jesse, and concluding with the Nativity on the right. Perhaps a mystery play provided the strange sequence of figures here.

The second level of the facade rises above a coursing of corbels with two arcades of ornate niches housing apostles and churchmen, all posed frontally. In the gable a broochlike lozenge is carved with Christ standing between angels. Thus the upper stories present a *Maiestas Domini* of sorts. It is clear, however, from the rich carpetlike texture of the facade and the endless repetition of figure types that there is little concern here for a comprehensive iconographic program. The ensemble of sculptures reminds one, in fact, of Mediterranean types of the period (see p. 328 ff.), and underlying the bespangled screen one can perceive the broader outlines of a more Classical facade.

Similar screen facades are found throughout Poitiers and Périgord, but surprisingly many of the churches between the Loire and the Garonne rivers depart from traditional Romanesque construction in that they are covered with a series of domes in a fashion that reminds one of Byzantine types. The most impressive of these is Saint Front at Périgueux

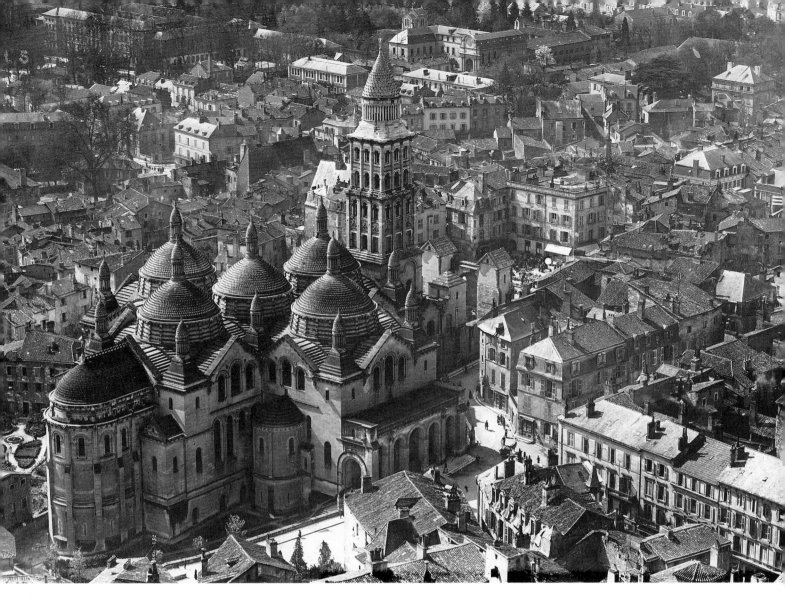

(figs. 378, 379), erected about 1120, which may have been inspired directly by San Marco in Venice. Huge open piers carry massive pendentives supporting five great domes over the center and the arms of the Greek-cross plan. In some churches (such as Saint Etienne at Périgueux, Fontevrault, Angoulême, and Souillac) the domes are lined up in a row over a basilical nave. It has been suggested that domes on such a scale were introduced into western France after the First Crusade in 1100, which William IX of Aquitaine joined. The bold austerity and emptiness of these domed interiors would no doubt have been relieved by painted decorations.

The painted ceiling of Saint-Savin-sur-Gartempe (figs. 380, 381; colorplate 48) miraculously survives, but here the interior is covered by a continuous tunnel vault that rests directly on the tall columns of the nave arcade, another church type in Aquitaine, the "hall church," in which the side aisles rise to the level of the nave vaults. A talented atelier executed the frescoes about 1100, probably while the scaffoldings for the erection of the vaults were still in place. The entire church was apparently painted at that time, and it is interesting to note that the general iconographic program follows Early Christian traditions for the most part.

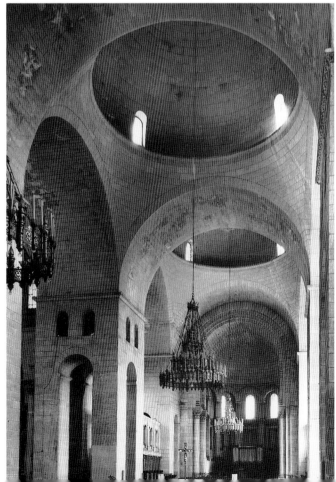

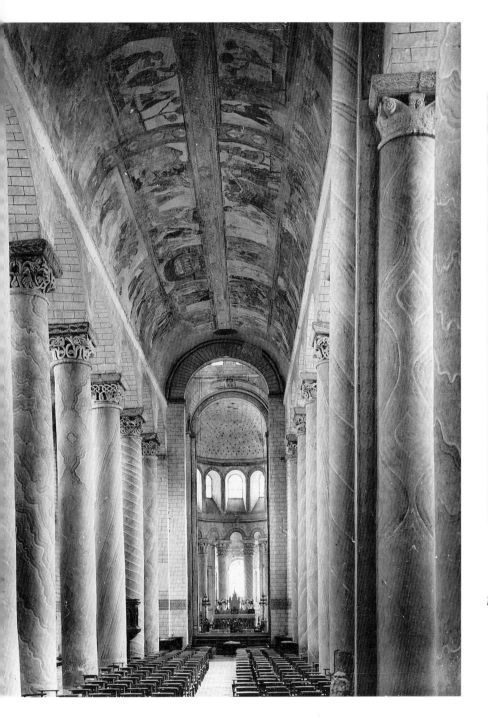

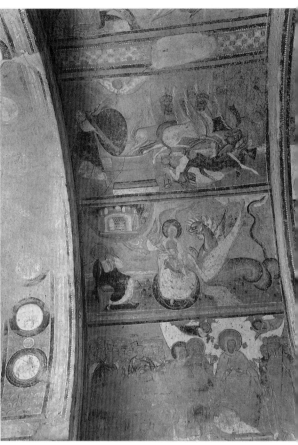

left: 380. Abbey Church, Saint-Savin-sur-Gartempe. Nave vaults. c. 1100

above: 381. *Plague of Locusts; Apocalyptic Woman;* and *New Jerusalem.* Frescoes in the narthex of the Abbey Churc Saint-Savin-sur-Gartempe

The porch or narthex is decorated with lively episodes from the Book of Revelation; the long vault of the nave has four registers of the history of ecclesia *ante legem* (before the law of Moses), with scenes from the first days of creation to the moment when Moses received the Tablets of the Law on Mount Sinai. The charming Ark of Noah (colorplate 48) resembles an enlarged miniature. The New Testament stories—only Passion pictures survive—were painted in the chapel gallery over the narthex, and frescoes in the crypt are devoted to the martyrdoms of Saint Savin and Saint Cyprian (similar remains of martyrs' histories are found in the chapels of the choir), appropriate for the function of that area as a miniature martyrium. Nothing remains of the apse painting.[47]

The frescoes in Saint-Savin are roughly contemporary with those in the chapel at Berzé-la-Ville (fig. 348), but they display little of the Byzantine stylizations found there. Rather, they seem to be distinctively Northern in style with tall, spindly figures moving in swinging, agitated postures that bring to mind the narratives in the *Bayeux Tapestry.*

There is little indication of space or modeling. It seems clear that manuscript models were employed in the frescoes of Saint-Savin.

As we have seen, there were two opposing styles of painting in France around 1100: the sophisticated Byzantine manner, especially evident in drapery conventions and head types (cf. the Cluny Lectionary, fig. 349), and the more indigenous Northern style of dynamic linearism. Typical of the latter is the "inspired" *Saint Mark* in the Corbie Gospels (fig. 382) with his wild gestures and twisted pose. The more static qualities of the "plaque" style of Languedocian sculpture are translated into the standing *Saint Matthew* in the Gospels from the region of Moissac (fig. 383), where the letter *L* resembles a sculptured pier (cf. fig. 330).[48]

A daring compromise of these styles can be seen in manuscript illumination in Limoges (colorplate 49). The hieratic qualities of the *Ascension* miniature in the Sacramentary of Saint Etienne in Limoges, dating about 1100, have been described as creative transformations of Byzantine style, and, to be sure, the iconography of the miniature reminds us

382. *Saint Mark.* Illustration in the Gospels of Corbie. 10¾ × 7⅞". c. 1120. Bibliothèque Municipale, Amiens (MS 24, fol. 53r)

383. *Saint Matthew.* Illustration in the Gospel Book of Moissac. 7½ × 4". c. 1110. Bibliothèque Nationale, Paris (MS lat. 254, fol. 10r)

of earlier Eastern manuscripts (cf. the Rabbula Gospels, fig. 102). However, the flashes of hot, metallic colors held within firm but vigorous outlines and the total suppression of space for the tall, compact figures are features that are prophetic of developments in the sculpture of the mature Romanesque style.

The metallic qualities of the miniatures in the Sacramentary anticipate the style of another art for which Limoges is famed: the enameled reliquary shrines that resemble tiny Antique sarcophagi, appropriate for containers of relics. The faces are decorated with *champlevé* and/or *cloisonné* enamels on copper plates affixed to a wooden core. A tabernacle with the Three Marys at the Tomb in the Metropolitan Museum of Art (fig. 384), dating about 1180–1200, is a fine example of such Limoges enamelwork.[49] *Champlevé* (in contrast to *cloisonné,* with its tiny partitions for the enamel) is a technique whereby the lines and shapes of the figures are actually dug out or engraved from the metal surface with a cutting

384. Reliquary. Limoges, 14¼ × 6¼″. End of the 12th century. The Metropolitan Museum of Art, New York. Gift of George Blumenthal, 1941

tool and then filled with enamel. Often, in late Limoges productions, separate cast heads or whole figures of bronze were applied to the enameled background. The sharp outlines and shapes of the engraved figures on the copper ground are comparable to the abstractions seen in the Sacramentary.

A specialty of Auvergne workshops was wooden statues of the seated Virgin and Child (see colorplate 50), an image of the Throne of Holy Wisdom (*sedes sapientiae*), a sculpture type we have already encountered in Ottonian art (cf. fig. 299). These imposing statues were very popular in churches along the pilgrimage roads, where they served as objects of pious devotion on an altar. They were, in fact, cult images like sculptured icons (some served as reliquaries as well—cf. the reliquary of Sainte Foy at Conques, colorplate 43). The harsh stylistic features that developed in these wooden statues, especially evident in the rigid frontality and the abstract conventions for drapery patterns, superbly convey the more transcendental or iconic function of the image.[50] This same frontal Virgin and Child was incorporated into more complex iconographies in Early Gothic art.

PROVENCE

The Rhône River flows near Cluny in Burgundy southward through Provence to empty into the Mediterranean near Arles, where it formed a major point for embarkation for the

385. Abbey Church, Saint-Gilles-du-Gard. Facade. Third quarter of the 12th century

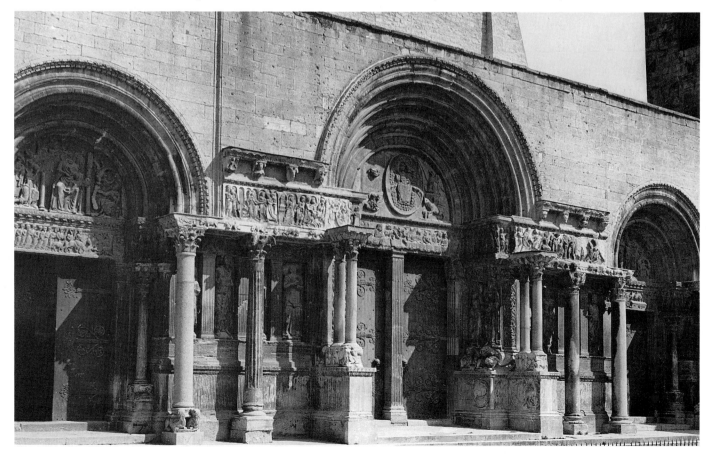

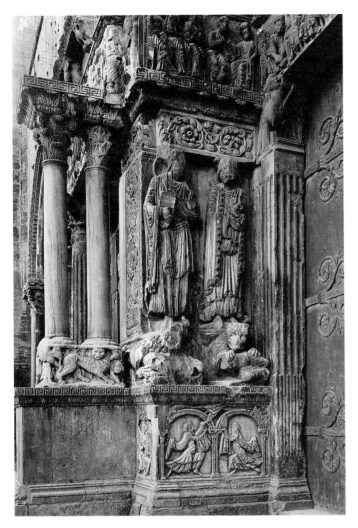

386. Abbey Church, Saint-Gilles-du-Gard. View into central portal

stage front, has been proposed), and the sculptures have been characterized as proto-Renaissance in character by some historians. On the other hand, it has been argued that the complex program of sculptures is indebted to developments in the Ile-de-France at Saint Denis and Chartres.[52]

The ensemble is clearly makeshift. Three recessed portals are tied together by a curious entablature with sculptured friezes supported by freestanding Antique columns stretching across the facade. Behind this projecting colonnade, on the wall of the church, appears a shallow gallery with standing apostles (an archangel on either end) carved in relief. The sculptured entablature, which rises and projects in the center, is decorated with reliefs illustrating in continuous fashion the Passion of Christ (the Last Supper is centrally placed). Various types and styles of sculpture—crouching lions, fighting beasts, and lacy reliefs with Old Testament figures—decorate the base and socles of the columns. Three large tympana with heavy, unadorned ranges of archivolts

387. *Saint John the Evangelist and Saint Peter.* Detail of fig. 386

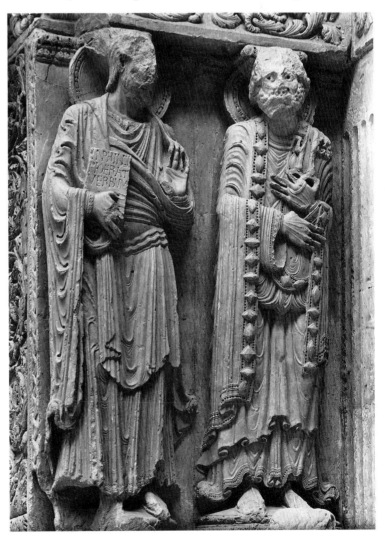

crusaders. The land east of the Rhone was politically part of the Holy Roman Empire that linked northern Europe to Italy, but the western lands of Provence, merging with Languedoc, were governed by the Counts of Toulouse. The Church of Saint-Gilles-du-Gard, a few miles from Arles, is one of the most controversial monuments in the story of Romanesque art.[51] Rebuilt in the early twelfth century, following a period of political unrest in the area, it was reformed and reorganized by Cluny (1122–1158). At some point, roughly about the middle of the century, a new facade was added with an ambitious scheme of sculptures serving as a monumental screen across the old church (figs. 385–88).

The facade owes as much to Italy as it does to France. Roman remains abound in this area, and it seems clear that something Antique provided the format for the broad, horizontal porch. It has been suggested that a triumphal arch was the model (more recently the Roman *scenae frons,* or theater

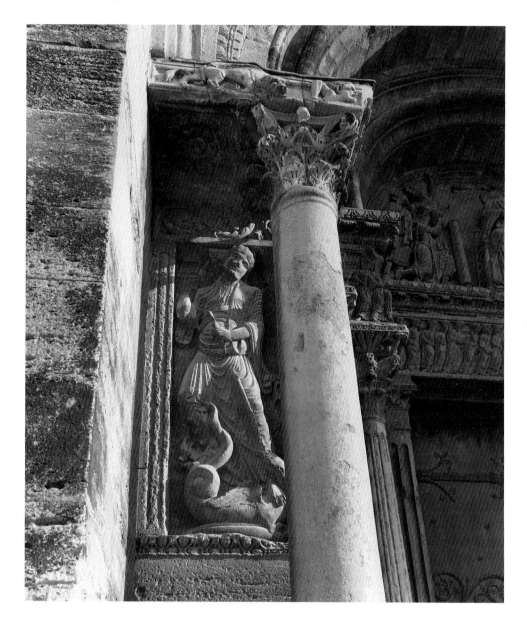

388. *Saint Michael.* Detail of
left portal of the Abbey Church,
Saint-Gilles-du-Gard. 3rd quarter
of the 12th century

display, from left to right, the Adoration of the Magi, the *Maiestas Domini* (now restored), and the Crucifixion.

The curious program makes sense. As explications of the doctrine of the Incarnation and the sacrificial role of Christ, the two side tympana are clear enough. The Madonna in the Adoration is, in fact, the *sedes sapientiae* just discussed; the Crucifixion, a rare theme on a tympanum, and the Last Supper beneath the *Maiestas Domini* illustrate the role of Christ's sacrifice for man as embodied in the Eucharist. The gallery of standing apostles can be seen as a monumentalization of those figures in the *Maiestas Domini* theme or, in more poetic terms, as the twelve "pillars" that support the church and its doctrines.

The styles of the sculptures have raised unanswerable questions. Those in the tympana, in spite of restorations, appear to be related to the more archaic phases of Early Romanesque style, although drapery patterns and propor-

tions mark them as later in date. Three distinct styles are evident in the standing apostles and archangels. The figures of Saint John and Saint Peter in the central portal (figs. 386, 387) have labored drapery patterns along the harsh, vertical folds; Saint Thomas (in the right portal), crossing his legs, reminds us of the earlier figures at Toulouse; while the figure of Saint Michael, to the far left (388), with his dancing posture and elegant, pressed folds with flared pockets, recalls Burgundian sculptures such as we see at Vézelay. Finally, the entablature reliefs can be compared to friezes on Early Christian sarcophagi, which abound in the region. Only an accurate dating of these sculptures—which seems futile at present—will provide us with a solution to the significance of Saint-Gilles for developments in Romanesque art. One thing is clear, however. This confusion or compromise of styles leads us southward to Italy. It is not a long journey from Saint-Gilles.

ITALY IN THE ELEVENTH AND TWELFTH CENTURIES — A RETURN TO THE GOLDEN AGE

MONTE CASSINO AND ROME

MONTE CASSINO, the cradle of Western monasticism, has had a turbulent history. Only a half-century after its founding by Benedict of Nursia (c. 480–543) on the formidable peak lying between Rome and Naples in Campania, the monastery was destroyed by the Lombards, and the small band of monks fled to Rome. It was razed again in the ninth century by Muslims, and it suffered through the next two centuries of intermittent warfare in south Italy, where three stubborn forces met head-on: the Byzantines, the Normans, and the Ottonians. Yet the Benedictine Order had acquired prestige and a mission by

the eleventh century, and under the leadership of the influential abbot Desiderius (later Pope Victor III), the abbey was gloriously rebuilt based on the architecture of the great basilicas of Early Christian Rome.[53]

Although smaller, the new basilica was planned to duplicate Saint Paul's Outside the Walls, which had become an important Benedictine abbey in Rome. A description of Desiderius's church survives in the *Chronica monasterii Casinensis,* written by Leo of Ostia on the occasion of the consecration in 1071. The general lines of the Early Christian basilica were followed in a simple fashion with a towered atrium, narthex, nave, transept, a raised choir, and a wooden roof (fig. 389).[54] Certain modifications were necessitated by changing liturgical needs: a *schola cantorum* (a rectangular

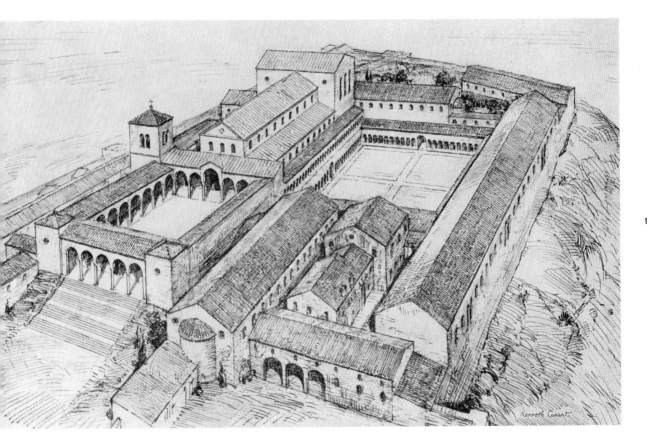

389. Monastery, Monte Cassino. Reconstruction of the New Church of Abbot Desiderius (after Conant). Consecrated 1071

area marked off for reading and singing) was introduced in the nave; a bell tower, or campanile, was added to the facade; and three apses replaced the single projection in the model.

In order to obtain rich building materials, Desiderius had columns and marbles brought in from Rome, and in planning the decorations for the interior, Early Christian models again were followed. But times had changed, and the good abbot was in sore need of competent craftsmen, and these he could recruit from Constantinople. Artisans from Byzantium reintroduced in Monte Cassino techniques for making mosaics and elegant stone furniture. Desiderius also ordered a bronze door from Constantinople as well as a great golden altar frontal decorated with scenes from the New Testament and the life of Saint Benedict. The splendid marble floor in the nave—a revival of the ancient type known as *opus alexandrinum*—was laid out as a giant stone intarsia work of

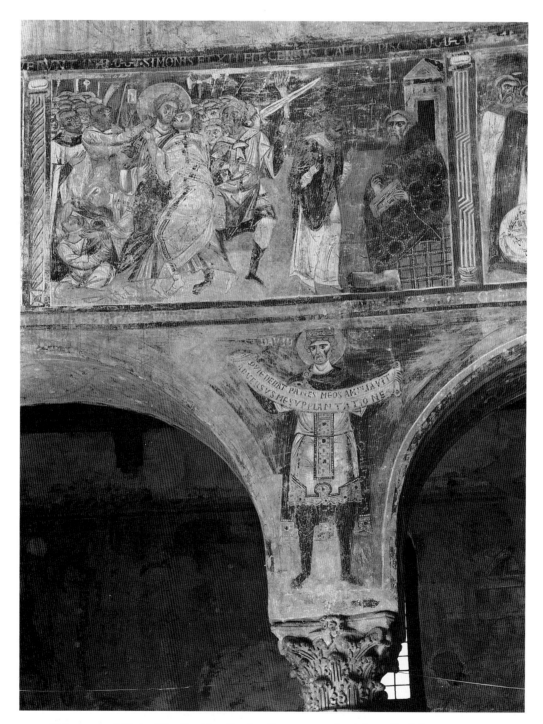

390. *Arrest of Christ; King David as Prophet.* Frescoes on the right wall of the nave arcade in Sant'Angelo in Formis (near Capua). c. 1085

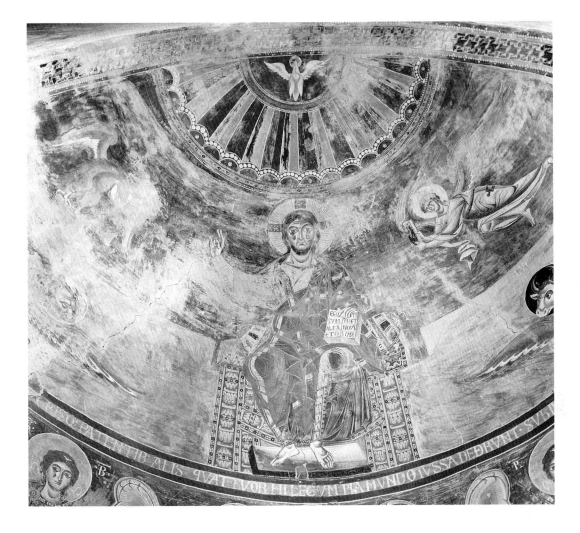

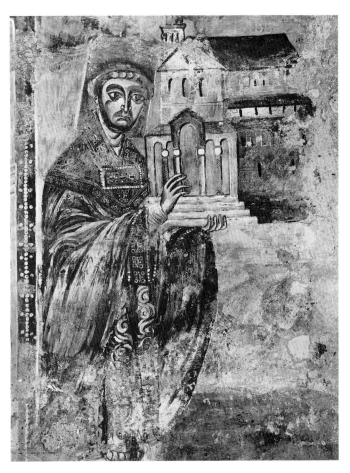

above: 391. *Christ Enthroned*. Detail of apse fresco in
Sant'Angelo in Formis

below: 392. *Desiderius Offering the Church to Christ*.
Fresco on the lower wall of the apse in Sant'Angelo in Formis

multicolored discs and geometric shapes tied together by
guilloches of white marble.[55]

Little remains of Desiderius's church and its furnishings,
but Monte Cassino must have been an influential exemplar,
for, as we have seen, the revival of the Early Christian
basilica form was echoed throughout Europe in the late
eleventh century. The extensive mural decorations in Monte
Cassino are reflected in those of another church built by
Desiderius in 1072, Sant'Angelo in Formis, near Capua (figs.
390–92).[56] Decorating the nave in two registers are painted
stories from the Old and New Testaments. In the apse is a
representation of the One in heaven flanked by the symbols
of the Evangelists. Below, on the wall of the apse, stands
Desiderius as patron, holding the church in his hands. All of
this is painted in fresco and displays something of an eclectic

393. Scenes from the Life of Saint Benedict. Illustration in the *Vita Benedicti.* 14¾ × 10″. 11th century. Vatican Library, Rome (MS lat. 1202, fol. 80r)

cinating for their iconographies, the Exultet Rolls display a wealth of unusual illustrations, including secular subjects such as *Terra* (the earth) and bees that produced the pure wax for the paschal candles.[57]

The elevation of Desiderius to the papacy in 1086 further testifies to the ascendancy of the Benedictines in the broader world of Christendom. In Rome it would seem that his program for the revival of the golden era of Early Christian culture would be quickened by the proximity of the hallowed monuments themselves, but this did not happen at once. These were troubled times in Rome. Since the days of Otto III, Rome had served as the residence of the Holy Roman emperors, and the antagonism between the papacy and the imperium never slackened, culminating in the notorious struggle over investiture (the right of the emperor to appoint the popes) and the excommunication of Henry IV in 1077, nine years before Desiderius moved to Rome. In 1083 Henry besieged the papacy, and the Normans, purportedly called in to protect the pope, sacked the city instead, leaving it in ruin.

394. Terra. Illustration in the Exultet Roll. Width 11⅜″. c. 1075. Vatican Library, Rome (Barberini lat. 592)

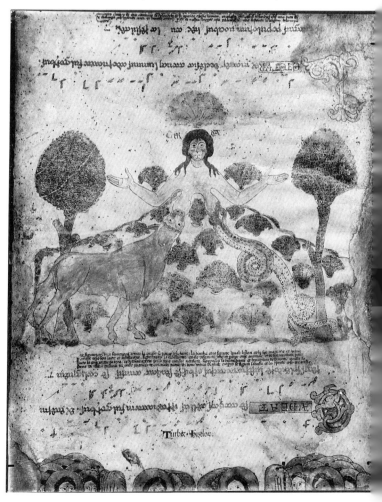

mixture of Byzantine and Latin elements that, in fact, can be called "Benedictine" in style. One distinctive detail that marks the figures is a red dot added to the cheeks of nearly every face.

The illustrated manuscripts produced at Monte Cassino show a similar hybrid style. This is apparent in the graceful illustrations in the *Vita Benedicti* (fig. 393), an eleventh-century manuscript, and in the curious Exultet Rolls (figs. 394, 395) produced at Monte Cassino. Named after their use in the ceremonies blessing the paschal candle on Holy Saturday in Easter (*Exultet iam angelica turba callorum*), these large scrolls are pictures painted upside down in the text so that the congregation could follow them while singing as the deacon unwound the roll downward from the pulpit. Fas-

It is no wonder then that Desiderius's program of recovery was stalled for a time, but under the patronage of later Benedictines in Rome, it was fully initiated in the early years of the twelfth century. A general program of urban development was promoted to restore the grandeur of ancient Rome. Ancient statuary was assembled on the grounds of the Lateran palace, including the famous bronze equestrian portrait of Marcus Aurelius, long identified as Constantine. An updated pilgrims' guide to Rome and its ancient and Medieval monuments was written by one Magister Gregory about 1200 to aid visitors. Enriched with stories of images "whether produced by magic art or human labor," the *Tales of the Marvels of the City of Rome* (*De Mirabilibus Urbis Romae*) is a useful manual today for studying the attractions of the eternal city as it appeared in the twelfth century.[58]

Between 1120 and 1130 the Church of San Clemente was rebuilt over the earlier fourth-century basilica, which remains, in part, as the lower church. It was lavishly decorated and outfitted with a *schola cantorum* set over an elegant floor of *opus alexandrinum,* much as at Monte Cassino (fig. 396).

A colorful mosaic filled the huge apse (colorplate 51). The Early Christian canopy of the heavens appears in the summit; a predella with the mystic lambs moving from diminutive representations of Bethlehem and Jerusalem serves as the base; and the broad surface of the conch is filled with an elaborate vine scroll, reminiscent of the elegant decoration in the apse of the Lateran Baptistry in the fourth century but here "peopled" with curious genre motifs—a woman feeding chickens, a shepherd and slave tending flocks, and others. In the center a Crucifixion grows out of a resplendent acanthus plant, forming a giant Tree of Life.[59] The mosaic execution is rather crude by Byzantine standards, but the treatment of Mary and John, flanking the cross, is comparable to that of the figures in the Desiderian frescoes in Sant'Angelo in Formis.

This same "Benedictine" style can be seen in the slightly earlier frescoes painted on the walls of the lower church, which is the original structure (fig. 397). Legends of Saint Clement and Saint Alexis are presented, with slim, rosy-cheeked figures gracefully lined up across colorful abstract

395. *Gathering of Honey*. Illustration in the Exultet Roll. Width 11⅜". c. 1075. Vatican Library, Rome (Barberini lat. 592)

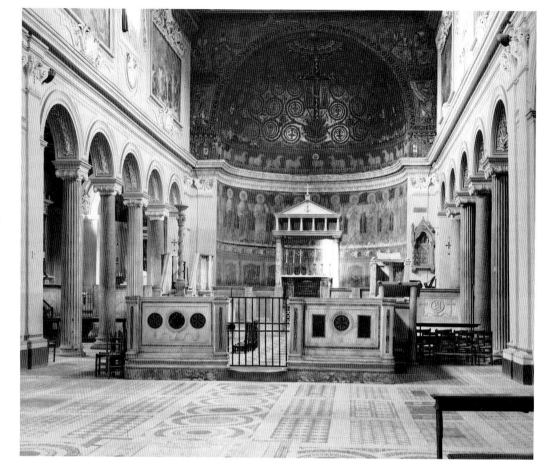

396. San Clemente, Rome.
View of upper church.
c. 1120–28

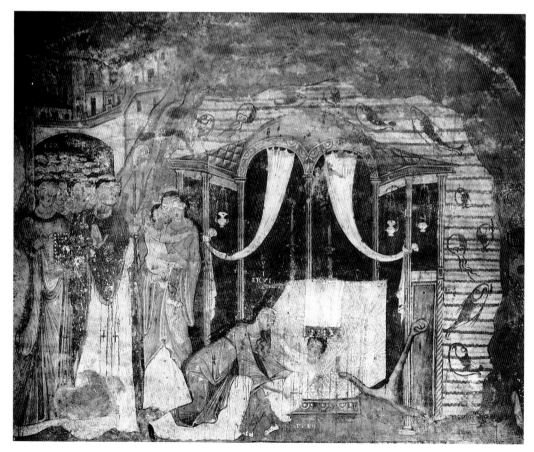

397. *Miracle of the Child.*
Wall fresco in the lower church
of San Clemente, Rome.
Late 11th century

backgrounds. In the *Miracle of the Child,* a pilgrim mother returns to the subterranean burial chapel of Saint Clement to find her lost child still alive after being left there by accident the year before. The sea filled with fishes covering the sunken shrine forms a particularly charming border.[60]

The Church of Santa Maria in Trastevere (partly rebuilt in the nineteenth century) was raised over the remains of Early Christian and Carolingian structures about 1120–30. The impressive nave with a colonnade of Ionic columns, mostly *spolia,* terminates in a gigantic apse (figs. 398, 399; color-plate 52).[61] As at San Clemente, the apse is decorated with an unusual mosaic representation that at first seems to be a combination of Early Christian and later themes. Beneath the canopy of the heavens and the Hand of God and above the familiar predella of the lambs, the Virgin and Christ appear enthroned together (he has his arm about her shoulders) between ecclesiastical saints and the benefactor, Pope Inno-

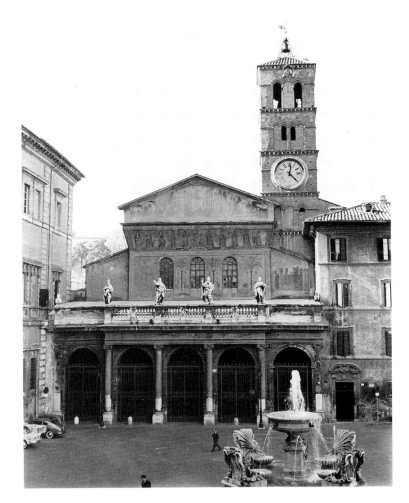

right: 398. Santa Maria in Trastevere, Rome. Facade. c. 1120–30; restored in the 19th century

below: 399. ANTONIO SARTI. *Santa Maria in Trastevere, Rome.* Engraving. 1825. Biblioteca Hertziana, Rome

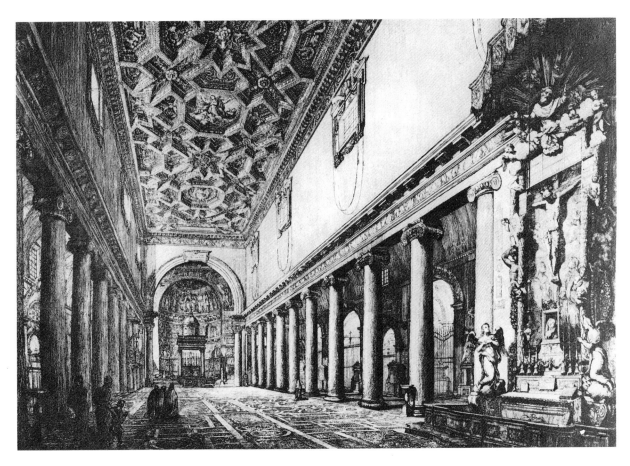

cent II (1130–43), all standing in rigid frontal positions. Sometimes referred to as one of the earliest representations of the Coronation of the Virgin, the curious central group should also be considered an image of the *Triumph of Maria Ecclesia* in the context of Early Christian art, for here the Virgin appears in the guise of the *Maria Regina* found in Early Christian churches dedicated to her (cf. fig. 64). The trecento mosaics (1291) by Pietro Cavallini beneath this monumental apse will be discussed later.

A number of other Early Christian and Carolingian churches in Rome were rebuilt or restored during these years. The handsome interior of Santa Maria in Cosmedin (fig. 401) preserves its twelfth-century *schola cantorum* and elegant "Cosmati" floor (named after the famous Cosma family of marble workers active in Rome in the twelfth and thirteenth centuries),[62] but most of the exterior (fig. 400) has been poorly restored in recent years, including the handsome Romanesque campanile. At this time, too, the Carolingian Church of Santa Maria Nova in the Forum (now Santa Francesca Romana) was enlarged and restored with its copy of an Early Christian apse mosaic, the *Maria Regina* (fig. 65).

TUSCANY

Desiderius had been a better abbot than a pope, and soon after he reluctantly donned the red cope in May 1086, he was deposed by the imperial "antipope," Clement III. To his rescue came Matilda of Canossa (1046–1114), countess of Tuscany, the leading aristocratic sponsor of the papacy in

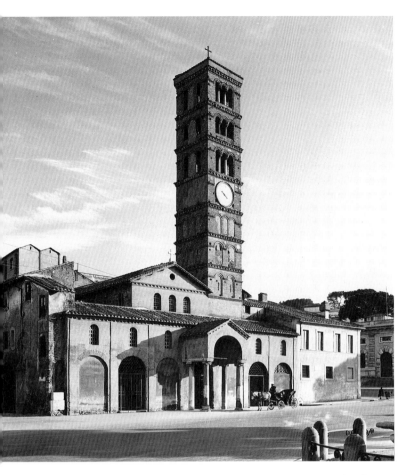

above: 400. Santa Maria in Cosmedin, Rome. West facade. 12th century (restored)

below: 401. Santa Maria in Cosmedin, Rome. Interior

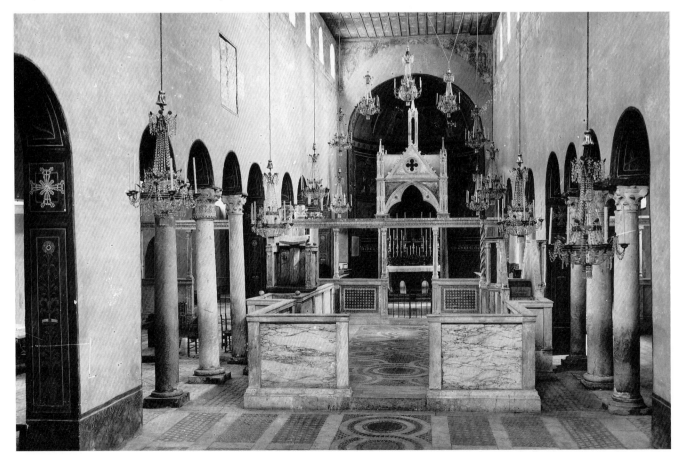

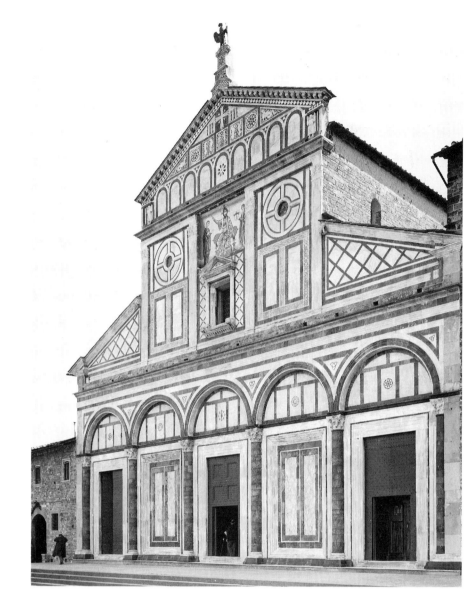

right: 402. San Miniato al Monte,
Florence. Facade. 1062–1150

below: 403. San Miniato al Monte.
Interior

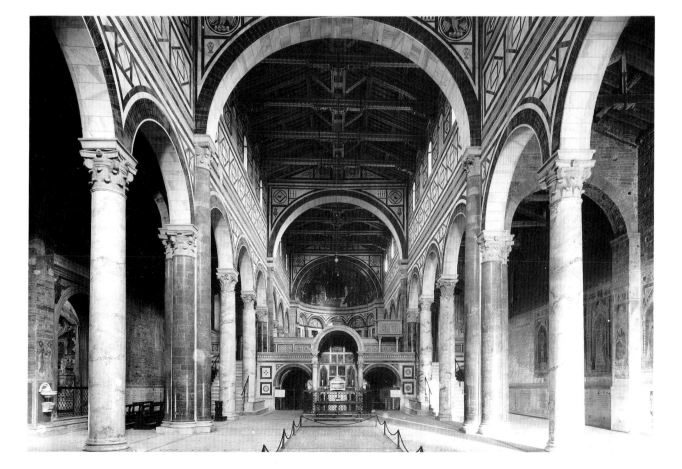

North Italy. From the time of the war over investiture between Pope Gregory VII and Henry IV in 1076, Matilda had been the protector of the pope, and in her will she bequeathed all of her domains to the Roman church. Matilda had been the wife of Duke Welf of Bavaria, and from this alliance a lasting rivalry in Medieval history descends. Lords of the house of Welf (Guelph in Italian) were initially supporters and sponsors of the papacy; the imperial leaders of the Holy Roman Empire were backed by the aristocratic Hohenstaufens of Swabia, their title Waiblingen (Ghibelline in Italian) coming from their ancestral castle in Franconia.

From the days of Matilda, the rival city-state powers in North Italy allied themselves with either the Guelph or the Ghibelline factions (the terms were not actually used in this

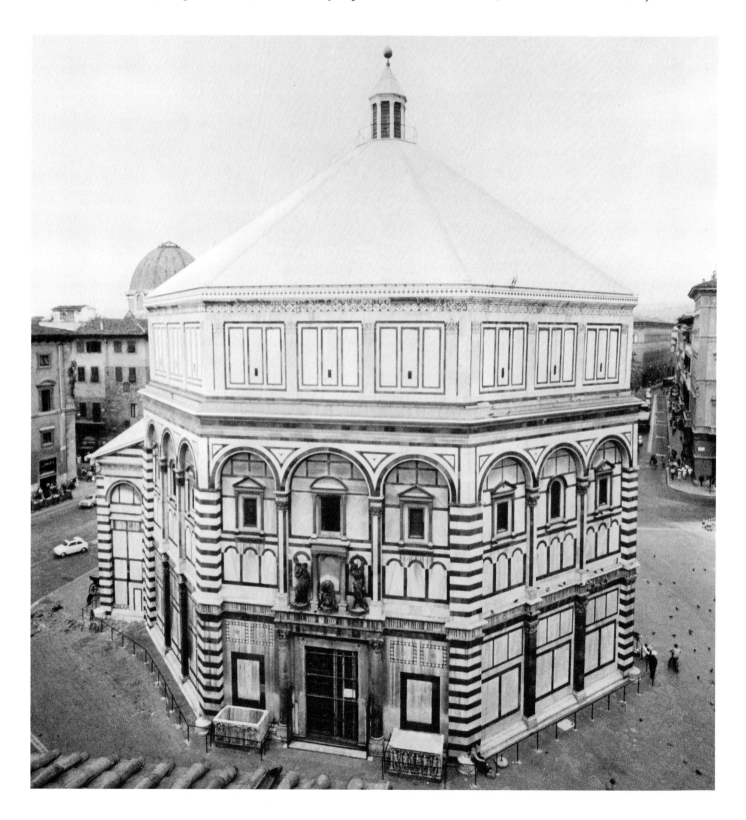

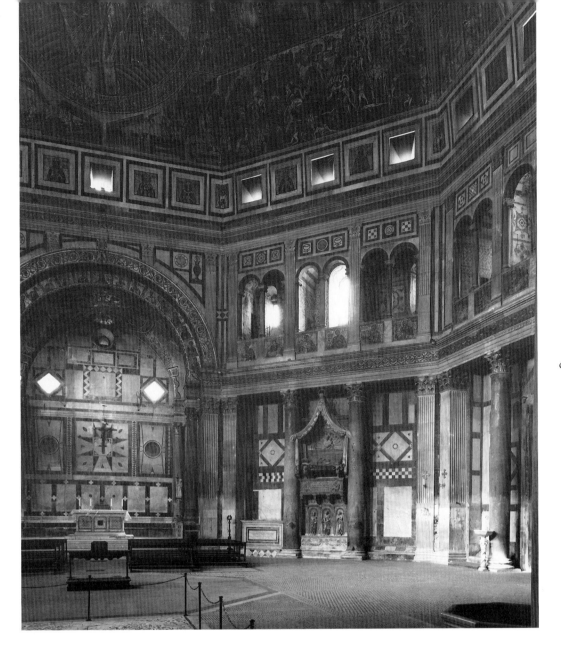

context until the early thirteenth century): Florence, Guelph, versus Siena, Ghibelline; Lucca versus Pisa; Milan versus Pavia; etc. In reality, it was the commercial rivalries between the independent city-states that set the tempo for cultural expression and exchange, and among these re-publics, two emerged as leaders in Tuscany during the Ro-manesque period: Florence (Guelph) and Pisa (Ghibelline).

One rarely thinks of Florence as anything but the capital of Italian Renaissance art, but it had a glorious flowering already in the Middle Ages. One of the richest Benedictine abbeys in Tuscany was San Miniato al Monte, situated high above the spectacular skyline of the central city (figs. 402, 403). Although much restored, San Miniato (begun by 1062) is captivating in its simplicity and purity of design. The Early Christian basilica provided the basic model; the building is a simple rectangular box, and the front is a gabled facade immaculately sheathed with large white marble panels divided into elegant geometric shapes by dark green bandings that roughly correspond to the divisions of the interior.[63] With its handsome facade circumscribed by a

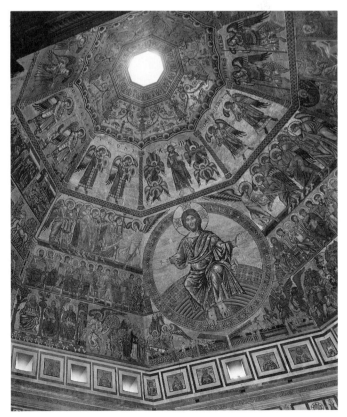

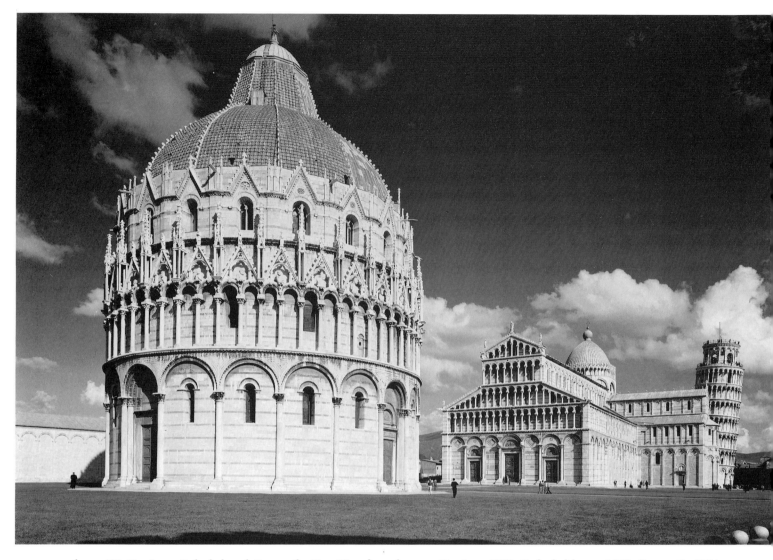

above: 407. Baptistry, Cathedral, and Campanile, Pisa. View from the west. Baptistry 1153; Cathedral begun 1063; Campanile 1174

opposite above: 408. Cathedral, Pisa. Plan

opposite below: 409. Cathedral, Pisa. Interior

large square with triangular and rectangular subdivisions traced in orderly fashion across it, San Miniato is a study in abstract design, the clarity of which seems to anticipate the refreshing logic of later Florentine art. The interior, too, is like a study in perspective, with the pristine marble revetment articulated by the straight lines formed by the darker bandings. There is nothing complicated about its plan or structure. The tripartite elevation extends in three well-marked bays formed by two piers separated by three arches. The roof is wooden.

The more famous Baptistry in Florence, San Giovanni (figs. 404–406), has foundations that go back at least to the fourth century (perhaps those of a Roman bath?). The present structure, also much restored, was dedicated by Pope Nicholas II in 1059. The simple octagonal building features the same superb revetment of white marble panels and dark green banding as are on San Miniato. The interior has the dignity of ancient Roman sanctuaries; indeed, it has been compared to the Pantheon or, as one scholar put it, "a Roman stone aqueduct bent around eight angles."[64] The attic and Italo-Byzantine mosaics above were added in the thirteenth and early fourteenth centuries (Venetian craftsmen were called in). San Giovanni boasts many riches, including its three sets of bronze doors, but it is the beauty and clarity of the Romanesque octahedron rising majestically in the piazza that we first remember.

Pisa was the major rival of Florence for leadership in Tuscany, but it was foremost a seaport, and after a decisive naval victory at Palermo in 1062, the Pisan fleets reigned as masters of the Mediterranean. With pride and prosperity

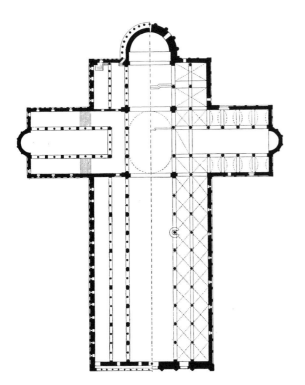

came aspirations for glory, and it was in the year following the victory over the Sicilians that the Pisans began the huge complex of buildings that remains today one of the most impressive Medieval sites in Italy with the huge baptistry, handsome cathedral, leaning tower or campanile, and large rectangular Campo Santo (figs. 407–409).[65] The simple volumetric structures of Tuscan architecture are found here in the form of cylinders and gabled boxes, but in place of the delicately articulated bandings and geometric veneers and inlays of Florentine structures are handsome colonnaded galleries stacked in tiers. The facade of the Cathedral is a wall of blind colonnades rising in five distinct stories; the Campanile "may be said to have been designed by rolling up the west front of the cathedral"; the Baptistry, its upper stories transformed into Gothic niches by later architects, is twice the diameter of the Campanile. How emphatically the complex of simple geometric forms—baptistry, church, campanile—is presented.

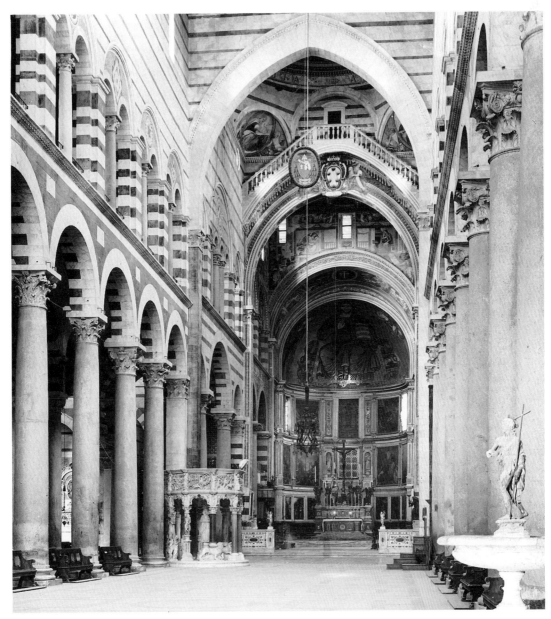

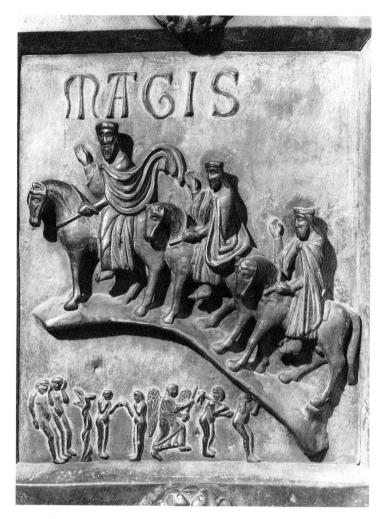

410. BONANNO PISANO. *The Three Magi*. Detail of the doors of the Porta San Raniero, Cathedral, Pisa. Bronze, height of doors 15′2″. c. 1180

The Cathedral is huge, rivaling in scale the great basilicas of Rome. Begun in 1063 by the Greek architect Busketos (Boschetto in Italian), it has a seemingly simple *T*-shaped ground plan which is deceptive. A great elliptical dome rises over the crossing, and the projecting transept arms are, in fact, two independent basilicas facing each other. The nave has double aisles that continue around the arms and into a rectangular choir, which is terminated by a simple apse. The interior has a continuous arcade carried on granite columns with Corinthian capitals and a handsome gallery featuring the distinctive Pisan "zebra" banded work, so familiar in later Tuscan architecture. The roof of the nave is wooden; the side aisles are groin vaulted.

The Baptistry, begun in 1153, is ninety-eight feet in diameter and is capped by a truncated cone roof (the present dome covering it was added later). The famous Campanile was started in 1174 by Bonanno Pisano, and it had already begun to sink on the southern side by the completion of the

first stage (thirty-five feet in height). Subsequent stories were accommodated for the unusual tilt. By the time of its completion in 1350, the Campanile was nine inches off axis; today it leans some thirteen feet from its foundations.

Bonanno Pisano also designed the bronze doors for the Cathedral. Only those for the Porta San Raniero survive (fig. 410). Indebted in part to the techniques of German casters, Bonanno's doors are schematic and a bit monotonous with twenty narrative episodes from the New Testament framed by ropelike colonnettes and bands of rosettes. The individual scenes are simple in design, with all aspects of the narratives reduced to essentials. Raised *tituli* briefly identify the stories. Bonanno executed a similar set of doors for Monreale Cathedral in 1186, which he signed.[66]

A sculptor, Guglielmo, much honored in Pisa, executed a marble pulpit for the Cathedral (now in the Cathedral of

411. GUGLIELMO. Pulpit for Pisa Cathedral. Marble. 1159–62. Cathedral of Cagliari

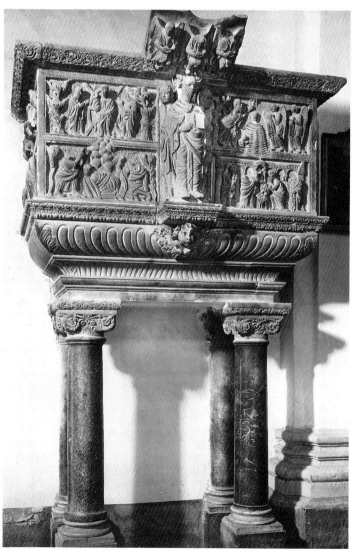

Cagliari) between 1159 and 1162 (fig. 411). Resting atop four columns, it is in the form of a rectangular box whose sides are divided in two registers with reliefs of the life of Christ on either side of standing figures supporting a lectern. The design is surprisingly static in conception, with stocky figures in ponderous mantles packed into the scenes in the fashion of Early Christian sarcophagus friezes, which may well have been the inspiration behind them. Guglielmo's pulpit, however, established a tradition in Tuscany that we shall return to. His pulpit was replaced by one executed by Giovanni Pisano in the late thirteenth century.

LOMBARDY

North of Tuscany, the broad expanse of Italy known as Lombardy has a rich history, but it is difficult to assess its contribution to art history. As noted earlier, Lombard masons are credited with introducing vaulting in "first" Romanesque churches, but the lines of development in the arts in general are obscured because of the precarious history of the region. The venerable Early Christian basilica of

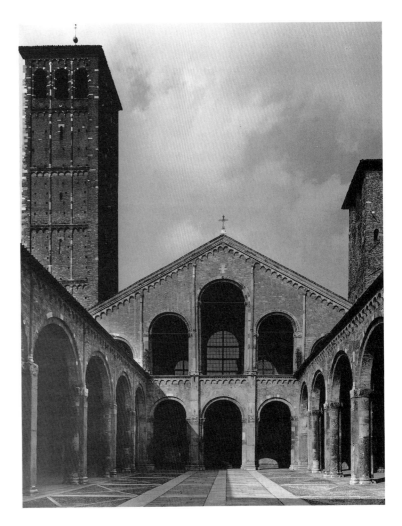

right: 412. Sant'Ambrogio, Milan. View of facade and atrium. 11th and 12th century

below: 413. Sant'Ambrogio, Milan. Interior. Vaulted after 1117

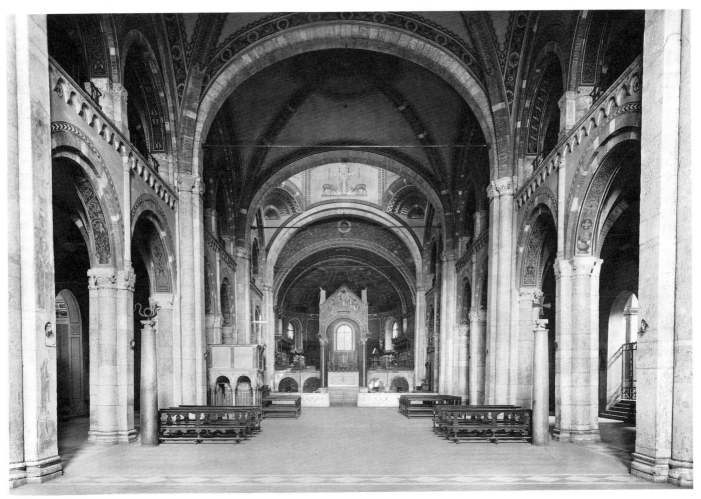

Sant'Ambrogio in Milan (see Part I, chapter IV) has often been cited as the first church to be covered with ribbed vaulting in the eleventh century, but now it is believed by most scholars that the Romanesque rebuilding took place after a devastating earthquake in 1117 (figs. 412, 413).[67] Whatever the story, the interior of Sant'Ambrogio today displays a sophisticated system of construction with heavy ribs applied to three domed-up bays resting on huge articulated piers. The side aisles, low with heavy walls, have ribbed groin vaults, and the general impression of Sant'Ambrogio is one of a heavy, earthbound structure. There is no clerestory. Although Sant'Ambrogio is wider than Cluny III, its vaults are forty feet lower.

The austere front of the narthex conceals the facade of the church, a broad gable in two stories with two flanking towers (actually campaniles) set back. Pilaster strips divide the two stories of the facade into five bands with arched openings that rise to the pitch of the gable. A spacious atrium with vaulted corridors and heavy unadorned walls dominates the exterior. Five great blind arches establish a severe rhythm across the entrance.

The austere gable facade of Sant'Ambrogio became the model for numerous churches in North Italy, and various attempts to relieve its severity can be noted. At San Michele in Pavia (fig. 414) a stepped arcaded gallery follows the pitch of the gable, and strange strips of relief sculpture are applied to the wall above the modest doorways. At the Cathedral of Modena (fig. 415), further south in the province of Emilia, the stepped gable was reintroduced with marked divisions in the facade corresponding roughly to the interior disposition of the building. Blocks of sculptural friezes are here more harmoniously integrated into the divisions of the facade. A

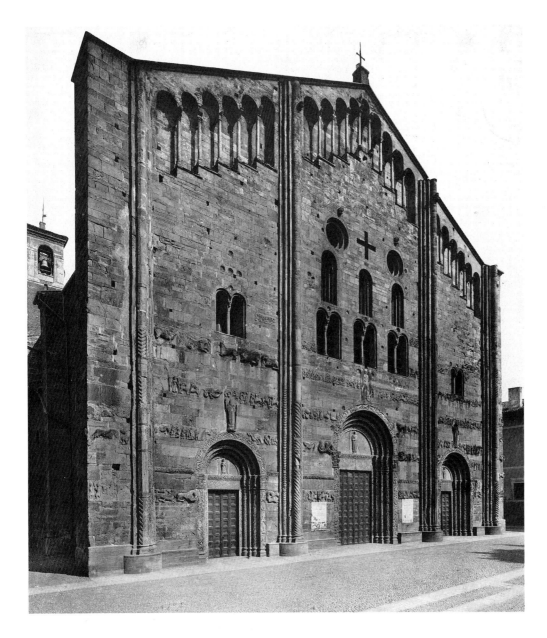

414. San Michele, Pavia. West facade. 12th century

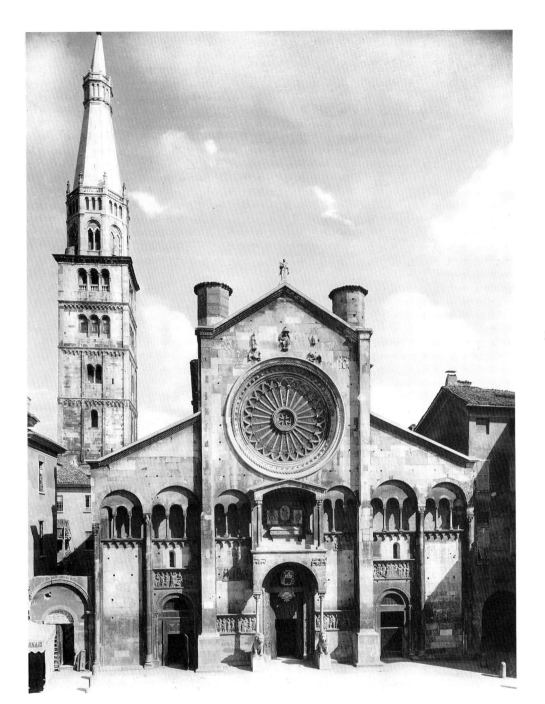

left: 415. Cathedral, Modena.
West facade. 1099–1120

below: 416. Wiligelmo.
Scenes from Genesis.
Frieze on the west facade
of Modena Cathedral.
Stone, height approx. 36″.
1106–20

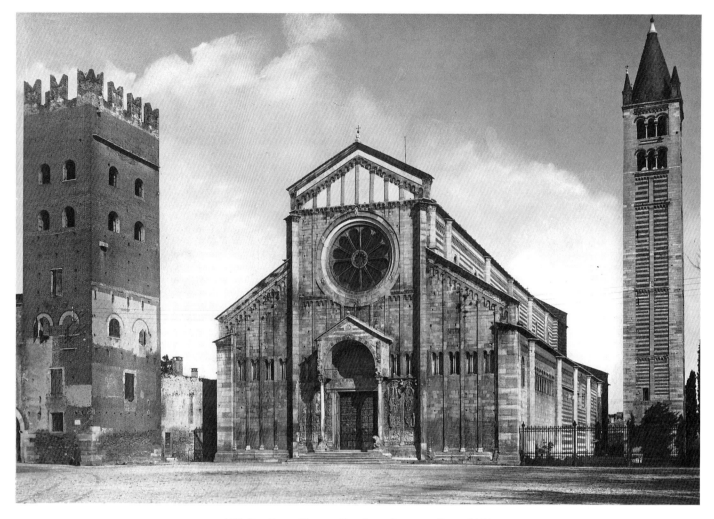

417. San Zeno, Verona. Facade and campanile. c. 1138

small but handsome porch with columns resting on the backs of carved lions projects from the central entrance.

The sculptor who executed the reliefs on the west facade at Modena (1106–20?) was one Wiligelmo, perhaps of German origin, who boastfully inscribed one plaque: "Among sculptors, your work shines forth, Wiligelmo."[68] Indeed, Wiligelmo has been lauded in recent scholarship as a leader in the introduction of stone sculpture on exteriors of Italian Romanesque churches. In areas comparable to the jambs are vertical moldings with "peopled" vine scrolls and prophets standing in niches, and in four high friezes above the side portals and flanking the projecting porch, stately narratives from the Creation to the Flood in Genesis appear beneath a decorative arcade (fig. 416). The figures of Wiligelmo remind us of the stocky forms found in later Pisan sculptures, but here they are even more ponderous in proportions and stilted in action. Often regarded as revivals of ancient Roman relief sculptures, the friezes of Wiligelmo seem more indebted to Ottonian models and the traditions of narration in Medieval manuscripts than to any specific Classical sources.

It is clear that the dynamic linearism of mature French Romanesque sculpture had made little impact in Italy.

Wiligelmo trained a large workshop. The sculptures of one of his more prolific followers, Master Nicolo, appear in numerous Emilian churches, including the facade reliefs on San Zeno in Verona (figs. 417–19), executed about 1138.[69] Of special interest is the decoration of the doors of this church (figs. 420, 421). In the tradition of Early Christian wooden doors (for example, Santa Sabina, p. 91), Old and New Testament scenes are disposed in square compositions on the two valves of the doorway.[70] And in keeping with the practice of the Byzantine doorways in South Italy, each composition is on a separate plate of bronze. But these are cast, and both in technique and style the individual plates clearly owe a debt to Ottonian bronze workers.

Two styles are discernible. The earlier plates, the twenty-four New Testament scenes (except one) on the left wing, have been dated to about 1100; the later panels, Old Testament scenes and the life of Saint Zeno on the right door, belong to the late twelfth century. Very likely, the bronze

doors of San Zeno were reconstituted from an earlier set, at which time the later plates were added. It is interesting to compare the earlier work with the famous cast doors at Hildesheim (figs. 290, 291), since it seems likely that a German-trained artist was active at San Zeno. An obvious deficiency in skill and technique in the New Testament series is apparent in the summary treatment of the figures, the crudity of the composition, and the rather haphazard assembly of the plates in general. Yet there is a certain naive charm, perhaps intended, in many of the earlier plates. In the Dance of Salome at the banquet of Herod, the lumpish figures behind the table witness an energetic young girl turn a backflip like a fish rising from water (see lower left panel, fig. 421).

The culmination of Lombard traditions in sculpture appears in the sophisticated works of Benedetto Antelami, active about 1160–1200.[71] His relief of the *Deposition* for the pulpit of Parma Cathedral, dated 1178 (fig. 422), displays a surprising elegance. Aligned in rows on either side of the cross are numerous figures present at the Crucifixion. The tormentors, including those dividing the cloak, appear to the right, while the male and female mourners are lined up in a row to the left, apparently to fill out the broad slab, each with his or her name inscribed. The figures are taller and more graceful, the heavy-jawed heads are more naturalistic and detailed than in earlier Lombard sculpture, but there are few indications of any emotional responses other than downcast eyes. The shallow draperies are rendered with a delicate

418. San Zeno, Verona.
Porch

419. MASTER NICOLO. Scenes from Genesis. Right portal of the Church of San Zeno, Verona

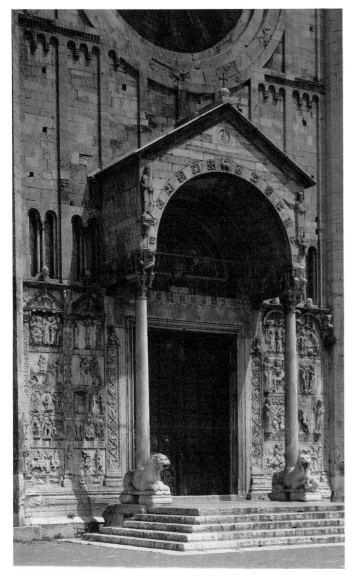

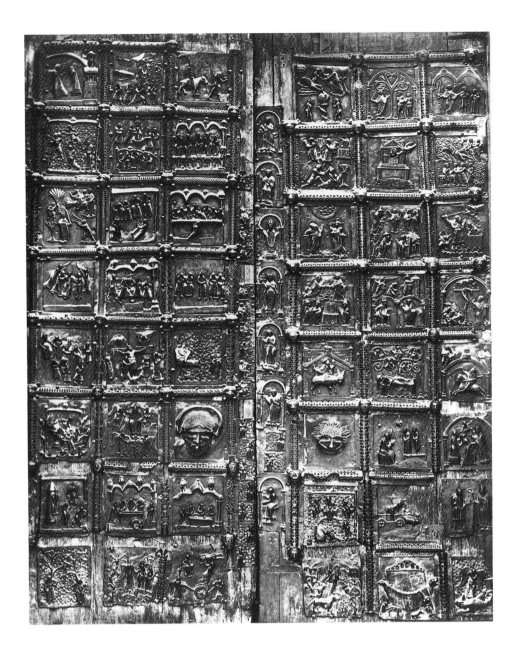

above: 420. San Zeno, Verona. Bronze doors. c. 1100;
late 12th century

left: 421. San Zeno, Verona. Bronze doors. Detail of fig. 420

line and a keen sense of subtle patterning reminiscent of French Romanesque sculpture. A special touch of Antelami is the black *niello* inlay for the scroll patterns that forms the elegant border.

In 1196 Antelami designed and decorated the great Baptistry in Parma (fig. 423). Handsome and imposing, the structure curiously seems neither wholly Medieval nor wholly Antique, although Antelami has sometimes been characterized as a proto-Renaissance artist. In fact, the sculptures he executed for the tympana of the Baptistry and the freestanding prophets carved for the Duomo at Borgo San Donnino (fig. 424) remind us of those at Saint-Gilles-du-Gard (fig. 387), which have also been described as proto-Renaissance.

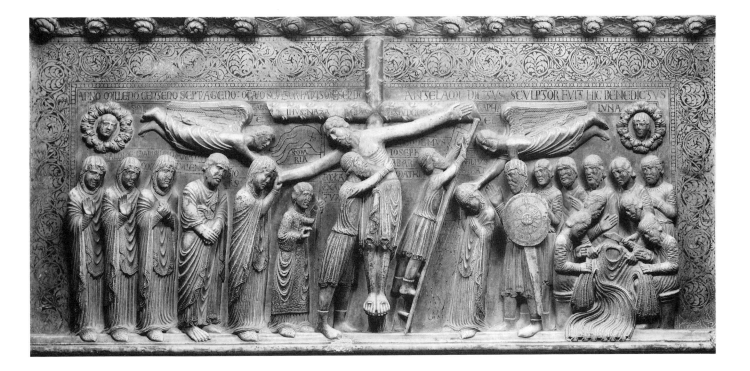

above: 422. BENEDETTO ANTELAMI. *Deposition.* Marble relief on the pulpit. 1178. Cathedral, Parma

left: 423. BENEDETTO ANTELAMI. Baptistry, Parma. 1196

below: 424. BENEDETTO ANTELAMI. *David.* Marble. c. 1190. West facade of the Cathedral, Borgo San Donnino (Fidenza)

WESTERN GERMANY

THE ARTISTIC traditions of the Holy Roman Empire formulated in Carolingian and Ottonian times persisted under the Franconian and Hohenstaufen rulers of Germany during the eleventh and twelfth centuries. The innovations in French Romanesque, namely, the elaboration of the pilgrimage choir and the ambitious sculpture programs on the exteriors of churches, are rarely encountered in western Germany, and, in general, the major foreign influences found there seem to stem from Lombardy (which was also part of the empire).

The *Kaiserdom,* or Imperial Cathedral, at Speyer (figs. 425, 426), the largest of the three major foundations along the Rhine River (Mainz and Worms are the others), is a powerful statement of imperial authority.[72] The foundations of the west front, the aisles, and the vaulted crypt preserve those features of the original structure consecrated in 1061, but much of the present church was built after 1080 by Henry IV following his "victories" over Pope Gregory VII and his political rival in the North, Rudolf of Swabia. Speyer stands as a mighty symbol of Henry's supremacy.

In the second building campaign, the apse and the transept arms were refashioned, and the nave was accommodated for stone vaulting in square bays by the addition of engaged colonnettes (or responds) to every other pier, thus creating an alternating system. The domed-up groin vaults (unribbed originally), soaring 107 feet from the floor, were added after 1106, presumably by North Italian masons (much of the nave was restored in the nineteenth century). On the exterior, "dwarf" Lombard galleries were added just below the eaves all around the church, a handsome feature that was repeated in numerous German churches. While simple in plan and conservative in structure, Speyer—435 feet long with 6 lofty towers dominating the exterior—is an imposing, grand monument in Latin Christendom.

Founded in 1093, the Benedictine Abbey of Maria Laach (colorplate 53), beautifully situated in the woods of the Laacher See above the Rhine, serves as an attractive example of this conservative strain in monastic architecture. Here the clustered geometric volumes repeat the traditional "double-ender" features of Ottonian churches (cf. Saint Michael, Hildesheim, fig. 285). The exterior is further enhanced by the Lombard corbel tables and pilaster strips of black stone. The rectangular groin vaults in the nave—the alternating system was not introduced here—were added in the thirteenth century, as was the impressive "Paradise" (open court) or atrium.

Whether due to conservative tastes or disconcern for elaborate figurative sculpture in general, the architectural

decorations of these German churches are limited mostly to purely ornamental additions such as the Lombard corbel tables. Works in sculpture are found, however, but these take the form of individual pieces placed in the interior or apart from the actual structure. One of the earliest freestanding sculptures on a monumental scale is the great Brunswick Lion (fig. 427), cast in bronze and gilded, that stood before the palace of Duke Henry the Lion of Saxony at Dankwarderode. The huge lion, dated 1166, is an imposing emblem of Henry's Welf (Guelph) family, but in form it resembles simply an enlarged lion aquamanile (an ornamental pitcher for washing hands at the altar; see fig. 428) with its stylized mane of rhythmic tufts and polished torso.

For the Cathedral at Brunswick, built by Henry the Lion between 1173 and 1195, the sculptor Imervard executed a large wooden Crucifix (fig. 429) about 1173 that copies a famous type with the frontal Christ, eyes open and sheathed in a massive, long-sleeved, belted tunic or *colobium,* that was

venerated as the *Volto Santo* in Lucca. According to legend, the original was carved by Nicodemus, a disciple of Christ, and brought to Italy in the eighth century (the present *Volto Santo* in Lucca is a replacement of the original and dates later[?] than the one in Brunswick).[73] This famous pilgrimage attraction has a complex background, but essentially its unusual iconography is derived from an Early Christian type for Christ on the cross in monumental form (cf. the Rabbula Gospels, fig. 102). Another cult statue, the frontal *Virgin and Child* from Paderborn (fig. 430), displays the harsh, iconic style of earlier Ottonian examples (cf. fig. 299) and serves as an interesting contrast to the more elaborate French Romanesque types such as that from Auvergne discussed earlier (colorplate 50).

It is in small metal sculptures for liturgical objects, reliquaries, and altarpieces that German craftsmen truly excelled. The traditions of metalwork and casting were, it will be remembered, well established in Germanic lands from

opposite: 425. Cathedral, Speyer. Interior after vaulting in 1106. Lithograph (made before 19th-century restorations)

right: 426. Cathedral, Speyer. Exterior. 1030–61; c. 1080

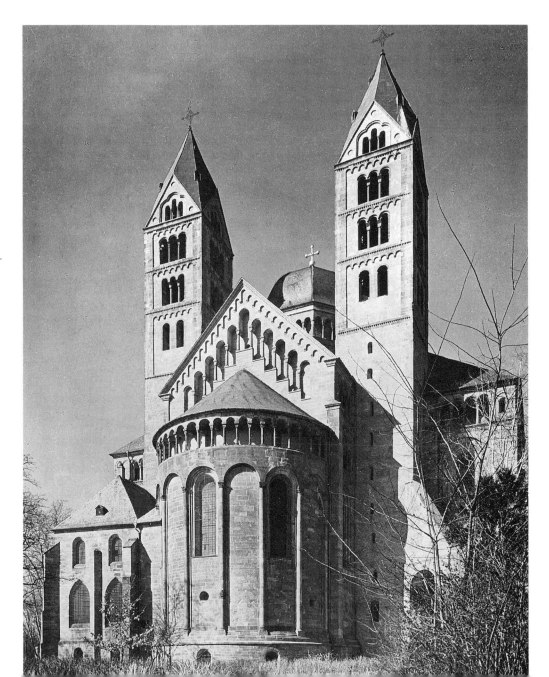

above left: 427. Lion Monument. Bronze, length 6'. 1166.
Cathedral Square, Brunswick

above right: 428. Aquamanile. Gilt bronze, height 7¼". c. 1130.
Victoria and Albert Museum, London

right: 429. Imervard. *Volto Santo.* Wood, height approx. 7'.
c. 1173. Cathedral, Brunswick

earliest times, especially in the Rhine and Meuse river valleys. An important manual on the techniques of painting, glassworking, and metalwork, *De diversis artibus,* written by one Theophilus about 1100, gives us a number of insights into the more practical aspects of the training of the Medieval craftsmen and the organization of their shops.[74]

It is clear that the author was aware of the importance of Greek (Byzantine) and Italian techniques as well as those of Northern craftsmen. The lengthy discussion of bronze-casting and goldsmith work suggests that the compiler was primarily a metalworker, and, indeed, he has been identified as an important goldsmith, Roger of Helmarshausen (Lower Saxony), to whom is attributed the handsome portable altar from the Abbey of Abdinghof (now in the Franciscan Church in Paderborn; fig. 431), executed about 1100. The sides are decorated in bronze-gilt openwork with fast-paced narratives of the lives of the patron saints of Abdinghof—Felix, Blaise, and Peter—and an unidentified martyr (Saint Paul?). The thinness and angularity of the vibrant figures are clearly Northern features, but the repeated drapery patterns, the so-called nested *V*-folds, are recognizable as Byzantine conventions pressed and interlocked across the costumes in a flat manner perhaps inspired by illustrations in German Romanesque manuscripts.

The leading centers for such sumptuary arts were located in the valleys of the Meuse (Maas) River.[75] In addition to the excellence of craftsmanship in many of these small Mosan works, as they are called, the sophistication in terms of complex subject matter is striking, particularly in the typologies of Old and New Testament narratives. Rainer of Huy, active in Liège, is one of the earliest and most impres-

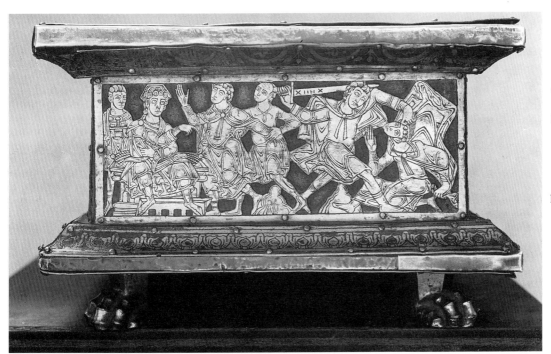

above: 430. *Virgin and Child.* Wood, height 3′9″. c. 1060. Diözesanmuseum, Paderborn

left: 431. ROGER OF HELMARSHAUSEN. *Martyrdom of Saint Paul*(?). Portable altar from Abdinghof Abbey. Silver, copper, and bronze, gilded, over wood, height 4½″. c. 1100. Franciscan Church, Paderborn

432. RAINER OF HUY. Baptismal font for Notre-Dame-des-Fonts, Liège. Bronze, height 23½"; diam. 31½". 1118. Saint-Barthélemy, Liège

encloses two smaller Byzantine reliquary triptychs containing, among other relics, a piece of the True Cross. Thought to have been commissioned by Abbot Wibald of Stavelot (an imperial Benedictine abbey near Liège) sometime shortly after his return from Constantinople in 1155–56, the Morgan triptych is an instructive piece to study as the meeting ground for Eastern and Western traditions in the sumptuary arts.[77] The smaller Byzantine reliquaries—gifts of the emperor Manuel I—are executed in the *cloisonné* technique in typical Middle Byzantine style.

The wings of the triptych are richly embellished with a series of *champlevé* enamel roundels, three on each side, set within elegant silver columns. These illustrate events from the legend of the True Cross. On the left the story of Constantine's conversion appears—his dream on the eve of battle with Maxentius, the defeat of Maxentius, and Constantine's baptism by Pope Sylvester in Rome—and on the right three episodes illustrate the miraculous recovery of the True Cross in Jerusalem by Constantine's mother, Helena. The style of the diminutive figures is dainty and bright, with the flesh parts of their bodies and the background in gilt, the costumes and settings in green, red, and blue enamel with white added for modeling effects. Unlike the iconic Byzantine enamels in *cloisonné,* those in *champlevé* resemble sparkling miniatures, and, indeed, the iconography of the six episodes conforms to Latin or Western narrative traditions.

About this time Abbot Suger of Saint Denis requested

sive of these Mosan artists.[76] His baptismal font (fig. 432), originally for the Church of Notre-Dame-des-Fonts (now in Saint-Barthélemy in Liège), completed in 1118, is especially interesting for its style. Serene figures, nearly three-dimensionally conceived, are placed gracefully in a sequence of five scenes divided by symbolic trees of paradise about a heavy bronze basin.

The Baptism of Christ is the major representation. The softly modeled figures, their draperies falling in long, lyrical folds, are naturally proportioned and elegantly posed. There is something distinctly Classical in the treatment of Rainer's quiet figures placed against the plain background. The font, cast in one piece, rests atop twelve (now ten) oxen cast in half-length. The inspiration for this remarkable font was surely the "molten sea . . . on twelve oxen" cast in bronze for the court of the Temple of Solomon (1 Kings 7:23–25), an Old Testament type for the Baptism of Christ (the twelve oxen were likened to the apostles) found in some learned treatises of the period (cf. Rupert of Deutz, *De Trinitate,* 1117).

The serene classicism of Rainer's font is not the most distinguishing feature of Mosan metalwork, however. The Stavelot triptych in the Pierpoint Morgan Library (colorplate 54) glitters with gems, silver pearls, and colorful *cloisonné* and *champlevé* enamels within the copper-gilt frame that

433. Base of the *Cross of Saint-Bertin.* Bronze and enamel, height 12⅛". c. 1150–60. Saint-Bertin Museum, Saint-Omer

434. NICHOLAS OF VERDUN. Altarpiece. Gold and enamel, height approx. 28″. 1181. Stiftsmuseum, Klosterneuberg
(originally the pulpit of the Benedictine Abbey in Klosterneuburg near Vienna)

435. *Flight into Egypt.* Detail of fig. 434

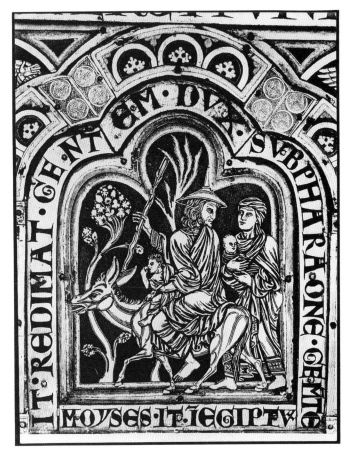

enamelers from the Mosan area to execute works for his new Gothic church on the outskirts of Paris (see Part V, p. 350 ff.), including a sumptuous altar Crucifix which had an elaborate base decorated with no fewer than sixty-eight figured scenes in enamel with Old and New Testament events juxtaposed. Suger's Crucifix is known today only from his own description of it, but the base of a Mosan work, dating about 1150–60, that must have been much like it, is preserved in the Museum at Saint-Omer (fig. 433).[78] The base with its typological enamels is supported by cast statuettes of the seated Evangelists in lively poses writing down their accounts. While the iconography of the enamels anticipates the more complex subject matter of the Gothic artists, the style of the cast figures of the Evangelists on the Saint-Omer base also announces new developments that will culminate in the Gothic sculpture in the Ile-de-France in the graceful poses, natural proportions, and softly modeled draperies.

The pivotal figure in this so-called transitional phase between Late Romanesque and Early Gothic is Nicholas of Verdun.[79] While the characterization "transitional" hardly seems appropriate for the accomplished style of Nicholas, there are features of his art that do anticipate developments in French Gothic. The elegant Classical figure style (already present in Rainer of Huy's font), with the assimilation of

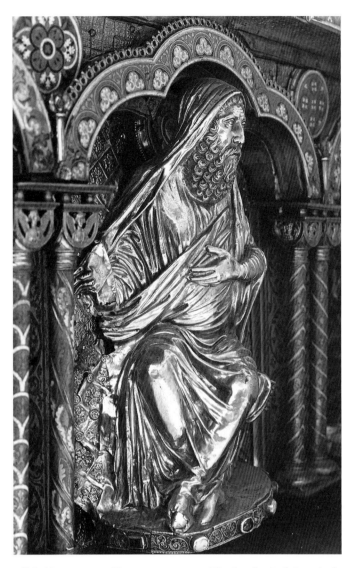

436. NICHOLAS OF VERDUN AND SHOP. *The Prophet Joel.* Detail of colorplate 55

sub lege, or under the law of Moses (following the handing over of the Tablets of the Law on Mount Sinai), is placed below. For the Last Supper, for instance, the Meeting of Abraham and Melchizedek (Gen. 14:18) appears above, the Gathering of Manna (Exo. 16:15) is placed below.

Such a complex iconographic scheme suggests that learned churchmen advised Nicholas in his project. In fact, the ambitious program of the Klosterneuburg altar presents a standard sequence of Old and New Testament parallels that we find in the more familiar Gothic typologies described in the *Biblia Pauperum* and the *Speculum Humanae Salvationis,* two important manuals written for preachers that were to have lasting influence in Northern art.[80]

The episodes on the individual *champlevé* plaques are squeezed under trefoil arches. Silhouetted against stunning blue enamel backgrounds, the figures are gilded with dark *niello* inlays vigorously marking out the draperies and features. Many of these present the subjects in traditional compositions, but as he worked, Nicholas became more and more dramatic, exploiting lively gestures and twisting movements in the figures with the racing *niello* lines. Facial expressions are intensified, too, and drapery lines are rapidly engraved, producing a pronounced clinging and flowing effect on the figures that suggests highlighted three-dimensional forms reminiscent of the so-called wet-drapery style of the ancients. Nicholas's draperies become such personalized interpretations of Byzantine conventions that they have been described as exhibiting the *Muldenstil* (literally, troughlike style) whereby the channels for the *niello* are deeply grooved, rounded at the ends, and bunched here and there to create rich pictorial effects and strong highlights. Parts of the anatomy are still rendered with the decorative loops and parallel curves that stem, once more, from Late Byzantine style.

The keen sense of plasticity with Classical drapery patterns is even more striking in the figures of the prophets executed by Nicholas about 1190 for the *Shrine of the Three Kings* in Cologne. The shrine is believed to have been made for the archbishop after the precious relics of the Magi were acquired from Emperor Frederick Barbarossa. The large shrine is an elaborate structure of silver and bronze studded with filigree, enamels, and inset gems (fig. 436; colorplate 55). Handsome *repoussé* figures in gold are placed along the sides and in the gables. The *Shrine of the Three Kings* (they appear with the Virgin and Child on the front) has been much restored, and no doubt it was a collaborative production of a large workshop, but the distinctive style of Nicholas can be discerned in some of the splendid *repoussé* apostles and prophets seated along the sides. In these, the so-called *Muldenstil* of Nicholas is realized in three dimensions, and, in fact, they remarkably anticipate classicizing tendencies in mature Gothic sculpture (cf. Reims, fig. 500), to which we shall now turn.

Byzantine drapery conventions in a new naturalism in modeling, marks a revolutionary break with the linear abstractions of Romanesque style in the North.

For the provost Wernher of Klosterneuburg (near Vienna) Nicholas of Verdun executed an elaborate pulpit with tiers of *champlevé* enamels in *niello* on blue backgrounds (completed in 1181). After a fire in 1330 the pulpit was remodeled in the form of an altarpiece in triptych form (figs. 434, 435). Some additions were necessary. In three horizontal registers the enamels are arranged to form an ambitious Old-New Testament typology (fifty-one in the final form). The middle row features New Testament scenes, labeled *sub gracia,* or the world under grace, from the Annunciation to Pentecost (the final side, to the right, includes scenes from the Apocalypse). For each New Testament episode a corresponding event from Genesis, *ante legem,* or before the law of Moses, appears in the row above, while one from the period

PART FIVE

GOTHIC ART

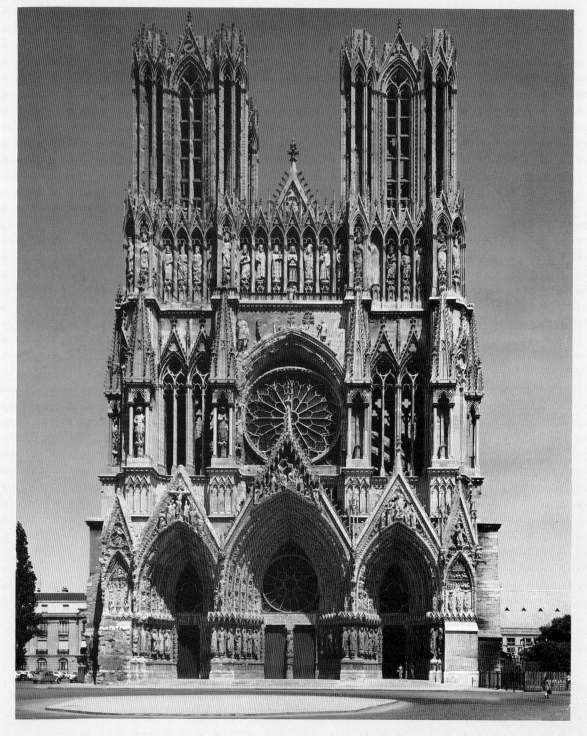

THE MEANING OF GOTHIC

FORESTS were the first temples of God [fig. 439], and in forests men grasped their first idea of architecture. This art has had to vary according to climates. The Greeks shaped the elegant Corinthian column, with its capital of leaves, on the model of the palm. . . . The forests of the Gauls passed in their turn into the temples of our fathers, and our oak forests have thus preserved their sacred origin. These vaults incised with leaves, these socles that support the walls and end brusquely like broken tree trunks, the coolness of the vaults, the shadows of the Sanctuary, the dark aisles, the secret passages, the low doors, all of this evokes in a Gothic church the labyrinths of the forests; it all makes us conscious of religious awe, the mysteries, and the divinity."[1] In his *Génie du Christianisme,* François-René Chateaubriand (1768–1848) described the cathedral in these poetic words that captured the meaning of Gothic for many of his day who shared the belief that Gothic alone expressed the essence of the Catholic faith.

Chateaubriand is but one of many eighteenth-century artlovers who reacted passionately to the hostile condemnation of the Gothic that had been voiced by the humanists of the Renaissance. The Italian Giorgio Vasari, acclaimed father of art history, wrote in the introduction to his *Lives of Artists* (1550) that Gothic architecture, "monstrous and barbarous," was "invented by the Goths, who . . . filled all Italy with these damnable buildings."[2]

For Vasari, Gothic was characterized as *il lavoro tedesco* (the German order), and while many later historians also considered Gothic an expression of Germanic lands, this attribution must be interpreted as referring to any style created north of the Alps, more specifically to the arts associated with the Franks and other tribes in northern Europe.[3] Actually, when the Church of Saint Peter in Wimpfen-im-Tal (Rhineland) was rebuilt in the Gothic style in 1269, the chronicler Burchard von Hall described it as being raised anew "in the French style [*opus francigenum*] by a very experienced architect who had recently come from the city of Paris."[4] And, indeed, if there is such a thing as the essence of Gothic, it must be admitted that it stems from the architecture created in the Ile-de-France.

However, there is much more to the understanding of

Gothic than its regional beginnings, for as we can read in many accounts by nineteenth-century historians, Gothic came to be considered an opposing pole to the Classical (Greco-Roman) styles in western Europe. In many respects this seemingly naive judgment makes sense, because in both the Classical and the Gothic the arts of an age were fully realized in architecture, be it the Athenian Parthenon in Antiquity (fig. 437) or the Cathedral of Reims in the thirteenth century (fig. 438). In both, architecture was truly the mother of the arts, embracing all others.

How diametrically opposed these two architectural styles seem. Viewed from a distance, the Greek temple stands like a solid, sculptural mass, an earthbound horizontal form, a tangible realization of an idea—the ideal house for the god. The initial impression of the Gothic cathedral is entirely different, with its soaring verticality, its tall towers and spires, and its countless lines racing upward from the congested lower doorways to the topmost pinnacles with the dynamism we have come to associate with Northern art. Furthermore, the Doric temple is a simple statement in stone. A steady regularity governs the basic additive assembly of its few individual members. One set of parts constitutes the elevation with a clarity and logic totally absent in the Gothic cathedral, where countless parts are integrated and interlocked into an intricate structure that seems to divide and multiply its basic motif—the pointed arch—endlessly. Rather than a harmony of masses, the cathedral achieves its consonance through the dynamic linearism of pointed arches flowing into bigger arches, twisting tracery turning into the delicate sunburst of the rose windows, pinnacles rising from pinnacles.

We attend the beauty of order and stability in the Greek temple, but our eye is drawn irresistibly upward by Gothic movement, creating a very different fascination with the building. The heart beats faster before Chartres, and the cathedral seems to grow before our eyes. It overwhelms any sense of the human scale that we emphatically sense before the proud Doric temple, where "man is the measure" of its parts and where weight and support seem so comfortably resolved. In contrast, the Gothic cathedral is like an engineer's grandiose dream of thrust and counterthrust diagrammed in stone lines.

As ultimate expressions of man's spiritual longings, the temple and the cathedral are not only antithetical in physical appearance but in symbolic meaning as well. The temple, after all, is an "ideal" house where only the god dwells. It forms an impressive backdrop for the pagan rites held before it, while the cathedral is a "living city of a living god," a New Jerusalem on earth. As the churchmen of the Middle Ages tell us, "the material church on earth signifies the spiritual church in heaven." Its sculptures and stained glass record the history of the pilgrimage of the faithful from the Old Testament through the New to final paradise at the end of time as celebrated in the Book of Revelation.[5] The worshipper actively participates in the space of the cathedral; the processions lead through its sculptured portals, down the deep longitudinal hallways to the final experience of Communion at the altar.

This temporal experience, of course, is not only that of the Gothic cathedral. It was announced already in the oration of Eusebius on the dedication of churches in the fourth century (see Part I, p. 40), and the Gothic cathedral represents the ultimate achievement of those spiritual aspirations whereby

440. *Christ (Le Beau Dieu)* (detail). Trumeau, central portal, west facade, Amiens Cathedral. 1220–35

the longitudinal movement of space is enhanced by the vertical ascension of high, lofty vaults. The worshipper is not only drawn down to the altar, but he experiences an elevation into the heavens at the same time. The flickering mosaics of the early basilica are aggrandized and transformed into vast walls of colored glass that metamorphose the natural lights of our world into the supernatural glow of pure colors. Clearly light and height contribute to the mystical content of the Gothic cathedral.

The highest achievements in Gothic architecture are realized in the mid-thirteenth century in and around Paris in northern France. It is precisely at this same time and place that the most profound statements of religious philosophy in the Latin West were formulated. The philosophy is known as Scholasticism, a school of reasoning based on highly intellectualized systems of logics and metaphysics—in part grounded in Aristotle—and the crowning achievement is the *Summa Theologica* written by Thomas Aquinas in Paris (a vast compendium of knowledge that forms the basis for most Catholic theology today). It is no wonder, then, that historians have sought out parallels between Scholasticism and the Gothic cathedral. To be sure, such relationships are misleading when carried to extremes, as often has been

done, but certain analogies can be made that are instructive for our understanding of Gothic in general.

Most inquiries into the makeup and significance of the *Summa* of Aquinas are addressed to the interpretations of his ideas on such basic philosophical issues as being, reason, faith, and knowledge. To many, Thomas Aquinas is a Christian Aristotle in his ingenious manner of reconciling and

441. *Virgin and Child* (detail). Trumeau, north transept portal, Cathedral of Notre Dame, Paris. c. 1250

harmonizing the philosophies of the ancients and those of the Christians. Others find his ideas masterful syntheses of the teachings of the Early Christian Fathers and the commentators who followed them—a grand summation of Christian thinking, so to speak. If we put aside the more detailed and pointed arguments in such studies and attend the general content and the organization of the *Summa Theologica,* some areas of comparison emerge that seem relevant for the arts. For one thing, an "idealism" forms the basis of the definitions in the *Summa* in a way that can be likened to the stylistic treatment of mature Gothic sculpture. Secondly, the vast, encyclopedic coverage in the writings of Aquinas parallels the completeness and complexity of the iconographic programs of the portal sculptures. Finally, the dialectical structuring of the arguments and demonstrations of Aquinas is analogous to the scaffolding of parts in Gothic architecture. Let us briefly consider these points.

Idealism. It may seem strange to speak of idealism in Gothic sculpture when we think of the linear expressionism so characteristic of Northern art, but it is clear that the conventionalized forms of Romanesque art were gradually transformed into more naturalistic types in the thirteenth century. Learned Old Testament prophets acquire thin, bony faces with long, arcing beards; determined apostles have well-structured faces with piercing eyes; benevolent angels are youthful figures with dimpled cheeks and comforting smiles (cf. figs. 479, 492, and 502). Christ and Mary become ideal types as well. The majestic *Beau Dieu* of Amiens (fig. 440) embodies the personality of a victorious leader who is not only stern but benevolent, and the Virgin on the north transept of Paris (fig. 441) strikes us as having the poise and countenance of an elegant queen. But the idealism of Gothic differs from that of Antiquity in a number of ways.

Idealism as a style in Greek art is based on the formula of direct observation of the nude human body (almost everything is personified) followed by a generalization based on mathematical proportions. For the Gothic artist this procedure involved the study of all of nature and generalization based on symbolic geometry. In the *Summa* we read that one must attend all of God's creations from primary matter through animals to angels, not just "man as the measure of all things." And rather than formulating an ideal canon of proportions for figures in terms of mathematical ratio—the Polycleitan canon was derived from Euclidian geometry—the Gothic artist sought out the symbolic structure within all forms.

According to Aquinas, not only was it necessary to attain knowledge through a direct study of all creation, but "all causes in nature can be given in terms of lines, angles, and figures." Basic geometric forms thus underlie ideal structures, whether they be in paintings, sculptures, or buildings. The lodge *Sketchbook* of a thirteenth-century French architect, Villard de Honnecourt, an encyclopedic manual with

442. VILLARD DE HONNECOURT. *Geometric Figures and Ornaments.*
Sketchbook, 9¼ × 6″. 1220–35. Bibliothèque Nationale, Paris
(MS fr. 19093, fol. 18v)

illustrations of ground plans, elevations, building devices, and ornamentation useful for the apprentice, informs us that in it "you will also find strong help in drawing figures according to the lessons taught by the art of geometry"[6] (fig. 442).

Even the lofty cathedral facades, as irregular as their growth seems to have shaped them, obey numerical and geometric codes. The main block is a square (cf. fig. 443)—the four sides have innumerable associations (Christ, the Evangelists, rivers of paradise, elements of nature, corners of the world, etc.). The triangle with its trinitarian symbolism is repeated throughout; the circle of the rose window, having neither beginning nor end, signifies the eternity of the one God. French Gothic builders followed schemes for elevations termed *ad quadratum* and *ad triangulorum* (according to the square, according to the triangle) whereby their ideal structures could be raised according to symbolic measure and number, reflecting the geometry of the New Jerusalem and its prototype, the Temple of Solomon.[7]

The world of nature was similarly transformed. The leaves that virtually encompass the capitals of Reims Cathedral (fig. 444) are species that we can now easily identify as distinct plants when compared to the conventionalized floral motifs that adorn the moldings and capitals of Romanesque churches. In fact, it is in such marginal areas—capitals, socles, doorposts—that new genres, some secular in subject matter, first bud with refreshing exuberance.

Encyclopedic content. In the *Summa Theologica,* Aquinas addressed more than six hundred and fifty fundamental articles of knowledge, from the creation of the world to the existence of angels, and this far-ranging scope of his summation—the A to Z of knowledge—seems to have been an obsession of the Gothic age. One of the most complete manuals on church symbolism is the *Rationale divinorum officiorum* written by a Dominican, William Durandus (1237–1296), who held titular canonries at Beauvais and Chartres. The treatise, written in eight books, is still valuable for iconographers of Gothic art, especially for the mystical interpretations of the Roman rite and the symbolism of churches and liturgical objects.[8] The encyclopedia of Durandus represents the culmination of a tradition, and numerous treatises survive from the twelfth and thirteenth centuries that attest to the widespread popularity of such exhaustive works.

Emile Mâle, in his brilliant study of Gothic iconography (first published in 1898!), found in the *Speculum majus* of Vincent of Beauvais (c. 1190–1264), priest and encyclopedist living in the monastery at Beauvais, the most complete statement for the interpretation of Gothic church programs in sculpture.[9] While Mâle was, no doubt, too zealous in claiming the authority of this work, the model is nevertheless instructive to review here. Containing some eighty books and nearly a thousand chapters, the *Speculum majus* ("Major Mirror"—the mirror being a familiar metaphor for knowledge in general) has four parts: (1) the *Speculum naturale,* or "Mirror of Nature," in which Vincent discusses creation in nature, beginning with the acts in Genesis and covering such esoteric subjects as the qualities of magnets used in navagation; (2) *Speculum doctrinale,* or "Mirror of Doctrine," that explains the roles of "works" and "knowledge" in the drama of man's redemption; (3) *Speculum historiale,* the "Mirror of History," wherein Vincent exhaustively recorded the pilgrimage of man from the Old Testament down to the lives of saints and contemporary events, a kind of grandiose *historia ecclesiae;* and (4) *Speculum morale,* or "Mirror of Morals," that is addressed to proper conduct, for example, the Virtues and Vices and the "active" and "contemplative" life. This last book is of dubious authorship and appears to have been a late addition to the original *Speculum majus.*

Of the four mirrors, that of history was by far the most important for the sculpture programs, and it is the history of the church—much as Saint Augustine recorded it in the *City of God*—that dominates the major areas of decoration. According to Mâle, a definite scheme applies. The foremost

443. Cathedral of Notre Dame,
Paris. Facade elevation
(after Dehio/Bezold)

444. Floral capital in the nave.
Reims Cathedral. c. 1230–45

445. *Zodiac and Labors of the Month* (June, July, August, September). West facade, left doorway, socle of the left jamb, Amiens Cathedral. 1225–35

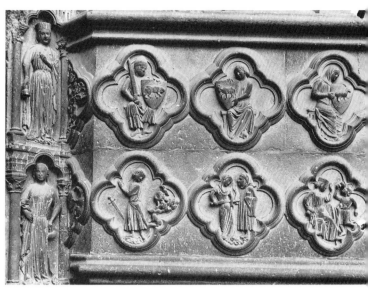

446. *Virtues and Vices* (fortitude: cowardice; patience: anger; sweetness: harshness?). West facade, central doorway, socle of the left jamb, Amiens Cathedral. 1220–35

history, that of the life of Christ, is presented on the major portals of the western facade of a Gothic cathedral. The role of Mary in that history is usually relegated to the north transept portals, while the stories of the lesser (often local) saints in the Christian hierarchy are assigned positions on the southern doorways. A definite hierarchy of subject matter from the *Speculum historiale* thus moved about the cathedral.

The other mirrors—Nature, Doctrine, Morals—were appended like "footnotes," as it were, about the major representations in areas such as archivolts, socles, and doorposts. On the facade of the Cathedral of Amiens, for instance, the socles of the saints and angels on the jambs of the left doorway present us with images in relief of the zodiac over those of the calendar (labors of the months), illustrating the *Speculum doctrinale* (fig. 445). Under the apostles in the central portal, similar reliefs in quatrefoils represent the Virtues and Vices of the *Speculum morale* (fig. 446).

The model that Mâle proposed for the sculptures of French Gothic cathedrals is especially attractive and, in many ways, convincing, but it would be wrong to argue that the Gothic churchmen and builders had the *Mirrors* of Vincent of Beauvais at hand when they laid out the schemes for decorating their churches. For one thing, there are many variations and developments within the programs (which Mâle readily admits), and some programs were apparently planned *ad hoc* to serve local needs and interests. Furthermore, considering the adjustments and gaps in chronology, it is not likely that all three areas of the cathedral—the west front, the porches for the transepts—would have been planned as a whole from the start. In fact, only Chartres preserves such an ambitious set of portal sculptures.

The Structure of Scholasticism. One of the major contributions of Scholasticism was the ingenious reconciliation of the knowledge of things through reason and through faith, a major dilemma in Christian philosophies. For Aquinas this was possible by means of demonstrations in the form of arguments, a dialectical process for resolving issues whereby first a question is posed (for example, Question XLVI: Concerning the Beginning and Duration of Creation) that, in turn, is followed by the presentation of an article of controversy (Article I: Whether the Universe of Creatures Always Existed) and is then answered by a series of objections and replies and followed by a solution by Aquinas (*Videtur quod—sed contra—respondeo dicendum*). The beauty, if not the truth, in such dialectical argumentation is the clarity of its outlining and organization of ideas: thesis, antithesis, synthesis (or solution). It is this outline system of thinking in constructing a demonstration in words—a fascinating intellectual exercise that often became an end in itself (clarification for clarification's sake)—with its intricate framework and organization that has been likened by some historians to the new mode of thinking in Gothic architecture. The cathedral is like a gigantic outline or scaffolding in stone (cf. Beauvais Cathedral, fig. 447), each part supporting the next, and the processes by which Gothic architecture developed can be seen as dialectical arguments among the builders.

Erwin Panofsky, in a dense little book entitled *Gothic Architecture and Scholasticism,* has expounded on this manner of procedure (*modus operandi*) as the essential link between the philosophy and art of the thirteenth century in France.[10] Important for Panofsky's thesis is the idea of the individual integrity of each part in the buildup and the clarification (*manifestatio*) of the structure through the systematic organization and outlining of parts into a harmonious arrangement. Panofsky even sees the development of Gothic "solutions" in terms of the dialectic of Scholasticism

(in architecture, the experiments in one direction, then in another, and finally a solution), and he illustrates this by describing the resolution of three Gothic "problems": the integration of the rose window in the facade, the adjustment of the triforium in the nave elevation, and the shaping of the articulated piers (*piliers cantonnés*) in the nave arcade. While it is true that the elevation of a Gothic cathedral does depart dramatically from the mural structuring of previous architecture with its skeleton of stone diagramming thrust and counterthrust like a modern engineer's rendering, one senses that Panofsky himself has fallen at times into the scholastic habit of "clarification for clarification's sake."

The analogies between Scholasticism and the Gothic cathedral discussed here are perhaps better sensed than understood in details, and the same is true of a wholly different sphere of religious philosophy that is embodied in the lofty interiors glowing with colored lights: *Mysticism*. This brings us to the subjective world of faith stimulated by our visual experiences and emotional responses to space and light that

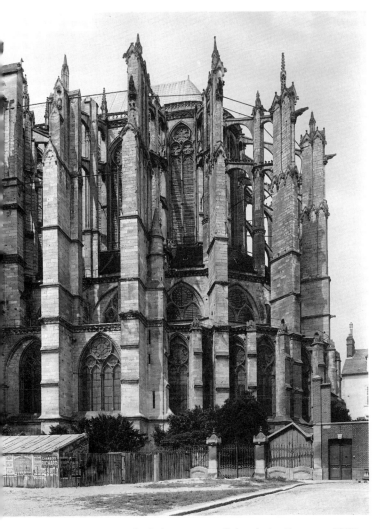

447. Beauvais Cathedral. Exterior of the choir. Begun c. 1235

are not conditioned by aspects of thrust, counterthrust, articulated piers, or flying buttresses. One historian, Wilhelm Worringer, described it thus: "As the interior is all mysticism, so the exterior construction is all scholasticism."[11] Having once passed through the sculptured portals of Chartres, one no longer responds to the intricacy of structure, the beauty of the many sculptures, or the fascinating stories in stone, but rather to the marvelous attraction of divine light filtering down from the high windows all about. In this twilight world one does not attend the mechanics of Gothic structure or the complexities of its imagery. What strikes us is the indescribable sensation of being engulfed in a vast, lofty space where the parts are hardly discernible.

The mystical aspect of the cathedral interior cannot be denied. It is true of the Early Christian basilica and the Byzantine domed churches as well. But in the Gothic interior, the contrasts between the rational, physical structure of the building and the otherworldly sensations of the "new light" of the interior—where the services take place—are even more extreme. Mysticism had not yet been codified as a means of worship (this occurred in the fourteenth century); there were as yet no prescribed aids for inducing a mystical experience (such as in rosary devotion), but it was an experience that could be achieved through the contemplation of colored lights. How frequently the term "light" occurs in descriptions of mystical revelation! Reason dissolves in mysticism; faith is lifted to the abstract realm of total absorption, as the mystics say, "to lift us out of our bodies."

There can be little question concerning the role of colored lights in this experience of the cathedral. Lights, whether they be created by great panes of colored glass in the tall windows or in the translucency and sparkle of precious gems set in bright golden objects on the altar, were the means of attaining a mystical union with God. The oft-quoted passage by Abbot Suger of Saint Denis concerning the beauty of the "wonderful" cross of Saint Eloy placed on the golden altar superbly conveys this sense of mystical exaltation: "Thus, when—out of my delight in the beauty of the house of God—the loveliness of the many-colored gems has called me away from external cares, and worthy meditation has induced me to reflect, transferring that which is material to that which is immaterial, on the diversity of the sacred virtues: then it seems to me that I see myself dwelling, as it were, in some strange region of the universe which neither exists entirely in the slime of the earth nor entirely in the purity of Heaven; and that, by the grace of God, I can be transported from this inferior to that higher world in an anagogical manner."[12]

It is this dramatic reconciliation in architecture of the two ways to Christian faith—through *reason and understanding* as achieved by the scholastics and through the *immediate experience* of divinity as revealed to us by the mystics—that gives meaning to the Gothic cathedral.

GOTHIC ART IN FRANCE

EW contributions to the development of Romanesque art have been attributed to northern France, but during the course of the twelfth century, just at the period when the Cluniac Order reached its apogee in Burgundy, important events in and around Paris led to historical changes of momentous consequences: the emergence of the Gothic age. Many factors have been cited for this change in spirit, not the least among them being the dramatic rise of the urban communities that replaced the older monastic colonies as centers of education and the arts, but certainly political developments had an important role in this as well. It was in these domains north of the Seine, known since the time of Hugh Capet (987–96) as the duchies of the Capetians, that there arose the idea of the monarchy that we call France today. Louis VI (1108–37) and his son Louis VII (1137–80) undertook through diplomacy and marriage (it will be recalled that Louis VII married Eleanor, duchess of Aquitaine, holder of the largest feudal estates in western Europe) to assert the authority of the Capetians over the lords and barons in neighboring counties. They also were able to align the church with their ambitions to create a powerful kingdom centered at Paris, and that is where our story begins.

ABBOT SUGER, SAINT DENIS, AND THE BEGINNINGS OF GOTHIC

Surprisingly, the leader in this political and cultural revolution was not a king but a Benedictine churchman. Abbot Suger of Saint Denis (1122–51), born of humble parents, can be said to have created the climate for the birth of the Gothic age, and, in many respects, it was under his supervision that the first great monument of the Gothic, the Abbey Church of Saint Denis (figs. 448–52), was created. Suger was friend and councillor to both Louis VI and Louis VII; he had served as regent of France during the latter's involvement in the Second Crusade (1146) and was instrumental in keeping Louis's marriage to Eleanor of Aquitaine from disintegrating (they were divorced the year after Suger's death). Since a child, Suger had been trained and nurtured at Saint Denis, and in time he rose in the ranks of the churchmen there, so much so that he was chosen to head the abbey upon

the death of Adam, a rather ineffectual abbot who had allowed the hallowed royal church of France to fall into disgrace in the eyes of the Cluniacs and the Cistercians.

Saint Denis was, after all, the first church in France; it was there that the relics of the founder of Christianity in France, Dionysius the "Apostle of Gaul," were venerated, and it was there that the French kings had been buried since Carolingian times. It was clear to the ambitious Suger that Saint Denis was in need of reform and rebuilding to reestablish its former prestige.

Saint Denis was situated just north of the city gates of Paris, the thriving capital of the realm (today it lies well within an industrial quarter of the city). With the assertion of political power on the part of the Capetians in Paris, Suger similarly dreamed of aggrandizing the ecclesiastical position of Saint Denis in Latin Christendom. Thus a curious marriage of church and state was celebrated in the Ile-de-France, and the birth of Gothic can be seen as the progeny of this alliance. One thing is certain: Suger of Saint Denis was a very different churchman from Saint Bernard of Clairvaux. The pious spokesman of the austere Cistercian Order vehemently criticized Suger's actions at first. He called Saint Denis a "synagogue of satan," and accused Suger of ostentation and flaunting. To be sure, Suger did not promote Bernard's asceticism; he was no crusading hermit—he enjoyed being surrounded by royalty—and, finally, he was no advocate of iconoclasm. For Suger art and splendor were all part of the worship of God, and these interests are clearly announced in three treatises that he composed concerning the reform and rebuilding of Saint Denis under his abbacy.

The old Carolingian church was described by Suger as being in deplorable condition and much too small. Yet, he tells us, its withered stones were very like relics themselves to be preserved, and while it is clear that he intended to offend no one in his redesigning of the ancient and sacred edifice, his project was tantamount, as Panofsky quips, to a "President of the United States . . . [having] the White House rebuilt by Frank Lloyd Wright."[13]

In the treatise entitled *Things Done under His [Suger's] Administration,* 1144–49, Suger relates how the rebuilding progressed. First of all, the old church was so narrow that

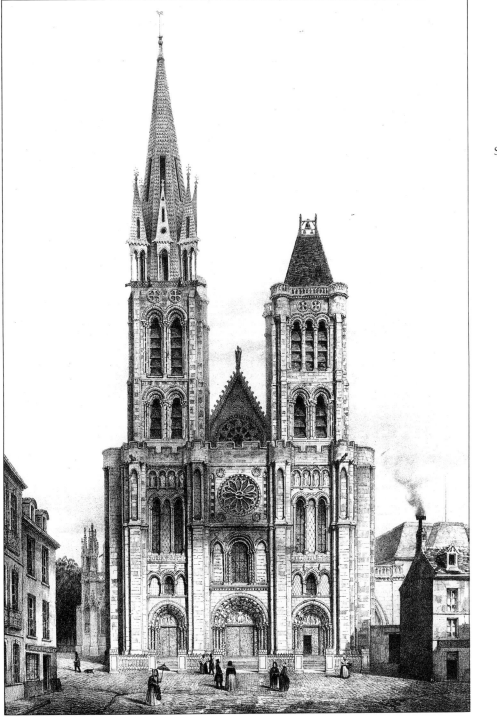

left: 448. Abbey Church of
Saint Denis. West facade. 1135–40.
Engraving (made before 1837)

below: 449. Abbey Church of
Saint Denis. Plan (after Frankl)

during feast days, he tells us, "the narrowness of the place forced the women to run toward the altar upon the heads of the men as upon a pavement with much anguish and noisy confusion." Suger then implores "Divine mercy that He Who is the One, the beginning and the ending, Alpha and Omega, might join a good end to a good beginning by a safe middle; . . . Thus we began work at the former entrance with the doors. We tore down a certain addition asserted to have been made by Charlemagne on a very honorable occasion (for his father, the Emperor Pepin, had commanded that he be buried, for the sins of his father Charles Martel, outside at the entrance with the doors, face downward and not recumbent); and we set our hand to this part. . . . with the enlarge-ment of the body of the church [the narthex?] as well as with the trebling of the entrance and the doors, and with the erection of high and noble towers." The subsequent activity involved the rebuilding of the choir of the church. Thus, the refashioning of the imperial westwork and the holy sanctuary—evoking the presence of the monarchy and the church—were Suger's first goals.[14]

The facade of Suger's new church is, at first sight, a monumental restatement of the two-towered westwork of earlier times (fig. 448).[15] It resembles, in fact, the great towering facade of Saint Etienne in Caen, the foundation of William the Conqueror (fig. 367), in its high towers and massive walls, with heavy pilaster strips dividing the block

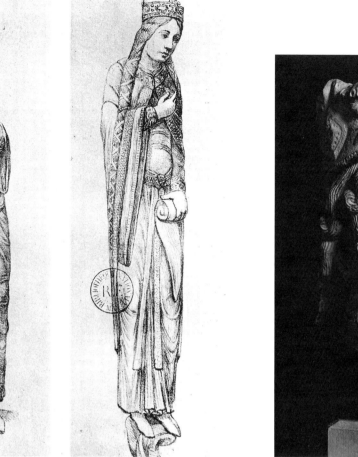

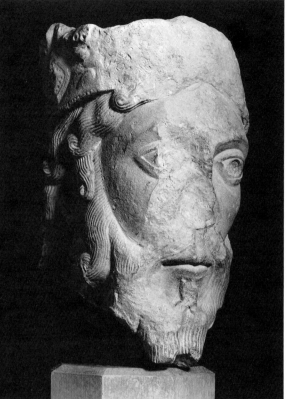

into three zones corresponding to the nave and side aisles. A tripartite division also marks the vertical organization. Much has been written concerning the influence of Norman architecture on Saint Denis.[16] So what can we say is new or "Gothic" about the facade? For one thing, the plain mural surface and solidity of the walls have been interrupted by a number of penetrations in the form of deep-set portals and ranges of trebled arcades above them in each division. Secondly, the upper part of the central division is punctured by a huge round window—the rose window—perhaps as a conscious aggrandizement of the traditional Carolingian "window of appearances" to symbolize the presence, not of the emperor, but of the "God of Light" in Suger's church. Finally, an amazing transformation of the portals has taken place. To relieve the austerity of the Normanesque entranceways, Suger added an elaborate screen of sculptures across them reminiscent of the decorated porches of Burgundian and Languedocian churches.

Little survives of Suger's sculptures (the north tympanum was decorated with a mosaic!). A much-restored tympanum with a representation of the Last Judgment preserves something of Suger's program for the central portal, and the doorpost reliefs of the south entranceway with the labors of the months survive relatively intact, but these fragments are hardly adequate for an analysis of style or iconography. The entire facade was, in fact, crudely restored in 1839–40, following the French Revolution.

Fortunately, drawings made by Antoine Benoist for Bernard de Montfaucon, a French antiquary, who published *Les Monuments de la monarchie française* in 1729, reproduce the tall, columnlike figures that originally decorated the door jambs, six on each of the lateral doorways, eight in the center (see fig. 450). Stylistic features such as the shallow, incised treatment of the drapery and the conventions employed for the heads have been linked to both Burgundian and Languedocian sculpture of the early twelfth century, and, in general, something of the abstract qualities of Romanesque figure style characterize these curious figures.[17]

A few fragments of heads (cf. fig. 451) have been linked to Montfaucon's illustrations (these are dubious attributions at best). But something new is clearly conveyed in the drawings that distinguishes these statues from the others. Rather than resembling the agitated, dancing figures carved in relief on the jambs at Vézelay or Moissac (cf. fig. 334), these are truly statues in-the-round by virtue of the fact that they are in the form of columnar supports set into the splays of the doorways, alternating with shafts of Romanesque decorative design. Their subordination to the shape of the slender columns denies these tall figures any movement. Indeed, they resemble fluted columns with mere indications of faces and draperies carved into them. And yet, this same inactivity brings with it a certain tranquility and dignity when compared to the wild contortions of the Romanesque jamb figures. Furthermore, these "column statues" initiate a genre of

portal decoration that will evolve into one of the most exciting areas of French Gothic sculpture. Montfaucon identified them as imaginary portraits of the early kings and queens of France, but this is wrong. Surely these are not secular personages; they are most likely Old Testament kings, queens, patriarchs, and prophets, and their role in the makeup of.the facade program assumes a very significant one, for they represent the early authorities of the Bible upon whose shoulders the holy figures of the New Testament above them rest.

If Suger's facade and its sculptures strike us as "transitional" contributions to Medieval art history, the new choir added in the second building campaign (1143–44) is a glorious presentation of the new principles of Gothic architecture (figs. 449, 452). An elevated stage for exhibiting the relics was raised over the old annular crypt built in the ninth century (which Suger wished to preserve) with staircases on either side giving access to the upper choir. This, in itself, is not new, but the elaborate construction that encases the area around the altar is a striking departure from the Romanesque.

Two rows of slender columnar supports resting on square bases form a double-aisled ambulatory terminating radially in nine chapels that circle the apse. The chapels are no longer the isolated architectural units that we find in Romanesque pilgrimage choirs, however, but they are integrated and merge with the aisles of the ambulatory along axes that radiate out from the central keystone of the apse like an intricate spider's web. The inner aisle has sections with irregularly shaped quadripartite vaults; the outer aisle with the apsidioles has five-part ribbed vaults that rest on the outer columns and the splayed piers in the wall.

Viewing the ambulatory from the side, we can see how the architect accomplished this unique solution to vaulting disparate areas. He employed pointed arches that can be easily adjusted to the desired heights (an impossibility with round arches) and added sturdy ribs along the structural lines, which were then filled in with a light webbing of stone. Unlike the more ponderous elevations of Romanesque choirs, the weight of the chevet of Suger's church is thus appreciably lessened, and the entire structure takes on the appearance of a diaphanous cage of skeletal construction. The supporting role of the outer walls is much reduced, too, so much so that they are nearly eliminated, allowing for large openings for high windows. A spaciousness and lightness result whereby the tubular delineations of ribs rising from

opposite left: 450.
ANTOINE BENOIST.
Jamb figures of the central portal of the Abbey Church of Saint Denis. Drawings for Bernard de Montfaucon's *Les Monuments de la monarchie française,* Paris, 1729. Bibliothèque Nationale, Paris (MS fr. 15.634)

opposite right: 451.
Head of a Jamb Figure. Formerly on the west facade of the Abbey Church of Saint Denis (?). Limestone, height 13¾". 1135–40. Walters Art Gallery, Baltimore

right: 452. Abbey Church of Saint Denis. Interior of the ambulatory. 1140–44

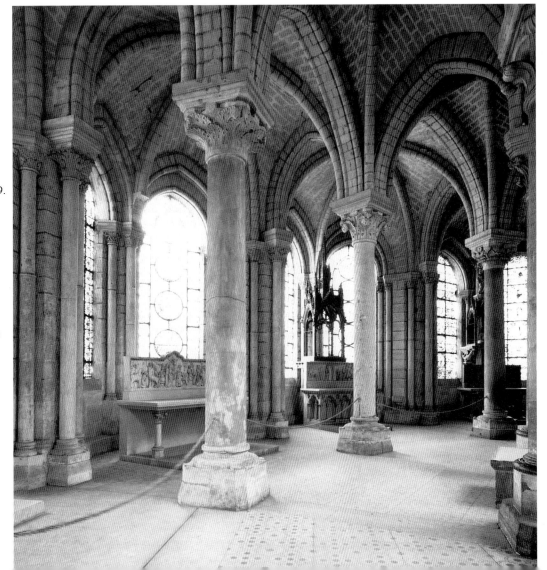

slim columns describe a hollow volume covered with a skin of stone.

What Suger's architect achieved here is essentially the major feature that distinguishes Gothic from Romanesque architecture: the use of pointed arches in a ribbed vault that is not only flexible but lessens the need for heavy wall supports (see fig. 453). The structure thus dissolved into a light and lofty cage construction. The advantages of the groin vault over the cumbersome tunnel vault have already been discussed, and now with the employment of pointed arches and ribs, Gothic architecture makes its appearance.

The role of the rib in Gothic vaulting has long been an issue of heated debate among art historians. Do the ribs serve a structural role once the vaulting is in place? Do they form a permanent frame that supports the weight of the stone vaults? Or are they simply decorative, serving an aesthetic role in guiding the eye into the summit of the vault while, at the same time, concealing the abrupt junctures of the groins? Should they be considered structural members of engineering or expressive elements of a work of art? These issues are not easily resolved. Examples can be cited in which the ribs have collapsed and the vaults remain intact, implying that ribbing was not structurally important. Conversely, there are instances where the stone webbing has fallen and the ribs remain. Clearly the ribs are essential elements in articulating

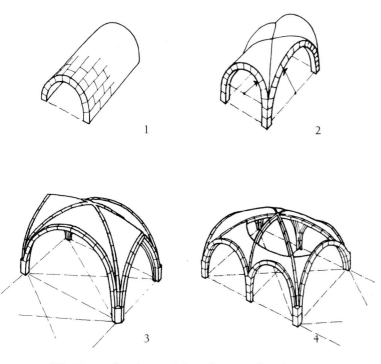

453. Types of vaulting: (1) barrel or tunnel vault; (2) groin vault over a rectangular bay; (3) Gothic vault with pointed arches and ribs over a rectangular bay; (4) sexpartite vault over two rectangular bays (after Swaan)

the vast spaces of Gothic vaults, dividing the space into discreet sections. At the same time, they are also necessary in forming the vault in the first place, providing the centering to shape the structure.[18]

The harmonious integration of the complex elements in Gothic architecture required the ingenuity of one especially trained in the science and techniques of building, an architect. Just when the architect emerged in history as an independent designer of buildings in the modern sense is difficult to determine. As we have seen (pp. 99–101), trained mathematicians were summoned to Constantinople in the sixth century to oversee the building of Hagia Sophia, and a number of churchmen in the Romanesque period are recorded as designers of buildings. Yet the new professional architect must have emerged from the urban societies of the twelfth and thirteenth centuries concurrent with the rise of strong artisans' guilds and the detachment of the builders' lodges (organizations of stonemasons) from the monasteries.

The commission or rebuilding of ecclesiastical structures within the city depended on the actions of the cathedral chapter (the administrative organization of the canons of a cathedral). The chapter, in turn, would appoint a *magister operis* (*maître des ouvrages,* or master of the works) to oversee the entire project, the "fabric" (*fabrica*), including the administration and maintenance of the building. The master of the masons (*maître maçon,* or *magister lathomorum*) was, in effect, the architect who had the specialized skills for planning the physical building *in toto,* and his prestige grew rapidly during the thirteenth century. The elevated status of the master of the masons is clearly suggested by the epitaph of one Parisian architect: "Here lies Pierre de Montreuil, a perfect flower of good manners in his life as a doctor of stones [*doctor lathomorum*]."[19]

Saint Denis was an abbey church and not a cathedral governed by a chapter, and yet it was in this monastic setting that the new principles of building were introduced on a grand scale. We know from Suger's writings that he personally sought out a quarry with proper stones and that he summoned excellent artisans from all over Europe. While Suger was no architect, it is interesting that he called in a master mason who was thoroughly familiar with the latest style in architecture. In fact, the motivation behind the rapid development of the new ribbed construction at Saint Denis was due, at least in part, to the interests of Abbot Suger himself. Ribbed vaults were common earlier; they are found in Norman churches (Durham Cathedral, Saint Etienne at Caen) and in Lombard structures that date before Saint Denis. And pointed arches—an Arab invention?—were used earlier in Burgundian churches, such as Cluny III. But what is new is the lightness, the transparency, and the thinness of parts, which allow the structure to open up and reduce its heavy walls.

below: 454. Sens Cathedral. Plan (after Dehio). Begun c. 1145

right: 455. Sens Cathedral. Interior

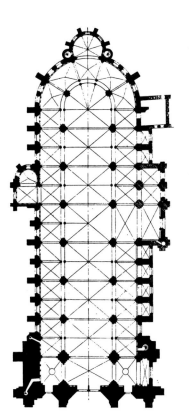

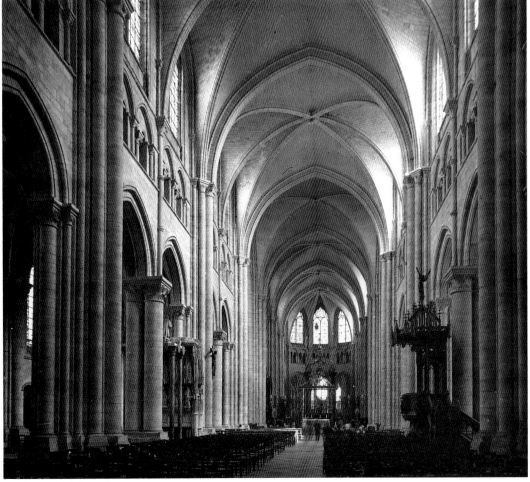

Space and light are important factors. Why did Suger desire such effects? After all, he vividly records the way the centering and vaults swayed precariously in a heavy storm that hit the church in January of 1143. His church must be as sturdy and stable as any other. Yet in his treatise on the consecration of the church, he tells us that he wanted the choir built with a "circular string of chapels, by virtue of which the whole [church] would shine with the wonderful and uninterrupted light [*lux continua*] of most luminous windows." And in another passage he states poetically that "Once the new rear part [the choir] is joined to the part in front [the facade], the church shines with its middle part brightened. For bright is that which is brightly coupled with the bright, and bright is the noble edifice which is pervaded by the new light [*lux nova*]".[20]

The *lux nova,* or "new light," filtering in through the lofty stained-glass windows was clearly an important feature of Suger's new chevet, and while there is some evidence for much earlier use of stained glass in windows, his concern for *lux continua,* or a continuous wall of such lights, in the chevet is new. Fragmentary remains of some of Suger's windows are preserved in the choir of Saint Denis.[21] In the chapel of the Virgin, directly behind the main altar on the central axis, were two tall windows appropriately decorated with scenes from the life of the Virgin (northern bay) and a resplendent Tree of Jesse (southern). Directly next to this chapel was that of Saint Peregrinus (now Saint Philip) with two windows, one dedicated to the story of Moses, the other, known as the "Anagogical" window, with typological mysteries of the church in roundels, including the "Mystic Mill" with Moses and Paul grinding grain into flour such as we find in the capital of Vézelay (fig. 357).

Much has been written about Suger's keen interest in the *lux nova.* It has been suggested that the abbot's interests in light and its symbolism were quickened by the writings of Pseudo-Dionysius the Areopagite (wrongly identified as Dionysius of Gaul, the first bishop of Paris) that were available in the library of Saint Denis (see pp. 110–11, 223), which Suger surely read. In *The Celestial Hierarchy* the metaphysics of Neoplatonic light are expounded, and it was the splendor and radiance of the "Father of Lights" that Suger sought in his mystical ascent through contemplation of "lights" by which he could be transported "from this inferior to that higher world." As discussed above, the reconciliation

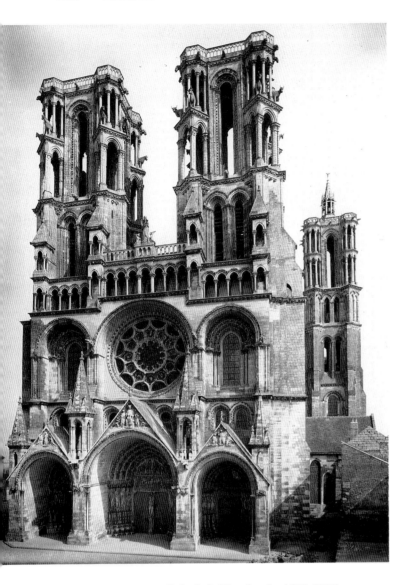

456. Laon Cathedral. West facade. 1190–1205

457. Laon Cathedral. Towers of the west facade

of the mystical experience with the scholastic structuring of thought was a major achievement of the Gothic, and Suger's choir at Saint Denis demonstrates this.

The "middle part" of Saint Denis was not finished until the mid-thirteenth century (1231–81), when a leading architect in Paris, perhaps Pierre de Montreuil, added the elegant nave in the contemporary "Court" style (see fig. 505). Had Suger completed the rebuilding, one wonders what appearance the nave might have had.[22] Two models for the hypothetical structure of the nave can be considered. The Cathedral of Sens (figs. 454, 455), south of Paris, built between about 1145 and 1164, has a somewhat simplified "hairpin" ground plan with single side aisles continuing into the semicircular ambulatory of the choir without projecting apsidioles as at Saint Denis (a single rectangular chapel projected from the east end). The handsome nave is broad and spacious with a

definite Norman appearance in the sexpartite vaults that rise from alternating pier supports.

The elevation displays an unusually handsome cadence as we move up through the three stages. Double columns alternate with huge compound piers, the latter carrying shafts that form the heavier transverse arches and diagonal ribs marking out the great hollows of the sexpartite vaults. The double columns carry shafts that form the intermediary transverse arches. Directly above, in a shallow triforium, the arches in the arcade are quadrupled above each arch in the nave arcade, while in the original clerestory, the windows were doubled. Thus for each double bay the tripartite division was marked with a cadence in consonance with the relative heights of each part. A fine vertical lift is thus articulated at Sens, but the vast width of the nave is what is striking.

North of Paris, the Cathedral of Laon (figs. 456–60) presents another solution to the nave elevation. Here the nave is also covered by great sexpartite vaults resting on an alternat-

458. VILLARD DE HONNECOURT. *The Tower of Laon*. Sketchbook, 9¼ × 6″. 1220–35. Bibliothèque Nationale, Paris (MS fr. 19093)

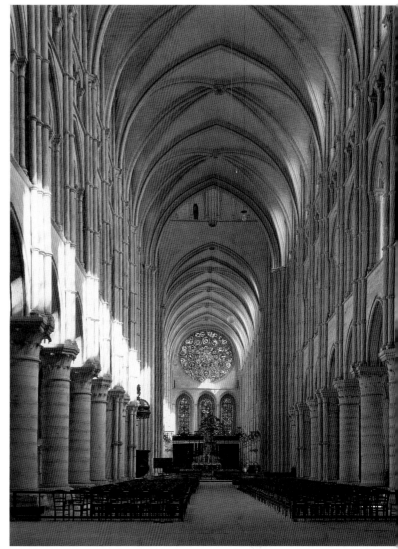

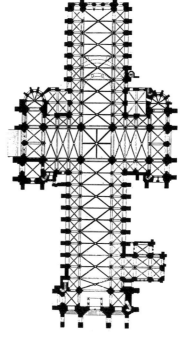

above: 459. Laon Cathedral. Interior. 1165–1205

left: 460. Laon Cathedral. Plan (after Dehio). 1165–1205

ing system of columnar supports in the nave arcade (fig. 459). Five, then three, clustered shafts rise from the capitals of the columns through the elevation to culminate in the transverse and diagonal ribs in the sexpartite vaults. The elevation of Laon has four stories, however, with a much more sculptural appearance in the dramatic sequence of arched members for each double bay. Directly above the nave arcade a deep tribune gallery is introduced with vaults that serve to buttress the high nave. A triforium of blind arches runs between the open tribune and the clerestory windows above.

Curiously, although it would seem that the emphatic four-story elevation of Laon would accent the longitudinal or horizontal sense of space, the higher proportions of Laon (it is fifteen feet narrower than Sens, although both rise to approximately eighty feet) reinforce the illusion of vertical lift for the visitor. As at Sens, great hollows of space are diagrammed with shafts, ribs, and rhythmic arches rising upward with a stately cadence, but at Laon space moves in

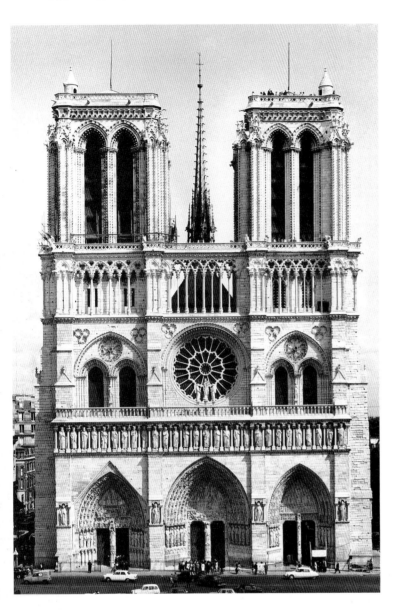

many directions, especially when one approaches the lantern over the crossing of the giant projecting transepts before the choir.

Neither Sens nor Laon employ flying buttresses—usually considered hallmarks of Gothic cathedrals—although the progressive thickening of the exterior wall buttresses of the transepts and the concealment of quadrant arches under the tribune roofs on the interior at Laon clearly anticipate this innovation. The introduction of true flying buttresses appears in the Cathedral of Notre Dame in Paris (figs. 461–66) about 1175–1200 (remodeled after 1225), where a series of free stone supports rise high above the triforium roof on the exterior of the nave and choir, resembling so many struts or fingers reaching up to support the thin walls of the nave carrying the high vaults (see fig. 464).[23] In some respects, this innovation can be seen as a natural development necessitated by the new vaulting schemes. The diminished wall supports of the high nave proved to be insufficient to counteract the stronger forces of the wind at the higher elevations of the galleries and clerestory.

Paris, one of the largest and highest (108 feet) of the Early Gothic cathedrals, has a fascinating history. Like Sens and Laon, the nave of Paris is covered by sexpartite vaults (fig. 466), although the alternating system of supports in the nave arcade was originally abandoned (it is retained in the side aisles). Like Sens, Paris has a simplified, continuous hairpin ground plan (fig. 465), but the aisles are doubled and con-

left: 461. Cathedral of Notre Dame, Paris. West facade. Begun 1163; lower story c. 1200; window 1220; towers 1225–50

below left: 462. Cathedral of Notre Dame, Paris. View from the south

below: 463. Cathedral of Notre Dame, Paris. Cross section of the nave (after Mark)

opposite: 464. Cathedral of Notre Dame, Paris. View of flying buttresses

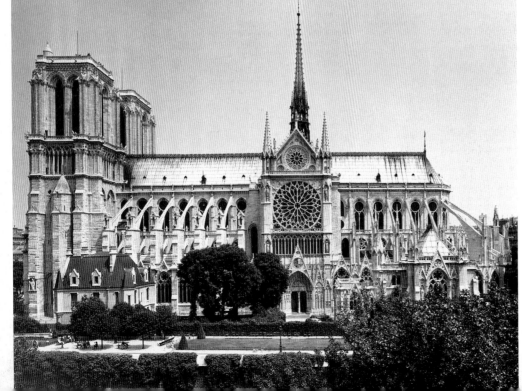

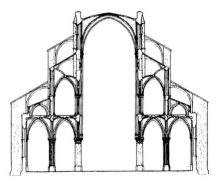

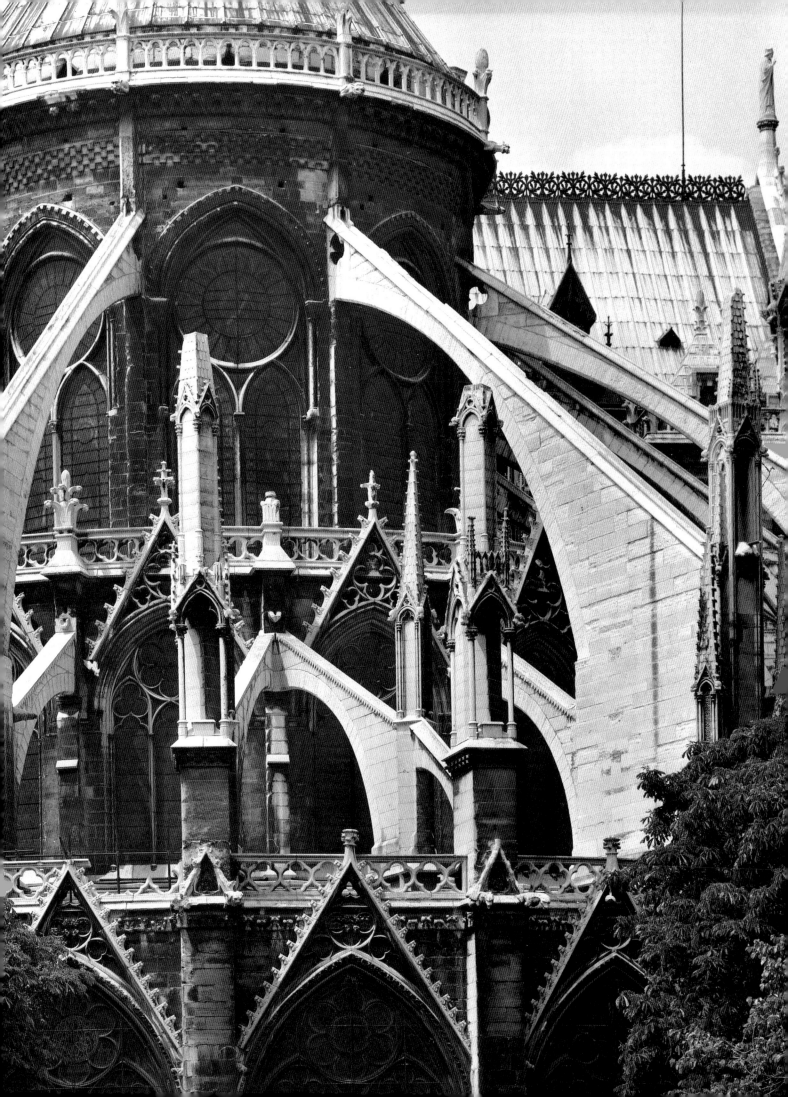

above: 465. Cathedral of Notre Dame, Paris. Plan

right: 466. Cathedral of Notre Dame, Paris. Interior toward the choir. Begun 1163; c. 1180–1200

tinue in that fashion around the chevet, as they do at Saint Denis. With Laon it shares a four-part elevation with a huge open tribune gallery directly over the nave arcade. Originally an additional wall punctured by oculi (see elevation, fig. 496), rather than the continuous arcading of a triforium, was introduced below the clerestory with its simple lancet windows.

This four-part elevation was "modernized," so to speak, in the thirteenth century by eliminating the band with the oculi and absorbing it in the clerestory with taller double-lancet windows with a rose, opening the upper third of the elevation for light (Viollet-le-Duc partially restored the four-part elevation in the first two bays of the nave). Another modernizing feature was added by later architects to the last bays on the western extension of the nave. Here colonnettes were added to the columnar piers (not visible in the illustration), enhancing the verticality of the elevation even more. Rather than presenting a modulated elevation of sculptural parts and cavities as at Laon, the nave of Paris preserves a distinctive mural character on the interior, particularly striking in its smooth, thin walls that rise so gracefully from the nave arcade.

The immense facade of Notre Dame in Paris, about 1210–

15, also is Early Gothic in the retention of the massive wall surfaces and the relatively shallow penetrations of the facade by the portals, galleries, rose window, and arcades (fig. 461). But what a beautifully integrated statement of simple geometric forms—square, triangles, and circle—it displays. In many respects, whether we think in terms of Romanesque or Gothic, this handsome, compact statement of the two-towered facade represents a majestic culmination of earlier traditions in Northern architecture.

In contrast to Paris, the facade of Laon Cathedral (fig. 456), about 1190–1205, is a daring experiment in architectural design of a wholly different temperament. Here the austere mural character of Notre Dame in Paris was rejected for a dramatic buildup of cavernous, scooped-out, arched projections with deep galleries, open niches, telescoping turrets and pinnacles. Staggered upward, these parts create an exciting movement of architectural forms, projecting and receding as they rise in a crescendo of great towers culminating in octagonal belfries.

To add further to the rich sculptural effects of the architecture, huge sculptured bulls appear in the openings of the towers, affectionate mementoes of the beasts of burden who carted the heavy stones to the site (see fig. 457). The travel-

ing architect Villard de Honnecourt, who left us that remarkable notebook of architecture cited earlier, made a drawing of one of the facade towers (fig. 458) and remarked, "I have been in many lands but nowhere have I seen a tower like that of Laon." Other towers were planned for the Cathedral of Laon, including paired towers for the large, aisled transept porches (they form two more facades actually) and one over the crossing of the nave and transept. One unusual feature of Laon is the great rectangular choir that was added in the thirteenth century to replace an earlier round apse and ambulatory construction.

CHARTRES

The Cathedral of Notre Dame at Chartres, the first of the so-called High Gothic cathedrals in the Ile-de-France, is one of the most beloved monuments in Europe (figs. 467–84; colorplates 56–60).[24] After a fire in 1020, the learned bishop Fulbert (1007–29), poet and professor as well as theologian of great prominence, rebuilt the old Carolingian basilica with monumental proportions that included a modified westwork, a long nave with transept covered by a wooden roof, and a large pilgrimage choir with three projecting apses. Below the old church lay a huge vaulted crypt where a precious relic—the tunic of the Virgin—was displayed for the pilgrims.

In 1134 the city was again devastated by a fire in which the west front of Fulbert's cathedral was seriously damaged. A new entranceway was immediately raised. Two great towers were set out before the western doors—apparently freestanding at first—that are still notable attractions of the great church because of the disparity of their spires (see fig. 467). The north tower was begun in 1134 and raised to the base of the present spire, which was added in 1507 in a style known as Flamboyant Gothic (see p. 401). The foundations of the magnificent south tower were laid in 1145; the elegant spire was completed by 1170. With its subtle growth from the simple, square base to the octagon of the spire that seems to emerge so harmoniously, the south tower represents the culmination of Romanesque traditions for such structures.

Another conflagration in 1194 destroyed all of Fulbert's church except the twelfth-century facade and the crypt. The miraculous survival of the Virgin's tunic spurred the bishop and the chapter to rebuild their church again with even greater glory to Notre Dame. Work began immediately, and within a quarter of a century the new cathedral was raised, so that in 1220 the poet Guillaume le Breton could write, "Springing up anew, now finished in its entirety of cut stone beneath elegant vaults, it fears harm from no fire 'til Judgment Day."[25]

It is unfortunate that we do not know the name of the *magister operis* for this great project, for he truly was an architect of genius. It has been suggested that he came to head the lodge at Chartres after working at Laon, since of all

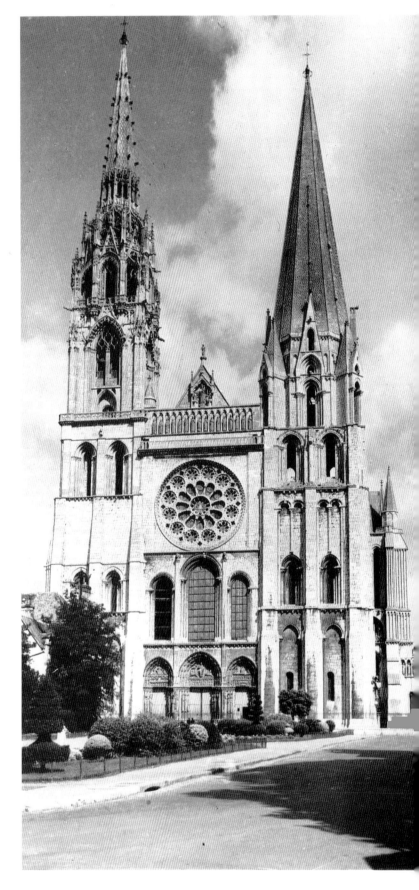

467. Chartres Cathedral. West facade. 1134–1220; portals c. 1145; rose window c. 1216; north spire 1507

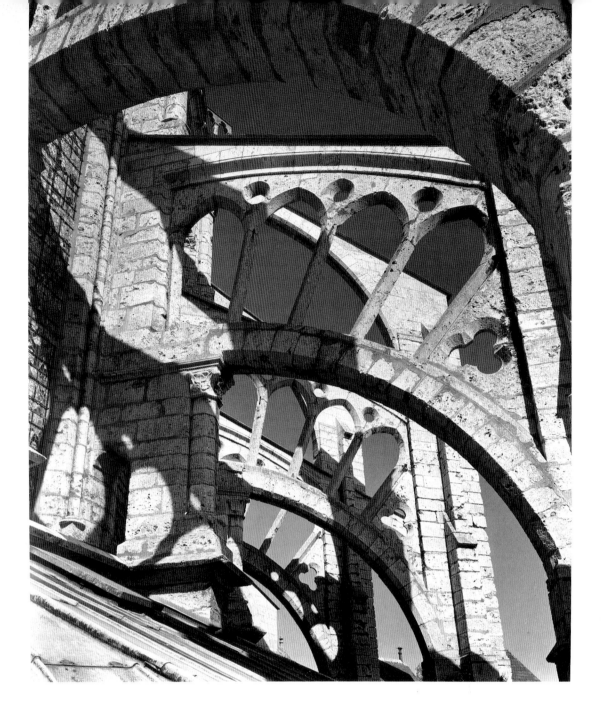

468. Chartres Cathedral. View of flying buttresses

the Early Gothic churches that seem to have served as inspiration for the new cathedral, Laon is clearly the foremost. This is evident in the complex ground plan, in the bold treatment of wall surfaces, and in the unusual proliferation of towers. The old facade remained, but the architect designed huge projecting transepts, as at Laon, to serve as major facades on the north and south sides of the church. Nine towers—Laon was planned for seven—were originally conceived: the two remaining of the west facade, two flanking each transept facade, one over the crossing, and two more abutting the beginnings of the hemicircle of the choir. These latter towers were never finished, however.

From Saint Denis came the elements of the much-expanded choir or chevet (see fig. 469). It now constitutes a third of the entire building and expands in width beyond the nave and side aisles with its double ambulatory and rings of

apsidioles with ribbed vaults. The slightly irregular spacing of the columnar supports in the choir was due to the architect's desire to incorporate the crypt and apse foundations of Fulbert's basilica over which the new cathedral was raised. Notre Dame in Paris provided one of the most significant innovations, the flying buttress, which enabled the builders of Chartres to eliminate the tiered walls in the nave (as well as in the choir) and still raise lofty vaults (fig. 468). One can, therefore, find precedents for many of the features of Chartres in churches built in the Early Gothic style, but the end result of its construction is a revolutionary statement of the cathedral. Most notable at Chartres are its colossal scale and the creative engineering exhibited. This cathedral is a giant scaffolding in stone, and the great articulated piers in the nave, the huge open walls filled with stained glass that constitutes nearly half of the elevation, and the vast spaces

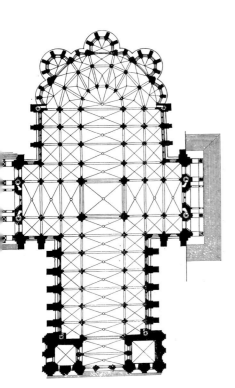

below: 469. Chartres Cathedral. Plan

right: 470. Chartres Cathedral. Interior toward the choir. 1194–1220

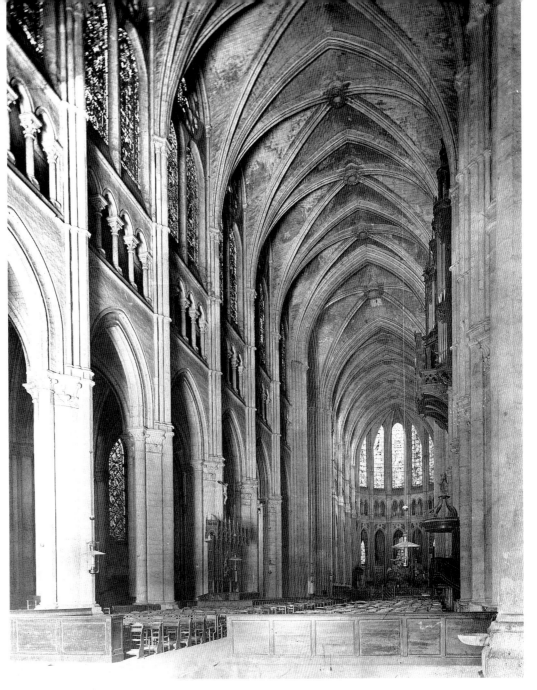

that spread and rise with compelling verticality everywhere completely annihilate any sensation of human scale.

One's first impression of the interior of Chartres is that of a marvelous unity in the vertical flow of space from the nave floor to the vaults (fig. 470; colorplate 56). A closer look reveals a number of changes and departures from the elevations in Early Gothic (see fig. 496). The tribune galleries have been eliminated entirely (this also is true of Sens); the nave piers are not columns but colossal *colonnes cantonnées* or *piliers cantonnés* (sectioned columnar or pier supports) with alternating octagonal and circular cores from which large engaged shafts (responds) project. The clerestory is enlarged to command nearly half of the elevation, with each bay between the piers (corresponding to the flying buttresses on the exterior) filled with two tall lancet windows surmounted by a rose, all glazed with colored glass. Five

clustered shafts rise uninterrupted from the capitals of the giant piers in the nave arcade through the shallow triforium to merge with the ribs of the vaults.

The alternating system has been nearly abandoned, with only vestigial forms of the system retained in the alternating circular and octagonal cores and shafts of the *piliers cantonnés,* as mentioned. The sexpartite vaults so familiar in Early Gothic churches are replaced by simpler quadripartite vaults that cover rectangular, not square, bay units. Thus the integrity of the individual bay is strongly marked throughout the longitudinal axis; the side aisles with quadripartite vaults over smaller square bays repeat the scheme, and this simplicity and unity are reflected on the exterior, where the sets of clerestory windows (two lancets and a rose) are framed by double flying buttresses in each unit. The double flying buttresses, one arcing above the other (see fig. 468),

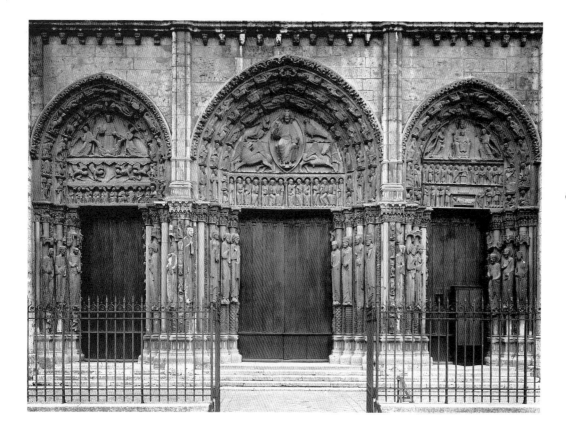

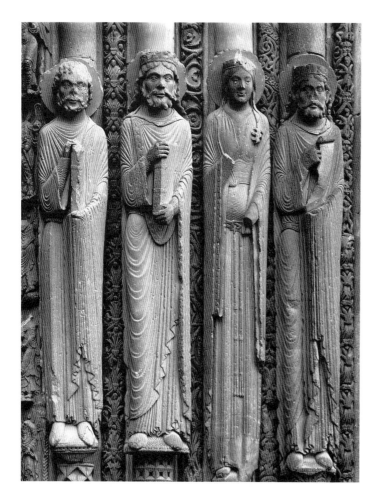

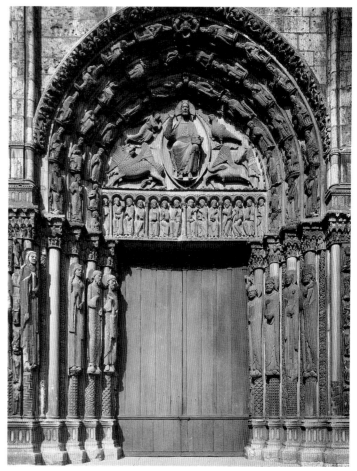

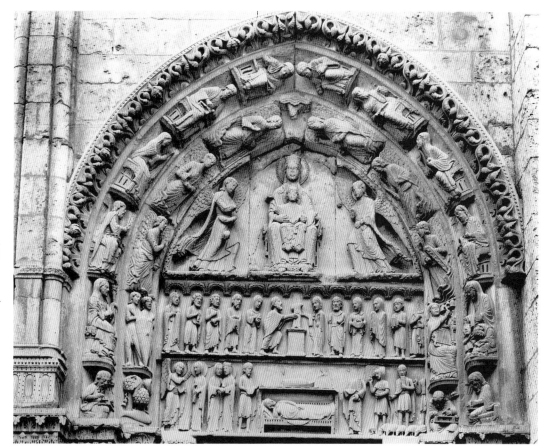

are massive, powerful struts that are tied together by round arches carried on columns like spokes between two wheel rims (the third, topmost, tier was added later), repeating a handsome architectural motif established by the great rose window added to the upper level of the western facade about 1205–10.

The transept facades are of a new design, too. A great rose window is placed over five lancets, filling the entire width of the wall between the flanking tower bases (see colorplate 58). Added about 1220–30, these windows introduce a fundamental change in the structure of the upper facade by conceiving the rose not as a punctured wall surface but as a giant circular opening in which a network of mullions or bars describe the petals of the rose outside the inner circle of columnar spokes. This intricacy and openness anticipate the elaborate windows of "bar tracery" that appear in the next generation of Gothic.

The three major building campaigns presented to us at Chartres—the earlier facade, about 1135–60; the nave and choir, about 1194–1220; and the outer transept porches, added about 1235—linking the transitional or Early Gothic with the mature or High Gothic, offer us a valuable sequence for studying the development of Gothic sculpture. The early sculptures of the west facade have frequently been linked to those at Saint Denis, and, in fact, it has been argued that the sculptor-masons moved to Chartres after completing their work on Abbot Suger's church.[26] This is evident in the close

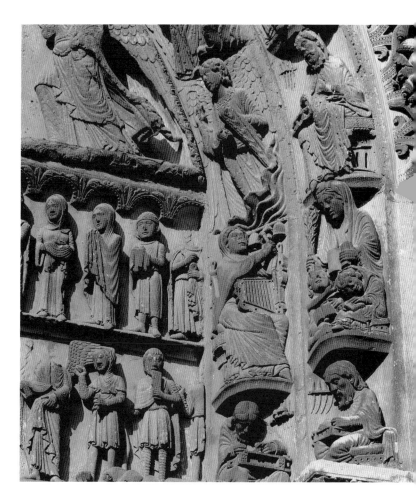

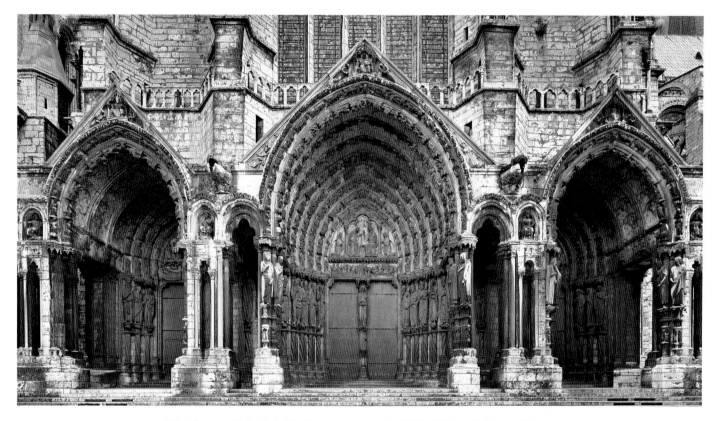

476. Chartres Cathedral. North transept portals. 1194–1220 with later additions

relationships between the column statues of Chartres and those of Saint Denis preserved in the drawings for Montfaucon (fig. 450). Twenty-two solemn figures of Old Testament precursors of Christ—kings, queens, patriarchs, and prophets, to judge by their dress—stand in regimentation across the jamb areas of the three portals (see fig. 472), and what marvelous figures they are!

The links to Romanesque style are obvious in the linear conventions employed to describe the shallow, fluted draperies and the masklike faces with tight ringlets of hair. Scale seems arbitrary, too. But more striking are the departures. Like the column statues at Saint Denis, those at Chartres are three-dimensional by virtue of the fact that they are carved on a round shaft and not a flat wall. While the geometric conventions delineating the abdomen, the breasts, the elbows, and so forth are reduced to simple circles, loops, and shallow fret-folds, these figures no longer appear as simple linear diagrams of energy; they are solid, static, and architectonic, and a sense of repose replaces the agitation and frantic movement of Romanesque jamb figures. They stand rigidly frontal and are described by simple, closed contours with little movement of body parts. A new articulation does appear, however, in some of the figures where the straight vertical folds of the under tunic, falling like so many plumb lines, is interrupted in the upper torso by diagonals of the outer mantle that lead upward and to the side. Furthermore,

the higher one lifts his eyes up the column, the more the shaftlike body is transformed into a recognizable human form. In the staring faces, the eye sockets are more deeply carved; eyelids are more naturally formed; and the mouths seem articulated with lips that slightly open.

Different hands have been discerned in these sculptures. The most talented, usually identified as the "head master," carved most of the column statues and the tympanum of the central portal with its splendid *Maiestas Domini* composition (fig. 473). One need only compare this masterful design with that of the same theme at Moissac (fig. 332) to see the revolutionary changes that were sweeping into architectural sculpture in the Ile-de-France at mid-century. The composition of the head master is balanced and controlled, with large triangular and arcing lines in the bodies of the four beasts complementing the simple ovate mandorla about the enthroned Christ. The gentle linear arcs and conventions of his ample mantle elegantly convey the serenity of his pose and noble bearing.[27]

The sculptures of the west facade present a clear and direct iconography (fig. 471). The *Maiestas Domini* appears in the central tympanum over a lintel-frieze with the twelve apostles and framed by the twenty-four elders in the archivolts. In the right tympanum appears an iconic Virgin enthroned between angels above a double register of reliefs illustrating episodes of the Infancy of Christ, proclaiming

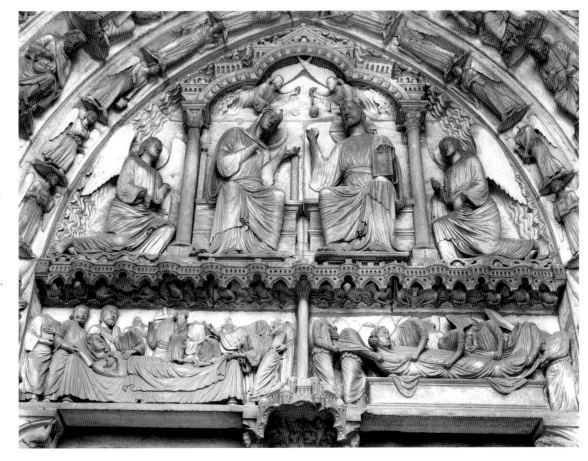

477. *Coronation of the Virgin* (tympanum of the central portal, north transept); *Dormition and Assumption of the Virgin* (lintel). Chartres Cathedral. c. 1205–15

Christ's first coming "in the flesh" with the Incarnation (fig. 474). The Virgin is portrayed as the *Theotokos,* or god bearer, and as the *sedes sapientiae,* or Throne of Holy Wisdom. This is made explicit. The narratives below her assure us that the divine god was born "in the flesh" as a man. The shepherds in the lower register appear at the Nativity to recognize his humble human nature at birth, while in the Presentation scene above, his divinity is recognized by the priest Simeon and the prophetess Hannah. Along the central axis appear the frontal *Theotokos,* the altar of the temple in the Presentation, and the mensa-crib of the Nativity with the Child placed atop it as if he were an offering at an altar, all obvious allusions to the sacramental significance of the Incarnation.

Finally, the image of Mary as the *sedes sapientiae* is augmented by the archivolt sculptures with personifications of the Liberal Arts—the trivium (grammar, rhetoric, dialectic) and the quadrivium (geometry, arithmetic, astronomy, and music)—and the authorities of these disciplines portrayed as seated scholars busy at work at their lap desks (see fig. 475).[28] The moralizing polemics of Romanesque themes thus give way to statements of doctrine; dynamic composition is replaced by diagrammatic clarity; and distortion of figures is rejected for composure.

The subject matter of the left tympanum, in accord with the idea of Christ's First and Second Coming in the flesh presented in the other two, is the Ascension, a theme closely related to that of the Second Coming, as we have seen, but here it alludes to Christ's resurrection "in the flesh." As at Vézelay (fig. 352) the mystery of the Ascension is footnoted in the archivolts with representations of the signs of the zodiac and labors of the months (two of which—Pisces and Gemini—are curiously displaced in the right portal). Finally, the capitals above the column statues of the Old Testament precursors narrate details in the lives of Mary and Christ in the fashion of an unwinding scroll of sculptures.

The fire of 1194 destroyed all but the west facade, and it is to the north transept that we move for the next sequence of sculptures at Chartres (fig. 476). Two dates are important.[29] It is generally agreed that the decorations of the north transept were planned and executed after 1204, when a precious relic was acquired, the head of Anne, the Virgin's mother (brought back from Constantinople after the Fourth Crusade), since the program for the central portal is dedicated to the Virgin, with Saint Anne on the trumeau carrying the infant Mary in her arms. The transept entrances were apparently finished by 1220, since we learn from the verses of Guillaume le Breton that the church was complete under stone vaults by that year, and, furthermore, documents of 1221 inform us that the canons of the church were occupying the choir stalls by then. Hence, the first sculptures should date between 1204 and 1220.[30] Work progressed rapidly, and the outer porches were completed by about

1230. The sculptures on the three portals of the southern transept were begun shortly after those on the north, about 1210–15, with additions to the jambs as late as 1235–40. The entire campaign, therefore, was uniformly carried out over a period of some thirty years, and the iconographic scheme seems intact.

The north transept, as Emile Mâle has pointed out, was devoted to the Virgin and her role as the link between the Old and New Testaments. This is emphatically announced in the central portal. The monumental Coronation of the Virgin as queen of heaven is presented in the tympanum, the genealogy of Mary and Christ in the Tree of Jesse appears in the four ranges of the archivolts, and, finally, important precursors of Christ from the Old Testament are lined along the jambs.

The Coronation of the Virgin was a relatively new theme,[31] but it was destined to become one of the most important Marian subjects in Gothic art (fig. 477). In a superbly balanced composition, Mary and Christ are enthroned side by side under a trefoil church facade and flanked by angels. Another row of angels appears in the first range of archivolts. Below, on the divided lintel block, are representations of the death and assumption of the Virgin. These three episodes—Dormition, Assumption, Coronation—were usually presented together as major events celebrated in the Feast of the Assumption of the Virgin (August 15), the principal devotion to Mary in the church calendar.

The statues on the jambs are especially fascinating (see figs. 478, 479). They can all be identified, as they carry specific attributes and stand atop figured consoles that allude to events in their lives. Also they are clearly differentiated as to types by facial features and costumes, and they are linked iconographically across the portals. On the far left stands the priest Melchizedek, who, as we have seen, is the

478. *Melchizedek, Abraham, Moses, Samuel, and David.* Left jamb, central portal, north transept, Chartres Cathedral. c. 1205–15

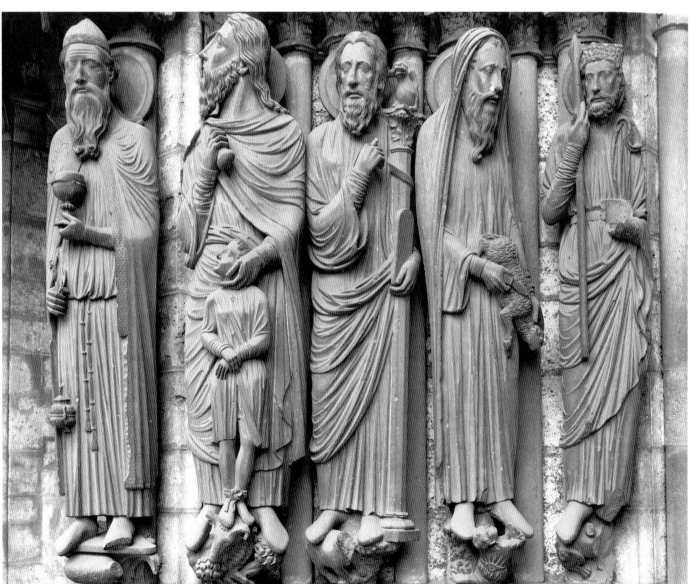

archetypal figure of Christ-priest in the Old Testament. He wears a miter and carries a censer. Directly opposite Melchizedek, on the far right, appears Saint Peter (identified by the keys and papal vestments), the first successor to Christ-priest in the New Testament. The second on the left is Abraham, about to sacrifice his son Isaac, another Old Testament figure for the sacrifice of Christ in the Mass, while opposite him stands Saint John the Baptist holding a disk with the sacrificial lamb—"Behold the Lamb of God"—another allusion to Christ's sacrificial role. These are followed on the left by Moses with the tablets of the Law, Samuel, and King David, while opposite them appear Simeon the high priest, and the prophets Jeremiah and Isaiah (from whom the Tree of Jesse, his prophecy, in the archivolts derives). Thus the jamb figures serve as Old Testament types of Christ as *priest* (Melchizedek et al.) and *king* (David and the royal lineage in the Tree of Jesse). A learned theologian

above: 480. *John the Baptist.* Detail of fig. 479

below: 479. *Isaiah, Jeremiah, Simeon, John the Baptist, and Peter.* Right jamb, central portal, north transept, Chartres Cathedral. c. 1205–15

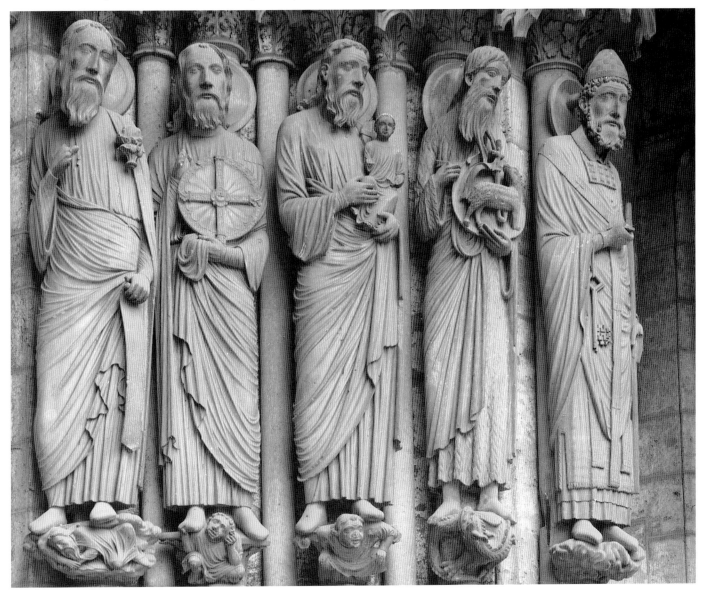

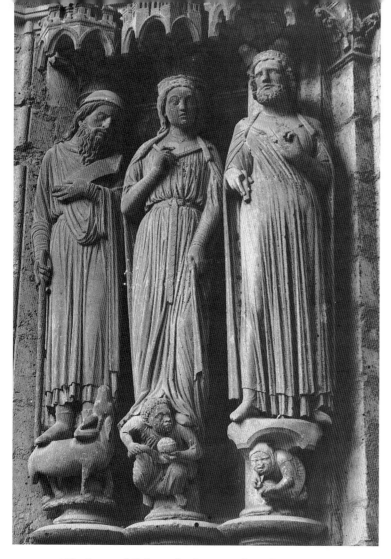

481. *Queen of Sheba and Solomon.* Left jamb, right portal, north transept, Chartres Cathedral. c. 1215–20

must have devised this comprehensive program of sculptures.

The jamb figures, dating about 1204–10, offer us an excellent opportunity to study the development of style from the earlier statues on the west facade, which date from about 1145–55. Similarities are at once apparent. The rigid frontality of the tall figures persists, as does the shallow carving of the draperies, which reminds us of fluted columns. The statues are tightly contained within closed contours, and their feet are turned downward into the consoles to further accentuate their function as columnar supports subordinated to the architecture. But the differences are striking. There is a uniformity in scale and more naturalistic proportions in the north transept figures no matter how tall and thin they may seem. Their bodies can move slightly now. Abraham stops and looks up across his space into the canopy over the head of Melchizedek, where the angel appears. Samuel turns to look directly across the portal at his counterpart on the right. And the drapery falls in long sweeping arcs and softly modeled grooves that are varied in the depth of carving.

The rudimentary formula for the draped figure, barely discernible in the jamb figures on the west facade—the vertical lines of the undergarment crossed diagonally by the outer mantle—is now evident in the figures of Moses and David and all five figures on the right. With this greater articulation comes a new naturalism. While far from being individualized portraits, the north transept figures are all recognizable types: the hollow-cheeked, elderly prophets and patriarchs with long tapering beards; the determined middle-aged leaders of the community, David and Saint Peter, with short, bristly beards and intense stares; and the emaciated hermit lost in dreamy contemplation, Saint John the Baptist (see fig. 480).

The figures on the jambs in the left portal, which is dedicated to events in the Infancy of Christ, are even more naturalistic. Mary and Elizabeth, in fact, now perform a little drama, the Visitation, on the jambs and turn to one another with an exchange of glances. Their feet rest firmly on consoles, and the architectural backdrop resembles a miniature stage on which the figures move and respond across the space of the portal.

These developments are even more apparent in the jamb figures on the right portal, which is devoted to Old Testament precursors and prefigurations: the suffering of Job in the tympanum; stories of Samson, Esther, Tobias, Gideon, and Judith in the archivolts. Wilhelm Vöge found the next steps in the liberation of sculpture from the architecture in the figures of Solomon and the Queen of Sheba (fig. 481).[32] He particularly noted the slight indications of *contrapposto* (twisting of the body off axis) in the projecting hip of Solomon, the wide stance, the movement of the arms, and attempts to reveal the protrusion of the body beneath the heavy drapery. Curiously, the sculptor who carved this figure placed the vigorous head of Solomon on the supple torso of a female figure.

The south transept sculptures show a greater uniformity in style. The atelier responsible for the central portal sculptures on the north apparently moved to the south side, where a series of New Testament saints were carved for the three portals there about 1210–20. The four outer jamb statues on the side portals obviously were added later by another shop about 1230–35. The side porches were dedicated to the martyrs (left) and the confessor saints (right) with appropriate themes in the tympana (the martyrdom of Stephen; stories of Saint Martin and Nicholas). The central portal presents Christ on the trumeau, the apostles on the jambs, and an impressive Last Judgment in the tympanum. This is a new program for portal decorations, and it is particularly appropriate for an age dedicated to the communal spirit of the church, for here Christ and the community of the apostles form the ideal model for Christian society. We will return to the iconography of the tympanum later at Amiens.

There is something dry and monotonous in the blank

countenances of these figures and in the repetitious treatment of the draperies, and, with the exception of some variations in costuming, this is true of the martyrs and confessors on the jambs of the side portals as well. The four outer statues, however, are surprising members of this community. The handsome warrior martyr, Saint Theodore (fig. 482), is a marvelous idealization of the "true and perfect" Gothic knight as he stands in a relaxed pose on the flat console. He wears the chain-mail armor of contemporary crusaders. Beside him stands the bland Saint Stephen, a work of the earlier carvers, 1210–20.

Complementing the iconography of the sculptures are the themes presented in the stained-glass windows of the clerestory and the side aisles (figs. 483, 484; colorplates 56–60).[33] The three lancets of the west facade are the earliest, about 1150–60, and give us some idea of the splendor of Suger's famous windows, known only in restorations at Saint

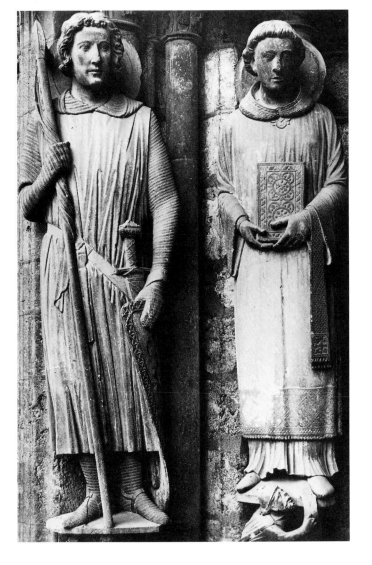

482. *Theodore* (1230–35) and *Stephen* (c. 1220). Left jamb, left portal, south transept, Chartres Cathedral

Denis. Stained glass has too often been treated marginally in the study of Gothic architecture. Much of it has been destroyed, and those windows that have escaped the ravages of time are usually so inaccessible that their rare stylistic qualities are difficult to study. But it should be remembered that the Gothic interior is not the diagram of structure that we see on the exterior, and in churches where we have only natural light illuminating the nave, our impressions are hardened and misleading. In Chartres, the one cathedral where the stained glass has survived nearly in its entirety, the effect is very different.

The deep colors—perhaps the most intense colors ever achieved in art—constantly change our perceptions of space and the visibility of the parts. The nave becomes a diaphanous, shimmering, structural web wrapped in veils of color that seem to float in layers with a "delirium of coloured light," as Henry Adams so described the windows of Chartres. Light is the medium here, and the closest comparisons that can be found for its mysterious qualities are in the bright "illuminations" in Gothic manuscripts, in mosaics, or, even more so, in the brilliant world of bejeweled golden objects and iridescent *cloisonné* enamels.

The *cloisonné* technique is, after all, somewhat analogous to that employed in composing the glowing panes of glass with leaden bars in cathedral windows. But there is more to consider. Scholars have often pondered the relationships between the metaphysics of light in Christian philosophy (cf. Saint Augustine) and mysticism (Pseudo-Dionysius the Areopagite) and that of the visual sensations of stained glass.[34] To what extent did the "light of the mind" influence this "light of the senses"? This much can be said: Colored light completely transforms the style of the Gothic interior, and that style immediately brings to mind Abbot Suger's writings. In his description of the anagogical manner in which the mind is transported from the material to the immaterial, from the earthly sphere to an otherworldly one, through the contemplation of the "lights," we have a contemporary account of the effects of pure color on the beholder.

The windows in the nave (see colorplate 56) were added as the building progressed, and the greater part of the interior would have been filled with stained glass by the time of its final consecration in 1260. The Chartres glass workshops were especially renowned. Villard de Honnecourt was attracted to the great rose of the west facade. Viollet-le-Duc, who devoted a lengthy chapter in his dictionary to these windows, acclaimed the "blue windows" of the facade as masterpieces of the craft. The later windows in the nave and choir have a marvelous reddish-violet tonality for the most part, although in a number of them, especially in the chevet, the depth of the blue forms an astonishing contrast to the brighter reds, yellows, and greens that seem to float atop it. One actually experiences color in three dimensions with the more intense colors emerging from a sea of blue tonalities.

Of the 186 stained-glass windows in Chartres, 152 are still in place. The overall scheme for the iconographic program conforms generally to that of the sculptures on the exterior, although the Virgin receives far greater attention in the windows. The western lancets and rose (colorplate 57) honor Christ and Mary. The north transept "Rose of France" has Mary and Christ surrounded by the Tree of Jesse, while the lancets carry standing figures of Saint Anne and other Old Testament persons (colorplate 58); the southern rose has a Last Judgment with portraits of the Evangelists carried on the shoulders of prophets in the lancets flanking the Virgin. The tall windows that fill the clerestory are glazed with single standing saints, analagous to the jamb sculptures, while in the lower side aisles and in the choir historiated windows appear that can be read as one might peruse miniatures in a manuscript.

Due to the countless sections of these windows, narrative possibilities are multiplied as they are in the more marginal areas of the sculptures. It is, however, difficult to "read" the histories since the light obliterates the heavy outlines of the bars that define the figures and settings. The window be-comes a transparent oriental carpet hanging on the wall, a web with confettilike patches of sparkling colors. But they can be read, and the wealth of subject matter is astonishing, ranging from Biblical stories and lives of saints (often those commemorated in the sculptures) to parables and even epic stories (for example, the Charlemagne window).

The colored glass is made by adding minerals to molten silica in molds of round or square "tables." The individual sections are then shaped or cut from the "tables" by hot rods and are pieced together with lead into armatures of geometric forms—squares, circles, semicircles, rhomboids, quatrefoils, etc.—that, in turn, are clamped to a rigid grid of horizontal and vertical bars embedded in the walls (see colorplate 57). In these earlier windows only the heavy leaden outlines describe forms and figures (other than the few facial features and general lines of the drapery folds that are painted in lead oxides and then fired for permanency).

This is the pictorial world of French Gothic painting par excellence. Space is nonexistent. Shading and modeling are minimal. Flat shapes of color, defined by dark outlines, create a transparent world for the narratives. With some of

483. *Adoration of the Magi.* Detail of stained-glass window. West facade, Chartres Cathedral. c. 1150–70

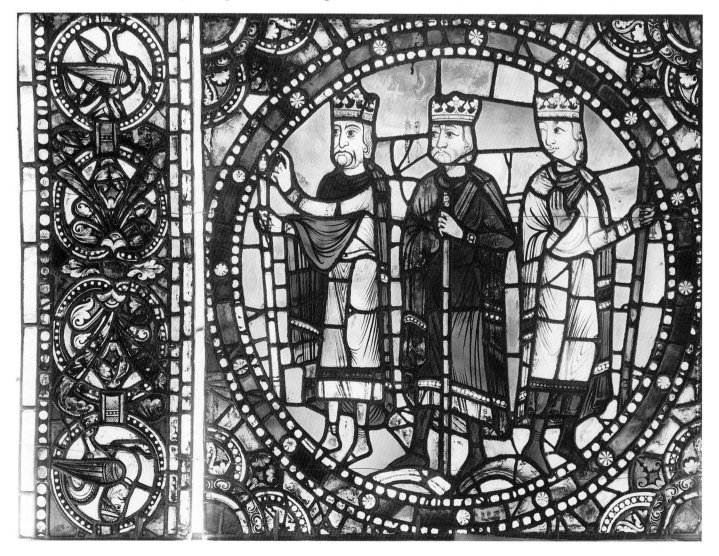

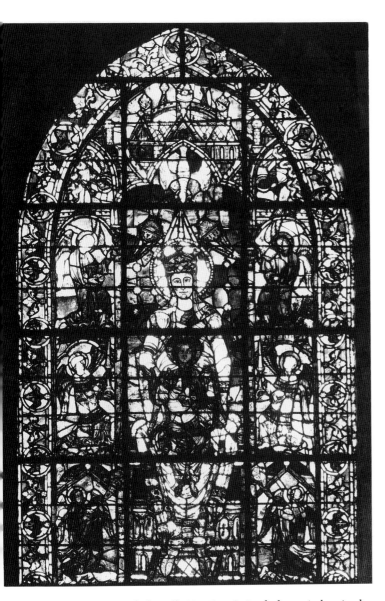

484. *Notre Dame de la Belle Verrière.* Stained-glass window in the choir, Chartres Cathedral. 16′ × 7′8″. Center, c. 1170; sides 13th century. See also colorplate 59

the larger figures, such as that of the *Notre Dame de la Belle Verrière* (fig. 484; colorplate 59), the spacelessness creates a stunning sensation of pure form in color residing between the spectator and the dark wall. This window—one of the most famous at Chartres—also provided inspiration for many later images of the majesty of the Madonna in Gothic art, including those in Italian panel painting.

The expense of this craft must have been astronomical, and it is interesting to note that the patronage clearly reflects the communal society of the Gothic age. Wealthy royalty provided the finances for the huge rose windows; lesser nobles and members of the clergy donated funds for a number of the lancets; but by far the greater number of windows were sponsored by the laboring class of Chartres, the guilds of the bakers, wheelwrights, weavers, furriers, goldsmiths,

carpenters, and others, and they left "signatures" in the form of marginal representations of their craftsmen at work (see colorplate 60). In this way, the rising working class, the new urban component in the estates of Medieval France, make their initial contribution to art history as patrons.

One of the finest accounts of the colored windows of Chartres is found in the memorable book by Henry Adams, *Mont-Saint-Michel and Chartres,* and while too romantic and poetic for the tastes of many modern scholars, his remarks regarding the mysterious quality of the stained glass of Chartres deserve quoting here: "One becomes, sometimes, a little incoherent in talking about it; . . . one loses temper in reasoning about what can only be felt."[35]

AMIENS

The architectural developments after Chartres were consistent but subtle. The tripartite elevation of the nave (nave arcade, triforium, and clerestory), the quadripartite vaults, the elaborate chevet, the flying buttresses, and the enrichment of the portal sculptures were the basic features of High Gothic in northern France. A final solution for the nave, if such is possible in Gothic, was achieved at Amiens (figs. 485–87).[36] A pronounced lightness in the interior is created by the soaring arcade of slender articulated piers rising some seventy feet. The shafts have no heavy capitals to break their rise, and the sensation of ponderous supports and weighty walls is lessened. In the clerestory a new form of window in bar tracery appears, a borrowing from the architect of Reims Cathedral. The clerestory is three-eighths of the elevation and actually merges with the narrow triforium with its stained glass.

With each step the Gothic builders reached higher (see fig. 496). Paris and Laon are approximately 78 feet from the floor to the summit of the vaults; Chartres rises 118 feet; Reims reaches 123 feet; and Amiens, 139 feet. But this dramatic sense of verticality is partly illusion. The width of the nave of Amiens is 49 feet, which means that the ratio of the width to the height is about 1:3, an unprecedented narrowing of the vast space that greatly accentuates the upward thrust. At Paris the ratio is 1:2.2; at Chartres and Reims approximately 1:2.4. Thus Amiens presents the ultimate in Gothic verticality.

The earlier cathedral at Amiens had been destroyed by fire in 1218, and two years later Bishop Evrard de Fouilloy laid the foundations for the new building. Inlaid in the pavement of the nave was a giant octagonal labyrinth (destroyed in 1825), an attribute and symbol of the architect—it was derived from the plan of the legendary labyrinth at Minos designed by the mythical ancestor of all architects, Daedalus. In the center of the labyrinth was a stone inscribed with the names of the three architects who directed the building to the year 1288: Robert de Luzarches, Thomas de Cormont, and the latter's son, Renaud de Cormont (Chartres

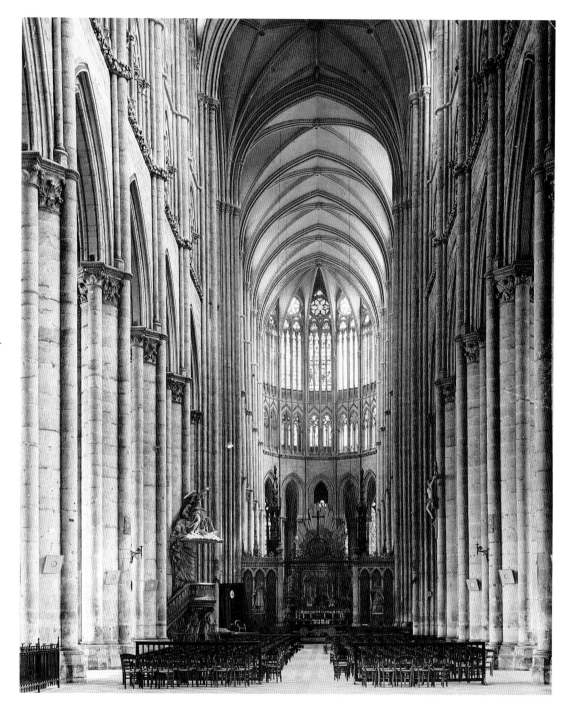

485. Amiens Cathedral.
Interior of the nave.
Begun 1220

has a similar labyrinth, but unfortunately no traces of the signatures are visible). The nave was raised and vaulted by 1236; the superb choir was completed by the second architect, Thomas de Cormont, by 1270.

Although harmoniously integrated in plan with the nave and aisles of the transept, the seven chapels of the choir display a new type of elevation with three sets of paired lancets and a rose in each that rise to the ambulatory vaults from the lower floor arcade uninterrupted by a triforium. This introduces even more transparency and lightness in the choir elevation. It has been suggested that Thomas de Cor-

mont later developed this new Gothic vocabulary, called the *rayonnant* style, in designing Sainte-Chapelle in Paris (fig. 507; colorplate 62), but this is not certain.[37]

The facade of Amiens (fig. 488) rises over the viewer like a staggered cliff of porches, galleries, and towers. Compared to the exquisite unity of the nave elevation, the facade is an array of storied elements that seem at odds with the interior. Perhaps it was the difficulty Luzarches faced in aligning the parts of the facade with the interior disposition of the tall nave and side aisles that led to this disparity. Three galleries are stacked over the huge portals. The lowest is punctured by

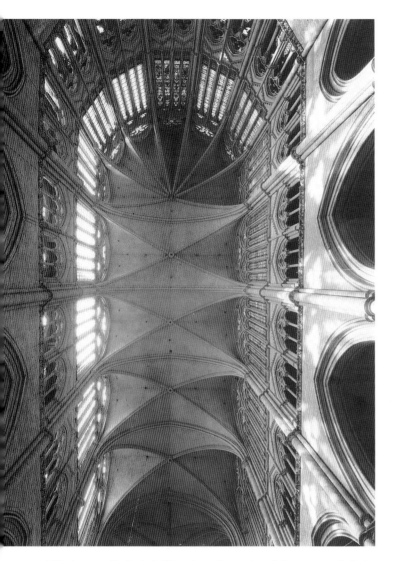

486. Amiens Cathedral. View into the vaults of the nave and choir

iconographic program is, in many ways, a compendium of what we have seen before at Chartres. The central portal, like that of the south transept of Chartres (c. 1210–20) and the (restored) west facade of Paris (c. 1220–30), features an elaborate scheme with Christ on the trumeau, the apostles on the jambs, and a Last Judgment in the tympanum. Thus the ideal Christian community commands the major entranceway.

The left portal is dedicated to Saint Fermin, an early bishop of Amiens, and other local saints. The right portal (figs. 489, 493) is devoted to the Virgin with a Coronation in the tympanum (partly copied from the one on the left portal of the facade at Paris). The Virgin on the trumeau, handsome figures of the Queen of Sheba and Solomon, the three Magi with Herod on the left jambs, and the Annunciation, Visitation, and Presentation in paired statues on the right recall those figures on the jambs of the north transept at Chartres.

487. Diagrammatic section of Amiens Cathedral with names of the parts in the elevation (after Viollet-le-Duc)

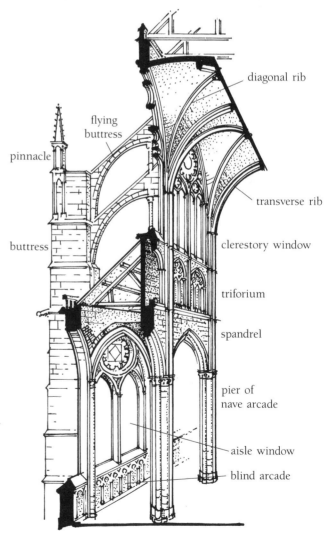

deep arches with stained glass opening on the side aisles; the middle gallery is open; and the uppermost forms a setting for the sculptured "kings." The great rose window was then lifted to the top of the center block (its tracery is later), and the two towers were added only in the fourteenth and fifteenth centuries.

The three deep porches, reminiscent of those at Laon, are filled with sculptures, and it is the stately procession of tall jamb figures that brings unity to the base of the facade at eye level. A continuous row of statue columns undulates in and out of the portals and around the projecting buttresses between them. Decorative quatrefoil reliefs stretch like a carpeted runner across the podia beneath the statues (see figs. 445, 446), and above them the deep vaults of the porches are lined with countless archivolt sculptures.

The sculptures of Amiens (figs. 489–94) display a unity of style and iconography that could only have resulted from a speedy and concentrated campaign led by Luzarches. The

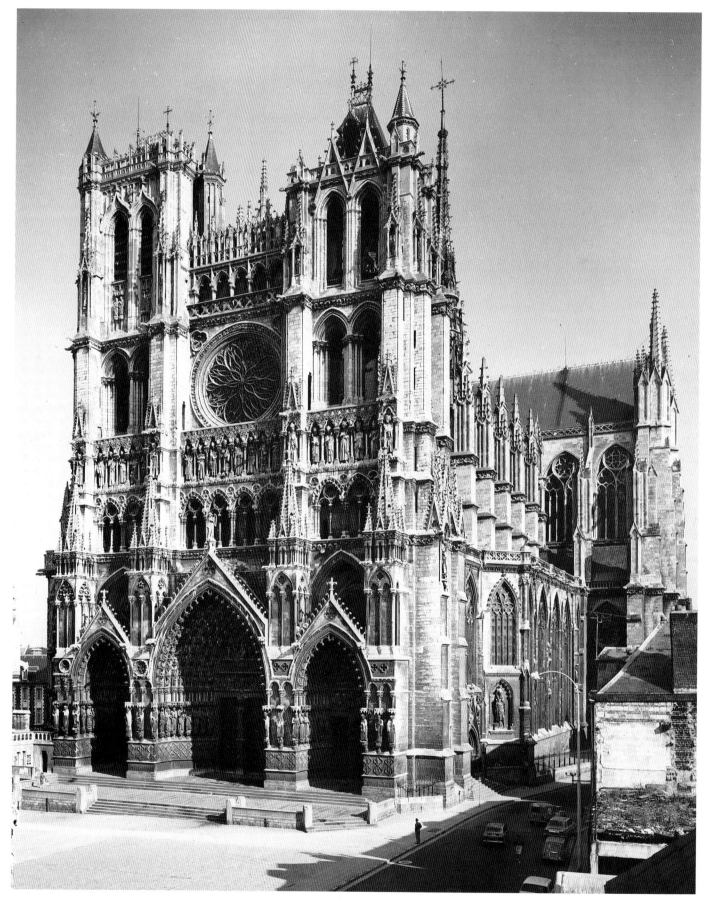

488. Amiens Cathedral. West facade. Begun 1220

blessed and the damned is presented in the next zone directly below Christ, and in the lowest register Saint Michael and two angels blowing trumpets announce the resurrection of the dead.

The Last Judgment presented in the tympanum spills over into the six ranges of archivolts capping it. The lowest row is filled with the blessed led by angels to the heavenly Jerusalem on the left; the damned are tormented by personifications of Luxuria and Avaritia, boiled in a caldron, and ravaged by two of the Apocalyptic horsemen on the right. Ranged concentrically above these are rows of standing angels, seated figures of martyrs, confessors, virgin saints, and the twenty-four elders, comprising the assembly of All Saints in heaven. The drama of the Last Judgment staged in four or five distinct acts as described by the encyclopedists is thus elaborately performed by countless figures at Amiens. Only the figure of Christ as judge, bared to the waist and displaying the wounds he suffered for man's salvation—a type sometimes called the Man of Sorrows—significantly departs

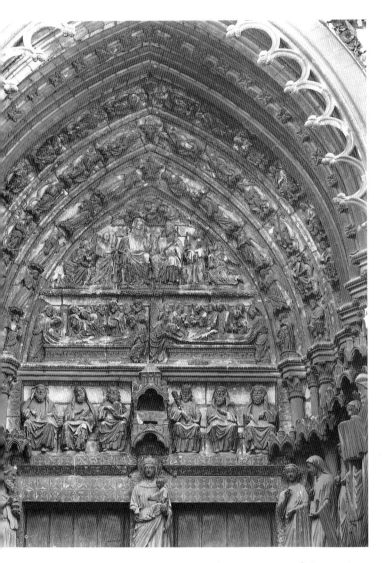

489. *Coronation of the Virgin* with the *Dormition* and *Assumption*. Right portal, west facade, Amiens Cathedral. 1220–30

Thus the ideal scheme proposed by Emile Mâle for the three sides of the cathedral—Christ on the west, Mary on the north, saints on the south—is here compressed into a single facade. However, there is one contradiction in the ordering at Amiens: the sculptures of the two side portals should be exchanged to maintain the Virgin's position of honor on the north side of the church.

The great Last Judgment tympanum (fig. 490) is an expansion of those at Chartres and Paris. Here a profusion of small figures in four registers detracts from the bold hieratic statements found earlier. In the topmost tier under the gable appears the One in heaven, between the sun and the moon, with a sword issuing from his lips, just as described in the opening lines of Revelation (1:16). The commanding figure of Christ as judge appears below, flanked by the kneeling intercessors, Mary and John the Evangelist, and by angels carrying instruments of the Passion. The division of the

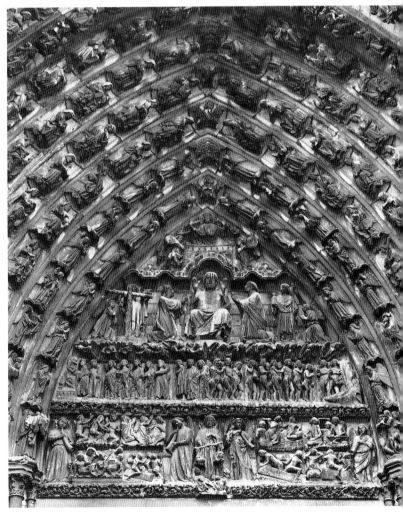

490. *Last Judgment*. Central portal, west facade, Amiens Cathedral. 1220–35

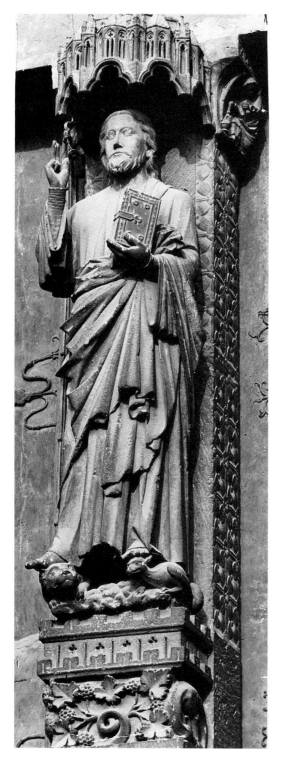

491. *Christ (Le Beau Dieu)*. Trumeau, central portal,
west facade, Amiens Cathedral. 1220–35

restored so that only a few can be identified accurately). A double row of quatrefoil relief sculptures on the podia beneath the apostles illustrate the Virtues and Vices (see fig. 446); the doorposts flanking the trumeau repeat another familiar subject that appears with the Last Judgment, the Five Wise and Five Foolish Virgins. The column statues in the outer extensions of the jambs, actually the projecting wall buttresses, are Old Testament prophets beneath whom are quatrefoil reliefs with unusual narratives pertaining to their missions and prophecies.[39]

The sculptures on the jambs and trumeau represent the culmination of a concept that we first saw on the south portal of Chartres—the ideal Christian community. It has been suggested that the sculptor who led the workshop had earlier worked on the south transept at Chartres, then on the west facade of Paris, before settling at Amiens about 1220–35. The uniformity of style in the sculptures across all three portals further suggests that he was in charge of the entire project for the west facade. The handsome Christ on the trumeau (fig. 491), known as *le Beau Dieu,* is his masterpiece and serves as a model for High Gothic style in general.

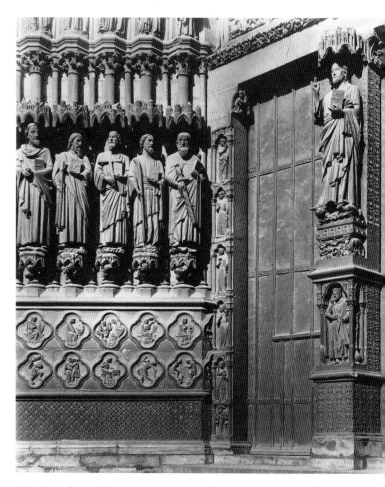

492. *Apostles* and *Virtues and Vices.* Left jamb, central portal, west
facade, Amiens Cathedral. 1220–35

from the terrifying vision of doomsday presented at Autun Cathedral a century earlier (fig. 358).[38]

The most impressive assembly of sculptures at Amiens is that of Christ on the trumeau of the central portal and the apostles that flank him on the jambs (these have been poorly

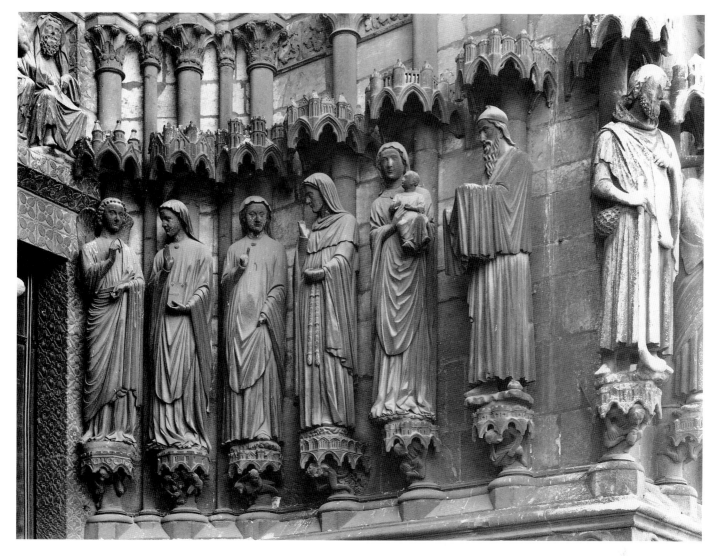

493. *Annunciation, Visitation, Presentation.* Right jamb, right portal, west facade, Amiens Cathedral. 1220–30

The Gothic formula for the draped figure is clearly stated in the massive folds that mark out the solid core of his body, but now the treatment is truly sculptural, with the linearism still found in the Chartres figures giving way to deeply grooved folds with irregular contours that create a dramatic sensation of light playing across a heavy, textured garment. The diagonals that sweep across the body from the left, no longer lines stretched across the torso, form intricate pockets of deep folds that seem to break under their own weight, falling one into the other in scooped-out cavities. The beauty of the head of *le Beau Dieu* resides in the symmetry of his features and the smooth, broad planes in the modeling of the cheeks and forehead. His piercing eyes stare out from deeper sockets, and his lips and chin are firmly set (see fig. 440). *Le Beau Dieu* of Amiens is a stern yet benevolent leader of his community.

The apostles have suffered from restoration, but their integration into the portal is masterfully realized. They turn more naturally on their pedestals as individuals, and yet they all share a common goal as they attend their leader, *le Beau Dieu,* reverently (fig. 492). The jambs on the Virgin's portal (right) have been described as the first products of the master's shop at Amiens (fig. 493). In these figures the drapery folds are not so plastically conceived or deeply carved; they are rendered as regular indentations with hard edges repeating certain geometric patterns, such as the falling V or chevron motifs in the dress of the Virgin in the Annunciation and Visitation.

A later generation of sculptors from Reims (or Paris?) added life and grace to the mold at Amiens, however. The charming *Vierge dorée* (fig. 494), about 1260–70, on the south transept portal, so named because of the gilt that originally covered the figure, seems coy and capricious compared to the earlier figures of Mary at Amiens. Her body

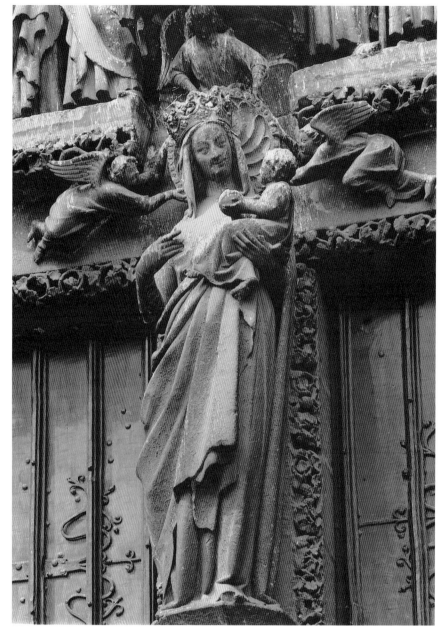

494. *Virgin and Child (Vierge dorée)*. Trumeau, south transept portal, Amiens Cathedral. c. 1260–70

sways gracefully, with the upper torso twisted off axis and her left hip raised to support the playful child. This contortion also allows the drapery to cascade in deep shelflike pockets beneath her right arm.

A slightly earlier Virgin on the north porch of Paris (fig. 441), about 1250, shares some of these same traits, but the latter displays a regal pose and a more matronly personality, a true queen of the court, and her position on the trumeau is beautifully coordinated with the architecture. In comparison, the *Vierge dorée* is no longer conceived as a jamb or trumeau figure at all but as an independent statue placed on the cathedral in a position that breaks across the trumeau and the lintel of the tympanum. She is characterized as a young, dimple-cheeked mother who is intimately involved with her infant, playing with him in fact, as she looks downward and smiles happily.

REIMS

For many, the Cathedral of Notre Dame at Reims is the most beautiful monument of the Gothic age (figs. 438, 495, 497–503; colorplate 61). Who can approach the portals of the

495. Reims Cathedral. Plan (after Frankl). Begun 1210

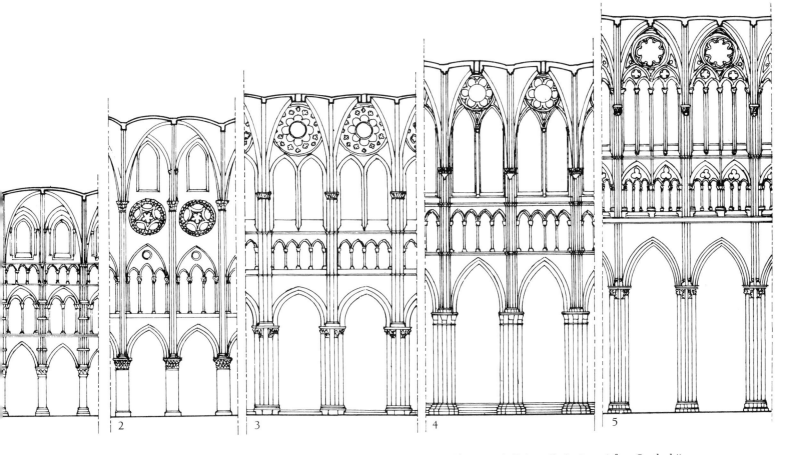

2 3 4 5

496. Comparison of nave elevations in the same scale: 1. Laon; 2. Paris; 3. Chartres; 4. Reims; 5. Amiens (after Grodecki)

west facade without feeling a sense of enchantment and happiness in the world? A smiling angel (fig. 502) greets you at the doorway, and countless exciting aspects of architecture and sculpture inform you on every side of the beauty of Gothic art. The scope and diversity of the sculptures that grow and spread like flowers in a gigantic trellis surpass that of any other site, and the lofty towered facade is breathtaking in its elegance and order.

Few dates can be pinpointed with regard to the construction of Reims Cathedral.[40] As the seat of the largest archdiocese in France, Reims was the coronation church for the French monarchy. It, like Chartres, had been the home of an important school, especially famous for the sciences, and from Carolingian times Reims had flourished as a center of the arts. The old cathedral burned in 1211, and the foundation stone of the new church was laid in that same year by the archbishop Aubri de Humbert. A seventeenth-century drawing preserves the labyrinth in the pavement of the nave and the names of the "masters of the works" in the thirteenth century, apparently in the chronological order of their activity: Jean d'Orbais, Jean le Loup, Gaucher de Reims, and Bernard de Soissons. Between 1233 and 1236 civil strife in Reims disrupted the building activities, and this interlude perhaps marks an important shift in the planning of the sculptured portals and the designing of the transepts and choir. Major restorations were carried out in 1611–12, and considerable damage was done to parts of the cathedral during World War I.

In plan (fig. 495) Reims displays a condensation and stricter alignment of the spatial divisions found at Chartres. The long nave with its single aisles has nine rectangular bays with quadripartite vaults. The transept now becomes part of a huge chevet by simply doubling the side aisles and continuing them into the choir, where the outer aisle is transformed into five radiating chapels in the hemicircle of the apse. Porches were planned for the north and south sides. The choir and transept must have been completed by Jean d'Orbais's successor in 1241, when the canons of Reims are recorded as occupying the choir.

The interior (colorplate 61) is, at first sight, a taller, narrower version of Chartres. The arches of the nave arcade are pitched higher, the divisions in the triforium are light and slender, and the clerestory is enlarged to three-eighths of the elevation. While not as lofty as Amiens, Reims (123 feet high) nevertheless demonstrates the logical development toward taller, higher, and lighter elevations (see fig. 496). A major innovation, perhaps by the architect Jean d'Orbais, appears in the design of the clerestory window. Whereas at Chartres the window complex of two lancets surmounted by a rose is an independent unit imposed on a wall, that at Reims is designed as an open space in the bay with the divisions of the window constructed of stone mullions (bar tracery). The lancet and rose punctures of Chartres become a latticelike construct of arches and petals filled with stained glass at Reims. The bar tracery of the Reims windows became the final solution for fenestration in Gothic architecture. It was this system that was employed at Amiens and most later Gothic cathedrals.

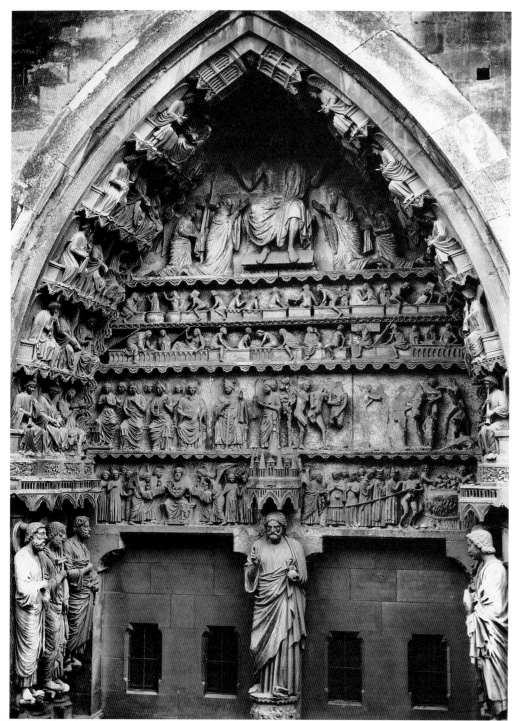

left: 497. *Last Judgment* (tympanum), *Christ* (trumeau), and *Apostles* (jambs). Judgment portal, north transept, Reims Cathedral. c. 1230

opposite: 498. Central portal, west facade, Reims Cathedral (sculptures installed c. 1245–55)

The facade of Reims (fig. 438) is a glorious and, in some ways, an ultimate statement of the grand tradition of regal, two-towered structures in northern Europe. The perfect geometry of Paris lies beneath the proliferation of pointed architectural forms, and yet the dramatic sculptural treatment of the deep porches, the penetrations and telescoping pinnacles that we see at Laon are here, too. The scaffolding of the facade has never been so successfully achieved, and, in fact, Reims resembles a huge open shrine rising majestically with pointed arches repeated and multiplied at every stage. A huge rose window, itself framed within a pointed arch, centralizes the entire block, and its center is touched by the soaring pinnacle of the central portal with its triangular projection rippling off to the side portals and corner buttresses. The deep porches are carved away, and diverse figures appear everywhere; the tympana are now openings into which stained-glass windows are set to complement the great rose above. Sculptures that usually fill the tympana are moved to the gables above. Except for the high king's gallery at the base of the towers, no horizontal lines are maintained,

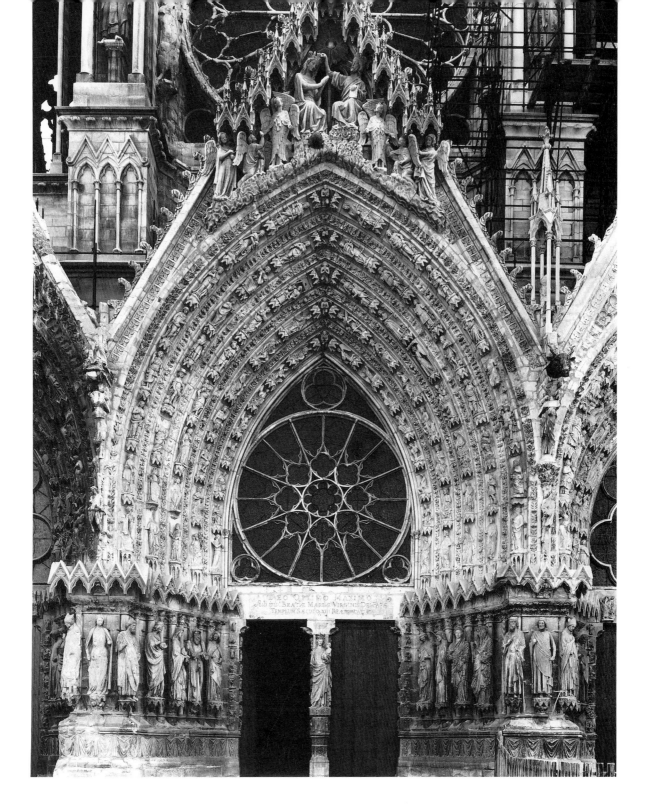

and yet the harmony of the architectural divisions between the facade and the interior elevation is beautifully expressed. And everywhere there is sculpture!

The diversity of sculptures at Reims is astonishing, but there are thorny problems for the art historian who wishes to study their programming and stylistic developments.[41] It seems that a number of the jamb figures have been moved from one portal to another, indeed, from the west facade to the north transept porch. For instance, a tympanum sculpture of the Virgin and Child enthroned in the right doorway

(the *Porte romane*) of the north transept must be a remnant from the earlier cathedral, dating about 1180, but it is not certain whether it formerly adorned an exterior portal or, more likely, the top of a wall tomb within the church.[42] Clearly it is a relic in its present position. The central and left doorways of the north transept have programs not unlike the center and left porches of Amiens—a Last Judgment tympanum with Christ and the apostles below in the center (fig. 497); legends of Reims in the tympanum and local saints on the jambs in the left (known as the Calixtus portal)—but

stylistically they display none of the unity that one sees at Amiens. Were these two portal sculptures originally intended for the west facade of Reims?

The west facade program at an early stage in planning had focused on the veneration of the Virgin. She clearly usurps the role of Christ in the central portal (fig. 498). In place of the *Maiestas Domini,* or Christ as judge, we find the Coronation of the Virgin filling the gable with the jambs devoted to the role of Mary in the Infancy (as on Chartres north, left portal, and Amiens west, right portal): the Annunciation and Visitation groups to the right, the Presentation in the Temple with four figures on the left. Mary appears on the trumeau as the "New Eve" standing atop reliefs of the story of the Fall of Adam and Eve (a frequent allusion in statues of the Virgin at this time).

The two side porches present highly original compositions and iconographies. To the left, the gable is decorated with a Crucifixion; the archivolts of the deep porch display one of the earliest known Passion narratives in architectural sculpture; and the jambs have statues of martyrs, some of whom are impossible to identify (one, Saint Dionysius?, is flanked by two angelic escorts). The right porch has an abridged Last Judgment in the gable and a most unusual sequence of sculptured archivolts that narrate Apocalyptic events described in the Book of Revelation. The jambs below include statues of a pope (Calixtus?) and two unidentified saints on the left, while those on the right side (fig. 499) represent Simeon, John the Baptist, Isaiah, and Moses and are clearly related to those same figures on the center bay of the north transept at Chartres (figs. 478, 479).

If this diversity of subject matter seems confusing, the stylistic features of the Reims sculptures are even more perplexing and clearly bear evidence that many of the jamb figures have been moved from their original positions. The chronology for the erection of the facade is itself very problematical. Exactly when the foundations were laid is not known, but a report that the third architect, Gaucher de Reims, was at work on the doorways of the facade in 1247–55 suggests that the foundations were laid sometime after the completion of the choir in 1241 by Jean le Loup. With these few facts and speculations in mind, let us turn to the sculptures.

Four basic Gothic styles are today displayed side by side in the jamb statues of the west facade. The earliest figures appear on the right portal (fig. 499) and have been dated about 1220 on the basis of their close affinities to their counterparts at Chartres, as mentioned above. These would appear to have been part of an early facade scheme planned by Jean d'Orbais but never realized. Jean le Loup, who laid the foundations for the present facade, proposed a new program for the sculptures about 1231–35, and it may be that the sculptures executed for his facade are those today on the north transept (recall it follows the general scheme of

Amiens west). It has been pointed out that the unusual classicizing style of figures such as Saint Peter (fig. 497) in the central portal north anticipates that of the "antique" Mary and Elizabeth in the Visitation group presently in the central portal west (fig. 500). Could this latter pair originally have been planned for the right portal on the west facade, echoing the arrangement at Amiens?

The new program for the facade sculptures by Jean le Loup was clearly meant to incorporate a major portal scheme for the Virgin. Further, it seems that at this time sculptors from Amiens (who carved the jambs of the Mary portal there about 1220–30) were enrolled at Reims to repeat their sculptures. The "Amiens Master" and his shop are very evident in many of the figures, including the Annunciate Mary in the central portal right and the statues of the Virgin and Simeon in the Presentation on the left. The same bland faces, the same monotonous repetitions of the V-shaped chevron folds, and the same rigid poses characterize these figures at Reims.

It was around this time, about 1230–35, that the Master of the Visitation worked (figs. 500, 501). His remarkable classicizing style has been an issue of bafflement for art historians. The two matronly figures at first seem to be ghosts from the Greco-Roman past, so much so, in fact, that some early accounts have described them as ancient statues reused. That they are Gothic, however, is apparent in the draperies that cascade from their wrists and elbows and in the rich folds that pile up about their feet. The complex, fussy draperies that break across their torsos in short, broken grooves and the sharp horizontal folds that wrap tightly about their bodies, to be sure, resemble the diaphanous drapery of the ancients, but this dramatic style—the *Muldenstil,* or "trough-fold" style of drapery—had already been introduced by Nicolas of Verdun in his metalwork (cf. fig. 436).

There can be no doubt, on the other hand, that we have here a phenomenon directly inspired by ancient sculpture, and herein lies the dilemma. This same classicism is found sporadically throughout Europe between the years about 1230 and 1260. It is as if various sculptors in diverse regions were consciously turning to the ancients for models at the same time. We find it at Bamberg Cathedral (fig. 552) about 1235; in Nicola Pisano's pulpit for the Baptistry in Pisa (fig. 572), dated 1260; and in the sculptures executed for Frederick II at Capua (cf. fig. 570) in the mid-thirteenth century. But after one generation, this proto-Renaissance mode was abandoned by the Gothic world for another new style represented by the fourth workshop at Reims, active about 1245–60—that of the "Saint Joseph" Master (also called the "Smiling Angel" Master)—whose works appear alongside those of the sculptors from Amiens and the Visitation group (figs. 502, 503).

The Annunciate angel Gabriel is the most striking representative of the new style. According to installation marks carved on the back of this statue, it can be determined that it

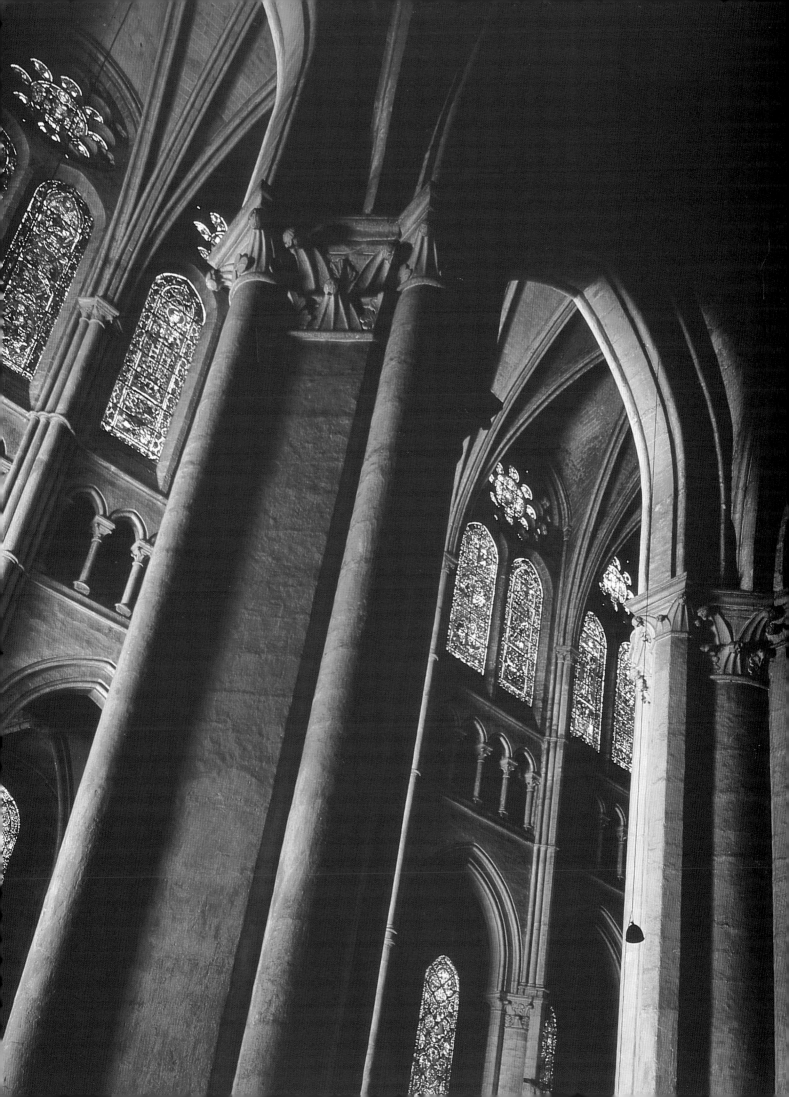

opposite: Colorplate 59. *Notre Dame de la Belle Verrière*. Stained-glass window. Choir, Chartres Cathedral. c. 1170; side angels added in the 13th century

above: Colorplate 60. *Furriers at Work*. Detail of stained-glass window. Nave, Chartres Cathedral. 13th century

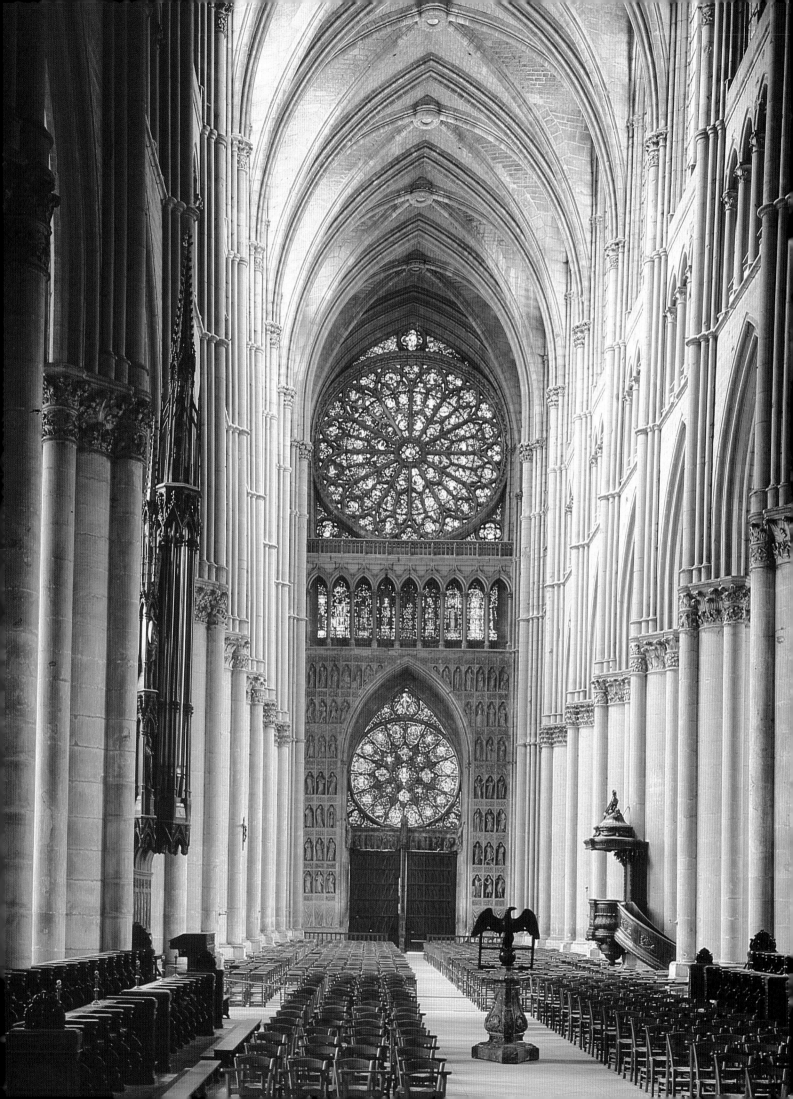

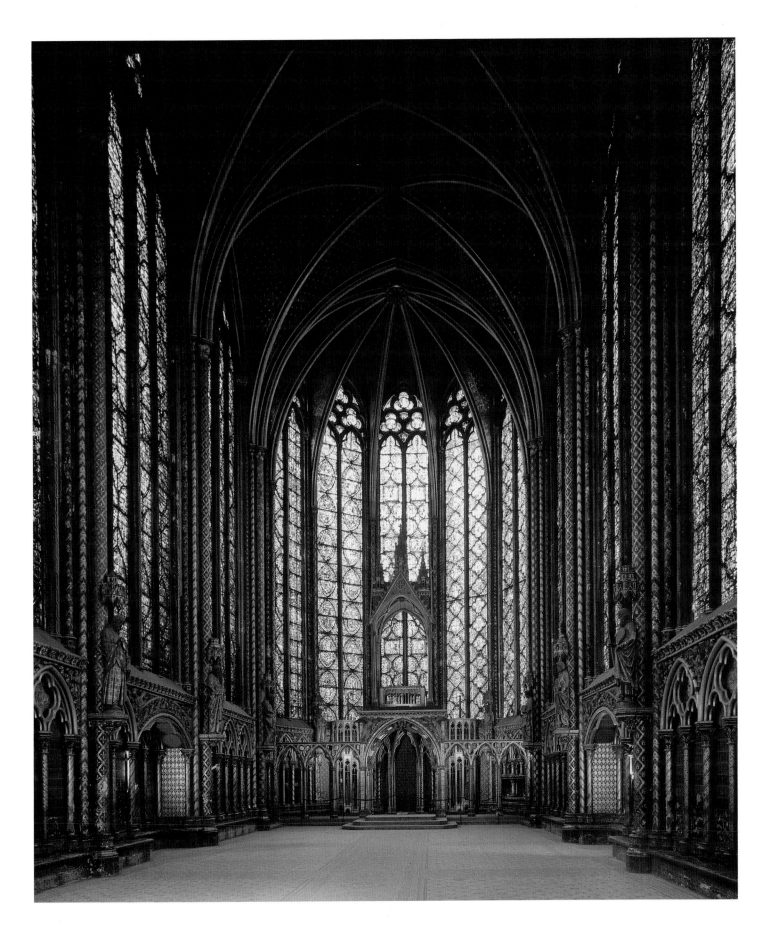

opposite: Colorplate 61. Reims Cathedral. Interior of nave. Begun 1210

above: Colorplate 62. Sainte-Chapelle, Paris. Interior of upper chapel. 1243–48

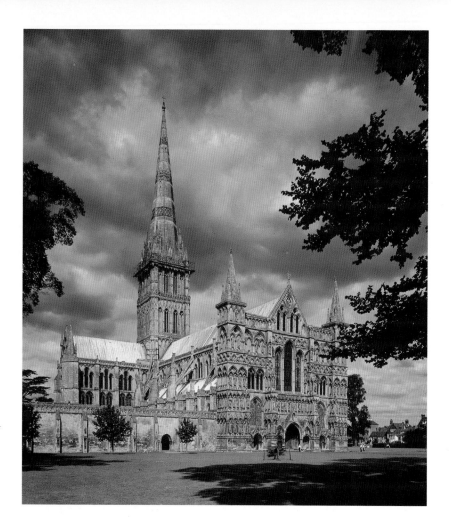

Colorplate 63. Salisbury Cathedral. Exterior
from the west. 1220–58; spire c. 1320–30

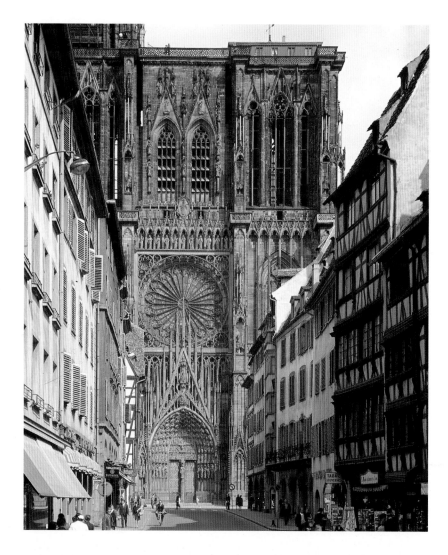

Colorplate 64. Strasbourg Cathedral.
West facade. Begun 1277

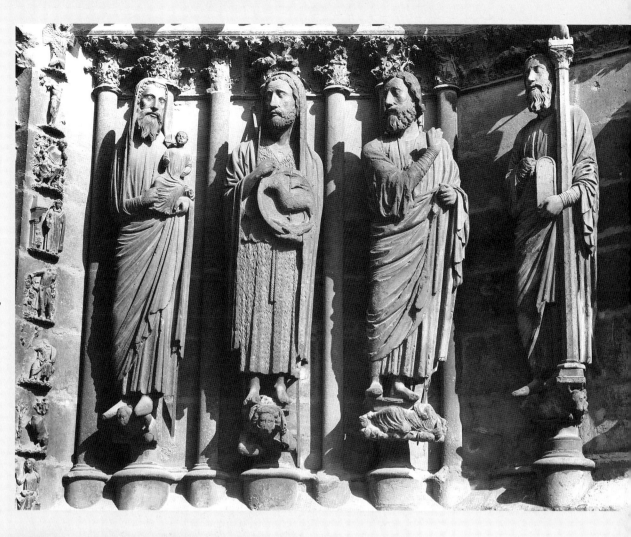

499. *Simeon,
John the Baptist,
Isaiah, and Moses.*
Right jamb, right portal,
west facade, Reims
Cathedral. c. 1220

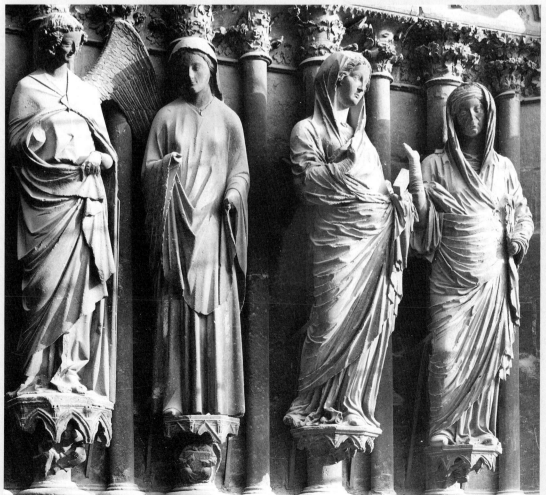

500. *Annunciation and
Visitation.* Right jamb,
central portal, west facade,
Reims Cathedral
(Annunciation Angel,
c. 1245–55; Virgin of
Annunciation, c. 1230;
Visitation group,
c. 1230–33)

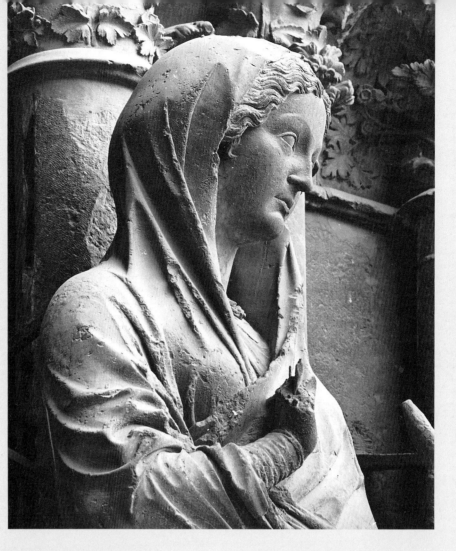

right: 501. *Virgin of the Visitation.* Detail of fig. 500

below: 502. *"Smiling" Angel.* Detail of fig. 500

below: 503. *Joseph.* Detail of jamb figure, left jamb, central portal, Reims Cathedral. c. 1245–55

opposite: 504. JAN VAN EYCK. *Annunciation* (detail). Panel transferred to canvas. c. 1435–37. National Gallery of Art, Washington, D.C. Andrew W. Mellon Collection, 1937

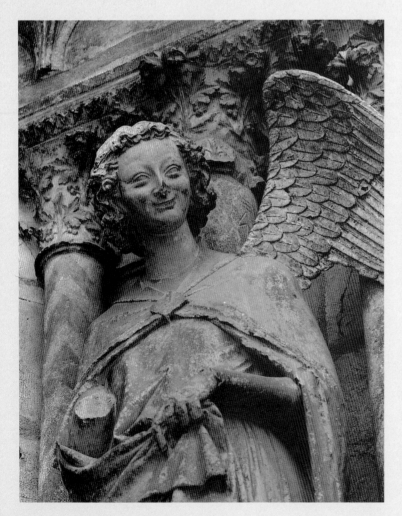

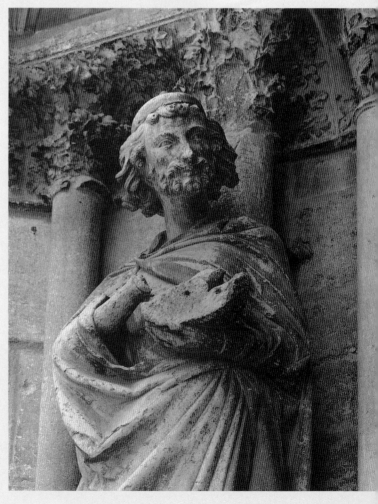

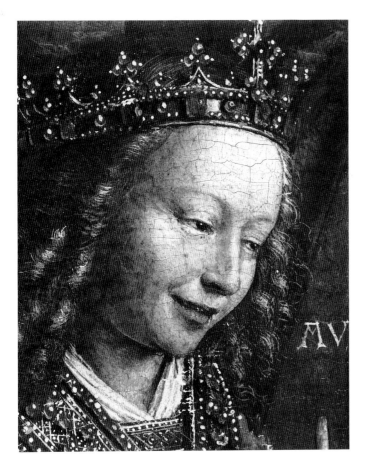

end piece of the mantle unfurls downward in elegant overlaps. At the feet the soft draperies pile up in abstract patterns anchoring the swaying figure to the pedestal gently.

It is in the head, however, where the true genius of this carver appears. The ideal for an angel has changed (and for most other figure types as well). For one thing, Gabriel is a feminine type elegantly posed to reveal the splendid draperies. A charm, almost a sweetness, pervades the face with its irresistible smile and sharply delineated features. This is no "archaic" smile as it is sometimes described; it is a smile that fills the face with radiance conveyed by the dimpled cheeks, the feline eyes with a slight puffing under the sockets, and the full but softly tapering chin.

The humanization of the holy figures by this master is enchanting; they seem so lifelike and approachable, and, of course, their smiles warm our hearts. Joseph (fig. 503), in the Presentation group on the left side, is winsome, too, with his coy, cocky expression and smile, his curly mustache and short-cropped beard. Indeed, although the husband of Mary appropriately wears the conical cap of the Jews, he looks more like a vintner who has just sampled one of the fine wines from the Champagne district of France. The sculptor who carved these figures may have been influenced by late stylistic developments in Paris (cf. fig. 509), but he is a true genius. His elegant new style established the mode for the draped figure that lasted for generations in the North. Jan van Eyck paid homage to his artistry in the smiling Gabriel approaching Mary in the Washington *Annunciation* nearly two centuries later (fig. 504).

PARIS AND THE *RAYONNANT* STYLE

The reign of Louis IX (1226–70) has always been considered the golden age of the French monarchy in the Middle Ages, and it was during this period that Gothic architecture reached a third stage of refinement characterized by some as the *rayonnant*, by others, as the Court style.[43] Essentially, the *rayonnant* style developed from a further sophistication of the High Gothic of Chartres, Amiens, and Reims. The mural character of the masonry walls is finally displaced by one of complete transparency with sheets of stained glass, and the sculptural qualities of the architecture, whether in undulating surfaces or punctures in stone, give way to flat surfaces wholly articulated by linear moldings and tracery.

The name, *rayonnant*, derives from the "radiating" bar tracery of the rose window, which now seems to spread through the entire elevation. The heavier columnar pier with four applied colonnettes is turned into a cluster of colonnettes that rise uninterrupted into the vaults; the triforium is completely merged with the huge windows of the clerestory and is "glazed," that is, the back wall is open and filled with stained glass, making it a sort of predella for the wall of glass above. But it is in the sophisticated articulation of the moldings, the tracery, and the colonnettes that the beauty and

was moved from its original position on the left portal as one of a pair of angelic escorts (one there now is in this same style) for Saint Dionysius to its present position beside the Annunciate Virgin. Why these changes were made has never been answered, but as we see them today, the four statues on the jambs of the right side of the central portal (fig. 500) present three distinctive and opposing styles in Gothic sculpture of the thirteenth century competing for the worshipper's attention. The smiling angel won the contest.

Several changes in the conception of the draped figure are evident. The smiling angel is posed gracefully as if swaying on the pedestal. With this pivotal stance the figure assumes a slight *S* curve as if dancing, while turning the shoulders, cocking the head downward, and leaning outward from the niche. The drapery is rendered in rich, voluminous folds that fall downward in long arcs, deeply undercut, with graceful undulations and overlaps terminating in gently curling edges. The overmantle is now a fashionable cape that fits snugly about the shoulders and is fastened by a brooch at the breasts, thus enveloping the upper arms like a cocoon. The elbows move slightly within it, and on the one side deep arcing pockets descend rhythmically, breaking the closed contour of the statue, while from the left hand of the angel an

logic of the *rayonnant* lie. Extreme systemization through multiplication or division of basic units repeated in sequential sets is the ultimate scholastic solution. As Panofsky writes, "arrangement according to a system of homologous parts and parts of parts" is one requirement of the Scholastic method.[44] Surfaces become flattened and transparent; linear elements are diagrammatic and fully integrated.

It was at this time, 1231–81, that Suger's church at Saint Denis was provided with a new nave (fig. 505). The elevation above the arcade in the choir was remodeled as well in order to make adjustments for the new style in the transept and nave (these changes are quite apparent when viewed from the triforium level today). The piers are compounded into bundles of twelve shafts, and the entire elevation resembles a work in filigree not unlike that in metal shrines.

The invention of the *rayonnant* style has frequently been credited to a Parisian builder, Pierre de Montreuil, recorded as the "architect of Saint Denis" in a document of 1247, but it is now generally believed that his predecessor, unnamed, introduced these adjustments at Saint Denis.[45] Notre Dame in Paris was also remodeled about 1225. The zone with the

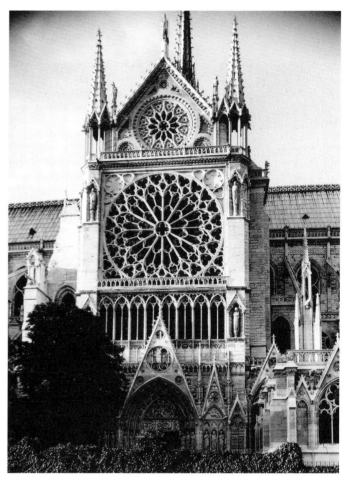

506. Cathedral of Notre Dame, Paris. View of the south transept facade. Begun 1258

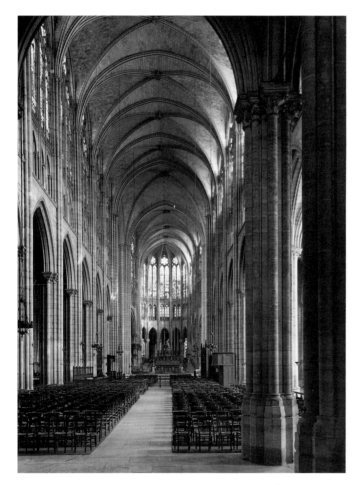

505. Abbey Church of Saint Denis. Interior of nave. Begun 1231

oculi above the tribune gallery of the four-part nave elevation was eliminated and the clerestory was dropped down to absorb that space for larger windows (fig. 466). The transept portals at Notre Dame were added about mid-century by the architect Jean de Chelles in the *rayonnant* style (the south transept facade was finished by Pierre de Montreuil; fig. 506). Here the mural surfaces are almost brittle, as if the tracery were incised or embossed on a sheet of light metal, enhancing the "shrine-work" appearance even more. The high-pitched gables of the doorway and buttresses rise into the glazed triforium as freestanding elements breaking through the horizontal divisions of the facade, much as we find at Reims.

The model for the *rayonnant* style of the French court is Sainte-Chapelle, situated near Notre Dame amid the cluster of buildings that served as royal apartments and government offices (figs. 507, 508; colorplate 62). In 1239 Louis IX acquired from Constantinople valuable relics of the Passion of Christ: the Crown of Thorns, a piece of iron from the lance, the sponge, and a piece of wood from the True Cross itself. For these treasures Louis commissioned a new palace chapel, adjoining the king's apartments, to serve as a monumental reliquary. Built between 1243 and 1248, Sainte-Chapelle truly does resemble a metal shrine, and in many

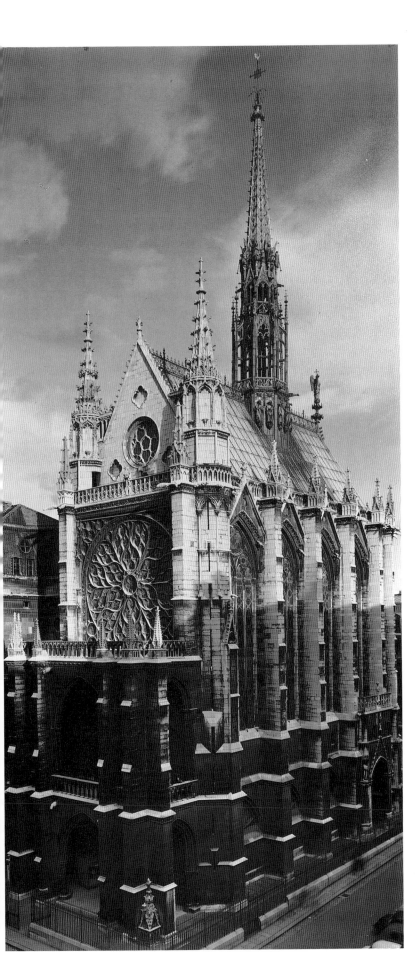

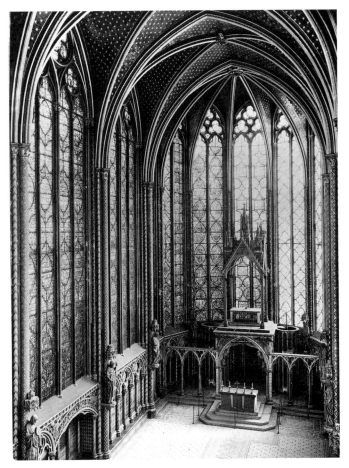

left: 507. Sainte-Chapelle, Paris. Exterior. 1243–48; rose window after 1485

above: 508. Sainte-Chapelle, Paris. Interior of upper chapel. See colorplate 62

below: 509. *Apostle*. From the upper chapel of Sainte-Chapelle. Marble. 1243–48. Musée de Cluny, Paris

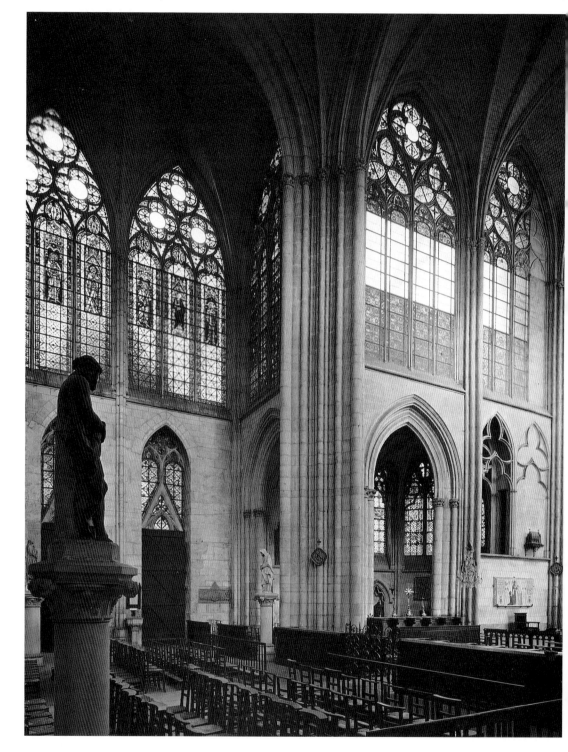

510. Saint Urbain, Troyes.
Interior

respects it is little more than a miniature Gothic chevet in two stories with a front porch.[46]

Traditionally, the architect of this masterpiece has been identified as Pierre de Montreuil, but numerous similarities between the elevation of both the upper and lower chapels and the choir of Amiens have led some to propose Thomas de Cormont as the architect. The windows of the lower chapel display the same curious "spherical triangles" of stained glass found in the western termination of the side aisles at Amiens, and in the upper chapel, which has no aisles, the walls are tall lancets of stained glass rising from a shallow wall arcade much like the windows in the radiating chapels of the choir at Amiens.

A new intimacy and privacy are achieved in the glass chapel of the king (his apartments had direct access to the upper chapel through the projecting porch on the west), and

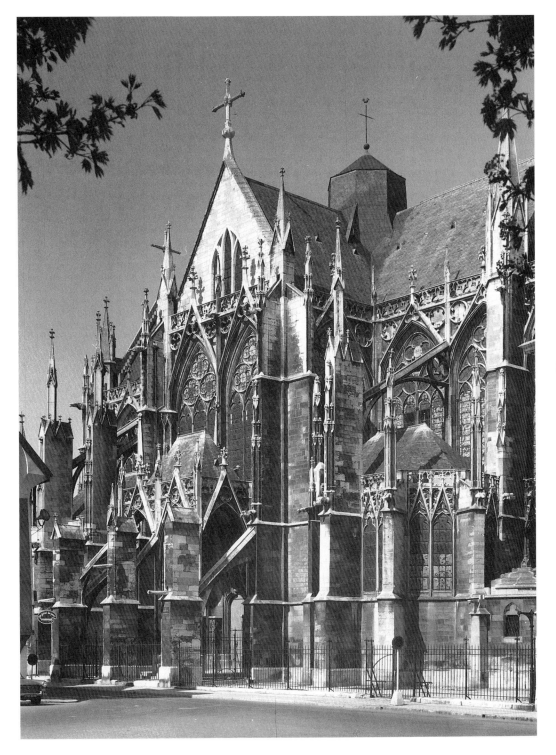

511. Saint Urbain, Troyes.
Exterior from the south

the stained glass that entirely fills the space, although much restored, still conveys the mystical sense of the *lux nova* that transforms the environment into a resplendent world of colored lights. The lancets in the nave are filled with rows of roundels that illustrate Old Testament events from Genesis to the Book of Kings (they are not in proper order) and the prophets; and behind the altar in the apse, a window of the Tree of Jesse and one devoted to John the Baptist appropri-

ately introduce us to two windows with episodes from the Infancy and the Passion of Christ. The cycle ends with lancets in the southwest bay with stories of the history of the relics of the Passion. The west rose window (replaced in the 1480s) originally featured events in the Book of Revelation and the Last Judgment.[47]

The wall piers of Sainte-Chapelle were decorated with statues of the twelve apostles placed on low consoles (see fig.

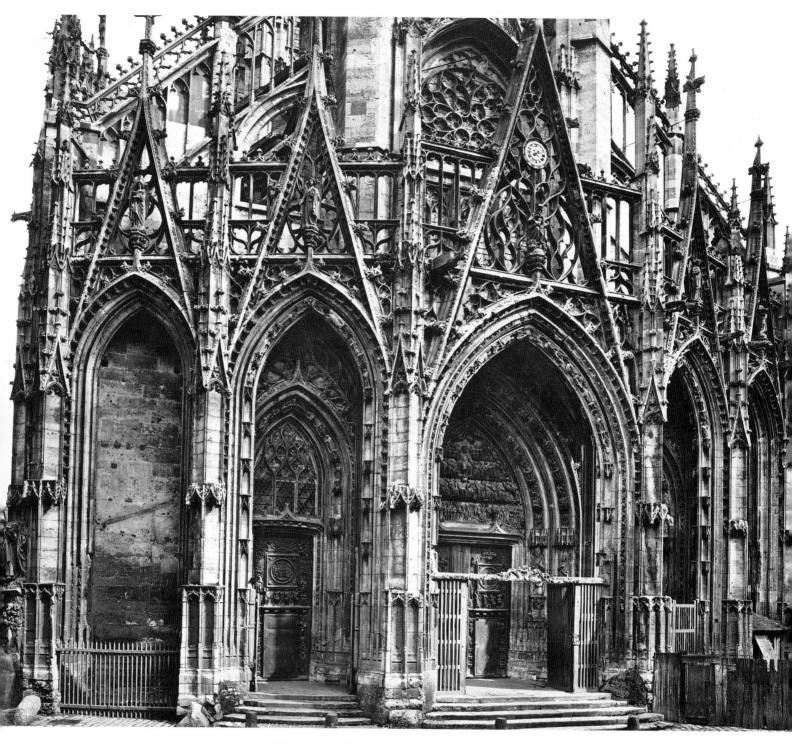

512. Saint Maclou, Rouen. West facade. Begun 1434

509). Only three of these are original (four more fragments are kept in the Musée Cluny in Paris), and they represent major sculptures in Paris at mid-century. The elegant treatment of the earlier sculptures of Notre Dame is here elaborated into gracefully posed figures with voluminous draperies falling in deeply cut folds of triangular pockets that cascade rhythmically, anticipating by a few years the rich style of the Saint Joseph Master at Reims. But the characterizations of the apostles are almost too precious. The features of the triangular faces are delicately delineated with small, pinched eyes and tiny mouths under curly mustaches, and their somewhat affected poses give them the appearance of a consortium of refined courtiers attending the king's precious relics.

The Court or *rayonnant* style of Paris soon became the standard mode for cathedral architecture in northern France. At Troyes the Church of Saint Urbain (figs. 510, 511) provides us with an extreme version, sometimes characterized as a "mannerist" phase of the *rayonnant*. Commissioned by Pope Urban IV (1261–64), a native of Troyes, and dedicated to his patron saint, the church has a simplified plan with three aisles, a square transept, and a polygonal apse. The triforium has been completely eliminated so that the interior rises in two stories with huge windows. The exterior displays a brittleness in the sharp linear scaffolding. As at Sainte-Chapelle, the gables over the upper windows are detached and crown the walls on all sides with openwork tracery of delicate design. Thin wall buttresses rise to needlelike spires, and the whole has the crisp fragility of a metal trellis framing large openings.

The ultimate refinement of French Gothic is found in the style called Flamboyant, which developed during the course of the late fourteenth century (and thus lies outside the scope of this study). Flamboyant means flamelike, and the name is very appropriate since the intricate patterns of curves and countercurves in the tracery form dense webs of surface decoration that have the captivating appearance of flickering undulations resembling the ascending swirls of flames in a bonfire. Whether this new vocabulary evolved naturally or was influenced by developments in English Gothic architecture, the so-called Decorated style, is an issue of much controversy, but very similar ornamental motifs appear in both.[48] Among the more capricious are the curling *mouchette,* the bulbous quatrefoil *soufflet,* and the double-curved *ogee* arch. The profusion of decoration overwhelms the clarity of structure; elaborate linear forms contradict the materials they cover; in fact, the mural character of the wall behind the veil of filigree returns, since the original purpose of the skeletal scaffolding has been lost to the caprice and mannered exuberance of surface decoration. A strange inversion of architectural principles thus takes place.

Saint Maclou in Rouen, a fifteenth-century church, is one of the masterpieces of French Flamboyant architecture (fig. 512). The simplified plan and the solid stone character of the walls are obscured in the profuse overlay of pointed and decorative motifs that cover the entrance and accent the sharp diagonal rises in the flying buttresses and the central tower. The facade is a suppressed octagonal or "bowed" front with three elaborate doorways perforated by balustrades and high-pitched gables. No longer do two great towers—one of the hallmarks of High Gothic—frame the block of the facade.

We can find the symptoms of these later developments at Reims, if not in the architecture, then certainly in the sculpture. The appealing beauty of the smiling angel with the convoluted turnings of the mantle, the coy sway, and the heartwarming smile and dimpled cheeks established a new canon in Gothic sculpture. These same qualities are carried to the extreme in the *Virgin* (fig. 513) in Notre Dame in Paris, about 1320, in the precious *Virgin of Jeanne d'Evreux* (see colorplate 67), a work of exquisite craftsmanship, dated 1339 on the base, and in numerous ivory statuettes of the Virgin of the late thirteenth and early fourteenth centuries (fig. 566).

513. *The Virgin of Paris.* c. 1320. Notre Dame, Paris

OPUS FRANCIGENUM ABROAD

514. Canterbury Cathedral. East end of the nave and choir.
After 1174

THE revolutionary new building techniques and concepts that developed in the Ile-de-France had an immediate impact on architecture throughout Europe, and the variations that occurred in neighboring lands, where the spirit of the Gothic supplanted that of the Romanesque, are many and fascinating to observe from the point of view of the art historian. Perhaps the most distinctive and instructive of these are the Gothic styles that were created in England.

ENGLAND

Following the conquest of England in 1066, William the Conqueror's ecclesiastical administrator, Lanfranc, rebuilt the Cathedral of Canterbury (1070–89) in the Norman style. The choir was finished under succeeding priors, Ernulph (1096–1107) and Conrad (1108–26), and it was there that Thomas à Becket, archbishop of Canterbury, was murdered by knights of Henry II in 1170. Four years later, 1174, the choir was destroyed by a fire that swept through the town—Lanfranc's nave survived the conflagration—and plans were made immediately for the restoration of the hallowed area. A witness to these events was the monk Gervase of Canterbury (c. 1141–c. 1210), who leaves a remarkable description of the rebuilding.[49] Gervase tells us that an architect from France, William of Sens, was called in to supervise the project and that he erected the choir (fig. 514) in a new style. William of Sens fell from the scaffolding in 1178 while overseeing the construction of the vaults, and his work was carried on by another William of English descent (the treatise ends in 1184). What is astonishing about the account is the clear perception that Gervase had of the differences between the earlier style, the Norman Romanesque, and the new, the French Gothic.

His descriptions of the new vaulting technique—*fornices arcuatae et clavatae* (vaults with ribs and keystones), the subtle carvings of the capitals, the tall, slender pier supports, and the fusion of elements (*convenire*) rather than the simple addition of parts—are very revealing and indicate what the *opus francigenum* meant to the Englishman. The new choir, in fact, resembles that of the Early Gothic choir of Sens Cathedral, with a semicircular ambulatory with coupled

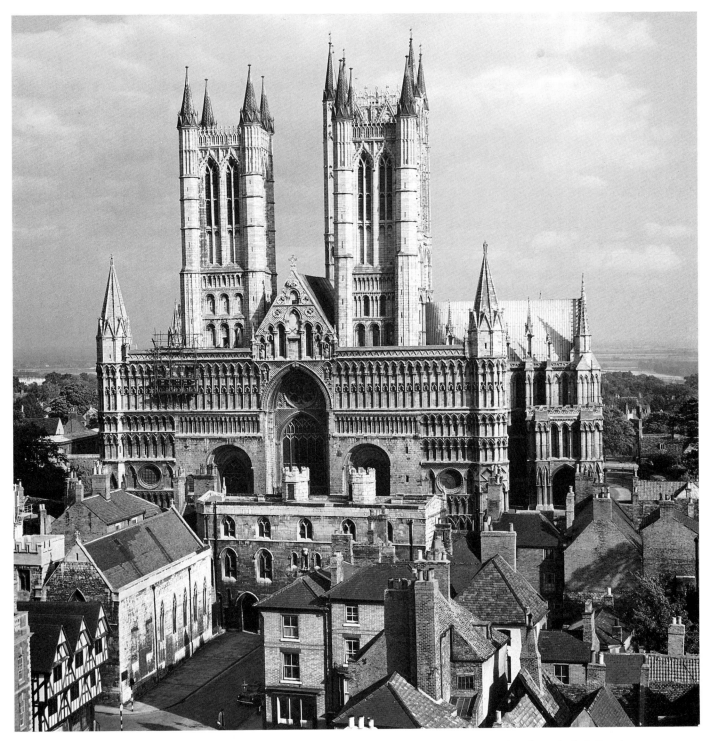

above: 515. Lincoln Cathedral. Facade

left: 516. Lincoln Cathedral. Plan (after Webb). Begun 1192

below: 517. Salisbury Cathedral. Plan. Begun 1220

columns in a tripartite elevation and the sexpartite vaults in the outer bays of the choir. Gervase also describes the use of dark brown-black Purbeck marble (from the island of that name) employed for the shafts and stringcourses as decorative accents to the light-hued stones of Normandy that were shipped in by William of Sens. The new vaulting techniques of French Gothic had an immediate impact on church building in England, but it is clear that English taste prevailed in the general layout of the plan and in the retention of solid mural construction.

If we take Lincoln and Salisbury cathedrals as representatives of Early Gothic in England, these features are at once apparent (cf. figs. 515–17; colorplate 63). The ground plan remains an emphatic cross form with double transepts (the latter often related to Cluny III). The long, narrow choir terminates in a square east end (cf. Cistercian plans) and is frequently extended with a "Lady's Chapel." The fronts are broad, shallow screens, usually unrelated to the interior elevation, that mask the two towers of the facade proper. Small turrets frame the multitiered registers of this false front, and the comprehensive, encyclopedic programming of French cathedral sculptures is lacking.

In general, a sturdy basilical core is merely embellished with decorative Gothic details in the form of pointed arches, tracery, moldings, pinnacles, and friezes. The heavy walls eliminate the need for flying buttresses, and horizontality, not verticality, characterizes the building in general. The "scholastic" structuring of many parts, the logical buildup of a complex scaffolding of architectural members, is rejected for solid mural construction with cubic forms added one to the other. The English House of God remains essentially a Romanesque building, earthbound and sprawling.[50] Furthermore, the setting for the English Gothic church is generally that of the earlier monastic communities, on a hilltop or in a meadow apart from the city, often with a separate chapter house and an adjoining cloister enhancing its rural character.

Due to the confusing political history (and the devastations caused by the Black Death in the fourteen century) many churches had extremely long periods of construction with successive builders, and hence few display a uniformity of style. The subdivisions of Gothic style are thus numerous. Four major phases can be noted here, and their names are derived from the nature of the decorative details and not the principles of construction, again indicative of the differences in the spirit of Gothic in England and France.[51]

The earliest phase is often called "Lancet" Gothic (c. 1200–1250) with reference to the type of windows penetrating the walls. The mature phase (c. 1250–1350) is "Decorated" Gothic, which is subdivided into (a) the "Geometric" style (1250–90), featuring elaborate decorative tracery of clearly delineated geometric shapes such as circles, trefoils, and quatrefoils, and (b) "Curvilinear" (c. 1290–1350),

518. "Crazy Vaults." St. Hugh's Choir, Lincoln Cathedral. Designed c. 1192; rebuilt 1239

where more flamboyant lines of intricate ogee arcs, undulating and intertwining tracery patterns, and curious new floral motifs predominate. The final phase (c. 1350–1550) is the "Perpendicular," a unique English contribution to Gothic architecture, featuring soaring walls of rectilinear design, often completely glazed, with thin vertical supports.

The English builders were masters in designing elaborate decorative ensembles in bar tracery that spread from the walls and windows into the vaults in a most colorful fashion. The Gothic style climaxes in spectacular star-and-fan vaults of ingenious design. Structure is not the aesthetic basis here, however. Rather it is line, and this English fondness for intricate surface patterns of line can be traced ultimately to the Hiberno-Saxon arts discussed in Part III.

Following an earthquake and fire, the Romanesque Cathedral of Lincoln was rebuilt by the French-born archbishop Hugh of Avalon in 1192. The architect was presumably another Frenchman, Geoffrey de Noiers (Noyers?), and the inspiration for the sexpartite vaulting of the transepts has usually been accredited to Canterbury. However, Hugh's architect was a highly original artist, and the "crazy vaults" that he designed for the four bays between the two transepts

(fig. 518) are wholly un-French in appearance and function.[52] A longitudinal rib in the summit, called a ridge rib, runs the length of the four bays, and for one of the first times the usual diagonal and transverse ribs of the sexpartite vault are replaced with what are called tiercerons. These are rib projections that extend from the side arches to some point along the ridge rib; they do not converge at a central point but split the bay into eight irregular segments of intricate shapes. The function of the rib vault is thus denied, and the result is one of pure decorative fancy. A contemporary account, the *Metrical Life of Saint Hugh* (c. 1225), compares the crazy vault to "a bird stretching out her broad wings to fly— planted on its firm columns, it soars to the clouds."[53]

Hugh's architect delighted in such unorthodox patterns in areas other than the vaults as well. He invented a new type of wall decoration in the transept arms and aisles of the choir known as syncopated arcading (fig. 519). Set flush against the wall are pointed arcades with light-colored limestone columns, and directly overlapping them is placed a series of trefoil arches carried by black Purbeck marble shafts. Thus he created a strange counterpoint in the lower walls analogous to the daring rhythm of the crazy vaults above. This pattern of decorative play of vaulting elements was continued in a less spectacular way by his successors in the construction of the nave and Galilee, about 1220–56, and to the old Norman towered facade was added a broad decorative screen front with tiers of arcading.

The Early Gothic Cathedral of Salisbury (fig. 520; color-plate 63), made famous by John Constable's romantic landscapes of its pastoral setting, displays an unusual unity for English churches. Salisbury was begun anew in 1220, having been relocated from its earlier site at Old Sarum to a valley of the Avon River a few miles south, and hence it was raised in one major campaign (1220–58) for the most part,

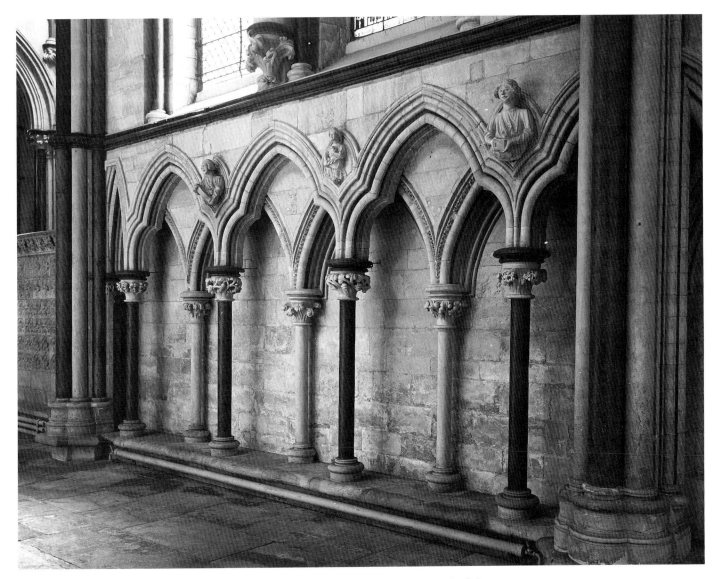

519. Lincoln Cathedral. St. Hugh's Choir. Lower wall of the transept

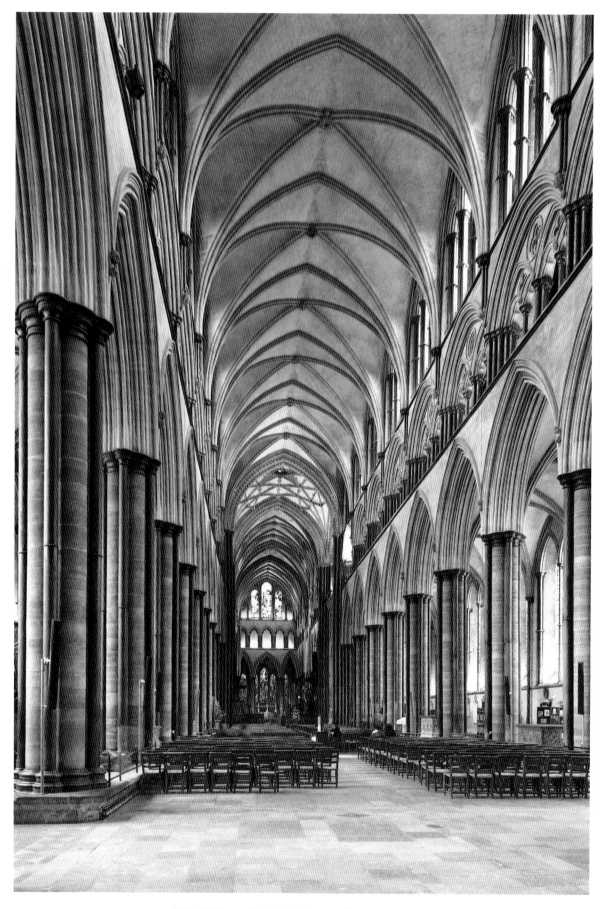

520. Salisbury Cathedral. Interior of nave. 1220–58

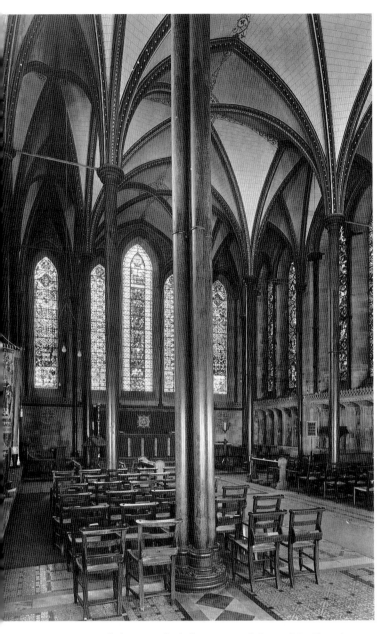

521. Salisbury Cathedral. Interior of the Lady's Chapel

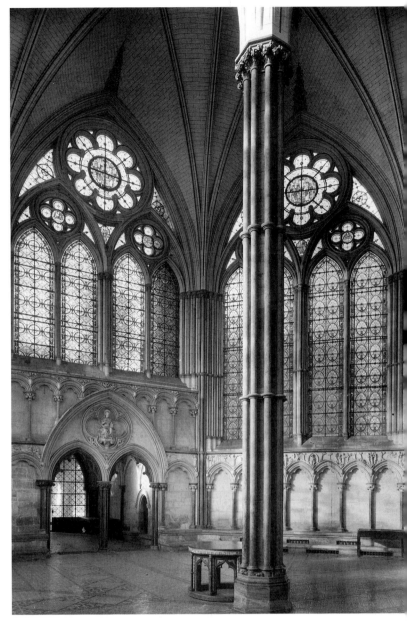

522. Salisbury Cathedral. Interior of the chapter house. c. 1275–84

with no earlier structures to restrict or compromise its construction. The architect of Salisbury, one Master Nicholas of Ely, added uniform rectilinear parts one after the other along an axis in the simple additive fashion of a monastic church (fig. 517). There are double transepts as usual, and the long nave has a Gothic three-part elevation (a squat gallery appears in the triforium register) with a handsome nave arcade of columnar piers bounded by Purbeck marble shafts that support ribbed quadripartite vaults. The height is uniform throughout, and the decorative effects are much restrained compared to other English churches. This austerity may be due in part to later restorations and the loss of the original stained glass in many lancet windows.

Master Nicholas commenced his project at the east with a typical Lady's Chapel that forms a miniature "hall church" with the side aisles reaching the same height as the nave (fig. 521). Here, however, there are no complex wall arcadings or tierceron vaults as at Lincoln. The tall lancet windows in the square box provide much light, and slender Purbeck marble shafts carry quadripartite vaults, allowing the space to flow freely from the chapel into the adjoining ambulatory. The west front is a narrow screen with tiers of arcades framed by small turrets and pierced in the center by three large lancet windows. A small porch with three doors projects from the center and gives access only to the nave. The chapter house (fig. 522), added to the eastern arm of the huge cloister, was built about 1275–84 in the later style of Gothic that the English call Decorated.

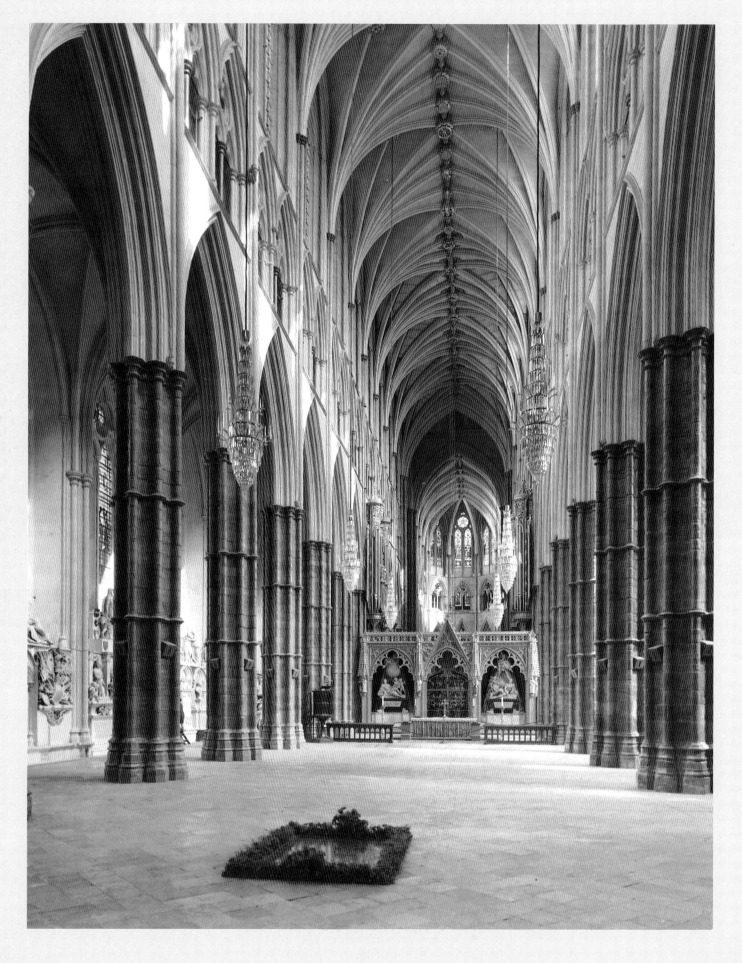

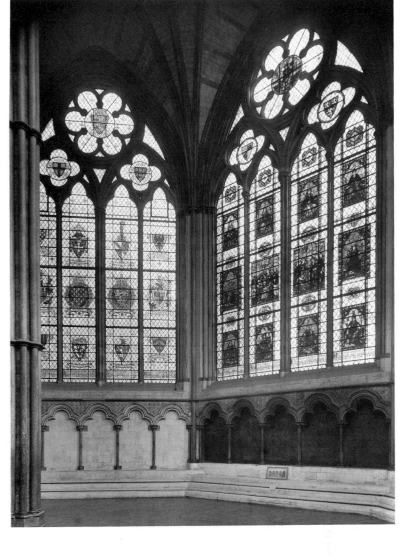

opposite: 523. Westminster Abbey, London. Interior of nave

above: 524. Westminster Abbey, London. Plan (after Webb). Begun 1245

right: 525. Westminster Abbey, London. Interior of the chapter house. c. 1253

In 1245 Henry III sponsored an ambitious building program at Westminster Abbey in London (figs. 523, 524) to commemorate his favored saint, Edward the Confessor. Henry had been impressed by the latest achievements in Paris, the Court style (Louis IX was his brother-in-law), and especially by Sainte-Chapelle. He called in a master mason, Henry de Reynes, to supervise the project.[54] The new church represents, in fact, something of a transitional monument between the earlier English Lancet Gothic and the later Decorated style.

The plan features a French chevet with a polygonal apse, ambulatory, and radiating chapels. The transept and the nave retain the earlier basilical form. In elevation, Westminster Abbey strikes one as a French building of mid-century, although the clerestory is not so high and galleries are retained in the triforium. But the nave elevation is narrow and high (103 feet as compared to 74 feet at Lincoln) with thin walls that require flying buttresses to support the soaring vaults. The bar tracery and foliate capitals remind one of Reims Cathedral, and the huge rose windows filling the facades of the transept arms bring to mind the elegant transept portals of Paris and Saint Denis, although the double row of six lancet windows below them are still fundamentally punctures in the wall.

A curious combination of vaulting appears in Westminster Abbey. Quadripartite vaults cover the central bays of the choir, the arms of the transept, and the side aisles of the nave, while the nave proper, vaulted about 1260, adapted the decorative scheme of vaulting employed in the nave at Lincoln (tiercerons converging on a continuous ridge rib), a concession to the English love for more linear, ornamental surface decoration.

Abutting the south transept and the cloister is a splendid octagonal chapter house (fig. 525), about 1253, that exploits the lightness of the Court style, recalling the upper church at Sainte-Chapelle, with the opening of the walls to windows of stained glass. As with the chapter house at Salisbury, these later constructions at Westminster Abbey introduce us to the beginnings of the Decorated style of English Gothic.

An example of fully developed Decorated Gothic appears

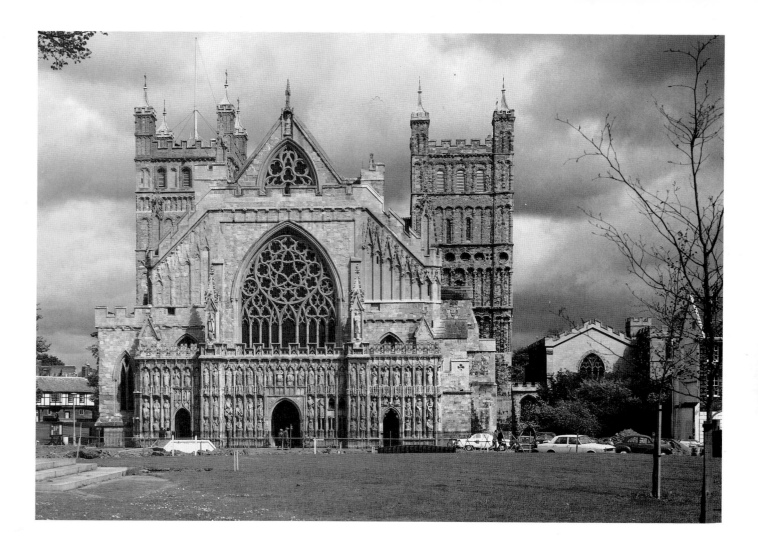

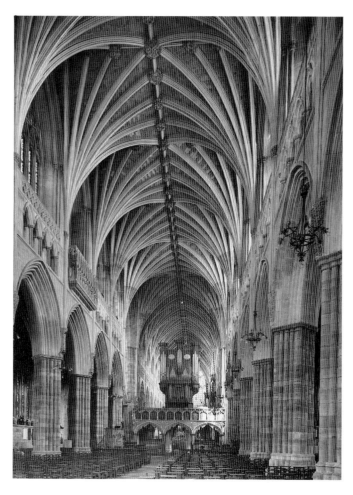

at Exeter (figs. 526, 527), where the earlier Norman church was rebuilt in 1275.[55] The two huge towers of the early structure were kept, however, and made into transepts, a nave and facade added before them, the choir behind. The new facade is a curious ensemble of three overlapping and recessed spatial surfaces. The broad screen with its galleries of sculptures projects in front at the lowest level, a truncated gable with a great window in bar tracery of the Decorated style rises behind it, and, finally, the whole is capped by the triangular roof line set back against the nave vaults. The stocky westwork transepts substitute for the usual crossing tower found in English Gothic churches.

This curious, and not entirely satisfying, exterior is soon forgotten when one enters the broad and deep interior, three hundred feet in length from the nave to the Lady's Chapel, which was realized in one campaign so that a remarkable unity was achieved. Only sixty-nine feet high, the immense interior has a strange, compelling horizontal pull like a vast funneled armature projecting in space. The entire elevation

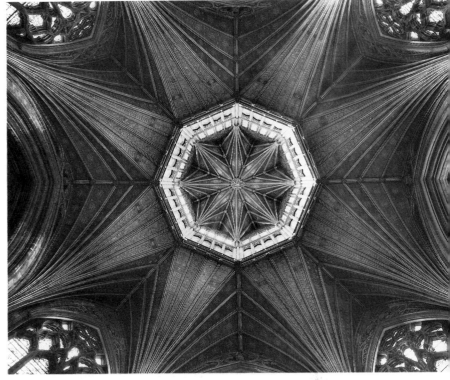

left: 528. Wells Cathedral. Strainer or Scissor arch. 1338

above: 529. William Hurley. Ely Cathedral. Dome over the crossing. 1328–47

is wrapped in lines; nearly every wall surface is overwhelmed with slender columns and ribs. The great diamond-shaped piers are smothered under sixteen shafts that create a rippling effect down the nave. From colorful foliate corbels in the arcade rise clusters of ribs, eleven in each bay, that rise smoothly and gracefully to the continuous ridge rib in the summit of the vaults. So many are the ribbed lines, in fact, that one hardly notices the webbing between them. Above an arcaded triforium surmounted by a quatrefoil balustrade—features that restore the horizontality of the elevation—rise huge clerestory windows with tracery in the Decorated style. The harmonious combination and overlay of stone—the unpolished Purbeck marble shafts are gray, the arches are of yellow sandstone, and the upper walls in white stone from Caen—lend the spacious interior an unusual warmth.

A variety of experimentation in more monumental aspects of the interior, especially in crossing towers and vaults, mark the developments of the Decorated style. One of the most bizarre innovations occurs at Wells Cathedral in the gigantic scissor or strainer arches built into the piers of the crossing tower (fig. 528). The tower, also in the Decorated style, began to show signs of failure in cracks along the foundations, and on three sides (the fourth abutted the chancel screen and was secure) massive stone arches, in the shape of scissors, were added for support. Similar inverted arch supports were added to the transept arms at Salisbury, but on a much smaller scale.

The effect at Wells is spectacular, to say the least, creating a most surprising and dramatic spatial sensation in the very middle of the church. Even more daring is the "Gothic dome" added to the crossing of Ely Cathedral (fig. 529).[56] The earlier Norman tower fell in 1322, leaving an enormous hole in the middle of the church, and rather than vaulting the gap in stone—seventy-two feet across—it was covered with a lofty wooden lantern with a star dome. Resting on eight stone piers is an elaborate superstructure of tierceron vaults in wood that, in turn, support the octagonal drum of windows for the intricate dome above. An ingenious system of concealed cantilevers under the vaulting actually carries the drum. For this masterpiece in wood, the king's carpenter, William Hurley, was called in as consultant (1328–47). The dramatic spatial effect with light streaming through the drum windows and illuminating the star above is captivating and mysterious. The vast hollows of space seem to float far above the nave and, much like the curious scissor arches in Wells, add to the mystery of the cathedral interior, creating at Ely an eerie sensation of otherworldly light penetrating the darkened interior.

York Minster (figs. 530–32) provides us with a sequence

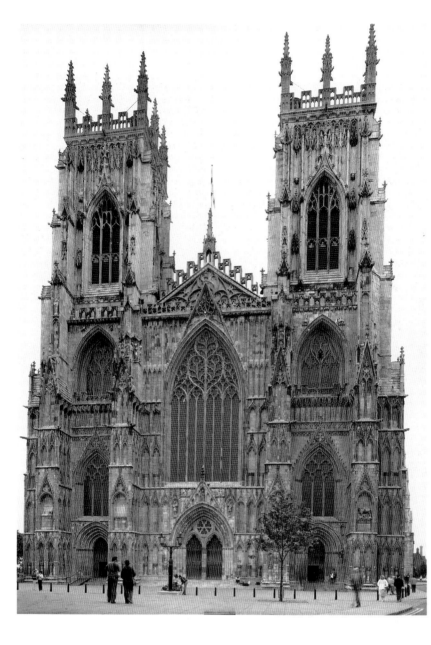

530. York Minster.
West facade.
Begun 1291;
window 1338

of styles ranging from the Romanesque to the Perpendicular.[57] The crypt is Norman; the transept arms were built in the Early Gothic style about 1220–41 (the famous lancets in the north transept, known as the "Five Sisters," are some of the finest grisaille windows in England). The nave elevation, about 1290, is modeled after French Gothic of the *rayonnant* or Court style, with a merging of the clerestory and the triforium (the vaults are of wooden construction). The handsome two-towered facade has a huge window, the "Heart of Yorkshire," with exuberant tracery in the Curvilinear Decorated style, 1338. Finally, the magnificent eastern Lady's Chapel (the size of a tennis court), with its great open windows of rectilinear lines and delicate curvilinear bar tracery, dating about 1400–1405, is representative of the Perpendicular style.

With the emergence of the Perpendicular style about 1350, English Gothic acquired a unique national expression. Developed directly from the Court and late Decorated style, the Perpendicular style is essentially a controlled rectilinear system of designing vast walls and windows with the repetition of cusped panels framed in huge grids of predominantly vertical lines in stone that soar from the ground to the vaults. So it appears in the huge east window of the choir at Gloucester (fig. 533), 1332–c. 1357.

The profuse curvilinear bar tracery in the windows grows into the vaults in two fashions. It can extend into the complex tierceron vaults of the Decorated style by multiplying the ribs in the form of countless *liernes* (short ribs that connect the tiercerons and ridge ribs), thus transforming the surface of the vault into an intricate spider's-web design of surface patterns. Or, it can be magically metamorphosed into "fan vaults" (see the cloister of Gloucester, c. 1370–77; fig. 534) with the multiplication of ribs rising from the walls in great open arcs, diverging in all directions, that are connected by tracery patterns and contained within a sweeping circular ridge rib that gives them the appearance of giant fans opening above us.

Basically, the fan vault is a false construction of concave semicones sheathing the ceiling to which bar tracery is applied with no structural role. The breathtaking intricacy of

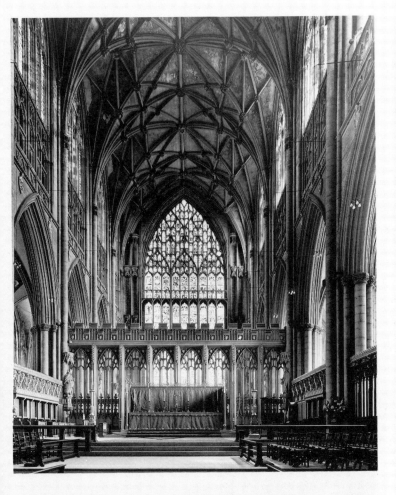

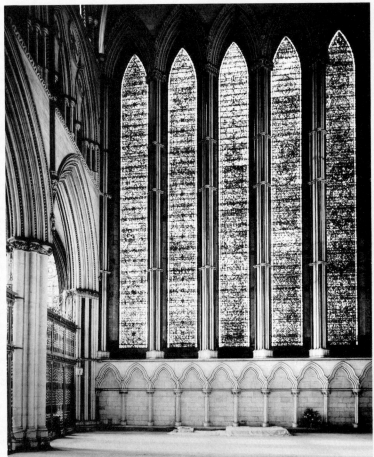

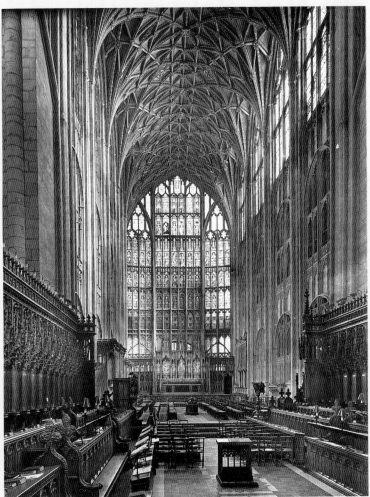

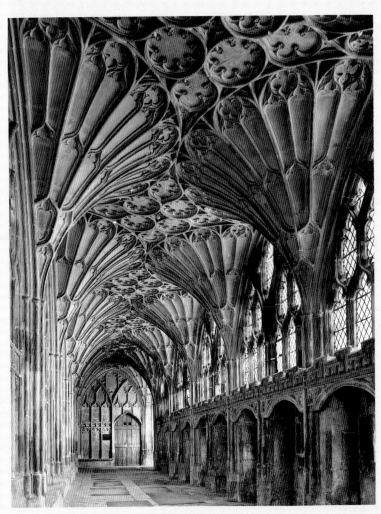

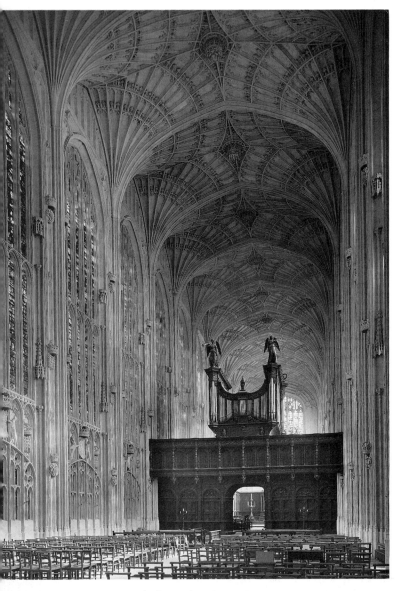

535. King's College Chapel, Cambridge, England. Interior.
1446–1515

the fan vault could be more easily applied to lower, narrower passages, such as cloisters, but in the fully developed Perpendicular, such as at King's College Chapel in Cambridge, 1446–1515 (fig. 535), the builders had the daring to apply such elaborate fabrications to the vast expanse of the nave. At this late point in history, the severance of the Church of England from the Roman Catholic faith had a profound effect on further developments in ecclesiastical architecture, and the English Gothic style passed into the building of the great country houses of the Tudor period.[58]

THE RHINELAND AND SOME CHURCHES IN EASTERN GERMANY

The sprawling domain known as the Holy Roman Empire came to an end with the death of Frederick II in 1250. His son Conrad IV died of fever in 1254; his grandson, Con-

radin, was murdered at the age of sixteen in Naples in 1268. Viewed in a broad perspective, the papacy had finally triumphed in the long struggle in Italy in which Frederick had tried to control the papal states by containing them within his kingdoms of Sicily in the south and the vast holdings of Germany in the north. At the Council of Lyon, 1245, Frederick was excommunicated, and Sicily was placed under interdict by the pope.

With the death of the last Hohenstaufen, Conradin, the German empire began to disintegrate into rival political states. In 1273 Rudolf of Hapsburg was elected king, but that title was little more than an honorary name. The powerful princes of the duchies asserted their independence—the Luxemburgs, the Hohenzollerns, the Hapsburgs—splitting the broad territory into the states we know today as Bohemia, Austria, Bavaria, Brandenburg, etc. Two other powers emerged to further complicate the polity: (1) the wealthy Hanseatic cities in North Germany whose mercantile league established them as "free" cities under limited royal authority; and (2) the influential archbishoprics, especially Mainz, Cologne, and Trier in the Rhine valley, who also claimed independence from the princes and frequently kept close ties with the papacy. To check the decentralization of their power, the nobility instituted the system of electors, made up of seven lords and three ecclesiastics from the archbishoprics, to determine the succession of rulers in Germany (a policy finalized by the Golden Bull of Charles IV of Bohemia in 1356).

It is surprising that with the passing of the Hohenstaufens, whose absolute authority had been stamped on the landscape of the Rhine with huge imperial westworks (Speyer, Worms, and Mainz cathedrals), the mode of architecture changed abruptly to that of the French Gothic. At Strasbourg (Strassburg in German) in the Upper Rhine—where German and French are still mixed in the dialect of the people—a new cathedral was raised (1176) on the burned-out foundations of the earlier church that clearly marks this transition (figs. 536, 537; colorplate 64).[59] By 1225 the apse and the north transept were completed in the Romanesque style. The south transept and the choir were built by the architect Rudolf in the 1240s, and the nave was completed by his son in 1275 in the new Gothic style. Only the wider proportions of the nave (1:2) distinguish the interior from the elegant structures in the High Gothic style of Pierre de Montreuil in Paris.

The facade was then further elaborated into a *rayonnant* front, based in part on Saint Urbain at Troyes, by an architect named Erwin von Steinbach, in 1277. Across the solid core of the stone facade, Von Steinbach constructed an intricate screen of tracery about two feet deep that transforms the central block into a masterpiece of Late Gothic ornament resembling a huge trellis surmounted by a splendid rose window. The upper parts of the facade were added much

later (c. 1365, 1384–99); the octagonal stage of the north tower and the ornate openwork spire were completed in the fifteenth century.

The sculptural decorations for Erwin von Steinbach's recessed portals display a surprisingly uniform style and an iconographic program that is a striking variation on what we have seen in France (figs. 538–40). Although much of the sculpture was mutilated during the French Revolution, the facade sculptures have been superbly restored. The central portal is dominated by tall, thin prophets wrapped in voluminous draperies staring down from the jambs. Their bearded faces are emaciated, with pointed features and highly stylized curlicues for beards and hair. Above them appears a tympanum with four registers of reliefs illustrating

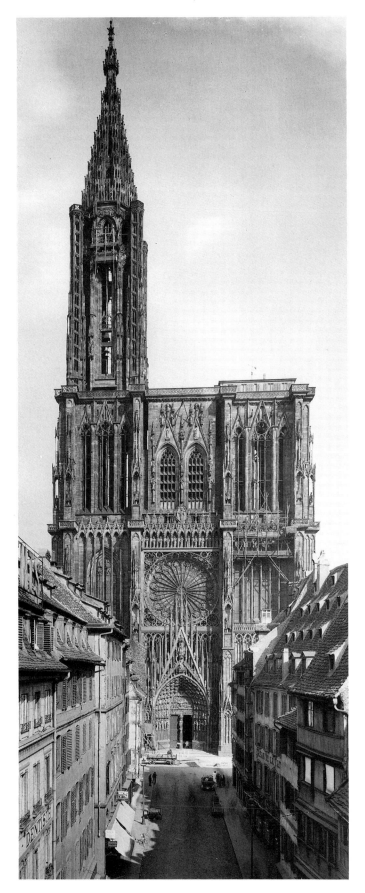

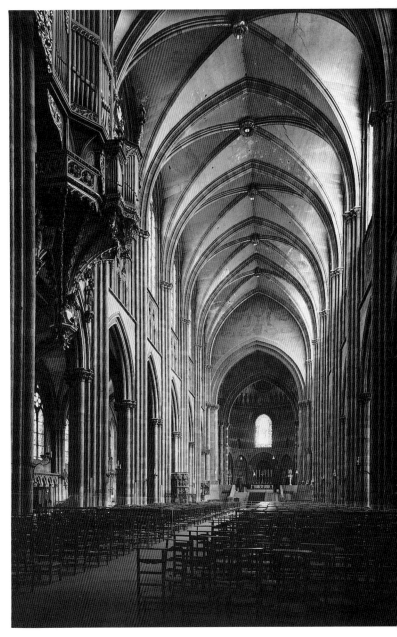

above: 536. Strasbourg Cathedral. West facade. Begun 1277; upper stories 1365, 1384–99. See also colorplate 64

right: 537. Strasbourg Cathedral. Nave. After 1240–75

the Passion of Christ (the Throne of Solomon in the sharply pointed gable and the Madonna that surmounts it are later). The left portal presents female personifications of the Virtues trampling on squirming representations of the Vices; the north portal features willowy figures of three Foolish Virgins with discarded lamps tempted by a youthful Satan holding an apple (fig. 540) opposite three Wise Virgins holding their lamps upright before the stern figure of the Bridegroom, Christ (see p. 86).

We have seen representations of the Virtues and Vices and the Wise and Foolish Virgins before but only as marginal or secondary sculptures in French cathedrals. In the tympanum above the heads of the Virgins appears, quite appro-

539. *Head of a Prophet.* Detail of fig. 538

538. *Prophets.* Right jamb, central portal, facade, Strasbourg Cathedral. c. 1280

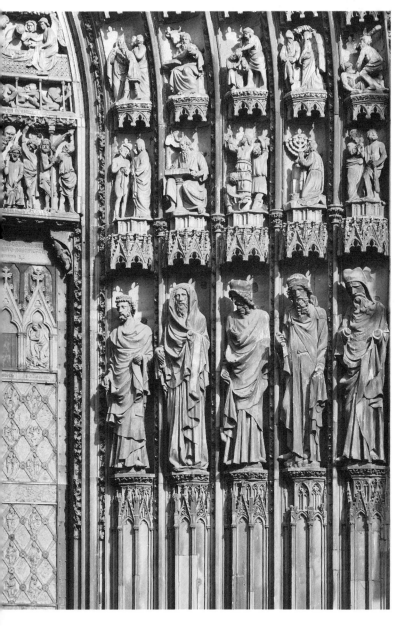

priately, a more conventional image of the Last Judgment. This interest in presenting the more capricious aspects of the dogmatic themes recurs frequently in Gothic sculpture in Germany, one of the most charming examples being the Foolish Virgins on the facade of Magdeburg Cathedral (fig. 541).

The mannered style of the west facade sculptures at Strasbourg is a clear forecast of developments in German sculpture of the late thirteenth and early fourteenth centuries and will be considered more carefully later. Of special interest at Strasbourg are the sculptures of the south transept that date in the first half of the thirteenth century. The program, which was planned for the north transept originally, displays two tympana that illustrate the final events in the life of the Virgin: the Dormition and Funeral (left), the Assumption and Coronation (right).

The style of the Dormition (fig. 542) is especially instructive to study if we think back to a similar scene in the central tympanum of Chartres north (fig. 477), dating about 1210–15. In place of the stately composition at Chartres, that at Strasbourg is agitated and crowded, with disembodied heads emerging from the curvature of the tympanum. The intense stares and twisted gestures of the apostles make them dis-

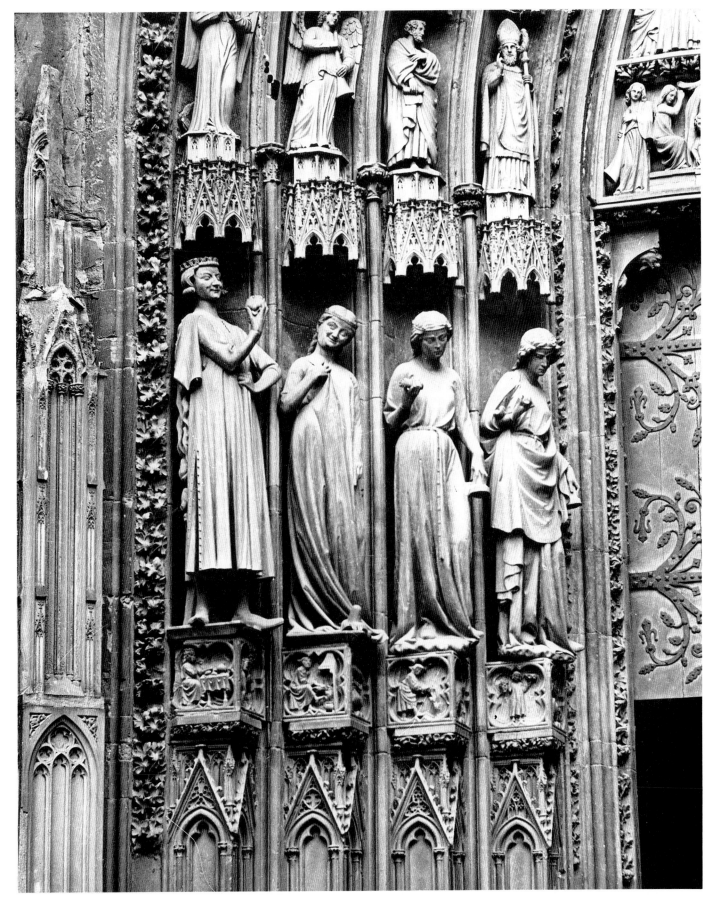

540. *Satan and the Foolish Virgins*. Left jamb, north portal, facade, Strasbourg Cathedral. c. 1280

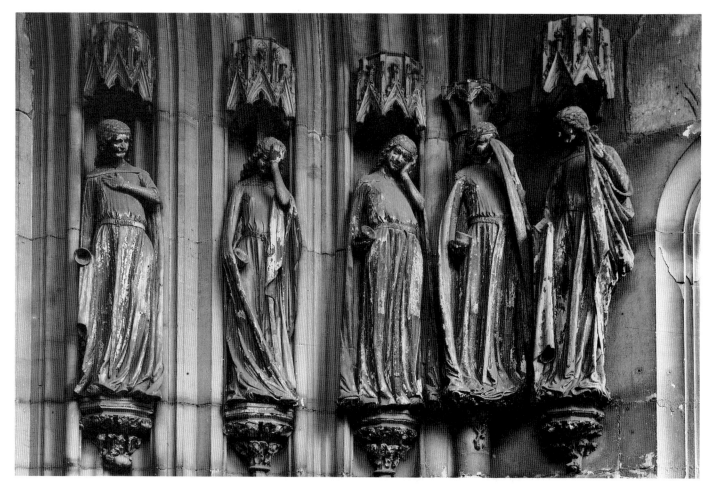

541. *The Foolish Virgins.* Left jamb, north transept portal, Magdeburg Cathedral. c. 1250–60

542. *Death of the Virgin.* Tympanum of the south transept portal, Strasbourg Cathedral. c. 1230

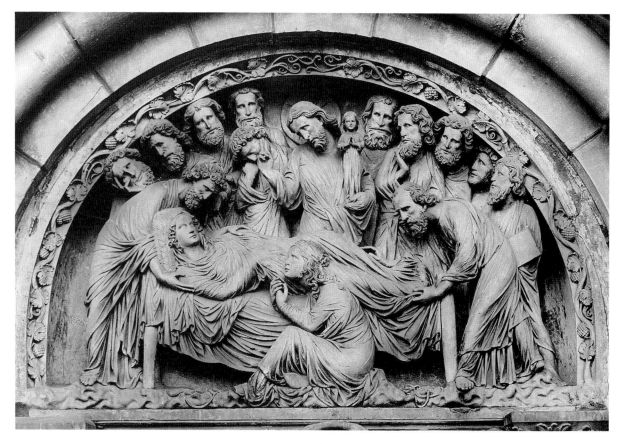

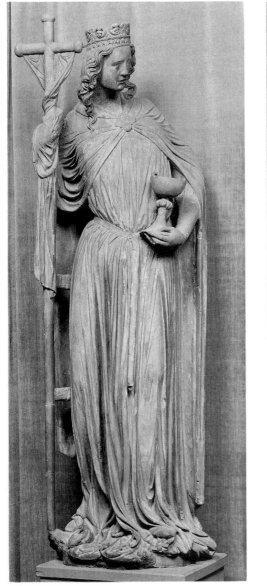
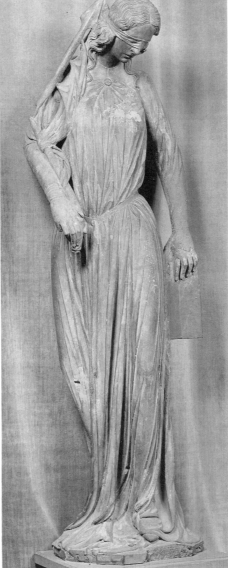

543. (a) *Ecclesia* and (b) *Synagoga.*
Formerly on the outer jambs
of the south transept portal,
Strasbourg Cathedral.
Height 6′5″. c. 1240.
Frauenhaus, Strasbourg

comforting caricatures of mourning figures, and to add to the overbearing theatrics, a seated figure of the Magdalene, wringing her hands frantically and grimacing in her heartache, is squeezed in before the bed of the Virgin.

These throbbing lines and angular movements are foreign to the French Gothic style and can be considered traits of a pronounced expressionism often found in Medieval German art. The treatment of the draperies of the reclining Virgin and the features of her face suggest that the sculptor, however original, knew the style of the Classical Master of the Visitation group at Reims (fig. 500). The fussy grooves that wrap tightly about her body and the exciting flow of restless lines in the sheet beneath her also remind us of the Classical *Muldenstil* of Nicholas of Verdun (fig. 436) that first announced this development in drapery.

The jambs and central post of the south portals were decorated originally with standing apostles about the en-

throned King Solomon. These sculptures were destroyed, but two figures placed on the extremities of the jambs (the originals are today in the Frauenhaus in Strasbourg), personifying *Ecclesia* and *Synagoga,* are exceptionally beautiful examples of the merging of French and Rhenish temperaments in sculpture around mid-century, about 1235–40 (figs. 543a, b). *Maria Ecclesia* is an elegant female figure, proud and dignified, who triumphantly plants the cross at her feet. Her left hand holds a chalice. In defeat, *Synagoga,* with downcast head, twists to the right. A diaphanous blindfold covers her eyes. The gracefully descending draperies, the creased tucks about the belts, and the rounded abstract folds that gather about their feet are strikingly similar to those features in the later transept sculptures at Chartres north, such as the Queen of Sheba and the delicately posed Saint Modeste on the outer reaches of the portal there. On the other hand, the manner in which the upper torsos are

treated, with the outer mantle stretched tightly about the shoulders and fastened by a brooch in front (note especially *Ecclesia*), reminds us of the elegantly draped figures of the Smiling Angel Master at Reims (fig. 500).

Further down the Rhine is one of the most impressive demonstrations of expressive scale (as opposed to human scale) in Gothic architecture: the facade of Cologne Cathedral (fig. 544).[60] A mammoth cliff of layered stone stories rises dramatically some five hundred feet, reducing the spectators in the view of the facade to mere ants scurrying about its foundations. This huge edifice is, however, mostly a product of nineteenth-century Gothic revival in Germany. Views of Cologne from the fifteenth and sixteenth centuries (fig. 545) show the skyline dominated by the lofty choir (fig. 546) and the huge crane that was used for lifting the stones in the building of the nave and facade. For three centuries

opposite: 544. Cologne Cathedral. Air view. Begun 1248; choir consecrated 1322; work stopped 1560; completed c. 1880

below: 545. ANTON WOENSAM. *The Construction of Cologne Cathedral.* Detail of a woodcut. c. 1530

546. Cologne Cathedral. View into the choir. Begun 1248; consecrated 1322

(1560–c. 1850) no work was carried out. The plans for the facade, designed by one Master Michael about 1350, were discovered in Darmstadt in the nineteenth century being used as a stretcher for drying beans, so the story goes, and it was then that the project was renewed and finally brought to completion by the inspired citizens of Cologne. The vicissitudes of history had dealt the city severe blows during and after the Reformation, but the glory of the once-powerful archbishopric was finally restored in 1880 with the completion of the largest cathedral in northern Europe. The finished product strikes us as being a classical solution to Gothic building no matter when it dates.

In 1164 Cologne Cathedral was presented with relics of the Three Magi (for which Nicholas of Verdun executed the famous shrine in 1181—colorplate 55), and it was there that the German kings offered gifts to the church of God following their coronation at Aachen. In 1247 the old Carolingian

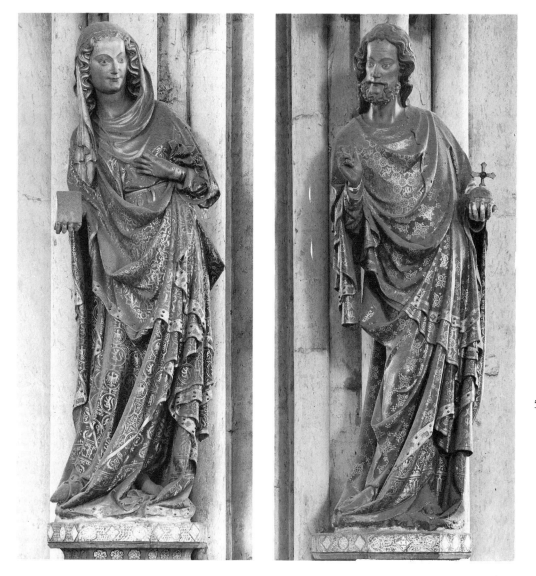

547. (a) *Virgin* and (b) *Christ*. Stone statues on the piers of the choir, Cologne Cathedral. c. 1320

structure, apparently in ruinous state, was torn down and an architect, Master Gerhard, who was certainly familiar with the buildings of Jean de Chelles and Pierre de Montreuil, began the rebuilding with the intent of creating on the site a grandiose French Gothic cathedral like Amiens (the influence of Beauvais Cathedral seems apparent, too). One wonders if this change in styles was not due, at least in part, to local opposition to the prevailing tastes of the Hohenstaufens as exemplified in the traditional Rhenish Romanesque churches.

Master Gerhard commenced with the erection of the choir (which was consecrated in 1322, some forty years after his death) and then laid the foundations for the giant, five-aisled nave—the church is 472 feet long—but work progressed only to the height of the nave arcade (it too was completed in the nineteenth century). The choir offers the best view of the Gothic style of Master Gerhard (fig. 546). Its elegant proportions and soaring verticality (150 feet) bring to mind the

choir of Amiens. The ground plan, with its corona of seven chapels, is like that of Amiens. From the exterior the majestic rise of the flying buttresses creates an even more pronounced sensation of lofty verticality and transparency, resembling, in fact, the choir of Beauvais Cathedral.

A few refinements in details are to be noted. The piers on the interior are grooved between the shafts so that they appear more sculptural, with concave penetrations and shadows along their contours. The exterior gables are pierced with tracery patterns of inverted Y bars (*Dreistrahlen* in German) that accentuate the openings with rhythmic regularity. In spite of certain indifferences in the architectural execution of the huge cathedral, the final effect is overwhelming. When Petrarch visited Cologne in 1333 he noted, "In the middle of the city I saw an uncommonly beautiful temple, which, though still incomplete, can be called with good reason the most magnificent."[61]

A profusion of sculptural decoration was planned for Co-

logne both inside and out. With the exception of the south portal of the facade, little work was accomplished in the Middle Ages. On the interior, the fourteen piers in the choir are adorned with statues, executed about 1320. On the north and south side at the beginning of the chancel, opposite each other, stand the Virgin and Christ (figs. 547a, b) followed by the twelve apostles, all standing on foliate corbels and covered by high tabernacles.

Perhaps inspired by the similar series at Sainte-Chapelle (c. 1248), the figures of the Cologne choir display the features of the mannered style of Late Gothic that we first saw on the west facade of Strasbourg. Their tall, lean bodies sway like fragile coatracks upon which their heavy mantles are cast. This drapery falls in generous arcs with intricate overlaps and cascades. Not only are the postures and draperies mannered in appearance, but the heads also strike one as extreme elaborations of the charming realism initiated by the Smiling Angel Master at Reims some eighty years earlier. Elegantly carved, the Cologne apostles, turning like court dancers on their consoles, are nonetheless weaker personalities with their insipid expressions and coy gestures.

East of Cologne, at Marburg on the river Lahn, the Church of Saint Elisabeth (1235–83) presents us with one of the earliest distinctive Germanic variations on French Gothic architecture (fig. 548), the so-called hall church (*Hallenkirche*). In the hall church the side aisles are the same height as the nave and the thin piers rise uninterrupted — galleries and triforium are eliminated — creating a lofty openess with an exceptional sense of free-flowing space through the interior.[62] The side walls of the aisles and the trefoil choir are lined with two rows of tall windows, one over the other, providing the high space with a soft, diffuse illumination very unlike that of the darker interiors of French Gothic. Saint Elisabeth served as a pilgrimage church and a mausoleum for local lords, and many of the later hall churches were built by the mendicant orders (as opposed to those built for the bishops), where the greater spatial unity enhanced their architectural character as "preaching halls."

One of the most beautiful of these is the Wiesenkirche (Santa Maria zur Wiese) at Soest in Westphalia (fig. 549), begun in 1331. The soaring ascension of the interior with its curious pear-shaped shafts and hollows in the tall piers is

548. Church of Saint Elisabeth, Marburg. Nave.
1235–83

549. Wiesenkirche (Santa Maria zur Wiese), Soest. Nave.
Begun 1331

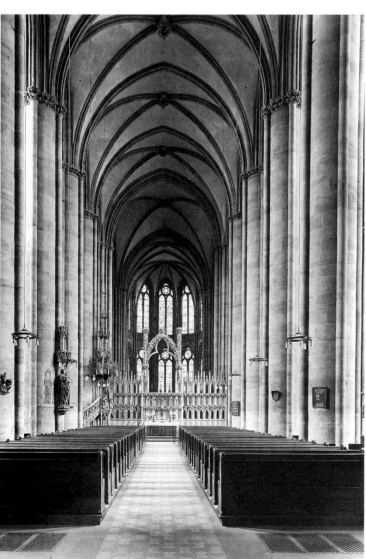

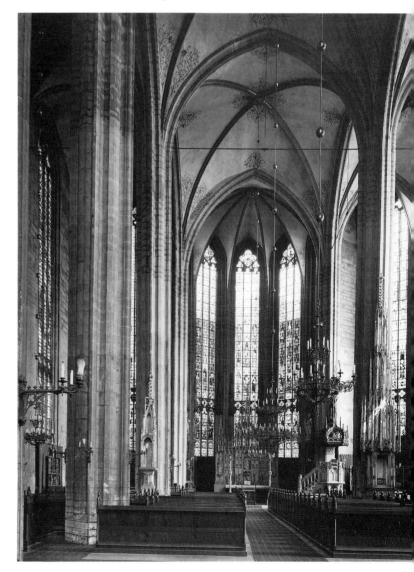

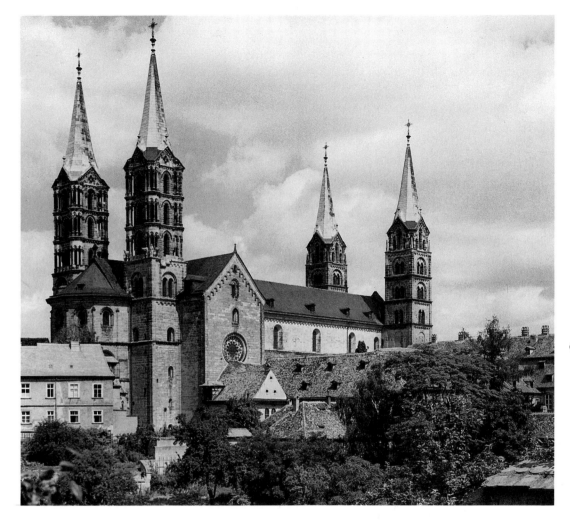

left: 550.
Bamberg Cathedral.
Exterior from the north.
1200–1237

below: 551.
Disputing Prophets.
Choir screen. Stone, height
approx. 4'. c. 1220–30.
Bamberg Cathedral

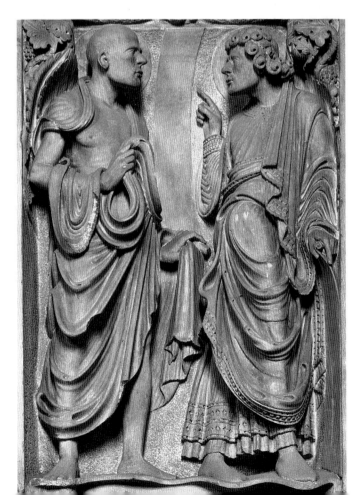

enhanced by the subtle proportions of height to width
which, according to some scholars, are based on the princi-
ples of the golden mean. As ideal preaching halls, the *Hal-
lenkirchen* spread rapidly throughout Germany following
the Reformation.

The new Gothic churches in western Germany asserted
their independence in style and spirit from the imperial
foundations such as Speyer, Worms, and Mainz, much as the
communities themselves, especially Cologne, broke with
the authority of the Hohenstaufens after the excommunica-
tion of Frederick II. Thus it seems that emergence of the
Gothic style not only depended on the proximity of France
but on political circumstances as well. Matters were different
further east. At Bamberg in northern Bavaria, Bishop Ekbert
of Andechs (1203–37) maintained close ties to Frederick,
who, in fact, was a major benefactor of the church during a
rebuilding campaign following a fire in 1183.[63]

The ties with the imperium are at once evident in the
general character of the new cathedral in Bamberg, erected
between about 1200 and 1237 (fig. 550). The sturdy church
with its long nave terminating in double choirs resembles
the so-called double-enders that we found in imperial foun-

Colorplate 65. *Crucifixion and Deposition*. Illustrations in the Psalter of Blanche of Castile. 11⅛ × 8″. c. 1230. Bibliothèque de l'Arsenal, Paris (MS franc. 1186, fol. 24r)

Colorplate 66. *Scenes from the Apocalypse*. Illustration in the *Bible moralisée*. 15 × 10½″. 1226–34. Pierpont Morgan Library, New York (MS 240, fol. 6r)

Colorplate 67. *The Virgin of Jeanne d'Evreux*. Silver gilt, height 27½″. 1339. The Louvre, Paris

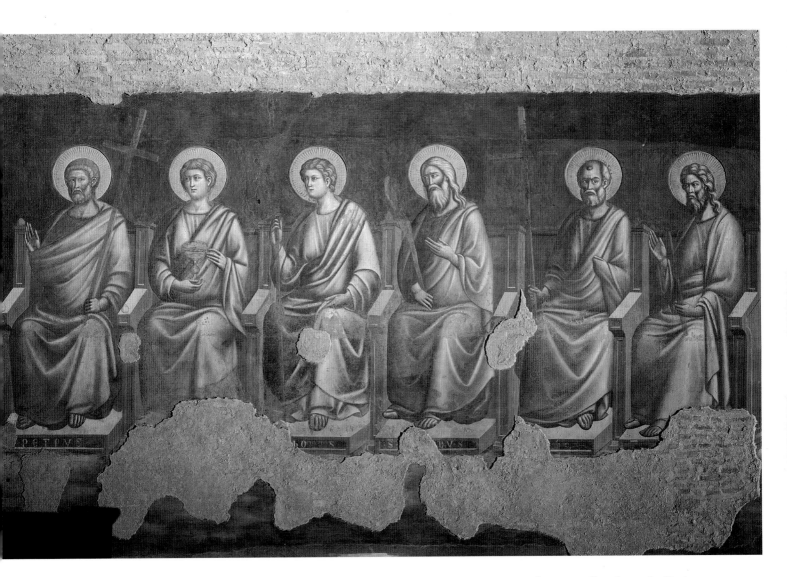

Colorplate 68. Pietro Cavallini. *Seated Apostles from a Last Judgment* (portion). Fresco on the west wall in Santa Cecilia in Trastevere, Rome. c. 1290

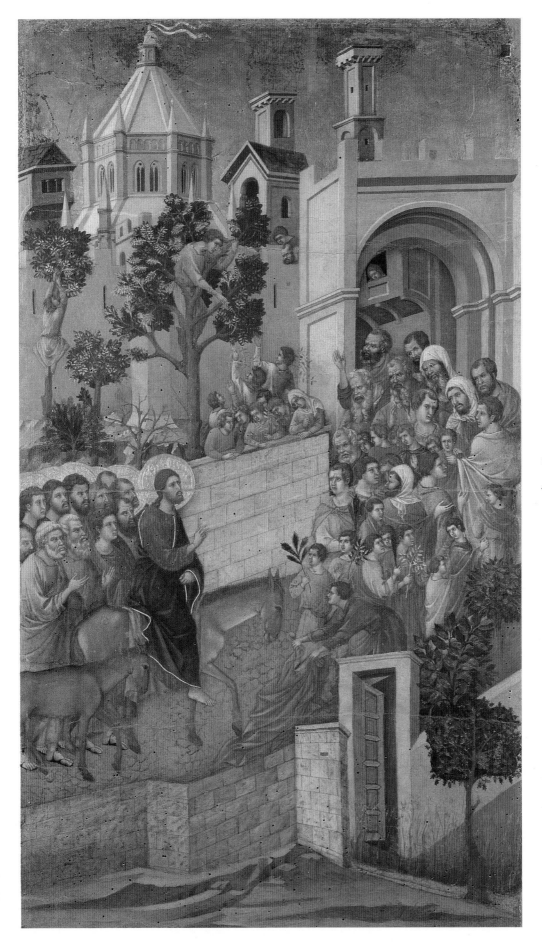

Colorplate 69. DUCCIO. *Entry
into Jerusalem*. Panel from the
back of the *Maestà*.
40⅛ × 21⅛″. 1308–11. Museo
dell'Opera del Duomo, Siena

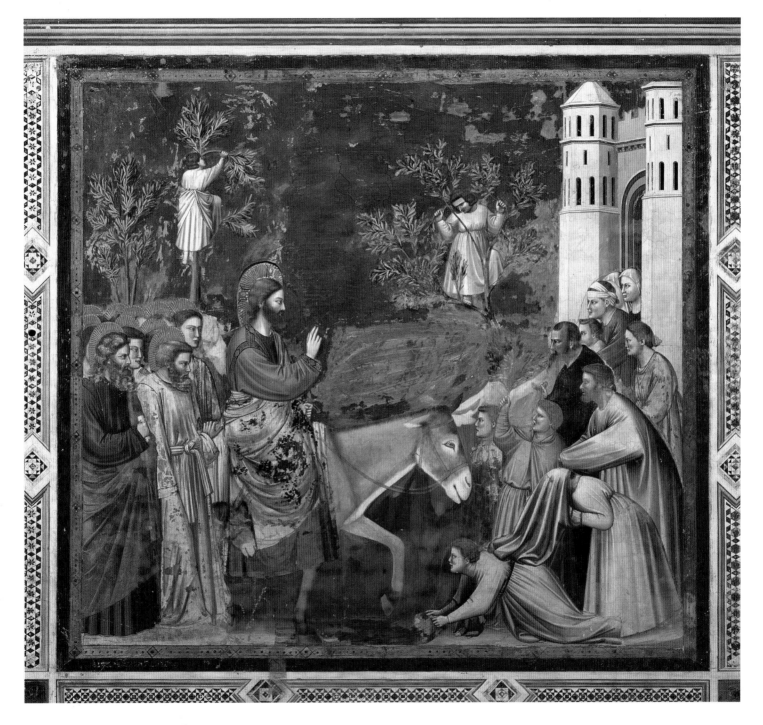

Colorplate 70. GIOTTO. *Entry into Jerusalem*. Fresco. After 1305. Arena Chapel, Padua

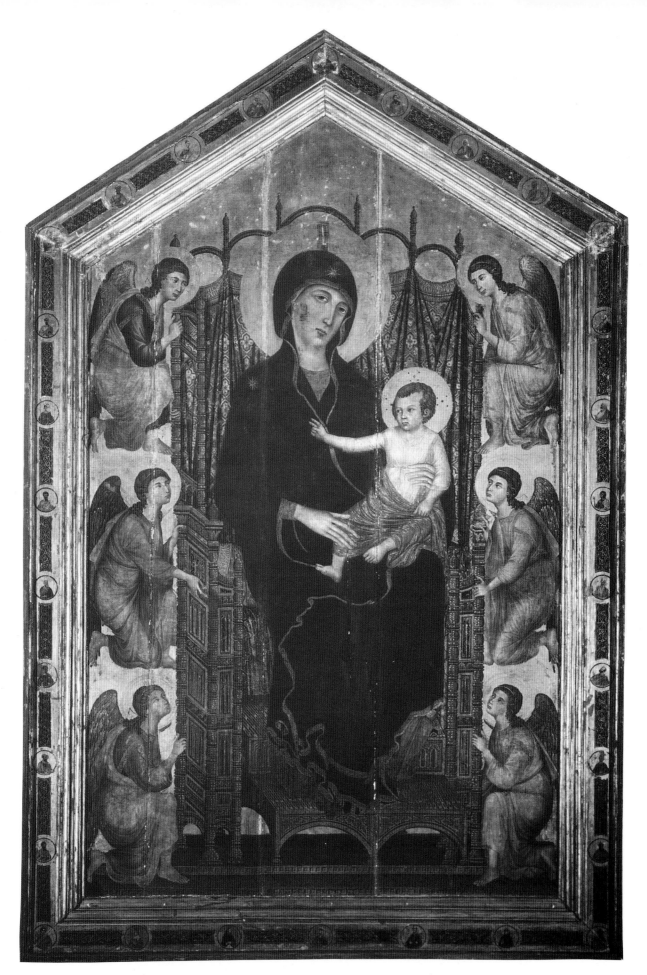

Colorplate 71. Duccio. *Rucellai Madonna*. Panel, 14'9⅛" × 9'6⅛". 1285. Uffizi Gallery, Florence

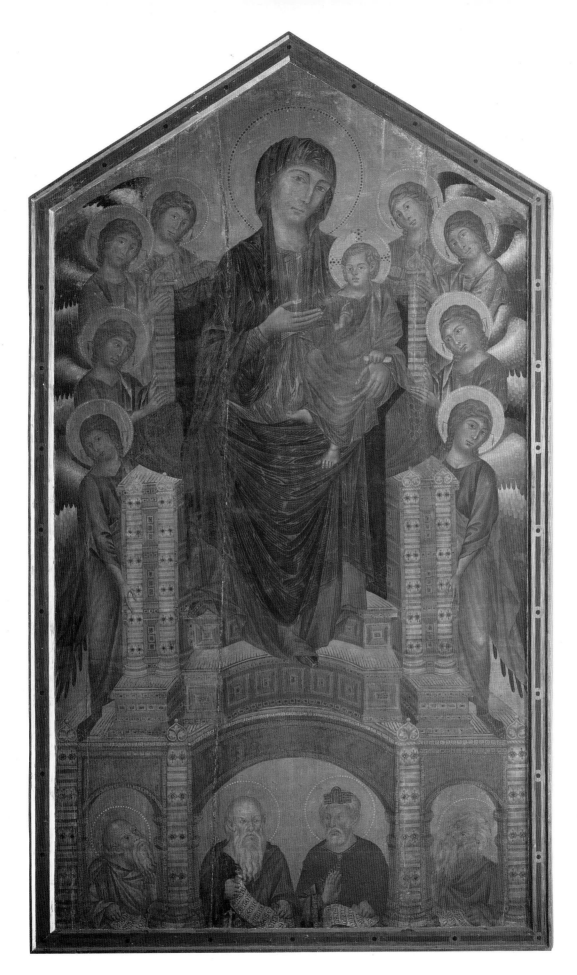

Colorplate 72. CIMABUE. *Enthroned Madonna and Child*. Panel 11′7″ × 7′4″. c. 1280. Uffizi Gallery, Florence

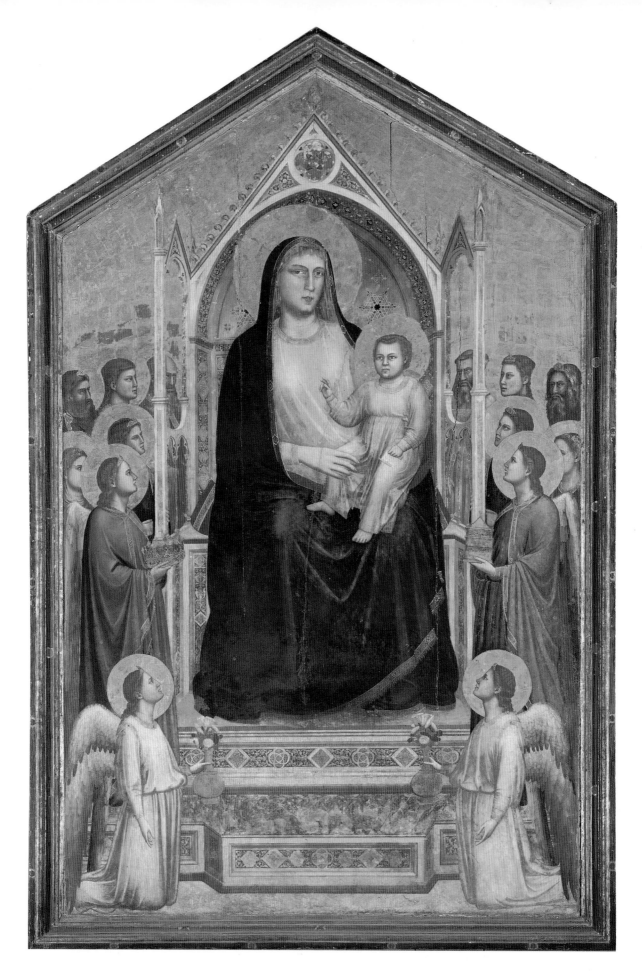

Colorplate 73. GIOTTO. *Enthroned Madonna and Child* (Ognissanti Madonna). Panel, 10′8″ × 6′8¼″. 1310.
Uffizi Gallery, Florence

552. (a) *Elizabeth* and (b) the *Virgin*.
Stone, height of each 6'2".
c. 1235–40. Bamberg Cathedral

dations along the Rhine. It is essentially a German Roman-esque structure, although the interior has something of the character of Late Cistercian architecture with quadripartite vaults in the nave and western choir (perhaps due to the employ of workman from the Cistercian foundation of Er-bach who were brought in by Ekbert about 1220–30). The architect, Wortvinus, has been credited with much of the rebuilding as well as the sculptural decorations for the new cathedral. These include the impressive stone reliefs adorn-ing the monumental choir screen on the east (Saint George choir) with paired figures of standing prophets, on one side (fig. 551), and apostles, on the other, in animated disputa-tion with each other, a theme that can be traced from Early Christian basilical decoration through the jamb reliefs at Vézelay (fig. 351), it will be recalled.

Although usually dated between 1220 and 1230, the fig-ures are surprisingly Romanesque in spirit and in the inten-sity of expression. The heads are vigorously modeled with thrusting jaws and piercing eyes. Archaic linear conventions are employed for the hair and beards. Their bodies, too, are normally proportioned, but their gestures are spastic, and the predominance given to the highly stylized loops and deeply carved arcs that churn about their stocky bodies conveys that sense of tension and nervousness that we asso-ciate with the dynamic linearism of French sculpture a century earlier.

Apparently working side by side with the "Romanesque" master of the choir-screen reliefs was another shop or shops which executed a variety of sculptures in the round for the exterior portals (some of these have been moved to the interior for preservation). Considerable controversy has arisen over the actual number of masters involved with these sculptures, but one aspect of the second style is its clear dependence on contemporary French models, especially those of Reims. This is particularly evident in the figures of Mary and Elizabeth, a Visitation group, that today adorns the inside of a pier in the eastern part of the nave (figs. 552a, b).

One is immediately reminded of the Visitation group on the west facade of Reims (see fig. 500). The monumental figures are posed similarly to those at Reims, and their elaborate draperies display the same fussy horizontal stria-tions with short grooves, even more deeply cut at Bamberg, that break across the body, marking out the protrusion of elbows and knees vigorously in the Classical fashion. The

head of Mary reminds us, too, of the Virgin in the Reims Visitation, although her face is fuller and her chin heavier. Elizabeth's face is a masterpiece in character study with near portraitlike features and a strained expression. Deep, cascading folds unfurl from the left arms of the figures. These overlapping folds appear at Reims, but at Bamberg they are greatly accentuated and enlarged, adding a sense of dramatic movement and plasticity that is missing in the more subdued silhouettes of the French pieces. How does one account for the classicizing style at Bamberg? Was it due solely to the influence of the Reims sculptures, as many French scholars argue? We shall return to this problem later (see p. 445 ff.).

Considered the masterpiece of the sculptor of the Bamberg Visitation group is the handsome and famous "Bamberger Rider" found today on the side of a nearby pier (fig.

553. *The "Bamberger Rider."* Stone, height 7′9″. c. 1235–40. Bamberg Cathedral

553). Much has been written concerning the identity of this striking equestrian figure.[64] He has been identified as one of the three Magi, as Saint George, and as a number of historical figures, including the emperor Constantine, Henry II, Stephen of Hungary, Conrad III, and Frederick II. Such large equestrian memorials are ultimately linked to Italy, of course, and one normally associates such likenesses with those of the first Christian emperor, Constantine. But the characterization here is very different from those of Constantine. The rider wears a crown, but he is not depicted as a conquering, militant leader. Furthermore, certain conventions employed in the characterization suggest a more contemporary figure in history.

The youthful countenance—unbearded, with bright eyes, long curls, and well-formed lips—reminds us of descriptions of the true Christian knight found in German epic literature of the period, such as that of Wolfram von Eschenbach's Parzival. The handsome bearing of the rider is that of a determined aristocrat with sound body and soul (*mens sana in corpore sano*) who courageously leads his people. It has been suggested that this statue originally appeared in the exterior tympanum of the so-called Adam's Portal of the east choir, where it would have been placed above jamb statues of Henry II and his wife Cunigunde, the original founders of Bamberg Cathedral. It is tempting, therefore, to see the rider as Frederick II, Bishop Ekbert's benefactor and sponsor of the new cathedral, but as one German scholar reminds us, his identity remains his secret. A similar equestrian portrait of approximately the same date was erected in the market square at Magdeburg, north of Bamberg.

The striking realism as well as ties to the styles of Reims in the second group of sculptures at Bamberg prepare us for a study of a remarkable series of German sculptures in the cathedral at Naumburg, a frontier town lying between Bamberg and Magdeburg on the Salle River. The earlier cathedral, raised on the site of the castle of the margraves in the eleventh century, was rebuilt in the first half of the thirteenth. The sturdy Romanesque structure with its double choirs was completed under Bishop Dietrich II of Wettin (1244–72), who added the impressive western choir as a memorial to the members of the ruling families of Naumburg, of which he was a descendant. A very gifted sculptor headed the workshop for Dietrich's choir.[65]

The huge stone screen leading into the west choir was decorated with a broad band of reliefs along the top depicting seven scenes from the Passion of Christ, from the Last Supper to the Carrying of the Cross, executed in a vigorous, expressionistic style (fig. 554). The Crucifixion is presented by three monumental, freestanding sculptures placed on the jambs and the trumeau of the projecting gabled porch that serves as the entrance. Traditionally, such a Calvary group would be placed atop the screen, but here the lifesize figures are brought down to the level of the worshippers, and the

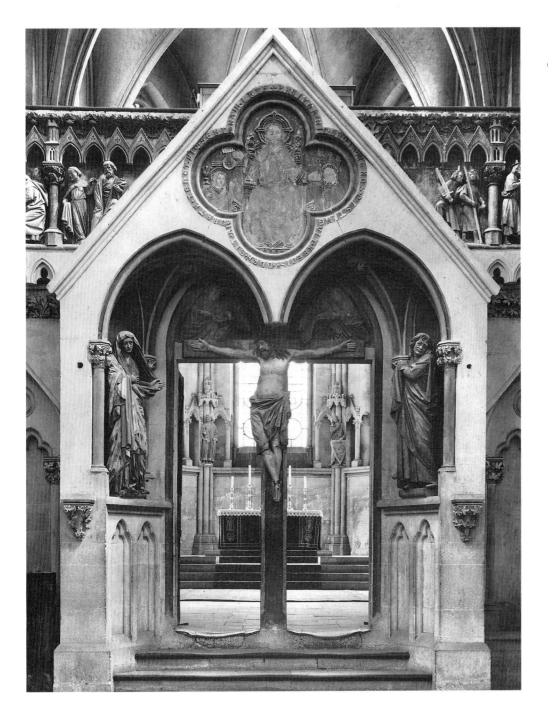

554. Choir screen with the Crucifixion. c. 1245–60. Naumburg Cathedral

exaggerated emotionalism of the two mourners, the Virgin and John the Evangelist, engages them directly. Mary, her faced lined with heartache and grief, gestures tenderly to the spectator, while, opposite her, John, sobbing openly, turns dramatically in his anguish, wringing his hands within the voluminous mantle folds as he glances tearfully downward.

Passing through this melodramatic entrance, we find ourselves in a deep, aisleless choir with tall stained-glass windows. Placed within tabernacles along the wall of the choir are astonishing, lifesize portraits of twelve ancestors of the houses of Billung and Wettin, who, although they counted notorious sinners among their members, were the benefactors of the original church. They stand in staid poses and look down at the altar as if attending a solemn Mass and reflecting on their fates.

Only the round-faced Regelindis, paired with her hus-

band, the margrave Hermann (fig. 555), on the left wall, breaks the serious calm that pervades the group. She glances back toward the entrance as if to welcome the worshipper, and her warm smile, reminiscent of that of the Smiling Angel of Reims Cathedral, offers a brief moment of relief in the quiet drama that unfolds here. The most famous member of the clan is the elegant Uta (fig. 556), opposite Regelindis, standing with her husband, Ekkehard of Meissen. This bewitching aristocrat, drawing the collar of her mantle mysteriously across her cheek, is proud but contrite, haughty but beautiful, and her special dignity is conveyed not only in her intense gaze and pouting lips but in the massive straight falls of her cloak that descend from the collar. The heavy stuff, gathered and pulled upward by her left hand, sinks under the tight grasp of her fingers and breaks into a lyrical cascade falling on the right. Although not actually portraits—these

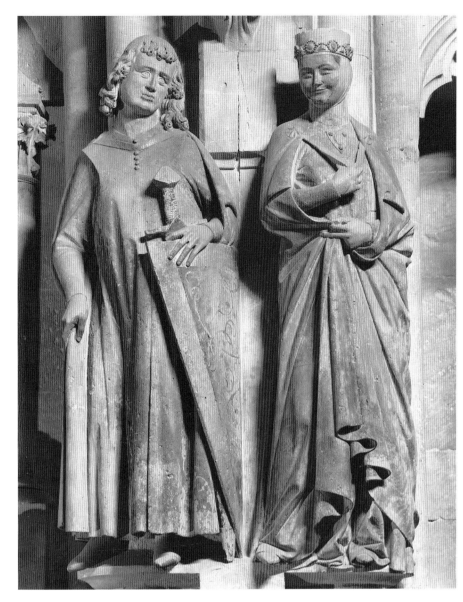

555. *Margrave Hermann and Regelindis.* Choir statues, height 6'2".
c. 1245–60. Naumburg Cathedral

556. *Uta.* Choir statue, height 6'2".
c. 1245–60. Naumburg Cathedral

ancestors lived many years before the execution of their likenesses—the sculptor of Naumburg achieved a haunting characterization of these aristocrats, who seem like very real people before us, waiting quietly to learn of their ultimate fates at final judgment.

The keen balance between emotionalism and realism that we find in the ancestors of Naumburg is upset in a genre of freestanding sculpture at the end of the century known as *Andachtsbilder,* or "contemplation images." These images served the needs of worshippers steeped more and more in the intense mystical devotion that swept through the North, especially in the Rhineland.[66] In some respects the *Andachtsbild* can be seen as a kind of "Gothic icon," but its origins lie not in hagiographic portraiture, as does the icon in Byzantine art. These haunting figures portray moments of extreme pathos or, conversely, quiet joy—the poles of mystical devotion—in the lives of Christ and Mary. The *Andachtsbilder,* in fact, are extractions from narratives whereby

the most poignant figures within a dramatic context are isolated and monumentalized. They become hieroglyphs of emotional states that transcend any precise illustration of a moment or place in a story.

The figures of Christ with the sleeping Saint John (fig. 557) are lifted, so to speak, from the familiar narrative composition of the Last Supper, and alone they vividly project the comfort and warmth of Christ's words that one must love his brother. At the opposite pole is the excruciatingly agonizing *Crucifix* (fig. 558), known as the *Pestkreuz,* or Plague Crucifix. The bleeding and broken body of Christ is placed directly before the worshipper at the altar in painful proximity, so that he may count every drop of blood, witness the terrible contortions of Christ's features, and shudder before the festered and emaciated limbs of the lifeless Christ, who died brutally for man's salvation.

In these moving figures, isolated in time and place as if they were personifications of emotional states, realism gives

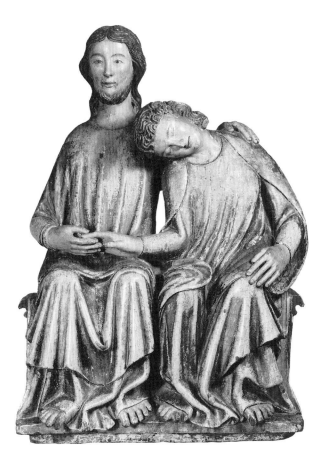

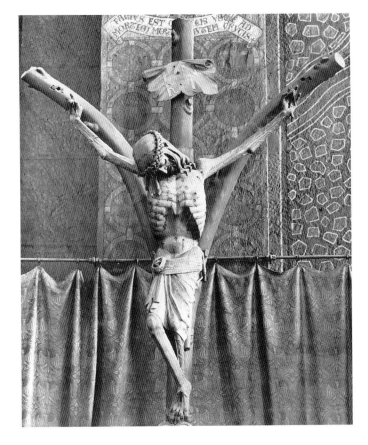

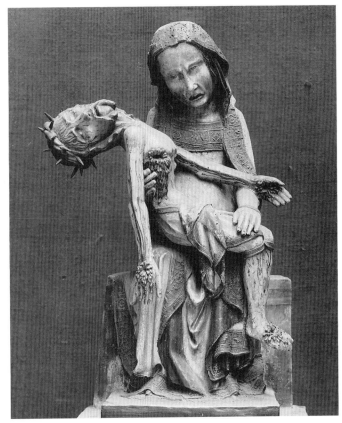

above: 557. *Christ with the Sleeping Saint John the Evangelist.* Wood, height 35¼". c. 1330. The Cleveland Museum of Art. Purchase, J. H. Wade Fund

below: 558. *Crucifix (Pestkreuz).* Wood, height 57". 1304. Schnütgen Museum, Cologne

below right: 559. *Pietà (Vesperbild).* Wood, height 34½". c. 1330. Landesmuseum, Bonn

way to expressionism. Gothic lyricism is replaced by a style that distorts and exaggerates the poses and countenances of the actors before us to convey their inner emotions and sufferings: hence the drastic angularity of Christ's body, the attenuation of his limbs to mere skeletal contortions, the deep, dark cavity of his stomach sucked into the bony rib cage through dehydration, and the harshly drawn features of the face with the head drooping like a grotesque mask on the chest. Furthermore, the *Andachtsbilder* are rarely framed on the altar. They are not meant to be representations of events placed there but embodiments of the real and continuous presence of the suffering Christ before the worshipper.

One of the most moving *Andachtsbilder* is that of the seated Virgin holding the dead Christ across her lap (extracted from the *Pietà,* or Lamentation, episode). This type is commonly called a *Vesperbild* because it is believed that it would convey the heartache and grief of Mary that was called for in the worshipper's contemplation during Vespers at the end of the day (fig. 559).[67] Here the poles of mystical devotion are dramatically illustrated in German art. The traditional image of the Virgin and Child, the pretty young mother cradling her newborn baby tenderly in her arms—her joy—is transformed into a brutal portrayal of the same mother, now aged, worn, and exhausted in grief, grasping her son's broken body for the last time—her sorrow. This poignant characterization of the Mother and Child had a profound influence in Marian imagery in the next centuries, the most famous being the sublime *Pietà* by Michelangelo in Saint Peter's, where distortion and ugliness are abandoned for beauty and idealism even in death.

GOTHIC PAINTING AND RELATED ARTS IN FRANCE

I N THE *Divine Comedy,* Dante referred to Paris as that "city famed for the art of miniature painting." Indeed, with the exception of some illuminated manuscripts dating in the early years of the thirteenth century produced in English scriptoria, the history of painting in the North is dominated by developments that took place in the capital of France. The same factors that conditioned the developments in architecture and sculpture in the Ile-de-France affected the rise of painting. The urban cathedral replaced the rural monastic abbey as the progressive building type in architecture, and so, too, did the illuminated manuscripts produced in secular city workshops supplant the service books that were the products of monastic scriptoria. It was the urban, secular artist, not the monastic scribe, who was now called upon by wealthy patrons and members of the university circles.

As was noted earlier, illumination held a secondary role in the arts of the Romanesque period, deriving much of its style and ornament from the sumptuary arts and from relief sculpture. In the Gothic period, miniaturists found exciting new models in the stained-glass windows that evolved in cathedrals of the thirteenth century.

The finest illuminated manuscripts were produced for kings and queens, as is to be expected, and the Capetian rulers were avid bibliophiles, especially Louis IX (Saint Louis), who accumulated vast libraries of secular as well as religious books that were passed down from generation to generation, ultimately forming the core of the Bibliothèque Nationale in Paris. For Louis's mother, Blanche of Castile, a splendid illuminated psalter was made about 1230 that serves as an excellent example of Early Gothic painting (colorplate 65). The Psalter of Blanche of Castile has twenty-five elegant pages with miniatures, the greater part being pairs (facing verso and recto sides) forming antithetical presentations of scenes from the Old and New Testaments, independent of the verses of the Psalms.[68]

The brilliance of the bright colors commands our attention in these pictures. The palette consists of rich reds and deep blues with gold backgrounds, and the miniatures stand out like *cloisonné* enamels on the page. Secondary hues—fresh greens, oranges, purples—accent the blocks of saturated pure colors contained within dark outlines marking out the

contours of the figures. The few lines of the drapery and the minuscule facial features resemble the leaden lines that served the compositions of stained-glass windows. Modeling in the figures and spatial projection of the settings are minimal. Often the ground is provided by the frame of the miniature, and when landscape is indicated, it is limited to an undulating line that serves more as an ornamental touch than a projecting stage. Further, the clarity of the organization of the compositions on each page, with intersecting circles superimposed on geometric blocks of blue with red

560. *Blanche of Castile and Her Son, Louis IX.* Dedication page in the *Bible moralisée.* 15 × 10½". 1226–34. Pierpont Morgan Library, New York (MS 240, fol. 8r)

borders, reminds one of the designs found in Gothic windows with their clear integration of parts.

The dependence of miniature compositions on stained glass is even more apparent in the huge moralizing Bibles that were produced in Paris (colorplate 66). The *Bible moralisée* was a kind of instructional manual that formed an encyclopedic picture book of Old and New Testament typologies. The text consists of short moralizing commentaries on passages in the Bible written in the margins of the page. The most complete copies required three volumes and over five thousand illustrations. The fragment in the Pierpont Morgan Library in New York, illustrated here, has a dedication page portraying Queen Blanche of Castile enthroned opposite her son, Louis IX, above a cleric dictating the text to a seated scribe (fig. 560). The illustrations of the texts are organized in two columns of eight superimposed medallions, a design clearly inspired by the glass in tall lancet windows, such as those in Sainte-Chapelle (colorplate 62).[69]

The dependence of miniature painting on the art of stained glass extended beyond that of the window, however. In a masterpiece of thirteenth-century painting, the Psalter of Saint Louis, dating sometime between 1253 and 1270, Old Testament narratives are placed like stained-glass panels within elaborate frames that culminate in petite cathedrals complete with pinnacles, fretted galleries, and rose windows (see fig. 561). These painted elevations copy, in fact, that of Sainte-Chapelle itself.[70] The wide border that frames the miniature is elaborated with colorful scrolls of red and blue interspersed with conventional floriate and animal motifs, a decorative touch that will gradually give way to the delicate sprays of ivy that fill the borders of later Gothic manuscripts. The tiny actors who animate the stories with their flat silhouettes are dressed in contemporary costumes.

Other aspects of the Psalter of Saint Louis are worth noting. The book is small, measuring only 5 × 3½ inches, but it contains over seventy-eight Old Testament illustrations (some are lost) ranging chronologically from the book of Genesis to the coronation of Saul as king of Israel in the Book of Kings. Unlike the "literal" illustrations of the Psalms in the Utrecht Psalter or the "allusive" pictures in Byzantine aristocratic psalters, those in the Psalter of Saint Louis lack any relationship with the text. It is, in effect, a precious picture book appended with Psalms. Because of the small size and the concentration of scenes on the feats of the militant heroes of the Old Testament, it was undoubtedly Louis's own personal devotional book and not one intended for the service of churchmen, a point of considerable interest in the changing role of art in the Gothic era.

The miniatures in the Psalter of Saint Louis display the refined qualities of the Court style that became the primary form of painting throughout northern Europe. Indeed, Paris had become the hub of all artistic activity during the thirteenth century. Artisans from various provincial centers in northern France, the Rhineland, the Netherlands, and England poured into the capital to perfect their skills in the ateliers of Paris and to enjoy the profits of a rapidly expanding art market, particularly in book illumination. The organization of these prolific workshops is worth investigating.

The members of the atelier were enrolled in the Confrérie de Saint-Jean, a guild that was responsible not to the provost of Paris, as were most others, but to the university. Representatives of the university regularly checked the accuracy of translations and transcriptions and virtually controlled the production of texts. Furthermore, much of the market for books was found in university circles. Students were required to have their own pocket Bibles for constant reference, and as the court and the ecclesiastical libraries grew, great demands were made on those who produced books. The various ateliers clustered in the quarters near the university (various street names still reflect this today), and for those who specialized in illustrated books, a number of trained artisans were required.

The main entrepreneur and bookseller was known as the

561. *The Feast of Abraham and the Three Men.* Illustration in the Psalter of Saint Louis. 5 × 3½". 1253–70. Bibliothèque Nationale, Paris (MS lat. 10525, fol. 7v)

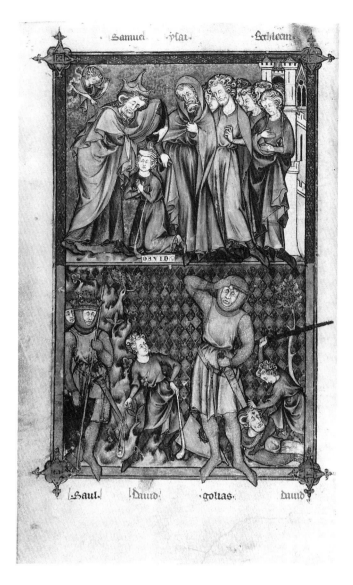

562. MASTER HONORÉ. *David Anointed by Samuel and the Battle of David and Goliath.* Illustration in the Breviary of Philippe le Bel. 7⅞ × 4⅞″. 1296. Bibliothèque Nationale, Paris (MS lat. 1023, fol. 7v)

librarius. Within each shop was the *chef d'atelier* (comparable to the master mason in architectural projects), who would lay out the book, so to speak, and organize the labor once a commission was received. The most valued member of the team was the scribe, who copied the texts in an elegant hand. The scribe was instructed to leave spaces and gaps in the text for the introduction of decorated initials and miniatures. He frequently acted as the rubricator, whose task was to fill in special entries and chapter headings in red or some other particular color.

The codex, assembled in gatherings of pages called quires, was then sent to the desks of the illuminators. These artisans often specialized in certain areas of painting, usually determined by their skills and experience, that involved the border decoration, the illuminated initials, and the painted *histoires,* or narrative illustrations. Distinctive border motifs developed in each shop, although delicate filigree work with

vine scrolls and flowers or leaves was the predominant scheme. The fancy initials required a more experienced hand because of their complex color patterns and gold inlay, and, finally, the miniatures with figures were entrusted to the most talented of the illuminators.

Frequently the *chef d'atelier* would indicate in the margins or in the gaps of the text left by the scribe the subject matter of the miniature to be inserted. This would be done by either a brief notation (for example, "*le sacrifice Isais*" for a representation of the Sacrifice of Isaac) or by a tiny sketch. Very likely those who drew and/or painted the figures had recourse to model books, much as modern commercial artists do, for elaborating standard poses, actions, face types, and costumes. After the outlines were drawn, the gold leaf (designated by "*dor*" in the notations of the *chef d'atelier*) would be carefully laid in and burnished. Then the areas of colors in the costumes and setting were added. The final touches, made in heavy ink, would trace the facial features, details of the costumes, and lines of drapery. When finished the illuminated book was sent to the bookbinder, the final specialist in the production.[71]

It is not surprising, considering the assembly-line production of the larger ateliers, that the personalities of individual artists would be submerged in the general style of the shop. It is amazing how uniform the style of Parisian miniatures is, and yet certain general lines of development can be noted. The fussier drapery style of earlier miniatures gradually gives way to broader and more lyrical sweeps of folds and pockets that enhance the beauty of the bright colors. Poses are exaggerated, almost mannered, in the affected swing and sway of the tiny figures and their costumes, and facial features acquire a studied elegance with their stereotyped expressions of joy or sorrow. Refinement, grace, and diminutiveness characterize the aristocratic style of French Gothic illumination, and while colorful details are sometimes added to indicate the setting as a throne room, a church, a city, or a woodland cove, there is no attempt to approximate a realistic setting in space. The backgrounds are filled with elegant gold leaf and bright red-and-blue diaper patterns.

Toward the end of the thirteenth century, distinguished artists emerge from the scores of painters in the workshops, and, in turn, their ateliers gained prestige among the wealthier patrons. One such atelier was headed by Master Honoré, whose name appears at the end of a volume of decrees of canon law: "In the year of our Lord twelve hundred and eighty eight I bought the present Decretals from Honoré the illuminator dwelling at Paris in the street Herenenboc de Bria [now rue Boutebrie] for the sum of forty Paris livres."[72] The Decretals of Gratian, illuminated by Honoré, are today in the Municipal Library in Tours. "Honoré the illuminator" is named again in royal accounts for the year 1296 before an entry listing a costly Breviary executed for King Philippe le Bel (r. 1285–1314). This book has been

identified as the elegant Breviary of Philippe le Bel in the Bibliothèque Nationale in Paris.

The miniature with the Anointing of David by Samuel above the Battle of David and Goliath is typical of many Parisian illuminations of the late thirteenth century (fig. 562). The facial features painted by Master Honoré, however, display a distinctive delicacy and refinement. The pincer-shaped beards and the tightly curled hair with a special lock that falls across the middle of the forehead are mannerisms that are found in his paintings.

What is revolutionary about his style, however, is the new treatment of the drapery. Subtle white washes appear along the lines of the projecting knees, about the wrists and shoulders, and in the overlapping folds that model the reds and blues of the costumes as if the figures were bathed in a raking light. Rather than silhouetting the actors with elegant outlines, Master Honoré shades his figures with light and dark tones, giving them a sculptural bulk and solidity. As yet they have no place to stand in the real world—note the feet of David and Goliath and those of Jesse and his sons in the anointing scene—but clearly the Parisian painter is responding to new interests that disturb the precious conventions of thirteenth-century style.

The influence of Master Honoré's more plastic modeling techniques can be seen in the charming miniatures in the Life of Saint Denis that was presented to Philippe V (le long) in 1317 by Gilles de Pontoise, abbot of Saint Denis. In one of the miniatures (fig. 563), Saint Denis appears preaching from an outdoor pulpit to a crowd of townsfolk seated on the ground behind their leader, identified by an inscription as "Lisbius." In the top right corner idols topple from their pedestals as the conversion of the heathen is accomplished. Throughout the cycle, the lower half of the miniature is devoted to colorful vignettes of everyday life on the bridges of Paris (Saint Denis was the first bishop of the city).[73]

Rendered on a diminutive scale like a toy cardboard city, these charming scenes give us keen insight into the secular activities of Medieval Paris. Here the noises of the city are alluded to. Below, adrift in a boat on the Seine, a group of clerics sings gleefully, but there are other sounds reverberating through the streets. To the left, in a shop built on the Grand Pont (it has four arches), a money changer haggles with a customer, while next door a goldsmith hammers away at an object. From the bridge gate in the center, a tollkeeper shouts down to a young horseman bringing a falcon into the city. To the right, on the Petit Pont (two arches), a porter carries a heavy sack over his shoulder and a shopkeeper displays her wares—wallets and knives—to a prospective buyer. While no attempt is made to render the city in perspective or realistic scale, the delightful details of urban life indicate another developing interest in the arts of the time, namely, that of everyday activities.

The concern for a more sculptural figure style, together

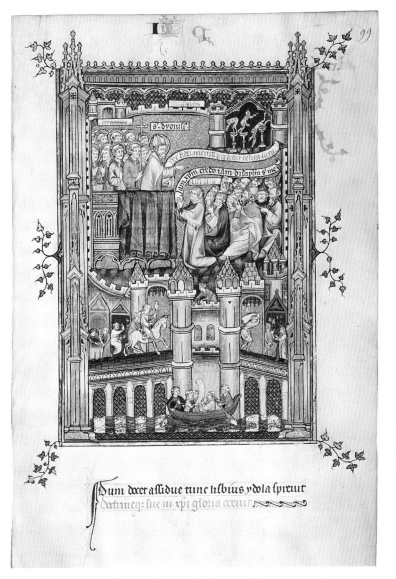

563. *Saint Denis Preaching to the People of Paris.* Illustration in the Life of Saint Denis. 9¼ × 5¾". c. 1317. Bibliothèque Nationale, Paris (MS fr. 2091, fol. 99)

with the interests in secular genre, can be followed more clearly in the miniatures found in a new type of devotional book that evolved during the late thirteenth century, the Book of Hours (*Horae*).[74] Essentially, the Book of Hours was a tiny breviary or missal for personal use. It included a calendar of the church year with special indications in colored inks of the major feast days and those of the saints venerated personally and in the diocese. There are many variations in the contents, but most follow a certain pattern that includes special readings from the Gospels, the "Little Office of the Virgin" (a sequence of prayers devoted to the canonical hours of each day with special veneration given to Mary), the Penitential Psalms, various litanies, the Office of the Dead, and finally a long series of prayers that served as commemorations to special saints (the Suffrages of the Saints).

The Little Office (or Hours) of the Virgin was the most

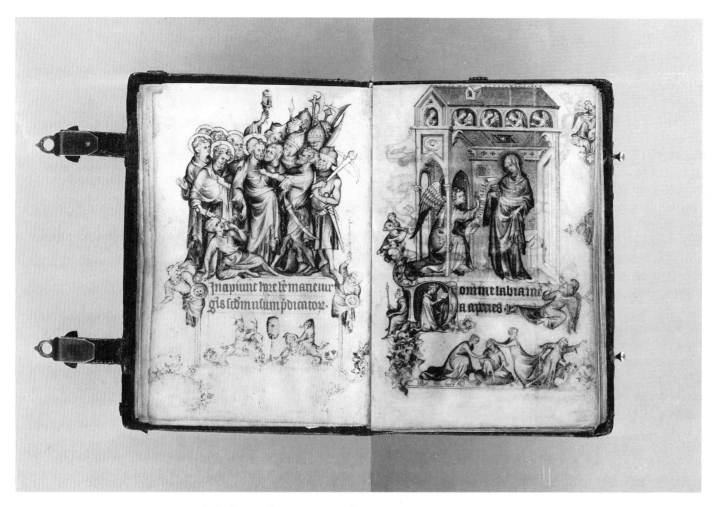

564. Jean Pucelle. *Betrayal of Christ* and *Annunciation*. Illustrations in the Hours of Jeanne d'Evreux. Each 3½ × 2½".
1325–28. The Metropolitan Museum of Art, New York. Cloisters Collection (fol. 11v)

important section and included eight canonical hours illustrated in a set pattern beginning with the major episodes in the Infancy cycle and concluding with the Coronation of Mary. In some manuscripts, the Hours of the Virgin were augmented with the "Hours of the Passion," which included scenes from the Betrayal of Judas to those leading up to and following the Crucifixion. Bound in a leather or metal cover encrusted with gems, the Book of Hours was thus a *joyaux,* an *objet d'art,* a piece of jewelry for show more than for devotion, and as a status symbol, it became the popular medium for painting in the North at the end of the thirteenth century.[75]

One of the most exquisite examples is the tiny Hours of Jeanne d'Evreux, executed by a Parisan miniaturist, Jean Pucelle, about 1325–28. It presumably was a wedding or coronation gift given to the French queen by her husband, Charles IV.[76] She appears kneeling at her *prie-dieu* in the beginning initial for prayers at Matins below a representation of the Annunciation (fig. 564). In spite of the small format (3½ × 2½ inches), the Hours of Jeanne d'Evreux is a complex production. The pages devoted to the calendar are illustrated with diminutive genre scenes of the labors or pastimes of the month and the zodiac signs for the month.

The "hours" proper have antithetical groupings of illustrations from the Infancy and the Passion facing one another. A special cycle of illustrations was dedicated to the "Hours of Saint Louis," who, recently canonized, was a favorite saint especially dear to the women of the court. Of interest, too, are the numerous drolleries (*drôleries*) that animate the marginal areas of the tiny pages with fanciful figures and grotesques performing various courtly games and other secular activities. The miniatures are executed in a *grisaille* technique—a black and gray tonality with occasional washes of light colors—that completely breaks with the tradition of saturated pure colors and gold normally found in French miniatures.

Jean Pucelle was a genius in his time, a progressive painter whose innovations were not fully understood or appreciated until many years after his death. Three of these innovations will be noted here: the introduction of the Italianate "space box" for settings; the imitation of current trends in sculpture with mannered drapery folds and swaying postures; and the new naturalism employed in marginal areas. There is good reason to believe that Pucelle had, in fact, traveled to Italy. A number of his compositions, including the *Annunciation* illustrated here, were clearly derived from panels of the great

Maestà executed by the Sienese painter Duccio (see below and figs. 581, 582).

This is particularly significant because the Northern painters before Pucelle had no facility for or interest in rendering figures and objects in deep space. Northern painting was traditionally an art of surface pattern, and it is in the tiny dollhouse perspective in Pucelle's *Annunciation* with its receding side walls and ceiling beams projecting diagonally to a central axis that we find the earliest attempts at illusionistic space in the North. Pucelle's little space-box even includes a special trapdoor to allow the Holy Ghost (in the form of a dove) to enter Mary's chamber. Above the room appears the more traditional flattened attic, where a choir of angels has assembled to sing praises to the Virgin.

It may well be that Pucelle experimented with the *grisaille* technique in order to exploit the volumetric qualities of figures so as to place three-dimensional bodies in the new projected space-boxes. By reducing the hues to black and gray (a few tints of color are added here and there), he has been able to make the modeling of the forms more sculptural, with emphasis on the plastic qualities of the figures rather than on their color shapes. Finally, the proliferation of animal and genre motifs in the margins (this interest appears earlier in English illuminations) is a startling break from the conventional border patterns of ivy that abound in French manuscripts of the Late Gothic period. It is in such secondary areas that many new themes, such as landscape, still life, and secular activities, are born in Northern art (fig. 565).

The diminutive Virgin in Pucelle's *Annunciation* bears an astonishing resemblance to the gilded statuette of Mary presented by Queen Jeanne d'Evreux to the Abbey of Saint Denis in 1339 (colorplate 67). The same refined elegance and mannered grace—a natural evolution from the style of the Smiling Angel Master of Reims—characterize both. This same development is also evident in the exquisite Virgin and Child, the so-called *Vierge de la Sainte-Chapelle* (fig. 566), executed about 1300 in ivory with faint touches of gold added to Mary's hair, belt, and the borders of her mantle.[77] Enveloped in elegant draperies, Mary sways gently to the side. Her face is that of a coy young princess, and her smiling infant reaches for the apple she offers teasingly in her right hand. This charming portrayal of Mother and Child in immaculate ivory would be a comforting image for the worshipper in the intimacy of a family chapel.

There is also something to be said of the aesthetic of this age that loved diminutives. *La Vierge de la Sainte-Chapelle* is only sixteen inches high, and our first impression is likely to be: "What a charming little Madonna!" For the greater part, the artistic energies of the later Gothic age were channeled into the creation of exquisite small objects in ivory, enamel, metal, and, of course, Books of Hours and their covers. This is characteristic of both religious and secular objects. A beautiful ivory crosier head, an insignia of the bishop's office

565. JEAN PUCELLE. *November.* Miniature in the Hours of Jeanne d'Evreux (fol. 15v–16). 3½ × 2½"

(fig. 567), presents the same demure Virgin and Child swaying between angels. A number of secular objects—mirror backs, jewelry coffers, combs—that were valued highly by the ladies of the court were also executed in ivory, perhaps because its shining white qualities were meant to reflect the virtues esteemed by the owners.

Typical of these secular objects is a jewelry casket in the Walters Art Gallery (fig. 568) which has carved ivory plaques clamped to the sides and the lid.[78] A charming panorama of courtly pastimes is presented: tiny demoiselles, with their slightly puffy eyes, their sweet smiles, and their mannered gestures, flit here and there on the occasion of a courtly festival. But there is a theme to these lively diversions: the power of youthful love embodied in the chaste young lady of the court. In the two central sections on the lid we find a tournament with two knights on horseback charging each other in an arena before a platform filled with charming young maidens. To the left is another familiar theme, the siege of the castle of love, an allegory derived in part from the *Romance of the Rose,* written by Guillaume de Lorris (finished by Jean de Meung about 1280). The scene on the right presents the finale to the contest with the prize, the fair lady, and the victor, the gallant knight.

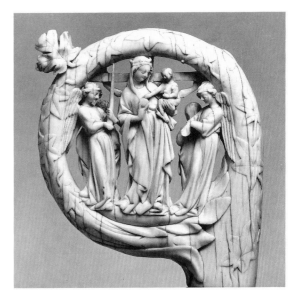

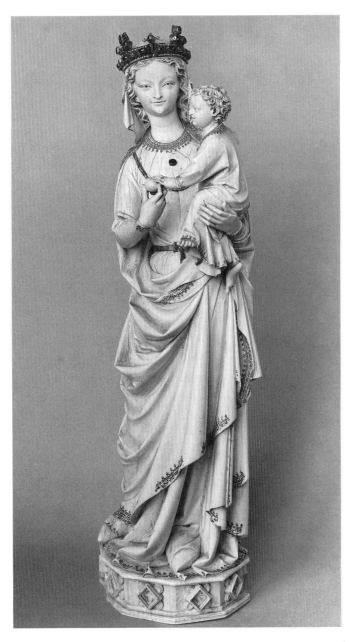

The episodes on the front of the casket, as well as on the ends, serve as footnotes, with references to a variety of secular allegories that illustrate the Virtues, Vices, and the power of women in courtly romance. On the front, for instance, the humorous story (popularized in the *Lai d'Aristote* of Henri d'Andeli) of the aged Aristotle captivated by the young princess Campase, whom he carried about on all fours—"horsyback"—illustrates the folly of even the most profound men when confronted with lustful desires.

On the left end of the casket are episodes from the legend of Tristan and Iseut with the duped husband, King Mark, juxtaposed with an allegory of moral purity, the lady and the unicorn. Only a virgin could attract the rare white horse with the ivory horn, and, as such, she exemplified the virtue of chastity. The right end has scenes from the life of Sir Galahad, and the plaque on the rear illustrates stories from Chrétien de Troyes's *Perceval,* with Sir Gawain battling the lion and Sir Lancelot crossing the narrow bridge on his way to rescue Guinevere. Few secular arts survive the Middle Ages, but in these precious ivory objects we are offered a fleeting glance of the richness that enhanced the world outside the protective walls of the church.

above: 566. *Virgin and Child (La Vierge de la Sainte-Chapelle).* Ivory, height 16⅛". c. 1300. The Louvre, Paris

above right: 567. *Virgin and Child with Angels.* Head of a bishop's crosier. Ivory, height 5¼". c. 1340. Walters Art Gallery, Baltimore

568. *The Power of Love.* Jewelry casket. Ivory, 4½ × 9¾". c. 1330–50. Walters Art Gallery, Baltimore

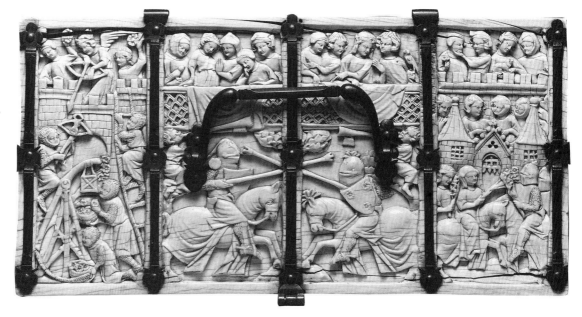

ITALY IN THE LATER MIDDLE AGES

I N CONTRAST to the continuity that marks the development of Gothic art in France, that of Italy during the thirteenth and fourteenth centuries (*dugento* and *trecento* in Italian) presents a confusing history. As we have noted, layers of cultural influences were deposited over the landscape of the ancient Romans during the Middle Ages. Three mainstreams of style can be discerned, however: the Classical or Antique, the Byzantine, and the French Gothic.[79]

THE CLASSICAL TRADITION

As the home of the Roman empire, Italy was the site of countless remains of Antique art and architecture in the later Middle Ages. Numerous cities were still distinguished by their old Roman gateways, their triumphal arches, and various temple remains, and sculpture in the form of commemorative statues, sarcophagi, and historical reliefs were visible. Often these remnants of the ancient world were reused in the building of the Christian community, and when time had dimmed the memories of pagan idolatry, these splendid art forms could be viewed more generously as works of enduring beauty from some glorious past. Often they served as models for the Medieval craftsman. For that reason, the issue of a renaissance in Italy has been a thorny problem for historians. It is not always clear when we are dealing with survival or revival of Classical art. To be sure, the Renaissance of the early fifteenth century—the conscious revival of ancient styles that we discern in the art of Masaccio and Donatello—constitutes the fullest definition of a renaissance, since this rebirth concerns both style and subject matter. Earlier revivals anticipate this rediscovery, however.

One of the more spectacular revivals occurred in South Italy in the first half of the thirteenth century. It was there that the emperor Frederick II (1194–1250), grandson of Barbarossa, initiated a cultural program that can be termed a "secular" renaissance of ancient Rome. Frederick was a fearsome yet extremely learned ruler. He gathered poets, philosophers, scientists, and artists about him to generate his Roman empire, one in which he actively participated as a political theorist, poet, and scientist. Frederick II was regarded by his contemporaries as a "world wonder" (*stupor mundi*), an appellation that brings to mind the stature of Otto III two centuries earlier.

Few remains of Frederick's renaissance survive. One of the most impressive of these is the great triumphal arch and gateway that he erected at Capua, 1232–40, twenty miles north of Naples on the Volturno River (figs. 569, 570).[80] Only the foundations remain, but fragments of sculpture and a few Renaissance drawings of the site allow us to make a tentative reconstruction of the huge arched gateway. It was in the form of ancient Roman portals with two towers squeezing in a massive central block with various sculptures placed in medallions and arcadès. The fragment illustrated here has usually been identified as *Justitia,* but this is only conjecture. It apparently was placed directly over the entranceway beneath a statue of the enthroned emperor. The head has a striking Classical flavor about it with the full lips and cupped chin, the wavy treatment of the hair, and the broad planes of the forehead and cheek.

Other remnants of Frederick's secular renaissance survive in coins with his handsome profile stamped on them in the pose of the deified emperors of ancient Rome. Admittedly, these few fragments do not permit one to build a strong case for a proto-Renaissance movement with Frederick II, but one tempting connection of his court with the awakening of that spirit in Tuscany—the birthplace of the Renaissance—can be found in the sculptures of Nicola Pisano.[81]

One "Nichola de Apulia" is recorded in the archives of Siena, 1265–68, where he was commissioned to execute the sculptured pulpit for the cathedral. He apparently came from the southeastern province of Apulia, where Frederick undertook many projects. This same Nicola had worked five years earlier, 1259–60, at Pisa (where he was known as Nicola Pisano) on a striking monument, the baptistry pulpit (figs. 571, 572), that features the same Classical style and spirit that are found in the sculptures executed for Frederick II. It has been argued, therefore, that Nicola had his training

in the south and then moved north to Tuscany, where he introduced the new style of sculpture. It has also been pointed out that the numerous Roman remains in Pisa could have influenced his style of sculpture. Vasari, in his *Vite* (1550), had, in fact, mentioned that Nicola copied figures from a Roman sarcophagus (still preserved in Pisa) for the pulpit reliefs.

The idea of placing a pulpit in a baptistry is not unusual in Tuscany. Such furnishings were commonplace due to the fact that the baptistry, usually a freestanding structure in North Italy, could also function as a civic meeting place. The hexagonal structure is supported by columns of variegated red marble and granite that alternatingly rest on the backs of lions. Five sides of the pulpit have huge marble slabs, quarried in nearby Carrara, that are carved in deep relief with stories from the life of Christ. The sixth side is open for the staircase leading to the platform. An eagle, the symbol of Saint John the Evangelist, serves as a handsome lectern. Episodes from the Infancy (Annunciation, Nativity, Adoration of the Magi, and Presentation), the Crucifixion, and the Last Judgment appear on the marble plaques. The ambitious relief that initiates the cycle (fig. 572), with the Annuncia-

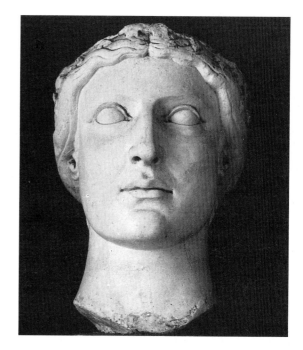

570. *Justitia*. Bust from the Triumphal Gateway of Frederick II. Marble, approx. height 32″. c. 1233. Museo Campano, Capua

tion to Mary, the Nativity, and the Annunciation to the Shepherds conflated into one cramped field, is instructive for our study.

How different these figures appear when compared to those of the pulpit in Pisa carved by Guglielmo a hundred years earlier (fig. 411). Mary resembles a Roman matron clad in heavy garments, and the casualness of her pose brings to mind the beauty in repose of ancient deities. Her face and hair are particularly Classical in appearance; note the straight line of her nose, the fleshy modeling of her features with deep eye sockets and cupped chin, and the distinctive coiffure with wavy tresses issuing from a central part. No one would mistake this for an ancient work, however, since a number of Medieval traits are present, too. The field is packed with figures, hieratic scale is employed (the larger Virgin commands the central axis), and, of course, the iconography is Byzantine, with the grotto serving as a shelter and the Child repeated in the bathing scene. While Nicola presents us with a familiar Christian story, there can be no doubt that he has looked hard and long at ancient remains.

This spirit is even more strikingly illustrated in the fine male nude that stands on top of one of the columns supporting the relief panels (fig. 573). Usually identified as a personification of one of the Virtues, this heroic figure was clearly modeled after an ancient statue or relief sculpture of Hercules, and while the head is oversized, the finely detailed anatomy and the polished texture of the torso anticipate the Classical nudes executed two hundred years later by Renaissance artists.

The heads of the female figures in the Nativity bear a striking resemblance to those of the classicizing types executed at Reims (fig. 500) and Bamberg (fig. 552) at about

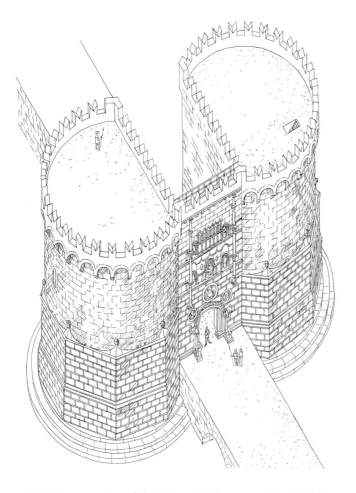

569. Reconstruction of the Triumphal Gateway of Frederick II, Capua (after Willemsen). 1232–40

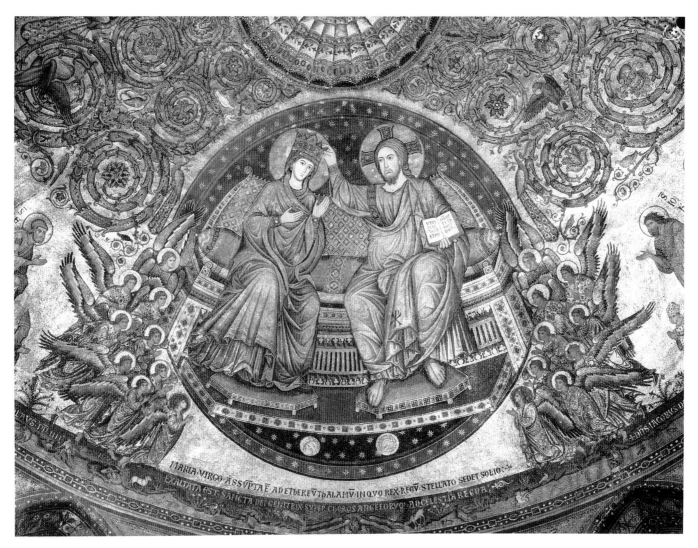

574. JACOPO TORRITI. *Coronation of the Virgin.* Apse mosaic in Santa Maria Maggiore, Rome. c. 1294

the same time in the mid-thirteenth century. The curious thing is that this Antique revival was a very short-lived interlude in Gothic art. Apparently the thirteenth-century viewer, even in Italy, was not ready to accept the new aesthetic, and Nicola responded to this situation. When he carved the pulpit for Siena five years later, his style reverted to the more lyrical and discursive manner of French Gothic sculpture. On this latter project, Nicola employed a number of assistants, one of whom was his son, Giovanni, who abandoned completely the classicism of his father's art.

Another assistant of Nicola Pisano was Arnolfo di Cambio, who moved to Rome in the 1270s and established a workshop that received papal commissions. Arnolfo was only one of many renowned Tuscan artists called to Rome. Cimabue and Giotto, whom we shall consider later, also received papal commissions.

The thirteenth century marks the climax of a vigorous program in Rome to restore the capital of Christendom to its early splendor.[82] Continuing the policies of renovation initiated in the twelfth century (see pp. 316–17), Popes Innocent III (1198–1216) and Honorius III (1216–27) promoted projects to restore or replace the great apse mosaics in Saint

Peter's and Saint Paul's (figs. 57, 61). Honorius called in craftsmen from Venice, trained by Byzantine artisans, to restore the mosaics. By the end of the thirteenth century, the renaissance of Rome's Early Christian art climaxed with the so-called Roman School of artists. Arnolfo di Cambio was one of these, but more important for our study are Pietro Cavallini and Jacopo Torriti, who apparently were Romans by birth.

For Pope Nicolas IV, Jacopo Torriti, active in the 1280s and 1290s, executed the monumental apse mosaic that replaced the earlier one in Santa Maria Maggiore (fig. 574).[83] To surpass the handsome mosaic put into the apse of Santa Maria in Trastevere (colorplate 52), depicting Christ and Mary enthroned amid a row of saints that was commissioned by Pope Innocent II (1130–43), Torriti designed a more grandiose version of the Coronation of the Virgin, placing Christ and the Virgin within a giant aureole against a golden background covered with Antique floral scrolls. The revival of ancient motifs is also found in the elaborate canopy of the heavens in the summit of the apse and the Nilotic riverscape below (where fragments of the fifth-century mosaic were reused).

The iconography is indebted to French Gothic types, such as the Coronation of the Virgin at Chartres north (fig. 477), with the scene of the Dormition included in the band directly below the Virgin and Christ. On the other hand, the figure style is clearly Byzantine, especially in the drapery formulas employed in the mantles of Christ and Mary and in the facial types of the angels and saints below the throne. Torriti's mosaic is fascinating to study in this light. It presents us with a fusion of the three main ingredients of thirteenth-century art in Italy: the Antique, the Byzantine, and the French Gothic.

This fusion of styles is more evident in the works of Pietro Cavallini, who executed the narrative scenes with the life of the Virgin directly below the twelfth-century mosaic in the apse of Santa Maria in Trastevere (fig. 575).[84] With Cavallini any lingering qualities of Byzantine conventions or French Gothic lyricism are submerged in a new synthesis that recaptures the Classical beauty of Early Christian style. The interior setting for the Birth of the Virgin brings to mind the clearly constructed space-boxes found in fifth-century miniatures, and the figures are rendered as simple, weighty forms with restrained gestures. The scene is pervaded by a splendid solemnity and gravity.

It is tempting to think that Cavallini was inspired directly by the Early Christian paintings that he restored in the nave of Saint Paul's Outside the Walls about 1277–90 (see p. 58 and fig. 57). He also executed a monumental fresco of the Last Judgment on the entrance wall of Santa Cecilia in Trastevere (colorplate 68) about 1290. The seated Christ and the apostles are beautifully simplified and rounded as volumes captured in a natural light that plays across the broad surfaces of their mantles and highlights the ridges of the drapery folds. The Byzantine conventions for the faces are more relaxed as well. It is, in fact, in the revival of the fresco technique in Italy where we find the major strides toward a more naturalistic style, a development that culminates in the fresco cycles of Giotto in Florence and Padua.

THE BYZANTINE

Byzantine art of the Comnenian period, which ended with the devastation wrought in Constantinople during the crusade of 1204, was the major component of Late Medieval art throughout Italy (see pp. 134–35), ranging from the splendorous mosaics lining the walls of Sicilian churches to the cycles of mosaics that filled San Marco in Venice. Greek artists and their Italian pupils were called to Rome and Florence during the thirteenth century, and in time the *maniera greca,* or "Greek manner," was gradually transformed into what is loosely referred to as an Italo-Byzantine style. Jacopo Torriti is a good representative of this home-grown variety of Byzantine art in Rome, and in Tuscany the head-on confrontation of Byzantine and French Gothic styles produced a fascinating hybrid art that until recently was often considered primitive and barbaric. Indeed, Vasari decried the so-called *maniera greca* as crude, and he found in the paintings of Cimabue and Giotto the harbingers of the "modern" or Renaissance style that was to liberate the Italians from these debased foreign modes.

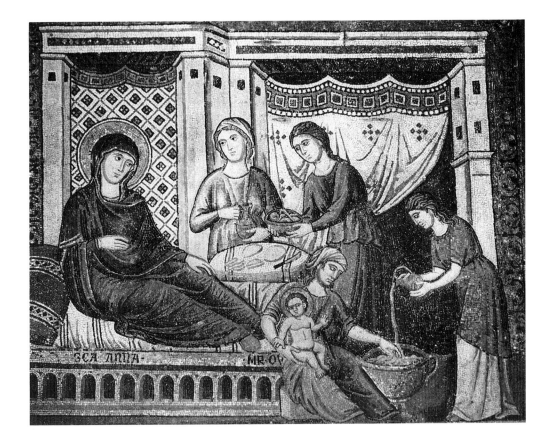

575. PIETRO CAVALLINI. *Birth of the Virgin.* Mosaic in Santa Maria in Trastevere, Rome. 1290s

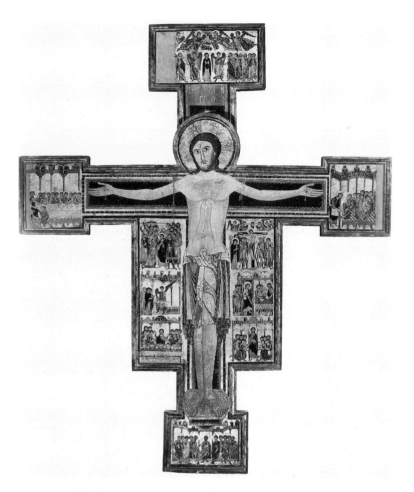

576. School of Pisa. *Crucifix No. 15.* Panel, 9'3" × 7'9¾". Late 12th century. Pinacoteca, Pisa

The city-states of Tuscany (primarily Pisa, Lucca, Siena, and Florence) were the leaders in the recovery and revitalization of Italian painting during the thirteenth century. The earliest forecasts of the new art can be studied in the large painted crosses and icons of the Virgin and Child.[85] A fine example of the early Crucifixion types is that known by scholars as Pisa No. 15 (fig. 576). The cross is huge (9 feet 3 inches × 7 feet 10 inches), and the corpus of Christ, posed in a strictly frontal position with eyes open, awkwardly fills the cross. Only a slight tilt of the head animates the flat body; anatomical details are reduced to linear arcs. At the four extremities of the cross are projecting boxes with episodes from the life of Christ painted like enlarged miniatures. On either side of the corpus are "aprons" with more scenes from the Passion, including another Crucifixion.

Such a type is known as a "storied" painted cross to distinguish it as one combining a main iconic presentation of the crucified Christ with marginal narrative scenes. The type itself is further designated a *Christus triumphans* (Triumphant Christ) since the bold presentation of the live Savior reduces any emotional or humanizing effects. He

stands before us and regards us directly, announcing that his crucifixion is a matter of doctrine, a symbol of salvation.

Numerous panels of the *Christus triumphans* are found in Lucca and Florence as well. A dramatic change in both style and iconography appears in the later thirteenth century in a second type known as the *Christus patiens,* or "suffering Christ" (fig. 577). In these a pronounced sway to the body is introduced. The hips swell outward and the legs taper downward and slightly overlap. The head falls to the shoulder, and the eyes are closed in death with bold shading lines about the sockets. A compelling emotional expression is conveyed. The biographer of the famed Gothic mystic, Saint Francis of Assisi, tells us that in his youth Francis was ineffably moved while contemplating such a painted cross in the Church of Saint Damiano near Assisi (see fig. 587).

The *Crucifix* illustrated here has been attributed to Coppo di Marcovaldo, a Florentine painter active in the 1260s and 1270s. Among other works attributed to Coppo are monumental images of the Virgin and Child that served as altarpieces for churches in Siena and Orvieto (fig. 578). His Italo-Byzantine style is easy to recognize. The *Madonna and Child*

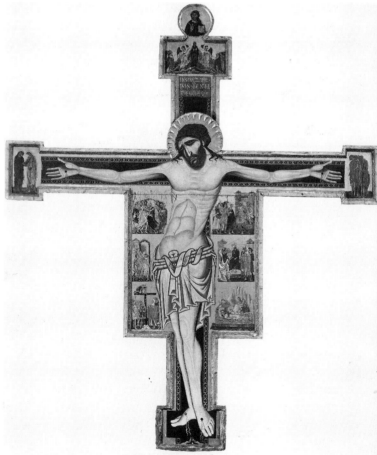

577. Coppo di Marcovaldo. *Crucifix.* Panel, 9'7⅜" × 8'1¼". Second half of the 13th century. Pinacoteca, San Gimignano

in San Martino ai Servi in Orvieto resembles Late Byzantine icons of the Virgin (cf. colorplate 25) with Mary seated in a frontal position on an elaborate throne holding her infant—hardly a *bambino*—rigidly on her right knee. Behind the lyre-backed throne, against a gold background, two diminutive angels serve as the Virgin's attendants. Byzantine conventions for the facial features and the draperies are followed, but a few peculiarly Italian elements can be noted. The golden striations in the Virgin's mantle are bold and crisp; the almond eyes, elongated nose, and pinched mouth are strained and slightly modeled, adding a more impassioned expression to her countenance.

A great number of icons of the Virgin were commissioned for Sienese churches, including one by Coppo in Santa Maria dei Servi, dated 1261. Siena was known as the "ancient city of the Virgin" (*vetusta civitas virginis*); the Duomo (cathedral) was dedicated to Mary, and the Sienese armies marched into battle under the banner of the Madonna and Child. And it is in Siena where the final golden age of Byzantine art was created in the Latin west by Duccio di Buoninsegna (active 1278–1318).[86]

How remarkably Duccio transforms the stereotyped Byzantine formula! The *Rucellai Madonna* (colorplate 71) is very likely a work commissioned by the Company of the Virgin Mary for the Church of Santa Maria Novella in Florence in 1285. It is an early work by Duccio, and while the same hieratic formula is followed (a modification of the *Hodegetria* type), one is immediately attracted to the more natural characterization of Mary and her Child achieved by subtle stylistic adjustments. Mary is not so rigidly posed; she turns slightly on the throne; her right hand relaxes as she more easily carries her son—now a true infant and not a miniature emperor—on her left knee. The conventions for the face are relaxed as well, and through subtle shading of the flesh, Duccio presents Mary as someone human and approachable.

The gold striations that dominate the draperies in the Byzantine icons are abandoned for subtle highlights and a free, meandering border of gold that is traced along the hem of her mantle. The deep blue of the costume has darkened over the years, but the delicacy of Duccio's drapery patterns can still be discerned in the softly modeled gowns of the angels that attend her. These graceful drapery patterns remind us, in fact, of those in French Gothic sculpture. Furthermore, the angels are no longer presented as symbolic attributes but as full-bodied attendants placed in vertical rows about the elegant throne, a complex structure of diminutive spools and spindles that is tilted in space. With its softer modeling, its lyrical accents of lines, and the rich detail, Duccio's *Rucellai Madonna* exhibits a curious Gothicizing of the Byzantine style.

It was for the Duomo in Siena that Duccio created his masterpiece, the many-paneled altarpiece known as the

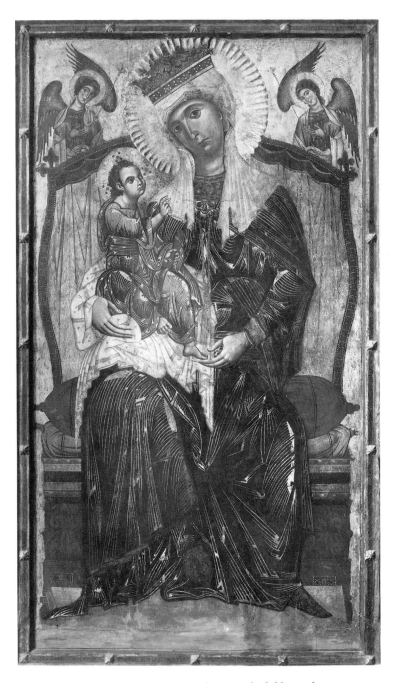

578. COPPO DI MARCOVALDO. *Madonna and Child.* Panel, 7′9¾″ × 4′5⅛″. c. 1265. San Martino ai Servi, Orvieto

Maestà, or Majesty of the Virgin (figs. 579–82; colorplate 69). This was an ambitious workshop production, with many assistants employed, but the style is astonishingly uniform throughout. Commissioned in 1308, the great work was completed in 1311, when it was carried in a grand procession through the city streets to its installation in the Duomo. In its original state, the *Maestà* formed a complex assembly of panels about the huge centerpiece (7 × 13 feet) where the Virgin appears enthroned amid rows of saints and angels.

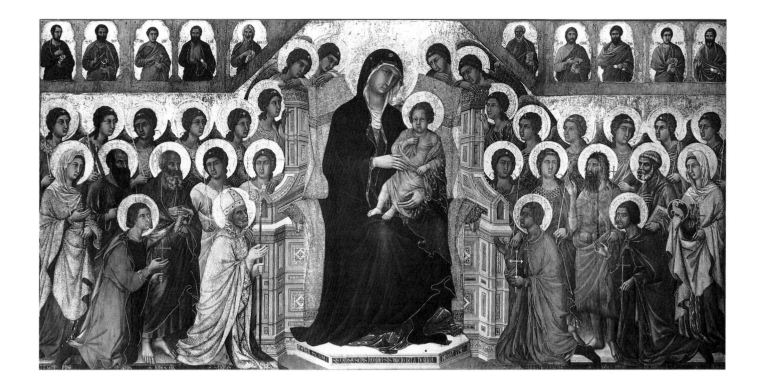

The Madonna, over twice the size of the figures about her, fills the central axis. The child is a charming blond-headed cherub who playfully tugs at his mantle rather than extend his fingers in benediction. The Virgin's blue mantle is modeled with graceful arcs and overlaps; from the right knee soft highlights fall naturally along the ridges of her mantle. The familiar gold spray is limited to a few touches at the feet, where her red dress is visible, and, as in the *Rucellai Madonna,* an elegant line of gold traces the hem of her mantle, which meanders gracefully across the expanse of blue.

Angels gather comfortably about the huge stone throne. They rest on its arms as they glance lovingly at the Virgin and Child. The two lower angels on each side of the throne turn and regard the beholder. Three rows of figures flank the Virgin. In the lowest, two local saints (identifiable only by the inscriptions beneath them) kneel on either side. In the second row, John the Baptist, Peter, and Agnes stand on the right, John the Evangelist, Paul, and Catherine on the left. The uppermost tier is filled with more angels who quietly attend the community of holy people. While Byzantine conventions for head types are followed throughout, the assembly of saints and angels here appears intimate and approachable. Indeed, one is reminded more of the communal spirit of French Gothic sculpture than the rigidly regimented rows of frontal figures in comparable Byzantine ensembles. This

above: 579. Duccio. *Maestà.* Central panel, 7′ × 13′. 1308–11. Museo dell'Opera del Duomo, Siena

right: 580. Duccio. *Nativity* and *Prophets Isaiah and Ezekiel.* Panels from the predella of the *Maestà.* Central panel, 17¼ × 17½″. 1308–11. National Gallery of Art, Washington, D.C. Andrew W. Mellon Collection

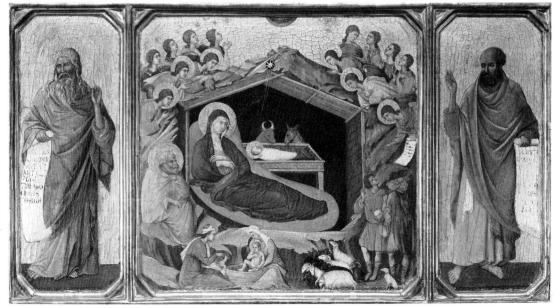

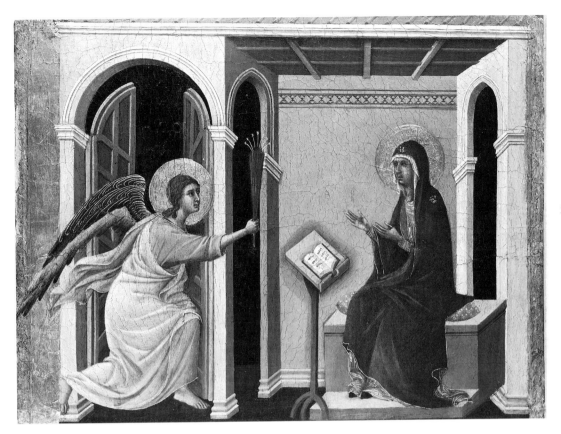

581. Duccio. *Annunciation of the Death of the Virgin.* Panel from the top register of the *Maestà* front, 21¼ × 22⅞″. 1308–11. Museo dell'Opera del Duomo, Siena

Gothic sense of community response anticipates a later theme in Italian painting frequently treated by Renaissance artists, the so-called *sacra conversazione,* or "sacred conversation."

From this central core the *Maestà* expands like a miniature Gothic cathedral into a complex ensemble of pinnacles and tiered panels. The central composition rests on a low horizontal predella, or pedestal, made up of small narrative panels illustrating the story of the Infancy. Between each scene stands an elderly prophet holding a scroll, reminiscent of those figures who stepped on stage to announce the mystery to be enacted in the popular religious plays of the time. Isaiah and Ezekiel appropriately perform that function for the *Nativity* (fig. 580). Duccio follows the traditional Byzantine iconography (cf. the relief by Nicola Pisano—fig. 572) with angels clustered about the grotto, the ox and ass behind the crib, the annunciation to the shepherds, the bathing of the Child by midwives, and the pensive Joseph huddled to the side. Curiously, the rocky grotto houses a timber shed, a feature usually associated with Western renderings of the birth. The miniaturelike qualities of the figures and the detailed landscapes are enriched by the juxtaposition of bright reds and blues accented by softer pastel shades ranging from lavenders to powdery pinks and blues.

The altarpiece was dismantled in the sixteenth century, and today the various panels are exhibited in the museum of the Cathedral, the Museo dell'Opera del Duomo, in Siena (a few panels, such as the *Nativity,* have been acquired by outside museums). There is some controversy as to the exact arrangement of the original ensemble. In the upper pinna-cles, scenes from the final days of the Virgin—from her death to her coronation—were lined up in a row. Exceptional is the episode of the *Annunciation of the Death of the Virgin* (fig. 581), a rare event derived from apocryphral accounts of Mary's life. The palm branch in Gabriel's hand is the only clue in distinguishing the story from that of the familiar Annunciation of the Incarnation that begins the Infancy cycle.

An important feature of this engaging scene is the dollhouse treatment of the chamber with the projection of the walls and ceiling beams that move diagonally to a vanishing axis on the back wall. Gabriel approaches from an antechamber that also projects illusionistically. Clearly Duccio has thought in terms of real figures in a real space here, rather than silhouettes with a flat backdrop. As we saw earlier (pp. 442–43), this innovation in treating figures in space illusionistically had important repercussions north of the Alps within a decade, as evident in the miniatures of Jean Pucelle (fig. 564).

The back side of the *Maestà* was covered by forty-three narrative panels arranged in six tiers that illustrate stories of the ministry, Passion, and post-Passion of Christ. When compared to the traditional Byzantine feast cycles for such programs, this amazing expansion of narrative appears as another Gothic characteristic, namely, the desire to be encyclopedic and discursive. The *Entry into Jerusalem* (colorplate 69), introducing the Passion sequence, is a tour de force in narrative detail when compared to typical Byzantine representations (colorplate 28). Christ and the apostles approach the elaborate city—Jerusalem is envisioned as a

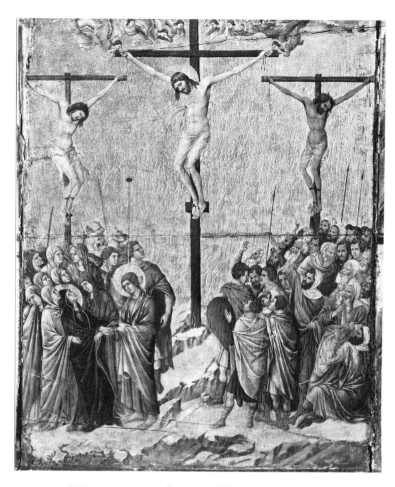

582. DUCCIO. *Crucifixion*. Panel from the back of the *Maestà*, 40⅛ × 29⅞″. 1308–11. Museo dell'Opera del Duomo, Siena

Tuscan hilltop village—in a grand Palm Sunday procession along a diagonal road that leads past a walled precinct complete with gateway and orchard. Throngs of citizens gather about the city gate to greet him; some peer down from the crenellations in the wall or from balconies; youngsters clamber about in trees fetching branches to place along Christ's way into the city.

These same discursive qualities distinguish Duccio's large panel of the *Crucifixion* (fig. 582). In contrast to the usual iconic Crucifixion that we see, for instance, at Daphni (fig. 177), where only the Virgin and John the Evangelist appear as hushed witnesses, Duccio presents us with a truly "historiated" Crucifixion. The bent body of the dead Christ hangs high over a throng of people about the cross; the faithful have gathered on the left, the tormentors on the right. The two crucified thieves flank the central cross, while weeping angels fly in clouds above the crossarms. Notable, too, is the Virgin in Duccio's *Crucifixion*. In contrast to the reserved pose that she assumes in Byzantine examples, the Virgin here falls back into the arms of a female mourner, while John the Evangelist turns to comfort her. Clearly Duccio's concern was to convey the emotional impact of the brutal death of Christ more so than the fact of Christ's destined sacrifice for man's salvation.

One of the most gifted followers of Duccio—he perhaps worked on the Duomo *Maestà*—was Simone Martini.[87] In 1315, four years after the installation of the great altarpiece, Simone executed a huge fresco of the *Virgin in Majesty with Saints and Angels* (40 feet wide) for the Palazzo Pubblico (civic palace) in Siena that is, in many respects, a creative copy of the central panel of Duccio's work (fig. 583). Occupying the west wall of the council chamber, Mary and her community of holy figures preside over the meetings held there.

Simone had close links to the French. He was employed in Naples, where he executed a large portrait of the French king, Robert of Anjou, receiving the imperial crown from Saint Louis of Toulouse (the king's brother, canonized in 1317). Sometime around 1339–40 Simone was called to Avignon in southern France to head a painters' workshop for the French popes residing there during the early years of the so-called Babylonian Captivity. Avignon was surely a major avenue for the flow of the Italo-Byzantine style from Siena to France, and the styles of Simone and Duccio were instrumental in the developments of the International Style in the North.

Simone's masterpiece is the *Annunciation* painted for the Duomo in Siena in 1333 (fig. 584), in which he was assisted by his brother-in-law, Lippo Memmi. The dazzling gilt frame consists of five cusped Gothic arches capped by intricate gabled pinnacles with crockets that transform the setting into a cross section of a Flamboyant Gothic cathedral. Two local saints, Ansanus and Giustina, stand like polychromed sculptures on consoles in the simulated side aisles. Simone's art represents the extreme refinement of Byzantine style in details. The lavish use of gold throughout places us in the environment of heaven, and the delicate tooling of the haloes and the borders of the mantles is a tour de force in craftsmanship. The Byzantine conventions for the faces are also carefully modulated with slight mannerisms in the renderings of details. The almond-shaped eyes of the Virgin give her the appearance of an exotic oriental princess.

The influence of French Gothic style is most conspicuous in the drapery. Cascading folds with sinuous overlaps and pocketed creases mark the costumes of the Madonna as well as the two standing saints. To express Mary's shyness at the moment of Gabriel's appearance, Simone depicts her as shrinking back from the messenger in discrete concave arcs formed by the elegant silhouette of her mantle. Her head and arms are enveloped in ovals under the adjoining arch of the frame, further underscoring her withdrawal and introversion at this poignant moment.

One of the most beautiful passages of abstract design in Italian art is found in the lower half of the figure, where the free-falling edges of Mary's blue mantle are complemented on either side by the lyrical bands of her red dress framed by the golden hem of the mantle. Gabriel enters and kneels

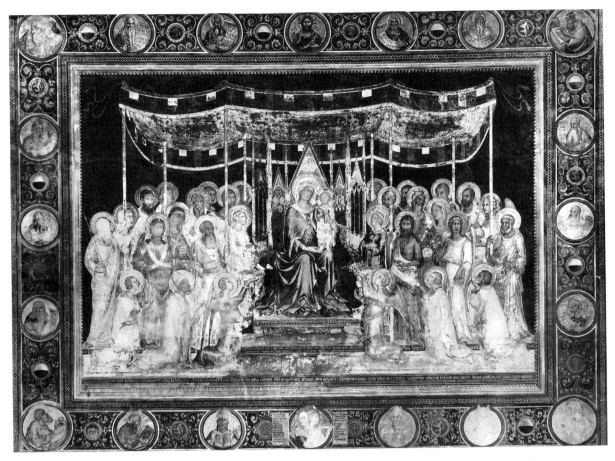

583. SIMONE MARTINI. *Maestà*. Fresco. 1315; partially repainted 1321. Council Chamber, Palazzo Pubblico, Siena

584. SIMONE MARTINI. *Annunciation*. Panel, 8'9" × 10'. 1333. Uffizi Gallery, Florence

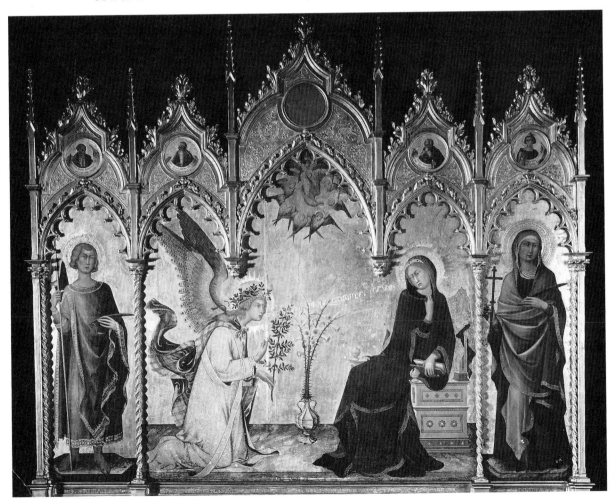

quietly before her. His body, rendered in gold, is nearly transparent, conveying an enchanting quality of his divine being. His sudden appearance to the Virgin is indicated by the fluttering of his colorful plaid mantle beneath the elegant peacock wings. Gabriel offers Mary a token of peace, an olive branch, and between them stands a fine golden vase containing fragile lilies, symbolizing the purity of the Virgin.

ASSISI

Before he painted the *Annunciation,* Simone Martini had worked at an important ecclesiastic center in Umbria, the Church of Saint Francis of Assisi (fig. 585), where he painted frescoes of the life of Saint Martin in a chapel in the lower church. His compatriot, Pietro Lorenzetti, another follower of Duccio, executed frescoes in the lower church as well, including the impressive *Deposition* (fig. 586). The bold compositional lines and the unusual pathos expressed are striking, although the mourners in Pietro's painting are rendered as simplified forms resembling huge carved boulders with sheets wrapped about them. Perhaps Lorenzetti was responding to the new Gothic style of a young Florentine painter, Giotto, who also worked at Assisi.

The prestige of this first Franciscan church drew a number of talented artists there from Tuscany and from Rome.[88] In some respects, San Francesco at Assisi served as a clear-inghouse for the various Medieval styles practiced in Italy at the end of the thirteenth century, and it is fitting that this important church and its decorations honored the leader of a new mystical devotion that spread rapidly in the Gothic world.

Saint Francis was the most moving force in Italian art and literature during the thirteenth century.[89] Born in 1182 of patrician parents, Francis experienced at the age of twenty-one a remarkable conversion, and he dramatically abandoned his opulent life-style as a rich courtier for one of extreme poverty. He dedicated his whole being to the imitation of the humble and charitable ways of life that Christ had preached. According to his biographer, Thomas of Celano, Francis happened on a small church in ruins, San Damiano near Assisi, and went inside to pray. While contemplating a painted Crucifix on the altar (fig. 587), "a thing unheard-of happened"; the painted image called out to him by name and asked Francis to repair his house, and "from that moment on compassion for the crucified Christ was fixed in his soul."

Francis gathered about him twelve disciples and began preaching to the poor and meek in the countryside. His message was simple and direct. Worry not over the complexities of orthodoxy as preached by the Dominicans and others. Read only the Gospels and dedicate your life to fellowship and love of your fellow man, nay, to all of God's creatures:

585. San Francesco, Assisi. Exterior view from the south. Consecrated 1253

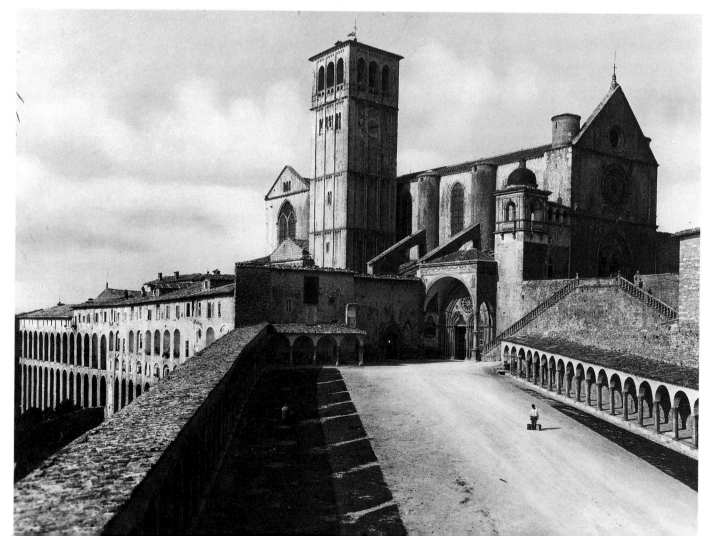

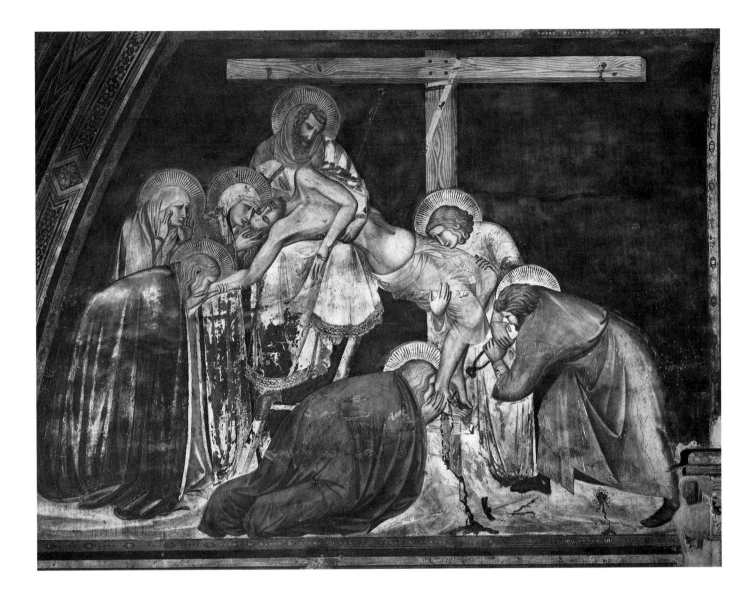

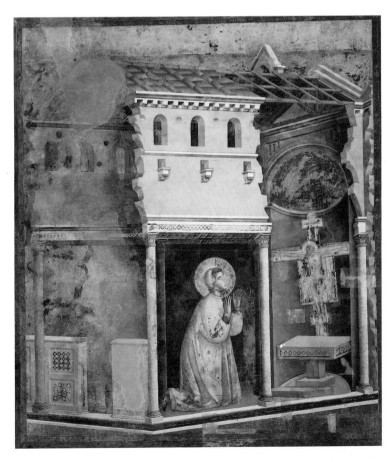

above: 586. PIETRO LORENZETTI. *Deposition.*
Fresco in the lower church of San Francesco,
Assisi. 1320s–30s

left: 587. MASTER OF THE SAINT FRANCIS CYCLE
(GIOTTO?). *Saint Francis Praying Before the Crucifix at
San Damiano.* Fresco in the upper church of
San Francesco, Assisi. Early 14th century

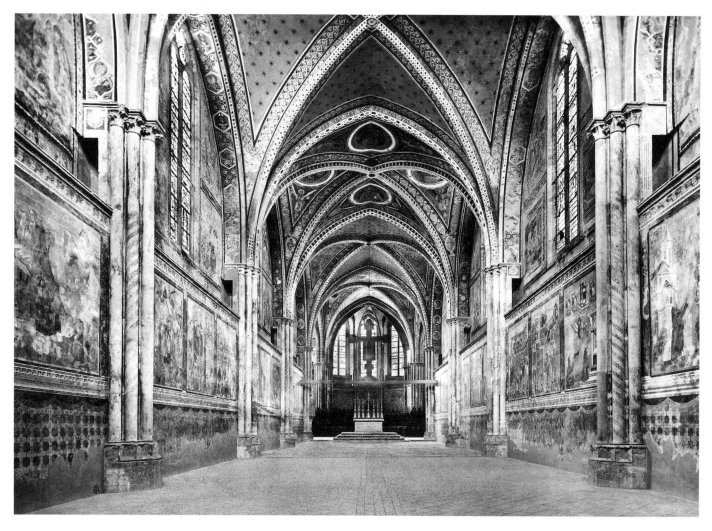

588. San Francesco, Assisi. Upper church

the birds, fishes, animals, even the sun. His mystical way involved one's behavior in daily life, but there were moments when Francis experienced astonishing visions. In 1224, while in prayer on Mount Alvera, a mountain retreat bequeathed to his newly founded order of the Friars Minor (*Frates Minore,* approved by Pope Innocent III in 1210), Francis had a vision of the crucified Christ, and shortly thereafter his body was marked by the stigmata of Christ—the wounds in his side, feet, and hands. Francis died two years later in 1226. He was canonized in 1228, and it was for this occasion that the great basilica was built in his honor in the city of his birth, Assisi.

San Francesco at Assisi has been described as one of the first "Gothic" churches in Italy, but there is little about it that is Gothic in structure. Rising on the slope of a hill, it is built in the form of a double church, an upper and lower structure laid out in the form of a simple *T*-shaped basilica with an aisleless nave consisting of four square bays with slightly pointed rib vaults (fig. 588). Consecrated in 1253 by Pope Innocent IV, the new center for Franciscan devotion was subsequently decorated with frescoes and stained-glass windows. Among the first artists called in was Cimabue of Florence, who worked in the choir and transepts of the upper

church. Only shadows of Cimabue's great frescoes are preserved, however, since the white lead he employed has oxidized over the years and turned black, making it necessary to use photographic negatives to study them (fig. 589). It is impossible to analyze Cimabue's great fresco of the *Crucifixion* in detail, but the general impression is one of surprising dramatic expression with the huge, sagging body of Christ dominating a packed composition of gesticulating figures crowded about the cross.

The upper walls of the nave were decorated in the fashion of Early Christian basilicas in Rome, and the execution was directed by a master from Rome familiar with the cycle of Old Testament pictures that Cavallini had restored in Saint Paul's Outside the Walls there.[90] Cavallini, in fact, has been named the painter of the frescoes by some, although there is much controversy about this. One of the most gifted artists in the Roman shop was the Isaac Master, so-named after the fresco of *Isaac and Esau* (fig. 590). The composition repeats its counterpart in the nave paintings in Saint Paul's (fig. 57). The striking luminosity of the draperies, the softly modeled heads, and the clarity of the space box that forms the setting for the weighty figures all bring to mind the stylistic features of Cavallini's art.

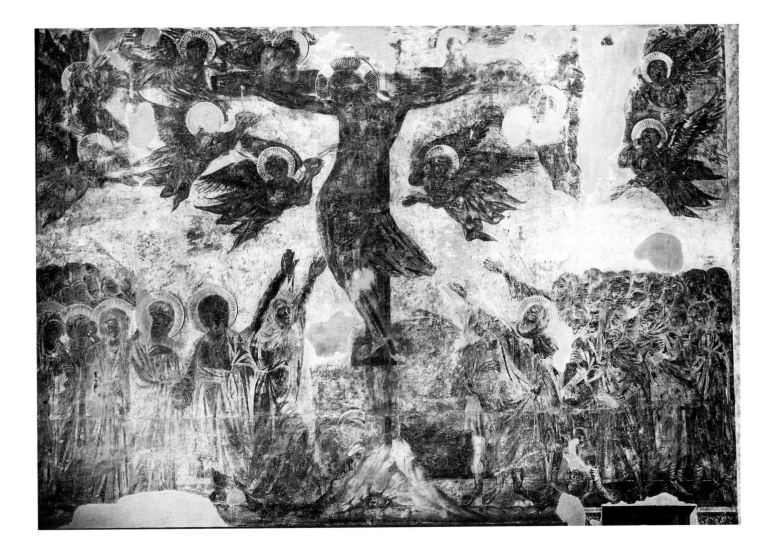

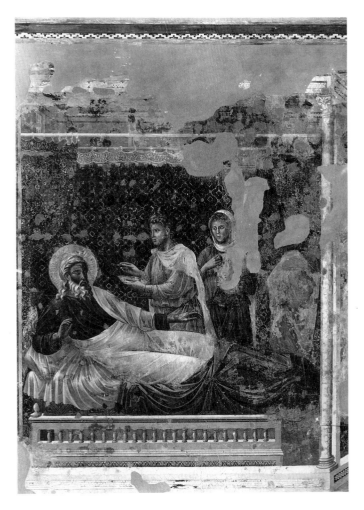

above: 589. CIMABUE. *Crucifixion.*
Fresco in the upper church of San Francesco,
Assisi. After 1279

right: 590. ISAAC MASTER. *Isaac and Esau.*
Fresco in the upper church of San Francesco,
Assisi. 1290s

The thorniest problems at Assisi are those presented by the vast cycle of frescoes illustrating the life of Saint Francis painted on the lower walls of the upper church (fig. 587). According to early Italian sources (Ghiberti and Vasari) and many contemporary scholars as well, the greater part of the twenty-eight pictures was executed by Giotto of Florence in his early years. In some respects this attribution makes sense since the paintings either anticipate or reflect the precocious style of Giotto as we know it in his frescoes in Florence and Padua. Whatever may be the truth in this matter, it is clear that the art of the "Master of the Saint Francis Cycle" bridges the gap between the monumental style of Cavallini in Rome and that of Giotto in Florence and forms a synthesis of what may be termed a Gothic style in later Italian painting.

THE GOTHIC AND GIOTTO

In the history of Italian painting, Giotto di Bondone (c. 1277–1337) has always received special praise, for it was he who abandoned the conventions and stylizations of Medieval traditions and announced the way for the naturalism of Renaissance painting.[91] He was praised by Dante as a leader in the arts; Boccaccio praised him as the "one who brought light back to art"; Vasari named him the first truly "modern" artist to break from the "crude manner of the Greeks" (Byzantine); and more-contemporary historians have described him as the precursor of Masaccio (1401–1428), the first great Renaissance painter in Florence.

Yet it would be wrong to isolate Giotto completely from the later Middle Ages. In many respects the naturalism of his paintings echoes the sentiments expressed by Saint Francis of Assisi, who made religion a simple, everyday experience that was emotionally appealing to the common man. And, in another light, Giotto's style parallels the *dolce stil nuovo* (beautiful new style) introduced by the revolutionary poets Guido Guinizelli and Guido Cavalcanti in the mid-thirteenth century. Indeed, the late-fourteenth-century theorist Cennino Cennini remarked that Giotto had translated the language of art from Greek into Latin (one might more properly say Italian), implying that Giotto had transformed the old-fashioned art forms into something comprehensible to everyone.

According to Vasari, Giotto's teacher was Cimabue of Florence (active c. 1272–1302). One work generally attributed to Cimabue is the *Enthroned Madonna and Child* in the Uffizi (colorplate 72), executed about 1280. The huge icon (11 feet 7 inches × 7 feet 4 inches) has much in common with contemporary works in Siena, such as the *Rucellai Madonna* by Duccio (colorplate 71), in the hieratic composition and the lingering Italo-Byzantine conventions in the draperies and head types. Cimabue's composition seems bolder, however. The throne has been fashioned as a huge, complex setting that actually seems to project in space and

not merely float against the gold background, and the angels overlap each other and appear to be standing on a sharply inclined plane. Furthermore, they turn out and smile gently as if inviting the spectator to join them in their adoration of the Virgin and Child. There is, however, little here to prepare us for the astonishing *Enthroned Madonna and Child* painted by Giotto for the Church of the Ognissanti (All Saints) in Florence, some forty years later, about 1310 (colorplate 73).

How the figures have grown in bulk and immediacy! The rudiments of the Italo-Byzantine composition are present, to be sure, but the conventions have been sloughed off and a new sense of space has been achieved. A delicate Gothic throne with pointed arches and pinnacles replaces the earlier spooled types, and Giotto clearly fashions the space in which the Madonna is placed as a deep box with projecting arms, podium, and a vaulted canopy that forms an ample architectural setting for the weighty figures. The three-dimensional qualities of the figures are powerfully stated, so much so that one scholar (Bernard Berenson) characterized Giotto's style in general as being "tactile," that is, evoking the qualities of objects we wish to touch as large rounded volumes, as if they were sculptures and no longer flat patterns.

Mary is a massive figure described by a simple shape heavily shaded on the sides and along the drapery folds to give her form rotundity and bulk. The angels gathered about the throne also have a pronounced weightiness with their heavy draperies marking out volumetric forms resembling fluted pillars placed one behind the other. Mary is like a huge cone; the robust Child resembles an assembly of polished cylinders with a spheroid head. Gone are the gold lines that are usually shot through the costumes and the crisp linear patterns for the draperies. And how dramatically Giotto has altered the expressions and features of the faces, especially those of the adoring angels who turn in and regard the Mother and Child with a heightened intensity that beautifully conveys the sense of community participation. Human emotions are now registered; a new warmth and intimacy are projected. Real people are placed before our eyes.

The genius of Giotto was recognized immediately. He received commissions in Rome, Naples, Ravenna, and Padua. The most impressive cycle of frescoes to survive are those Giotto executed about 1305 for the wealthy Paduan, Enrico Scrovegni, who had converted an old Roman arena into grounds for a palace and chapel (figs. 591–93; colorplate 70). The chapel is a modest rectangular box with a barrel-vaulted ceiling and windows in the eastern and southern walls. It was Giotto's task to articulate the barren interior into an elaborate gallery for pictures juxtaposing the life of the Virgin and her parents with that of Christ.

A Last Judgment covers the entrance wall. To this end, Giotto divided the side walls into four tiers. The lowest forms a painted dado with imitation marble panels and simulated marble bas-reliefs depicting personifications of

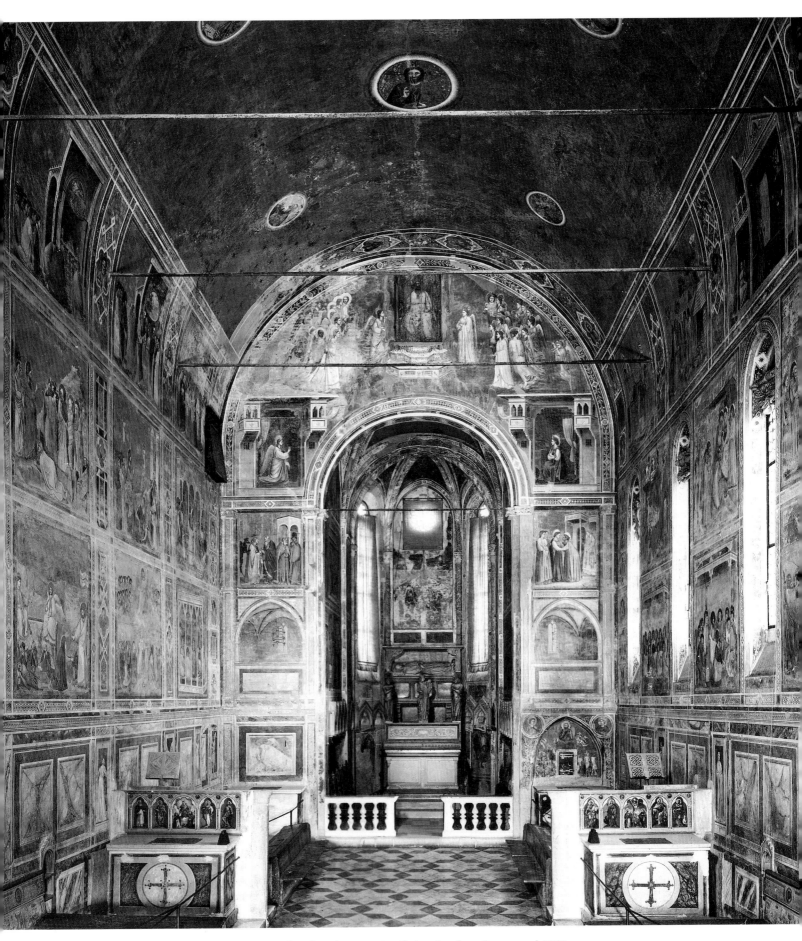

591. Arena Chapel, Padua. Interior, facing the altar. Consecrated 1305

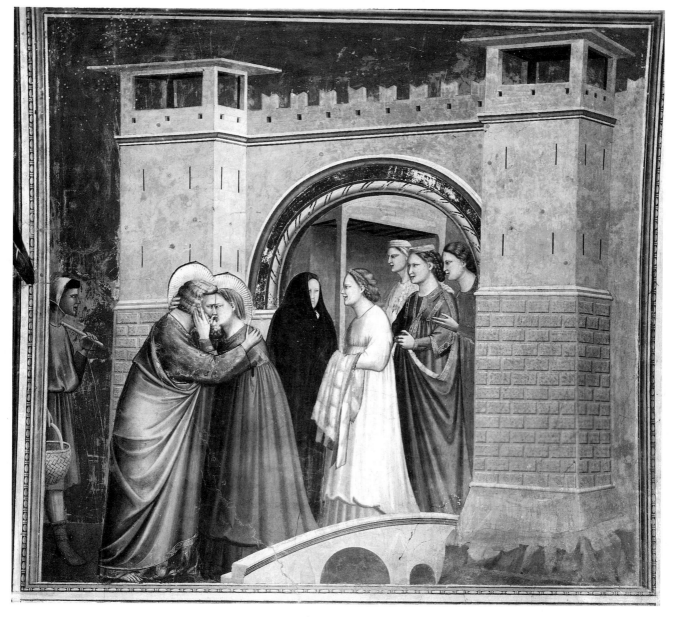

592. GIOTTO. *Meeting of Anna and Joachim at the Golden Gate.* Fresco in the Arena Chapel, Padua. After 1305

the seven Virtues and seven Vices. Above this base, Giotto painted the sequence of narratives in boxes, beginning in the topmost zone in the southeast. Drawing upon more contemporary apocryphal sources (the *Golden Legend* by Jacopo Voragine, c. 1270, and the *Meditations on the Life of Christ* by the pseudo-Bonaventura, c. 1300),[92] the cycle begins with a lengthy series illustrating the stories of Mary's parents, Anna and Joachim, and continues on the top of the north wall with episodes of her infancy. In the second register, he then placed the events from Christ's infancy (south) and ministry (north). The lowest zone of narratives was dedicated to the Passion of Christ.

The *Meeting of Anna and Joachim at the Golden Gate* (fig. 592) is one of Giotto's most impressive compositions. Having been separately informed by angels that they would finally be blessed with a child after many years of hoping, they each rushed to tell the other the blissful news, Joachim from the fields, Anna from her chamber. They met at the Golden Gate in Jerusalem and there embraced. The kiss of the elderly couple was, in fact, interpreted as the moment of the conception of the Virgin Mary (the Immaculate Conception), and therefore it was a delicate theme in which Giotto wished to avoid the melodramatic aspects for the sake of decorum.

How majestically he does this! Dominating the composition is the huge gateway, a massive, blocky form that imparts

a powerful sense of monumentality to the story. Except for the shepherd, half cut off by the left margin, the main figures are contained within the giant portal. Giotto avoids such obvious compositional devices as symmetry and centrality—they would focus too boldly on the embrace—and places Anna and Joachim alone to the left of the arched opening of the gate. But he turns our attention to them by the directional focus of the friends of Anna, gathered beneath the arch, who warmly regard the happy couple.

The close proximity of the spectators would be a disturbing psychological element in the intimate story, and Giotto isolates them within an architectural box or frame inside the arched opening. Between them and Anna and Joachim he inserts an enigmatic figure in black, her face half-veiled, who stares outward and away, forming an emphatic wedge between the smiling women and the embracing couple. To further bind his composition into a compact whole, he repeats the arch motif throughout: the opening in the gate, the bridge, and the silhouette of the elderly pair embracing.

Giotto's figures are massive, unadorned volumes that seem like great stone blocks wrapped in pastel sheets that fall in even, shallow ridges. He also discreetly organizes the

593. GIOTTO. *Lamentation.* Fresco in the Arena Chapel, Padua. After 1305

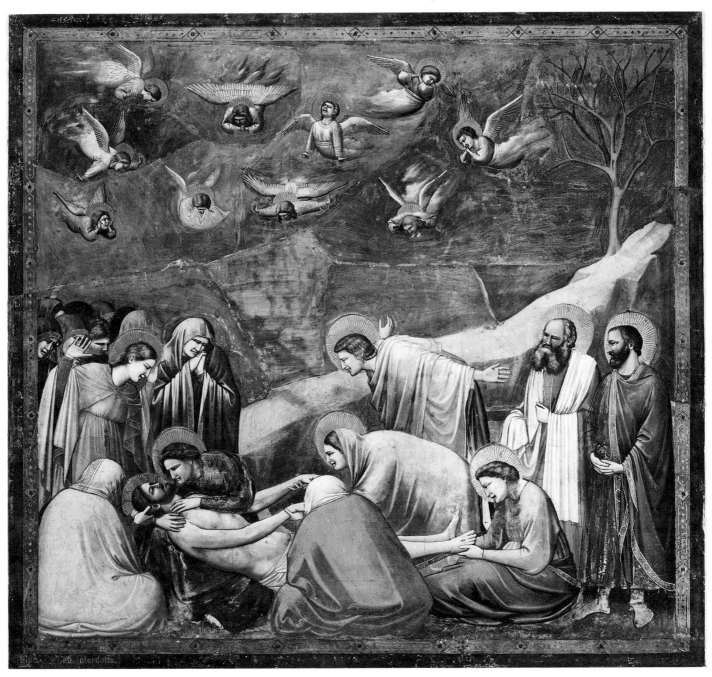

actors into groups of two, three, or four figures that are easily read as single units by the viewer. The dignity of the intimate moment is thus maintained by subtle formal means.

The *Entry into Jerusalem* (colorplate 70) offers us an excellent opportunity to compare the Italo-Byzantine style of Duccio of Siena and the Gothic expression of Giotto of Florence. The same narrative elements are presented, but how different they appear when viewed side by side. Giotto simplifies the story by reducing the elements to the basic components. The apostles following Christ on the donkey

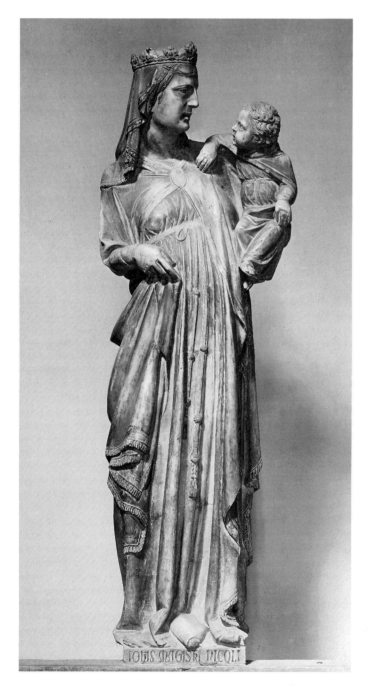

594. GIOVANNI PISANO. *Madonna and Child*. Marble, height 4'3"
c. 1305. Arena Chapel, Padua

form a solid rectangular block that dominates the left half of the composition. The central axis is free, and the citizens issuing from the towered gateway are presented as a compact pyramidal assembly descending to the kneeling boy, who places his shirt before the hooves of the donkey. Here, again, Giotto controls our attention span through the subtle psychology of directional focus of all figures, keeping our eyes turned to Christ, who is slightly larger in scale.

Through a rhythmic crescendo in the poses of the towns-people, who gradually move from an upright position to one of *proskynesis*—like a fan slowly opened—an immediate sense of adoration is conveyed. Furthermore, the angle of vision is straight on. We see the procession as a frieze of weighty figures across a simple stage directly before us. In comparison, Duccio's composition (colorplate 69) seems like a miniature pageant performed by doll-like actors strewn about an elaborate toy village tilted upward. From a high angle of vision we can see all of the colorful details and be enchanted by the wealth of buildings, courtyards, and other eye-catching details that easily distract us from the main point of the story. Duccio's discursive treatment of the story has its special appeal, to be sure, but compared to Giotto's dramatic presentation of the Entry, his has more the charm of a Sunday School play. And herein lies Giotto's greatness as a mural painter. An overwhelming sense of propriety, decorum, and force resides in Giotto's big figures. We cannot miss the point of the story, and we are invited to participate in the tableau rather than study it as an interesting story. In this respect, Giotto truly appears as the spiritual forefather of the great fresco painters of the Renaissance, from Masaccio to Michelangelo.

Another masterpiece in the Paduan series is the *Lamentation* (fig. 593). The upper torso of the dead Christ rests in the arms of the Virgin, off axis, in the lower left corner. Before them are placed the ponderous figures of the seated mourners. To either side stand other grieving figures closing the compositional field like parentheses. Again Giotto employs the clever device of unfolding their postures, on the right, from an upright to a kneeling and, finally, a seated position. The great stony forms of the two women huddled to the left with their backs to us, totally weighed down by their grief, convey a sense of universal sadness. A few rhetorical gestures—hands thrust backward, hands waving above the shoulders, hands clenched to the cheek—are sufficient to communicate the range of emotions among the mourners, emotions that the tiny angels in the sky echo as they weep and wail.

Giotto fashions a new reality for religious art, one in which man is a mortal with emotions, fears and joys, who can regain his dignity, whatever his sins might have been. Even the landscape is reduced to a metaphor of the tragedy. Golgotha is presented as a firm diagonal ridge of parched land that moves sharply downward from the top right to the

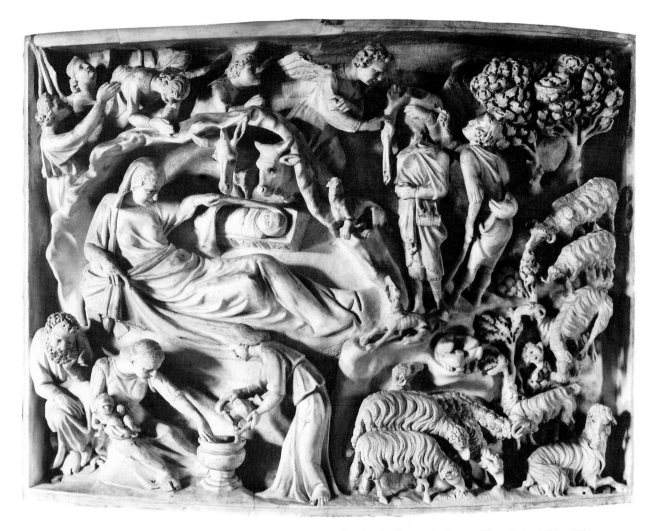

595. GIOVANNI PISANO. *Nativity* and *Annunciation to the Shepherds*. Panel of a marble pulpit, 34⅜ × 43″
1302–10. Cathedral, Pisa

head of Christ in the lower left. Its barrenness is made explicit by the one tree on its slope, a dry tree, an image of death and sterility in Medieval art.

For the altar in the Arena Chapel, Enrico Scrovegni commissioned Giovanni Pisano, the son of Nicola, to execute a marble statue of the Virgin and Child (fig. 594).[93] The exaggerated sway in the upper torso and the rich cascades of drapery that fall from the Virgin's right hand bring to mind the manneristic features of French ivories, and, indeed, it is very possible that Giovanni was directly indebted to such models. The intensity of the gaze between Mother and Child, on the other hand, indicates that Giovanni was also influenced by the new emotional expression of Giotto.

Between 1302 and 1310 Giovanni Pisano executed marble reliefs for the pulpit in the Cathedral at Pisa (fig. 595). A comparison of these reliefs with those of his father for the Pisa Baptistry pulpit (fig. 572) demonstrates how the spirit of the French Gothic pervades his work. The blocky, compact figures with their Antique head types and the broad planes of creased drapery in Nicola's *Nativity* were rejected

for a new pictorial vocabulary in Giovanni's version. The same iconographic scheme is followed, but now the figures are slender, and they sway beneath flowing draperies. The projection of the relief varies widely. Many of the heads are turned outward on long necks, arms are attenuated, and gestures curve gracefully inward so that a flickering pattern of light and dark accents sweeps across the composition like a shimmering arabesque.

Giovanni's interests in pictorial effects lead him to exploit the charm of the landscape setting. Compared to the cramped surface of Nicola's relief, where all figures are squeezed into one plane, that of Giovanni is open and interlaced like a giant vine or scroll issuing from a single source — the curved back of the maiden pouring water. Graceful tendrils of landscape tie the Virgin to the grotto, the grotto to the hills with the shepherds, and the meadows with the grazing flocks to the maiden once more.

Giovanni's talents ranged widely. He worked as an assistant to his father when the shop was called to Siena to execute the pulpit for the Duomo there between 1265 and

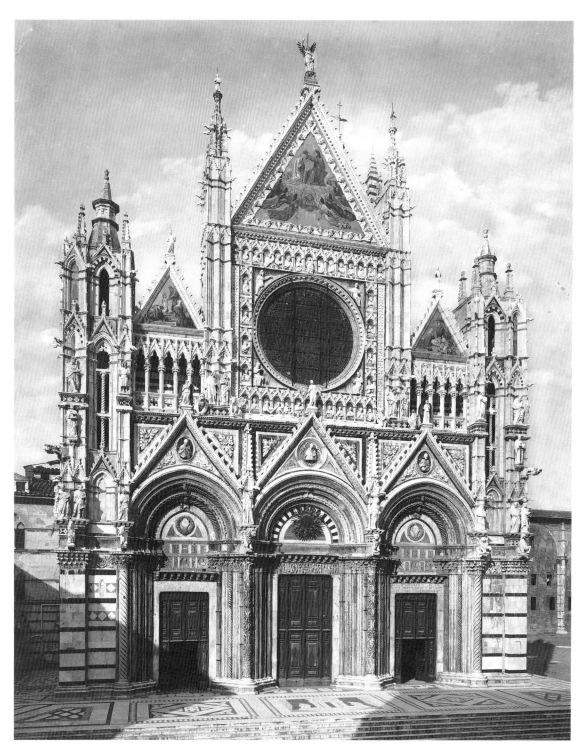

596. Giovanni Pisano and others. Cathedral, Siena. Facade. 1284–99

1268. He apparently settled in Siena and eventually worked on the facade of the Duomo (fig. 596) after the main building was completed. In a document of 1290 he is referred to as the *caput magistrorum,* or "man in charge," of the cathedral works.[94] Giovanni designed the resplendent facade with its handsome zebra banding of dark green and white marble. The lower half of the front—up to the pinnacles of the side portals—was completed by his shop along with the sculptures; the upper parts with the rose window were added in the 1370s.

The basic elements of the French Gothic facade are present: the three portals, rose window, galleries, two towers, and the profusion of sculpture, but the richly textured surface is little more than an elaborate screen. The portals do not correspond exactly to the disposition of the nave and side aisles, nor are they decorated in the French fashion. Giant marble statues stand between and atop the pinnacles, but they are independent creations placed there and not actually coordinated within the fabric of the structure. A strong cornice divides the facade into two parts. The central block

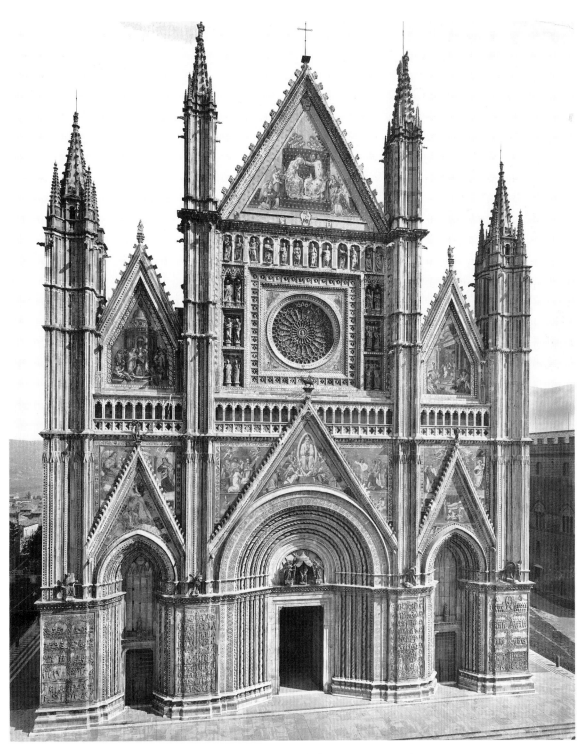

597. Lorenzo Maitani and others. Cathedral, Orvieto. Facade. Begun 1310

is raised as a square penetrated by a huge round window with stained glass (attributed to designs by Cimabue or Duccio). The towers shrink to ornate turrets framing the central block. One is aware of standing before a simple stepped-gabled building, much like San Miniato in Florence, to which a lavish veneer of Gothic detail has been added.

Following difficulties with the city council of Siena in 1297, Giovanni left Siena. In 1311 Duccio's great *Maestà* was installed, and in 1316 new additions were planned for the Duomo. These included a baptistry at the foot of the hill that

provided the substructure for two bays added to the choir. Structural problems were immediately encountered, and a special commission was appointed to advise the architects concerning the additions. Among the new advisors was Lorenzo Maitani, a Sienese architect, who had served since 1310 as the *capomaestro* at Orvieto, where he completed work on the interior and erected the handsome facade of the huge church (fig. 597). His advice was rejected by the Sienese council.

Maitani's design for the facade of the Duomo in Orvieto

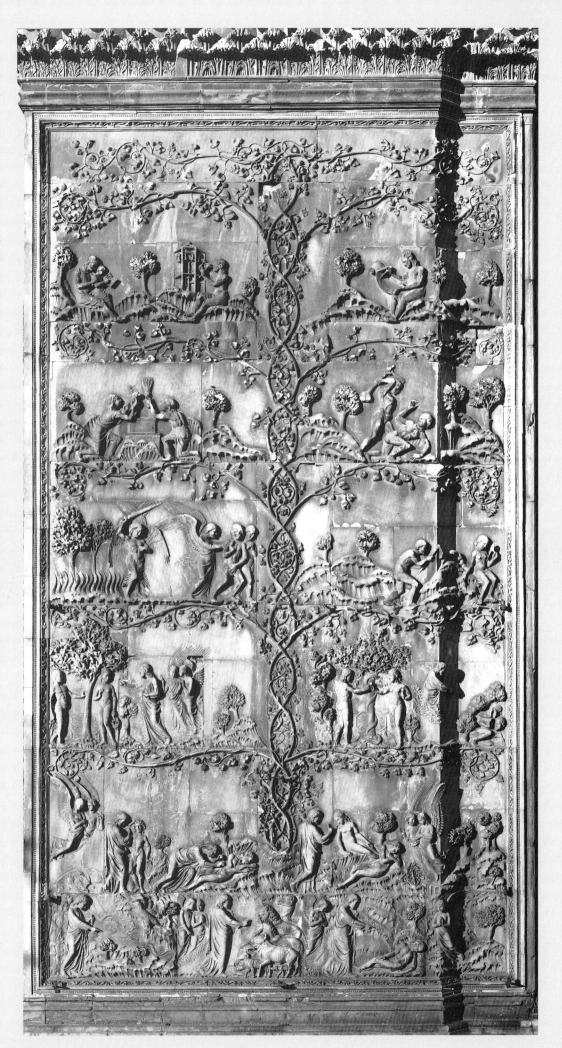

left: 598.
LORENZO MAITANI.
Scenes from Genesis.
First pilaster
of the facade,
Orvieto Cathedral.
c. 1310–15

opposite: 599.
LORENZO MAITANI.
Detail of Hell from
the *Last Judgment.*
Fourth pilaster
of the facade,
Orvieto Cathedral.
c. 1310–30

clearly resembles that of the Duomo in Siena, but it displays more regularity and order with the three portals clearly marked off to conform to the interior divisions. Of special interest is the unusual sculpture decoration designed by Maitani for the facade (see fig. 598). Four high marble reliefs adorn the pilasters that flank and separate the three portals. These depict, from left to right, stories from Genesis, the Tree of Jesse, the life of Christ, and the Last Judgment. Conceived as monumental door sculptures, they resemble the valves that were cast in bronze at Hildesheim (fig. 290), with superimposed registers of individual scenes.

Maitani's reliefs are delicate and refined in detail, and the tiers of figures are gracefully unified by means of meandering vines (ivy, acanthus, and grape) that grow up the central axis of each pilaster and sprout tendrils that frame the individual scenes. However poetic these sculptures strike us in their general appearance, certain details, especially in the Last Judgment, convey a startling pathos. The poor soul who finds himself dying in the grip of a menacing hybrid monster (fig. 599) strikes a pose so moving that it has been suggested that Michelangelo consciously repeated it in his anguished marble *Pietà* in the Cathedral of Florence some two hundred years later.

That the arts were a product of the new urban societies in the Gothic era is more clearly demonstrated in Italy than in France. The pride and comfort of Gothic city life is admirably summed up in the panoramic view of the *Effects of Good Government in the City and the Country,* a huge fresco

painted by Ambrogio Lorenzetti on the walls of the Sala della Pace in Siena's Palazzo Pubblico in 1338–39 (figs. 600, 602).[95] The sweeping view of the city and countryside of Siena is astonishing in its vast scope and wealth of detail, and the everyday activities and pastimes of the citizens, so realistically scattered here and there, seem like echoes of the vitality the Sienese enjoyed in the earlier years of the fourteenth century.

But the good life was not to last. The year 1343 has often been cited as the end of the Middle Ages in Europe. In that year the infamous Black Death, the bubonic plague, swept up the boot of Italy and spread rapidly throughout northern Europe, decimating the population and bringing a halt to many cultural enterprises. It took decades for Europe to recover from the shock of such an apocalyptic disaster, and the gradual restoration of artistic life reflected more a lamentation than a rejuvenation. This story has been vividly described by Millard Meiss (*Painting in Florence and Siena After the Black Death*), who noted the conscious revival of archaic iconic imagery in works of such artists as Giovanni da Milano (fig. 601), Andrea Orcagna, Nardo di Cione, and Barna da Siena, late followers of Giotto and Duccio. Francesco Traini's forbidding fresco of the *Triumph of Death* in the Campo Santo (cemetery) at Pisa (fig. 603) chronicles the

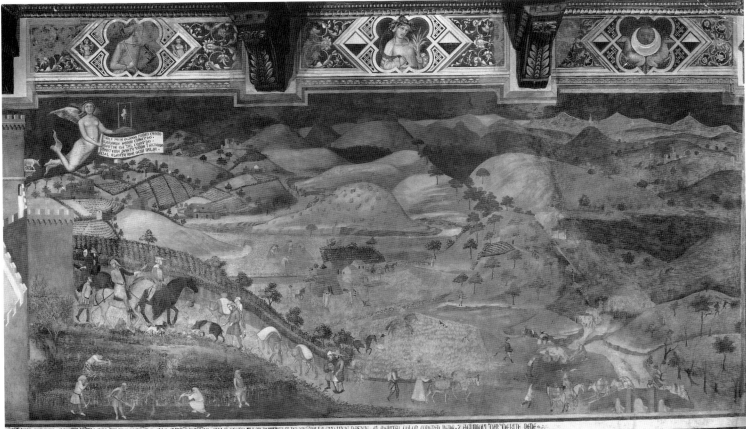

opposite above: 600.
AMBROGIO LORENZETTI.
Allegory of Good Government:
The Effects of Good Government
in the City and the Country
(portion of the city). Fresco in
the Sala della Pace, Palazzo
Pubblico, Siena. 1338–39

opposite below: 601.
GIOVANNI DA MILANO. *Pietà.*
Panel, 48 × 22¾″. 1365.
Accademia, Florence

above: 602.
AMBROGIO LORENZETTI.
Allegory of Good Government:
The Effects of Good Government
in the City and the Country
(portion of the country)

right: 603. FRANCESCO TRAINI.
Triumph of Death. Detail of a
fresco in the Campo Santo,
Pisa. Mid-14th century

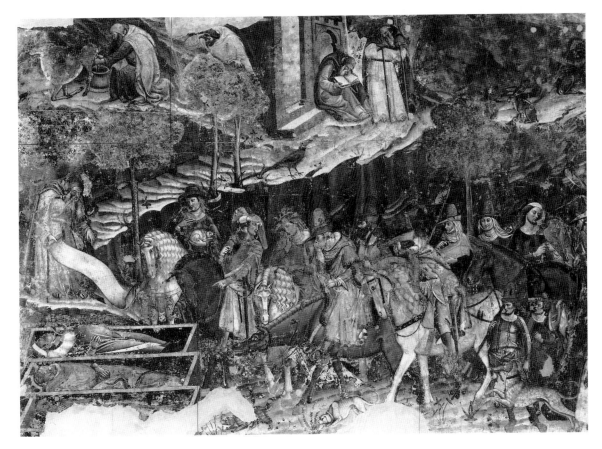

obsession with impending death that horrified all of Europe in the mid-fourteenth century. Here the "Three Living" meet the "Three Dead," a gruesome theme that sums up the feelings of an era. It was this same catastrophe that silenced the sounds of hammers and chisels in workshops throughout Italy.[96]

While beyond the limits of the present study, the Duomo of Milan (figs. 604–606) deserves a few words here since the history of the building clearly reveals the conflicts between the Mediterranean and Nordic temperaments in Late Medieval art.[97] At first sight the Duomo, with its countless spires, turrets, and pinnacles, resembles a Northern Gothic cathedral more so than other Italian churches of the period. But this impression is misleading. The core of the structure is Lombard Romanesque—a solid, geometric mass—and the "Gothic" is merely veneer, icing on the cake, so to speak. Also we should remember that much of what we see on the exterior was added during the course of the eighteenth and nineteenth centuries.

Lengthy documentation survives that records the building of the Duomo, particularly regarding the heated arguments between members of the city council and architects concerning its "Gothic" construction. The grandiose project was initiated in 1386 by Duke Gian Galeazzo Visconti, an ambitious tyrant who wanted to secure Milan's preeminence in Italy, culturally as well as politically. The cathedral was to be something new on Italian soil, a masterpiece in the style of the *opus francigenum* that reigned supreme north of the Alps. The original *capomaestro*, Simone da Orsenigo, a Milanese builder, laid out the foundations and then ran into trouble in determining the height and elevation.

The city council responsible for the building called in a series of French and German architects as advisors in the techniques of Gothic construction, but each lasted less or little more than a year in residence. First came Nicolas de Bonaventure, a Parisian, in 1389, who devised an elevation and plan with double aisles that the Milanese rejected. He was fired immediately. A second Northerner, Johann von Freiburg, was then summoned to revise the elevation based on the square (the height equaling the width), a system known as *ad quadratum*. He was dismissed five months later, and an Italian mathematician, Gabriele Stornaloco, from Piacenza, was asked to devise a compromise, *ad triangulorum,* whereby the measurements of the nave and the height would be based on the equilateral triangle, thus reducing the height considerably. Heinrich Parler of Gmünd, a member of an illustrious family of architects in Germany, was enrolled to carry out Stornaloco's new elevation, but he soon refused, preferring to return to the original square measurements and reenforce the buttressing. He, too, was dismissed.

By this time, 1399, the nave piers were completed, and once again the troublesome issues regarding the vaulting and

its support were pressing hard upon the Milanese builders. Jean Mignot of Paris was then brought to Milan to supervise the erection of the upper elevation and vaults. He lasted one year (1400–1401), but his arguments with the Milanese were vigorous and substantial. Mignot declared that the building would collapse if carried through as they planned. His arguments and objections (recorded in a scholastic outline form) concentrated on the technical aspects of construction—weakness of the piers, inaccuracies of measurement throughout, misuse of proportions for smaller elements such as cornices and capitals, and lack of good craft. He also repeatedly stressed the relative merits of the pointed arch over the round arch (the Milanese did not object to round arches or to the use of iron tie rods to secure the piers).

Mignot's ultimate appeal was that "art without science is nothing" (*ars sine scientia nihil est*), but this got him nowhere with the Italian builders, who felt strongly that science was one thing and art was another. The Italian point of view was that practicality, not geometry, should rule. Mignot appears as an extreme purist in terms of the engineering of Gothic, unwilling to concede to the aesthetic considerations that interested the Milanese.

The disputes between the French architect and the city council tell us much about the aesthetics of the diverse cultures. It is clear that for Mignot the Gothic cathedral was to be a fragile, open composite of the "scholastic" exterior and the "mystic" interior (see p. 348 ff.) and that the elevation should be a precise, organic diagram reflecting the mechanics needed to support a lofty interior and achieve a spiritual climax through height and light. For the Italians the cathedral was not to abandon the beauty of solid Mediterranean buildings but was essentially to maintain a simpler beauty consisting of additive parts coordinated by self-sufficient, not interdependent, elements. The cathedral was to retain its mural character and not become a scaffolding of parts.

Alas, no matter how impressive the mammoth structure may seem today, the Cathedral of Milan remains a sad swan song for Gothic architecture in Italy. Strip away the multiple turrets and pinnacles that overlay the front and flanks and you will find a sturdy, stepped-gable structure. The effect upon entering the lofty church is also misleading in some ways. A sense of horizontality rules here, too, with the emphatic longitudinal axis accentuated by huge figured capitals (about which Mignot complained vehemently). The ascending height of the doubled side aisles eliminates the glazed triforium in the nave, and the blocky chevet, retaining a tight polygonal plan, also contributes to a darkened interior. The essential features of French Gothic architecture, height and light, are thus seriously compromised. But Mignot was wrong in warning the Milanese that their cathedral would collapse. It stands magnificently today, dominating one of the most colorful piazzas in Italy.

above: 604. Milan Cathedral. Exterior. Begun 1386

right: 605. Milan Cathedral. Plan

overleaf: 606. Milan Cathedral. Interior

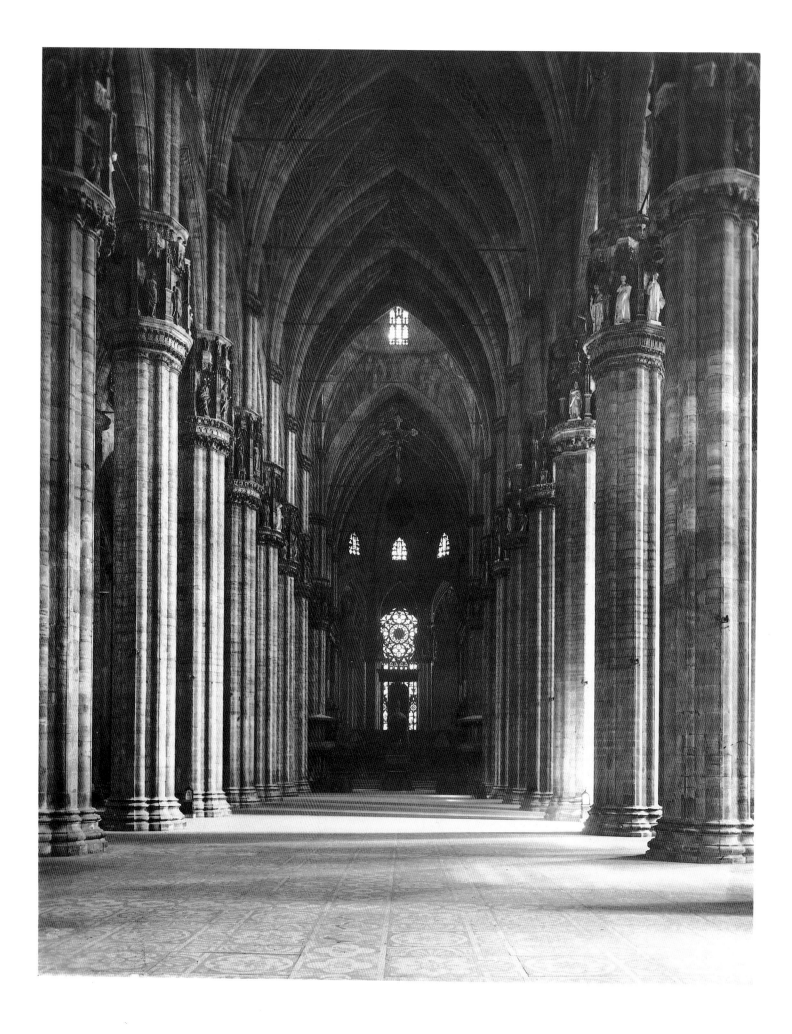

NOTES

Unless otherwise cited, scriptural translations in the text are from *The Holy Bible Translated from the Latin Vulgate,* New York, Douay Bible House, imprimatur 1938.

PART ONE

1. For inscriptions see especially G. de Rossi, *Inscriptiones christianae urbis Romae,* 3 vols., Rome, 1861–88; O. Marucchi, *Eléments d'archéologie chrétienne,* 3 vols., Paris and Rome, 1899–1903. For the catacombs in general see G. de Rossi, *La Roma sotteranea cristiana,* 3 vols., Rome, 1864–77; O. Marucchi, *Le Catacombe romane,* Rome, 1932; J. Wilpert, *Roma Sotterranea: Die Malereien der Katakomben Roms,* 2 vols., Freiburg i. B., 1903; M. Dvořák, *Kunstgeschichte als Geistesgeschichte,* Munich, 1924 (chap. 1: "Katakombenmalerei, die Anfänge der christlichen Kunst," 3–40); A. Grabar, *The Beginnings of Christian Art, 200–395,* London and New York, 1966. For the sarcophagi see P. Styger, *Die altchristliche Gräberkunst,* Munich, 1927; J. Wilpert, *I Sarcofagi cristiani antichi,* 3 vols., Rome, 1929–36. A handy general book on this material is W. Lowrie, *Art in the Early Church,* 2nd rev. ed., New York, 1966. See also G. Bovini, "Catacombs," in *Encyclopedia of World Art,* New York, 1962, III, 143 ff.; J. Stevenson, *The Catacombs: Rediscovered Monuments of Early Christianity,* London, 1978.

2. H. Koch, *Die altchristliche Bilderfrage nach den literarischen Quellen,* Göttingen, 1917; W. Elliger, *Die Stellung der alten Christen zu den Bildern in den ersten vier Jahrhunderten,* Leipzig, 1930; J. Gutmann, ed., *No Graven Images: Studies in Art and the Hebrew Bible,* New York, 1971, reprints a number of articles related to the Jewish position on iconoclasm. In general see A. Grabar, *L'Iconoclasme byzantin,* Paris, 1957; A. Bryer and J. Herrin, eds., *Iconoclasm: Papers Given at the Ninth Spring Symposium of Byzantine Studies,* University of Birmingham (Eng.), Birmingham, 1977.

3. Letter to Serenus, bishop of Marseilles, *Epistula IX. 28 — Monumenta Germaniae historica,* Ep. 9, p. 195; and *Epistula XI — Monumenta Germaniae historica,* Ep. 11, p. 270.

4. For the general problems of early liturgies, see G. Dix, *The Shape of the Liturgy,* London, 1945, 78 ff.; J. A. Jungmann, *The Mass of the Roman Rite,* New York, 1951, 7 ff.; A. von Harnack, *The Expansion of Christianity,* New York and London, 1904; B. Stewart, *The Development of Christian Worship,* London, 1953.

5. A. Grabar, *The Beginnings of Christian Art,* 41 ff., 101 ff.

6. Cf. J. Wilpert, *Fractio Panis: Die älteste Darstellung des eucharistischen Opfers in der "Cappella Greca,"* Freiburg i. B., 1897.

7. See also the representations of the sacraments in F. van der Meer and C. Mohrmann, *Atlas of the Early Christian World,* Amsterdam, 1958, 125–35.

8. The prayer is later in date, but it reflects Early Christian types. See E. Le Blant, *Sarcophages de la ville d'Arles,* Paris, 1878, who relates it to the Roman *Ordo commendationis animae quando infirmus est in extremis* (cited in W. Lowrie, *Art in the Early Church,* 41).

9. C. Cecchelli, "A proposito del mosaico dell' absidale lateranense," in *Miscellanea Bibliothecae Hertzianae,* Munich, 1961, 13–18; J. Kollwitz, "Christus als Lehrer und die Gesetzesübergabe an Petrus," *Römische Quartalschrift,* 44, 1936, 49–60; T. Buddensieg, "Le Coffret en ivoire de Pola, Saint-Pierre et le Latran," *Cahiers archéologiques,* 10, 1959, 157–200; for a general discussion of the theme of the Mission of the Apostles see A. Katzenellenbogen, "The Sacrophagus in Saint Ambrose," *Art Bulletin,* 29, 1947, 249–59.

10. W. D. Wixom, "Early Christian Sculptures at Cleveland," *Bulletin of the Cleveland Museum of Art,* 54, 1967, 67 ff.

11. See especially F. Gerke, *Der Sarkophag des Junius Bassus,* Berlin, 1936, and "Studien zur Sarkophagplastik der theodosianischen Renaissance," *Römische Quartalschrift,* 42, 1934, 1–34.

12. J. Toynbee and J. W. Perkins, *The Shrine of St. Peter and the Vatican Excavations,* London, 1956, 135–94.

13. For a general discussion see R. Krautheimer, *Early Christian and Byzantine Architecture* (Pelican History of Art, no. 24), Harmondsworth, 1965, 3–15.

14. C. H. Kraeling, *Excavations at Dura-Europos: Preliminary Report of the Fifth Season,* New Haven, 1934, 1; and *The Christian Baptistry: The Excavations at Dura-Europos: Final Report,* VIII, pt. 2, New Haven, 1967.

15. H. Bettenson, *Documents of the Christian Church,* New York and London, 1947, 22–23.

16. There is a vast literature on Constantine. See especially N. H. Baynes, *Constantine the Great and the Christian Church,* London, 1929; A. Alföldi, *The Conversion of Constantine,* Oxford, 1948; K. M. Setton, *Christian Attitude Towards the Emperor,* New York, 1941; H. Dorries, *Konstantin der Grosse,* Stuttgart, 1958. For a general history of the period see P. Brown, *The World of Late Antiquity: A.D. 150–750,* London, 1971.

17. A discussion of the arguments is summarized in B. Berenson, *The Arch of Constantine or the Decline of Form,* London, 1954, 31 ff. Cf. the remarks of E. Kitzinger, *Byzantine Art in the Making: Main Lines of Stylistic Development in Mediterranean Art, 3rd–7th Century,* Cambridge, Mass., 1977, 7–21.

18. The positive evaluation of the style of the Constantinian friezes was mainly inspired by the provocative study of A. Riegl (*Die spätrömische Kunstindustrie,* Vienna, 1927). For a balanced analysis of the problem see especially E. Kitzinger, *Byzantine Art in the Making.*

19. R. Krautheimer, *Early Christian and Byzantine Architecture,* 316, n. 6, reviews this literature. See especially N. Duval, "Les origines de la basilique chrétienne — état de la question," *L'Information de l'histoire de l'art,* 7, 1962, 1–19.

20. For the most complete reports on early basilicas in Rome, see R. Krautheimer et al., *Corpus basilicarum christianarum Romae,* Vatican City, 5 vols., 1937–77. For more general accounts see R. Krautheimer, *Early Christian and Byzantine Architecture,* and F. Deichmann, *Frühchristliche Kirchen in Rom,* Basel, 1948.

21. L. Duchesne, *Le Liber Pontificalis,* 3 vols., Paris, 1881–92; reprinted 1957. An English translation of the earlier history is found in E. Atchley, *Ordo Primus Romanus,* London, 1905. Also see L. R. Loomis, *The Book of the Popes* (Records of Civilization, no. 3), New York, 1916.

22. R. Krautheimer, *Early Christian and Byzantine Architecture,* 30 ff.

23. See B. M. Apollonj-Ghetti et al., *Esplorazioni sotto la confessione di San Pietro in Vaticano . . . 1940–1949,* Vatican City, 1951; J. Toynbee and J. W. Perkins, *The Shrine of St. Peter and the Vatican Excavations.*

24. T. Buddensieg, "Le Coffret," 157–200.

25. The precise definition of the *martyrium* as a building type is extremely elusive, ranging from churches raised over martyrs' tombs to any structure commemorating a site that bears witness to Christian faith by reference to Christ's life or passion. See A. Grabar, *Martyrium: Recherches sur le culte des reliques et l'art chrétien antique,* 2 vols., Paris, 1943–46.

26. A. Muñoz, *Il restauro della basilica di Santa Sabina,* Rome, 1938; F. Darsy, *Santa Sabina* (Chiese di Roma illustrate, nos. 63–64), Rome, 1961.

27. For a concise discussion of the baptistry, see F. van der Meer and C. Mohrmann, *Atlas of the Early Christian World,* 125–31. See also R. Krautheimer, "Introduction to an Iconography of Medieval Architecture," *Journal of the Warburg and Courtauld Institutes,* 5, 1942, 1–33.

28. A. Stange, *Das frühchristliche Kirchengebäude als Bild des Himmels,* Cologne, 1950, 13–16, 102–9; L. Kitscheldt, *Die frühchristliche Basilika als Darstellung des himmlischen Jerusalem,* Munich, 1938, *passim.*

29. For interpretations of these associations see O. A. Piper, "The Apocalypse of John and the Liturgy of the Ancient Church," *Church History,* 20, 1951, 10–22; L. Mowry, "Revelation 4–5 and the Early Christian Liturgical Usage,"

Journal of Biblical Literature, 71, 1952, 75–84; M. H. Shepherd, Jr., *The Paschal Liturgy and the Apocalypse* (Ecumenical Studies in Worship, no. 6), London, 1960, 77 ff.; A. T. Nikolainen, "Der Kirchenbegriff in der Offenbarung des Johannes," *New Testament Studies,* 9, 1963, 351–60.

30. Eusebius, *Ecclesiastical History,* X, iv. 1–72, translated by J. Oulton in *The Ecclesiastical History,* Loeb Classical Library, New York, 1932, II, 398–440.

31. H. Stern, "Les mosaïques de l'église de Sainte Costance à Rome," *Dumbarton Oaks Papers,* 12, 1958, 160–218.

32. Prudentius, *Lines to be Inscribed Under Scenes from History,* translated by H. J. Thompson in the Loeb Classical Library, London, 1953, II, 346–71. Reprinted by C. Davis-Weyer, *Early Medieval Art: 300–1150* (Sources and Documents), Englewood Cliffs, N. J., 1971, 25–33.

33. R. Goldschmidt, *Paulinus' Churches at Nola,* Amsterdam, 1940; A. Weis, "Der Verteilung der Bilderzyklen in der Basilika des hl. Paulinus in Nola," *Römische Quartalschrift,* 52, 1957, 129–51; C. Davis-Weyer, *Early Medieval Art: 300–1150,* 17–22.

34. See W. Green, "Augustine on the Teaching of History," *University of California Publications in Classical Philology,* 12, 1944, 320 ff.

35. E. B. Smith, *Architectural Symbolism of Imperial Rome and the Middle Ages,* Princeton, 1956, 10 ff. See also T. L. Donaldson, *Architecture numismatica,* London, 1859, 205 ff., 305 ff.; E. Kantorowicz, "The King's Advent and the Enigmatic Panels in the Doors of Santa Sabina," *Art Bulletin,* 26, 1944, 207–31.

36. F. van der Meer, *Maiestas Domini: Théophanies de l'Apocalypse dans l'art chrétien* (Studi di antichità cristiana, no. 13), Rome, 1938.

37. W. Meyer-Barkhausen, "Die frühmittelalterlichen Vorbauten am Atrium von Alt-St. Peter in Rom," *Wallraf-Richartz Jahrbuch,* 20, 1958, 22 ff.; H. Belting, "Das Fassadenmosaik des Atrium von alt St. Peter in Rom," *Wallraf-Richartz Jahrbuch,* 23, 1961, 37–54.

38. Grimaldi compiled invaluable information with illustrations of the basilica before the final demolition. See Biblioteca Vaticana, Vat. lat. 6438 and 2733. For reproductions and bibliography see S. Waetzoldt, *Die Kopien des 17. Jahrhunderts nach Mosaiken und Wandmalereien in Rom,* Vienna, 1964.

39. Anastasius Bibliothecarius (c. 810–878) in J. P. Migne, *Patrologia Latina,* 128, col. 267 (with reference to Santa Maria Maggiore). Cf. S. Lang, "A Few Suggestions Towards a New Solution for the Origin of the Early Christian Basilica," *Rivista di Archeologia Cristiana,* 30, 1954, 189 ff.; for the use of the term in general see C. Weichert, "Noack—Triumph and Triumphbogen," *Gnomon,* 5, 1929, 24–30.

40. G. Matthiae, *SS. Cosma e Damiano e S. Teodoro,* Rome, 1948, 39–65. For early mosaics in Rome see G. Matthiae, *Mosaici medioevali delle chiese di Roma,* I, Rome, 1967; and W. Oakeshott, *The Mosaics of Rome from the Third to the Fourteenth Centuries,* London, 1967.

41. C. Cecchelli, *I mosaici della basilica di S. Maria Maggiore,* Turin, 1956, 197–246. Much controversy centers around the subject matter of the Infancy scenes on the arch. See especially B. Brenk, *Die frühchristlichen Mosaiken in Santa Maria Maggiore zu Rom,* Wiesbaden, 1975, who suggests the influence of Leo the Great and his sermons on the makeup of the unique cycle; N. A. Brodsky, *L'iconographie oubliée de l'arc éphésien de Sainte-Marie Majeure à Rome,* Brussels, 1966, rejects any references to apocryphal sources and cites Augustine's *City of God* as the primary textual inspiration; S. Spain, " 'The Promised Blessing': The Iconography of the Mosaics of Santa Maria Maggiore," *Art Bulletin,* 61, 1979, 518–40, also rejects apocryphal sources and stresses the uniqueness of the iconography. Spain identifies the Presentation scene as the Betrothal of Mary and Joseph, the Annunciation as the Annunciation to Abraham and Sarah, and argues that the elaborately dressed woman in the mosaics usually identified as the *Maria Regina* is not the Virgin at all (she is the one dressed in somber blue in the Adoration of the Magi and in the scene usually identified as the Presentation, according to Spain).

42. C. Picard, "Le trône vide d'Alexandre," *Cahiers archéologiques,* 7, 1954, 1–17. Cf. n. 39.

43. J. Garber, *Wirkungen der frühchristlichen Gemäldezyklen der alten Peters- und Paulsbasiliken in Rom,* Berlin, 1918; see also S. Waetzoldt, *Die Kopien,* 69 ff. For an excellent discussion of the influence of Saint Peter's nave program, see W. Tronzo, "The Prestige of Saint Peter's: Observations on the Function of Monumental Narrative Cycles in Italy," *Studies in the History of Art,* National Gallery of Art, Washington, D.C., 16, 1985, 93–112.

44. C. Cecchelli, *I mosaici della basilica di S. Maria Maggiore,* 197–246; H. Karpp, *Die frühchristlichen und mittelalterlichen Mosaiken in S. Maria Maggiore zu Rom,* Baden-Baden, 1966. Also see the discussion in E. Kitzinger, "The Role of Miniature Painting in Mural Decoration," in *The Place of Book Illumination in Byzantine Art,* Princeton, 1975, 122 ff., who points out the close relationships of the mosaics to book illustration but rightly emphasizes the unique nature of the Old Testament series, suggesting that they were composed in an *ad hoc* fashion from a unique set of working drawings made up for the nave.

45. G. Bandmann, "Zur Bedeutung der romanischen Apsis," *Wallraf-Richartz Jahrbuch,* 15, 1953, 30 ff.; A. M. Schneider, "Apsis," in *Reallexikon für Antike und Christentum,* Stuttgart, 1950, I, 57. For the decoration of the apse in Early Christian Rome see L. von Sybel, "Mosaiken römischer Apsiden," *Zeitschrift für Kirchengeschichte,* 37, 1918, 274 ff.; U. Rapp, *Das Mysterienbild,* Munsterschwarzach, 1952, 89 ff.; C. Ihm, *Die Programme der christlichen Apsismalerei vom vierten Jahrhundert bis zur Mitte des achten Jahrhunderts* (Forschungen zur Kunstgeschichte und christlichen Archäologie, no. 4), Wiesbaden, 1960.

46. For these see especially K. Lehmann, "Dome of Heaven," *Art Bulletin,* 27, 1945, 10, 15 ff.

47. U. Rapp, *Das Mysterienbild, passim;* see also O. von Simson, *The Sacred Fortress: Byzantine Art and Statecraft in Ravenna,* Chicago, 1948, 22 ff., *passim.*

48. C. Ihm, *Die Programme,* 5–40; P. Testini, "Osservazioni sull'iconografia del Cristo in trono fra gli Apostoli," *Rivista dell'istituto nazionale d'archaeologia e storia dell'arte,* n.s. 11–12, 1963, 230 ff.

49. J. Wilpert, *Die römischen Mosaiken und Malereien der kirchlichen Bauten vom IV. bis XIII. Jahrhundert,* Freiburg i. B., 1916, II, 1066. M. van Berchem and E. Clouzot, *Mosaïques chrétiennes du IVme au Xme siècle,* Geneva, 1924, 63 ff.; W. Köhler, "Das Apsismosaik von S. Pudenziana als Stildokument," in *Festschrift für J. Ficker,* Leipzig, 1931, 167–79; C. Ihm, *Die Programme,* 130 ff.; S. Waetzoldt, *Die Kopien,* 74; R. W. Montini, *Santa Pudenziana,* Rome, 1959.

50. K. J. Conant, "The Holy Sites at Jerusalem in the First and Fourth Centuries, A.D.," *Proceedings of the American Philosophical Society,* 102, 1958, 14–24, and "The Original Buildings at the Holy Sepulchre in Jerusalem," *Speculum,* 31, 1956, 1–48.

51. See especially F. van der Meer and C. Mohrmann, *Atlas of the Early Christian World,* 158–59; C. Davis-Weyer, "Das Traditio-Legis-Bild und seine Nachfolge," *Münchner Jahrbuch der bildenden Kunst,* 12, 3rd ser., 1961, 7–45; M. Sotomayor, *S. Pedro en la iconografía paleocristiana* (Biblioteca Teologica granadina), Granada, 1962, 25 ff.; C. Ihm, *Die Programme, passim.*

52. A. Katzenellenbogen, "The Sarcophagus in Saint Ambrose," 249–59.

53. G. J. Hoogewerff, "Il mosaico absidale di San Giovanni in Laterano," *Atti della Pontificia Accademia Romana di Archeologia Rendiconti,* 27, 1951–54, 297–326; T. Buddensieg, "Le Coffret," 157–200; C. Cecchelli, "A proposito del mosaico dell'absidale Lateranense," 13–18; W. N. Schumacher, "Dominus legem dat," *Römische Quartalschrift,* 54, 1959, 1 ff.

54. G. Matthiae, *SS. Cosma e Damiano,* 9 ff.; C. Ihm, *Die Programme,* 137 ff.; C. Davis-Weyer, "Das Traditio-Legis-Bild," 17 ff.

55. For this verse see J. Wilpert, *Die römischen Mosaiken,* III, pl. 88; R. Goldschmidt, *Paulinus' Churches at Nola,* 38 ff.; C. Ihm, *Die Programme,* 140; cf. A. W. Bijvanck, "Die Grabeskirche in Jerusalem und die Bauten am Grabe des hl. Felix bei Nola in Kampanien," in *Festschrift für A. Heisenberg* (Byzantinische Zeitschrift, no. 30), Munich, 1929/30, 547–54; C. Davis-Weyer, *Early Medieval Art,* 23.

56. M. Lawrence, "Maria Regina," *Art Bulletin,* 7, 1925, 150–60; C. Cecchelli, *Mater Christi,* Rome, 1947, I, 54 ff., 75 ff. In the Byzantine world the portrayal of the Virgin as the *Nikopoia,* or bearer of victory, had become widespread by the sixth century, when she appears dressed in a simple blue mantle and veil (*maphorion*), usually flanked by two angels. This and other Eastern types will be discussed in Part II. For a reconstruction of the apse see J. Snyder, "The Mosaic in Santa Maria Nova and the Original Apse Decoration of Santa Maria Maggiore," in R. Enggass and M. Stokstad, eds., *Hortus Imaginum: Essays in Western Art,* Lawrence, Kan., 1974, 1–10.

57. C. Ihm, *Die Programme,* 141. Cf. A. Grabar, *Martyrium,* II, 60 ff.

58. Eusebius, *Vita Constantini* in J. P. Migne, *Patrologia Graeca,* XX, 905 ff., translated by P. Schaff and H. Wace in *A Select Library of the Nicene and Post-Nicene Fathers,* 2nd ser., New York, 1890, I, 473 ff. For the foundations of Constantinople in general see D. Dagren, *Naissance d'une capitale: Constantinople,* Paris, 1974; R. Janini, *Constantinople Byzantine,* Paris, 1964. Also see C. Mango, "Antique Statuary and the Byzantine Beholder," *Dumbarton Oaks Papers,* 17, 1963, 53 ff.; for an extensive discussion of the *spolia* and sculptures see the study by S. Basset, " 'Omnium Paene Urbium Nuditate.' The Re-use of Antiquities in Constantinople, Fourth through the Sixth Centuries," Ph.D. diss., Bryn Mawr College, 1985.

59. J. Ebersolt, *Le Grand Palais de Constantinople,* Paris, 1910.

60. A. Heisenberg, *Grabeskirche und Apostelkirche,* 2 vols., Leipzig, 1908. See also summaries in T. F. Mathews, *The Early Churches of Constantinople: Architecture and Liturgy,* University Park and London, 1971; R. Krautheimer, *Three Christian Capitals: Topography and Politics,* Berkeley and London, 1983, and "Zu Konstantins Apostelkirche in Konstantinopel," in *Mullus: Festschrift Theodor Klauser,* Münster, 1964, 224–29.

61. The churches are fully discussed in A. Calderini et al., eds., *Storia Milano,* I, Milan, 1965. See also R. Krautheimer, *Early Christian and Byzantine Archi-*

tecture, 55 ff., and *Three Christian Capitals*, 69 ff. For the Arian problem see H. Lietzmann, *A History of the Early Church*, IV, translated by B. L. Woolf, New York, 1952.

62. Numerous controversies concern the date and foundation of San Lorenzo. See A. Calderini et al., *La Basilica di San Lorenzo Maggiore in Milano*, Milan, 1951; W. Kleinbauer, "Toward a Dating of San Lorenzo in Milan," *Arte Lombarda*, 13, 1969, 1–22; D. Kinney, "The Evidence for the Dating of San Lorenzo in Milan," *Journal of the Society of Architectural Historians*, 31, 1972, 92 ff.; S. Lewis, "San Lorenzo Revisited: A Theodosian Palace Church at Milan," *Journal of the Society of Architectural Historians*, 32, 1973, 197–222.

63. S. Lewis, "Function and Symbolic Form in the Basilica Apostolorum," *Journal of the Society of Architectural Historians*, 28, 1969, 83 ff., and "The Latin Iconography of the Single-Naved Cruciform Basilica Apostolorum," *Art Bulletin*, 51, 1969, 214–18. Also see her "Problems of Architectural Style and the Ambrosian Liturgy in Late Fourth-Century Milan," in R. Enggass and M. Stokstad, eds., *Hortus Imaginum*, 11–19.

64. R. Krautheimer, *Early Christian and Byzantine Architecture*, 58–60.

65. G. Downey, *A History of Antioch*, Princeton, 1961, 358 ff.

66. For a general discussion of these churches see R. Krautheimer, *Early Christian and Byzantine Architecture*, 51 ff.; W. MacDonald, *Early Christian and Byzantine Architecture*, New York, 1962; E. Baldwin Smith, *The Dome*, Princeton, 1950; A. Grabar, *Martyrium*, I, 214 ff. For the Golden Octagon in Antioch see W. Davis, "The First Christian Palace-Church Type," *Marsyas*, 11, 1962–64, 2 ff.

67. The relevant texts are discussed in L. H. Vincent and F. M. Abel, *Jérusalem nouvelle*, 2 vols., Paris, 1925; J. W. Crowfoot, *Early Churches in Palestine*, London, 1941.

68. W. Harvey, *The Holy Sepulchre*, London, 1935; K. J. Conant and G. Downey, "The Original Buildings of the Holy Sepulchre," *Speculum*, 31, 1956, 1 ff.; A. Parrot, *Golgotha and the Holy Sepulchre*, London, 1957; G. Coüason, *The Church of the Holy Sepulchre in Jerusalem*, London, 1974.

69. R. Krautheimer, *Early Christian and Byzantine Architecture*, 36 ff.

70. See F. van der Meer and C. Mohrmann, *Atlas of the Early Christian World*, 105–6.

71. A. Grabar, *Les Ampoules de Terre Sainte*, Paris, 1958.

72. H. C. Butler, *Architecture and Other Arts*, Pt. II: *Architecture* (Publications of the Princeton Archaeological Expeditions to Syria in 1904–1905 and 1909, pt. 2), Leiden, 1910–23; H. C. Butler and E. B. Smith, *Early Churches in Syria*, Princeton, 1929; J. Lassus, *Sanctuaires chrétiens de Syrie*, Paris, 1974.

73. S. Clarke, *Christian Antiquities in the Nile Valley*, London, 1912; U. Monnerat de Villard, *Les Couvents de Sohag*, Milan, 1925.

74. See *The Catholic Encyclopedia*, New York, 1913, XIII, 635–40.

75. T. Birt, *Die Buchrolle in der Kunst*, Leipzig, 1907. For a further discussion see K. Weitzmann, *Illustrations in Roll and Codex*, Princeton, 1947. In the development of narrative art, Weitzmann distinguishes three basic steps: (1) simultaneous illustration in archaic Greek art where several actions occur in a single scene; (2) monoscenic, or single-scene, pictures; (3) cyclical method with a series of consecutive scenes with separate actions but the same actors. See also K. Weitzmann, *Ancient Book Illumination*, Oxford, 1959, and *Late Antique and Early Christian Book Illumination*, New York, 1977. Cf. R. Kozodoy, "The Origin of Early Christian Book Illumination: The State of the Question," *Gesta*, 10, 1971, 33–40.

76. F. Wickhoff, *Römische Kunst*, Berlin, 1912. This text served as Wickhoff's introduction to his *Die Wiener Genesis* and was translated into English by Mrs. S. A. Strong as *Roman Art: Some of its Principles and Their Applications to Early Christian Painting*, London and New York, 1900. Wickhoff's theory was refuted by K. Lehmann-Hartleben, *Die Trajanssäule*, Berlin, 1926, who argued that the frieze was invented for this particular monument.

77. J. de Wit, *Die Miniaturen des Vergilius Vaticanus*, Amsterdam, 1959; cf. K. Weitzmann, *Late Antique*, 11 ff., 32–40.

78. R. Bianchi Bandinelli, *The Hellenistic Byzantine Miniatures of the Iliad*, Olten, 1955.

79. A. M. Friend, Jr., "The Portraits of the Evangelists in Greek and Latin Manuscripts," pt. 1, *Art Studies*, 5, 1927, 115 ff., and pt. 2, *Art Studies*, 7, 1929, 3 ff.

80. C. H. Kraeling, *The Synagogue: The Excavations at Dura-Europos, Final Report*, VIII, pt. 1, New Haven, 1956.

81. See H. Riesenfeld, "The Resurrection in Ezekiel XXXVII and in the Dura-Europos Paintings," *Uppsala Universitets Arsskrift*, 2, 1948, 3–38; R. Wischnitzer, *The Messianic Theme in the Paintings of the Dura Synagogue*, Chicago, 1948, 117–24.

82. W. von Hartel and F. Wickhoff, *Die Wiener Genesis* (facsimile), Vienna, 1895; H. Gerstinger, *Die Wiener Genesis*, Vienna, 1931; P. Buberl, *Die Byzantinischen Handschriften I* (Beschreibendes Verzeichnis der illuminierten Handschriften in Österreich), VIII, pt. 4, Leipzig, 1937, 65 ff.; K. Weitzmann, *Late Antique*, 16 ff.

83. K. Weitzmann, "Observations on the Cotton Genesis Fragments," in *Late Classical and Mediaeval Studies in Honor of A. M. Friend, Jr.*, Princeton, 1955, 112 ff.; E. Kitzinger, "The Role of Miniature Painting in Mural Decoration," in *The Place of Book Illustration in Byzantine Art*, 99–110.

84. O. von Gebhard, *The Miniatures of the Ashburnham Pentateuch*, London, 1883; J. Gutmann, "The Jewish Origin of the Ashburnham Pentateuch Miniatures," *Jewish Quarterly Review*, 44, 1953, 55–72, gives a summary of scholarship. Cf. A. Grabar, "Fresques romanes copiées sur les miniatures du Pentateuque de Tours," *Cahiers archéologiques*, 9, 1957, 329 ff.

85. A. Muñoz, *Il codice purpureo di Rossano*, Rome, 1907; A. Grabar, *Les Peintures de l'Evangéliaire de Sinope*, Paris, 1948. For an excellent analysis of the miniatures in the Rossano Gospels see W. C. Loerke, "The Monumental Miniature," in *The Place of Book Illumination in Byzantine Art*, 68–97.

86. A. Grabar, *The Golden Age of Justinian*, New York, 1967, 208; W. C. Loerke, "The Miniatures of the Trial in the Rossano Gospels," *Art Bulletin*, 43, 1961, 171 ff.

87. C. Nordenfalk, *Die spätantiken Kanontafeln*, Göteborg, 1938, and "The Apostolic Canon Tables," *Gazette des Beaux-Arts*, 62, 1963, 17 ff. Also see C. Cecchelli et al., *The Rabbula Gospels* (facsimile), Olten and Lausanne, 1959.

88. For a discussion of the theophanies see especially F. van der Meer, *Maiestas Domini*; W. Neuss, *Das Buch Ezechiel in Theologie und Kunst bis zum Ende des XII. Jahrhunderts*, Münster, 1912.

89. W. Frere, *The Anaphora*, London, 1929, 69 ff.; for a more specific association with the Church on the Mount of Olives see S. Euringer, "Die Anaphoren des hl. Jacobus von Serug," *Orientalis cristiana*, 33, no. 90, 1934, 79–122, esp. n. 54. Cf. K. Weitzmann, "Loca Sancta and the Representational Arts of Palestine," *Dumbarton Oaks Papers*, 28, 1974, 31 ff., and *Late Antique*, 101.

90. J. Kollwitz, *Die Lipsanothek von Brescia*, Berlin, 1933; for this and other ivories see J. Natanson, *Early Christian Ivories*, London, 1953; W. F. Volbach, *Elfenbeinarbeiten der Spätantike und des frühen Mittelalters*, Mainz, 1953; G. Bovini and L. Ottolenghi, *Catalogo della mostra degli avori dell'alto medio evo*, Ravenna, 1956; W. F. Volbach, *Early Christian Art*, New York, 1961; W. Lowrie, *Art in the Early Church*, 156 ff.

91. J. Wiegand, *Das altchristliche Hauptportal an der Kirche der hl. Sabina*, Trier, 1900; W. F. Volbach, *Early Christian Art*, nos. 103–5.

92. E. Kantorowicz, "The King's Advent and the Enigmatic Panels in the Doors of Santa Sabina," 207 ff. Cf. R. Delbrueck, "Notes on the Wooden Doors of Santa Sabine," *Art Bulletin*, 34, 1952, 138–44.

93. See W. Lowrie, *Art in the Early Church*, 163.

94. For a discussion of this iconography see E. Panofsky, *Early Netherlandish Painting*, Cambridge, Mass., 1953, I, 278, n. 1.

95. E. Hennecke, *New Testament Apocrypha*, edited by W. Schneemelcher, Philadelphia, 1963, I, 370–88 (for the Proto-evangelion of James).

96. C. Cecchelli, *La cattedra di Massimiano*, Rome, 1936; G. Bovini, *La cattedra eburnea del vescovo Massimiano di Ravenna*, Faenza, 1957; E. Kitzinger, *Byzantine Art in the Making*, 94 ff.

PART TWO

1. G. Ostrogorsky, *History of the Byzantine State*, Oxford, 1956; W. G. Holmes, *The Age of Justinian and Theodora*, 2 vols., London, 1905–7; C. Mango, *Byzantium: The Empire of New Rome*, New York, 1980. See especially the writings of Procopius in the Loeb Classical Library, I–VI, edited by H. B. Dewing, and VII, edited by G. Downey, 1959, and *Procopius' Secret History*, translated by R. Atwater, Ann Arbor, 1976.

2. R. Delbrueck, *Die Consulardiptychen und verwandte Denkmäler*, Berlin and Leipzig, 1929, 12 ff.; K. Wessel, "Das Diptychon Barberini," in *Akten des XI. Internationalen Byzantinistenkongresses*, Munich, 1960, 665 ff.; W. F. Volbach, *Elfenbeinarbeiten der Spätantike und des frühen Mittelalters*, 3rd ed., Mainz, 1976, 47 ff., no. 48; E. Kitzinger, *Byzantine Art in the Making: Main Lines of Stylistic Development in Mediterranean Art, 3rd–7th Century*, Cambridge, Mass., 1977, 96–98.

3. Procopius, *Buildings*, translated by H. B. Dewing and G. Downey in the Loeb Classical Library, London, 1959. A. van Millingen et al., *Byzantine Churches in Constantinople*, London, 1912; E. H. Swift, *Hagia Sophia*, New York, 1940; R. L. van Nice, *Saint Sophia in Istanbul: An Architectural Survey*, Washington, D.C., 1965; H. Köhler, *Hagia Sophia*, translated by E. Childs, London, 1967; H. Jantzen, *Die Hagia Sophia des Kaisers Justinian in Konstantinopel*, Cologne, 1967; T. F. Mathews, *The Early Churches of Constantinople: Architecture and Liturgy*, University Park and London, 1971; C. Mango, *Byzantine Architecture*, New York, 1976; R. Krautheimer, *Early Christian and Byzantine Architecture* (Pelican History of Art, no. 24), 2nd ed., Harmondsworth, 1981, 215–44.

4. T. F. Mathews, *Early Churches*, 88–116. For the influence of liturgy in general see K. Liesenberg, *Der Einfluss der Liturgie auf die frühchristliche Basilika*, Neustadt a. d. Haardt, 1928; L. Bouyer, *Architecture et liturgie*, Paris, 1967. C. Walter, *Art and Ritual of the Byzantine Church*, New York, 1982; M. M. Solovey, *The Byzantine Divine Liturgy*, Washington, D.C., 1970. The tenth-century ceremonies at Hagia Sophia are recorded by Constantine VII Porphyrogenitus in the *Book of Ceremonies*. See J. Ebersolt, *Ste. Sophie de Constantinople d'après les cérémonies*, Paris, 1910.

5. R. Krautheimer, *Early Christian and Byzantine Architecture*, 233–38; T. F. Mathews, *Early Churches*, 42–76; A. van Millingen, *Byzantine Churches*, 62 ff.; C. Mango, *Byzantine Architecture*, 101 ff.

6. C. Mango and E. J. W. Hawkins, "The Apse Mosaics of St. Sophia at Istanbul," *Dumbarton Oaks Papers*, 19, 1965, 115–49; R. Cormack, *Writing in Gold: Byzantine Society and its Icons*, New York, 1985, 114–58.

7. For the patriarchal palace see R. Cormack, *Writing in Gold*, 107 ff.; for the mosaic in Kalenderhane Djami see C. L. Striker and Y. D. Kuban, "Work at Kalenderhane Camii in Istanbul: Third and Fourth Preliminary Reports," *Dumbarton Oaks Papers*, 25, 1971, 255 ff.

8. See especially R. Delbrueck, *Consulardiptychen*, and W. F. Volbach, *Elfenbeinarbeiten*, for numerous examples. For a general discussion see J. Beckwith, *Early Christian and Byzantine Art* (Pelican History of Art, no. 33), Harmondsworth, 1970, 78 ff.

9. L. Matzulewitsch, *Byzantinische Antike*, Berlin, 1929. E. Kitzinger, "On the Interpretation of Stylistic Changes in Late Antique Art," *Bucknell Review*, 15, no. 3, 1967, 1–10 (reprinted in E. Kitzinger, *The Art of Byzantium and the Medieval West*, Bloomington, Ind., 1976, 32 ff.).

10. E. Kitzinger, "Byzantine Art in the Period Between Justinian and Iconoclasm," in *Berichte zum XI. Internationalen Byzantinisten-Kongress*, IV, pt. 1, Munich, 1958, 20 ff. (reprinted in *The Art of Byzantium*, 157 ff.). K. Weitzmann, "Prolegomena to the Study of the Cyprus Plates," *Metropolitan Museum Journal*, 3, 1970, 97–111. Cf. S. H. Wander, "The Cyprus Plates: The Story of David and Goliath," *Bulletin of The Metropolitan Museum of Art*, 8, 1973, 89–104; S. Spain, "Heraclius, Byzantine Imperial Ideology, and the David Plates," *Speculum*, 52, 1977, 28 ff.

11. H. Torp, *Mosaikkene i St Georg-Rotunden i Thessaloniki*, Oslo, 1963; A. Grabar, "A propos des mosaïques de la coupole de Saint-Georges à Salonique," *Cahiers archéologiques*, 17, 1967, 59 ff.; M. G. Sotiriou, "Sur quelques problèmes de l'iconographie de la coupole de Saint-Georges de Thessalonique," in *In Memoriam Panayotis A. Michelis*, Athens, 1971, 218 ff.; W. E. Kleinbauer, "The Iconography and the Date of the Mosaics of the Rotunda of Hagios Georgios, Thessaloniki," *Viator*, 3, 1972, 27 ff.; E. Kitzinger, *Byzantine Art in the Making*, 56–58.

12. J. Snyder, "The Meaning of the Maiestas Domini in Hosios David," *Byzantion*, 37, 1967, 143–52; R. Cormack, *Writing in Gold*, 132–33.

13. G. A. and M. G. Sotiriou, *He basilike tou hagiou Demetriou Thessalonikes*, Athens, 1952; R. Krautheimer, *Early Christian and Byzantine Architecture*, 132–35. For the mosaics see R. Cormack, "The Mosaic Decoration of S. Demetrios, Thessaloniki: A Re-examination in the Light of the Drawings of W. S. George," *Annual of the British School at Athens*, 64, 1969, 17–52, and *Writing in Gold*, 50–94; E. Kitzinger, *Byzantine Art in the Making*, 105–7; A. Grabar, "Notes sur les mosaïques de Saint-Démétrios à Salonique," *Byzantion*, 48, 1978, 64–77.

14. J. D. Jones, *Pseudo-Dionysius Areopagite: The Divine Names and Mystical Theology* (Medieval Philosophical Texts in Translation, no. 21), Milwaukee, 1980, 211–12. Cf. C. E. Rolt, *Dionysius the Areopagite on the Divine Names and Mystical Theology*, New York, 1920, 191–92 (reprinted 1957). See the discussion by P. Rorem, *Biblical and Liturgical Symbols Within the Pseudo-Dionysian Synthesis* (Pontifical Institute of Medieval Studies; Studies and Texts, no. 71), Toronto, 1984, esp. 99–116.

15. *Plotinus, The Enneads*, translated by S. MacKenna, 3rd ed., London, 1962, esp. 56–64 for texts cited here. Cf. A. Grabar, *Plotin et les origines de l'esthétique médiévale*, Paris, 1945; P. A. Michelis, *An Aesthetic Approach to Byzantine Art*, London, 1955; G. Mathew, *Byzantine Aesthetics*, New York, 1963, 12–21.

16. F. W. Deichmann, *Ravenna, Hauptstadt des spätantiken Abendlandes*, I: *Geschichte und Monumente*, Wiesbaden, 1969; II, pt. 1: *Kommentar*, Wiesbaden, 1974; III: *Frühchristliche Bauten und Mosaiken von Ravenna*, 2nd ed., Wiesbaden, n.d.; E. Kitzinger, *Byzantine Art in the Making*, 53–57. For the early history of Ravenna see Agnellus, *Liber pontificalis ecclesiae Ravennatis*, edited by A. Testi-Rasponi in the new edition of L. A. Muratori, *Rerum Italicarum scriptores*, III, pt. 3, Bologna, 1924.

17. F. W. Deichmann, *Ravenna*, I, 158; II, 51 ff.

18. F. W. Deichmann, *Ravenna*, I, 130 ff.; II, pt. 1, 15 ff.; S. K. Kostof, *The Orthodox Baptistry of Ravenna*, New Haven and London, 1965.

19. F. W. Deichmann, *Ravenna*, I, 171 ff.; II, pt. 1, 125 ff.; O. von Simson, *The Sacred Fortress: Byzantine Art and Statecraft in Ravenna*, Chicago, 1948, 40–62; G. Bovini, *Sant'Apollinare Nuovo*, Milan, 1961; C. O. Nordström,

Ravennastudien: Ideengeschichtliche und ikonographische Untersuchungen über die Mosaiken von Ravenna, Uppsala, 1953, 55–88; E. Kitzinger, *Byzantine Art in the Making*, 62 ff.

20. Compare the interpretations of O. von Simson, *Sacred Fortress*, 78, who sees a type of *dittochaeon* in the arrangement; A. Baumstark, "I mosaici di Sant'Apollinare Nuovo e l'antico anno liturgico ravennate," *Rassegna Gregoriana*, 9, 1919, 33 ff., who relates the selection of stories to the Office of the Syrian Jacobites; and C. O. Nordström, *Ravennastudien*, 63 ff.

21. F. W. Deichmann, *Ravenna*, I, 226 ff.; G. Rodenwaldt, "Bemerkungen zu den Kaisermosaiken in San Vitale," *Jahrbuch des Deutschen Archäologischen Instituts*, 59–60, 1944–45, 88 ff.; O. von Simson, *Sacred Fortress*, 23–39; C. O. Nordström, *Ravennastudien*, 88–119; E. Kitzinger, *Byzantine Art in the Making*, 81–87. For the architecture see R. Krautheimer, *Early Christian and Byzantine Architecture*, 219 ff.

22. *Procopius' Secret History*, 41.

23. *Procopius' Secret History*, 53.

24. Quoted in Procopius, *History of the Wars*, bk. 1, chap. 24, sec. 33–37. For a discussion of Theodora's famous speech see J. W. Barker, *Justinian and the Later Roman Empire*, Madison, 1966, 87–88.

25. F. W. Deichmann, *Ravenna*, I, 257 ff.; O. Demus, "Zu den Apsismosaiken von Sant'Apollinare in Classe," *Jahrbuch der österreichischen byzantinistik Gesellschaft*, 18, 1969, 229 ff.; O. von Simson, *Sacred Fortress*, 40–62; C. O. Nordström, *Ravennastudien*, 120–32; E. Kitzinger, *Byzantine Art in the Making*, 101–3; J. Engemann, "Zu den Apsis-Tituli des Paulinus von Nola," *Jahrbuch für Antike und Christentum*, 17, 1974, 21 ff.

26. G. H. Forsyth and K. Weitzmann, *The Monastery of Saint Catherine at Mount Sinai: The Church and Fortress of Justinian*, Ann Arbor, 1973; E. Kitzinger, *Byzantine Art in the Making*, 99 ff.

27. G. A. Sotiriou, "Icones Byzantines du Monastère du Sinai," *Byzantion*, 14, 1939, 325 ff., and *Icones du Mont Sinai*, 2 vols., Paris, 1956 and 1958; E. Kitzinger, "On Some Icons of the Seventh Century," in *Late Classical and Mediaeval Studies in Honor of A. M. Friend, Jr.*, Princeton, 1955, 133–50 (also in *The Art of Byzantium*, 233–53); K. Weitzmann, *Icons*, New York, 1980, 13–30.

28. J. D. Breckenridge, *The Numismatic Iconography of Justinian II*, New York, 1959, 59 ff.; E. Kitzinger, "Some Reflections on Portraiture in Byzantine Art," in *The Art of Byzantium*, 256–69; R. Cormack, *Writing in Gold*, 95–102.

29. E. Kitzinger, "The Cult of Images in the Age Before Iconoclasm," *Dumbarton Oaks Papers*, 8, 1954, 83–150 (also in *The Art of Byzantium*, 90–155); and G. Mathew, *Byzantine Aesthetics*, 94–107. See especially A. Grabar, *Martyrium: Recherches sur le culte des reliques et l'art chrétien antique*, Paris, 1946, II, esp. 343 ff.

30. A. Grabar, *La Sainte Face de Laon: Le Mandylion dans l'art orthodoxe*, Prague, 1931; K. Weitzmann, "The Mandylion and Constantine Porphyrogenitus," *Cahiers archéologiques*, 11, 1960, 163 ff. For the icons of the Virgin see C. Cecchelli, *Mater Christi*, 3 vols., Rome, 1960; G. A. Wellen, *Theotokos: Eine ikonographische Abhandlung über das Gottesmutterbild in frühchristlicher Zeit*, Utrecht, 1961.

31. For this and other sources see A. Bryer and J. Herrin, eds., *Iconoclasm: Papers Given at the Ninth Spring Symposium of Byzantine Studies*, University of Birmingham (Eng.), Birmingham, 1977, 183, no. C. 20; A. Grabar, *L'Iconoclasme byzantin*, Paris, 1957.

32. G. Ladner, "The Concept of the Image in the Greek Fathers and the Byzantine Iconoclastic Controversy," *Dumbarton Oaks Papers*, 7, 1953, 1–34; A. Bryer and J. Herrin, eds., *Iconoclasm*, 181.

33. A. Bryer and J. Herrin, eds., *Iconoclasm*, 182, no. B. 15; C. Mango, *The Art of the Byzantine Empire, 312–1453* (Sources and Documents), Englewood Cliffs, N.J., 1972, 123 ff.

34. A. Bryer and J. Herrin, eds., *Iconoclasm*, 183, no. C. 19; C. Mango, *Art*, 165–68.

35. C. Mango, *The Brazen House—A Study of the Vestibule of the Imperial Palace of Constantinople*, Copenhagen, 1959, 126–28; A. Bryer and J. Herrin, eds., *Iconoclasm*, 185, no. E. 25.

36. C. Mango, *The Homilies of Photius, Patriarch of Constantinople*, Cambridge, Mass., 1958, 293–94; R. Cormack, *Writing in Gold*, 143–58; A. Bryer and J. Herrin, eds., *Iconoclasm*, 185, no. F. 27.

37. F. Dvornik, *The Photian Schism*, Cambridge, Eng., 1948; S. Runciman, *The Eastern Schism*, Oxford, 1955. For the history of the period in general see R. Jenkins, *Byzantium: The Imperial Centuries, A.D. 610–1071*, London, 1966.

38. Constantine VII Porphyrogenitus, in A. Vogt, ed., *Le Livre des Cérémonies*, Paris, 1935.

39. N. Mesarites, *Description of the Church of the Holy Apostles*, translated by G. Downey in *Transactions of the American Philosophical Society*, n.s.47, pt. 6, 1957, 855–925. For Rhodius see C. Mango, *The Art of the Byzantine Empire*, 199–201.

40. C. Mango, *The Mosaics of St. Sophia at Istanbul* (Dumbarton Oaks Studies,

no. 8), Washington, D.C., 1962; A. Grabar, *Byzantine Painting*, Geneva, 1953, 91–106.

41. A. Grabar, *Byzantine Painting*, 97; N. Oikonomides, "Leo VI and the Narthex Mosaic of Saint Sophia," *Dumbarton Oaks Papers*, 30, 1976, 151 ff.; J. Beckwith, *Early Christian and Byzantine Art*, 89 ff. C. Walter, "Two Notes on the Deësis," *Revue des études byzantines*, 36, 1968, 332 ff., stresses the Virgin's role as intercessor.

42. For ivories in general see A. Goldschmidt and K. Weitzmann, *Die byzantinischen Elfenbeinskulpturen des X. bis XIII. Jahrhunderts*, Berlin, 1934; K. Weitzmann, "Ivory Sculpture of the Macedonian Renaissance," in *Kolloquium über spätantike und frühmittelalterliche Skulptur*, Mainz, 1970, II, 1 ff.

43. For this see the articles by K. Weitzmann in H. L. Kessler, ed., *Studies in Classical and Byzantine Manuscript Illumination*, Chicago and London, 1971: "The Classical Heritage in the Art of Constantinople," 126–50; "The Classical in Byzantine Art as a Mode of Individual Expression," 151–75; and especially "The Character and Intellectual Origins of the Macedonian Renaissance," 176–223.

44. K. Weitzmann, *Greek Mythology in Byzantine Art* (Studies in Manuscript Illumination, no. 4), Princeton, 1951.

45. H. Omont, *Miniatures des plus anciens manuscrits grecs de la Bibliothèque Nationale du VIe au XIVe siècle*, 2nd ed., Paris, 1929; H. Buchthal, *The Miniatures of the Paris Psalter: A Study in Middle Byzantine Painting*, London, 1938; K. Weitzmann, "The Macedonian Renaissance," 176–84.

46. K. Weitzmann, *The Joshua Roll: A Work of the Macedonian Renaissance* (Studies in Manuscript Illumination, no. 3), Princeton, 1948; M. Schapiro, "The Place of the Joshua Roll in Byzantine History," *Gazette des Beaux-Arts*, 35, 1949, 161 ff.

47. A. M. Friend, Jr., "The Portraits of the Evangelists in Greek and Latin Manuscripts," pt. 1, *Art Studies*, 5, 1927, 134 ff., and pt. 2, *Art Studies*, 7, 1929, 9 ff.; K. Weitzmann, "The Macedonian Renaissance."

48. H. Omont, *Evangiles avec peintures byzantines du XIe siècle*, 2 vols., Paris, 1908; G. Millet, *Recherches sur l'iconographie de l'Evangile*, Paris, 1916; K. Weitzmann, "The Narrative and Liturgical Gospel Illustrations," in *Studies in Classical and Byzantine Manuscript Illumination*, 247–70, esp. 250–53.

49. For illustrated copies of the Octateuchs, 11th–13th centuries, see K. Weitzmann, "The Illustrations of the Septuagint," in *Studies in Classical and Byzantine Manuscript Illumination*, 53–55, 73 ff.

50. F. W. Hasluck, *Mount Athos*, London, 1924; R. Coate, *Mount Athos*, Grenoble and Paris, 1948; P. M. Mylonas, "L'Architecture du Mont Athos," in *Le Millénaire du Mont Athos*, Chevetogne (Belgium), 1963, III, 229 ff. For general discussion see R. Krautheimer, *Early Christian and Byzantine Architecture*, 398 ff.; W. Braunfels, *Monasteries of Western Europe*, Princeton, 1972, 99 ff., *passim*.

51. On variations on the central plan see R. Krautheimer, *Early Christian and Byzantine Architecture*, 353–60, 405 n. 45; C. Mango, *Byzantine Architecture*, 212 ff. For Hosios Lukas see R. W. Schultz and S. H. Barnsley, *The Monastery of Saint Luke of Stiris*, London, 1901; for Daphni see G. Millet, *Le Monastère de Daphni*, Paris, 1899.

52. O. Demus, *Byzantine Mosaic Decoration*, Boston, 1953, 13, *passim*.

53. O. Demus, *Byzantine Mosaic Decoration*, 34. Demus ascribes the quote to an encomium of the Nea, but see C. Mango, *The Art of the Byzantine Empire*, 185 ff., who argues that the church was that of the Virgin of the Pharos in Constantinople. For the mosaics of Daphni also see E. Diez and O. Demus, *Byzantine Mosaics in Greece: Hosios Lucas and Daphni*, Cambridge, Mass., 1931, 92 ff.; and M. Chatzidakis, *Byzantine Monuments in Attica and Boeotia*, Athens, 1956, 17 ff.

54. O. Demus, *Byzantine Mosaic Decoration*, 35.

55. For the various dates and provenances attributed to the Mellon Madonna see B. Berenson, "Two Twelfth-Century Paintings from Constantinople," in *Studies in Medieval Painting*, New Haven, 1930, 1 ff. (12th century, Constantinople); O. Demus, "Zwei Konstantinopler Marienikonen des 13. Jahrhunderts," *Jahrbuch der österreichischen byzantinistik Gesellschaft*, 7, 1958, 87 ff., and *Byzantine Art and the West*, New York, 1970, 212–18 (c. 1260, Constantinople); J. Stubblebine, "Two Byzantine Madonnas from Calahorra, Spain," *Art Bulletin*, 48, 1966, 379 (late 13th century, Italo-Byzantine); and J. Beckwith, *Early Christian and Byzantine Art*, 140 (end of 13th century, Byzantine artist working in Spain).

56. J. Beckwith, *Early Christian and Byzantine Art*, 38, discusses this. For the iconography of the standard icons of the Virgin, including the *Hodegetria*, see G. A. Wellen, *Theotokos*. For a discussion of the *Hodegetria* Madonna as a *Palladium* of the empire, see R. L. Wolff, "Footnote to an Incident of the Latin Occupation of Constantinople: The Church and Icon of the Hodegetria," *Traditio*, 6, 1948, 323 ff.

57. W. F. Volbach et al., *La Pala d'Oro*, Florence, 1965; J. de Luigi-Pomorisac, *Les Emaux byzantins de la Pala d'Oro de l'église de Saint-Marc à Venise*, 2 vols., Zurich, 1966; K. Wessel, *Die byzantinische Emailkunst vom fünften bis*

dreizehnten Jahrhundert, Recklinghausen, 1967 (also in English, *Byzantine Enamels*, Greenwich, Conn., 1967); and O. Demus, *Byzantine Art and the West*, 209 ff. For the original setting of the six "Great Feast" enamels in the Comnenian monastery, the Church of the Pantocrator in Constantinople, see C. Walter, *Studies in Byzantine Iconography*, London, 1977 (published originally in "The Origins of the Iconostasis," *Eastern Churches Review*, 3, 1971, 251–67).

58. For Byzantine art in Italy see W. Köhler, "Byzantine Art in the West," *Dumbarton Oaks Papers*, 1, 1941, 61 ff.; F. Hermanin, *L'arte in Roma dal secolo VIII al XIV*, Bologna, 1945; G. Matthiae, *Pittura Romana del medio evo*, I, Rome, 1965, and *Mosaici medioevali delle chiese di Roma*, I, Rome, 1967; K. Weitzmann, "Various Aspects of Byzantine Influence on the Latin Countries from the Sixth to the Twelfth Centuries," *Dumbarton Oaks Papers*, 20, 1966, 3 ff.; B. Brenk, "Early Byzantine Mural Paintings in Rome," *Palette*, 26, 1967, 13 ff.; W. Oakeshott, *The Mosaics of Rome from the Third to the Fourteenth Centuries*, London, 1967; H. Belting, "Byzantine Art Among Greeks and Latins in Southern Italy," *Dumbarton Oaks Papers*, 28, 1974, 1 ff. For the frescoes in Santa Maria Antiqua see W. de Gruneisen, *Sainte-Marie Antique*, Rome, 1911; M. Avery, "The Alexandrian Style at Santa Maria Antiqua in Rome," *Art Bulletin*, 7, 1925, 132 ff.; and P. Romanelli and P. J. Nordhagen, *Santa Maria Antiqua*, Rome, 1965.

59. G. P. Bognetti et al., *Santa Maria di Castelseprio*, Milan, 1948; K. Weitzmann, *The Fresco Cycle of S. Maria di Castelseprio*, Princeton, 1951; C. R. Morey, "Castelseprio and the Byzantine 'Renaissance,'" *Art Bulletin*, 34, 1952, 173 ff.; and M. Schapiro, "Notes on Castelseprio," *Art Bulletin*, 39, 1957, 292 ff.

60. The major studies on San Marco have been written by Otto Demus. See his *The Church of San Marco in Venice—History, Architecture, Sculpture*, Washington, D.C., 1960, and *The Mosaics of San Marco in Venice*, I: *The Eleventh and Twelfth Centuries*, and II: *The Thirteenth Century*, Chicago and London, 1984.

61. O. Demus, *Byzantine Mosaic Decoration*, esp. 19–22.

62. K. Weitzmann, "Observations on the Cotton Genesis Fragments," in *Late Classical and Mediaeval Studies in Honor of A. M. Friend, Jr.*, 112 ff., and his contribution in vol. II of O. Demus, *The Mosaics of San Marco*, 105–42.

63. M. Brunetti et al., *Torcello*, Venice, 1940; O. Demus, "Studies Among the Torcello Mosaics," *Burlington Magazine*, 82–83, 1943, 136 ff.; 84–85, 1944, 41 ff., 195 ff.; and I. Andreescu, "Torcello. I: Le Christ inconnu; II: Anastasis et Jugement Dernier: Têtes vraies, têtes fausses," *Dumbarton Oaks Papers*, 26, 1972, 185 ff., and "Torcello, III: La chronologie relative des mosaïques pariétales," *Dumbarton Oaks Papers*, 30, 1976, 245 ff.

64. For the portrait see especially E. Kitzinger, "On the Portrait of Roger II in the Martorana in Palermo," *Proporzioni*, 3, 1950, 30–35 (also in *The Art of Byzantium*, 320–26). For the imperial policies of the Normans, see below p. 291.

65. The standard reference for Sicilian architecture and mosaics is O. Demus, *The Mosaics of Norman Sicily*, New York, 1950 (with an exhaustive bibliography). Also see F. di Pietro, *I mosaici Siciliani dell' eta Normana*, Palermo, 1946. For an excellent discussion of the history see J. J. Norwich, *The Kingdom in the Sun*, New York and Evanston, 1971.

66. E. Kitzinger, "The Mosaics of the Cappella Palatina in Palermo," *Art Bulletin*, 31, 1949, 269–92 (also in *The Art of Byzantium*, 290–319). See also W. Krönig, "Zur Transfiguration der Cappella Palatina in Palermo," *Zeitschrift für Kunstgeschichte*, 19, 1956, 162 ff. O. Demus (*The Mosaics of Norman Sicily*) attributes the "dynastic axis" of the royal box to William I (1154–66).

67. O. Demus, *The Mosaics of Norman Sicily*, 2 ff.

68. O. Demus, *The Mosaics of Norman Sicily*, 91 ff., 271 ff., 418 ff.; E. Kitzinger, *The Mosaics of Monreale*, Palermo, 1960.

69. See especially E. Kitzinger, "Norman Sicily as a Source of Byzantine Influence on Western Art in the Twelfth Century," in *Byzantine Art: An European Art, Ninth Exhibition Held Under the Auspices of the Council of Europe; Lectures*, Athens, 1966, 121 ff. (also in *The Art of Byzantium*, 357–88), and "Byzantium and the West in the Second Half of the Twelfth Century," *Gesta*, 9, no. 2, 1970, 49 ff.

PART THREE

1. B. Colgrave and R. A. B. Mynors, eds., *Bede's Ecclesiastical History of the English People*, Oxford, 1969, 183–85.

2. M. Rostovtzeff, *The Animal Style*, Princeton, 1929, 65, 68 ff.; V. Blawatsky, *Art on the North Coast Area of the Black Sea in Antiquity*, Moscow, 1947; D. Carter, *The Symbol of the Beast: The Animal Style of Eurasia*, New York, 1957; T. T. Rice, *The Scythians*, London and New York, 1957; K. Jettmar, *Art of the Steppes*, New York, 1967, esp. 36 ff.; see also V. Blawatsky, "Greco-

Bosporan and Scythian Art," in *Encyclopedia of World Art,* New York, 1962, VI, 846 ff.

3. W. Worringer, *Form in Gothic,* translated by H. Read, London, 1927, 7 ff.

4. P. Jacobsthal, *Early Celtic Art,* Oxford, 1944; C. Fox, *Pattern and Purpose: A Survey of Early Celtic Art in Britain,* Cardiff, 1958; W. Holmqvist, *Germanic Art During the First Millennium,* London, 1955; T. G. E. Powell, *The Celts,* London, 1958; H. Hubert, *Les Celtes depuis l'époque La Tène,* 2nd ed., Paris, 1950; R. Lantier, "Celtic Art," in *Encyclopedia of World Art,* New York, 1960, III, 177 ff.; N. K. Sanders, *Prehistoric Art in Europe* (Pelican History of Art, no. 30), Harmondsworth, 1968; S. Piggot, ed., *Early Celtic Art,* Edinburgh, 1970; I. Finlay, *Celtic Art,* London, 1973.

5. R. L. S. Bruce-Mitford, *The Sutton Hoo Ship-Burial,* British Museum, London, 1978, II, 536 ff.; T. D. Kendrick, *The Sutton Hoo Ship Burial: A Provisional Guide,* British Museum, 9th ed., London, 1964, 53 ff.

6. F. Henry, *Irish Art in the Early Christian Period,* London, 1940, 195.

7. Gregory of Tours, *History of the Franks,* edited and translated by O. M. Dalton, Oxford, 1927. For the "Golden Church" in Toulouse, see the translation of the description of *la Daurade* in the *Monasticon Benedictinum* (Paris, Bibliothèque Nationale, MS lat. 12680, fols. 231–35) in C. Davis-Weyer, *Early Medieval Art: 300–1150* (Sources and Documents), Englewood Cliffs, N.J., 1971, 59–66.

8. A. Haseloff, *Pre-Romanesque Sculpture in Italy,* New York, 1931, 46 ff. See also A. Grabar, *L'Art du moyen âge en Occident,* London, 1980, 23–26.

9. For a general discussion and bibliography see E. Rosenthal, *The Illuminations of the Vergilius Romanus,* Zurich, 1972; K. Weitzmann, *Late Antique and Early Christian Book Illumination,* New York, 1977, 11 ff.

10. F. Wormald, *Studies in Medieval Art: 6th to the 12th Centuries,* London, 1984, 13–35.

11. For these see E. H. Zimmermann, *Vorkarolingische Miniaturen,* 5 vols., Berlin, 1916.

12. K. Jackson, *Studies in Early Celtic Nature Poetry,* Cambridge, Eng., 1935, 9. For early history see J. Ryan, S.J., *Irish Monasticism: Origins and Early Development,* Dublin, 1931; R. Flower, *The Irish Tradition,* Oxford, 1947.

13. C. Davis-Weyer, *Early Medieval Art,* 75.

14. J. O'Meara, "Giraldus Cambrensis in Topographia Hibernie," *Proceedings of the Royal Irish Academy,* 100, 1949, 113; F. Henry, *Irish Art During the Viking Invasions,* Ithaca, 1967, 95; G. Henderson, *From Durrow to Kells,* London, 1987, 195–98.

15. T. Burckhardt, ed., *Codex Durmachensis* (facsimile), 2 vols., Olten and Lausanne, 1960; F. Henry, *Irish Art in the Early Christian Period,* 60–68; C. Nordenfalk, *Celtic and Anglo-Saxon Painting,* New York, 1977, 19 ff., 35–47; J. J. G. Alexander, *Insular Manuscripts: Sixth to the Ninth Century,* London, 1978; R. Calkins, *Illuminated Books of the Middle Ages,* Ithaca, 1983, 30–92; G. Henderson, *From Durrow to Kells,* 19–56.

16. For a discussion of oriental models see especially C. Nordenfalk, "An Illustrated Diatessaron," *Art Bulletin,* 50, 1968, 119–40 (cf. M. Schapiro, "The Miniatures of the Florence Diatessaron," *Art Bulletin,* 55, 1973, 494–531).

17. C. Nordenfalk, *Celtic and Anglo-Saxon Painting,* 48–55; G. Henderson, *From Durrow to Kells,* 102 ff.

18. F. Masai, *Essai sur les origines de la miniature dite irlandaise,* Brussels, 1947.

19. T. D. Kendrick et al., eds., *Evangelia Quattuor Codex Lindisfarnensis* (facsimile), Olten and Lausanne, 1956–60; F. Henry, "The Book of Lindisfarne," *Antiquity,* 37, 1950, 100–110; C. Nordenfalk, "Eastern Elements in the Book of Lindisfarne," *Acta archaeologica,* 13, 1942, 157–69; J. Backhouse, *The Lindisfarne Gospels,* Ithaca, 1981.

20. Paper presented by B. D'Argarville at the College Art Association meeting, Philadelphia, Feb. 18, 1983.

21. R. L. S. Bruce-Mitford, "The Art of the Codex Amiatinus," *Journal of the British Archaeological Association,* ser. 3, 32, 1969, 1–23; C. Nordenfalk, *Celtic and Anglo-Saxon Painting,* 24 ff. The original manuscript would have been part of the vast library of Cassiodorus brought by Biscop to England from South Italy. The lists of feasts prefixed to the Lindisfarne Gospels contain names of saints particularly venerated in the environs of Naples. Such a provenance for the model might also explain the curious intrusion of the Greek *Hagios.*

22. See C. Nordenfalk, "A Note on the Stockholm Codex Aureus," *Nordisk tidskrift för bok-och biblioteks väsen,* 38, 1951, 1–11.

23. E. H. Alton, ed., *Evangeliorum quattuor Codex Cenannensis* (facsimile), 3 vols., Olten and Lausanne, 1950–51; F. Henry, *The Book of Kells,* New York, 1974; T. J. Brown, "Northumbria and the Book of Kells," *Anglo-Saxon England,* 1, 1972, 219–46; C. Nordenfalk, "Another Look at the Book of Kells," in *Festschrift Wolfgang Braunfels,* Tübingen, 1977, 275–79; P. Brown, *The Book of Kells,* London, 1980; G. Henderson, *From Durrow to Kells,* 131–98.

24. A. M. Friend, Jr., "The Canon Tables of the Book of Kells," in *Medieval Studies in Memory of Arthur Kingsley Porter,* Cambridge, Mass., 1939, II,

611–66; T. J. Brown, "Northumbria and the Book of Kells," 219–46; G. Henderson, *From Durrow to Kells,* 131–41.

25. M. Werner, "The Miniature of the Madonna in the Book of Kells," *Art Bulletin,* 54, 1972, 1–22, 129–39; see also E. Kitzinger, "The Coffin Reliquary," in C. F. Battiscombe, ed., *The Relics of Saint Cuthbert,* Oxford, 1966, 202 ff.; G. Henderson, *From Durrow to Kells,* 153–62.

26. R. Calkins, *Illuminated Books,* 78–92; S. Lewis, "Sacred Calligraphy: The Chi Rho Page in the Book of Kells," *Traditio,* 36, 1980, 139–59; O. K. Werckmeister, *Irisch-northumbrische Buchmalerei des 8. Jahrhunderts und monastische Spiritualität,* Berlin, 1967, esp. 171–74.

27. S. Mussetter, "An Animal Miniature on the Monogram Page of the Book of Kells," *Mediaevalia,* 3, 1977, 119–30.

28. F. Henry, *Irish Art,* 196–97.

29. J. Backhouse, *The Lindisfarne Gospels,* 27–32. For this and other riddles see also *The Exeter Book: Part II* (Early English Text Society, no. 194), Oxford, 1934, 117; K. Crossley-Holland, *Storm and Other Old English Riddles,* London, 1970.

30. For the Lindau book cover see M. Harrsen, *Central European Manuscripts in the Pierpont Morgan Library,* New York, 1958, 8 ff.; J. Guilman, "The Enigmatic Beasts of the Lindau Gospels Lower Cover," *Gesta,* 10, 1971, 3–18.

31. G. Henderson, *Early Medieval,* Harmondsworth, 1972, 214–19.

32. Cf. the "Travels of Saint Willibald (ca. 700–786)" written by Huneberc, a contemporary Anglo-Saxon nun at Heidenheim. She stressed the role of the stone crosses as posts for outdoor worship as opposed to services in the church. See C. R. Dodwell, *Anglo-Saxon Art,* Ithaca, 1982, 111.

33. See especially M. Schapiro, "The Religious Meaning of the Ruthwell Cross," *Art Bulletin,* 26, 1944, 230–45 (also in his collected essays, *Late Antique, Early Christian and Medieval Art,* New York, 1979, 150–95).

34. Indispensible for any study of Carolingian art is W. Braunfels et al., eds., *Karl der Grosse, Werk und Wirkung* (catalogue of the Aachen exhibition, 1965) and *Karl der Grosse, Lebenswerk und Nachleben,* 5 vols., Düsseldorf, 1965–68. For the idea of the Carolingian Renaissance see especially E. Panofsky, *Renaissance and Renascences in Western Art,* Stockholm, 1960. For Charlemagne and his coronation see A. Kleincausz, *Charlemagne,* Paris, 1934; F. Lot et al., *Les Destinées de l'Empire en Occident de 395 à 888,* II, Paris, 1940; F. L. Ganshof, *The Imperial Coronation of Charlemagne: Theories and Facts,* Glasgow, 1949, and *The Coronation of Charlemagne: What Did It Signify?,* Boston, 1959; H. Fichtenau, *The Carolingian Empire,* Oxford, 1957; D. Bullough, *The Age of Charlemagne,* New York, 1966. For the biography by Einhard see S. Painter, ed., *The Life of Charlemagne by Einhard,* Ann Arbor, 1960.

35. P. Lauer, *Le Palais de Latran,* Paris, 1911, 481–84, 581–82; M. van Berchem and E. Clouzot, *Mosaïques chrétiennes du IVme au Xme siècle,* Geneva, 1924; I. H. Belting, "I mosaici dell'aula Leonina," in *Roma e l'età Carolingia,* Rome, 1976, 167 ff.; R. Krautheimer, *Rome: Profile of a City, 312–1308,* Princeton, 1980, 113–42. For translations of the *Vita Leonis III* in the *Liber Pontificalis* by Onuphrius Panvinius, Jacopo Grimaldi et al., see C. Davis-Weyer, *Early Medieval Art,* 88–92.

36. C. Odegaard, *Vassi and Fideles in the Carolingian Empire,* Cambridge, Mass., 1945; D. Bullough, *The Age of Charlemagne, passim.*

37. L. Jones and C. R. Morey, *The Miniatures of the Terence Manuscripts Prior to the 13th Century,* Princeton, 1931. For the Prudentius manuscripts see R. Stettiner, *Die illustrierten Prudentius Handschriften,* 2 vols., Berlin, 1905.

38. B. de Montesquiou-Fezensac, "L'Arc de Triomphe d'Eginhard," *Cahiers archéologiques,* 4, 1945, 79–83, and 8, 1956, 147–74. Also see K. Hauck, ed., *Das Einhardkreuz: Vorträge und Studien der Münsteraner Diskussion zum arcus Einhardi* (Abhandlungen der Akademie der Wissenschaften in Göttingen, Phil.-Hist. Klasse, 3, no. 87), Göttingen, 1974.

39. See W. Braunfels et al., *Karl der Grosse, Lebenswerk und Nachleben,* esp. III, 301 ff., 463–534; E. Lehmann, *Der frühe deutsche Kirchenbau,* 2 vols., Berlin, 1938; 2nd ed., 1949; H. Schnitzler, *Der Dom zu Aachen,* Düsseldorf, 1950; K. J. Conant, *Carolingian and Romanesque Architecture: 800–1200* (Pelican History of Art, no. 13), Harmondsworth, 1959; 2nd ed., 1966.

40. E. B. Smith, *Architectural Symbolism of Imperial Rome and the Middle Ages,* Princeton, 1956, 74–106, esp. 104 ff.; E. Kantorowicz, *Laudes Regiae: A Study in Liturgical Acclamations and Mediaeval Ruler Worship* (University of California Publications in History, no. 33), Berkeley, 1948, 56–62.

41. R. Krautheimer, "The Carolingian Revival of Early Christian Architecture," *Art Bulletin,* 24, 1942, 1–38.

42. For westwork see O. Grüber, "Das Westwerke: Symbol und Baugestaltung," *Zeitschrift des deutschen Vereins,* 3, 1936, 149–73; A. Fuchs, "Entstehung und Zweckbestimmung der Westwerke," *Westfälische Zeitschrift,* 100, 1950, 227–91; G. Bandmann, *Mittelalterliche Architektur als Bedeutungsträger,* Berlin, 1951; W. Rave, *Corvey,* Münster, 1957; E. B. Smith, *Architectural Symbolism of Imperial Rome.* Cf. H. Shaefer, "Origin of the

Two-Towered Facade in Romanesque Architecture," *Art Bulletin*, 27, 1945, 85–108.

43. Abbot Suger, *De Administratione*, XXV, translated by E. Panofsky in *Abbot Suger*, Princeton, 1946, 44–45.

44. W. Rave, *Corvey*.

45. W. Effmann, *Centula—St. Riquier*, Münster, 1912; J. Hubert et al., *The Carolingian Renaissance*, New York, 1970, 1–4.

46. H. Reinhardt, *Der Klosterplan von St. Gallen*, St. Gall, 1952; W. Horn and E. Born, *The Plan of St. Gall: A Study of the Architecture and Economy of, and Life in a Paradigmatic Carolingian Monastery*, 3 vols., Berkeley and London, 1979; L. Price, *The Plan of St. Gall in Brief*, Berkeley and London, 1982 (a summary of the above). See also W. Braunfels, *Monasteries of Western Europe*, Princeton, 1972, 37–46.

47. See above note and W. Horn, "The Dimensional Inconsistencies of the Plan of S. Gall and the Problem of the Scale of the Plan," *Art Bulletin*, 48, 1966, 285 ff.; cf. the criticism of W. Sanderson, "The Plan of St. Gall Reconsidered," *Speculum*, 60, 1985, 615–32.

48. C. Davis-Weyer, *Early Medieval Art*, 84–88.

49. A. Grabar, "Les mosaïques des Germigny-des-Prés," *Cahiers archéologiques*, 7, 1954, 171–83; P. Bloch, "Das Apsismosaik von Germigny-des-Prés," in W. Braunfels et al., *Karl der Grosse, Lebenswerk und Nachleben*, III, 234 ff. For a discussion of Theodulf as the author of the aniconic treatise *Libri Carolini*, see A. Freeman, "Libri Carolini . . . ," *Speculum*, 40, 1965, 203–89.

50. For this and other Carolingian wall paintings see also J. Hubert et al., *Carolingian Renaissance*, 5–28; A. Grabar and C. Nordenfalk, *Early Medieval Painting from the Fourth to the Eleventh Century*, Lausanne, 1957; H. Schrade, *Vor- und frühromanische Malerei*, Cologne, 1958.

51. J. Hubert et al., *Carolingian Renaissance*, 344, no. 22.

52. For these numerous divisions see A. Boinet, *La Miniature carolingienne*, Paris, 1913; A. Goldschmidt, *German Illumination*, I, Florence, 1928; A. Grabar and C. Nordenfalk, *Early Medieval Painting*; J. Hubert et al., *Carolingian Renaissance*, *passim*; W. Braunfels, *Die Welt der Karolinger und ihre Kunst*, Munich, 1968, *passim*; G. Zarnecki, *Art of the Medieval World*, New York, 1975, 119–40; J. E. Gaehde and F. Mütherich, *Carolingian Painting*, New York, 1976. The definitive study of the standard schools is W. Köhler, *Die Karolingischen Miniaturen*, 7 vols., Berlin, 1930–71 (I: *Die Schule von Tours*; II: *Die Hofschule Karls des Grossen*; III: *Die Gruppe des Wiener Krönungs-Evangeliars—Metzer Handschriften*; IV: *Die Hofschule Kaiser Lothars-Einzelhandschriften aus Lotharingien*; V: *Die Hofschule Karls des Kahlen*).

53. Cf. D. Denny, "Allusions to Old Saint Peter's in the Soissons Gospels," *Marsyas*, 9, 1961, 1–5.

54. This curious conflation of the four portraits in a single panoramic setting may be a reflection of an earlier introductory miniature for the Gospel prefaces of Saint Jerome (*Plures fuisse*), where this quaternity signified a parallelism and harmony in their writings (four beasts, four corners of the world, four rivers of Paradise, etc.) presented in one frontispiece.

55. E. DeWald, *The Illustrations of the Utrecht Psalter*, Princeton, 1932; D. Panofsky, "The Textual Basis of the Utrecht Psalter Illustrations," *Art Bulletin*, 25, 1943, 50–58; D. Tselos, *The Sources of the Utrecht Psalter Miniatures*, Minneapolis, 1955; J. H. A. Engelbregt, *Het Utrechts Psalterium: Een eeuw wetenschappelijke bestudering (1860–1960)*, Utrecht, 1964; S. Dufresne, *Les Illustrations du Psautier d'Utrecht: Problèmes des sources et de l'apport carolingien*, Strasbourg, 1973; F. Wormald, "The Utrecht Psalter," in J. J. G. Alexander et al., eds., *Collected Writings of F. Wormald*, London, 1984, 36–46.

56. See especially H. Kessler, *The Illustrated Bibles from Tours*, Princeton, 1977; J. Duft et al., *Die Bibel von Moûtier-Grandval* (facsimile), Bern, 1971.

57. H. Kessler, *Illustrated Bibles from Tours*, 3 ff.

58. W. Köhler, *Die Karolingischen Miniaturen*, I, pt. 1.

59. H. Kessler, *Illustrated Bibles from Tours*, 7 ff.; J. Gaehde, "The Bible of San Paolo fuori le mura in Rome: Its Date and Relation to Charles the Bald," *Gesta*, 5, 1966, 9–212, and "The Touronian Sources of the Bible of San Paolo fuori le mura in Rome," *Frühmittelalterliche Studien: Jahrbuch des Instituts für Frühmittelalterforschung der Universität Münster*, 5, 1971, 359–400; 8, 1974, 351–404; and 9, 1975, 359–89. Also see the catalogue of the exhibition *La Bibbia di S. Paolo fuori le Mura*, edited by V. Jemolo and M. Morelli, Rome, 1981.

60. F. Mütherich, *Sakramentar von Metz: Fragment*, Graz, 1972; R. Calkins, *Illuminated Books*, 162–79.

61. A. M. Friend, Jr., "Carolingian Art in the Abbey of Saint Denis," *Art Studies*, 1, 1923, 67–75.

62. W. Köhler, *Drogo-Sakramentar: Manuscript Latin 9428, Bibliothèque Nationale, Paris*, Graz, 1974; R. Calkins, *Illuminated Books*, 162 ff.

63. R. Laufner and P. Klein, *Trierer Apokalypse, Vollständige Faksimile: Codex 31 der Stadtbibliothek, Trier*, Graz, 1972; W. Braunfels, *Die Welt der Karolinger*, 179–81; J. Snyder, "The Reconstruction of an Early Christian Cycle of Illustrations for the Book of Revelation—The Trier Apocalypse," *Vigiliae Christianae*, 18, 1964, 146–58.

64. A. Goldschmidt, *Die Elfenbeinskulpturen aus der Zeit der karolingischen und sächsischen Kaiser*, 4 vols., Berlin, 1914–26.

65. A. Goldschmidt, *Die Elfenbeinskulpturen, passim*; S. Ferber, "Crucifixion Iconography in a Group of Carolingian Ivory Plaques," *Art Bulletin*, 48, 1966, 323–34.

66. V. H. Elbern, *Der karolingische Goldaltar von Mailand*, Bonn, 1952.

67. R. Krautheimer, *Rome: Profile of a City*, 123 ff.; C. Davis-Weyer, "Die Mosaiken Leo III," *Zeitschrift für Kunstgeschichte*, 29, 1966, 111 ff.; G. Matthiae, *Mosaici medioevali Roma e suburbio*, Rome, 1934–40; P. Nordhagen, "Un problema . . . a S. Prassede," in *Roma e l'età Carolingia*, 159 ff.; for the Zeno chapel see M. Pautler-Klass, "The Chapel of Saint Zeno at S. Prassede in Rome," Ph.D. diss., Bryn Mawr College, 1971.

68. F. Wormald, *English Drawings of the 10th and 11th Centuries*, New York, 1952, and *Collected Writings: Studies in Medieval Art from the 6th to the 12th Century*, London, 1984, esp. 47 ff.; H. Swarzenski, *Monuments of Romanesque Art*, New York, 1954, *passim*; R. Deshman, "Anglo-Saxon Art After Alfred," *Art Bulletin*, 56, 1974, 177–200; E. Temple, *Anglo-Saxon Manuscripts 900–1066* (Survey of Manuscripts in the British Isles, no. 2), London, 1976; J. Campbell, *The Anglo-Saxons*, Ithaca, 1982; D. M. Wilson, *Anglo-Saxon Art*, New York, 1984; R. Camp, *Corpus of Anglo-Saxon Stone Sculpture in England*, I–II: *County Durham and Northumbria*, London, 1984; D. H. Turner et al., *The Golden Age of Anglo-Saxon Art, 966–1066*, London, 1984.

69. F. Wormald, *Collected Writings*, I, 85–100; O. Homburger, *Die Anfänge der Malschule von Winchester im X. Jahrhundert*, Leipzig, 1912.

70. E. Kantorowicz, "The Quinity of Winchester," *Art Bulletin*, 29, 1947, 73–85.

71. For the Bury Psalter see R. Harris, "The Marginal Drawings of the Bury St. Edmunds Psalter," Ph.D. diss., Princeton, 1960; E. Temple, *Anglo-Saxon Manuscripts 900–1066*, no. 84, 102–5.

72. For Ottonian art in general see H. Jantzen, *Ottonische Kunst*, 2nd ed., Hamburg, 1959; P. E. Schramm and F. Mütherich, *Denkmäler der deutschen Könige und Kaiser*, Munich, 1962; L. Grodecki et al., *Le Siècle de l'an mil*, Paris, 1973; H. Holländer, *Early Medieval Art*, London, 1974.

73. L. Grodecki, *L'Architecture ottonienne*, Paris, 1958.

74. F. J. Tschan, *Saint Bernward of Hildesheim*, 3 vols., South Bend, Ind., 1942–52.

75. R. Wesenberg, *Bernwardische Plastik*, Berlin, 1955.

76. For earlier discussions see A. Boeckler, "Die Reichenauer Buchmalerei," *Die Kultur der Abtei Reichenau*, Munich, 1925, 956–98; A. Goldschmidt, *German Illumination*, II; A. Grabar and C. Nordenfalk, *Early Medieval Painting*, 193–218. Cf. the recent arguments of C. R. Dodwell and D. H. Turner, *Reichenau Reconsidered: A Reassessment of the Place of Reichenau in Ottonian Art*, London, 1965.

77. H. Buchthal, "Byzantium and Reichenau," in *Byzantine Art: An European Art, Ninth Exhibition Held Under the Auspices of the Council of Europe; Lectures*, Athens, 1966, 58–60.

78. E. Kantorowicz, *The King's Two Bodies: A Study of Medieval Political Theology*, Princeton, 1957.

79. K. Hoffmann, "Die Evangelistenbilder des Münchener Otto-Evangeliars," *Zeitschrift für Kunstwissenschaft*, 20, 1966, 17–46.

80. E. Panofsky, *Die deutsche Plastik des elften bis dreizehnten Jahrhunderts*, 2 vols., Munich, 1924; H. Schrade, "Zur Frühgeschichte der mittelalterlichen Monumentalplastik," *Westfalen*, 35, 1957; E. Steingräber, *Deutsche Plastik der Frühzeit*, Königstein, 1961; E. G. Grimme, *Goldschmiedekunst im Mittelalter*, Cologne, 1961; P. Lasko, *Ars Sacra: 800–1200* (Pelican History of Art, no. 36), Harmondsworth, 1972; U. Mende, *Die Bronzetüren des Mittelalters*, Munich, 1984.

81. A. Grabar and C. Nordenfalk, *Early Medieval Painting*, 161 ff.

82. For general discussion see P. de Palol and M. Hirmer, *Early Medieval Art in Spain*, New York, 1967; J. Domínguez Bordona, *Spanish Illumination*, I, New York, 1930; M. Gómez-Moreno, *Iglesias mozárabes: Arte español de los siglos IX a XI*, 2 vols., Madrid, 1919; A. Garcia Fuente, *La miniatura española primitiva, siglo VIII–XI*, Madrid, 1936; C. R. Dodwell, *Painting in Europe 800–1200* (Pelican History of Art, no. 34), Harmondsworth, 1971, 96–117; for an excellent brief survey of Mozarabic book illumination see J. Williams, *Early Spanish Manuscript Illumination*, London, 1977; for the Beatus Apocalypse manuscripts see especially W. Neuss, *Die Apokalypse des Hl. Johannes in der altspanischen und altchristlichen Bibelillustration*, 2 vols., Münster, 1931.

83. A. Grabar and C. Nordenfalk, *Early Medieval Painting*, 161 ff.; J. Williams, *Early Spanish Manuscript Illumination*, 44–47.

84. See the studies of J. Williams, "The Beatus Commentaries and Spanish Bible Illustration," *Actes del Simposio para el Estudio de los Codices del "Comentario al Apocalypsis" de Beato de Liebana*, 1, 1980, 203–19; "A Castilian

Tradition of Bible Illustration," *Journal of the Warburg and Courtauld Institutes,* 28, 1965, 66–85; and "A Model for the León Bibles," *Mitteilungen des Deutschen Archäologischen Instituts,* 8, 1967, 281–86.

85. J. Williams, "Spanish Bible Illustration," 218; cf. G. G. King, "Divagations on the Beatus," *Art Studies,* 8, 1930, 9 ff.; W. Neuss, *Die Apokalypse, passim;* J. Marqués Casanovas et al., *Sancti Beati Liebana in Apocalypsin Codex Gerundensis,* Lausanne, 1962; U. Eco and L. Vázquez de Parga Iglesias, *Beato in Liébana: Miniature del Beato de Fernando I y Sancha,* Parma, 1973; J. Camón Aznar et al., *Beati in Apocalipsin Libri Duodecim: Codex Gerundensis,* Madrid, 1975; A. M. Mundó and M. Sánchez Mariana, *El Comentario de Beato al Apocalipsis: Catálogo de los códices,* Madrid, 1976; P. Klein, *Der ältere Beatus-Kodex Vitr. 14–1 der Biblioteca Nacional zu Madrid. Studien zur Beatus-Illustration und der spanischen Buchmalerei des 10. Jahrhunderts,* Hildesheim, 1976.

86. M. Schapiro, "From Mozarabic to Romanesque in Silos," in *Romanesque Art,* New York, 1977, 28–101 (first published in *Art Bulletin,* 21, 1939, 313–74).

87. C. K. Werckmeister, "Pain and Death in the Beatus of Saint-Sever," *Studi medievali,* 14, pt. 2, 1973, 565–626; E. Moé, *L'Apocalypse de Saint-Sever,* Paris, 1943.

PART FOUR

1. For a useful summary see D. Hay, "The Concept of Christendom," in D. T. Rice, ed., *The Dawn of European Civilization: The Dark Ages,* New York, 1965, 328–43.

2. D. Hay, "The Concept of Christendom," 343.

3. For these see J. Bédier, *Les Légendes épiques, recherches sur la formation des chansons de geste,* 4 vols., Paris, 1908–13; R. Lejeune and J. Stiennon, *La Légende de Roland dans l'art du moyen âge,* 2 vols., Brussels, 1966; E. Mâle, *Religious Art in France, The Twelfth Century: A Study of the Origins of Medieval Iconography,* translated by M. Mathews, Princeton, 1978, 246 ff.; R. S. Loomis, *Arthurian Legends in Medieval Art,* London and New York, 1938; A. S. Napier, ed., *History of the Holy-Rood Tree* (Early English Text Society, no. 103), London, 1894.

4. E. G. Holt, *A Documentary History of Art,* New York, 1957, I, 18. Cf. H. Focillon, *The Art of the West,* I: *Romanesque,* Ithaca, 1963, 25 ff., and *L'An mil,* Paris, 1952, for further bibliography. It should be remembered that the reign of Otto III coincides with the year 1000. For a useful survey of art around the year 1000 see L. Grodecki et al., *Le Siècle de l'an mil,* Paris, 1973.

5. A. de Caumont, *Abécédaire d'archéologie,* Caen, 1871. For the earliest use of the term (1818) see H. Focillon, *The Art of the West,* I, 29. A useful summary of the term Romanesque in English is found in T. Bizzaro, "Romanesque Criticism: A Prehistory," Ph.D. diss., Bryn Mawr College, 1985.

6. For the traditional arguments for regional-school priorities see especially C. Enlart, *Manuel d'archéologie française,* 2 vols., Paris, 1902–3; R. de Lasteyrie, *L'Architecture religieuse en France à l'époque romane,* 2nd ed., Paris, 1929; C. Oursel, *L'Art roman de Bourgogne,* Dijon, 1928; R. Rey, *La Sculpture romane languedocienne,* Toulouse and Paris, 1936, and *L'Art romain et ses origines,* Paris, 1945; W. Vöge, *Die Anfänge des monumentalen Stiles im Mittelalter,* Strassburg, 1894. For the primacy of Cluny see E. Viollet-le-Duc, *Dictionnaire raisonné de l'architecture française du XIe au XVIe siècle,* 10 vols., Paris, 1854–68; W. Weisbach, *Religiöse Reform und mittelalterliche Kunst,* Munich, 1945; J. Evans, *Cluniac Art of the Romanesque Period,* Cambridge, Eng., 1950; K. J. Conant, *Cluny: Les Eglises et la maison du chef d'ordre,* Cambridge, Mass., 1968. For the pilgrimage roads see E. Mâle, *Religious Art in France, The Twelfth Century,* 246–315; A. K. Porter, *Romanesque Sculpture of the Pilgrimage Roads,* 10 vols., Boston, 1923; reprinted 1969. For summaries of these arguments see H. Focillon, *Romanesque,* 118–33; K. J. Conant, *Carolingian and Romanesque Architecture: 800–1200* (Pelican History of Art, no. 13), Harmondsworth, 1959; A. Clapham, *Romanesque Architecture in Western Europe,* Oxford, 1936.

7. J. Puig i Cadafalch, *La premier art roman,* Paris, 1928. See also W. M. Whitehill, *Spanish Romanesque Architecture of the Eleventh Century,* London, 1941. Cf. G. G. King, *Pre-Romanesque Churches of Spain* (Bryn Mawr Notes and Monographs, no. 7), London, 1924.

8. K. J. Conant, *Carolingian and Romanesque Architecture,* 54 ff., 60; G. T. Rivoira, *Lombardic Architecture, Its Origins and Development,* 2nd ed., Oxford, 1934, I, 71 ff.; G. Downey, "Byzantine Architects—Their Training and Methods," *Byzantion,* 18, 1946–48, 99 ff.

9. J. Pijoan, "Oliba de Ripoll," *Art Studies,* 6, 1928, 81–96.

10. W. Neuss, *Die katalanische Bibelillustration um die Wende des ersten Jahrtausends und die altspanische Buchmalerei,* Bonn, 1922.

11. M. Schapiro, "From Mozarabic to Romanesque in Silos," in *Romanesque Art,* New York, 1977, 28–101 (first published in *Art Bulletin,* 21, 1939, 313–74).

12. For the pilgrimage to Santiago see J. Bédier, *Les Légendes épiques,* 2nd ed., Paris, 1921, III, 75–114; G. G. King, *The Way of Saint James,* 3 vols., New York, 1920; W. M. Whitehill, *Liber Sancti Jacobi, Codex Calixtinus,* Santiago de Compostela, 1944, III, xiii–lxxv; W. F. Starkie, *The Road to Santiago,* New York, 1957; E. Mâle, *Religious Art in France, The Twelfth Century,* 282 ff.; J. Vielliard, ed., *Le Guide du pèlerin de Saint-Jacques de Compostelle,* 3rd ed., Mâcon, 1965; Y. Bottineau, *Les Chemins de Saint-Jacques,* Paris and Grenoble, 1964; V. and H. Hell, *The Great Pilgrimage of the Middle Ages: The Road to Saint James of Compostela,* New York, 1966; M. Stokstad, *Santiago de Compostela in the Age of the Great Pilgrimages,* Norman, Okla., 1978.

13. K. J. Conant, *The Early Architectural History of the Cathedral of Santiago de Compostela,* Cambridge, Mass., 1926.

14. A. Auriol and R. Rey, *La Basilique Saint-Sernin de Toulouse,* Paris and Toulouse, 1930.

15. W. Sauerländer, "Die Skulpturen von St.-Sernin in Toulouse," *Kunstchronik,* 24, 1971, 341–47; B. Rupprecht, *Romanische Skulpturen in Frankreich,* Munich, 1975, 78–80; M. F. Hearn, *Romanesque Sculpture: The Revival of Monumental Stone Sculpture in the Eleventh and Twelfth Centuries,* Ithaca, 1981, 76 ff. Cf. J. Cabanot, "Le Décor sculpte de la basilique Saint-Sernin de Toulouse," *Bulletin monumental,* 132, 1974, 99–145.

16. H. Focillon, *The Art of the West,* I, 48 ff., referred to this as the "frieze-style." In his *L'Art des sculpteurs romans: Recherches sur l'histoire des formes,* Paris, 1931, Focillon developed the theory of the "law of the frame" in Romanesque sculpture whereby figures were purposely distorted to fill the frame or setting. J. Baltrusaitis, *La stylistique ornementale dans la sculpture romane,* Paris, 1931, extended Focillon's "law of the frame," especially in capital sculptures. Cf. M. Schapiro, "On Geometric Schematism in Romanesque Art," in *Romanesque Art,* 265–84. For a summary of these arguments see M. F. Hearn, *Romanesque Sculpture,* 14 ff.

17. E. Rupin, *L'Abbaye et les cloîtres de Moissac,* Paris, 1897. For a study of the sculptures see especially M. Schapiro, "The Romanesque Sculptures of Moissac," *Art Bulletin,* 13, 1931, 249–352, 464–531 (issued with new photographs in book form in 1985).

18. E. Mâle, *Religious Art in France, The Twelfth Century,* 5–11. Cf. L. Grodecki, "Le Problème des sources iconographiques du tympan de Moissac," in *Moissac et l'occident au XIe siècle, Actes du Colloque international de Moissac,* Toulouse, 1964, 59–68. For the iconography of these tympana in general see Y. Christe, *Les grands portails romans: Etudes sur l'iconographie des théophanies romanes,* Geneva, 1969, who finds these hieratic images of Christ (Theophanies) dependent on the writings of the Pseudo-Dionysius the Areopagite (especially the *Celestial Hierarchy*), which would have been available in the library at Cluny in Latin translation. For an excellent discussion of the "Theophany in the Portal" see M. F. Hearn, *Romanesque Sculpture,* 169–91. Cf. K. J. Conant, "The Theophany in the History of Church Portal Design," *Gesta,* 15, 1976, 127–34.

19. M. Schapiro, "The Sculptures of Souillac," in *Medieval Studies in Memory of Arthur Kingsley Porter,* Cambridge, Mass., 1939, II, 359–87 (reprinted in *Romanesque Art,* 28–101). Cf. J. Thirion, "Observations sur les fragments sculptés du portail de Souillac," *Gesta,* 15, 1976, 161 ff.; R. Labourdette, "Remarques sur la disposition originelle du portail de Souillac," *Gesta,* 18, 1979, 29–35.

20. K. J. Conant has published extensively on the excavations at Cluny. See especially his *Cluny: Les Eglises et la maison du chef d'ordre.* Cf. W. Braunfels, *Monasteries of Western Europe,* Princeton, 1972, 47–66.

21. For the role of music at Cluny in general see K. J. Conant, *Carolingian and Romanesque Architecture,* 116 ff., and "Systematic Dimensions in the Buildings of Cluny," *Speculum,* 38, 1963, 1–45; cf. E. R. Sunderland, "Symbolic Numbers and Romanesque Church Plans," *Journal of the Society of Architectural Historians,* 18, 1959, 94–105.

22. Cf. the discussion of W. Braunfels, *Monasteries of Western Europe,* 54–58, and appendix VI for the description in the *Consuetudines Farvenses,* 238–39. C. E. Armi, *Masons and Sculptors in Romanesque Burgundy: The New Aesthetic of Cluny III,* University Park, Pa., and London, 1983, 151 ff., refutes some of Conant's reconstruction of Cluny II.

23. K. J. Conant, *Cluny, passim.*

24. K. J. Conant, "The Apse at Cluny," *Speculum,* 7, 1932, 35 ff. Cf. M. F. Hearn, *Romanesque Sculpture,* 102–17; B. Rupprecht, *Romanische Skulpturen,* 106–8; W. S. Stoddard and F. Kelly, "The Eight Capitals of the Cluny Hemicycle," *Gesta,* 20, 1981, 51–57.

25. See especially K. J. Conant, "The Iconography and Sequence of the Ambulatory Capitals of Cluny," *Speculum,* 5, 1930, 279 ff.; K. Meyer, "The Eight Gregorian Modes on the Cluny Capitals," *Art Bulletin,* 34, 1952, 75–94.

26. W. Köhler, "Byzantine Art in the West," in *Dumbarton Oaks Inaugural Lectures,* Cambridge, Mass., 1941, 61–87.

27. F. Salet, *La Madeleine de Vézelay,* Melun, 1948.

28. E. Mâle, *Religious Art in France, The Twelfth Century,* 326 ff.; M. F. Hearn, *Romanesque Sculpture,* 168 ff.; A. Katzenellenbogen, "The Central Tympanum at Vézelay," *Art Bulletin,* 26, 1944, 141–51; cf. M. Taylor, "The Pentecost at Vézelay," *Gesta,* 19, 1980, 9–12.

29. See R. Wittkower, "Marvels of the East," *Journal of the Warburg and Courtauld Institutes,* 5, 1942, 176 ff.

30. *Apologia ad Guillelmum,* in J. P. Migne, *Patrologia Latina,* CLXXXII, 914–16. For a translation see W. Braunfels, *Monasteries of Western Europe,* 241–42. Cf. M. Schapiro, "On the Aesthetic Attitude in Romanesque Art," in *Art and Thought: Issued in Honor of Dr. Ananda K. Coomaraswamy,* London, 1947, 130–50 (also reprinted in *Romanesque Art,* 1–27). Also see C. Weyer-Davis, *Early Medieval Art,* 168–70.

31. From the preface of *in canticum canticorum in librum primum regum,* attributed to Gregory the Great (*Corpus christianorum, series Latina,* 144, Turnholt, 1963, 3–5).

32. V. Terret, *La Sculpture bourguignonne aux XIIe et XIIIe siècles,* II: *Autun,* Autun, 1935; D. Grivot and G. Zarnecki, *Gislebertus, Sculptor of Autun,* New York, 1961; W. Sauerländer, "Uber die Komposition des Weltgerichts-Tympanons in Autun," *Zeitschrift für Kunstgeschichte,* 29, 1966, 261 ff.

33. V. Terret, *Autun, passim;* E. Mâle, *Religious Art in France, The Twelfth Century,* 408 ff.; Y. Christe, *Les grands portails romans,* 127–31.

34. D. Grivot and G. Zarnecki, *Gislebertus,* 149 ff.; D. Jalabert, "L'Eve de la cathédrale d'Autun," *Gazette des Beaux-Arts,* 35, 1949, 300 ff.; O. K. Werckmeister, "The Lintel Fragment Representing Eve from Saint-Lazare, Autun," *Journal of the Warburg and Courtauld Institutes,* 35, 1972, 1–30.

35. See n. 30. Cf. E. R. Elder, *Cistercians and Cluniacs,* Kalamazoo, 1977.

36. For these see W. Braunfels, *Monasteries of Western Europe,* 75 ff. Also see M. Aubert, *L'Architecture cistercienne en France,* Paris, 1947; F. van der Meer, *Atlas de l'ordre cistercien,* Haarlem, 1965; M. A. Dimier, *L'Art cistercien,* Paris, 1962.

37. C. Oursel, *Miniatures cisterciennes (1109–1134),* Mâcon, 1960.

38. C. H. Williams, "The Norman Anonymous of 1000," *Harvard Theological Studies,* 18, 1951, 165–94.

39. M. Anfray, *L'Architecture normande,* Paris, 1939; E. G. Carlson, "The Abbey Church of Saint-Etienne at Caen in the Eleventh and Twelfth Centuries," Ph.D. diss., Yale University, 1968; R. Liess, *Der frühromanische Kirchenbau des 11. Jahrhundert in der Normandie,* Munich, 1967.

40. E. Maclagan, *The Bayeux Tapestry,* London, 1949; F. Stenton et al., *The Bayeux Tapestry,* London, 1957; H. Gibbs-Smith, *The Bayeux Tapestry,* London, 1973; D. Wilson, *The Bayeux Tapestry,* New York, 1985. Cf. C. R. Dodwell, "The Bayeux Tapestry and the French Secular Epic," *Burlington Magazine,* 108, 1966, 549–60.

41. J. Bilson, "Durham Cathedral and the Chronology of its Vaults," *Archaeological Journal,* 79, 1922, 101 ff.; A. W. Clapham, *English Romanesque Architecture After the Conquest,* Oxford, 1934; G. Webb, *Architecture in Britain: The Middle Ages* (Pelican History of Art, no. 12), Harmondsworth, 1956; J. P. McAleer, *The Romanesque Church Facade in Britain,* New York, 1984.

42. O. Pächt et al., *The Saint Albans Psalter,* London, 1960. For English Romanesque manuscripts see M. Rickert, *Painting in Britain: The Middle Ages* (Pelican History of Art, no. 5), Harmondsworth, 1954, 59–104; C. M. Kauffmann, *Romanesque Manuscripts, 1066–1190,* London and Boston, 1975. For an excellent discussion of the sources and iconography, see O. Pächt, *The Rise of Pictorial Narrative in Twelfth-Century England,* Oxford, 1962.

43. O. Pächt, "Hugo Pictor," *Bodleian Library Record,* 3, 1950, 96–103; C. M. Kauffmann, "The Bury Bible," *Journal of the Warburg and Courtauld Institutes,* 29, 1966, 65 ff.

44. T. P. F. Hoving, "The Bury Saint Edmunds Cross," *Bulletin of The Metropolitan Museum of Art,* 22, 1964, 317–40; K. Hoffmann, ed., *The Year 1200: A Centennial Exhibition at The Metropolitan Museum of Art,* New York, 1970, no. 60, 52–57.

45. A. Kelly, *Eleanor of Aquitaine and the Four Kings,* New York, 1957.

46. R. Crozet, *L'Art roman en Poitou,* Paris, 1948. For the sculptures see B. Rupprecht, *Romanische Skulpturen,* 93 ff.

47. G. Gaillard, *The Frescoes of Saint-Savin: The Nave,* New York, 1944; A. Grabar and C. Nordenfalk, *Romanesque Painting,* Geneva, 1958, 87–95; G. Henderson, "The Sources of the Genesis Cycle at Saint-Savin-sur-Gartempe," *Journal of the British Archaeological Society,* 26, 1963, 11–26. For Romanesque frescoes in general see also O. Demus, *Romanesque Mural Painting,* New York, 1970; E. W. Anthony, *Romanesque Frescoes,* Princeton, 1951.

48. For these and other French Romanesque manuscripts see P. Lauer, *Les enluminures romanes de la Bibliothèque Nationale,* Paris, 1927; J. Porcher, *Medieval French Miniatures,* New York, 1959, 24–30; H. Swarzenski, *Monuments of Romanesque Art,* New York, 1954; A. Grabar and C. Nordenfalk, *Romanesque Painting,* 154 ff.; J. Porcher, *Le Sacramentaire de Saint-Etienne de Limoges,* Paris, 1953; W. Wixom, *Treasures from Medieval France,* exh. cat., Cleveland Museum of Art, 1967, 50–53, 350; E. Mâle, *Religious Art in France, The Twelfth Century, passim.*

49. K. Hoffmann, ed., *The Year 1200,* no. 159, 153. For Limoges enamels in general see E. Rupin, *L'Oeuvre de Limoges,* Paris, 1890; M. S. Gauthier, *Emaux limousins: Champlevés des XIIe à XIVe siècles,* Paris, 1950; J. Maury et al., *Limousin roman,* La-Pierre-qui-Vire, 1960.

50. I. H. Forsyth, *The Throne of Wisdom: Wood Sculptures of the Madonna in Romanesque France,* Princeton, 1972.

51. R. Hamann, *Die Abteikirche von Saint-Gilles,* 3 vols., Berlin, 1955; W. S. Stoddard, *The Facade of Saint-Gilles-du-Gard: Its Influence on French Sculpture,* Middletown, Conn., 1973; B. Rupprecht, *Romanische Skulpturen,* 128–31; M. F. Hearn, *Romanesque Sculpture,* 204–15.

52. C. O'Meara, *The Iconography of the Facade of Saint-Gilles-du-Gard,* New York, 1977; M. F. Hearn, *Romanesque Sculpture,* 204 ff.

53. E. Bertaux, *L'Art dans l'Italie méridionale,* Paris, 1904, 15 ff.; H. Bloch, "Montecassino, Byzantium, and the West," *Dumbarton Oaks Papers,* 3, 1946, 166 ff.; W. Braunfels, *Monasteries of Western Europe,* 24 ff.; O. Demus, *Byzantium and the West,* New York, 1970; K. J. Conant, *Carolingian and Romanesque Architecture,* 222–24.

54. K. J. Conant and H. M. Willard, "A Project for the Graphic Reconstruction of . . . Monte Cassino," *Speculum,* 10, 1935, 144 ff. For a translation of the text of Leo of Ostia (J. P. Migne, *Patrologia Latina,* CLXXIII, 555 ff.) see W. Braunfels, *Monasteries of Western Europe,* 34–35.

55. T. R. Preston, *The Bronze Doors of the Abbey of Monte Cassino and of Saint Paul's Outside the Walls,* Princeton, 1915; G. Matthiae, *Le Porte bronzee bizantine in Italia,* Rome, 1977; M. English, "The Bronze Doors of S. Michele al Monte," Ph.D. diss., Bryn Mawr College, 1966; U. Mende, *Die Bronzetüren des Mittelalters 800–1200,* Munich, 1983.

56. J. Wettstein, *Les Fresques de S. Angelo in Formis,* Geneva, 1960; O. Morisani, *Gli affreschi di S. Angelo in Formis,* Naples, 1962; A. Moppert-Schmidt, *Die Fresken von S. Angelo in Formis,* Zurich, 1967; A. Grabar and C. Nordenfalk, *Romanesque Painting,* 33–39.

57. M. Avery, *The Exultet Rolls of South Italy,* Princeton, 1936.

58. J. S. Ackerman, "Marcus Aurelius on the Capitoline Hill," *Renaissance News,* 10, 1937, 69 ff.; H. Toubert, "Le renouveau paleochrétien à Roma au début du XIIe siècle," *Cahiers archéologique,* 20, 1970, 100 ff. For the text of the *Marvels of Rome* see G. M. Rushforth in the *Journal of Roman Studies,* 9, 1919. A discussion of Rome and its Medieval monuments is given in R. Krautheimer, *Rome: Profile of a City, 312–1308,* Princeton, 1980 (see esp. chaps. 6 and 7, 143–202).

59. G. Matthiae, *Mosaici medioevali delle chiese di Roma,* Rome, 1967; F. Hermanin, *L'arte in Roma dal secolo VIII al XIV,* Bologna, 1945.

60. G. Matthiae, *Pittura romana del medioevo,* Rome, 1965; A. Grabar and C. Nordenfalk, *Romanesque Painting,* 25–32; L. Nolan, *The Basilica of San Clemente in Rome, Lower Church Frescoes,* Rome, 1934.

61. R. Krautheimer, *Rome,* 161 ff.; D. Kinney, "Santa Maria in Trastevere from its Founding to 1215," Ph.D. diss., New York University, 1975.

62. G. B. Giovenale, *La basilica di S. Maria in Cosmedin,* Rome, 1927. For the Cosmati see E. Hutton, *The Cosmati: The Roman Marble Workers of the 12th and 13th Centuries,* London, 1950.

63. C. Ricci, *Romanesque Architecture in Italy,* London, 1925; E. Anthony, *Early Florentine Architecture and Decoration,* Cambridge, Mass., 1927, 3 ff.; W. Horn, "Romanesque Churches in Florence," *Art Bulletin,* 25, 1943, 112 ff.; K. J. Conant, *Carolingian and Romanesque Architecture,* 231 ff.

64. K. J. Conant, *Carolingian and Romanesque Architecture,* 231.

65. R. Krautheimer, *Early Christian and Byzantine Architecture* (Pelican History of Art, no. 24), Harmondsworth, 1965, 263; C. Smith, "The Date and Authorship of the Pisa Duomo Facade," *Gesta,* 19, 1980, 95–108.

66. W. Biehl, *Toscanische Plastik des frühen und hohen Mittelalters,* Leipzig, 1926, pls. 72–74; M. Salmi, *Romanesque Sculpture in Tuscany,* Florence, 1928, 83 ff.; G. H. Crichton, *Romanesque Sculpture in Italy,* London, 1954, 106 ff.; A. Boeckler, *Die Bronzetüren des Bonanus von Pisa und des Barisanus von Trani,* Berlin, 1953.

67. F. Reggiori, *La basilica di Sant'Ambrogio a Milano,* Florence, 1945. For the earlier dating see A. K. Porter, *Lombard Architecture,* New Haven, 1915–17, II, 532 ff.

68. G. de Francovich, "Wiligelmo da Modena e gli inizii della scultura romanica in Francia e in Spagna," *Revista del Reale Istituto di archeologia e storia dell'arte,* 7, 1940, 225–94; R. Jullian, *L'Eveil de la sculpture italienne,* Paris, 1945; R. Salvini, *Wiligelmo e le origini della scultura romanica,* Milan, 1956; E. Fernie, "Notes on the Sculpture of Modena Cathedral," *Arte Lombarda,* 14, 1969, 88–93; A. C. Quintavalle, *Da Wiligelmo a Nicolo,* Parma, 1969; M. F. Hearn, *Romanesque Sculpture,* 85–98.

69. G. H. Crichton, *Romanesque Sculpture,* 22–40; A. C. Quintavalle, *Da Wiligelmo,* 47–108; R. Salvini, *Wiligelmo,* 113–62; M. F. Hearn, *Romanesque Sculpture,* 163 ff.

70. A. Boeckler, *Die frühmittelalterlichen Bronzetüren*, III: *Die Bronzetür von S. Zeno*, Marburg, 1931.

71. A. C. Quintavalle, *Antelami, Sculptor*, Milan, 1947; G. Francovich, *Benedetto Antelami, architetto e scultore*, 2 vols., Milan, 1952.

72. P. E. Schramm and F. Mütherich, *Denkmäler der deutschen Könige und Kaiser: Ein Beitrag zur Herrschergeschichte von Karl dem Grossen bis Friederich II, 768–1250*, Munich, 1962. For Romanesque architecture in Germany see P. Frankl, *Die frühmittelalterliche und romanische Baukunst*, I, Potsdam, 1926; E. Lehmann, *Der frühe deutsche Kirchenbau*, Berlin, 1938; H. E. Kubach, *Romanesque Architecture*, New York, 1975; for Speyer see P. W. Hartwein, *Der Kaiserdom zu Speyer*, Speyer, 1927; and E. Gall, *Cathedrals and Abbey Churches of the Rhine*, New York, 1963.

73. R. Haussherr, "Das Imervardkreuz und der Volto-Santo-Typ," *Zeitschrift für Kunstwissenschaft*, 16, 1962, 129–70.

74. C. R. Dodwell, *Theophilus: The Various Arts*, London, 1961 (Latin and Eng. trans.); J. G. Hawthorne and C. S. Smith, *On Divers Arts: The Treatise of Theophilus,* Chicago, 1963.

75. For Mosan art see S. Collon-Gevaert et al., *Art roman dans la vallée de la Meuse*, Brussels, 1965; H. Swarzenski, *Monuments of Romanesque Art*, 2nd ed., London, 1967; J. J. Timmers, *De kunst van het Maasland*, Assen, 1971; P. Lasko, *Ars Sacra: 800–1200* (Pelican History of Art, no. 36), Harmondsworth, 1972, 181–211; *Rhin-Meuse: Art et civilization 800–1400*, exh. cat., Cologne and Brussels, 1972.

76. K. H. Usener, "Reiner von Huy und seine künstlerische Nachfolge," *Marburger Jahrbuch*, 12, 1933, 77–134; P. Lasko, *Ars Sacra*, 162–68.

77. J. Brodsky, "The Stavelot Triptych: Notes on a Mosan Work," *Gesta*, 11, 1972, 19–33; and "Le groupe du triptyque de Stavelot: Notes sur un atelier mosan et sur les rapports avec Saint-Denis," *Cahiers de la civilization médiévale*, 21, 1978, 103–20; W. Voelkle, *The Stavelot Triptych: Mosan Art and the Legend of the True Cross*, New York, 1980.

78. M. Laurent, "Godefroid de Claire et la croix de Suger à l'abbaye de Saint-Denis," *Revue archéologique*, 19, 1924, 79 ff.; P. Verdier, "La grande Croix de l'Abbé Suger à Saint-Denis," *Cahiers de la civilization médiévale*, 13, 1970, 13 ff.; P. Lasko, *Ars Sacra*, 188–91.

79. F. Röhrig, *Der Verduner Altar*, Klosterneuburg, 1955; P. Lasko, *Ars Sacra*, 240–54; *Der Meister des Dreikönigsschrein*, exh. cat., Cologne, 1964. For Byzantine influence see E. Kitzinger, "The Byzantine Contribution to Western Art of the 12th and 13th Centuries," *Dumbarton Oaks Papers*, 20, 1966, 38 ff. Concerning the "transitional" aspects of the art of this period see especially W. Sauerländer, *Von Sens bis Strassburg*, Berlin, 1966.

80. For a concise table of these typologies see J. J. M. Timmers, *Symboliek en iconographie der christelijke kunst*, Roermond-Maaseik, 1947, esp. 223–315.

PART FIVE

1. François-René Chateaubriand, *Génie du Christianisme*, Paris, 1801, III, chap. 8. For a discussion and translation see P. Frankl, *The Gothic: Literary Sources and Interpretations Through Eight Centuries*, Princeton, 1960, 482 ff.

2. G. Vasari, *Le vite*, edited by G. Milanesi, Florence, 1878, I, 137. See translation and discussion in P. Frankl, *The Gothic*, 290–92.

3. See E. S. de Beer, "Gothic: Origin and Diffusion of the Term," *Journal of the Warburg and Courtauld Institutes*, 11, 1948, 144 ff. The modern definition of Gothic is, as an adjective: "1: of, or pertaining to, the Goths or their language. 2: *Obs.* Teutonic; Germanic. 3: [*often not cap.*] of, pertaining to, or characteristic of the Middle Ages; medieval; romantic as opposed to classical; derogatorily, rude; barbarous . . . 4: Pertaining to, or designating, a style of building . . . 5: *Print.* Designating or pertaining to a style of type." And as a noun: "1: the language of the Goths . . . 2: Gothic architecture, ornament, etc. 3: Gothic type." For the confusing use of the phrase "classic Gothic" see especially P. Frankl, *Gothic Architecture* (Pelican History of Art, no. 19), Harmondsworth, 1962, esp. 94. Cf. R. Wittkower, *Gothic versus Classic*, London, 1974.

4. P. Frankl, *The Gothic*, 55.

5. See especially H. Sedlmayr, *Die Entstehung der Kathedrale*, Zurich, 1950, 234 ff.; G. Bandmann, *Mittelalterliche Architektur als Bedeutungsträger*, Berlin, 1951, 67ff., 89 ff.; P. Frankl, *Gothic Architecture*, 217 ff.; H. Jantzen, *High Gothic*, Princeton, 1984, 170 ff. For more traditional interpretations of Gothic see H. Focillon, *The Art of the West*, II; *Gothic*, Ithaca, 1963; R. Branner, *Gothic Architecture*, New York, 1961; W. S. Stoddard, *Art and Architecture in Medieval France*, New York, 1972; L. Grodecki, *Gothic Architecture*, New York, 1977; and J. Bony, *French Gothic Architecture of the Twelfth and Thirteenth Centuries*, Berkeley, 1983.

6. J. Gimpel, *The Cathedral Builders*, New York, 1961, 108. Villard de Honne-court was probably an itinerant architect from Picardy. The *Sketchbook* dates from 1235 and later. See H. R. Hahnloser, *Villard de Honnecourt, Kritische Gesamtausgabe des Bauhüttenbuches ms fr 19093 der Pariser Nationalbibliothek*, Vienna, 1935. For an English translation see T. Bowie, *The Sketchbook of Villard de Honnecourt*, Bloomington, Ind., 1959. Also see P. Frankl, *The Gothic*, 35–47.

7. P. Frankl, *The Gothic*, 63–86; and "The Secret of the Medieval Masons," *Art Bulletin*, 27, 1945, 46 ff.

8. *The Symbolism of Churches and Church Ornaments: A Translation of the First Book of the Rationale Divinorum Officiorum, Written by William Durandus*, translated by J. M. Neale and B. Webb, London, 1893; cf. J. Sauer, *Symbolik des Kirchengebäudes und seiner Ausstaltung*, Freiburg i. B., 1902.

9. E. Mâle, *Religious Art in France, The Thirteenth Century: A Study of Medieval Iconography and its Sources*, translated by M. Mathews, Princeton, 1984 (also appeared as *The Gothic Image*, translated by D. Nussey, New York, 1958). Cf. the review of the Princeton edition by W. Sauerländer in the *Times Literary Supplement*, May 30, 1986, 594.

10. E. Panofsky, *Gothic Architecture and Scholasticism*, Latrobe, Pa., 1951.

11. W. Worringer, *Form in Gothic*, translated by H. Read, London, 1927, 161.

12. Abbot Suger, *De Administratione*, XXXIII, translated in E. Panofsky, *Abbot Suger on the Abbey Church of St.-Denis and Its Art Treasures*, 2nd ed., by G. Panofsky-Soergel, Princeton, 1979, 63–64.

13. E. Panofsky, *Abbot Suger*, 27.

14. E. Panofsky, *Abbot Suger*, 43, 45.

15. S. M. Crosby, *The Royal Abbey of Saint-Denis, From its Beginnings to the Death of Suger, 475–1151*, edited and completed by P. Z. Blum, New Haven and London, 1987; S. M. Crosby et al., *The Royal Abbey of Saint-Denis in the Time of Abbot Suger (1122–1151)*, New York, 1981; P. Gerson, ed., *Abbot Suger and Saint-Denis: An International Symposium*, The Metropolitan Museum of Art, New York, 1986; J. Bony, *French Gothic Architecture*, 61–64, 90 ff.

16. M. Anfray, *L'Architecture normande: Son influence dans le nord de la France aux XIe et XIIe siècles*, Paris, 1939; cf. J. P. McAleer, "Romanesque England and the Development of the *Facade Harmonique*," *Gesta*, 23, no. 2, 1984, 87–105.

17. M. Aubert, *French Sculpture at the Beginning of the Gothic Period, 1140–1225*, Florence and Paris, 1929, 4 ff.; W. S. Stoddard, *The West Portals of Saint-Denis and Chartres*, Cambridge, Mass., 1952; B. Kerber, *Burgund und die Entwicklung der französischen Kathedralskulptur im 12. Jahrhundert*, Recklinghausen, 1966, 30 ff.; W. Sauerländer, *Gothic Sculpture in France, 1140–1270*, New York, 1972, 43 ff., 379–83.

18. In his *Dictionnaire raisonné de l'architecture française du XIe au XVIe siècle* (Paris, 1854–68, see esp. vol. IX), Viollet-le-Duc stressed the rationalism and functionalism of the Gothic rib as a structural member, a view that was carried to extremes by A. Choisy (*Histoire de l'architecture*, Paris, 1899, II, 239 ff.), who claimed that "the history of Gothic construction will be that of the rib and the flying buttress." Viollet's theories were seriously rejected by P. Abraham (*Viollet-le-Duc et le rationalisme mediéval*, Paris, 1935). He argued that the rib was merely decorative, serving an aesthetic purpose only. More recent scholars have tended to find a compromise between the functionalism of Viollet and the illusionism of Abraham (cf. H. Focillon, *The Art of the West*, II: *Gothic*, 7 ff.). For further literature concerning the controversy see G. Kubler, "A Late Gothic Computation of Rib Vault Thrusts," *Gazette des Beaux-Arts*, 6th ser., 26, 1944, 135 ff., and especially P. Frankl, *The Gothic*, 563 ff., 805–26. Recently Robert Mark, a professor of both architecture and civil engineering, has studied the problem with plastic models of cutaway sections of cathedrals and reports that the ribbing functions as centering during the construction of the vault, but once the vaults are in place their role is aesthetic. See his *High Gothic Structure: A Technological Reinterpretation*, Princeton, 1985. Cf. J. James, "The Rib Vaults of Durham Cathedral," *Gesta*, 22, 1983, 135–45.

19. N. Pevsner, "The Term 'Architect' in the Middle Ages," *Speculum*, 17, 1942, 549–62; P. Booz, *Der Baumeister der Gotik*, Munich, 1956, 25 ff.; J. Gimpel, *The Cathedral Builders*, 107–46; P. Frankl, *The Gothic*, 35 ff. For the complex history of the masons' guild and lodges see P. Frankl, *The Gothic*, 110–58.

20. E. Panofsky, *Abbot Suger*, 101, 22.

21. See E. Panofsky, *Abbot Suger*, 73–78 for this and 18 ff. for his discussion of the influence of the writings of Pseudo-Dionysius the Areopagite. For the remains of these windows see L. Grodecki, *Les Vitraux de Saint-Denis*, I: *Histoire et restitution* (Corpus Vitrearum Medii Aevi, France, Etudes I), Paris, 1976; and his "Les vitraux allégoriques de Saint-Denis," *Art de France*, 1, 1961, 19 ff.

22. J. Bony, *French Gothic Architecture*, 94; C. Bruzelius, *The Thirteenth-Century Church at Saint-Denis*, New Haven and London, 1986.

23. J. Bony, *French Gothic Architecture*, 180–84; W. Clark and R. Mark, "The First Flying Buttresses: A New Reconstruction of the Nave of Notre-Dame

de Paris," *Art Bulletin,* 66, 1984, 47–65. C. Bruzelius, "The Construction of Notre-Dame at Paris," *Art Bulletin,* 69, 1987, 540–69.

24. See J. Bony, *French Gothic Architecture,* esp. 220 ff.; H. Jantzen, *High Gothic.* The literature on Chartres is vast. See especially M. J. Bulteau, *Monographie de la cathédrale de Chartres,* 3 vols., Chartres, 1887–92; E. Mâle, *Notre-Dame de Chartres,* Paris, 1948; W. Sauerländer, *Die Kathedrale von Chartres,* Stuttgart, 1954; O. von Simson, *The Gothic Cathedral,* New York, 1956; Y. Delaporte, *Notre-Dame de Chartres,* Paris, 1957; G. Richter, *Chartres: Idee und Gestalt der Kathedrale,* Stuttgart, 1958; R. Branner, *Chartres Cathedral,* New York, 1969; L. Grodecki, *Chartres,* Paris, 1963; C. F. Barnes, "The Cathedral of Chartres and the Architect of Soissons," *Journal of the Society of Architectural Historians,* 22, 1963, 63–74; J. van der Meulen, "Recent Literature on the Chronology of Chartres Cathedral," *Art Bulletin,* 49, 1967, 152–72; J. van der Meulen, *Chartres: Biographie der Kathedrale,* Cologne, 1984.

25. R. Branner, *Chartres,* 96–97.

26. A. Priest, "The Masters of the West Facade of Chartres," *Art Studies,* 1, 1923, 28–44; W. S. Stoddard, *The West Portals of Saint-Denis and Chartres;* P. Kidson, *Sculpture at Chartres,* New York, 1959; A. Lapeyre, *Des Façades occidentales de Saint-Denis et de Chartres aux portails de Laon,* Paris, 1960; W. Sauerländer, *Gothic Sculpture,* 383–86.

27. W. Vöge, *Die Anfänge des monumentalen Stiles im Mittelalter,* Strassburg, 1894. See translation in R. Branner, *Chartres,* 126–49.

28. A. Katzenellenbogen, *The Sculptural Programs of Chartres Cathedral,* Baltimore, 1959. Cf. E. Mâle, *Religious Art in France, The Thirteenth Century, passim.*

29. R. Branner, *Chartres,* 95–99.

30. W. Sauerländer, *Gothic Sculpture,* 430–38.

31. G. Zarnecki, "The Coronation of the Virgin on a Capital from Reading Abbey," *Journal of the Warburg and Courtauld Institutes,* 13, 1950, 1–13.

32. W. Vöge, "Die Bahnbrecher des Naturstudiums," *Zeitschrift für bildende Kunst,* n.s. 25, 1914, 193–216 (translated in R. Branner, *Chartres,* 207–32).

33. Y. Delaporte, *Les Vitraux de la cathédrale de Chartres,* 3 vols., Chartres, 1926; M. Aubert et al., *Le Vitrail français,* Paris, 1958; L. Grodecki and C. Brisac, *Gothic Stained Glass: 1200–1300,* Ithaca, 1985. For a fragment of a Chartres window at the Princeton University Art Museum (Saint George, from a roundel in the choir until 1788) see F. Stohlman, "A Stained Glass Window of the Thirteenth Century," *Art and Archaeology,* 20, 1925, 135; and "A Stained Glass Window from Chartres Cathedral," *Bulletin of the Department of Art and Archeology of Princeton University,* Oct. 1927, 3–9. Cf. H. B. Graham, "A Reappraisal of the Princeton Window from Chartres," *Record of the Art Museum, Princeton University,* 121, no. 2, 1962, 30–45.

34. See especially O. von Simson, *The Gothic Cathedral.* W. Schöne, *Uber das Licht in der Malerei,* Berlin, 1954, esp. 42 ff., 55, 70.

35. H. Adams, *Mont-Saint-Michel and Chartres,* Boston, 1905, 128.

36. P. Frankl, "A French Gothic Cathedral: Amiens," *Art in America,* 35, 1947, and *Gothic Architecture,* 91 ff.; J. Bony, *French Gothic Architecture,* 275 ff. The standard book on Amiens remains G. Durand, *Monographie de la cathédrale d'Amiens,* 2 vols., 1901–3. See also L. Lefrançois-Pillion, *La Cathédrale d'Amiens,* Paris, 1937.

37. R. Branner, *Saint Louis and the Court Style in Gothic Architecture,* London, 1965, and "Paris and the Origins of Rayonnant Gothic Architecture down to 1240," *Art Bulletin,* 44, 1962, 39–51. Cf. J. Bony, *French Gothic Architecture,* 388–91.

38. See E. Mâle, *Religious Art in France, The Thirteenth Century,* 351–91, for an excellent analysis.

39. G. Durand, *Amiens,* I, 299 ff.; W. Medding, *Die Westportale der Kathedrale von Amiens und ihre Meister,* Augsburg, 1930; A. Katzenellenbogen, "The Prophets on the West Facade of the Cathedral at Amiens," *Gazette des Beaux-Arts,* 6e, 40, 1952, 241 ff.; W. Sauerländer, *Gothic Sculpture,* 460–66.

40. L. Demaison, *La Cathédrale de Reims,* Paris, 1910; P. Vitry, *La Cáthedrale de Reims,* 2 vols., Paris, 1919; J. Bony, *French Gothic Architecture,* 266–75; P. Frankl, *Gothic Architecture,* 86 ff., 112 ff. Cf. the articles by R. Branner ("Historical Aspects of the Reconstruction of Reims Cathedral, 1210–1241," *Speculum,* 36, 1961, 23–37; "Jean d'Orbais and the Cathedral of Reims," *Art Bulletin,* 43, 1961, 131–33; "The Labyrinth of Reims Cathedral," *Journal of the Society of Architectural Historians,* 21, 1962, 18–25).

41. The first serious study of these sculptors was W. Vöge, "Vom gotischen Schwung und der plastischen Schule des 13. Jahrhunderts," *Repertorium für Kunstwissenschaft,* 1904, 1 ff. For later studies see L. Lefrançois-Pillion, *Les Sculpteurs de la cathédrale de Reims,* Paris, 1928; E. Panofsky, "Uber die Reihenfolge der vier Meister von Reims," *Jahrbuch für Kunstwissenschaft,* 1927, 55–82; R. Branner, "The North Transept and the First West Facades of Reims," *Zeitschrift für Kunstgeschichte,* 24, 1961, 220–41 (and articles listed in n. 40, above); W. M. Hinkle, *The Portal of the Saints of Reims Cathedral,* New York, 1965; F. Salet, "Chronologie de la cathédrale [de

Reims]," *Bulletin monumental,* 125, 1967, 345 ff.; W. Sauerländer, *Gothic Sculpture,* 474–88.

42. W. Sauerländer, *Gothic Sculpture,* 415–17, 481–83; R. Branner, "The North Transept and the First West Facades of Reims," 197–203.

43. R. Branner, "Paris and the Origins of Rayonnant Gothic Architecture down to 1240," 39–51, and *Saint Louis and the Court Style.* Cf. J. Bony, *French Gothic Architecture,* 365–81; P. Frankl, *Gothic Architecture,* 223 ff.

44. E. Panofsky, *Gothic Architecture and Scholasticism,* 45 ff.

45. J. Bony, *French Gothic Architecture,* 366–81; R. Branner, "A Note on Pierre de Montreuil," *Art Bulletin,* 45, 1963, 355–57; S. M. Crosby, *L'Abbaye royale de Saint-Denis,* Paris, 1953, 57–65; see n. 22.

46. F. Gebelin, *La Sainte-Chapelle,* Paris, 1931; L. Grodecki, *Sainte-Chapelle,* Paris, 1962; 2nd ed., 1975; R. Branner, *Saint Louis and the Court Style.*

47. L. Grodecki, *Sainte-Chapelle,* 49–70. A complete description of the windows appears in vol. I of *Les Vitraux de Notre-Dame et de la Sainte-Chapelle de Paris* (Corpus Vitrearum Medii Aevi, France), Paris, 1959, compiled by M. Aubert et al.

48. J. Bony, *The English Decorated Style,* Oxford and Ithaca, 1979.

49. *Chronica Gervasi,* translated in R. Willis, *The Architectural History of Canterbury Cathedral,* London, 1845; W. Stubbs, *The Historical Works of Gervase of Canterbury,* I, London, 1879; P. Frankl, *The Gothic,* 24–33. See also F. Woodman, *The Architectural History of Canterbury Cathedral,* London, 1981.

50. The term Romanesque was actually used earlier in England, where it was applied to Norman and Early Gothic structures. See T. Bizzaro, "Romanesque Criticism: A Prehistory," Ph.D. diss., Bryn Mawr College, 1985.

51. This somewhat arbitrary nomenclature was introduced by T. Rickman, *An Attempt to Discriminate the Styles of Architecture in England from the Conquest to the Reformation,* London, 1817. For English Gothic see F. Bond, *Gothic Architecture in England,* London, 1905; G. Webb, *Architecture in Britain—The Middle Ages* (Pelican History of Art, no. 12), Harmondsworth, 1956; H. Batsford and C. Fry, *The Cathedrals of England,* London, 1960; L. F. Salzman, *Building in England down to 1540: A Documentary History,* Oxford, 1967; J. Bony, *The English Decorated Style;* P. Johnson, *British Cathedrals,* New York, 1980. For a survey of all buildings see N. Pevsner, *The Buildings of England,* 46 vols., London, 1951–76.

52. For the problem of dating the crazy vaults see the arguments in the *Journal of the Royal Institute of British Architects,* 18, 1911; P. Frankl, "The Crazy Vaults of Lincoln Cathedral," *Art Bulletin,* 35, 1953, 95 ff.; G. H. Cook, *A Portrait of Lincoln,* London, 1950.

53. P. Johnson, *British Cathedrals,* 74.

54. R. Branner, "Westminster Abbey and the French Court Style," *Journal of the Society of Architectural Historians,* 23, 1964, 3–18; W. R. Lethaby, *Westminster Abbey Re-examined,* London, 1925; H. K. Westlake, *Westminster Abbey,* 2 vols., London, 1923.

55. For the Decorated Style see especially J. Bony, *The English Decorated Style;* and H. Bock, *Der Decorated Style,* Heidelberg, 1962. For Exeter see H. E. Bishop and E. K. Prideaux, *The Building of the Cathedral Church of Exeter,* Exeter, 1922; V. Hope and J. Lloyd, *Exeter Cathedral,* Exeter, 1973.

56. G. Webb, *Ely Cathedral,* London, 1950.

57. G. Webb, *Architecture in Britain,* 148–50; G. E. Aylmer and R. Cant, eds., *A History of York Minster,* Oxford, 1977.

58. For King's College Chapel see F. Woodman, *The Architectural History of King's College Chapel and its Place in the Development of Late Gothic Architecture in England and France,* London, 1986; J. Harvey, *The Perpendicular Style,* London, 1978. Gothic had a long afterlife and periods of revival. See G. Germann, *The Gothic Revival in Europe and Britain,* London, 1972; K. Clark, *The Gothic Revival,* London, 1928; R. Wittkower, *Gothic versus Classic;* N. Pevsner, *Ruskin and Viollet-le-Duc: Englishness and Frenchness in the Appreciation of Gothic Architecture,* London, 1969.

59. For Gothic architecture in Germany see E. Gall, *Die gotische Baukunst in Frankreich und Deutschland,* Munich, 1926; G. Dehio, *Handbuch der deutschen Kunstdenkmäler,* 5 vols., Berlin, 1920; E. Hempel, *Deutsche Kunstgeschichte,* I: *Geschichte der deutschen Baukunst,* Munich, 1953; J. Baum, *German Cathedrals,* London, 1956; P. Frankl, *Gothic Architecture;* H. Busch, *Deutsche Gotik,* Vienna and Munich, 1969; W. Swaan, *The Gothic Cathedral,* New York, 1969, 225–58; E. Gall, *Cathedrals and Abbey Churches of the Rhine,* New York, 1963; W. Braunfels, *Die Kunst im Heiligen Römischen Reich Deutscher Nation,* 5 vols., Munich, 1979–85 (three more volumes are to appear). For Gothic sculpture in Germany see E. Panofsky, *Die deutsche Plastik des elften bis dreizehnten Jahrhunderts,* Munich, 1924; W. Pinder, *Die deutsche Plastik* (Handbuch der Kunstwissenschaft), 2 vols., Wildpark-Potsdam, 1924; H. Jantzen, *Deutsche Bildhauer des 13. Jahrhunderts,* Munich, 1939; A. Feuler and T. Muller, *Deutsche Kunstgeschichte,* II: *Geschichte der deutschen Plastik,* Munich, 1953. For Strasbourg see H. Weigert, *Das Strassburger Münster,* 2nd ed., Berlin, 1935 (see p. 64 for earlier bibliography); and H. Reinhardt and E. Fels, "La façade de la

Cathédrale de Strasbourg," *Bulletin de la Société des Amis de la Cathédrale de Strasbourg,* Strasbourg, 1935.

60. H. Rosenan, *Der Kölner Dom,* Cologne, 1931; P. Clemen, *Der Dom zu Köln,* Düsseldorf, 1937; and articles in the *Festschrift des Kölner Domes,* Cologne, 1948.

61. Quoted by P. Frankl, *The Gothic,* 238.

62. For a discussion of the hall churches see P. Frankl, *Gothic Architecture,* 60 ff.

63. G. Dehio, *Der Bamberger Dom,* Berlin, 1924; W. Pinder, *Der Bamberger Dom und seine Bildwerke,* Berlin, 1927; W. Broeck, *Der Bamberger Meister,* Tübingen, 1960.

64. For a summary see W. R. Valentiner, *The Bamberg Rider,* Los Angeles, 1956, esp. 116–38.

65. W. Pinder, *Der Naumburger Dom und seine Bildwerke,* 5th ed., Berlin, 1935.

66. For a definition of *Andachtsbild* see E. Panofsky, "Imago Pietatis," in *Festschrift für M. J. Friedländer,* Leipzig, 1927, 264–68; W. Pinder, *Die deutsche Plastik,* I, 92 ff.; J. Snyder, "The Early Haarlem School of Painting: I," *Art Bulletin,* 42, 1960, 123 ff.

67. W. Pinder, *Die deutsche Plastik,* I, 92 ff.

68. P. Lauer, *Les principaux manuscrits à peintures de la Bibliothèque de l'Arsenal,* Paris, 1929; G. Haseloff, *Die Psalterillustration im 13. Jahrhundert,* Kiel, 1938; V. Leroquais, *Les Psautiers manuscrits des bibliothèques publiques de France,* Paris, 1940–41; J. Dupont and C. Gnudi, *Gothic Painting,* Geneva, 1954, 27–30; J. Porcher, ed., *Les Manuscrits à peintures en France du XIIIe au XVIe siècle,* cat., Bibliothèque Nationale, Paris, 1955; J. Porcher, *Medieval French Miniatures,* New York, 1959, 45 ff.; R. Branner, *Manuscript Painting in Paris During the Reign of Saint Louis,* Berkeley, 1977.

69. M. R. James, *Catalogue of the Manuscripts . . . of the Library of J. Pierpont Morgan,* 2 vols., London, 1906–7; A. de Laborde, *La Bible moralisée conservée à Oxford, Paris et Londres,* 5 vols., Paris, 1911–27; R. Haussheer, *Bible moralisée,* Graz, 1973.

70. H. Martin, *Psautier de Saint Louis et de Blanche de Castille,* Paris, 1909; M. Thomas, *Le Psautier de Saint Louis,* Graz, 1970.

71. For a discussion of manuscript production in Paris see R. Branner, *Manuscript Painting in Paris,* 1–21. For model books in general see R. W. Scheller, *A Survey of Medieval Model Books,* Haarlem, 1963. Still useful is the pioneering study by G. Vitzthum, *Die Pariser Miniaturmalerei von der Zeit des hl. Ludwig bis zu Philipp von Valois,* Leipzig, 1907.

72. E. Millar, *The Parisian Miniaturist Honoré,* London, 1959, 11–16.

73. J. Porcher, ed., *Les Manuscrits à peintures en France au XIIIe au XVIe siècle,* 22–24; F. Avril, *Manuscript Painting at the Court of France — The Fourteenth Century (1310–1380),* New York, 1978, 12, 40 ff. See the lively discussion of the activities in V. W. Egbert, *On the Bridges of Mediaeval Paris,* Princeton, 1974.

74. For the Book of Hours see V. Leroquais, *Les Livres d'heures manuscrits de la Bibliothèque Nationale,* 3 vols. and supplement, Paris and Mâcon, 1927–43; J. Harthan, *The Book of Hours,* New York, 1977; R. Calkins, *Illuminated Books of the Middle Ages,* Ithaca, 1983, 243–82.

75. The significance of the Book of Hours in the development of Late Gothic painting is discussed at length by E. Panofsky, *Early Netherlandish Painting,* Cambridge, Mass., 1953, I, *passim.*

76. J. Rorimer, *The Hours of Jeanne d'Evreux* (partial facsimile), New York, 1957. E. Panofsky, *Early Netherlandish Painting,* 29–34, 43–44. See the special issue of the *Bulletin of The Metropolitan Museum of Art,* n.s. 16, 1958, 269–92, with articles by R. H. Randall, Jr., and E. Winternitz. Also see S. Ferber, "Jean Pucelle and Giovanni Pisano," *Art Bulletin,* 66, 1984, 65–72.

77. W. Wixom, *Treasures from Medieval France,* exh. cat., Cleveland Museum of Art, 1967, 182; R. Koechlin, *Les Ivoires gothique français,* Paris, 1924, I, 94; II, no. 95; L. Grodecki, *Ivoires français,* Paris, 1947, 88; J. Natanson, *Gothic Ivories of the 13th and 14th Centuries,* London, 1951, 19 ff.

78. R. Koechlin, *Les ivoires gothiques français,* II and III, no. 1281; R. S. Loomis and L. H. Loomis, *Arthurian Legends in Medieval Art,* London and New York, 1938, 66, 70, 76; W. Wixom, *Treasures from Medieval France,* 208.

79. In general see A. Venturi, *Storia dell'arte italiana,* III, Milan, 1901–4; R. van Marle, *The Development of the Italian Schools of Painting,* I–III, The Hague, 1924; P. Toesca, *Storia dell'arte italiana,* II, Turin, 1927; J. White, *Art and Architecture in Italy, 1250–1400* (Pelican History of Art, no. 28), Harmondsworth, 1966; F. Hartt, *History of Italian Renaissance Art,* New York, 1980.

80. E. Kantorowicz, *Kaiser Friedrich der Zweite,* Berlin, 1927 (Eng. ed., *Frederick the Second, 1194–1250,* translated by E. O. Lorimer, London, 1931); P. E. Schramm, *Die deutschen Kaiser und Könige in Bildern ihrer Zeit,* Berlin, 1928; C. Shearer, *The Renaissance of Architecture in Southern Italy: A Study of Frederick II of Hohenstaufen and the Capua Triumphator Archway and Towers,* Cambridge, Eng., 1935; C. A. Willemsen, *Kaiser Friedrichs II. Triumphtor zu Capua,* Wiesbaden, 1953.

81. G. Swarzenski, *Nicola Pisano,* Frankfurt a. M., 1926; G. H. Crichton, *Nicola Pisano and the Revival of Sculpture in Italy,* Cambridge, Eng., 1938; G. N. Fasola, *Nicola Pisano,* Rome, 1941; E. M. Angiola, "Nicola Pisano, Federigo Visconti, and the Classical Style in Pisa," *Art Bulletin,* 59, 1977, 1–27; E. Carli, *Il pulpito del Battistero di Pisa,* Milan, 1971.

82. R. Krautheimer, *Rome: Profile of a City, 312–1308,* Princeton, 1980, 203–28; R. Bretano, *Rome Before Avignon,* New York, 1974.

83. J. Gardner, "Pope Nicholas IV and the Decoration of S. Maria Maggiore," *Zeitschrift für Kunstgeschichte,* 36, 1973, 1 ff.

84. E. Lavagnino, *Pietro Cavallini,* Rome, 1943; J. White, "Cavallini and the Lost Frescoes in S. Paolo," *Journal of the Warburg and Courtauld Institutes,* 19, 1956, 84 ff.; E. Sindona, *Pietro Cavallini,* Milan, 1958; G. Matthiae, *Pietro Cavallini,* Rome, 1972; P. Hetherington, "The Mosaics of Pietro Cavallini in S. Maria in Trastevere," *Journal of the Warburg and Courtauld Institutes,* 33, 1970, 84 ff.

85. For an excellent introduction to these types see E. Sandberg-Vavalà, *Sienese Studies: The Development of the School of Painting of Siena,* Florence, 1953, and *Uffizi Studies: The Development of the Florentine School of Painting,* Florence, 1948.

86. C. Brandi, *Duccio,* Florence, 1951; E. Carli, *Duccio,* Milan, 1952; J. White, *Duccio,* London, 1979; J. Stubblebine, *Duccio,* Princeton, 1980.

87. G. Paccagnini, *Simone Martini,* London, 1957. For Simone's activity in Avignon see J. Rowlands, "The Date of Simone Martini's Arrival in Avignon," *Burlington Magazine,* 107, 1965, 25–32.

88. A. Smart, "The St. Cecilia Master and His School at Assisi," *Burlington Magazine,* 102, 1960, 405 ff., 431 ff.; M. Meiss, *Giotto and Assisi,* New York, 1960; L. Tintori and M. Meiss, *The Painting of the Life of St. Francis in Assisi,* New York, 1962; for a succinct summary see J. White, *Art and Architecture in Italy,* 115–48. J. Poesche, *Die Kirche San Francesco in Assisi und ihre Wandmalereien,* Munich, 1985.

89. J. R. Moorman, *Early Franciscan Art and Literature,* Manchester, 1943; G. Kaftal, *St. Francis in Italian Painting,* London, 1950; L. Di Fonzo and A. Pompei, "Francesco da Assisi," in *Bibliotheca sanctorum,* Rome, 1964, cols. 1052–1150; O. Schmucki and S. Gerlach, "Franz von Assisi," *Lexikon der christlichen Ikonographie,* 6, 1974, cols. 260–315; J. Stubblebine, *Assisi and the Rise of Vernacular Art,* New York, 1985.

90. J. Garber, *Wirkungen der frühchristlichen Gemäldezyklen der alten Peters- und Paulsbasiliken in Rom,* Berlin, 1918.

91. W. Ueberwasser, *Giotto: Frescoes,* New York, 1950; C. Gnudi, *Giotto,* Milan, 1959; M. Meiss, *Giotto and Assisi;* E. Borsook, *The Mural Painters of Tuscany, from Cimabue to Andrea del Sarto,* London, 1960; E. Baccheschi and A. Martindale, *The Complete Paintings of Giotto,* New York, 1966; E. Battisti, *Giotto: Biographical and Critical Study,* Cleveland, 1966; J. Stubblebine, *Giotto: The Arena Chapel Frescoes,* New York, 1969; M. Baxandall, *Giotto and the Orators,* Oxford, 1971; B. Cole, *Giotto and Florentine Painting, 1280–1375,* New York, 1976; M. Barasch, *Giotto and the Language of Gesture,* Cambridge, Eng., 1987.

92. For translations of these texts see G. Ryan and H. Ripperger, *The Golden Legend of Jacobus Voragine,* 2 vols., London, 1941; I. Ragusa and R. Greene, *Meditations on the Life of Christ,* Princeton, 1961.

93. J. Pope-Hennessy, *Italian Gothic Sculpture,* London, 1955; M. Ayrton, *Giovanni Pisano,* New York, 1969.

94. P. Frankl, *The Gothic,* 119 ff.; V. Lusini, *Il Duomo di Siena,* Siena, 1911; J. White, *Art and Architecture in Italy,* 20 ff., 165–69.

95. G. Rowley, *Ambrogio Lorenzetti,* 2 vols., Princeton, 1958.

96. M. Meiss, *Painting in Florence and Siena After the Black Death,* Princeton, 1951.

97. J. S. Ackerman, "*Ars sine scientia nihil est:* Gothic Theory of Architecture at the Cathedral of Milan," *Art Bulletin,* 31, 1949, 84 ff.; P. Frankl, *The Gothic,* 80 ff.; J. White, *Art and Architecture in Italy,* 336–50. A fine summary of the problem of the textual sources appears in T. G. Frisch, *Gothic Art, 1140–c. 1450* (Sources and Documents), Englewood Cliffs, N.J., 1971, 143–48.

SELECT BIBLIOGRAPHY

The following bibliography does not include articles and monographs on individual monuments or artists. Consult the text and notes for more specialized studies. Books that cover more than one category in the bibliography are listed only once under that which seems most appropriate for their contents.

I. EARLY TEXTS AND DOCUMENTS, LITURGY, AND ICONOGRAPHY

A. EARLY TEXTS AND DOCUMENTS

For the series Sources and Documents in the History of Art, see under the individual periods to which their contents pertain.

BEDE. *A History of the Abbots of Wearmouth and Jarrow* (Loeb Classical Library). Trans. by J. E. King. Cambridge, Mass.: Harvard University Press, 1954.

————. *Bede's Ecclesiastical History of the English People.* Ed. by B. Colgrave and R. A. B. Mynors. Oxford: Oxford University Press, 1969.

BENEDICT THE CANON. *Mirabilia urbis Romae.* Trans. by Fr. M. Nichols in *The Marvels of Rome.* London: Ellis and Elvey, 1889.

BOLLANDUS, J. and EDS. *Acta sanctorum.* 66 vols. Paris: V. Palmé, 1863–.

Corpus christianorum, series Latina. 176 vols. Turnholt, Belgium: Typographi Brepols editores pontificii, 1953–65.

COULTON, G. G. *A Medieval Garner.* London: Constable and Co., 1910.

DIONYSIUS OF FOURNA. *Painter's Handbook (Hermeneia).* Fr. trans. in A. N. Didron, *Manuel d'iconographie chrétienne,* Paris: Imprimerie Royale, 1845; Eng. trans. of Didron by M. Stokes, *Christian Iconography.* 2 vols. London: H. G. Bohn, 1886–91.

DURANDUS, W. *The Symbolism of Churches and Church Ornaments: A Translation of the First Book of the Rationale Divinorum Officiorum.* Trans. by J. N. Neale and B. Webb. London: Gibbings & Co., 1893.

EUSEBIUS. *Vita Constantini.* Trans. by P. Schaff and H. Wace in *A Select Library of the Nicene and Post-Nicene Fathers.* 2nd ser. Vol. I. New York: The Christian Literature Co., 1890.

————. *Ecclesiastical History.* Trans. by H. J. Lawlor and J. E. Dutton. Harmondsworth: Penguin, 1965.

Fathers of the Church. 75 vols. Washington, D.C.: The Catholic University of America Press, 1947–86.

GREGORY OF TOURS. *History of the Franks.* Trans. by L. Thorpe. Harmondsworth: Penguin, 1974.

HOLT, E. G. *A Documentary History of Art,* I: *The Middle Ages and the Renaissance.* Garden City, N.Y.: Doubleday, 1957.

Liber pontificalis. Fr. ed. edited by L. Duchesne, *Le Liber Pontificalis.* 3 vols. Paris: E. Thorin, 1881–92; reprinted 1957; Eng. ed. by L. R. Loomis, *The Book of the Popes* (Records of Civilization, no. 3). New York: Columbia University Press, 1916.

LOT, F. *Collection des textes pour servir à l'étude et à l'enseignement de l'histoire.* Paris: A. Picard, 1894.

MIGNE, J. P. *Patrologiae cursus completus . . . series Graeca (Patrologia Graeca).* 161 vols. Paris, J. P. Migne, 1857–1903. Usually noted as *M. P. G.* or *P. G.*

————. *Patrologiae cursus completus . . . series Latina (Patrologia Latina).* 221 vols. Paris: Garnier fratres and J. P. Migne, 1844–79. Usually noted as *M. P. L.* or *P. L.*

MORTET, V. *Recueil de textes rélatifs à l'histoire de l'architecture et à la condition des architectes en France au Moyen Age.* Paris: A. Picard, 1911.

PAUL THE DEACON. *History of the Lombards.* Trans. by W. D. Foulke. Philadelphia: University of Pennsylvania Press, 1974.

PROCOPIUS. *De aedificiis.* Eng. trans. by H. B. Dewing and G. Downey, *Procopius.* Vol. 7. London: W. Heinemann, 1954.

RICHTER, J. P. *Quellen der byzantinischen Kunstgeschichte* (Quellenschriften für Kunstgeschichte und Kunsttechnik des Mittelalters und der Renaissance, n.s. 8). Vienna: C. Graeser, 1897.

ROSSI, G. DE. *Inscriptiones christianae urbis Romae.* 3 vols. Rome: Libraria Pontificia, 1861–88.

SCHLOSSER J. VON. *Quellenbuch zur Kunstgeschichte des abendländischen Mittelalters.* Vienna: C. Graeser, 1896.

————. *Schriftquellen zur geschichte der Karolingischen Kunst.* Vienna: C. Graeser, 1896.

A Select Library of Nicene and Post-Nicene Fathers of the Christian Church. 14 vols. New York: The Christian Literature Co., 1886–90.

THEOPHILUS. *De diversis artibus.* Trans. by C. R. Dodwell as *Theophilus: The Various Arts.* London: Nelson, 1961; J. G. Hawthorne and C. S. Smith. *On Divers Arts.* Chicago: University of Chicago Press, 1963.

UNGER, F. W. *Quellen der byzantinischen Kunstgeschichte.* Vienna: W. Braumüller, 1878.

B. LITURGY

CABASILAS, N. *A Commentary on the Divine Liturgy.* Trans. by J. Hussey and P. McNulty. London: Society for the Promotion of Christian Knowledge, 1960; reprinted 1977.

CABROL, F. and LECLERCQ, H. *Dictionnaire d'archéologie chrétienne et de liturgie.* 15 vols. Paris: Letouzey et Ané, 1907–.

DIX, G. *The Shape of the Liturgy.* London: Dacre, 1945.

DUCHESNE, L. *Christian Worship, Its Origin and Evolution: A Study of Latin Liturgy up to the Time of Charlemagne.* Trans. by M. L. McClure. London: E. and J. B. Young, 1903.

JUNGMANN, J. A. *The Mass: An Historical, Theological, and Pastoral Study.* Trans. by J. Fernandes and M. E. Evans. Collegeville, Minn.: Liturgical Press, 1976.

KLAUSER, T. *A Short History of Western Liturgy.* Trans. by J. Halliburton. London and New York: Oxford University Press, 1969.

SOLOVEY, M. M. *The Byzantine Divine Liturgy.* Washington, D. C.: Catholic University of America Press, 1970.

C. ICONOGRAPHY

BONAVENTURA, SAINT. *Meditationes vitae Christi.* See I. Ragusa and R. Green, *Meditations on the Life of Christ: An Illustrated Manuscript of the Fourteenth Century* (Paris, Bibliothèque Nationale, MS. ital. 115). Princeton: Princeton University Press, 1961.

BRENK, B. *Tradition und Neuerung in der christlichen Kunst des ersten Jahrtausends: Studien zur Geschichte des Weltgerichtsbildes.* Vienna: H. Böhlaus, 1966.

BUTLER, A. *Lives of the Saints.* Ed. and rev. by H. Thurston and D. Attwater. 4 vols. New York: P. J. Kenedy, 1963.

CURTIUS, E. *European Literature and the Latin Middle Ages.* New York: Pantheon, 1953.

FERGUSON, G. *Signs & Symbols in Christian Art.* New York: Oxford University Press, 1959.

GRABAR, A. *Christian Iconography: A Study of its Origins.* Princeton: Princeton University Press, 1968.

HALL, J. *Dictionary of Subjects and Symbols in Art.* New York: Harper and Row, 1974.

JAMES, M. R. *The Apocryphal New Testament.* Oxford: Oxford University Press, 1924.

————. *The Apocalypse in Art.* London: British Academy, 1931.

JAMESON, A. B. *Legends of the Monastic Order.* London: Longmans, Green, 1852.

————. *Legends of the Madonna.* Boston: Osgood, 1877.

————. *Sacred and Legendary Art.* Boston: Houghton Mifflin, 1896.

JANSON, H. W. *Apes and Ape Lore in the Middle Ages and the Renaissance.* London: Warburg Institute, 1952.

KAFTAL, G. *The Saints in Italian Art.* 2 vols. Florence: Sansoni, 1952–56.

KATZENELLENBOGEN, A. *Allegories of the Virtues and Vices in Medieval Art.* London: Warburg Institute, 1939.

KIRSCHBAUM, E. et al. *Lexikon der christlichen Ikonographie.* Freiburg i. B.: Herder, 1968–72.

KÜNSTLE, K. *Ikonographie der christlichen Kunst.* 2 vols. Freiburg i. B.: Herder, 1924–28.

LEJEUNE, R. and STIENNON, A. *The Legend of Roland in the Art of the Middle Ages.* 2 vols. London: Phaidon, 1971.

LOOMIS, R. S. and LOOMIS, L. H. *Arthurian Legends in Medieval Art.* London: Oxford University Press, 1938; reprinted 1966.

MARLE, R. VAN. *Iconographie de l'art profane au moyen âge et à la Renaissance.* 2 vols. The Hague: M. Nijhoff, 1932.

MEER, F. VAN DER. *Maiestas Domini: Théophanies de l'Apocalypse dans l'art chrétien.* Vatican City: Pontificio istituto di archeologia cristiana, 1938.

NEUSS, W. *Das Buch Ezechiel in Theologie und Kunst.* Münster: Aschendorff, 1912.

PANOFSKY, E. *Studies in Iconology.* New York: Oxford University Press, 1939.
———. *Meaning in the Visual Arts.* Garden City, N.Y.: Doubleday, 1955.

Reallexikon für Antike und Christentum. Ed. by T. Klauser et al. Stuttgart: A. Hiersemann, 1950–.

Reallexikon zur byzantinischen Kunst. Ed. by K. Wessel and M. Restle. Stuttgart: A. Hiersemann, 1966–.

Reallexikon zur deutschen Kunstgeschichte. Ed. O. Schmitt. 8 vols. Stuttgart: J. B. Metzler, 1937–.

RÉAU, L. *Iconographie de l'art chrétien.* 6 vols. Paris: Presses Universitaires de France, 1955–59.

SAUER, J. *Symbolik des Kirchengebäudes.* 2 vols. Freiburg i. B.: Herder, 1924.

SCHILLER, G. *Iconography of Christian Art.* Trans. by J. Seligman. 2 vols. Greenwich, Conn.: New York Graphic Society, 1971–72.

SEZNEC, J. *The Survival of the Pagan Gods.* New York: Pantheon, 1953.

THOBY, P. *Le Crucifix: Des origines au Concile de Trente.* Nantes: Bellanger, 1959.

TIMMERS, J. J. M. *Symboliek en iconographie der christelijke kunst.* Roermond-Maaseik: J. J. Romen and Sons, 1947.

VORAGINE, J. DE. *Legenda aurea.* See *The Golden Legend of Jacobus de Voragine.* Trans. by G. Ryan and H. Ripperger. 2 vols. London: Longmans, Green, 1941.

WATSON, A. *The Early Iconography of the Tree of Jesse.* Oxford: Oxford University Press, 1934.

WEBSTER, J. C. *The Labours of the Months in Antique and Medieval Art to the End of the Twelfth Century.* Princeton: Princeton University Press, 1938.

WELLEN, G. A. *Theotokos: Eine ikonographische Abhandlung über das Gottesmutterbild in frühchristlicher Zeit.* Utrecht: Spectrum, 1961.

WHITE, T. H. *The Book of Beasts, Being a Translation from a Latin Bestiary of the 12th Century.* New York: G. P. Putnam, 1954.

WINTERNITZ, E. *Musical Instruments and Their Symbolism in Western Art.* London: Faber and Faber, 1967.

II. GENERAL CULTURAL HISTORIES AND SURVEYS

ADHÉMAR, J. *Influences antiques aans l'art du moyen âge français.* London: Warburg Institute, 1939.

ALEXANDER, J. J. G. *The Decorated Letter.* New York: Braziller, 1978.

ANTHONY, E. W. *A History of Mosaics.* Boston: P. Sargent, 1935.

AUBERT, M. *La sculpture française au moyen-âge.* Paris: Flammarion, 1947.

BALTRUSAITIS, J. *Le moyen âge fantastique.* Paris: A. Colin, 1955.

BRAUNFELS, W. *Monasteries of Western Europe: The Architecture of the Orders.* Princeton: Princeton University Press, 1972.

———. *Die Kunst im Heiligen Römischen Reich Deutscher Nation.* 5 vols. to date. Munich: C. H. Beck, 1979–.

BROOKE, C. *The Structure of Medieval Society.* London: Thames and Hudson, 1971.

———. *The Monastic World, 1000–1300.* New York: Random House, 1974.

BRYER, A. and HERRIN, J., eds. *Iconoclasm: Papers Given at the Ninth Spring Symposium of Byzantine Studies,* University of Birmingham, March 1975. Birmingham, Eng.: University of Birmingham Press, 1977.

CALKINS, R. *Monuments of Medieval Art.* New York: Dutton, 1979.

———. *Illuminated Books of the Middle Ages.* Ithaca: Cornell University Press, 1983.

———. *Programs of Medieval Illumination.* Lawrence, Kan.: University of Kansas Press, 1984.

DAVIDSON, C. *Drama and Art.* Kalamazoo: Western Michigan University Press, 1977.

DEHIO, G. and BEZOLD, G. VON. *Die Kirchliche Baukunst des Abendlandes.* 7 vols. Stuttgart: J. G. Cotta, 1884–1901.

DODWELL, C. R. *Painting in Europe 800–1200* (Pelican History of Art, no. 34). Harmondsworth: Penguin, 1971.

DOMÍNGUEZ BORDONA, J. *Spanish Illumination.* Florence: Pantheon, 1929.

EGBERT, V. W. *The Medieval Artist at Work.* Princeton: Princeton University Press, 1967.

ENLART, C. *Manuel d'archéologie française.* 2nd ed. 5 vols. Paris: A. Picard, 1919–32.

EVANS, J. *Art in Medieval France, 987–1498.* London: Oxford University Press, 1948.

FILLITZ, H., ed. *Das Mittelalter I* (Propyläen Kunstgeschichte, vol. 5). Berlin: Propyläen Verlag, 1969.

FOCILLON, H. *The Life of Forms in Art.* New Haven: Yale University Press, 1942.

GALL, E. *Cathedrals and Abbey Churches of the Rhine.* New York: Harry N. Abrams, Inc., 1963.

GARDNER, A. *Medieval Sculpture in France.* New York: Macmillan, 1931; reprinted 1969.

GRODECKI, L. *Les vitraux des églises de France.* Paris: Editions du chêne, 1947.
———. *Vitraux de France du XIe au XVI siècle* (exh. cat.). Paris, Musée des arts décoratifs, 1953.

HARVEY, J. H. *The Master Builders: Architecture in the Middle Ages.* New York: McGraw-Hill, 1971.

HAUTTMANN, M. *Die Kunst des frühen Mittelalters* (Propyläen Kunstgeschichte, vol. 6). Berlin: Propyläen Verlag, 1929.

HERMANIN, F. *L'arte in Roma dal secolo VIII al XIV.* Bologna: L. Cappelli, 1945.

HUSSEY, J. M. et al. *The Cambridge Medieval History.* 10 vols. Cambridge, Eng.: Cambridge University Press, 1957–67. See also C. W. Previté-Orton, *The Shorter Cambridge Medieval History.* Cambridge, Eng.: Cambridge University Press, 1953.

KITZINGER, E. *Early Medieval Art, with Illustrations from the British Museum Collection.* Bloomington, Ind.: Indiana University Press, 1964 (reprint of 1940 London ed.).

KRAUTHEIMER, R. *Studies in Early Christian, Medieval and Renaissance Art.* New York: New York University Press, 1969.

———. *Rome: Profile of a City, 312–1308.* Princeton: Princeton University Press, 1980.

LASKO, P. *Ars Sacra: 800–1200* (Pelican History of Art, no. 36). Harmondsworth: Penguin, 1972.

LIETZMANN, H. *A History of the Early Church.* 4 vols. New York: Scribner's, 1937–52.

MARTINDALE, A. *The Rise of the Artist in the Middle Ages and Early Renaissance.* New York: McGraw-Hill, 1972.

MATTHIAE, G. *Pittura romana del medioevo.* Rome: Fratelli Palombi, 1965.

———. *Mosaici medioevali delle chiese di Roma.* 2 vols. Rome: Istituto poligrafico dello stato, 1967.

MONTAGU, J. *The World of Medieval and Renaissance Musical Instruments.* London: David and Charles, 1976.

MOREY, C. R. *Medieval Art.* New York: W. W. Norton, 1942.

NEES, L. *From Justinian to Charlemagne, European Art, 565–787: An Annotated Bibliography.* Boston: G. K. Hall, 1985.

OAKESHOTT, W. *Classical Inspiration in Medieval Art.* London: Chapman and Hall, 1959.

———. *The Mosaics of Rome from the Third to the Fourteenth Centuries.* Greenwich, Conn.: New York Graphic Society, 1967.

PALOL, P. DE and HIRMER, M. *Early Medieval Art in Spain.* New York: Harry N. Abrams, Inc., 1967.

PEVSNER, N. *An Outline of European Architecture.* 7th ed. Harmondsworth: Penguin, 1974.

PICKERING, F. P. *Literature and Art in the Middle Ages.* Coral Gables: University of Miami Press, 1970.

PORTER, A. K. *Medieval Architecture: Its Origins and Development.* 2 vols. New Haven: Yale University Press, 1912.

———. *Lombard Architecture.* 4 vols. New Haven: Yale University Press, 1915–17.

POST, C. R. *A History of Spanish Painting.* 12 vols. Cambridge, Mass.: Harvard University Press, 1930–58.

Rhin-Meuse: Art et civilization 800–1400 (exh. cat.). Cologne, Kunsthalle, and Brussels, Musées royaux des Beaux-Arts, 1972.

RICKERT, M. *Painting in Britain: The Middle Ages* (Pelican History of Art, no. 5). Harmondsworth: Penguin, 1954; 2nd ed., 1965.

ROBB, D. M. *The Art of the Illuminated Manuscript.* South Brunswick, Eng.: Barnes, 1973.

SALMI, M. *Italian Miniatures.* New York: Harry N. Abrams, Inc., 1956.

SAXL, F. and WITTKOWER, R. *British Art and the Mediterranean.* London: Oxford University Press, 1948.

SCHAPIRO, M. *Late Antique, Early Christian and Medieval Art.* New York: Braziller, 1979.

SCHELLER, R. W. *A Survey of Medieval Model Books.* Haarlem: De Erven F. Bohn, 1963.

SIMSON, O. VON. *Das Mittelalter II* (Propyläen Kunstgeschichte, vol. 6). Berlin: Propyläen Verlag, 1972.

SMITH, E. B. *The Dome.* Princeton: Princeton University Press, 1950.
———. *Architectural Symbolism of Imperial Rome and the Middle Ages.* Princeton: Princeton University Press, 1956.

STODDARD, W. S. *Art and Architecture in Medieval France.* New York: Harper and Row, 1972.

STOKSTAD, M. *Medieval Art.* New York: Harper and Row, 1986.

STONE, L. *Sculpture in Britain: The Middle Ages* (Pelican History of Art, no. 9). Harmondsworth: Penguin, 1955.

TOESCA, P. *Storia dell'arte italiana.* 3 vols. Turin: Unione tipografico-editrice torinese, 1927–51.

TRISTRAM, E. *English Medieval Wall Paintings.* 3 vols. London: Oxford University Press, 1944.

VENTURI, A. *Storia dell'arte italiana.* 11 vols. Milan: C. Hoepli, 1901–40.

VOLBACH, W. F. and LAFONTAINE-DOSOGNE, J. *Byzanz und der christliche Osten* (Propyläen Kunstgeschichte, vol. 3). Berlin: Propyläen Verlag, 1968.

WEBB, G. *Architecture in Britain—The Middle Ages* (Pelican History of Art, no. 12). Harmondsworth: Penguin, 1956.

WEITZMANN, K. *Illustrations in Roll and Codex.* Princeton: Princeton University Press, 1947; rev. ed., 1970.

WILPERT, J. *Die römischen Mosaiken und Malereien der kirchlichen Bauten vom IV. bis XIII. Jahrhundert.* 3rd ed. 4 vols. Freiburg i. B.: Herder, 1924; Condensed version edited by W. N. Schumacher, 1976.

WIXOM, W. *Treasures from Medieval France* (exh. cat.). Cleveland Museum of Art, 1967.

ZARNECKI, G. *Art of the Medieval World.* New York: Harry N. Abrams, Inc., 1975.

III. EARLY CHRISTIAN

BECKWITH, J. *Coptic Sculpture.* London: A. Tiranti, 1963.

———. *Early Christian and Byzantine Art* (Pelican History of Art, no. 33). Harmondsworth: Penguin, 1970.

BERCHEM, M. VAN and CLOUZOT, E. *Mosaïques chrétiennes du IVme au Xme siècle.* Geneva: "Jour de Genève," 1924.

BIANCHI-BANDINELLI, R. *Rome, The Center of Power, 500 B.C. to A.D. 200* (Arts of Mankind). New York: Braziller, 1970.

———. *Rome: The Late Empire, Roman Art A.D. 200–400* (Arts of Mankind). New York: Braziller, 1971.

BUTLER, H. C. and SMITH, E. B. *Early Churches in Syria.* Princeton: Princeton University Press, 1929.

DAVIES, J. G. *The Origin and Development of Early Christian Church Architecture.* London: SCM Press, 1952.

DAVIS-WEYER, C. *Early Medieval Art: 300–1150* (Sources and Documents in the History of Art). Englewood Cliffs, N.J.: Prentice-Hall, 1971.

DEICHMANN, F. W. *Frühchristliche Kirchen in Rom.* Basel: Amerbach Verlag, 1948.

———. *Ravenna, Hauptstadt des spätantiken Abendlandes.* 3 vols. I: *Geschichte und Monumente,* Wiesbaden: F. Steiner, 1969; II: *Kommentar,* Wiesbaden: F. Steiner, 1974; III: *Frühchristliche Bauten und Mosaiken von Ravenna,* Wiesbaden: F. Steiner, 1968–76.

DELBRUECK, R. *Die Consulardiptychen und verwandte Denkmäler.* 2 vols. Berlin and Leipzig: W. de Gruyter, 1929.

GOUGH, M. *The Origins of Christian Art.* London: Thames and Hudson, 1974.

GRABAR, A. *Martyrium: Recherches sur le culte des reliques et l'art chrétien antique.* 2 vols. Paris: Collège de France, 1943–46.

———. *Les Ampoules de Terre Sainte (Monza, Bobbio).* Paris: C. Klincksieck, 1958.

———. *Early Christian Art, from the Rise of Christianity to the Death of Theodosius* (Arts of Mankind). New York: Odyssey Press, 1969.

HAMBERG, P. G. *Studies in Roman Imperial Art with Special Reference to the State Reliefs of the Second Century.* Copenhagen: E. Munksgaard, 1945.

IHM, C. *Die Programme der christlichen Apsismalerei vom vierten Jahrhundert bis zur Mitte des achten Jahrhunderts* (Forschungen zur Kunstgeschichte und christlichen Archäologie, no. 4). Wiesbaden: F. Steiner, 1960.

KRAUTHEIMER, R. *Early Christian and Byzantine Architecture* (Pelican History of Art, no. 24). Harmondsworth: Penguin, 1965; 2nd ed., 1981.

———. *Three Christian Capitals: Topography and Politics.* Berkeley: University of California Press, 1983.

——— et al. *Corpus basilicarum christianarum Romae.* 5 vols. Vatican City: Pontificio istituto di archeologia cristiana, 1937–77.

LASSUS, J. *Sanctuaires chrétiens de Syrie.* Paris: P. Geuthner, 1947.

LOWRIE, W. *Art in the Early Church.* New York: Pantheon Books, 1947; 2nd rev. ed., 1966.

MACDONALD, W. *Early Christian and Byzantine Architecture.* New York: Braziller, 1962.

MÂLE, E. *The Early Churches of Rome.* Chicago: Quadrangle Books, 1960.

MEER, R. VAN DER. *Early Christian Art.* Chicago: University of Chicago Press, 1967.

——— and MOHRMANN, C. *Atlas of the Early Christian World.* London: Nelson, 1958.

MOREY, C. R. *Early Christian Art.* 2nd ed. Princeton: Princeton University Press, 1953.

NATANSON, J. *Early Christian Ivories.* London: A. Tiranti, 1953.

L'ORANGE, H. P. *Art Forms and Civic Life in the Late Roman Empire.* Princeton: Princeton University Press, 1965.

ROSTOVTZEFF, M. I. *The Excavations at Dura-Europos . . . ,* Preliminary Reports I–IX. New Haven: Yale University Press, 1929–46.

———. *Dura-Europos and Its Art.* Oxford: Clarendon Press, 1938.

SIMSON, O. VON. *The Sacred Fortress.* Chicago: University of Chicago Press, 1948.

VOLBACH, W. F. *Early Christian Art.* New York: Harry N. Abrams, Inc., 1961.

———. *Elfenbeinarbeiten der Spätantike und des frühen Mittelalters.* 3rd ed. Mainz: P. von Zabern, 1976.

WAETZOLDT, S. *Die Kopien des 17. Jahrhunderts nach Mosaiken und Wandmalereien in Rom.* Vienna: Schroll Verlag, 1964.

WEITZMANN, K. *Ancient Book Illumination.* Cambridge, Mass.: Harvard University Press, 1959.

———. *Late Antique and Early Christian Book Illumination.* New York: Braziller, 1977.

WESSEL, K. *Coptic Art in Early Christian Egypt.* New York: McGraw-Hill, 1975.

WILPERT, J. *Roma Sotterranea: Le pitture delle catacombe romane.* Rome: Deselée, Lefebvre & Cie, 1903.

———. *I Sarcofagi cristiani antichi.* 3 vols. Vatican City: Pontificio istituto di archeologia cristiana, 1929–36.

IV. BYZANTINE

AINALOV, D. V. *The Hellenistic Origins of Byzantine Art.* New Brunswick, N.J.: Rutgers University Press, 1961.

BECKWITH, J. *The Art of Constantinople: An Introduction to Byzantine Art 300–1453.* New York: Phaidon, 1961.

BICEV, M. and BOSSILKOV, S. *Byzanz und der christliche Osten* (Propyläen Kunstgeschichte, vol. 3). Berlin: Propyläen Verlag, 1968.

CHATZIDAKIS, M., ed. *Byzantine Art: An European Art, Ninth Exhibition Held Under the Auspices of the Council of Europe; Lectures.* Athens: Office of the Minister, 1966.

CORMACK, R. *Writing in Gold: Byzantine Society and its Icons.* New York: Oxford University Press, 1985.

DALTON, O. M. *Byzantine Art and Archaeology.* Oxford: Oxford University Press, 1911; reprinted 1965.

DEICHMANN, F. W. *Studien zur Architektur Konstantinopels.* Baden-Baden: B. Grimm, 1956.

DEMUS, O. *Byzantine Mosaic Decoration: Aspects of Monumental Art in Byzantium.* London: Paul, Trench, Trubner, 1948.

———. *The Mosaics of Norman Sicily.* London: Routledge & Kegan Paul, 1950.

———. *Byzantine Art and the West.* New York: New York University Press, 1970.

———. *The Mosaics of San Marco in Venice.* 2 vols. Chicago: University of Chicago Press, 1984.

——— and DIEZ, E. *Byzantine Mosaics in Greece: Hosios Lucas and Daphni.* Cambridge, Mass.: Harvard University Press, 1931.

DIEHL, C. *Manuel d'art byzantine.* 2nd ed. 2 vols. Paris: A. Picard, 1925–26.

DODD, E. CRUIKSHANK. *Byzantine Silver Stamps.* Washington, D.C.: Dumbarton Oaks Research Library and Collection, 1961.

GOLDSCHMIDT, A. and WEITZMANN, K. *Die byzantinischen Elfenbeinskulpturen.* 2 vols. Berlin: B. Cassirer, 1930–34.

GRABAR, A. *L'Empereur dans l'art byzantin.* Paris: Belles lettres, 1936.

———. *Miniatures byzantines de la Bibliothèque Nationale.* Paris: Belles lettres, 1939; reprinted 1971.

———. *Byzantine Painting.* Geneva: Skira, 1953; reprinted 1979.

———. *L'Iconoclasme byzantin.* Paris: Collège de France, 1957.

———. *Sculptures byzantines de Constantinople, IVe–Xe siècle.* Paris: Librarie Adrien Maissoneuve, 1963.

———. *The Art of the Byzantine Empire.* New York: Crown, 1966.

———. *The Golden Age of Justinian: From the Death of Theodosius to the Rise of Islam* (Arts of Mankind). New York: Odyssey Press, 1967.

HAMILTON, J. A. *Byzantine Architecture and Decoration.* London: B. T. Batsford, 1956.

HODDINOTT, R. F. *Early Byzantine Churches in Macedonia and Southern Serbia.* London: Macmillan, 1963.

KITZINGER, E. *The Mosaics of Monreale.* Palermo: S. F. Flaccovio, 1960.

———. *The Art of Byzantium and the Medieval West: Selected Studies by Ernst Kitzinger.* Ed. W. E. Kleinbauer. Bloomington, Ind.: Indiana University Press, 1976.

———. *Byzantine Art in the Making: Main Lines of Stylistic Development in Mediterranean Art, 3rd–7th Century.* Cambridge, Mass.: Harvard University Press, 1977.

LAZAREV, V. *Storia della pittura bizantina.* Turin: Einaudi, 1967.

MAGUIRE, H. *Art and Eloquence in Byzantium*. Princeton: Princeton University Press, 1981.

MANGO, C. *The Brazen House* (Kgl. Dansk Vidensk. Selskab., Arkaeologisk-kunsthistoriske meddelelser, no. 4). Copenhagen: I kommission hos Munksgaard, 1959.

———. *The Art of the Byzantine Empire, 312–1453* (Sources and Documents in the History of Art). Englewood Cliffs, N.J.: Prentice-Hall, 1972.

———. *Byzantine Architecture*. New York: Harry N. Abrams, Inc., 1976.

———. *Byzantium: The Empire of New Rome*. London: Weidenfeld and Nicolson, 1980.

MATHEW, G. *Byzantine Aesthetics*. New York: Viking Press, 1963.

MATHEWS, T. F. *The Byzantine Churches of Istanbul*. University Park, Pa.: Pennsylvania State University Press, 1976.

MATZULEWITSCH, L. *Byzantinische Antike*. Berlin and Leipzig: W. de Gruyter, 1929.

MICHELIS, P. A. *An Aesthetic Approach to Byzantine Art*. London: B. T. Batsford, 1955.

MILLET, G. *Recherches sur l'iconographie de l'Evangile*. Paris: Fontemoing, 1916.

MILLINGEN, A. VAN et al. *Byzantine Churches in Constantinople: Their History and Architecture*. London: Macmillan, 1912.

NICE, R. L. VAN. *Saint Sophia in Istanbul: An Architectural Survey*. Washington, D. C.: Dumbarton Oaks Center for Byzantine Studies, 1965.

OMONT, H. *Evangiles avec peintures byzantines du XIe siècle*. 2 vols. Paris: Berthaud frères, 1908.

———. *Miniatures des plus anciens manuscrits grecs de la Bibliothèque Nationale du VIe au XIVe siècle*. Paris: H. Champion, 1929.

RESTLE, M. and WESSEL, K., eds. *Reallexikon zur Byzantinischen Kunst*. Stuttgart: Anton Hiersemann, 1966.

RICE, D. T. *Byzantine Art*. Oxford: Clarendon Press, 1935; revised 1968.

———. *The Appreciation of Byzantine Art*. London: Oxford University Press, 1972.

SOTIRIOU, G. A. and SOTIRIOU, M. *Icones du Mont Sinai*. Athens: Institut français, 1956–58.

SWIFT, E. H. *Hagia Sophia*. New York: Columbia University Press, 1940.

VENDITTI, A. *Architettura bizantina nell'Italia meridionale*. Naples: Edizione Scientifiche Italiana, 1967.

WEITZMANN, K. *Studies in Classical and Byzantine Manuscript Illumination*. Chicago: University of Chicago Press, 1971.

———. *The Monastery of Saint Catherine at Mount Sinai: The Icons*. Princeton: Princeton University Press, 1976.

———. *The Icon: Holy Images, Sixth to Fourteenth Century*. New York: Braziller, 1978.

———. *The Icon*. New York: Knopf, 1982.

——— et al. *A Treasury of Icons: Sixth to Seventeenth Centuries*. New York: Harry N. Abrams, Inc., 1968.

———, ed. *The Age of Spirituality* (exh. cat.). New York, The Metropolitan Museum of Art, 1978–79.

———. *The Age of Spirituality: A Symposium*. New York: The Metropolitan Museum of Art, 1980.

WESSEL, K. *Byzantine Enamels*. Greenwich, Conn.: New York Graphic Society, 1967.

WHITTEMORE, T. *The Mosaics of St. Sophia at Istanbul. Third Preliminary Report: The Imperial Portraits of the South Gallery*. Oxford: Oxford University Press, 1942.

V. PRE-ROMANESQUE

ÅBERG, N. *The Occident and the Orient in the Art of the Seventh Century*. 3 vols. Stockholm: Wahlström and Widstrand, 1943–47.

ALEXANDER, J. J. G. *Insular Manuscripts: Sixth to the Ninth Century*. London: H. Miller, 1978.

BACKES, M. and DÖLLING, R. *Art of the Dark Ages*. New York: Harry N. Abrams, Inc., 1971.

BANDMANN, G. *Mittelalterliche Architektur als Bedeutungsträger*. Berlin: Gebr. Mann, 1951.

BECKWITH, J. *Early Medieval Art*. New York: Praeger, 1964; rev. ed., 1969.

BOINET, A. *La Miniature carolingienne*. Paris: A. Picard, 1913.

BRAUN, J. *Meisterwerke der deutschen Goldschmiedekunst der vorgotischen Zeit*. Munich: Riehn & Reusch, 1922.

BRAUNFELS, W. *Die Welt der Karolinger und ihre Kunst*. Munich: Callwey, 1968.

——— et al., eds. *Karl der Grosse, Werk und Wirkung* (exh. cat.). Aachen, Town Hall and Cathedral, 1965.

———. *Karl der Grosse: Lebenswerk und Nachleben*. 5 vols. Düsseldorf: L. Schwann, 1965–68.

BROWN, G. B. *The Arts in Early England*. 7 vols. London: Clarendon Press, 1903–37.

BULLOUGH, D. *The Age of Charlemagne*. London: Elek Books, 1965.

CONANT, K. J. *Carolingian and Romanesque Architecture: 800–1200* (Pelican History of Art, no. 13). Harmondsworth: Penguin, 1959.

DODWELL, C. R. *Anglo-Saxon Art: A New Perspective*. Ithaca: Cornell University Press, 1982.

FOCILLON, H. *L'An mil*. Paris: A. Colin, 1952; Eng. ed., *The Year 1000*. New York: F. Ungar, 1969.

FOOTE, P. G. and WILSON, D. M. *The Viking Achievement*. 2nd ed. London: Sidgwick & Jackson, 1980.

FOX, C. *Pattern and Purpose: A Survey of Early Celtic Art in Britain*. Cardiff: National Museum of Wales, 1958.

GAEHDE, J. E. and MÜTHERICH, F. *Carolingian Painting*. New York: Braziller, 1976.

GOLDSCHMIDT, A. *Die Elfenbeinskulpturen aus der Zeit der karolingischen und sächsischen Kaiser*. 4 vols. Berlin: B. Cassirer, 1914–26.

———. *Die deutschen Bronzetüren des frühen Mittelalters*. 3 vols. Marburg: Verlag des Kunstgeschichlichen Seminars der Universität Marburg, 1926–32.

———. *German Illumination*. 2 vols. New York: Harcourt Brace, 1928.

GÓMEZ-MORENO, M. *Iglesias mozárbes*. 2 vols. Madrid: Centro de estudios históricos, 1919.

———. *El arte árabe español hasta los Almohades, Arte Mozárabe* (Ars Hispaniae, vol. 3). Madrid: Plus-Ultra, 1951.

GRABAR, A. and NORDENFALK, C. *Early Medieval Painting from the Fourth to the Eleventh Century*. Lausanne: Skira, 1957.

GRODECKI, L. *L'Architecture ottonienne*. Paris: A. Colin, 1958.

——— et al. *Le siècle de l'an mil*. Paris: Gallimard, 1973.

HASELOFF, A. *Pre-Romanesque Sculpture in Italy*. New York: Harcourt Brace, 1931.

HENDERSON, G. *Early Medieval*. Harmondsworth: Penguin, 1972.

HENRY, F. *Irish Art in the Early Christian Period*. London: Methuen, 1940; rev. ed., 1965.

———. *Irish High Crosses*. Dublin: Three Candles, 1964.

———. *Irish Art During the Viking Invasions*. Ithaca: Cornell University Press, 1967.

———. *Studies in Early Christian and Medieval Irish Art*. London: Pindar Press, 1983.

HINKS, R. *Carolingian Art*. London: Sidgwick & Jackson, 1935; reprinted 1962.

HOLLÄNDER, H. *Early Medieval Art*. London: Weidenfeld and Nicolson, 1974.

HOLMQVIST, W. *Germanic Art During the First Millennium A.D.* Stockholm: Kungl. Vitterhets, 1955.

HUBERT, J. *L'Art pré-roman*. Paris: Les Editions d'art et d'histoire, 1938.

——— et al. *Europe of the Invasions* (Arts of Mankind). New York: Braziller, 1969.

———. *The Carolingian Renaissance* (Arts of Mankind). New York: Braziller, 1970.

JANTZEN, H. *Ottonische Kunst*. Munich: Münchner Verlag, 1947; 2nd ed., 1959.

KENDRICK, T. D. *Anglo-Saxon Art to A. D. 900*. London: Methuen, 1938.

———. *Late Saxon and Viking Art*. London: Methuen, 1949.

KÖHLER, W. *Die Karolingischen Miniaturen*. 7 vols. Berlin: B. Cassirer, 1930–71.

LASKO, P. *The Kingdom of the Franks*. London: Thames and Hudson, 1971.

LEHMANN, E. *Die frühe deutsche Kirchenbau*. 2 vols. Berlin: Deutscher Verein für Kunstwissenschaft, 1938.

MICHEL, P. H. *Romanesque Wall Paintings in France*. London: Thames and Hudson, 1950.

NEUSS, W. *Die katalanische Bibelillustration um die Wende des ersten Jahrtausends und die altspanische Buchmalerei*. Bonn: K. Schroeder, 1922.

———. *Die Apokalypse des Hl. Johannes in der altspanischen und altchristlichen Bibelillustration*. 2 vols. Münster: Aschendorff, 1931.

NORDENFALK, C. *Celtic and Anglo-Saxon Painting: Book Illumination in the British Isles 600–800*. New York: Braziller, 1977.

PAOR, M. and PAOR, L. DE. *Early Christian Ireland*. London: Thames and Hudson, 1960.

PICTON, H. *Early German Art and Its Origins*. London: B. T. Batsford, 1939.

PORCHER, J. *Les manuscrits à peintures en France du VIIe aux XIIe siècles* (exh. cat.). Paris, Bibliothèque Nationale, 1954.

RICE, D. T., ed. *English Art, 871–1100*. Oxford: Clarendon Press, 1952.

———. *The Dawn of European Civilization: The Dark Ages*. New York: McGraw-Hill, 1965; 3rd ed., 1969.

ROTH, H. *Kunst der Volkerwanderungszeit* (Propyläen Kunstgeschichte, supp. vol. 4). Frankfort: Propyläen Verlag, 1979.

SCHLUNK, H. *Arte Visigodo, Arte Asturiano* (Ars Hispaniae, vol. 2). Madrid: Plus-Ultra, 1947.

SCHRADE, H. *Vor- und frühromanische Malerei*. Cologne: Dumont Schauberg, 1958.

SCHRAMM, P. E. *Die deutschen Kaiser und Könige in Bildern ihrer Zeit*. Leipzig: Teubner, 1928.

——— and MÜTHERICH, F. *Denkmäle der deutschen Könige und Kaiser*. 2 vols. Munich: Prestel, 1962–78.

SPEAKE, G. *Anglo-Saxon Animal Art and Its Germanic Background.* New York: Oxford University Press, 1980.

Studies in Western Art: Romanesque and Gothic. Acts of the XX International Congress of the History of Art. 2 vols. Princeton: Princeton University Press, 1963.

SULLIVAN, R. *Aix-en-Chapelle in the Age of Charlemagne.* Norman, Okla: University of Oklahoma Press, 1974.

TAYLOR, H. and TAYLOR, J. *Anglo-Saxon Architecture.* 3 vols. Cambridge, Eng.: Cambridge University Press, 1965–78.

VERDIER, P. and ROSS, M. C. *Arts of the Migration Period in the Walters Art Gallery.* Baltimore: Walters Art Gallery, 1961.

VERZONE, P. *The Art of Europe: The Dark Ages from Theodoric to Charlemagne.* New York: Crown, 1968.

WILLIAMS, J. *Early Spanish Manuscript Illumination.* New York: Braziller, 1977.

WILSON, D. M. *The Anglo-Saxon Art from the Seventh Century to the Norman Conquest.* New York: Overlook Press, 1984.

———— and KLINDT-JENSEN, O. *Viking Art.* Ithaca: Cornell University Press, 1966.

WORMALD, F. *English Drawings of the Tenth and Eleventh Centuries.* London: Faber and Faber, 1952.

ZIMMERMANN, E. H. *Vorkarolingische Miniaturen.* 5 vols. Berlin: Deutscher Verein für Kunstwissenschaft, 1916.

VI. ROMANESQUE

ANKER, P. and ANDERSSON, A. *The Art of Scandinavia.* 2 vols. London: Hamlyn, 1970.

ANTHONY, E. W. *Romanesque Frescoes.* Princeton: Princeton University Press, 1951.

ARMI, C. E. *Masons and Sculptors in Romanesque Burgundy: The New Aesthetic of Cluny III.* University Park, Pa.: Pennsylvania State University Press, 1983.

El arte románico (exh. cat.). Barcelona, Palacio de bellas artes, and Santiago de Compostela, 1961.

AUBERT, M. *L'Art français à l'époque romane.* 4 vols. Paris: A. Morancé, 1930–50.

————. *La sculpture romane.* Paris: Alpina, 1937.

————. *L'Art roman en France.* Paris: Flammarion, 1961.

————. *Cathédrales abatiales, collégiales, prieures romans de France.* Paris: Arthaud, 1965.

BARASCH, M. *Crusader Figural Sculpture in the Holy Land.* New Brunswick, N.J.: Rutgers University Press, 1971.

BAUM, J., ed. *Romanesque Architecture in France.* 2nd ed. New York: B. Westermann, 1928.

BERTAUX, E. *L'Art dans l'Italie méridionale.* 3 vols. Paris: Fontemoing, 1904; reprinted 1968. See also updated edition, ed. A. Prandi, Rome, 1978.

BOASE, T. *English Art, 1100–1216.* Oxford: Clarendon Press, 1953.

BORG, A. *Architectural Sculpture in Romanesque Provence.* Oxford: Oxford University Press, 1972.

BROOKE, C. et al. *English Romanesque Art, 1066–1200.* London: Abner Schram, 1984.

BUSCH, H. and LOHSE, B., eds. *Romanesque Sculpture.* London: B. T. Batsford, 1962.

CAHN, W. *Romanesque Bible Illumination.* Ithaca: Cornell University Press, 1982.

———— and SEIDEL, L. *Romanesque Sculpture in American Collections.* New York: B. Franklin, 1979.

CHRISTE, Y. *Les grands portails romans: Etudes sur l'iconographie des théophanies romanes.* Geneva: Librarie Droz, 1969.

CLAPHAM, A. *Romanesque Architecture in Western Europe.* Oxford: Clarendon Press, 1936.

CONANT, K. J. *Cluny: Les Eglises et la maison du chef d'ordre.* Mâcon: Protat frères, 1968.

COOK, W. and GUDIOL I RICART, J. *Pintura románica: Imaginería románica* (Ars Hispaniae, vol. 6). Rev. ed. Madrid: Plus-Ultra, 1979.

CRICHTON, G. H. *Romanesque Sculpture in Italy.* London: Routledge & Kegan Paul, 1954.

DECKER, H. *Romanesque Art in Italy.* London: Thames and Hudson, 1958.

DEMUS, O. *Romanesque Mural Painting.* New York: Harry N. Abrams, Inc., 1970.

DESCHAMPS, P. *French Sculpture of the Romanesque Period.* Florence: Pantheon, 1930; reprinted 1972.

———— and THIBOUT, M. *La peinture murale en France.* Paris: Plon, 1951.

DODWELL, C. R. *The Canterbury School of Illumination, 1066–1200.* Cambridge, Eng.: Cambridge University Press, 1954.

EVANS, J. *Monastic Life at Cluny, 910–1157.* London: Oxford University Press, 1931.

————. *The Romanesque Architecture of the Order of Cluny.* Cambridge, Eng.: Cambridge University Press, 1938.

————. *Cluniac Art of the Romanesque Period.* Cambridge, Eng.: Cambridge University Press, 1950.

FERGUSSON, P. *Architecture of Solitude: Cistercian Abbeys in Twelfth-Century Europe.* Princeton: Princeton University Press, 1984.

FOCILLON, H. *L'Art des sculpteurs romans.* Paris: E. Leroux, 1931; new ed., 1964.

————. *The Art of the West in the Middle Ages,* I: *Romanesque Art.* New York: Phaidon, 1963; reprinted 1980.

FORSYTH, I. H. *The Throne of Wisdom: Wood Sculptures of the Madonna in Romanesque France.* Princeton: Princeton University Press, 1972.

GAILLARD, G. *Les débuts de la sculpture romane espagnole.* Paris: P. Hartmann, 1938.

————. *La sculpture romane espagnole.* Paris: P. Hartmann, 1946.

GARRISON, E. B. *Italian Romanesque Panel Painting.* Florence: L. S. Olschki, 1949.

————. *Studies in the History of Medieval Italian Painting.* 4 vols. Florence: L'Impronta, 1952–62.

GÓMEZ-MORENO, M. *El arte románico español.* Madrid: Blass, 1934.

GRABAR, A. and NORDENFALK, C. *Romanesque Painting from the Eleventh to the Thirteenth Century.* Geneva: Skira, 1958.

HASKINS, C. H. *The Renaissance of the Twelfth Century.* Cambridge, Mass.: Harvard University Press, 1927.

HEARN, M. F. *Romanesque Sculpture.* Ithaca: Cornell University Press, 1981.

HUTTON, E. *The Cosmati.* London: Routledge & Kegan Paul, 1950.

JULLIAN, R. *L'Eveil de la sculpture italienne: La sculpture romane dans l'Italie du nord.* Paris: G. van Oest, 1945.

KUBACH, H. E. *Romanesque Architecture.* New York: Harry N. Abrams, Inc., 1975.

LASTEYRIE, R. DE. *L'Architecture religieuse en France à l'époque romane.* 2nd ed. Paris: A. Picard, 1929.

LEISINGER, H. *Romanesque Bronzes: Church Portals in Medieval Europe.* New York: Praeger, 1957.

MÂLE, E. *L'Art religieux du XIIe siècle en France.* Paris: A. Colin, 1922; Eng. ed., H. Bober, ed., *Religious Art in France, The Twelfth Century.* Princeton: Princeton University Press, 1978.

MENDELL, E. *Romanesque Sculpture in Saintonge.* New Haven: Yale University Press, 1940.

MILLAR, E. G. *English Illuminated Manuscripts from the Tenth to the Thirteenth Century.* Paris and Brussels: G. van Oest, 1926.

OAKESHOTT, W. *The Artists of the Winchester Bible.* London: Faber and Faber, 1945.

OURSEL, C. *L'Art roman de Bourgogne.* Dijon: L. Venot, 1928.

————. *Miniatures cisterciennes (1109–1134).* Mâcon: Protat frères, 1960.

OURSEL, R. and KRES, A. M. *Les églises romanes de l'Autunois et du Brionnais: Cluny et sa region.* Mâcon: Protat frères, 1956.

PÄCHT, O. *The Rise of Pictorial Narrative in Twelfth-Century England.* Oxford: Clarendon Press, 1962.

PANOFSKY, E. *Die deutsche Plastik des elften bis dreizehnten Jahrhunderts.* 2 vols. Munich: K. Wolff, 1924.

PORTER, A. K. *Romanesque Sculpture of the Pilgrimage Roads.* 10 vols. Boston: Marshall Jones, 1923.

————. *Spanish Romanesque Sculpture.* 2 vols. Florence: Pantheon, 1928.

PUIG I CADAFALCH, J. *Le premier art roman.* Paris: H. Laurens, 1928.

QUINTAVALLE, A. C. *Wiligelmo e la sua scuola.* Florence: Sadea-Sansoni, 1967.

REY, R. *La sculpture romane languedocienne.* Toulouse: E. Privat, 1936.

RICCI, C. *Romanesque Architecture in Italy.* London: William Heinemann, 1925.

Romanische Kunst in Oesterreich (exh. cat.). Krems, Minoritenkirche, 1964.

SALMI, M. *Romanesque Sculpture in Tuscany.* Florence: Rinascimento del Libro, 1928.

SALVINI, R. *Wiligelmo e le origini della scultura romanica.* Milan: A. Martello, 1956.

SAXL, F. and SWARZENSKI, H. *English Sculptures of the Twelfth Century.* London: Faber and Faber, 1954.

SCHAPIRO, M. *The Parma Ildefonsus: A Romanesque Illuminated Manuscript from Cluny and Related Works.* New York: College Art Association, 1964.

SCHER, S. *Romanesque Art: Selected Papers.* New York: Braziller, 1977.

SEIDEL, L. *Songs of Glory: The Romanesque Facades of Aquitaine.* Chicago: University of Chicago Press, 1981.

SWARZENSKI, H. *Monuments of Romanesque Art.* 2nd ed. Chicago: University of Chicago Press, 1967.

TIMMERS, J. J. M. *A Handbook of Romanesque Art.* New York: Macmillan, 1969.

TURNER, D. H. *Romanesque Illuminated Manuscripts in the British Museum.* London: British Museum, 1966.

VIELLIARD, J., ed. *Le Guide du pèlerin de Saint-Jacques de Compostelle.* 2nd ed. Mâcon: Protat frères, 1960.

VÖGE, W. *Die Anfänge des monumentalen Stiles im Mittelalter.* Strassburg: J. H. E. Heitz, 1894.

WEIGERT, H. *Die Kaiserdome am Mittelrhein, Speyer, Mainz, und Worms.* Berlin: Deutscher Kunstverlag, 1933.

WEISBACH, W. *Religiöse Reform und mittelalterliche Kunst.* Zurich: Benzinger, 1945.

WHITEHILL, W. M. *Spanish Romanesque Architecture of the Eleventh Century.* London: Oxford University Press, 1941.

ZARNECKI, G. *English Romanesque Sculpture, 1066–1140.* London: A. Tiranti, 1951.

————. *Later English Romanesque Sculpture, 1140–1210.* London: A. Tiranti, 1953.

————. *Romanesque Art.* New York: Universe Books, 1972.

Zodiaque, pub. Series on Romanesque art and architecture. 46 vols. La Pierre-qui-Vire, 1956–.

VII. GOTHIC

A. GENERAL

AUBERT, M. *The Art of the High Gothic Era.* New York: Crown, 1965.

BALDASS, P. et al. *Gotik in Oesterreich.* Vienna: Forum Verlag, 1961.

BRIEGER, P. *English Art, 1216–1307.* Oxford: Clarendon Press, 1957.

L'Europe Gothique XIIe–XIVe siècles (exh. cat.). Paris, Musée du Louvre, 1968.

EVANS, J. *English Art, 1307–1461.* Oxford: Clarendon Press, 1949.

Les Fastes du Gothique: Le siècle de Charles V (exh. cat.). Paris, Grand Palais, 1981–82.

FOCILLON, H. *The Art of the West in the Middle Ages,* II: *Gothic Art.* New York: Phaidon, 1963; reprinted 1980.

FRANKL, P. *The Gothic: Literary Sources and Interpretations Through Eight Centuries.* Princeton: Princeton University Press, 1960.

FRISCH, T. G. *Gothic Art, 1140–ca. 1450* (Sources and Documents in the History of Art). Englewood Cliffs, N. J.: Prentice-Hall, 1971.

Gothic Art 1360–1440 (exh. cat.). Cleveland Museum of Art, 1963.

HARVEY, J. *Gothic England: A Survey of National Culture, 1300–1550.* London: B. T. Batsford, 1947.

HENDERSON, G. *Gothic Style and Civilization* (Style and Civilization Series). Harmondsworth: Penguin, 1967.

HUIZINGA, J. *The Waning of the Middle Ages.* London: E. Arnold, 1924; reprinted 1954.

LAMBERT, E. *L'Art gothique en Espagne aux XIIe et XIIIe siècles.* Paris: H. Laurens, 1931.

LORD, C. *Royal French Patronage of Art in the Fourteenth Century: An Annotated Bibliography.* Boston: G. K. Hall, 1985.

MÂLE, E. *L'Art religieux du XIIIe siècle en France.* Paris: E. Leroux, 1898. First Eng. ed. published as *The Gothic Image.* New York: Harper and Row, 1958; new Eng. ed., H. Bober, ed., *Religious Art in France, The Thirteenth Century.* Princeton: Princeton University Press, 1984.

————. *L'Art religieux de la fin du moyen âge en France.* Paris: A. Colin, 1908.

MARTINDALE, A. *Gothic Art from the Twelfth to the Fifteenth Century.* London: Thames and Hudson, 1967.

PEVSNER, N. *Ruskin and Viollet-le-Duc: Englishness and Frenchness in the Appreciation of Gothic Architecture.* London: Thames and Hudson, 1969.

SWAAN, W. *The Gothic Cathedral.* Garden City, N.Y.: Doubleday, 1969.

————. *The Late Middle Ages: Art and Architecture from 1350 to the Advent of the Renaissance.* London: Elek Books, 1977.

Transformations of the Court Style: Gothic Art in Europe 1270–1330 (exh. cat.). Providence, R. I., Rhode Island School of Design and Brown University, 1977.

VERDIER, P. *The International Style: The Arts in Europe Around 1400* (exh. cat.). Baltimore, Walters Art Gallery, 1962.

————. *Art and the Courts: France and England from 1259 to 1328* (exh. cat.). Ottawa, National Gallery of Canada, 1972.

WHITE, J. *Art and Architecture in Italy, 1250–1400* (Pelican History of Art, no. 28). Harmondsworth: Penguin, 1966.

The Year 1200 (exh. cat.). 2 vols. New York, The Metropolitan Museum of Art, 1970.

B. PAINTING

ANTAL, F. *Florentine Painting and Its Social Background.* London: Kegan Paul, 1948.

AUBERT, M. et al. *Le Vitrail français.* Paris: Editions Deux Mondes, 1958.

————. *Les Vitraux de Notre-Dame et de la Sainte-Chapelle de Paris.* Paris: Caisse nationale des monuments historiques, 1959.

AVRIL, F. *Manuscript Painting at the Court of France—The Fourteenth Century (1310–1380).* New York: Braziller, 1978.

BORSOOK, E. *The Mural Painters of Tuscany.* London: Phaidon, 1960.

BRANNER, R. *Manuscript Painting in Paris During the Reign of Saint Louis.* Berkeley: University of California Press, 1977.

CHRISTIE, A. G. I. *English Medieval Embroidery.* Oxford: Clarendon Press, 1938.

DUPONT, J. and GNUDI, C. *Gothic Painting.* Geneva: Skira, 1954.

DVORÁKOVÁ, V. et al. *Gothic Mural Painting in Bohemia and Moravia 1300–1378.* London: Oxford University Press, 1964.

GRODECKI, L. and BRISAC, C. *Gothic Stained Glass: 1200–1300.* Ithaca: Cornell University Press, 1985.

GUDIOL I RICART, J. *Pintura gotica* (Ars Hispaniae, vol. 9). Madrid: Plus-Ultra, 1959.

HARTHAN, J. *Books of Hours and Their Owners.* London: Thames and Hudson, 1977.

HAYWARD, J. and CAVINESS, M. *Stained Glass Before 1700 in American Collections,* I: *New England and New York State.* Washington, D.C.: National Gallery of Art, 1985.

JOHNSON, J. R. *The Radiance of Chartres: Studies in the Early Stained Glass of the Cathedral.* London: Phaidon, 1964.

LEMOISNE, P. A. *Gothic Painting in France.* Florence: Pantheon, 1931.

MARCHINI, G. *Italian Stained Glass Windows.* New York: Harry N. Abrams, Inc., 1957.

MARLE, R. VAN. *The Development of the Italian Schools of Painting.* Vols. I–III. The Hague: M. Nijhoff, 1923–24.

MEISS, M. *Painting in Florence and Siena After the Black Death.* Princeton: Princeton University Press, 1951.

MILLAR, E. G. *English Illuminated Manuscripts of the XIVth and XVth Centuries.* Paris and Brussels: G. van Oest, 1928.

MINER, D. *Illuminated Books of the Middle Ages and the Renaissance* (exh. cat.). Baltimore Museum of Art, 1949.

OERTEL, R. *Early Italian Painting to 1400.* New York: Praeger, 1966.

Opus Anglicanum: English Medieval Embroidery (exh. cat.). London, Victoria and Albert Museum, 1963.

PANOFSKY, E. *Early Netherlandish Painting: Its Origins and Character.* 2 vols. Cambridge, Mass.: Harvard University Press, 1953.

PORCHER, J. *Medieval French Miniatures.* New York: Harry N. Abrams, Inc., 1959.

RAGUIN, V. C. *Stained Glass in Thirteenth-Century Burgundy.* Princeton: Princeton University Press, 1982.

RANDALL, L. *Images in the Margins of Gothic Manuscripts.* Berkeley: University of California Press, 1966.

SANDBERG-VAVALÀ, E. *La Croce dipinta italiana e l'iconografia della Passione.* 2 vols. Verona: Apollo, 1929; reissued 1980.

————. *Uffizi Studies: The Development of the Florentine School of Painting.* Florence: L. S. Olschki, 1948.

————. *Sienese Studies: The Development of the School of Painting of Siena.* Florence: L. S. Olschki, 1953.

STUBBLEBINE, J. *Dugento Painting: An Annotated Bibliography.* Boston: G. K. Hall, 1983.

————. *Assisi and the Rise of Vernacular Art.* New York: Harper and Row, 1985.

WEIGELT, C. H. *Sienese Paintings of the Trecento.* New York: Harcourt Brace, 1930.

C. SCULPTURE

AUBERT, M. *French Sculpture at the Beginning of the Gothic Period, 1140–1225.* Florence: Pantheon, 1929.

BEHLING, L. *Die Pflanzenwelt der mittelalterlichen Kathedralen.* Cologne: Böhlau, 1964.

CRICHTON, G. H. and CRICHTON, E. *Nicola Pisano and the Revival of Sculpture in Italy.* Cambridge, Eng.: Cambridge University Press, 1938.

DURAN Y SANPERE, A. and AINAUD, J. *Escultura Gótica* (Ars Hispaniae, vol. 8). Madrid: Plus-Ultra, 1956.

GRODECKI, L. *Ivoires français.* Paris: Larousse, 1947.

HUNT, J. *Irish Medieval Figure Sculpture, 1200–1600.* 2 vols. Dublin: Irish University Press, 1974.

JANTZEN, H. *Deutsche Bildhauer des 13. Jahrhunderts.* Leipzig: Insel Verlag, 1925.

KATZENELLENBOGEN, A. *The Sculptural Programs of Chartres Cathedral.* Baltimore: Johns Hopkins Press, 1959.

KIDSON, P. *Sculpture at Chartres.* London: A. Tiranti, 1958.

KOECHLIN, R. *Les Ivoires gothiques français.* 3 vols. Paris: A. Picard, 1924.

LAPEYRE, A. *Des Facades occidentales de Saint-Denis et de Chartres aux portails de Laon.* Paris, 1960.

NATANSON, J. *Gothic Ivories of the 13th and 14th Centuries.* London: A. Tiranti, 1951.

PEVSNER, N. *The Leaves of Southwell.* Harmondsworth: Penguin, 1945.

PINDER, W. *Die deutsche Plastik* (Handbuch der Kunstwissenschaft). 2 vols. Munich: K. Wolff, 1924.

POPE-HENNESSY, J. *Italian Gothic Sculpture.* 2nd ed. London: Phaidon, 1972.

SAUERLÄNDER, W. *Von Sens bis Strassburg.* Berlin: W. de Gruyter, 1966.

————. *Gothic Sculpture in France: 1140–1270.* London: Thames and Hudson, 1972.

STODDARD, W. S. *The West Portals of Saint-Denis and Chartres*. Cambridge, Mass.: Harvard University Press, 1952.

VITRY, P. *French Sculpture During the Reign of Saint Louis, 1226–1270*. New York: Harcourt Brace, n.d.

D. ARCHITECTURE

AUBERT, M. *Notre-Dame de Paris*. Paris: A. Morancé, 1920.

BONY, J. *The English Decorated Style*. Ithaca: Cornell University Press, 1979.

———. *French Gothic Architecture of the Twelfth and Thirteenth Centuries*. Berkeley: University of California Press, 1983.

BRANNER, R. *Burgundian Gothic Architecture*. London: A. Zwemmer, 1960.

———. *Gothic Architecture*. New York: Braziller, 1961.

———. *La cathédrale de Bourges et sa place dans l'architecture gothique*. Paris: Tardy, 1962.

———. *Saint Louis and the Court Style in Gothic Architecture*. London: A. Zwemmer, 1965.

BRUZELIUS, C. *The Thirteenth-Century Church at Saint-Denis*. New Haven: Yale University Press, 1986.

CROSBY, S. M. *L'Abbaye royale de Saint-Denis*. Paris: Paul Hartmann, 1953.

——— et al. *The Royal Abbey of Saint-Denis in the Time of Abbot Suger (1122–1151)*. New York: The Metropolitan Museum of Art, 1981.

EYDOUX, H. P. *L'Architecture des églises cisterciennes d'Allemagne*. Paris: Presses Universitaires de France, 1952.

FITCHEN, J. *The Construction of Gothic Cathedrals: A Study of Medieval Vault Erection*. Oxford: Clarendon Press, 1961.

FRANKL, P. *Gothic Architecture* (Pelican History of Art, no. 19). Harmondsworth: Penguin, 1962.

GIMPEL, J. *The Cathedral Builders*. New York: Grove Press, 1961.

GRODECKI, L. *Gothic Architecture*. New York: Harry N. Abrams, Inc., 1977.

HARVEY, J. *The Gothic World, 1100–1600: A Survey of Architecture and Art*. London: B. T. Batsford, 1950.

———. *English Medieval Architects: A Biographical Dictionary down to 1550*. London: B. T. Batsford, 1954.

JANTZEN, H. *High Gothic: The Classic Cathedrals of Chartres, Reims, Amiens*. New York: Pantheon Books, 1962; reprinted 1984.

JOHNSON, P. *British Cathedrals*. New York: W. Morrow, 1980.

LASTEYRIE, R. DE. *L'Architecture religieuse en France à l'époque gothique*. 2nd ed. 2 vols. Paris: A. Picard, 1929.

LONGHI, L. F. DE. *L'architettura delle chiese cisterciensi italiane*. Milan: Ceschina, 1958.

MARK, R. *High Gothic Structure: A Technological Reinterpretation*. Princeton: Princeton University Press, 1985.

PANOFSKY, E. *Gothic Architecture and Scholasticism*. Latrobe, Pa.: Archabbey Press, 1951.

SEDLMAYR, H. *Die Entstehung der Kathedrale*. Zurich: Atlantis Verlag, 1950.

SIMSON, O. VON. *The Gothic Cathedral: Origins of Gothic Architecture and the Medieval Concept of Order*. New York: Pantheon Books, 1956; reprinted 1967.

TORRES BALBAS, L. *Arquitectura gotica* (Ars Hispaniae, vol. 7). Madrid: Plus-Ultra, 1952.

TIMETABLES OF MEDIEVAL HISTORY AND ART

	ROME AND THE LATIN WORLD	BYZANTIUM AND THE EAST
300	Last persecutions of the Christians (303–11) Constantine the Great defeats Maxentius (312) Diocletian (d. 313) Edict of Milan (313) Pope Sylvester (314–35)	Council of Nicaea (325) Constantinople founded as the new Rome (330) Death of Eusebius, bishop of Caesarea, author of the *Historia ecclesiastica* and *Vita Constantini* (340)
350	Julian the Apostate restores paganism (361) Ambrose, bishop of Milan (374–97) Theodosius I the Great, emperor (379–95) Jerome translates the Bible, the Vulgate (382) Honorius, emperor of the West (395–423) Augustine, bishop of Hippo (395–430)	Gregory of Nazianzus, *Homilies* (c. 370) Arcadius, emperor of the East (395–408)
400	Alaric invades Italy (400); sacks Rome (410) Honorius moves capital to Ravenna (402) Galla Placidia, regent (424–50) Pope Sixtus III (432–40) Pope Leo the Great (440–61) Venice founded by refugees from the Huns (457)	Theodosius II, emperor of the East (408–50) Council of Ephesus (431)
450	Odoacer, Heruli chieftain, conquers empire of the West (474–93) Theodoric the Great, king of Ostrogoths (488–526) at Ravenna	Council of Chalcedon (451)
500	Priscian, Latin grammarian, writes *Institutiones grammaticae* (520) Boethius writes *De Consolatione philosophiae* in prison in Pavia before his execution (524) Monte Cassino founded by St. Benedict (c. 529) Totila, the Ostrogoth, enters Rome (546)	Neoplatonic writings of Pseudo-Dionysius the Areopagite (c. 500) Justinian I, Byzantine emperor (527–65) Nika riots in Constantinople (532) Byzantine army recaptures Ravenna (540)
550	Lombards capture North Italy (568); Pavia made capital (c. 575) Lombards capture Monte Cassino (581) Pope Gregory the Great (590–604)	Justin II, emperor (565–78)
600	Isidore, bishop of Seville (600–636), writes *Etymologiae* by 635 Recceswinth, king of Visigoths (649–72)	Heraclius I, Byzantine emperor (610–41) Mohammed flees to Medina (622) Caliph Omar captures Jerusalem (637)
650		Justinian II, emperor (685–95) Quinisext Council (692) Muslims destroy Carthage (697)
700	Muslim conquest of Visigothic Spain (711)	Leo III the Isaurian, Byzantine emperor (717–41) Iconoclasm (726–843)
750	Desiderius, king of the Lombards (756–74) Pope Leo III (795–816)	Nicephorus, patriarch of Constantinople (758–829) Irene, Byzantine empress (780–90) Council of Nicaea, temporary rejection of iconoclasm (787)
800	Pope Paschal I (817–24) Saracens invade Sicily (827)	Theophilus, Byzantine emperor (829–42) Michael III, first emperor of Macedonian dynasty (842–67) Theodora, Byzantine empress (843–56) Council of Constantinople, end of iconoclasm (843)
850		Photius, patriarch of Constantinople (858–67; 877–86) Basil I, Byzantine emperor (867–86); Macedonian dynasty begins

NORTHERN EUROPE

THE ARTS

	Arch of Constantine, Rome (312) **300**
	Lateran Baptistry, Rome (founded c. 320)
	St. Peter's, Rome (founded c. 324)
	Church of the Holy Sepulcher, Jerusalem (c. 335)

Huns invade Europe (c. 360)
St. Martin, bishop of Tours (371–97)
Roman legions gradually evacuate Britain; Angles, Saxons, and
 Jutes move in (383–436)

San Lorenzo Maggiore, Milan (c. 355–75) **350**
Sarcophagus of Junius Bassus (359)
San Paolo fuori le mura (385)

St. Patrick's mission to Ireland (432)
Attila, king of the Huns (433–53)

Santa Sabina, Rome (422–32) **400**
Mausoleum of Galla Placidia, Ravenna (425–50)
Santa Maria Maggiore, Rome (432–40)

Anglo-Saxon raids on England (450–650)
Huns withdraw from Europe (470)
Clovis, king of the Franks (481–511)

Orthodox Baptistry, Ravenna (c. 450) **450**
Pilgrimage Church, Qal'at Si'man (c. 470)

St. Columbanus (c. 540–615)

Sant'Apollinare Nuovo, Ravenna (c. 500) **500**
Hagia Sophia, Constantinople (532–37)
San Vitale, Ravenna, mosaics (c. 548)
San Apollinare in Classe (c. 549)

St. Gregory, bishop of Tours (573–93); *History of the Franks*
 (c. 575)
St. Augustine of Canterbury sent to England (597)

St. Catherine, Mt. Sinai, mosaic (c. 550) **550**
Rabbula Gospels (c. 586)

Dagobert I, Merovingian king (628–39)

Hagios Demetrios, Thessaloniki (c. 610–40) **600**
Cyprus silver plates (c. 610–41)
Sutton Hoo ship burial (c. 625–33)

Synod of Whitby, England accepts Roman liturgy (663)
The Venerable Bede (673–735)

Votive crown of Recceswinth (649–72) **650**
Book of Durrow (c. 660–80)

Charles Martel, mayor of the Franks (714–41)
Boniface (d. 755) appointed bishop of Germany (722)
Battle of Poitiers, defeat of Muslims (732)

Altar of Duke Ratchis, Cividale (731–44) **700**

Pepin III crowned king of Franks at St. Denis (754)
Charlemagne defeats Desiderius (774)
Defeat of Roland at Roncesvalles (778)
Vikings destroy Lindisfarne (793)
Frankfurt Synod, *Libri Carolini* (794)

St. Denis rebuilt (754) **750**
Godescalc Gospels (781–83)
Beatus of Liebana, *Commentary on the Apocalypse* (786)

Charlemagne crowned emperor of the West (800)
Louis the Pious, Carolingian emperor (814–40)
Viking raids on England (835)
Charles the Bald, Carolingian emperor (840–77)
Treaty of Verdun; the beginnings of modern Europe (France,
 Germany, Italy) (843)

Utrecht Psalter (816–35) **800**
Santa Prassede, Rome, mosaics (817–24)
Moûtier-Grandval Bible (c. 840)

Viking raids in France (853; 885)
Alfred the Great, king of England (871–99)

Hagia Sophia, Constantinople: apse mosaic (before 867) **850**
Homilies of Gregory of Nazianzus (880–83)

ROME AND THE LATIN WORLD

BYZANTIUM AND THE EAST

900

Constantine VII Porphyrogenitus, Byzantine emperor (913–59)

950 Gerbert, scholar and churchman, elected Pope Sylvester II (999)

Romanus II, Byzantine emperor (959–63)
Basil II, Byzantine emperor (976–1025)

1000 Norman conquest of Sicily begins (1043)

Turks take Asia Minor from Byzantines (1007)
Armenia annexed by Byzantines (1046)

1050 Desiderius, abbot of Monte Cassino (1058–86)
Lateran Council (1059)
Normans sack Rome (1064)
Alfonso VI, king of León and Castile (1072–1109)
Hildebrand becomes Pope Gregory VII (1073)
Henry IV submits to Pope Gregory VII at Canossa (1077)
Pope Urban II (1088–99)
First Crusade to Holy Land (1095–99)
Latin kingdom of Jerusalem founded (1099)

Papacy in Rome excommunicates Byzantine patriarch (1054)
Comneni dynasty (1081–1185); consolidation of the Byzantine
 state under Alexius I Comnenus (1081–1118)
Latin kingdom of Jerusalem founded (1099)

1100 Roger II, king of Sicily (1130–54)
Pope Innocent II (1130–43)

Manuel I Comnenus, emperor (1143–80)

1150 Frederick I (Barbarossa), Holy Roman Emperor (1152–90)
William II, king of Sicily (1166–89)
Lombard League established (1167)
Frederick Barbarossa defeated at Legnano (1176)
Third Crusade (1189)

Saladin captures Jerusalem (1187)

1200 Fourth Crusade and the sack of Constantinople (1202–4)
Franciscan Order founded, Assisi (1209)
Frederick II Hohenstaufen, Holy Roman Emperor (1220–50)

Sack of Constantinople by Venetians during Fourth Crusade
 (1204); Latin dynasty rules (1204–61)
Nikolaos Mesarites writes description of the Church of the Holy
 Apostles in Constantinople (c. 1220)

1250 End of the Hohenstaufen reign with death of Conrad IV (1254)
Marco Polo returns from China (1285)

Byzantines retake Constantinople from Latins (1261); beginning
 of the Palaeologus dynasty (1261–1453)
Turks take Acre (1291)

1300 Papacy moves to Avignon, the "Babylonian captivity" (1309–78)
Dante Alighieri (d. 1321)
Black Death (1347–49)

1350 Boccaccio (d. 1375)

NORTHERN EUROPE

Cluniac Order founded (910)
Conrad, the Frank, turns the crown over to Henry I, the Saxon
(918)

Otto I the Great crowned Holy Roman Emperor (962)
Otto II Holy Roman Emperor (973–83); marries Theophano,
Byzantine empress (972)
Otto III, Holy Roman Emperor (983–1002)
Hugh Capet, king of France (987–96)
Bruno, cousin of Otto III, appointed Pope Gregory V (996)

Henry II, Holy Roman Emperor (1002–24)
William the Conqueror, duke of Normandy (1035–87)
Henry III, Holy Roman Emperor (1039–56)
Edward the Confessor, king of England (1042–66)

Hugh, abbot of Cluny (1049–1109)
Battle of Hastings (1066)
Carthusian Order founded (1084)
Cistercian Order founded (1098)

Henry V, Holy Roman Emperor (1106–25)
St. Bernard, abbot of Clairvaux (1115–53)
Concordat of Worms (1122)
Suger, abbot of St. Denis (1122–51)
Death of Henry V initiates conflicts between the Guelphs and
Ghibellines (1125)
Eleanor of Aquitaine, queen of France (1137–52)
Henry the Lion, duke of Saxony (1139–95)
Saint Bernard preaches the Second Crusade at Vézelay (1146)
Second Crusade to Acre and Damascus (1147)

Henry II Plantagenet, king of England (1154–89)
Philip II Augustus, king of France (1180–1223)
Richard I *Coeur-de-lion,* king of England (1189–99)

Albigensian Crusade (1208)
Battle of Bouvines (1214)
Magna Carta (1215)
St. Thomas Aquinas (1225–74)
St. Louis IX, king of France (1226–70)

Philip III the Bold, king of France (1270–85)
Edward I, king of England (1272–1307)
Philip IV the Fair, king of France (1285–1314)

Jeanne d'Evreux, queen of France (1325–28)
Hundred Years War begins (1337–1453)

John II the Good, king of France (1350–64)

THE ARTS

First church at Cluny (c. 910)	900
Benedictional of Ethelwold (971–84) Golden Virgin of Essen (973–82) Codex Egberti (977–93)	950
St. Michael's, Hildesheim (1010–33) Katholikon, Hosios Lukas (c. 1020) St. Genis-des-Fontaines, lintel (1020–21) Santa Maria, Ripoll (c. 1020–32) Cathedral, Speyer (1030–61)	1000
San Marco, Venice (after 1063) St. Etienne, Caen (1064–77) Bayeux Tapestry (1070–80) Cathedral, Santiago de Compostela (1075–1120) Cluny III (1088–1130)	1050
RAINER OF HUY, baptismal font, Liège (1107–18) St. Pierre, Moissac, south portal sculptures (c. 1115–30) Ste. Madeleine, Vézelay (1120–32) Cathedral, Chartres, west facade (begun 1134) St. Denis, west facade (1135–40) Abbey Church, Fontenay (1139–47)	1100
GUGLIELMO, pulpit for Cagliari Cathedral (1159–62) Notre Dame, Paris (begun 1163) Cathedral, Monreale (1174–83) BENEDETTO ANTELAMI, *Deposition* sculpture, Parma (1178) NICHOLAS OF VERDUN, Klosterneuburg altar (1181) Cathedral, Chartres, transepts (1194–1240)	1150
Cathedral, Reims (begun 1211) San Francesco, Assisi (1228–53) Cathedral, Bamberg: choir sculptures (c. 1230–40) Ste. Chapelle, Paris (1243–48)	1200
NICOLA PISANO, pulpit, Pisa Baptistry (1260) PIETRO CAVALLINI, mosaics in Santa Maria in Trastevere, Rome (1290s) JACOPO TORRITI, apse mosaic, Santa Maria Maggiore, Rome (c. 1294)	1250
GIOVANNI PISANO, pulpit, Pisa Cathedral (1302–10) GIOTTO, frescoes in the Arena Chapel, Padua (1305–) DUCCIO, *Maestà,* Duomo, Siena (1308–11) JEAN PUCELLE, *Hours of Jeanne d'Evreux* (1325–28) AMBROGIO LORENZETTI, frescoes in the Palazzo Pubblico, Siena (1338–39)	1300
	1350

INDEX

S

PHOTOGRAPH CREDITS

The author and publisher wish to thank the libraries, museums, and churches for permitting the reproduction of works of art in their collections. Photographs have been supplied by the following, whose courtesy is gratefully acknowledged. Figure numbers in roman type refer to black-and-white illustrations; those in italics signify colorplates.

Alinari, Florence: 21–23, 36, 38, 39, 41, 47, 49–54, 58, 59, 62, 66, 90, 102, 108, 140, 147, 148, 150, 178, 184, 186, 187, 190, 191, 197, 199, 272, 273, 411, 413–15, 417, 419, 420, 571, 573, 578, 582–89, 591–99, 601, 606; Archives Photographiques, Paris: 48, 210, 243, 244, 298, 324, 330, 331, 333, 335, 336, 340, 350, 352, 353, 357, 364, 365, 377, 381, 382, 387, 440, 446, 447, 461, 470, 474, 481–83, 489–92, 497, 499, 505, 508, 509, 511; Archivio Historico Nacional, Madrid: 302; James Austin, Cambridge, Eng.: 358, 438; Aurora Art Publishers, Leningrad: 202, 203; Bavaria Verlag, Munich: 53; Bayerische Staatsbibliothek, Munich: 40, 269, 271, 294; Courtesy Ville de Bayeux: 46, 369; Biblioteca Ambrosiana, Milan: 93; Biblioteca Apostolica Vaticana, Vatican City: 9, 21, 28, 43, 48, 55–57b, 61, 63, 91, 92, 164, 205, 212, 227, 228, 280, 393–95; Bibliothèque Municipale, Epernay: 252; Bibliothèque Nationale, Paris: 7, 19, 20, 22, 30, 35, 36, 45, 49, 65, 89, 96, 122, 163, 166, 214, 229, 240, 247–49, 259–61, 263–65, 277, 307, 341, 343, 344, 349, 383, 442, 458, 561–63; Prof. Charalabos Bouras, Athens: 131; W. Braunfels, Monasteries of Western Europe, 1972: 363; Beat Brink, Basel: 104, 133; British Library, London: 31, 37, 39, 275, 278, 279, 281, 306, 354; British Museum, London: 106, 111, 123, 206–8, 218, 258; Photographie Bulloz, Paris: 359; H.C. Butler, Princeton University: 85; Ludovico Canali, Rome: 2, 4, 38, 51, 52, 68, 180–82, 390, 397, 398, 401, 410, 602, 603; Samuel Chamberlain: 459; The Cleveland Museum of Art: 12, 557; K.J. Conant, Carolingian and Romanesque Architecture, 1959: 230, 311, 337, 338, 389; Conway Library, Courtauld Institute of Art, London: 211, 285, 289, 332, 342, 370, 374, 375, 448, 450, 477, 478; Corpus Christi College, Cambridge, Eng.: 213; G. Dehio and G. von Bezold, Die Kirchliche Baukunst des Abendlandes, 1887–1901: 119, 144, 320, 443, 454, 460; O. Demus and E. Diez, Byzantine Mosaics in Greece: Hosios Lucas and Daphni, 1931: 172; Deutschen Archäologischen Institut, Rome: 14, 20; Deutscher Kunstverlag, Munich: 290, 427, 554; Diözesanmuseum, Paderborn: 430; Dumbarton Oaks, Washington, D.C.: 23, 24, 117, 124, 126, 128, 132, 154, 155, 158, 161; W. Effmann, Centula–St. Riquier, 1912: 239; Philip Evola, New York: 425; Federal Archive for Historical Monuments, Bern: 245, 246; Foto Grassi, Siena: 69; Foto Marburg, Marburg/Lahn: 71, 129, 167, 168, 231–34, 236–38, 251, 282, 284, 287, 292, 299–301, 386, 403, 423, 431, 433–36, 444, 466, 471, 472, 510, 513, 530, 536, 541, 542, 548, 549, 556, 570; Fotostudio Mario Quattrone, Florence: 71–73; Fototeca Unione, Rome: 40, 68; P. Frankl, Gothic Architecture, 1962: 449, 495; Alison Frantz, Princeton: 170, 173; Gabinetto Fotografico Nazionale, Rome: 26, 46, 64a, 590; German Information Center, New York: 544, 550; Germanisches Nationalmuseum, Nurnberg: 296; Photographie Giraudon, Paris: 267, 347, 484, 488, 512; A. Grabar, The Golden Age of Justinian, 1967: 67; The Green Studio Ltd., Dublin: 32, 33, 216, 217, 221–23; L. Grodecki, Gothic Architecture, 1977: 496; Hirmer Verlag, Munich: 1, 7, 8, 13, 15, 24, 42, 44, 55, 60, 69, 72, 80, 99, 100, 103, 105, 107, 109a–b, 121, 127, 129, 131, 145, 146, 149, 162, 183, 194, 204, 316, 348, 437, 462, 476, 493, 498, 543a–b, 551; Irish Tourist Board, New York: 215; Istituto Centrale del Restauro, Archivio Fotografico, Rome: 579, 581; A.F. Kersting, London: 62, 319, 371, 372, 507, 514, 515, 519–23, 525–27, 529, 535; G.E. Kidder Smith, New York: 115, 143, 396, 409; R. Krautheimer, Early Christian and Byzantine Architecture, 1965: 29, 31, 34, 45, 70, 76, 77, 78c, 79, 81, 82, 86, 87, 130, 156, 157; Kungliga Biblioteket, Stockholm: 220; Kunsthistorisches Museum, Vienna: 250; E. Lehmann, Die frühe deutsche Kirchenbau, 1938: 283; Reproducciones y Ampliciones MAS, Barcelona: 295, 303–5, 309, 310, 313, 318; The Metropolitan Museum of Art, New York: 13, 47, 50, 125, 376, 384, 564, 565; Michigan-Princeton-Alexandria Expedition to Mount Sinai, The University of Michigan, Ann Arbor: 151–53; Ann Munchow, Aachen: 293; Musei Vaticani, Archivio Fotografico, Vatican City: 30; National Gallery of Art, Washington, D.C.: 25, 97, 188, 504, 580; National Museum of Ireland, Dublin: 209, 224; New York Public Library, New York: 439; Oesterreichische Nationalbibliothek, Vienna: 5, 6, 95; Pierpont Morgan Library, New York: 34, 41, 54, 66, 270, 560; Donato Pineider, Florence: 101, 219; Pontificio Istituto di Archaeologia Christiana, Rome: 2–6, 9–11; Josephine Powell, Rome: 142, 169, 174–77, 189; Rev. da Fabbrica di San Pietro, Vatican City: 16; Jean Roubier, Paris: 314, 322, 323, 345, 346, 360–62, 367, 368, 379, 380, 385, 445, 456, 500, 501, 540; San Simpliciano, Parrocchia Prepositurale, Milan: 75; Guido Sansoni, Florence: 8; Scala, Rome: 26, 70, 392, 600; Helga Schmidt-Glassner, Stuttgart: 537–39, 547a–b, 552a–b; A.M. Schneider, Die Hagia Sophia zu Constantinopel, 1939: 116; Scottish Development Department, Historic Buildings and Monuments, Edinburgh: 225; Service Photographique, Paris: 11, 67, 566; Staatliche Museen, Berlin: 297; Stadtsbibliothek, Trier: 266; Wim Swaan, New York: 12, 42, 56–61, 63, 64, 201, 308, 312, 329, 334, 351, 355, 356, 388, 405–7, 412, 418, 421, 441, 457, 464, 468, 475, 479, 480, 494, 502, 503, 518, 528, 531, 532, 534, 545, 546; W. Swaan, The Gothic Cathedral, 1969: 453; J. Toynbee and J.W. Perkins, The Shrine of St. Peter and the Vatican Excavations, 1956: 35; Marvin Trachtenberg, New York: 133, 402, 404, 452, 455, 506; Trinity College Library, Cambridge, Eng.: 276; Utrecht Bibliotheek der Rijksuniversiteit, Utrecht: 253–56, 267; Victoria and Albert Museum, London: 268, 428; Leonard von Matt, Buochs: 10, 15–18, 43, 44, 112–14, 134–39, 141, 274, 315, 422, 574; Walters Art Gallery, Baltimore: 29, 451, 567, 568; Warburg Institute, University of London: 226; Clarence Ward, Oberlin: 473, 486; G. Webb, Architecture in Britain: The Middle Ages, 1956: 373, 516, 524; Prof. Kurt Weitzmann, Princeton University: 165; C.A. Willemsen, Kaiser Friedrichs II Triumphtor zu Capua, 1953: 569; J. Wilpert, Die römischen Mosaiken und Malereien der kirchlichen Bauten von IV. bis XIII. Jahrhundert, 1916: 64b; Yale University Art Gallery, Dura-Europos Collection, New Haven: 19, 24; YAN Photo-Dieuziade, Toulouse: 321, 326–28.

Maps on pages 8–12 by Joseph P. Ascherl.